W9-ATB-154

A Gift to America

Masterpieces of European Painting

from the Samuel H. Kress Collection

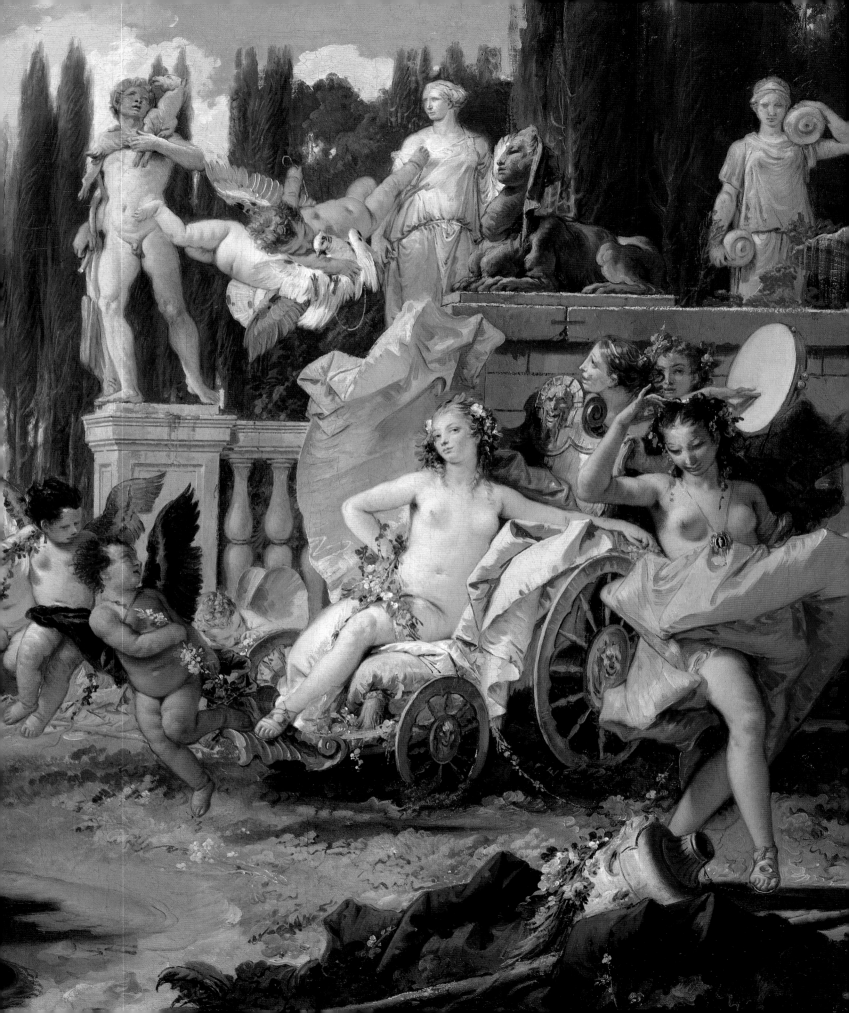

A Gift to America

———⬦———

Masterpieces of European Painting
from the Samuel H. Kress Collection

CHIYO ISHIKAWA

LYNN FEDERLE ORR

GEORGE T. M. SHACKELFORD

DAVID STEEL

with essays by Marilyn Perry
and Edgar Peters Bowron

Harry N. Abrams, Inc., in association with the North Carolina Museum of Art; The Museum of
Fine Arts, Houston; the Seattle Art Museum; and The Fine Arts Museums of San Francisco

Editor
Margaret Rennolds Chace
Harry N. Abrams, Inc.

Designer
Katharine Douglass
North Carolina Museum of Art Design Department

Published on the occasion of the exhibition "A Gift to America: Masterpieces of European Painting from the Samuel H. Kress Collection," organized jointly by the North Carolina Museum of Art; The Museum of Fine Arts, Houston; the Seattle Art Museum; and The Fine Arts Museums of San Francisco.

This exhibition and catalogue have been made possible by generous grants from the Samuel H. Kress Foundation. Additional funding has been provided by the National Endowment for the Arts and Sotheby's, New York.

Exhibition Itinerary

North Carolina Museum of Art
Raleigh, North Carolina
February 5–April 24, 1994

The Museum of Fine Arts, Houston
Houston, Texas
May 22–August 14, 1994

Seattle Art Museum
Seattle, Washington
September 15–November 20, 1994

The Fine Arts Museums of San Francisco
San Francisco, California
December 17, 1994–March 4, 1995

Library of Congress Cataloging-in-Publication Data

A Gift to America: masterpieces of European painting from the Samuel H. Kress
Collection / catalogue entries by Chiyo Ishikawa . . . [et al.].
p. cm.
"In association with the North Carolina Museum of Art, The Museum of Fine Arts
Houston, the Seattle Art Museum, and The Fine Arts Museums of San Francisco."
Includes bibliographical references and index.
ISBN 0–8109–3383–7
1. Painting, European—Exhibitions. 2. Painting, Modern—Europe—Exhibitions.
3. Kress, Samuel Henry, 1863–1955—Art collections—Exhibitions. 4. Painting—
Private collections—United States—Exhibitions. I. Ishikawa, Chiyo. II. Title:
Samuel H. Kress Collection.
ND454.G44 1994
759.94'074'73—dc20 93–23102
ISBN 0–8109–2562–1 (mus. pbk.) CIP

Published in 1994 by Harry N. Abrams, Incorporated, New York
A Times Mirror Company

Frontispiece: Giovanni Battista Tiepolo, *The Empire of Flora* (detail of cat. 48).
Page 11: Gerrit van Honthorst, *Shepherdess Adorned with Flowers* (detail of cat. 22).
Page 61: Pompeo Girolamo Batoni, *The Triumph of Venice* (detail of cat. 45).

Contents

Lenders to the Exhibition

Allentown Art Museum

Birmingham Museum of Art

Columbia Museum of Art

El Paso Museum of Art

The Fine Arts Museums of San Francisco

High Museum of Art, Atlanta

Memphis Brooks Museum of Art

The Metropolitan Museum of Art, New York

Musée du Louvre, Paris

The Museum of Fine Arts, Houston

National Gallery of Art, Washington

The Nelson-Atkins Museum of Art, Kansas City, Missouri

New Orleans Museum of Art

North Carolina Museum of Art, Raleigh

The Philbrook Museum of Art, Tulsa

Seattle Art Museum

University of Arizona Museum of Art, Tucson

Directors' Preface

This exhibition of superb Old Master paintings, "A Gift to America: Masterpieces of European Painting from the Samuel H. Kress Collection," celebrates the vision and philanthropy of one man. In a series of donations from the 1930s into the 1960s, Samuel Kress and the Kress Foundation, under the direction of his brother Rush H. Kress, presented almost three thousand works of European art to ninety-six museums, universities, and other institutions across America, significantly changing the cultural terrain of the country. Viewed together, these donations constitute the single most important gift of art in the nation's history. Kress gifts enriched the National Gallery of Art in Washington (which received 376 European paintings, 94 sculptures, 1,307 bronzes, and 38 prints and drawings), but scores of smaller institutions also benefited from Kress donations that either formed the core of nascent European holdings or greatly enhanced established collections.

Principal recipients of Kress largesse, our four museums have collaborated on presenting this exhibition. Collectively we have sought to acknowledge Samuel Kress the philanthropist and to share with our various audiences some of the outstanding European Old Master paintings that Kress the collector brought together and then gave to museums beyond the art-rich eastern corridor.

From the first, this splendid exhibition has been a cooperative effort of the staffs of our four institutions. Curators Chiyo Ishikawa (Seattle), Lynn Orr (San Francisco), George Shackelford (Houston), and David Steel (Raleigh) have worked together to develop the scope and specific content of the exhibition and this accompanying catalogue. The complex and lengthy organizational tasks, which are required to bring any exhibition to fruition, have been shared among the four museums.

In this endeavor the organizing museums have been greatly aided by the constant encouragement and support of the Samuel H. Kress Foundation in New York. Foundation President Marilyn Perry has been an unwavering and enthusiastic supporter of this exhibition project and has herself contributed to the catalogue an engrossing essay on Kress's taste and collecting activities. The place of Samuel Kress in the American history of collecting Old Master paintings, particularly his pursuit of Italian Baroque works, which anticipated by at least twenty years later trends in the art market, is discussed in a lively essay by Edgar Peters Bowron, Senior Curator of Paintings at the National Gallery of Art.

Additional staff members at the Kress Foundation, including Lisa M. Ackerman, Chief Administrative Officer, Gail Bartley, Assistant for Foundation Archives, and Sheila McInerney, Fellowship Program Administrator, have been exceedingly helpful in many aspects of preparation of this exhibition and the accompanying catalogue. Special acknowledgment and gratitude are also due to Mario Modestini, Conservator Emeritus, and Dianne Dwyer Modestini, Conservation Consultant for the Kress Collection, who have generously shared their technical expertise and intimate knowledge of the Kress paintings with the exhibition's organizers. In addition to all these individual contributions from the Kress Foundation staff, it must be noted that the foundation has also supported "A Gift to America" with a substantial grant to help defray the cost of the exhibition and catalogue research. We extend to all those at the Kress Foundation our deepest appreciation for their unfaltering support.

Assistance has also come from the National Endowment for the Arts, which underwrote the exhibition with a generous grant. In addition, Sotheby's, New York, gave funds toward the preparation of the exhibition catalogue, as part of its ongoing program to support scholarship within the museum community. It is only through such generosity that American museums can continue to present exhibitions of such high quality to their audiences. Thus with sincere gratitude and appreciation we thank these corporations and granting agencies that promote America's cultural life.

And finally we wish to acknowledge the lenders to the exhibition. Samuel Kress's contribution to our country's artistic heritage is illustrated here with paintings lent from many of America's most prestigious museums. To each of them we extend our deepest appreciation.

Richard S. Schneiderman
North Carolina Museum of Art

Peter Marzio
The Museum of Fine Arts, Houston

Jay Gates
Seattle Art Museum

Harry S. Parker III
The Fine Arts Museums of San Francisco

Acknowledgments

———⦿———

The Kress Collection spans the North American continent. It is fitting, then, that this exhibition of its masterpieces is the result of the planning and effort of people across the United States. In its present form, the exhibition was conceived by David Steel in Raleigh, with encouragement from his colleagues Susan Barnes in Raleigh, Roger Ward in Kansas City, Nora Desloge in San Diego, and George Shackelford in Houston. About the same time, Chiyo Ishikawa in Seattle made plans for a comparable exhibition, which was proposed to the directors and curators of the museums now participating in this collaborative venture. Curators from Raleigh, Houston, and Seattle were joined by Lynn Federle Orr of San Francisco in 1991 and, since then, have worked together to bring the project to its happy conclusion.

From the beginning, the exhibition has received the enthusiastic support of the Samuel H. Kress Foundation. To the Trustees of the foundation, and especially to Franklin Murphy, former Chairman, we owe a great debt. We particularly want to thank Marilyn Perry, President, and Lisa Ackerman, Chief Administrative Officer, for their help at every stage of our planning. Thanks also go to Gail Bartley and Sheila McInerney for their help with catalogue research. We are especially grateful for the expert advice and encouragement of Mario and Dianne Dwyer Modestini, who have skillfully treated a number of paintings in the exhibition. Jocelyn Kress has shared our enthusiasm for the collections formed by her uncle Samuel H. Kress and by her father, Rush H. Kress, without whose vision, after all, none of this would have been possible.

Dr. Perry and Edgar Peters Bowron, Senior Curator of Paintings of the National Gallery of Art, contributed insightful essays to this catalogue. With them, we wish to thank Paul Gottlieb, Samuel N. Antupit, and Margaret R. Chace of Harry N. Abrams, Inc., for their lively interest in the book and for their help in assuring its publication and distribution. The catalogue's handsome design was the work of Katharine Douglass of the North Carolina Museum of Art.

The museums across America that have benefited from the Kress Foundation's generosity have been generous and gracious to us in the long and fascinating process of assembling works for the exhibition and preparing its catalogue. The directors, curators, and staff members of each of the Kress regional galleries, many of which are lenders to the exhibition, deserve our warmest thanks. We would particularly like to recognize at the Allentown Art Museum: Peter F. Blume, Sarah Anne McNear, Patricia Delluva; at The University of Arizona Museum of Art: Peter Bermingham, Peter S. Briggs, Betsy Hughes; at the Birmingham Museum of Art: John E. Schloder, John Wetenhall, Donna Antoon; at the Columbia Museum of Art: Salvatore G. Cilella, Jr., Lin Nelson-Mayson, Kevin Tucker; at the Denver Art Museum: Lewis I. Sharp, Timothy Standring, Tony Wright, Ronald Otsuka; at the El Paso Museum of Art: Becky Duval Reese, Kevin Donovan, Stephen Vollmer; at the High Museum of Art: Ned Rifkin, Ronni Baer, Frances Francis; at the Honolulu Academy of Fine Arts: George R. Ellis, Jennifer Saville; at the Lowe Art Museum: Brian Dursum, Perri Lee Roberts; at the Memphis Brooks Museum of Art: E. A. Carmean, Alexander Gaudieri, Michelle O'Malley, Patricia Bladon, Kip Peterson, Marilyn Masler; at the Nelson-Atkins Museum of Art: Marc F. Wilson, Roger Ward, Eliot Rowlands, Ann Erbacher; at the New Orleans Museum of Art: E. John Bullard, Bill Fagaly, Paul Tarver, Denise Klingman; at the Philbrook Museum of Art: Marcia Manhart, Richard Townsend, Christine Knop Kallenberger; and at the Portland Art Museum: Dan Monroe, Philip Bogue, and Marc Pence.

We owe special thanks to our colleagues at the National Gallery of Art, Washington, including J. Carter Brown, Earl A. Powell III, David Bull, Charles S. Moffett, E. Peters

Bowron, Arthur K. Wheelock, Diane DeGrazia, David Brown, Gretchen Hirschauer, C. Douglas Lewis, Maygene Daniels, Nancy Yeide, Ruth Philbrick, Jerry Mallick, Karen Weinberger, Barbara Bernard, Stephanie Belt, Eric Denker, Mary Suzor, Dennis Weller, Megan Teare, Grace Eleazer, Gregory P. J. Most, Lamia Doumato, George T. Dalziel, Frances P. Lederer, and Andrew Krieger.

We are also grateful to Michel Laclotte and Pierre Rosenberg of the Musée du Louvre for their willingness to lend back to America a painting formerly in the Kress Collection —and before that the property of the kings of France—by Pier Francesco Mola (cat. 32). For their friendly cooperation, we owe a debt of gratitude to Philippe de Montebello, Walter Liedtke, Yvette Bruijnen, Els Vlieger, and John Buchanan at The Metropolitan Museum of Art, New York.

In preparing the exhibition and its catalogue, the curators and essayists have benefited from the advice and assistance of many other colleagues, including: David Alexander, Maxwell L. Anderson, Colin Bailey, Joseph Baillio, Audrey Jones Beck, Ronald Cohen, Tracy Cooper, David Park Curry, Hugo Douwes Dekker, Melissa De Medeiros, Robert Echols, Colin Eisler, Lorenz Eitner, Larry Feinberg, Fausta Franchini Guelfi, Michael Gallagher, Maria Gilbert, Valerie Hart, William F. Jordan, Alison Kettering, George Keyes, Ann Leary, Thomas P. Lee, Jr., Mark Leonard, Robert Manning, Paola Marini, Cheryl Minard, Hans Naef, Lawrence Nichols, Eric Domela Nieuwenhuis, Roger Rearick, Karen E. Schaffers-Bodenhausen, Sarah Schroth, Gerry Scott, Peter Sutton, Carol Togneri, Peter van den Brink, William Wallace, James Welu, Betsy Wieseman, Scott Wilcox, Thomas Willette, Carolyn Wilson, and Alison Zucrow. The staffs of the libraries at our museums, at the National Gallery of Art, at the Getty Center for the History of Art and the Humanities and at the Getty Provenance Index, at the University of Washington, and at Stanford University have been unfailingly helpful in our research.

As always, we owe the greatest thanks to the many people with whom we work every day. At the North Carolina Museum of Art, we would like to thank: Paula Mehlhop, Katharine Douglass, John Coffey, Lisa Eveleigh, Richard Schneiderman, Judy Kim, Anna Dvořák, R. Douglas Penick, Peggy Jo Kirby, Carrie Hedrick, Anne Jones, Bert Armstrong, Tony Janson, David Findley, Bill Brown, David Beaudin, David Goist, Bill Gage, Lynn Ruck, Dan Gottlieb, Mary Humphrey, Graham McKinney, Joseph Covington, Hal McKinney, Anna Upchurch, and Theda Tiffany. Many thanks to Diane Harrell of Marathon Typography for her extraordinary work on the type for this catalogue.

At The Museum of Fine Arts, Houston: Emily Ballew Neff, Ashley Scott, and Clifford Edwards, as well as Celeste Adams, Charles Carroll, Mary Christian, Kathleen Crain, Jeannette Dixon, Tom DuBrock, Jack Eby, Alison Eckman, Karyn Galetka, Gwendolyn Goffe, Tammie Kahn, Peter Marzio, Barbara Michels, Wynne Phelan, Gregory J. Rice, Beth Schneider, Margaret Skidmore, Marcia K. Stein, and Karen Bremer Vetter.

At the Seattle Art Museum, special thanks go to Patterson Sims, Gail Joice, Philip Stoiber, Vicki Halper, Zora Hutlova Foy, Helen Abbott, Riva Davis, Susan McKinney, Michael McCafferty, Nanette Pyne, Jill Rullkoetter, Laura Kearney, Elizabeth DeFato, Paul Macapia, Susan Dirk, Torie Stratton, Heather McLeland, and Jacquelyn Leone-Pleasant.

At The Fine Arts Museums of San Francisco: Marion C. Stewart, Elise Breall, Ann Heath Karlstrom, Debra Pughe, Therese Chen-Huggins, Bill White, Virginia Kelly, Ron Rick, Bill Huggins, Cynthia Lawrence, Jennifer Sherman, Carl Grimm, Melissa Leventon, Lois Gordon, Linda Jablon, and Steven Nash.

Finally, we would like to thank the people who are closest to us for all their patience, support, and love. We would like to dedicate our work to our loved ones, including Daryl, Jesse, and Ben Steel; Moore Murray; and Dick, Lucy, and Nap Cantwell.

Chiyo Ishikawa
Seattle Art Museum

Lynn Federle Orr
The Fine Arts Museums of San Francisco

George Shackelford
The Museum of Fine Arts, Houston

David Steel
North Carolina Museum of Art

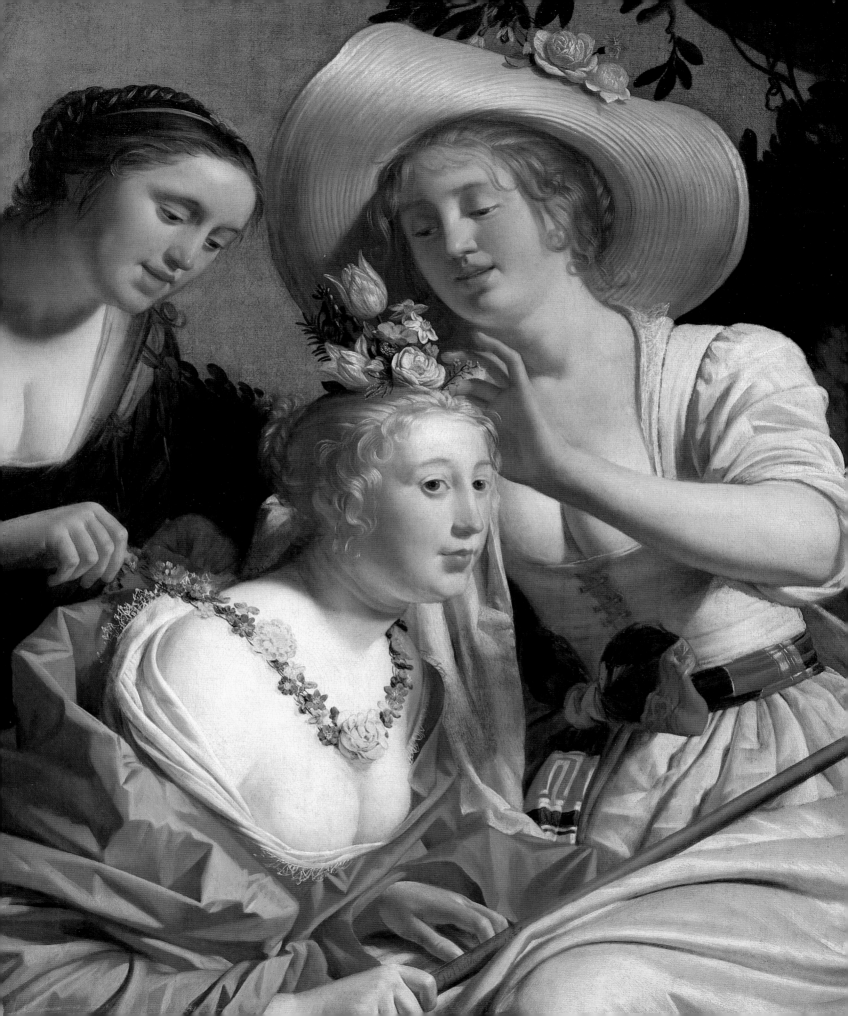

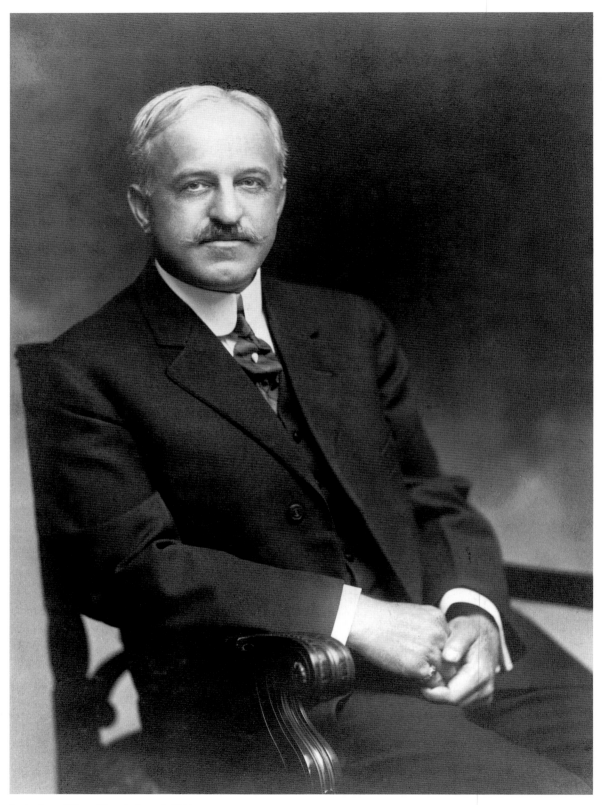

fig. 1 Samuel Henry Kress in the early 1900s.

The Kress Collection

by Marilyn Perry

"I congratulate you that such a splendid collection has come to Houston and I feel, as you do, a deep sense of gratitude for what Mr. Samuel Kress and his brother, Mr. Rush Kress, and the Kress Foundation are doing for your city and for the cause of art throughout the United States. The program on which the Kress Foundation is engaged is nation-wide in extent and based upon a far-seeing and generous conception of the country's needs in the field of art. Furthermore, it is a program that is unique in any country in any period of the world's history."

David E. Finley, Director of the National Gallery of Art, Washington, on the presentation of the Samuel H. Kress Regional Collection to The Museum of Fine Arts, Houston, October 1, 1953

"When, some five years ago during our first discussions about a Samuel H. Kress Collection in San Francisco, Mr. Rush H. Kress asked me what specific desires we had for its contents, I answered that we had no particular program, except to get works of art of the highest quality. Somewhat facetiously I added that what we really would like to see in San Francisco was a 'Miniature National Gallery,' that is to say, a Kress Collection like the one in our big sister institution in Washington which covers the entire field of European painting from the end of the Middle Ages to the threshold of modern art. . . . Mr. Kress liked and accepted the idea. But no one could have foreseen at that time how well it has since been brought to realization."

Walter Heil, Director of the M. H. de Young Memorial Museum, San Francisco, accepting the Samuel H. Kress Regional Collection, February 19, 1955

"The Trustees of the Samuel H. Kress Foundation have recognized the importance of art in the life of every human being. As a result of the gifts which will be made here this evening of these collections of painting and sculpture, millions of people will gain an insight into values that lie beyond the reach of time."

Earl Warren, Chief Justice of the United States and Chairman of the Board of the National Gallery of Art, Washington, on the presentation of deeds of gift for the Samuel H. Kress Collection, December 9, 1961

Life magazine called it "The Great Kress Giveaway"—a fortune in European art amassed from the nation's nickels and dimes and bestowed on museums and galleries across the country to enrich the cultural life of the people.[1] The donor, Samuel H. Kress (1863–1955), self-made founder of the vast chain of S. H. Kress & Co. variety stores, dedicated collector of Italian art, and generous benefactor of the National Gallery of Art in Washington, was customarily de-

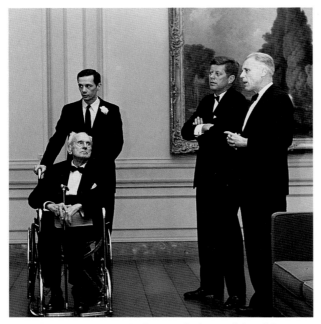

fig. 2 The inauguration of "Art Treasures for America," the exhibition celebrating the completion of the Kress Collection, at the National Gallery of Art in Washington on December 9, 1961. Pictured here are the president of the Samuel H. Kress Foundation, Rush H. Kress (in wheelchair), President John F. Kennedy, and John Walker, director of the National Gallery of Art.

scribed as a modern merchant prince in the Renaissance mode, an American Medici. On his death in 1955, *Time* magazine praised him as "Collector No. 1."[2]

Thirty years ago, the story was as familiar as the superlatives were deserved. As the 1950s drew to a close, the nation's premier collection of European art from the thirteenth to the nineteenth century—in round numbers, almost 3,000 objects, including more than 1,400 Old Master paintings, 150 works of Italian and French sculpture, 1,300 Italian bronzes, and a wealth of important frames, furniture, tapestries, porcelains, and other decorative pieces—was in the final phases of distribution throughout the United States, in preference to being settled in a purpose-built Kress Museum. A heady, extravagant, uniquely American adventure in the long history of great art collections—and a sublime gesture in art philanthropy—was drawing to an end.

The grand finale of the Kress Collection was celebrated in December 1961 with a series of events at the National Gallery of Art, the museum most deeply indebted to Kress munificence. Since its founding twenty years before, the National Gallery had been so enriched with major Kress benefactions that they by then numbered more than a third of the works of art on view. Most extensive were the great Italian masters, including—to select from the most familiar names—Cimabue, Duccio, Giotto, Botticelli, Fra Angelico, Filippo Lippi, Verrocchio, Raphael, Andrea del Sarto, Pontormo, Correggio, Bellini, Carpaccio, Giorgione, Titian, Lotto, Tintoretto, Veronese, Bernini, Strozzi, Tiepolo, Canaletto. In addition, a wonderful group of early German artists (Dürer, Grünewald, Altdorfer, Holbein, Cranach), a stellar company of seventeenth- and eighteenth-century French painters and sculptors (Poussin, Claude, Watteau, Chardin, Boucher, Fragonard, Houdon, David, Ingres), and important Flemish and Spanish artists (Petrus Christus, Bosch, Memling, El Greco, Rubens, Van Dyck, Zurbarán, Goya) also shared the distinction of being part of "The Samuel H. Kress Collection."[3] No fewer than thirty-four galleries in the vast marble temple to art in the nation's capital were devoted to the display of Kress treasures.[4]

Beyond Washington, an even larger number of spacious new fireproof, air-conditioned galleries in eighteen selected museums from Pennsylvania to Hawaii were similarly dedicated to more than six hundred other European paintings in the Kress Collection. From these reservoirs of Old Masters —the Kress regional galleries—ninety-six pictures had been chosen for a representative six-week exhibition, "Art Treasures for America," at the National Gallery. On loan from their distant homes were works by Rembrandt and Jan Steen (Allentown), Tiepolo and Sebastiano Ricci (Atlanta), Paris Bordon and Jacopo del Sellaio (Birmingham), Magnasco and Guardi (Columbia, South Carolina), Isenbrandt and Jordaens (Coral Gables), early German and Spanish masters (Denver), Canaletto and Bellotto (El Paso), Moroni and Salviati (Honolulu), Gentileschi and Murillo (Houston), Bernardo Daddi and Lippo Memmi (Kansas City, Missouri), Romanino and Canaletto (Memphis), Lotto and Veronese (New Orleans), Ghirlandaio and Strozzi (Portland, Oregon), Giotto and Botticelli (Raleigh), El Greco and Goya (San Francisco), Honthorst and Rubens (Seattle), Piazzetta and Vigée Le Brun (Tucson), Carpaccio and Tanzio da Varallo (Tulsa), plus another sixty more. Joined by a selection of decorative arts objects and the immense Kress holdings in the National Gallery's permanent collection, this was the largest-ever display of the Kress Collection, a visual feast to commemorate an unparalleled event.

On the evening of December 9, 1961, the elite of America's art establishment dined at Washington's best addresses and proceeded to the black-tie opening of the exhibition in the company of President John F. Kennedy (*fig. 2*). The brilliance and abundance of the art gave a special exhilaration to the ceremony in the auditorium that celebrated the accomplishment of the Kress Collection.

The guests were welcomed by the chairman of the National Gallery, Chief Justice Earl Warren, and by the president of the Samuel H. Kress Foundation, Rush H. Kress, the founder's brother. On behalf of the Kress Foundation, the chairman of the Executive Committee, Dr. Franklin D. Murphy, spoke of the bold vision of Samuel H. Kress —"at once vigorous, determined, sensitive and imaginative . . . who dared to dream that Americans from Washington to Honolulu and from New York to El Paso would have the opportunity to explore the genius of the artist in qualitative terms and at first hand." Owing to the Kress donations, "a significant segment of the artistic flowering of western Europe" would henceforth permanently belong to American institutions. "What we here do tonight is comparable to few other such acts in history—indeed, it invokes the memory of the day when Anna Maria Louisa of Tuscany and the Palatinate so richly endowed the Tuscan State."[5]

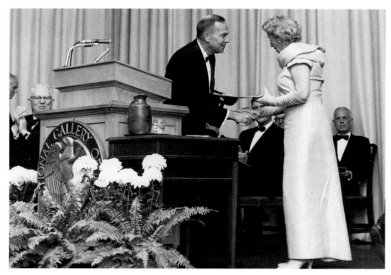

fig. 3 At the National Gallery of Art, December 9, 1961, Dr. Franklin D. Murphy, chairman of the executive committee of the Samuel H. Kress Foundation, presents Phyllis de Young Tucker with a deed of gift for the works of art in the Kress regional collection at the M. H. de Young Memorial Museum in San Francisco. Chief Justice Earl Warren, the chairman of the National Gallery, is visible at the left.

Deeds for gifts of art—from twenty to sixty Old Masters each—were presented to representatives from the eighteen museums in the Kress regional galleries program to establish a core collection of fine European paintings (a Kress regional collection) in their part of the country (*fig. 3*). With additional gifts of Kress study collections to twenty-three colleges and universities, and major gifts of special collections to the Metropolitan Museum of Art (French porcelains and furniture, and a complete Robert Adam room with Gobelins tapestries), the Pierpont Morgan Library (a bound volume of drawings by Piazzetta and rare illuminated manuscripts), the Philadelphia Museum of Art (a reunited set of tapestries designed by Rubens and Pietro da Cortona), and—above all—the immense donation to the National Gallery of Art, most of the Kress Collection was now the property of forty-five institutions in twenty-nine states, Puerto Rico, and the District of Columbia. A patrimony of priceless European art, loosely assessed in value in 1960 at more than $100 million, was henceforth the inalienable possession of "all the people of the land."[6]

SAMUEL H. KRESS AND THE ORIGINS OF THE KRESS COLLECTION

Contemporary biographical sketches of Samuel H. Kress typically divided his life into three distinct phases: the hard-won struggles of his youth in rural Pennsylvania, the brilliance of his mercantile success with the S. H. Kress & Co. variety stores, and the extraordinary philanthropy associated with his incomparable collection of Italian art. The Kress story, once common knowledge, epitomized American opportunity and the recognized virtues of stern discipline, vigorous hard work, and patriotic generosity.

Nothing in his background predicted future prominence as a collector of European—or even less, Italian—art. Descended from German and Irish immigrants of the 1750s, Samuel Henry Kress was the second of seven children of a modestly prosperous family in Cherryville, Pennsylvania (*fig. 4*). Born in the midst of the Civil War on July 23, 1863, he was named for an uncle recently slain at Gettysburg. A studious and enterprising lad, from the age of seventeen he taught in a one-room schoolhouse for $25 a month. Seven years later, his savings made him the proud owner of a small stationery and notions shop, and three years later a wholesaler's. In retailing he discovered his calling.[7]

Sam Kress was thirty-three when the first S. H. Kress & Co. Five- and Ten-Cent store opened its doors in Memphis, Tennessee, in the spring of 1896 to a grateful public that virtually bought out the stock (*fig. 5*). The instant success was based on two shrewd calculations: the viability of selling quality merchandise at fixed low prices by cutting out the middlemen (a significant refinement of Woolworth's pioneering scheme), and the economic future of the under-

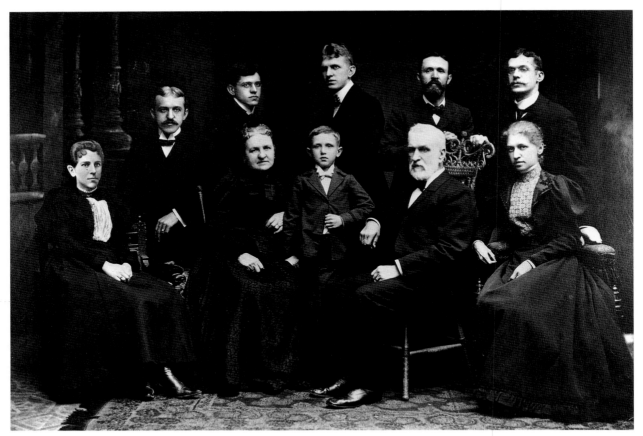

fig. 4 The family of John Franklin Kress and Margaret Connor Kress, photographed in Cherryville, Pennsylvania, in the mid-1890s. In the back row are sons Samuel, Rush, and Claude Kress, son-in-law John Williams, and son Palmer. In the front are Palmer's wife Helen, mother Margaret, grandson Earl Williams, father John, and daughter Mary Kress Williams.

served South. By the century's end, bright red Kress store-fronts beckoned to shoppers in a dozen southern cities; when S. H. Kress & Co. incorporated in New York in 1907, the nickels, dimes, and quarters spent annually at fifty-one Kress stores totaled well over $3 million.[8] Personally super-vising his growing empire, the forty-four-year-old founder and president spent his days in his stores and his nights in a Pullman sleeping car.

Like so much else in the Kress story, it is difficult, now, to recapture the adventure of "going to Kress's" in the early decades of this century, before radio and the automobile shattered the isolation of American communities. Few com-mercial buildings were as architecturally imposing—or as beloved—as the main street "Dime Store," an emporium of assorted merchandise at inexpensive prices that met all needs, from the practical (shelf paper and bobby pins), to the social (the soda fountain), to the celestial (rhinestone earrings).[9] Well stocked, well priced, and well run, the pop-ular S. H. Kress & Co. chain expanded during the founder's

lifetime to 264 stores throughout the South and the West.[10] As his name became a household word, the former $25-a-month schoolteacher joined the ranks of America's wealthiest men (*fig. 1*).

Although he lived well out of the public eye, by the mid-1920s the rewards of success were apparent in Samuel Kress's personal life, most notably in a new and consuming fascination with early Italian art. A confirmed bachelor, he created a home that replicated an Italian palazzo in a grand Fifth Avenue apartment across from the Metropolitan Museum of Art and filled it with fine paintings, sculpture, and furnishings from Italy. The tone—and the scale—befit a merchant prince with an expanding collection of art (*fig. 6*).[11]

Credit is given to his friend Delora Kilvert, "the cultured and beautiful ex-wife of an American illustrator," for inclining Samuel Kress's interest toward European travel and art.[12] She may also have introduced him to Count Alessandro and Countess Vittoria Contini-Bonacossi,

recently ennobled Italian collector/dealers whose capacity to discover available Old Masters, especially of the Italian schools, became the wellspring of the Kress Collection. Together they conceived the ambitious, improbable project of acquiring a fine work by every known Italian master. The outcome would be the most comprehensive collection of Italian paintings ever assembled.

The new pursuit was especially timely for Kress. Confident of the future of S. H. Kress & Co. under the leadership of his younger brothers Claude and Rush, he retained the chairmanship but relinquished daily responsibilities.[13] Concern for his health led him to European spas and specialists, and perhaps to the discovery of European museums. Sometime in his mid-sixties, the American retailer began to turn his leisure, his vast resources, and his formidable business acumen to the collecting of Italian art.

Coincidentally, there was also the fascination of dealing with Contini-Bonacossi. Similar in temperament—both men were notably taciturn—they formed a complicated personal and business relationship that went far beyond the

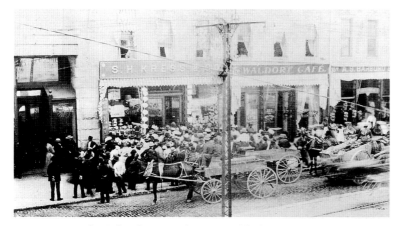

fig. 5 Crowds awaiting the opening of the first S. H. Kress & Co. store in Memphis, Tennessee, on April 18, 1896.

normal transactions between collector and dealer and lasted to the end of their lives (in the same year). Fifteen years younger and also self-made, Alessandro Contini (1878–1955) rose from modest half-Jewish/half-noble origins in Ancona to brilliant success as a dealer, progressing rapidly from postage stamps to Old Masters. He was widely traveled, well connected, and well established in the highest Fascist circles. Rewarded with the titles of Count (Bonacossi was his mother's name) and Senator, by the late 1920s Contini had also acquired a magnificent villa in a large park in the heart of Florence and an impressive personal collection of art.

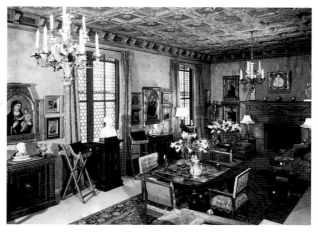

fig. 6 The *salone* of Samuel Kress's seventeen-room apartment on Fifth Avenue as it appeared in the late 1930s with works of art from the Kress Collection on display.

The achievements of "The Count," as Kress affectionately referred to him, owed much to his wife's talents. The perfect foil for her husband, the small, energetic, intelligent, and high-spirited Countess Vittoria (1872–1949) took a very active role in their operations, from selecting paintings to entertaining clients and even masterminding sales strategies. Her charm and spirit were especially valuable in the fervent social and financial interplay that became the pattern in transactions with Kress.

Angling for American millionaires, the Contini-Bonacossi would sail to New York in the spring of the year with selections from their inventory. During one such sojourn from early April to mid-June 1932, the countess kept a private diary, recording her daily life amidst the absurdity of the Prohibition and the anxiety of severe economic depression.[14] Established with their pictures in a suite on the twenty-first floor of the Pierre Hotel (with a terrace overlooking the park), the couple passed their time in society, entertaining and being entertained on a grand scale. Friends took them to the opera, the circus, the Empire Club, the Cotton Club; they were introduced to the mayor; they visited museums and galleries and dealers. Their great and almost only hope was their friend Kress (*l'amico Kress*), a constant presence with gifts of whiskey and flowers, the loan of his Rolls-Royce, and reciprocal invitations to dinner, luncheon, and tea. They visited his home, his business headquarters, his paintings storage. They admired again his collection of nearly two hundred pictures purchased from them in the past. And in vain they awaited a sign.

A month of parties, of dressing up, of amusing conversation, of miserable food ("*addio stomaco mio*," she sighed after one particularly awful meal) brought no response from Kress

(nor from Felix Warburg, another former client). Admiring American efficiency, she despaired for the American soul. A visit to Boston produced enthusiasm but no orders. Delora Kilvert returned to New York; *à quatre* they dined at the Kress apartment (beautiful flowers, more bad food), picnicked together in the country, visited a private club in a former Rockefeller mansion (not as beautiful as their villa in Florence), dined at what Kress asserted to be the best restaurant in New Jersey (another deplorable meal).

After two months there was still no end to the silent struggle as they again lunched with *caro Kress* (dear Kress), awaited visits from his agent, responded to his calls. Advising her husband, Donna Vittoria tried to remain calm and determined, despite their increasing desperation. Another two weeks passed. At last Kress took paintings in exchange and on approval. The Contini delayed their departure. An entire day was spent in negotiations; after supper the following evening they were still in discussion, and might again miss their sailing. But all was resolved, well enough, at the end. With enormous relief she arranged their departure the next afternoon. *"Sempre avanti. Addio New York."* ("Ever onward. Farewell, New York.")

Such were the social and psychological winds that whirled about the exchange of art for money at the vortex of the Kress/Contini relationship. The intensity and complexity of their dealings are likewise visible in the more mundane written evidence—the invoices and lists, the authentications and X-ray reports, the notes of loans and payments, of pictures returned or price reductions credited—that chronicle their transactions from 1927 to 1941. Perused en masse, the documents make an extraordinary impression, not only for the intricacies of the dealings but also for the sheer quantity of the works involved.

Even a summary is complicated. In 1932, to remain in the same year, Contini submitted several invoices to Kress for pictures attributed to both familiar and less familiar artists. For example, the bills from late winter list works by Matteo Balducci, Bronzino, Carpaccio, Cornelius de Vos, Correggio, Crespi, Bernardo Daddi, Dosso Dossi, Gaudenzio Ferrari, Domenico Fetti, Franciabigio, Garofalo, Vittore Ghislandi, Giovanni da Milano, Bernardino Licinio, Filippino Lippi, Lorenzo Lotto, Francesco Salviati, Paolo Schiavo, G. B. Tiepolo, Jacopo Tintoretto, Ugolino da Siena, Van Dyck, Bonifazio Veronese, Bartolomeo Vivarini, and several unidentified early masters. Altogether, during this one year Kress purchased forty-six paintings (guaranteed by Contini for stated condition and attributions) and a few

other works of art for a total of $1,060,200, free of export duty. At the same time, Kress negotiated returns, reductions, and credits on previous purchases, loans, and expenses amounting to $568,680. And of course the negotiations did not end there. Notes in red ink on the bills of sale record that in subsequent years Kress received credits on his 1932 purchases of $42,000 and returned two pictures (a Carpaccio *Portrait of a Boy* and a Lotto *Portrait of a Woman*) for another $24,000 credit. A Giorgione *Venus and Cupid with Landscape*, priced at $90,000, was eventually reduced to the value of a $60,000 loan. Not to be quantified were the constant negotiations, the indecisions, the renegotiations —in Donna Vittoria's phrase, *"la contraietà negli affari!"* ("the contrariness of business!")

Since Kress sought to acquire well-documented works, Contini's invoices made reference to notable provenances, including, in the 1932 group, pictures from the collections of Prince Barberini in Rome, Prince Giovanelli in Venice, Marchese Doria in Genoa, and other distinguished families in Milan, Florence, and Sicily. North of the Alps, the dealer's nets gathered Italian art from as far afield as England, Germany, and even the Soviet Union. As always in periods of unrest, the sheer availability of long-held works of art betrayed the adversity of the time.

Regarding the scope of the growing Kress Collection, it should be borne in mind that in the early decades of this century the beauties of Italian art were largely unfamiliar except to a small circle of predominantly European connoisseurs and historians. Beyond the great European museums, fine examples of a master's work were often widely scattered, travel was laborious, and photographs—if they existed— were at best shadowy *aides-mémoire*. In the United States there were no major public collections of Italian painting outside of Boston, Philadelphia, and New York, where even the Metropolitan Museum of Art, at least in the view of Vittoria Contini-Bonacossi, was shamefully lacking in Italian art.[15]

In this vacuum Kress began to gather examples of the works of as many Italian artists as Contini could make available. An important component of the process, upon which the collector was necessarily dependent, was the authentications provided by a cadre of experts in Italy who wrote appraisals of each painting regarding its subject, provenance, condition, and probable creator.[16] It has been suggested that on occasion these expertises unduly enhanced a picture's qualities, to the advantage of its asking price.[17] If so, this was a risk that Kress found acceptable, since

Contini guaranteed a full refund for any picture falsely attributed, or ill-restored according to expert opinion. All of the evidence suggests a remarkable give-and-take in a market ultimately limited only by the buyer's ambitions and expertise. Kress bought abundantly, but he also bought carefully; he received the protection of authoritative opinion, options for refund or exchange, and the opportunity to employ his inimitable bargaining techniques. The degree of trust in their dealings is indicated by the sizable loans from Kress to Contini, the regular reassessment of prices, the return of paintings for credit, and above all the long association. The creation of the Kress Collection was a continuing, mutual endeavor.

Six paintings in the present exhibition came into Kress's possession between 1927 and 1939, all from Contini's inexhaustible supply. Melchior d'Hondecoeter's *Peacocks* (cat. 27) was an early acquisition as a special gift to the Metropolitan Museum of Art in 1927.[18] Following the 1932 visit to New York chronicled in Vittoria Contini's diary, Kress's purchases from their inventory included Giovanni Battista Tiepolo's *Portrait of a Boy Holding a Book* (cat. 47) from the collection of Viscount di Modrone in Milan. Gian Antonio Guardi's *Holy Family with Saint John the Baptist and Saint Catherine of Alexandria* (cat. 39), previously owned by Princess Galitzin in St. Petersburg, and Veronese's *Baptism of Christ* (cat. 4) were sold to Kress by Contini in 1935, as were Vernet's portrait *The Marchesa Cunegonda Misciattelli with Her Infant and Its Nurse* (cat. 57) in 1936, and Tanzio da Varallo's *Saint John the Baptist in the Wilderness* (cat. 15), from the Roman collection of Count Marinucci, in 1939.

Contini's prewar prices ranged from a few thousand dollars to a high of $175,000 for Van Dyck's *Lady in Black, White and Gold* from the Doria Collection in Genoa, acquired by Kress in 1932 and given a place of honor in his library.[19] Quality pictures with outstanding provenances sold in the range of $30,000–$70,000, but many remarkable paintings were priced at $10,000 or less. These were all, of course, quite considerable sums in a period when—the economic depression aside—a filling lunch might cost twenty-five cents, a decent hotel room five dollars, or a round-trip voyage to Europe not quite two hundred dollars.[20]

By 1935 Kress's confidence and vision began to carry him beyond Contini-Bonacossi, at least on occasion. Late that summer, the merchant indulged in a single purchase that, in the opinion of *Time* magazine, "lifted his little known collection of Italian paintings to front-rank eminence." For $250,000, Kress acquired Duccio di Buoninsegna's *Calling of Saint Peter and Saint Andrew*, one of twenty-four small panels painted for the back of the glorious *Maestà* altarpiece in Siena that is the artist's masterpiece. The previous owner, Clarence Hungerford Mackay, had bought it from Lord Duveen in 1927, and, as reported, now "sold it to Mr. Kress for exactly what he paid for it less the Duveen commission."[21] As usual, Kress had struck a bargain.

Purchases of reliable and cheerful five-, ten-, and twenty-five-cent Kress merchandise continued strongly on the main streets of America throughout the Great Depression, as did the purchases from the more exclusive Contini inventory that arrived from Italy every spring. So ritualized were these dealings that in May 1936, on their sixth New York sojourn, Countess Vittoria was reduced to despair by the unvarying routine of the same friends, invitations, conversation, compliments, and even the same ladies' dresses —"*infine, una vera noia*" ("in truth, a real bore").[22] Perhaps it was some consolation that during the previous nine years Samuel Kress had acquired almost four hundred Old Master paintings, of which all but a few non-Italian works had come from his friends Count and Countess Contini-Bonacossi.

THE FIRST KRESS GIFTS

An especially appealing feature of the Kress story is the imagination and generosity with which, virtually from the beginning, Samuel Kress shared his collection with the American people. Held in thrall by his new passion for "old art," he appears to have felt almost a moral obligation to extend this pleasure to a larger audience well beyond the sophisticated East Coast art establishment. A philosophy was articulated that would distinguish the Kress Collection throughout its entire history: the Kress fortune had been made from the people of the United States, and the fruits of that fortune would be returned to them, for their education and personal enrichment, in artistic treasures from Europe.

The years of the Great Depression witnessed this philosophy in action, as Samuel Kress began to bestow paintings from his collection on cities in the distant American heartland of the Kress stores. With characteristic punctiliousness, Kress established a special storage area in New York to house the pictures selected for distribution, along with master lists, photographs, documentation, and albums of letters and newspaper clippings devoted to previous gifts. A visit in 1932 both impressed and dismayed Vittoria Contini, who found it all too Anglo-Saxon, despite the pleasure of seeing many of their paintings again. Nevertheless, she decided, if Kress was so exact as to be frightening, he

was still a great man—*un cervello di bronzo e un cuore d'oro* ("a brain of bronze and a heart of gold").[23] Communities that received one or more of the paintings wholeheartedly concurred.

After preliminary correspondence about the proposed gift, often initiated by the donor, the painting would be selected and prepaid shipment arranged. The donation also included photographs and photographic plates, information about the work, and authentications by European experts. A letter of transmittal from Kress stated his intentions—"I have desired to do something that will be of interest and benefit to the people of San Diego"—and the proviso that the picture be accepted in perpetuity by the recipient institution.

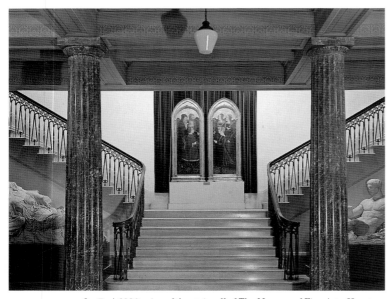

fig. 7 A 1930s view of the stairwell of The Museum of Fine Arts, Houston, with a pair of late-fifteenth-century Lombard school paintings, *Two Spouses as Donors in Prayer, Accompanied by Saints*. The panels were purchased by Samuel Kress from Count Alessandro Contini-Bonacossi in 1932 and donated to Houston in 1934.

Since the entire undertaking was totally unprecedented, a good deal of fuss accompanied the arrival of the painting on the local scene. Not only was it a boost to civic pride to be remembered by Mr. Kress in far away New York City, but in most cases the Kress picture or pictures were the first Old Masters to belong to a public institution in the region, a fact that drew attention and occasionally even other donations to the favored museum. Throughout the 1930s, these singular acts of generosity placed European paintings on the walls of civic museums, art associations, and educational institutions in cities across America as the gift of Samuel H. Kress (*fig. 7*).[24]

The significance of these donations was far greater than the actual works of art involved, no matter how beautiful. Sixty years ago, the vast majority of the population of the United States had never seen a work of European art. The few collections on public view were clustered in major metropolitan centers, long-distance travel was a luxury, and only the most privileged Americans ever visited Europe. In a small or middle-sized community, the gift of a genuine Old Master painting from a fabulously wealthy man with a familiar name generated an enormous amount of curiosity and excitement.[25] That the picture would belong to the community became a matter of pride and responsibility. Its permanent presence made it a magnet for study and admiration as a piece of the past, an inspiration for the future, and a link to the larger world.

These responses are best demonstrated by example. To celebrate the thirtieth anniversary of The Museum of Fine Arts, Houston, Samuel Kress donated to the museum its first Italian masterpiece, Lorenzo Lotto's *Holy Family with Saint Catherine*. When the painting was placed on public view on Founders Day, April 12, 1930, the president of the Rice Institute, Dr. Edgar Odell Lovett, delivered an acceptance speech entitled "The Significance of the Gift."[26] His remarks ranged from the relevance of history and the classical ages to the appearance of Halley's Comet exactly twenty years previously, then looped back again with the comet to Renaissance Venice and Florence, the life and art of Lorenzo Lotto, the artist's works in European museums, his personality, and the full text of Roberto Longhi's authentication of the picture donated to Houston. Dr. Lovett congratulated the founders of the museum on their achievements and on meriting the Kress gift, noting that "Houston is one of 200 cities on this continent in all of which Mr. Kress holds citizenship." By his "noble gift . . . the donor has in this fine deed carried the faith of the founders of this institution to further fulfillment. And what was that faith? That Houston should be as great as Athens, Florence, and Venice were great. . . . These celebrated cities of commerce became also conspicuous centers of vigorous intellectual activity, irradiating the life of the spirit of man in letters, in science, in art. I honor the donor of this gift because into that great company he has lifted himself and Houston."[27]

"An Exhibition of Italian Paintings Lent by Mr. Samuel H. Kress of New York"

Although the Kress gifts of Old Masters generated enormous admiration, the appreciation of Italian art remained well beyond the experience of most Americans in the early

1930s. Typically, Kress responded with another forthright and highly original act of philanthropy—a traveling exhibition of more than fifty paintings from his collection that commenced in the autumn of 1932. The foreword to the catalogue, reprinted for each venue, described his purpose.[28] "Mr. Samuel H. Kress, a patron of art, has selected from his well-known collection and is lending to the City of Colorado Springs, a group of paintings which he believes will afford an unusual opportunity for the study of the development of the art of painting in Italy in its principal schools." As with his gifts to museums, he hoped that his exhibition might encourage "a more cultured understanding of art." Far from the now-familiar pattern of corporate sponsorship for advertising and good will, the Kress exhibition was an act of personal generosity and genuine sharing—in effect, a new and higher application of the successful Kress retailing philosophy that made accessible to the American people, in their own communities, the means to brighten and improve their lives.

Again without precedent, this private traveling exhibition of Old Master paintings required the meticulous attention to detail that Kress enjoyed. He not only selected the pictures (one of which, Tiepolo's *Portrait of a Boy Holding a Book* [cat. 47], appears in the present exhibition) but also generally supervised everything from the extensive correspondence regarding venues and schedules to the design and construction of the special trays, cases, and steel vaults required for railway shipping.[29] Responsibility for preparing the paintings and the catalogue and coordinating the logistical arrangements fell to Kress's longtime conservator and consultant, Stephen S. Pichetto.[30] An agent assigned to travel with the pictures oversaw all of the local details and corresponded regularly with Kress in New York.[31]

Originally scheduled to travel for nine months (October 1932–July 1933) to eight cities (Atlanta, Memphis, Birmingham, New Orleans, Houston, Dallas, Denver, and Colorado Springs), the Kress exhibition proved so popular that it was extended to an additional sixteen venues (Salt Lake City, Seattle, Portland, Sacramento, San Francisco, Los Angeles, San Diego, San Antonio, Nashville, Montgomery, Waco, Tampa, Winter Park, Savannah, Charleston, and Charlotte) and did not return to New York until June 1935. Altogether, the Kress pictures circulated for thirty-two months to twenty-four American cities, but even this liberal extension could not satisfy the potential demand. Kress was forced to disappoint another eighty museums, art clubs, artists' associations, women's clubs, colleges, and universities in thirty-five states and Canada that wrote to him to request the show.

Open to the public without charge and accompanied by an illustrated catalogue, the exhibition offered a unique experience to a large number of Americans. For a few brief weeks in the depths of the Great Depression, it was possible to explore five centuries of Italian painting on the walls of the local museum or art association. Arranged geographically and chronologically by school, the Kress show included nine early Sienese panels, twenty Florentine pictures, nine central and northern Italian artists, and eighteen Venetian paintings. More important than the names of the artists (though there were several outstanding paintings and most of the attributions have stood the test of time), the thoughtful balance of the exhibition promoted its educational and aesthetic purposes.

Something of the excitement and success of the event is preserved in faded scrapbooks of old newspaper clippings with headlines such as "The South's Greatest Art Exhibit" (Atlanta), "Six Tons of Art Arriving Today in Steel Vaults" (Montgomery), "Governor Pays Tribute to Work of Early Artists" (Salt Lake City), "Old Italian Paintings at Free Art Exhibit" (Denver), and "Great Art from Little Dimes" (San Francisco). City after city reported record attendance. The exhibition was regularly held open long past normal hours. Special lectures were scheduled, schoolchildren were invited, artists were given permission to copy the works on display. In Nashville, during one of the hottest summers on record, an estimated seventy-five thousand people, nearly half of the population, visited the Kress show. And finally, the most telling index of all, the private letters of gratitude. For most of the people who viewed it, Mr. Kress's exhibition held the only genuine Italian paintings they would ever be privileged to see.

THE SAMUEL H. KRESS FOUNDATION

Enthusiastic audiences across America welcomed the Kress exhibition for almost three years. By the time that the paintings eventually returned to New York from their last venue at the Mint Museum of Art in Charlotte, the success of the show had persuaded the lender to consider an even more ambitious idea. Under the auspices of the Samuel H. Kress Foundation, chartered in 1929 "to promote the moral, physical and mental well-being and progress of the human race," Kress proposed to make his entire collection permanently accessible to the public.[32]

His vision for the future of both the Kress Collection and the Kress Foundation was outlined by the founder and president in a formal statement in October 1935. Speaking to

his fellow trustees—at that date, his brothers, Claude and Rush, and two Kress Company retainers—and also for the records of the foundation, Kress described his collection of art and emphasized the time, effort, and expense that it involved. It was his hope that the Samuel H. Kress Foundation would continue these activities for the benefit of the public. He viewed his wealth, "accumulated through a long lifetime of the hardest kind of work and self denial," as from the people, and he desired to return a great part of it in charitable and educational programs.[33]

Several locations on upper Fifth Avenue were under consideration "for the establishment of an appropriate museum or building for the purposes of the Foundation," and Kress intended to donate his collection to the foundation once it could be adequately cared for and his current activities continued. To date, however, he had personally borne all of the normal expenses of collecting paintings ("renovating, shipping, insuring, obtaining reports as to their genuineness, etc. etc."), as well as the costs of the traveling exhibition, in order to build up the assets of the foundation for the greater objectives in view. "Mr. Kress further stated that to show the substantial amounts involved he had already spent over five million dollars in acquiring, handling, exhibiting, etc. the collection of paintings and objects of art which he now owns. . . ." By 1935, in the eyes of its founder, the Kress Collection had ceased to be a private hobby and had become a public trust.

The newfound sense of purpose prompted vast new expenditures. Having already invested the rough equivalent of $60 million in today's money in his collection, Kress proceeded to more than double that outlay over the next two years. While continuing his accustomed transactions with Contini-Bonacossi, the collector also turned—for the first time—to the fabled offerings of Duveen Brothers, where his purchases in 1936 alone apparently equaled more than half of the entire cost of his collection to date.[34] Concurrently Samuel Kress was also elected to the board of the Metropolitan Museum of Art.[35]

As it, too, became more active, the Kress Foundation assumed the function of donating selected paintings from the Kress Collection to museums around the country. Purchase of real estate for a Kress Museum was deferred in favor of the massive purchases of art that rapidly became the foundation's primary activity.[36] For sheer quantity, in the period from 1936–40, Contini-Bonacossi supplied the greatest number of works (196) for the most cash ($1,256,000); his last invoice, for seventy paintings, was dated September 1, 1939, as war broke over Europe. By

contrast, the foundation's single purchase of twelve paintings from Duveen Brothers in April 1937 cost $880,000. A handful of dealers in New York and Europe and an estate sale in New Jersey accounted for a few other acquisitions.

To the educational and charitable ends served by forming a great collection of art for the public, Kress now added a new, patriotic motive—"the performance of a distinct service to America"—as he led the foundation to take advantage of the opportunities "afforded under present conditions of obtaining and building up collections of pictures and objects of art which would otherwise never be obtainable for the benefit at least of this country."[37] Europe's loss would be America's gain.

BERNARD BERENSON

During this period of dedicated activity in the late 1930s, Kress also made contact, for the first time, with the most renowned Italian paintings connoisseur of the day, Bernard Berenson (1865–1959). Writing to the scholar at his home in Florence in March 1937 with regrets that they had never met, Kress ventured to introduce his collection by way of several parcels of photographs of the paintings. Berenson's expert eye responded with approval: ". . . while I do not always agree with the attributions suggested, I very rarely saw an ascription superior in artistic value to one I myself would assign."[38]

On this favorable note, an alliance between collector and connoisseur developed rapidly. Visiting Italy that September, Kress lunched with Berenson at his summer home at Consuma.[39] They discussed specialized medical treatments and the future of the Kress Collection. More photographs were subsequently delivered to Berenson at Villa I Tatti, on the understanding that any new attributions would not cause "retroactive" returns of pictures to dealers. Despite an extended winter sojourn for treatment in Vienna, by March 1938 Berenson had completed his study. The annotated photographs were sent back to New York, with congratulations to Kress for "having made such an interesting collection so late in the day."[40]

During the spring, Berenson's notes were compared with previous attributions from other experts, new lists were compiled, and new photographs of disputed works were sent to Florence for further consideration. Appropriate revisions were recorded in the files. Toward the end of 1938, still working from photographs, the connoisseur divided four hundred paintings in the Kress Collection into four classes. Sixty-four "masterpieces of the highest order in their kind"

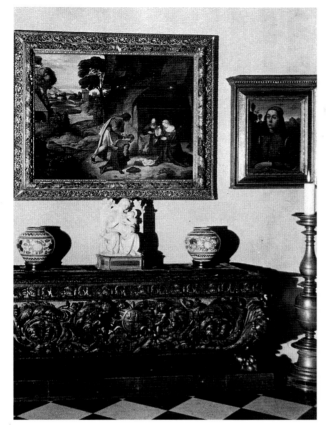

fig. 8 The Adoration of the Shepherds by Giorgione, seen in the Kress apartment next to the *Portrait of a Youth* by the Master of Santo Spirito. Both paintings were acquired from Duveen Brothers in 1938 and donated to the National Gallery of Art in 1941.

headed the list, followed by fifty-four pictures to be exhibited successively with them. A larger group—196 works—was commended for artistic and/or historic interest. The remaining eighty-six were "Pictures I venture to advise discarding. Most are quite good, but not good enough for a collection like yours." He added that John Walker, the future chief curator of the National Gallery of Art, had been staying with him and was in entire agreement.[41]

No compensation was offered to Berenson for his expertise, although the scholar did propose an elegant exchange.[42] When the new three-volume edition of his *Drawings of the Florentine Painters* was published by the University of Chicago Press in 1939, the Kress Foundation purchased and distributed copies to museums, libraries, and private scholars in the United States, Europe, and Japan.[43]

Curiously lacking in their correspondence is any exchange regarding Kress's continuing—and increasingly intense—activity as a collector. Once, however, in October 1937, Berenson could not resist a pointed reference to the most important Italian masterpiece then on the market, the ex-

quisite *Adoration of the Shepherds* (*fig. 8*) known as the Allendale Nativity, recently purchased by Lord Duveen. Remarking that he had studied the painting "again & again & again in the course of the last forty years" and that Duveen had just sent it to him at Consuma for two days, Berenson declared that "it is not by Giorgione, but a marvellously enchanting picture of Giorgione's following."[44] In spite of this unsolicited opinion, Kress eventually acquired the painting, as a Giorgione (an attribution now almost universally accepted). Such was his pride in the picture that in December 1938 it was presented as the Christmas display in the show window of the great Kress emporium on Fifth Avenue.[45]

THE NATIONAL GALLERY OF ART

The growing reputation of the Kress Collection attracted the attention of the art world and drew regular visitors to the Kress apartment at 1020 Fifth Avenue.[46] Early in 1938, Kress received two guests from Washington, Jeremiah O'Connor, the curator of the Corcoran Gallery of Art, and Herbert Friedmann, the curator of birds at the Smithsonian Institution, whose mutual hobby was visiting private collections of art. As remembered by Friedmann some years later, the two men were "so thrilled and impressed by what we saw that we immediately began to wonder if there might be some way to divert this great collection to the already announced, but not yet built, National Gallery of Art."[47] Returning to Washington, they composed a letter presenting the idea and its advantages for Kress, his paintings, and the public. Not only would the Kress Collection be in the highest artistic company in the most modern museum in the world, but it would be maintained by the United States government and would truly belong to the American people. "Would it not be fitting for your splendid paintings, a heritage from the ages, to become a national treasure?"[48]

No serious collector of art would have been unaware, at the time, of the great gifts soon to be bestowed upon the nation by the former secretary of the treasury, Andrew W. Mellon (1855–1937), whose offer to build a National Gallery of Art—at $15 million, the largest single benefaction ever made by a private citizen to a government—had been accepted by Congress in March 1937, just months before his death.[49] Now, on the site of the old Baltimore & Potomac Railroad station, within view of the Capitol, construction was underway on the world's largest marble building, designed by John Russell Pope.[50] When completed, the founding gift would be 152 supreme masterpieces from the Mellon Collection. However, there were to be almost one hundred galleries to fill with private donations of art.

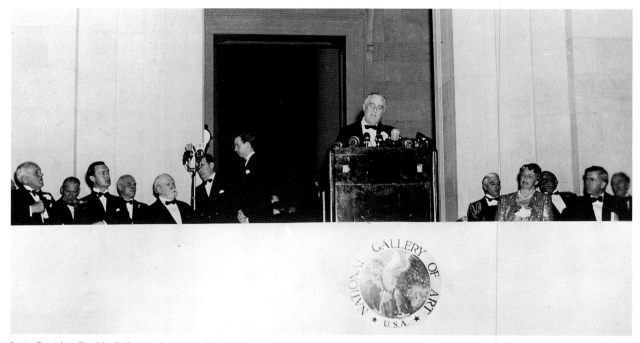

fig. 9 President Franklin D. Roosevelt accepts the National Gallery of Art for the nation on March 17, 1941. Samuel H. Kress, Paul Mellon, and the chairman of the National Gallery of Art, Chief Justice Charles Evans Hughes, are seated in the front row on the left. Mrs. Roosevelt is on the right.

Kress responded to O'Connor's letter by inviting him to New York to discuss it further, and in April 1938 an invitation was conveyed to the director of the National Gallery, David E. Finley, to call upon Mr. Kress. The seven-hour visit was of great consequence for the nation's collection.[51]

Of course there were extensive negotiations. The final agreement was typical of Samuel Kress, reflecting his preoccupation with details regarding the opening display of the Kress Collection (specific galleries, labels, inscriptions, etc.), and also his sensitivity to both the short- and the long-term needs of the gallery. He offered a generous selection of works of art, enough to fill a substantial portion of the new building, but he did not bind the museum to their permanent arrangement. On the contrary, there were provisions for substitutions and replacements of "less desirable items previously donated," and 25 percent of the paintings were on long-term loan. The indenture insured that the Kress Collection and the National Gallery of Art would flourish together.[52]

In May 1939 cables went out to international scholars soliciting their opinions of the Kress Collection.[53] On the first of July, Samuel Kress wrote to President Franklin D. Roosevelt informing him of the proposed donation. David K. E. Bruce, Mellon's son-in-law and the president of the board of the National Gallery, issued a statement: "Experts state that there is no private collection in the world, and few museums, which can illustrate in as complete a manner

as the Kress Collection the development of the Italian school of painting and sculpture during the Renaissance period." When it opened its great bronze doors to the public, the National Gallery would possess a distinguished—and extensive—display of Italian art to complement the Mellon treasures. Both in contents and timing, the Kress commitment was a splendid confirmation of the future importance of the gallery to the nation.[54]

Preparations continued for another year and a half. France fell to the Nazis, London smoldered under the Blitz, and Roosevelt entered his third term. At last, on the bitter cold evening of March 17, 1941, nearly eight thousand government officials, diplomats, museum and university heads, artists, scholars, patrons of the arts, and gate-crashers—"one of the most distinguished groups of men and women ever assembled in Washington," according to the *New York Times*—gathered for the formal inauguration of the National Gallery of Art.[55]

The thirty-minute ceremony was broadcast by radio nationwide. Chief Justice Charles Evans Hughes, chairman of the National Gallery, introduced Paul Mellon, who presented his father's building and the Mellon Collection to the nation. Samuel Kress, now a trustee of the new institution, endorsed Mellon's vision of a collection of the finest works of art, to be shared by all Americans and offered his own extensive collection "of the Italian School of painting and sculpture of quality" from thirteenth-century Tuscany to

eighteenth-century Venice. He would miss his Italian paintings, the walls of his home would be bare, "But I am happy in the thought that, during my lifetime, my collection intact is settled in my country, in a permanent home within this magnificent modern structure. . . . And so, Mr. President, I turn over my collection to you for the benefit and enjoyment of all the people, to be preserved as part of that spiritual heritage which is our greatest and most treasured possession."

President Roosevelt's acceptance speech concluded the proceedings. He spoke with gratitude of Mellon's great gift to the nation, and praised the generosity of the donors who recognized that "great works of art have a way of breaking out of private ownership into public use." The gallery signified a new relationship "between the whole people of the country and the old, inherited tradition of the arts." Just as the construction of the dome of the Capitol had continued during the Civil War as a symbol that the Union would last, the president pledged the new building and its contents as "the measure of the earnestness of our intention that the freedom of the human spirit shall go on" (*fig. 9*).[56]

Approximately six hundred works of art were displayed in the skylit marble rooms and vaulted sculpture halls of the nation's new gallery.[57] As expected, the Mellon gift provided the most familiar masterpieces, but these were surrounded and enhanced by the abundance and range of the Italian art in the Kress galleries. In a typical assessment, *Time* magazine praised the Mellon and Kress donations, noted that "the Gallery is long on portraiture, short on Spanish art, entirely lacking in important French works," and predicted that it "might well grow some day into one of the world's greatest national museums."[58]

For the first time, a major part of Samuel Kress's achievement as a collector—some 416 Italian paintings and 35 works of Italian sculpture—could be seen on display in one setting. Not only had this not been physically possible before, but the dizzying growth of the Kress Collection, especially in the period immediately prior to the National Gallery's opening, precluded even the donor's enjoyment of his new treasures. Kress's negotiations, especially with Duveen Brothers, continued unabated throughout 1940 and early 1941, and such important new acquisitions as Filippo Lippi's *Annunciation*, Botticelli's *Madonna and Child*, Raphael's *Bindo Altoviti*, and Bernini's *Louis XIV* were placed on loan to the National Gallery in the weeks before it opened.[59] Previously owned paintings departed from the Kress apartment and Kress Foundation storage depots to receive conservation treatment and new frames or shadow boxes. Sculpture vanished to be fitted with pedestals designed from old cabinets. When it all was assembled at last in Washington, the beauty and depth of his collection may well have amazed even Samuel Kress.

Within nine months of the inauguration of the National Gallery, the United States was swept into war. Although the nation's most precious masterpieces were sent to safekeeping in the Blue Ridge Mountains of North Carolina, the popularity of the new gallery—especially among servicemen—was a point of considerable pride.[60] In New York Samuel Kress and, increasingly, the trustees of the Kress Foundation were attentive to the new institution as they continued throughout the war to bargain for Italian art. Works by Ghiberti, Verrocchio, Melozzo da Forlí, Domenico Veneziano, Titian—and, in the present exhibition, Lavinia Fontana's *Angels Supporting the Body of Christ* (cat. 6) and Panini's *Pantheon and Other Monuments of Ancient Rome* (cat. 44)—entered the Kress Collection. New dealers offered new wares. Samuel Kress donated shares of Kress Company stock, paintings, sculpture, and an outstanding credit at Duveen's (for $262,500) to the foundation. Pictures were acquired confidentially from other collectors. Efforts were made to get important works of art out of Europe. Three years of negotiation yielded an acceptable price for the magnificent Dreyfus Collection of small bronzes, medals, and plaquettes.[61]

Even desirable French pictures were found for the National Gallery's greatest void. Two days before Christmas 1942 the foundation authorized the acquisition of seven eighteenth-century French paintings—including Watteau's *Italian Comedians* (cat. 36)—and four early Italian works from Wildenstein & Co. for "a reasonable price, i.e. $1,500,000.00, which is less than one half of the original price demanded."[62] Conveying the gallery's gratitude, the chairman of the board, Chief Justice Harlan Stone, praised Kress for "the far-sighted and intelligent manner in which you are planning your gifts," and especially for the proposed French gallery, which would create "one of the finest rooms to be found in this or any other museum."[63] Formally announced in July 1944, the gift had grown to nineteen pictures—by Boucher, Chardin, Claude, David, Drouais, Fragonard, Greuze, Ingres, Le Nain, Nattier, Poussin, Rigaud, Vigée Le Brun, and Watteau—by the end of the year.

Coinciding with the return of the works stored during the war, a third Kress donation to the National Gallery of "a large new collection of rare Italian art" was announced by director David Finley in October 1944. Joined with the orig-

inal Kress gift, "more than eighty paintings and pieces of sculpture . . . will make the National Gallery's collection of Italian art one of the most comprehensive in the world, rivalled only by the four leading European collections in Florence, London, Paris, and Berlin."[64]

The new Kress donations—including the stunning last-minute addition of El Greco's majestic *Death of Laocoön and His Sons* (cat. 9), acquired from Prince Paul of Yugo-slavia while he was still a war detainee in South Africa, were presented in new installations for the National Gallery's fifth-anniversary celebration.[65] Critics were thrilled by the quality, the public loved the variety and especially the new French pictures, and society columnists rejoiced that Lady Astor, on a visit from Britain, had joined President and Mrs. Truman at the opening ceremonies on February 2, 1946. The only notable absentee was the president of the board of trustees of the National Gallery of Art, Samuel H. Kress.

THE KRESS REGIONAL GALLERIES PROGRAM

Kress's declining health took a turn for the worse in 1946 from which he never recovered. Responsibility for the Kress Foundation effectively passed to his brother Rush Harrison Kress (1877–1963), who as vice president and an original trustee had been actively involved with the foundation from its beginning. Respecting the founder, his interests, and his current disability, a loosely defined ten-year plan was charted to focus on the areas of medicine and the collection and distribution of art. In particular, the foundation would continue Samuel Kress's efforts to strengthen the Kress Collection at the National Gallery of Art.

A 1947 survey of the Kress Collection in Washington registered 605 works of art, including 135 pictures "in storage on chicken wire in the basement of the National Gallery." Another 101 paintings were likewise in storage on the tenth floor of the Kress Company headquarters in New York. Overall, it was concluded, "greater benefit to the people will be obtained by their distribution elsewhere."[66] The idea of the Kress regional galleries began to glimmer.

In retrospect, the nationwide expansion of the swelling Kress Collection appears logical or even inevitable, given the vast empire of Kress stores, the example of Samuel Kress's early donations of art to local museums, the charitable and educational purposes of the Kress Foundation, and the dearth of European art in the South and the West. Rather than hold a noteworthy collection of Old Master paintings in storage, the Kress trustees proposed a physi-cally separated but integrated collection, headquartered in the National Gallery of Art and apportioned across the country. It was a novel, intriguing, and logistically complex idea for a wholly original national program of art philanthropy.

A team of key individuals with the skills and experience to define and guide the Kress art programs was assembled in the late 1940s under the leadership of trustee Guy Emerson, a banker and amateur ornithologist who gradually stepped into an administrative role as the foundation's art director.[67] Another new position was filled when the re-spected Viennese art historian William E. Suida assumed responsibility for scholarship and archival records as cura-tor of art research.[68] They were subsequently joined by the Italian paintings conservator Mario Modestini, who became the new curator of the Kress Collection after the sudden death of Stephen Pichetto in January 1949.[69] New staff required new premises (the foundation's first independent offices) and specialized equipment to facilitate the study and conservation of works of art.[70]

The new professionalism intensified the foundation's collaboration with the National Gallery of Art, where, as William Suida reported, "The sublime goal is, to create the most complete collection of Italian Art existing in the world." Working closely with chief curator John Walker, Suida undertook a detailed analysis of all of the Kress paintings with a view to planning a new arrangement of the Kress galleries, identifying desirable acquisitions for the future, and selecting works for regional distribution. Not only artistic quality but also physical condition, histor-ical interest, the range of works by the same artist, and the subtle interrelations among the pictures were consid-ered. Since it was Rush Kress's intention "to use every Kress painting for public exhibition in the National Gallery of Art or elsewhere," the 130 "dispensable" works would be released for other American museums, while those labeled "undecided," including "an astounding number of good Cassoni" paintings, were held in abeyance for the time being.[71]

Many of Suida's listings were necessarily tentative simply because the Kress Collection was, as yet, far from com-plete. Continuing its wartime pattern, the Kress Foundation remained the most active buyer of European art in the American art market. In the five years following Samuel Kress's illness in 1946, the value of the art owned by the foundation, carried at cost, rose from $6,011,033 to $20,560,843.[72] A tide of Italian art from Giotto to Bellotto swept in, led by the exquisite *Adoration of the Magi* by Fra Angelico and Fra Filippo Lippi (rescued from a warehouse

on the brink of returning to England after the war).[73] In the present exhibition, Leandro Bassano's *Last Judgment with the Saints in Paradise* (cat. 7), Sebastiano Ricci's *Finding of Moses* and *Jephthah and His Daughter* (cats. 37, 38), and Bellotto's *Entrance to a Palace* (cat. 43) all entered the Kress Collection during this period. Contini-Bonacossi made a notable reappearance, resuming his prewar activities with an impressive new stock of masterpieces that included such works as Titian's *Ranuccio Farnese* (cat. 2), Paris Bordon's *Perseus Armed by Hermes and Athena* (cat. 3), Tanzio da Varallo's *Rest on the Flight into Egypt* (cat. 16), and Baciccio's paired canvases (*fig. 10*), *The Thanksgiving of Noah* and *Abraham's Sacrifice of Isaac* (cats. 33, 34), as well as nearly five hundred fine Italian period frames.[74]

Nor was the enrichment of the Kress Collection limited to the Italian schools. In the immediate postwar period, France yielded precious treasures of Baroque and Rococo painting and sculpture from Poussin to Ingres, and (via England) the famous Hillingdon Collection of Louis XV and Louis XVI furniture and ceramics. From farther afield—and with greater effort—came Spanish altarpieces and portraits such as Juan Pantoja de la Cruz's *Margaret of Austria, Queen of Spain* (cat. 10); early Flemish panel pictures by Petrus Christus, Memling, and Bosch; two rare paintings by the German Albrecht Dürer; and exuberant works of the Dutch Baroque such as Hendrick ter Brugghen's *David Praised by the Israelite Women* (cat. 21).[75] Except for the French decorative arts, most of the acquisitions were destined—at least in the immediate future—for the National Gallery of Art, sometimes on specific request.[76]

As 1949 gave way to the new decade, the energies of the Kress Foundation art staff were occupied with purchasing, photographing, conserving, and cataloguing the feast of new acquisitions—113 paintings and 16 sculptures—that would go on exhibition to celebrate the National Gallery's tenth anniversary in 1951.[77] To cope with the heavy work load, the foundation set up a conservation studio in the Carnegie Hall Tower, but its efficiency was severely hampered by limited space and the inconvenient storage of art in depots and with dealers all over town. Confronted with the inadequacy of these arrangements, the prospect of another 174 pictures in Washington awaiting treatment, and the threat that the war in Korea might escalate to an atomic bomb attack on New York, the Kress trustees voted in October 1950 to construct new facilities for conservation, art storage, and housing at Huckleberry Hill, a Kress estate in the Pocono Mountains of Pennsylvania about ninety-five miles away.[78] Fully operational by the winter of 1952, the complex was one of the most secure and best-equipped

centers for paintings restoration in the world. Here, for the rest of the decade, an international team of skilled conservators under the supervision of Mario Modestini would complete the monumental assignment of preparing the Kress Collection for its final distribution.[79]

fig. 10 Rush Harrison Kress seated before *Abraham's Sacrifice of Isaac* by Giovanni Battista Gaulli, called Il Baciccio (cat. 34). The painting was purchased by the Kress Foundation from Count Alessandro Contini-Bonacossi in 1950 and donated to the High Museum of Art in Atlanta in 1958.

In the meantime Rush Kress and Guy Emerson were at work on the first phases of the Kress regional galleries program. Selecting a promising group of cities in the West and the South where Kress stores could provide backup support, Emerson made exploratory visits to local art museums and civic leaders to evaluate levels of interest, facilities, reputation, and the ability to serve a regional population. What he presented was the opportunity to select twenty to thirty Old Masters—"with some element of real distinction and at the same time a group that will fit suitably together"[80]—from among available paintings in the Kress repositories, in return for the commitment that the collection would be permanently displayed in a secure and attractive fireproof space with appropriate light, temperature, and humidity controls. All costs of art preparation, shipment, and insurance would be borne by the Kress Foundation, which would also provide photographs, X rays, scholarly documentation, and conservation records.

Kress staff and consultants were similarly available for all aspects of gallery design and installation. In effect the museum would receive an "integral part" of the Kress Collection.[81]

The offer of a well-balanced, good-quality, representative survey of several centuries of Italian art was an extraordinary—and usually galvanizing—opportunity, with implications from the boardroom to the guard stations. Each prospective regional museum was forced to consider such issues as available space, technical equipment, existing collections, and eventual plans for expansion, as well as staffing, education, fund-raising, and long-term community support. In general the response was as remarkable as the proposal. Local residents rallied, trustees opened their

fig. 11 In 1953 the Kress Foundation acquired El Greco's *Saint Francis Venerating the Crucifix* (cat. 8) for the Kress regional collection at the M. H. de Young Memorial Museum in San Francisco. The painting is seen here under examination by the museum's director, Walter Heil, and the foundation's art director, Guy Emerson, on its arrival in San Francisco in 1955.

checkbooks, bond issues passed. Half of the eighteen regional museums built new galleries for their Kress collections, and two found the funds for entirely new buildings, such was the enthusiasm created by the prospect of the Kress gift and the honor it bestowed.[82]

Of course the greatest adventure lay in selecting the pictures. Suida's preliminary groupings of available Kress objects offered a basis for initial discussion, followed by "many tentative arrangements and changes" before a final collection took shape. The process began with visits by museum directors, curators, and trustees to the Kress

Foundation's storage areas at Huckleberry Hill and the National Gallery of Art, to be followed by extended discussions, lists, comparisons, measurements, analyses, wish-lists, and return visits as other paintings were acquired or released from the National Gallery. Considerations of size, variety, and subject matter were often as important as quality and condition. Museums in predominantly Protestant communities sought to avoid "a high percentage of Madonnas, saints and other religious subjects of a particularly Catholic nature." Similarly, erotic themes (not numerous in the Kress Collection) and "unpleasant subjects, for example Cleopatra putting an asp to her breast" (there were several of this theme) tended to remain unchosen.[83]

Allowing for available space and existing collections, each regional collection was designed as a representative survey of Italian and/or European art that balanced two or three "leaders" (Rush Kress's term for masterpieces) with attractive works by less familiar artists. It was a natural temptation to negotiate for the best possible selection. The young assistant director of the Seattle Art Museum, Sherman Lee, wrote to the Kress Foundation in April 1950 that "while one or two of the proposed gifts are extraordinarily exciting, notably the Tiepolo sketch (incidentally, the ceiling itself is too large for us) and the Veronese, and others are good examples for their period and style, we feel that the greater proportion of the proposed group is not of sufficient importance to warrant an absolutely permanent installation."[84] When assured that after ten years the Kress pictures could be rearranged by mutual agreement, Lee wrote back with a list of eight paintings then in the Kress Collection that would be especially welcome in Seattle, and another eight specific examples of "types we feel to be desirable" that were currently on the art market. "My point is that our Ancient, Medieval, and Oriental collections contain many master works comparable to some of the famous paintings in the National Gallery and those in Mr. Kress' marvelous living room. Consequently, we are interested in seeing our own Western tradition of painting represented by works which will bear comparison with the others."[85] By 1952 twenty-three paintings—some by the same artists Lee had proposed—were selected for Seattle, including both the sketch *and* the ceiling fresco *The Glory of the Porto Family* by Giambattista Tiepolo from the original list.

On occasion the foundation did purchase paintings to match the needs of a particular regional gallery. The M. H. de Young Memorial Museum, for example, was awarded El Greco's *Saint Francis Venerating the Crucifix* (cat. 8) "because St. Francis is the patron saint of San Francisco" (*fig. 11*).[86] Another special request, Goya's *Don Ramón de*

Posada y Soto (cat. 55), was also acquired for the same collection at the same time.[87] And a dramatic last-minute addition occurred just weeks before the inauguration when the de Young's director, Walter Heil, "fell in love with" a gentle interior scene by Pieter de Hooch at a New York dealer's in December 1954. With Guy Emerson's complicity, Heil flew to Tucson with the canvas to convince Rush Kress that it would perfectly complete the main wall of San Francisco's new Kress galleries. He won approval and "flew on home, still clutching the cherished picture in my hands. It was one of the happiest Christmases of my life."[88]

Each museum molded its Kress Collection into its own distinctive character. Model galleries were constructed, arrangements studied, original choices reconsidered. There was a good deal of consultation with the staff of the Kress Foundation—"Modestini and I are leaving tomorrow for a quick three-day trip to New Orleans, Houston and Tulsa to settle details of gallery arrangement, wall color and lighting," Emerson reported to Rush Kress in December 1952 —especially as the last decisions were made.[89] In the meantime, the paintings received attention in the conservation studio at Huckleberry Hill, where as necessary they were cleaned, relined, revarnished, and reframed, then photographed, and finally packed for shipping in specially developed containers. Often they were met at their destination by a special committee of welcome. An escort of motorcycle police took the Birmingham Kress Collection directly to City Hall.[90]

The final and greatest excitement took place once the walls were painted, the humidity tested, the lighting adjusted, the catalogues printed[91]—and a collection of approximately thirty-five carefully chosen, beautifully presented, fine-quality European (mostly Italian) paintings now actually hung in the local museum. Opening the doors occasioned widespread hospitality and conspicuous civic pride. To give the event its full importance, the Kress Foundation encouraged a brief address by either John Walker ("on the artistic interpretation of the paintings which he does very well and in a popular manner") or David Finley ("the broader subject of the development of art in America and the development of galleries"), to tie the newly created Kress regional gallery to the great Kress Collection in Washington.[92] If possible, Mr. and Mrs. Rush Kress would also be in attendance as the public was invited to view, for the first time, the new Old Masters.

The first Kress regional gallery was opened on November 16, 1951, in the University Art Gallery of the University of Arizona at Tucson, an event described by Rush Kress

as "probably the outstanding occasion in the history of the University."[93] Five more galleries were readied and opened in 1952—at the Birmingham Museum of Art (April 1952), the Honolulu Academy of Arts (June 1952), the Portland Art Museum (June 1952), the Seattle Art Museum (June 1952), and the William Rockhill Nelson Gallery of Art in Kansas City (October 1952). During the next year the Isaac Delgado Museum of Art in New Orleans (April 1953), the Philbrook Art Center in Tulsa (October 1953),[94] and The Museum of Fine Arts, Houston (October 1953), joined the Kress regional galleries, followed by the Columbia Museum of Art (April 1954), the Denver Art Museum (October 1954), and the M. H. de Young Memorial Museum in San Francisco (February 1955). In three years and three months, in a dozen cities across the country (and in the Hawaiian Islands), the Kress Foundation had placed "approximately 387" European paintings on loan to the American people.[95]

Only in Seattle were there any serious problems. Although the Seattle Art Museum had gone to exceptional heights (raising the ceiling by five feet) to provide an appropriate illusion for the ceiling fresco by Giambattista Tiepolo in its Kress Collection, the crowded arrangement of the other twenty-three paintings and two sculptures in the same room greatly disturbed Rush Kress, who made his opinions known at the inaugural luncheon in his honor.[96] Rather than risk the loss of the pictures, a museum trustee, Norman Davis, anonymously donated funds for a new wing. Taking an active role in the project, Davis also hoped to expand the scope of the collection to include more Baroque art: "If we can get some Dutch, Flemish and French, as well as Italian paintings, we could have a wonderfully fresh and vivid gallery from a field where quality is more freely available and at far less cost."[97] When reopened in October 1954, not only was the Seattle Kress Collection far more spaciously displayed, it was also fourteen paintings and one sculpture richer (*fig. 12*). Five of the six new northern pictures—a small oil sketch by Rubens (cat. 12), a still life by Abraham van Beyeren (cat. 26), a church interior by Emanuel de Witte (cat. 28), a pastoral group by Gerrit van Honthorst (cat. 22), and a genre scene by Jan Miense Molenaer (cat. 23)—appear in the present exhibition, testimony to the wisdom and range of the Seattle selections.[98]

Remarkably, as more Kress objects went out on loan, more became available. In 1952 the redistribution pool was enlarged by 266 pictures and 2 sculptures previously at the National Gallery, which accepted 109 paintings and 22 sculptures in exchange.[99] Three years later yet more works of art—"a number of excellent panels and canvases which duplicate others in the Collection"—were released

during the preparations for the National Gallery's fifteenth-anniversary celebration, which Emerson predicted would be "one of the great events in world art history."[100]

It was fitting that the Samuel H. Kress Foundation was so actively focused on the Kress Collection in the National Gallery of Art when, on September 22, 1955, at the age of ninety-two, the founder died. Nor could there have been a greater memorial to his generosity and vision than the brilliant display of art then in preparation. Working behind closed doors from October 1955 to March 1956, the staffs of the Kress Foundation and the National Gallery re-arranged the Kress rooms to incorporate the great master-pieces purchased over the previous decade. The most recent additions—eighty-four paintings and twenty-nine sculptures soon to be shown for the first time—included such astonishing acquisitions as Clouet's *Lady in a Bath*, Grünewald's *Small Crucifixion*, Sebastiano del Piombo's *Portrait of a Humanist* (cat. 1), Titian's *Doge Andrea Gritti*, Van Dyck's *Queen Henrietta Maria with Sir Jeffrey Hudson* (cat. 13), Houdon's *Cagliostro*, and David's *Napoleon in His Study*. An enviable collection of European art was permanently at home in America, and Samuel Kress's commitment to the National Gallery of Art abundantly ful-filled. Even to David Finley, retiring after fifteen years of close association with the Kress brothers and the Kress Foundation, "their achievement seems almost incredible."[101]

Not that it was yet time for final assessments. At the National Gallery—now under the directorship of John Walker—the foundation continued "with the greatest possible care to supplement, strengthen and perfect the collection." Tar-geting the museum's twentieth-anniversary celebrations in 1961, a dozen experts "under the personal supervision of Mr. R. H. Kress" created a master plan for rearranging the entire Kress Collection, "to bring out its beauty and logical sequence" so that it might be considered complete. And of course several outstanding commitments for Kress regional galleries remained to be fulfilled.[102]

Approaching the art market with greater circumspection, the foundation slowed its pace of acquisitions appreciably. Nonetheless, important or unusual pictures still won favor, as illustrated by the nine paintings in the present exhibition added to the Kress Collection in 1957: Domenico Tintoretto's *Tancred Baptizing Clorinda* (cat. 5), Rubens's *Marchesa Brigida Spinola Doria* (cat. 11), Juan van der Hamen y León's *Still Life with Fruit and Glassware* (cat. 18), *Young Man with a Sword*, attributed to Govert Flinck (cat. 25), Jan Steen's "*Soo de Ouden Songen*" (cat. 24), Canaletto's *Grand Canal from the Campo San Vio* and *View of the Molo*

(cats. 40, 41), Giacomo Ceruti's *Card Game* (cat. 51), and Ingres's *Monsieur Marcotte d'Argenteuil* (cat. 56). Exchanges within the collection were also employed to balance recognized needs.[103]

The concluding stages of the regional galleries program reflect the smoothness with which the entire operation was run. Between 1956 and 1961, continual fine-tuning (from light levels and humidity controls to exchanges of paintings and new gifts of Renaissance furniture) improved the twelve established collections. Lavish southern hospitality welcomed the new regional museums in Atlanta (the High Museum of Art) and Memphis (the Brooks Memorial Art Gallery) in April 1958, and an expanded Kress Collec-tion in a brand-new building in Birmingham a year later (May 1959).[104] In New York the Metropolitan Museum of Art installed two major Kress donations of eighteenth-century French decorative art: the Gobelins Tapestry Room from Croome Court (November 1959), and the Hillingdon Collection of Sèvres porcelain and rare porcelain furni-ture (spring 1960). After four years of intensive restoration, twenty-six large panels from an exceptionally beautiful Spanish altarpiece by Fernando Gallego were presented to the public at the University of Arizona at Tucson (February 1960). Three substantial regional collections opened successively at the Allentown Art Museum (November 1960), the North Carolina Museum of Art (November 1960), and the El Paso Museum of Art (December 1960). In Novem-ber 1961 the last Kress regional collection was installed in the Joe and Emily Lowe Art Gallery at the University of Miami in Coral Gables. Still under restoration in Europe were thirteen tapestries designed by Rubens and Pietro da Cortona—*The History of Constantine the Great* from the Barberini Palace in Rome—soon to be reunited for a new hanging in the Great Hall of the Philadelphia Museum of Art (October 1964).[105]

Among the Kress regional galleries, the North Carolina Museum of Art inspired particular pride since it was argu-able that the new state museum in Raleigh actually came into being as a result of Kress philanthropy. In 1947 the expectation of support from Samuel Kress gave the North Carolina State Legislature the impetus to approve (by a three-vote margin) an appropriation of $1 million for the purchase of art, contingent upon a gift of a similar magni-tude. Winning the promise of a Kress regional collection of at least equivalent value from Rush Kress four years later, the state released funds, purchased art, and converted its Highway Commission Building into a temporary museum that opened in 1956.[106] Although doubts regarding the

museum's safety troubled the Kress Foundation, and doubts regarding the scope of their Kress Collection troubled the museum, mutual goodwill and persistence prevailed to create "the largest and most important donation to have been made by the Kress Foundation to any single museum except the National Gallery"—a group of seventy works of art from Giotto's *Peruzzi Altarpiece* to Pompeo Batoni's *Triumph of Venice* (cat. 45).[107] In the present exhibition, paintings by Veronese (cat. 4), Ter Brugghen (cat. 21), Stanzione (cat.

fig. 12 The *Bacino di San Marco* by an artist in the studio of Canaletto was purchased by the Kress Foundation from Alessandro Contini-Bonacossi in 1950 and added to the Kress regional collection at the Seattle Art Museum in 1954. Three members of the Kress Foundation staff— Mario Modestini (curator), Mary M. Davis (assistant), and Guy Emerson (art director)—admired the picture before its hanging in October 1954.

17), Berckheyde (cat. 29), Magnasco (cat. 49), and Ceruti (cat. 51) confirm the quality and range of the Kress gifts to the people of North Carolina.

With the last selections settled for the National Gallery and the regional galleries, it was calculated that the foundation still owned a residual group of approximately 224 pictures that had not been chosen for reasons of size, condition, subject, anonymity, or, in the case of a Sargent portrait, because it fell outside the European focus of the Kress Collection. Recognizing that the very qualities that limited a picture's value to the general public might recommend it for study purposes, the trustees approved the creation of Kress study collections at "colleges with well-organized art history departments and some kind of museum facilities for taking care of the paintings and displaying them."[108] In the early 1960s twenty-four Kress study collections were donated to universities and colleges in nineteen states and Puerto Rico. Future art historians, conservators, and art

lovers have since studied Kress paintings close at hand in the Museo de Arte de Ponce in Puerto Rico and at campus museums in Arizona, California, Connecticut, Georgia, Illinois, Indiana, Kansas, Maine, Massachusetts, Missouri, Nebraska, New York, Ohio, Pennsylvania, Tennessee, Texas, Wisconsin, and the District of Columbia. Here, again, the Kress Foundation observed the importance of the meaningful allocation of art.

Once all of the art was distributed, there remained a final obligation to make the Kress Collection fully accessible to scholars and the interested public. Continuing an already distinguished record of publications in the field of art history, the Kress Foundation commissioned an international team of scholars to research and write a definitive, fully illustrated catalogue to the entire Kress Collection. This, too, was a monumental undertaking that continued over fifteen years (the last volume appearing in 1976). The Italian paintings alone filled three substantial volumes, arranged chronologically by artist, and an even larger fourth volume was devoted to the paintings of the other European schools. To these were added—in five additional volumes—the European sculpture, the Renaissance bronzes, the Renaissance medals, the French decorative arts, and the Constantine tapestries. Never to be enjoyed in a single setting, the Kress Collection may nonetheless be measured through these catalogues in the fullness of its extraordinary achievement.[109]

What cannot be measured are its consequences. Guided by a sense of the moral force of great art and the belief that it can be cultivated, Samuel H. Kress and the Samuel H. Kress Foundation embarked for more than two decades upon an uncharted mission—"envisaging the spiritual elevation and education of the American people"[110]— that came to its memorable conclusion on the evening of December 9, 1961, at the National Gallery of Art. The treasures of the Kress Collection entered the public domain— and the permanent artistic heritage—of the New World. Summarizing the events, the editor of a distinguished British journal of art also ventured a prophecy: "So typical of America is the confidence with which extravagant schemes of this kind are launched, on a scale never before contemplated, with no very clear object in view, but in the unshakeable belief that in time the scheme will bring its own rewards. We can be sure that these altar-pieces from Italian churches, these allegorical panels from French *châteaux*, which now stray across the American continent like bewildered refugees, will one day work their way, like every other foreign body in this astonishing country, into the very fabric of American life."[111]

1. *Life* 1953.

2. *Time* (October 3, 1955). "Collector No. 1" refers to Kress purchases from Duveen Brothers that eventually surpassed even those of Andrew Mellon.

3. The full scope of the Kress Collection at the National Gallery of Art encompasses 376 paintings, 94 sculptures, 38 works on paper, and 1,307 medals, plaquettes, and small bronzes.

4. See John Walker's prefatory note in Washington 1961–62, the volume published to accompany the exhibition commemorating the conclusion of the Kress Collection.

5. The parallel is drawn to the great donation of Medici art treasures—including the collections of the Uffizi and Pitti galleries—from the family's last direct descendant in 1743. Her bequest to the Tuscan state specified that "None of these collections should ever be removed from Florence, and that they should be for the benefit of the public of all nations." See Taylor 1948, 115–17.

6. Emerson 1961, 823.

7. The genealogy of the American Kresses was traced by Charles Rhoads Roberts for Von Frank zu Döfcring 1930. Samuel Henry Kress appears as entry no. 699.

8. In November 1946 the trade publication *Chain Store Age* ran an article by Ben Gordon, "50 Years of the Kress Idea" (1–8), describing the many innovations that had contributed to the success of the Kress stores from 1896 to 1946. These included ruthless attention to cost control, new and higher standards of merchandise value, and lower profit margins than the competitors—in effect, the smoothly run Kress operations elevated retailing to a fine science.

9. The design of the Kress stores was outstanding in both the distinctive architectural facades and the attractive retailing layout, features to which Kress paid particular attention. Although the company no longer exists, approximately one hundred Kress buildings across the country have been adapted to other purposes. See Thomas 1993 for an overview of the architectural history of the Kress stores (a book on the subject by the same author is in preparation).

10. When Samuel Kress died in 1955, the company he founded had branches in twenty-nine states and Hawaii, employed 22,000 people, and grossed almost $170 million annually. See *Time* (October 3, 1955).

11. The condominium apartment building at 1020 Fifth Avenue was nearing completion in 1925 when Kress's purchase of the top two floors for $150,000 was reported in the *New York Herald Tribune* (May 26, 1925). Among Kress's neighbors were the operatic soprano Amelita Galli-Curci and Charles Evans Hughes, the future chief justice who would also serve as the first chairman of the National Gallery of Art. The elaborate interior design of the Kress apartment was the work of Ernest L. Brothers, a highly successful New York decorator whose clientele included many of the city's wealthiest. Blueprints for the 1925–26 decor are preserved in the Brothers Archive at the National Building Museum in Washington, D.C.

12. *Life* 1953.

13. Claude Washington Kress (1876–1940) and Rush Harrison Kress (1877–1963) both joined their elder brother in his business. Claude succeeded Samuel Kress as president of S. H. Kress & Co. in 1924.

14. The diary is transcribed in de' Giorgi 1988, 53–80.

15. Recording a visit to the Metropolitan Museum in April 1932, Countess Contini remarked that although there were even too many Rembrandts (and not all beautiful), there was a disgraceful lack of Italian art ("*è una cosa vergognosa, hanno quasi nulla di roba italiana*"). See de' Giorgi 1988, 61.

16. Over the years, opinions were provided by the scholars Roberto Longhi, Giuseppe Fiocco, Lionello Venturi, F. Mason Perkins, Bernard Berenson, and William Suida. Paintings were X-rayed in New York by Alan Burroughs.

17. Walker 1974, 135–36. There is no evidence to support this allegation, however. On the contrary, to take one example, Berenson's subsequent approval of the artistic value (if not necessarily the name of the artist) assigned by most of the attributions would suggest that both Kress and Contini—not to speak of the pictures—were well served by the experts.

18. Contini's invoice of October 14, 1927, for three paintings—the Hondecoeter, a tondo of the *Madonna and Child* by Rafaellino del Garbo, and a *Triumph* from Mantegna's school—includes the note: "If any of the above named paintings which you intend presenting to the Metropolitan Museum of New York is not accepted by same, I hereby agree to exchange any or all of them for other objects of art of equal value from my collection, to be selected by you at your convenience."

19. Photographs record the picture, then identified as Dona Polyxena Spinola, in Kress's library at 1020 Fifth Avenue. It was donated to the National Gallery of Art in 1950.

20. For purposes of comparison, $1.00 in 1933 is the equivalent of $12.29 in 1992.

21. *Time* (August 26, 1935): 36.

22. de' Giorgi 1988, 82.

23. de' Giorgi 1988, 62–63.

24. By 1940 Kress had "given more than 75 fine paintings to museums and colleges throughout the United States." See McBride 1940, 32. The sites of Kress gifts of art are listed in the Appendix.

25. Although he rarely if ever attended these presentations, Kress took a keen interest, often encouraging representatives from the local Kress store to participate and to report to him. Typical is a handwritten letter from a company employee in San Antonio describing the presentation of Giuliano Bugiardini's *Holy Family* to the Witte Memorial Museum in January 1937: "Mrs. J. K. Beretta Chairman of the board of directors said that this was the happiest moment of her life. What she was so proud of was to know that this is the first Old Master permanently placed on the museum walls here."

26. The text of the speech was reprinted in its entirety by two local newspapers on the following day.

27. These sentiments were typical of the time. For example, when Kress donated a large panel painting by Luca di Tommé to the Los Angeles County Museum of Science, History and Art, it was announced in the museum's *Bulletin* (May 1931) as the beginning of the Renaissance in Los Angeles, the donor was praised as a merchant prince of the New World, and it was proclaimed that "under such guidance and in time Los Angeles as the fourth city in the Union will have collections of art worthy of her position."

28. *An Exhibition of Italian Paintings Lent by Mr. Samuel H. Kress of New York.* The introductory pages were substituted to include a reference

to each new site. There was also a leather-bound edition of the catalogue that listed the dates and venues of the entire tour, a copy of which Kress sent to President Franklin Roosevelt as a Christmas gift in 1935.

29. So novel was the entire undertaking that it was described in detail in the in-house magazine for Railway Express. See "Early Italian Paintings on Tour," *The Express Messenger* (November 1932): 5–6.

30. At this date Pichetto was "consulting restorer of the Metropolitan Museum of Art" as well as a consultant to Kress. He maintained responsibility for the conservation of the Kress Collection until his death in 1949. From 1936 to 1946 Pichetto also served as a trustee of the Samuel H. Kress Foundation. He worked regularly for Duveen Brothers, and his successful career owed much to his association with Kress and Duveen; see Behrman 1972, 181–82. For a description of Pichetto's studio, an entire floor of the Squibb building, and his role in the development of the National Gallery of Art, see Walker 1974, 142–43.

31. The correspondence with the agent reflects the close attention paid by Kress to everything from crowd response to taxi fares. One of the agent's responsibilities was to observe which pictures found particular favor in different cities, thereby aiding the project of donating paintings to selected institutions.

32. The Samuel H. Kress Foundation was established on March 6, 1929, by Samuel H. Kress and incorporated in the state of New York.

33. Annual meeting of the board of trustees of the Samuel H. Kress Foundation, October 30, 1935.

34. The Kress Foundation does not possess records of Kress's personal acquisitions from Duveen Brothers. However, as reported by Simpson (1986), Samuel Kress made purchases from Duveen's amounting to $1,240,000 in May 1936; $1,500,000 in December 1936; $2,300,000 in March 1937; and $897,000 and $1,448,000 in April 1937. Other evidence confirms Kress's continuing purchases in subsequent years. Indeed, according to Behrman (1972, 205), "In terms of sheer quantity, Kress was the biggest customer of Duveen's entire career." From 1937 to 1957 the Kress Foundation also regularly purchased works of art from Duveen Brothers.

35. Tomkins 1989, 316–17.

36. The Kress Foundation also made grants for the restoration of artistic monuments in Italy, continuing another of Kress's special interests. During the 1930s Kress funds aided preservation projects in Ravenna, Spoleto, Bari, and—a particular favorite—the Ducal Palace in Mantua, including Mantegna's Camera degli Sposi.

37. Special meeting of the board of trustees of the Samuel H. Kress Foundation, June 3, 1936.

38. Bernard Berenson to Samuel H. Kress, June 19, 1937.

39. It seems likely that this was the only time that Kress and Berenson met.

40. Berenson to Kress, March 20, 1938. Kress and Berenson corresponded regularly between 1937 and early 1940. After the outbreak of war, Kress also sent regular parcels of coffee, sugar, tea, and medications to Berenson in Florence.

41. Berenson to Kress, November 23, 1938. See Walker 1974, 137–40, for the role of these lists in his own dealings with Kress for the National Gallery.

42. Berenson to Kress, October 8, 1938. "My book on the Drawings of the Florentine Painters will soon be out, & I trust of some use to serious students. . . . I most humbly suggest, & do no more than suggest, that if you could distribute copies of this book among institutions that cannot afford to buy it, you would not be throwing away your money."

43. In the 1950s the Kress Foundation also sponsored the publication of seven illustrated volumes of Berenson's "lists," *Italian Pictures of the Renaissance.*

44. Berenson to Kress, October 2, 1937. This was the painting—and the attribution—that caused the disruption of Berenson's long-standing financial arrangements with Duveen Brothers. For a version of the complex events, see Simpson 1986, 256–59.

45. Behrman 1972, 204–5. See also Walker 1974, 142.

46. See, for example, Frankfurter 1932, 7ff., describing "a particular section of the large collection of old Italian art which [Mr. Samuel H. Kress] has gathered in his magnificent apartments in Fifth Avenue."

47. "Statement of Herbert Friedmann, concerning his connection with the Samuel H. Kress Collection, as requested by Mr. Rush H. Kress, July 27, 1955." In this typewritten document, Friedmann describes his role in encouraging Samuel Kress to consider offering his collection to the National Gallery of Art, the creation of the book *Signs and Symbols in Christian Art*, and articles that he wrote about pictures in the Kress Collection.

48. Jeremiah O'Connor to Samuel H. Kress, February 8, 1938. Friedmann and O'Connor jointly composed the letter but sent it on the stationery of the Corcoran Gallery of Art, where O'Connor was the curator.

49. Mellon's gift was $1 million *more* than the then budget of the State Department, or the price of one battleship. See Kopper 1991, 15.

50. See the fiftieth-anniversary exhibition catalogue, Thomas 1991.

51. Finley's powers of persuasion were legendary. See the remarks by both Walker and Emerson in Washington 1961–62, vii–xxii.

52. *Indenture of June 29, 1939, between Samuel H. Kress and Samuel H. Kress Foundation with Smithsonian Institution and National Gallery of Art.*

53. Berenson's response was typical: "There are two types of collections those like Widener Gardner Frick or Bache consisting of masterpieces only and those like Johnson Philadelphia constituting historical series STOP Kress combines both satisfying students as well as amateurs STOP Few Italian painters between 1300 and 1600 missing and the greatest represented by highly characteristic examples in excellent condition STOP Here are some names Bartolommeo Veneto Carpaccio Correggio Cossa Crivelli Domenico Veneziano Duccio Gaddi Gentile Girolamo Benvenuto Filippino Filippo Lippi Lotto Mantegna Masolino Nardo Neroccio Pesellino Piero di Cosimo Roberti Simone Titian Tintoretto Veronese STOP Regards, Bernard Berenson." Cable to David Finley, May 23, 1939. Similar opinions were also received from Contini-Bonacossi, Roberto Longhi, F. Mason Perkins, Leo van Puyvelde, Lionello Venturi, and William Suida.

54. Unlike Joseph Widener, who arranged to bequeath his collection to the National Gallery after his death, Kress had recognized the importance of making his gift available to be on display when the building opened. Kenneth Clark, among others, congratulated Kress on this decision in an undated letter (c. June 1939) in the Kress Foundation files.

55. Kopper 1991, 15–25.

56. On March 18, 1941, the complete text of Roosevelt's speech was published in the *New York Herald Tribune.* An accompanying article by Joseph Driscoll described it as "obviously aimed at dictators abroad."

57. Only about half of the exhibition rooms on the main floor were utilized. See Thomas 1991, 43.

58. *Time* (March 24, 1941): 58ff.

59. Executive committee meetings and special meetings of the board of the Kress Foundation approved purchases and loans on February 10, 1941; February 19, 1941; March 3, 1941; and March 10, 1941.

60. Stephen Pichetto reported to the annual meeting of the board of trustees of the Kress Foundation on October 21, 1942, about servicemen visiting the National Gallery. "The fact that so many of them find their relaxation in this way proves the high cultural effect that art has on the morale of our men."

61. Executive committee meetings, and special and annual meetings of the board of trustees of the Kress Foundation, 1941–44 (passim). Kress purchases managed to keep in the country works of art from several of the most important American collections of Italian art of the day, including those of Clarence H. Mackay, Henry Goldman, Philip Lehman, Dan Fellows Platt, and Otto H. Kahn. In addition to Duveen Brothers and Wildenstein, the Kress Foundation was now buying art from almost all of the major dealers.

62. Special meeting of the board of trustees of the Kress Foundation, December 23, 1942.

63. Harlan F. Stone to Samuel H. Kress, February 10, 1943. In Kress's letter of response, he acknowledged his continuing concern "to assist in securing an outstanding collection for our national capital, comparable to the leading European galleries. . . . I hope I will be able to continue my efforts in helping to build up the National Gallery Collection at least in the Italian school, since, as you know, it is the principal school in all European collections and is therefore shown most prominently in those museums." Kress to Stone, February 25, 1943.

64. National Gallery of Art press release, for Monday papers of October 30, 1944.

65. Payment for the El Greco was authorized at an executive committee meeting of the Kress Foundation on January 8, 1946. The circumstances of the sale are described by Walker (1974, 144–46). See also cat. 9.

66. Special meeting of the board of trustees of the Kress Foundation, May 23, 1947: "We will take our time in donating these paintings to galleries throughout the cities in which there are Kress stores so that we obtain the best benefit from it as well as do the most good for the people of the communities where we are doing business."

67. Guy Emerson was elected to the board of the Kress Foundation in December 1946 to replace Stephen Pichetto, who was appointed full-time curator of the Samuel H. Kress Collection. In October 1947, Emerson was employed by the foundation to assist Rush Kress and served until his retirement in 1962.

68. Dr. William E. Suida was employed as librarian of the Kress Foundation in 1947 and was named art research curator of the Samuel H. Kress Foundation in 1950. He served until his death in 1959.

69. Alessandro Contini-Bonacossi recommended Modestini (without naming him) in a letter to Rush Kress dated February 9, 1949: "This man has the temperament of a Master. His technical and artistic knowledge and his ability to inculcate into others love and care in their work make him substantially quite unique." Modestini joined the Kress Foundation later that year and subsequently directed the conservation of the Kress Collection.

70. From 1949 to 1984 the Kress Foundation maintained an office on the eighth floor of a bank building on West Fifty-seventh Street, next door to the Art Students League.

71. Reports and memoranda written by William Suida regarding his activities at the National Gallery of Art during 1949. In the same period, he also reviewed and updated all of the files on individual works of art owned by the Kress Foundation.

72. As reported on the foundation's annual audits by Price Waterhouse. Of course these figures did not include the 546 paintings and 52 sculptures previously donated to the National Gallery of Art.

73. See Walker 1952, 74–75, and Walker 1974, 147–49, for the events regarding the purchase of this painting from the Cook Collection while still in its wartime safekeeping in the United States.

74. Over time the foundation collected almost eight hundred Italian Renaissance frames, which were restored and used on paintings in the Kress Collection. Important period frames were also donated to the National Gallery of Art in Washington and the Metropolitan Museum of Art in New York.

75. Walker (1952, 74) credits the Kress Foundation for acting "with wisdom and speed. . . . For example, during the winter of 1950–51, an emissary flew three times from America to various parts of Europe to bring back only four paintings, but each is of immense significance."

76. In a confidential memorandum of March 21, 1949, John Walker ranked a group of European paintings on the New York market, singling out three—Botticelli's *Portrait of Giuliano de Medici* (Wildenstein), Benozzo Gozzoli's *Salome Dancing before Herod* (Wildenstein), and Gossaert's *Saint Jerome* (Duveen)—as "*of the GREATEST rarity and IMPORTANCE for the gallery.*" Along with most of the other paintings listed, they were purchased by the Kress Foundation. Walker was less fortunate with his recommendations for sculpture, since he hoped that Michelangelo's *Rondanini Pietà*, Bernini's *Truth*, and Giambologna's *Hercules and the Philistine* might be available. (For a while it did seem that the foundation would acquire the Bernini, though an export license from Italy was ultimately refused.)

77. Washington 1951.

78. Annual meeting of the board of trustees of the Kress Foundation, October 18, 1950. Huckleberry Hill was a six-hundred-acre forest and wildlife preserve.

79. The foundation was fortunate in its efforts to recruit experienced conservators in Europe, although it was not always easy. Guy Emerson reported to the Kress board on October 7, 1959, that two additional Italian restorers had been hired to join the team at Huckleberry Hill, plus a Belgian and "one younger man from the staff of the Metropolitan Museum of Art." However, "Modestini found in Germany, Italy, Belgium and Holland that they were having quite as much trouble as we are. In other words, good restorers who are available to come to America hardly exist and in fact many of the good galleries of Europe are without an outstanding or competent restorer."

80. Memo from Guy Emerson to William Suida, February 5, 1951.

81. For the special meeting of the board of trustees of the Kress Foundation on February 13, 1957, Guy Emerson prepared a summary of the "art project" to date, which reflects the foundation's approach: "Naturally, every possible effort will be made to use effectively every good painting

now in our stock. But the Regional program does not contemplate the use of any but first class paintings as these collections are established throughout the country as integral parts of the Kress Collection with their artistic headquarters in the National Gallery of Art in Washington. Most communities want chronological collections covering five or six centuries of Renaissance art."

82. New galleries were constructed in Atlanta, Columbia, Coral Gables, Denver, El Paso, Houston, Memphis, San Francisco, and Seattle. Birmingham and Tucson built new buildings. Many of the other museums substantially renovated older buildings.

83. Memorandum for the art committee from Guy Emerson, April 6, 1959.

84. Sherman E. Lee to Guy Emerson, April 13, 1950.

85. Lee to Emerson, May 22, 1950.

86. The acquisition of the painting from Rosenberg and Stiebel for the de Young Museum was approved at the special meeting of the board of trustees of the Kress Foundation, September 22, 1953.

87. On September 28, 1953, Guy Emerson wrote to Walter Heil, the director of the de Young Museum, reporting the Kress Foundation's acquisition of the El Greco and the Goya "with the intention of presenting them to San Francisco. . . . These paintings are now reposing in my office and the more I see them, the more I like them." Pictures by Van der Heyden, Claesz., and Strozzi had also been purchased "with San Francisco chiefly in mind."

88. Walter Heil described the incident in his contribution to a privately printed commemorative volume given to Guy Emerson on his retirement from the Kress Foundation in 1962.

89. Memo from Guy Emerson to Rush Kress, December 12, 1953.

90. Emerson 1961, 833–34.

91. The Kress Foundation provided extensive scholarly research and photographic documentation, but the design and publication of the catalogue were the responsibility of the regional museum.

92. Emerson to Lee, April 1, 1952.

93. Letter to the trustees of the Kress Foundation, January 23, 1952. The Kress family wintered in Tucson and maintained close ties to the university.

94. A study of the creation of the Kress regional collection in Tulsa was undertaken by Inhofe (1992).

95. As Guy Emerson noted in a report to the board of trustees of the Kress Foundation, February 13, 1957, the wisdom of placing the pictures on loan permitted substitutions or withdrawals "from time to time," as refinement of the Kress regional gallery collections continued.

96. "Seattle Given Ultimatum on Art Collection," *Seattle Post Intelligencer*, June 25, 1952. Kress reported his reaction in a memo of the same date to Guy Emerson.

97. Norman Davis to the president and director of the Seattle Art Museum, Richard Fuller, September 4, 1953 (curatorial file, Seattle Art Museum).

98. In his introduction to the catalogue for the expanded Kress Collection (Seattle 1954, 5) the museum's president and director Richard Fuller described the search for "a variety of subject matter and style, but keeping in mind the balance and harmony of each wall . . . we at times favored a major work of a less known artist, especially when the painting was in fine condition."

99. Annual meeting of the board of trustees of the Kress Foundation, October 15, 1952.

100. Guy Emerson, report to the trustees of the Kress Foundation, October 10, 1955.

101. Washington 1956, 5–7.

102. Guy Emerson, report to the trustees of the Kress Foundation, February 13, 1957.

103. On October 7, 1959, Emerson reported to the trustees of the Kress Foundation that "In order to obtain additional paintings for the Regional Galleries, an exchange was arranged during the year which released five paintings to us in return for a similar number, given to the National Gallery of Art."

104. Credit was given to the presence of the Kress pictures in Birmingham for the bequest that made the new building possible. See Birmingham 1959, 1–5.

105. Guy Emerson, report to the trustees of the Kress Foundation, October 7, 1959.

106. The prime mover behind the entire project was Robert Lee Humber, an indefatigable international lawyer who presided over the North Carolina State Art Society. A measure of his success is the description of the museum, on its opening in April 1956, as "the newest major art museum in the U.S., and the first to have a collection fully subsidized by state funds." *Time* (April 9, 1956).

107. See the address by Perry B. Cott, chief curator of the National Gallery of Art, that inaugurated the Kress Collection at the North Carolina Museum of Art, November 30, 1960.

108. Guy Emerson, report to the trustees of the Kress Foundation, October 7, 1959. The program was suggested by trustee Franklin D. Murphy and was outlined by Professor Edward A. Masur of the University of Kansas.

109. These catalogues of the Kress Collection are listed in the Bibliography under Dauterman, Parker, and Standen 1964, Dubon 1964, Eisler 1977, Hill and Pollard 1967, London 1964, Middledorf 1976, Pope-Hennessy 1965, Shapley 1966, Shapley 1968, and Shapley 1973.

110. Memorandum by William Suida, April 19, 1950.

111. *Burlington* 1962.

★ **NATIONAL GALLERY OF ART**

★ **KRESS REGIONAL GALLERIES**

✳ **KRESS SPECIAL COLLECTIONS**

▲ **KRESS STUDY COLLECTIONS**

● **KRESS COLLECTION GIFT LOCATIONS**

Hawaii

Puerto Rico

Appendix

Washington, D.C. **National Gallery of Art**
376 paintings, 94 sculptures,
1,307 bronzes, 38 drawings and prints,
180 frames

KRESS REGIONAL GALLERIES

Allentown, Pennsylvania **Allentown Art Museum**
50 paintings, 3 sculptures, 8 frames

Atlanta, Georgia **High Museum of Art**
29 paintings, 3 sculptures, 13 pieces
of Italian Renaissance furniture

Birmingham, Alabama **Birmingham Museum of Art**
34 paintings, 2 sculptures, 13 pieces
of Italian Renaissance furniture,
4 stained-glass panels

Columbia, South Carolina **Columbia Museum of Art**
46 paintings, 2 sculptures, 11 bronzes,
9 pieces of Italian Renaissance furni-
ture, 10 velvets

Coral Gables, Florida **Lowe Art Museum**
44 paintings, 3 sculptures

Denver, Colorado **The Denver Art Museum**
46 paintings, 4 sculptures

El Paso, Texas **El Paso Museum of Art**
57 paintings, 2 sculptures

Honolulu, Hawaii **Honolulu Academy of Arts**
14 paintings

Houston, Texas **The Museum of Fine Arts, Houston**
30 paintings

Kansas City, Missouri **The Nelson-Atkins Museum of Art**
9 paintings, 2 sculptures

Memphis, Tennessee **Memphis Brooks Museum of Art**
27 paintings, 2 sculptures

New Orleans, Louisiana **New Orleans Museum of Art**
29 paintings

Portland, Oregon **Portland Art Museum**
30 paintings, 2 sculptures

Raleigh, North Carolina **North Carolina Museum of Art**
73 paintings, 2 sculptures

San Francisco, California **The Fine Arts Museums of San Francisco**
37 paintings, 1 candlestick

Seattle, Washington **Seattle Art Museum**
33 paintings, 2 sculptures

Tucson, Arizona **University of Arizona Museum of Art**
60 paintings, 3 sculptures

Tulsa, Oklahoma **The Philbrook Museum of Art**
30 paintings, 6 sculptures

KRESS SPECIAL COLLECTIONS

New York, New York **The Metropolitan Museum of Art**
10 paintings, 43 pieces of French furni-
ture, 45 bronzes, 17 tapestries, 67 objects
of decorative art, 26 velvets, 2 rugs,
205 frames

New York, New York **The Pierpont Morgan Library**
1 bound volume of drawings,
2 illuminated manuscripts

Philadelphia, Pennsylvania **Philadelphia Museum of Art**
13 tapestries

KRESS STUDY COLLECTIONS

Amherst, Massachusetts **Mead Art Museum, Amherst College**
15 paintings

Athens, Georgia **Georgia Museum of Art,
The University of Georgia**
12 paintings

** The names of institutions are given as of 1993. The distribution is compiled as of 1965.*

Berea, Kentucky	**Berea College Museums** 11 paintings, 1 sculpture, 1 organ	Tempe, Arizona	**University Art Museum,** **Arizona State University** 4 paintings
Bloomington, Indiana	**Indiana University Art Museum** 14 paintings	Waco, Texas	**Baylor University** 5 paintings
Bridgeport, Connecticut	**The Discovery Museum** 10 paintings	Washington, D.C.	**Howard University Gallery of Art** 11 paintings, 1 sculpture
Brunswick, Maine	**Bowdoin College Museum of Art** 12 paintings	Williamstown, Massachusetts	**Williams College Museum of Art** 5 paintings, 1 sculpture
Chicago, Illinois	**The David and Alfred Smart Museum** **of Art, University of Chicago** 15 paintings, 1 sculpture, 1 reliquary, 1 tabernacle, 2 vases, 1 candlestick		

Claremont, California	**Montgomery Art Gallery,** **Pomona College** 12 paintings, 1 sculpture	Albany, New York	**Albany Institute of History & Art** 1 painting
Columbia, Missouri	**Museum of Art and Archaeology,** **University of Missouri** 14 paintings	Alexander City, Alabama	**Alexander Public Library** 3 paintings
Hartford, Connecticut	**Trinity College** 8 paintings	Allentown, Pennsylvania	**St. John's Lutheran Church** 1 painting
Lawrence, Kansas	**Spencer Museum of Art,** **University of Kansas** 18 paintings, 1 sculpture	Atlanta, Georgia	**Marist College** 2 paintings
Lewisburg, Pennsylvania	**Bucknell University** 23 paintings	Augusta, Georgia	**Gertrude Herbert Institute of Art** 1 painting
Lincoln, Nebraska	**University of Nebraska Art Galleries** 11 paintings	Brooklyn, New York	**The Brooklyn Museum** 1 architectural fragment
Madison, Wisconsin	**University of Wisconsin** 14 paintings	Cambridge, Massachusetts	**Fogg Art Museum, Harvard University** 7 paintings
Nashville, Tennessee	**Vanderbilt Fine Arts Gallery** 12 paintings	Cambridge, Massachusetts	**Harvard University School of** **Business Administration** 1 painting
Notre Dame, Indiana	**The Snite Museum of Art,** **University of Notre Dame** 16 paintings, 1 sculpture	Charleston, South Carolina	**Gibbes Museum of Art** 2 paintings
Oberlin, Ohio	**Allen Memorial Art Museum,** **Oberlin College** 10 paintings	Charlotte, North Carolina	**Mint Museum of Art** 4 paintings
Ponce, Puerto Rico	**Museo de Arte de Ponce** 14 paintings, 1 object of decorative art	Cherryville, Pennsylvania	**St. Paul's United Church of Christ** 1 painting
Staten Island, New York	**Staten Island Institute of Arts** **and Sciences** 5 paintings	Colorado Springs, Colorado	**Broadmoor Art Academy** 1 painting
		Dallas, Texas	**Dallas Museum of Art** 3 paintings

Fort Worth, Texas	**Modern Art Museum of Fort Worth** 1 painting	*Pittsfield, Massachusetts*	**Miss Hall's School** 1 painting
Granville, Ohio	**Denison University Gallery** 1 sculpture	*Poughkeepsie, New York*	**Vassar College Art Gallery** 1 painting
Helena, Arkansas	**Philips County Museum** 2 paintings	*Sacramento, California*	**Crocker Art Museum** 2 paintings
Jacksonville, Florida	**Cummer Gallery of Art** 1 painting	*San Antonio, Texas*	**Witte Museum** 2 paintings
Little Rock, Arkansas	**Fine Arts Club of Arkansas** 2 paintings	*San Diego, California*	**San Diego Museum of Art** 2 paintings
Los Angeles, California	**Los Angeles County Museum of Art** 3 paintings	*Savannah, Georgia*	**Telfair Academy of Arts and Sciences** 1 painting
Los Angeles, California	**University of California, Los Angeles** 6 paintings, 1 book	*Seattle, Washington*	**Henry Art Gallery, University of Washington** 1 painting
Macon, Georgia	**Wesleyan College Art Collection** 3 paintings	*Stockton, California*	**The Haggin Museum** 1 painting
Montgomery, Alabama	**Huntington College** 1 painting	*Stockton, California*	**University of the Pacific** 1 painting
Montgomery, Alabama	**Montgomery Museum of Fine Arts** 2 paintings	*Trenton, New Jersey*	**New Jersey State Museum** 3 paintings
Monticello, Illinois	**National Art Foundation** 1 painting	*Tucson, Arizona*	**St. Philips-in-the-Hills** 12 paintings, 6 sculptures
New York, New York	**Cooper-Hewitt Museum, Smithsonian Institution** 9 tapestries	*Tulsa, Oklahoma*	**Southwestern Art Association** 1 painting
New York, New York	**Hunter College, Sara Delano Roosevelt Memorial House** 1 painting	*Versailles, France*	**Château de Versailles** 2 French 18th-century cabinets
New York, New York	**Samuel H. Kress Foundation** 8 paintings, 2 sculptures, 1 Venetian glass bowl	*Washington, D.C.*	**Dumbarton Oaks Research Library and Collection, Harvard University** 1 plaque
New York, New York	**New York University Medical Center** 2 paintings, 1 sculpture	*Washington, D.C.*	**Georgetown University Collection** 2 paintings
Northampton, Pennsylvania	**Northampton Area School Board** 1 painting	*Washington, D.C.*	**St. John's Church** 1 painting
Orlando, Florida	**St. John's Evangelical Church** 1 organ	*Washington, D.C.*	**Washington Cathedral** 1 painting
Phoenix, Arizona	**Arizona Museum of Art** (currently on loan to the Phoenix Art Museum) 2 paintings	*Wichita, Kansas*	**The Wichita Art Association** 2 paintings
		Winter Park, Florida	**The George D. and Harriet W. Cornell Fine Arts Museum, Rollins College** 2 paintings

The Kress Brothers and Their "Bucolic Pictures":

THE CREATION OF AN ITALIAN BAROQUE COLLECTION

by Edgar Peters Bowron

"In Europe itself art history must avoid what has not contributed to the main stream, no matter how interesting, how magnificent in itself. It should exclude, for instance, most German and even Spanish and Dutch art. It should dwell less and less on Italian art after Caravaggio, and end altogether by the middle of the eighteenth century with Solimena and Tiepolo."

Bernard Berenson, *Aesthetics and History in the Visual Arts* (New York, 1948)

Judging from the variety, number, and quality of Italian Baroque paintings in the Samuel H. Kress Collection, one may easily forget in what low regard such works once were held in the United States.[1] Virtually none of the great American collectors— Bache, Frick, Huntington, Mellon, Morgan, Rockefeller, Widener—considered Italian seventeenth- and eighteenth-century pictures to be of any significance, and what few they did purchase were restricted to the occasional sketch by Tiepolo or view by Canaletto or Guardi. Thus when Samuel Kress acquired Tanzio da Varallo's extraordinary *Saint Sebastian* (*fig. 1*) in 1935, he was truly swimming against the tides of taste. The prejudice in America against the art of the Catholic Counter-Reformation, deeply rooted in aesthetic, social, and religious traditions, was not overturned until relatively recently, in the 1950s and 1960s. For years the hostility to Baroque art was pervasive, as Hans Tietze adroitly summarized in the catalogue of an exhibition in Baltimore in 1944 of the works of Strozzi, Crespi, and Piazzetta: "Let us not deceive ourselves. There is hardly any period within the art of the past to which we find the approach more difficult than to the Italian Baroque and its counterparts elsewhere. This dislike is a matter of general spiritual attitude rather than of mere artistic taste. The essential point is less that there are very few paintings and works of sculpture in this style which we wholeheartedly enjoy, than that the whole civilization of which this art is offspring and reflection contains elements which provoke our resistance."[2]

The resurgence of interest in the Baroque began in Europe around World War I with the work of a handful of scholars including the Swiss art historian Heinrich Wölfflin. Wölfflin's influential *Principles of Art History* (1915, translated into English in 1932) fought against the stigma of decadence attached to the period and introduced categories of style that he believed were specific to the Baroque age and that could be used to analyze and appreciate its distinctive qualities. Between the two world wars the Baroque continued to acquire increasing academic status, and a new generation of scholars such as Giuseppe Fiocco, Roberto Longhi, Matteo Marangoni, and Antonio Muñoz among the Italians, and A. E. Brinckmann, Dagobert Frey, Sir Nikolaus Pevsner, Hans Posse, Hermann Voss, and Werner Weisbach among the Germans, made the art of the period increasingly familiar and acceptable to specialists and students.[3]

The great "Mostra della Pittura Italiana del Seicento e del Settecento," which brought together in 1922 at the Palazzo Pitti in Florence more than a thousand seventeenth- and eighteenth-century paintings by artists ranging from

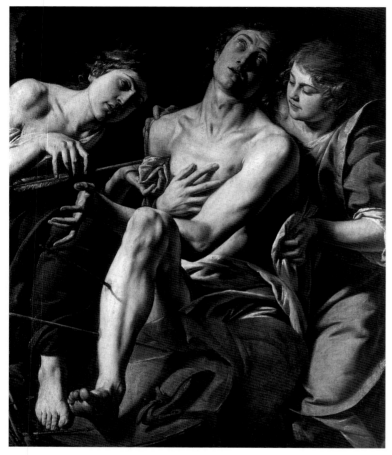

fig. 1 Tanzio da Varallo. *Saint Sebastian*. c. 1620–30. Oil on canvas, 46½ x 37 in. (118 x 94 cm). National Gallery of Art, Washington, Samuel H. Kress Collection

Francesco Albani (1578–1660) to Francesco Zuccarelli (1702–1778) aroused dealers, collectors, scholars, and the general public with a selection of the finest works of a period that was still largely unfamiliar. This exhibition was followed by a growing number of specialist studies, most notably Hermann Voss's *Die Malerei des Barock in Rom* (Berlin, 1924), which even seventy years later remains a useful guide to painting in Rome from Caravaggio (1573–1610) to Domenico Corvi (1721–1803). Exhibitions on the subject increased in number and spread to the United States—the first was apparently held at the Fogg Art Museum in 1929. A few years later Arthur McComb, a lecturer at Harvard, published the first general introduction to Baroque painting in English, *The Baroque Painters of Italy: An Introductory Historical Survey* (Cambridge, 1934).

Still, in the 1920s Baroque painting was appreciated only by the dedicated few, and in America these zealots were fewer in number. The earliest—certainly the most flamboyant—collector was the circus master and entrepreneur John W. Ringling (1866–1936).[4] Ringling began collecting almost by accident in 1925 when he and the German art dealer Julius Böhler traveled to Italy in search of decorative sculpture for a hotel Ringling intended to build in Sarasota, Florida. During the last few days of a visit to Naples, Ringling discussed with Böhler the idea of creating a museum and forming an art collection, and shortly thereafter he purchased his first Italian paintings. Ringling began to buy art in England and Europe at a furious pace and within six years had acquired 625 Italian paintings from the Renaissance and Baroque periods, including works by Albani, Sisto Badalocchio, Canaletto, Pietro da Cortona, Carlo Dolci, Luca Giordano, Francesco Guardi, Guercino, Pietro Liberi, Anton Raphael Mengs, Pier Francesco Mola, Giovanni Antonio Pellegrini, Salvator Rosa, and Sassoferrato. Some of these pictures, like Cortona's *Hagar and the Angel*, are still among the finest Baroque paintings in America, and the museum Ringling opened in Sarasota in 1929 remains one of the premier collections of Italian Baroque painting in the United States.[5]

Another tastemaker who appreciated Italian Baroque painting at an early date was A. Everett Austin, Jr. (1900–1957). Appointed director of the Wadsworth Atheneum in 1927, Austin was a great admirer of seventeenth- and eighteenth-century painting and, as he wrote to Ringling in 1929, aspired "to do all I can to change the underestimation in which it has been held for so many years."[6] In 1930, a year after the Fogg exhibition, Austin organized an important Baroque exhibition in Hartford, "Italian Art of the Sei- and Settecento," which included important examples of all the major painters in the Italian regional schools, from the Carracci to Tiepolo. The exhibition greatly stimulated interest in the Baroque and helped Austin strengthen the museum's collections with the acquisition of paintings from the period, including works by Salvator Rosa and Luca Giordano and in 1933 a dazzling *Saint Catherine of Alexandria* by Bernardo Strozzi. During Austin's tenure as director at Hartford (which lasted until 1945, when he became director of the John and Mable Ringling Museum of Art) the collection he created of Italian painting of the Baroque and Rococo eras brought renown to the Wadsworth Atheneum. His greatest purchase was Caravaggio's *Saint Francis*, for years the only authentic (and still the most important) work by the artist in this country, which he bought for $17,000 from Arnold Seligmann, Rey & Co., New York, in 1943.

From this background Samuel Kress emerged to form what would eventually become the largest and greatest collection of Italian Baroque paintings in America. A businessman who turned to art collecting late in life, his motivation for collecting has been ascribed to his boredom with commerce. But if Kress was a "lonely collector, who was never quite sure why he was collecting," art soon became his passion, and shortly before his death *Life* magazine reported that "he had shelled out more money for art than any other man in United States history."[7] By purchasing paintings that were virtually ignored in this country, Kress also acquired for himself a prominent niche in the history of American art collecting. The collection he launched in the 1920s, completed by others in the 1950s, has been published over the years in scholarly catalogues by the Samuel H. Kress Foundation, but none of these volumes reveals much about how the Kress brothers actually acquired their paintings, sculpture, tapestries, and decorative arts, or about the dealers, restorers, art historians, and Kress Foundation officials who assisted them. Even a brief account illuminates an interesting episode in the collecting of Old Master paintings in this century.

The Italian art dealer Alessandro Contini-Bonacossi (1878–1955) sold Kress his first painting in 1927 and started him on the enterprise that was to occupy him for the remainder of his life.[8] Contini was described by John Walker, former director of the National Gallery of Art, as "a modern Cagliostro"[9]— he was certainly a persuasive salesman, and his influence on Kress was hypnotic. Kress bought exclusively from Contini from 1927 until 1936, when he suddenly began to acquire works from New York dealers, most notably Joseph Duveen.[10] In accordance with the taste of his day, his first purchases in 1927 were almost all Italian Renaissance works from the thirteenth to sixteenth century, except for the surprising presence of a Hondecoeter animal and fruit still life exhibited here (cat. 27) and a fine work, *The Interior of the Pantheon* by Giovanni Paolo Panini (*fig. 2*).

Yet within a few years Kress had acquired a group of eighteenth-century Venetian paintings that were to become the nucleus of the National Gallery of Art's collection of later Italian paintings. These included a pair of conversation pieces by Pietro Longhi, *The Faint* and *A Game of Pentola* (*fig. 3*); pastels by Rosalba Carriera, *Allegory of Painting* and *Sir John Reade, Bart.*; oil sketches by Sebastiano Ricci, *A Miracle of Saint Francis of Paola* and *The Finding of the True Cross*; *Campo San Zanipolo* by Francesco Guardi; a pair of fanciful female heads by Pietro Rotari; and a luminous oil sketch by Giovanni Battista Tiepolo, *The Apotheosis of a Poet*.

The presence of a number of settecento pictures among Samuel Kress's growing collection of Renaissance works suggests that he might actually have *enjoyed* the Venetian Rococo, but he never revealed the depth or extent of his feelings for art. Kress was among the millionaire art collectors that Duveen's biographer, S. N. Behrman, called the "silent men" because they hardly uttered a word to express their feelings for the art they collected.[11] Since Kress purchased his pictures from Contini in lots—"there was something in Kress's nature that could not resist a gross of anything," Behrman wrote[12]— he appears to have accepted more or less what Contini offered, relying almost entirely on the dealer's judgment. Whatever he might have felt about his Venetian paintings, one thing was important to him —they had to be well known. Kress was a businessman who demanded value for his money, and the fact that almost all of these Venetian eighteenth-century paintings had appeared in the exhibition "Il Settecento Italiano" in Venice

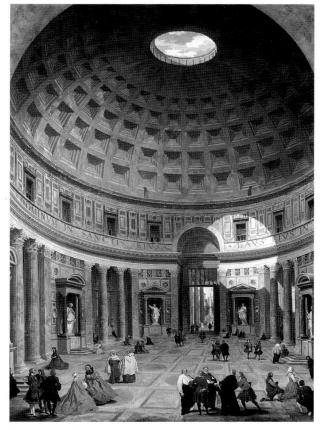

fig. 2 Giovanni Paolo Panini. *The Interior of the Pantheon*. c. 1734. Oil on canvas, 50½ x 39 in. (128 x 99 cm). National Gallery of Art, Washington, Samuel H. Kress Collection

in 1929, and thus bore the stamp of scholarly endorsement, was important. Kress was further pleased when the critic Alfred Frankfurter (later editor and publisher of *Art News*) admired the group in his apartment at 1020 Fifth Avenue

(*fig. 3*) and featured them in 1932 in *The Fine Arts*, a leading art periodical: "Actually a collection within a collection, these fifteen pictures by eighteenth-century Venetian painters are hung nearly all in a single room, offering the beholder a handsome opportunity to reconstruct not only artistic forms but also much of the curious civilization of the period."[13]

In the early 1930s Kress bought another dozen or so Venetian and northern Italian paintings by Tiepolo and several of the artists already represented in the collection,

fig. 3 The dining room in Samuel Kress's apartment at 1020 Fifth Avenue, New York, in the 1930s, displaying works from his collection of eighteenth-century Venetian paintings. A pair of conversation pieces by Pietro Longhi, *The Faint* and *A Game of Pentola* (both in the collection of the National Gallery of Art, Washington), are prominent.

as well as additional works by Giuseppe Bazzani, Gaspare Diziani, Gian Antonio Guardi (cat. 39), and Alessandro Magnasco. The touchstone of these early acquisitions is certainly *The World Pays Homage to Spain* by Tiepolo (*fig. 4*), an oil sketch for the ceiling fresco in the throne room in the Royal Palace, Madrid, which Tiepolo reckoned one of his greatest achievements.

It may be that Contini shrewdly kept from Kress the excesses of Italian seicento painting—the martyrdoms, adorations, and penitent saints that Victorian writers like John Ruskin thought showed the sick sensuosity, melodrama, superstition, and popery of the period.[14] Or perhaps Kress actually preferred to concentrate on the settecento. In any case, in the 1930s he bought only a handful of seventeenth-century pictures, including a fine workshop version of Domenico Fetti's *Parable of Lazarus and the Rich Man* (acquired in 1932); a *Still Life* that for years was accepted as a genuine and important work by Caravaggio, although

it now is assigned to an anonymous painter called the "Pensionante del Saraceni" (acquired in 1935); and the *Saint Sebastian* by Tanzio da Varallo (acquired 1935), all of which are today in the National Gallery of Art.

The work of Tanzio remains as shockingly original as it did in 1922 when the *Saint Sebastian* startled visitors to the ground-breaking exhibition of Baroque paintings at the Palazzo Pitti (where it was correctly identified by Roberto Longhi) and brought the vivid character of this eccentric Lombard artist to a wide audience for the first time. Whatever Kress himself thought of the painting, he nonetheless bought from Contini a second painting by the artist, a *Saint John the Baptist in the Wilderness* (cat. 15), in 1939; a third, *The Rest on the Flight into Egypt* (cat. 16), was added to the collection by the Kress Foundation in 1950.

The breadth of Kress's expanding collection was praised by critics at the time. Helen Comstock wrote of the collection in *The Connoisseur* in 1939: "It is rare to find the Seventeenth and Eighteenth Centuries as well represented as the early and late Renaissance. . . . Not only are Tiepolo, Longhi, and Canaletto relied upon to give conventional representation to the later Italians, but there are important works by Pannini, Bassano, Domenico Fetti, and Giuseppe Maria Crespi."[15] It is precisely because Kress deliberately set out to create a collection ranging from Cimabue to the end of the eighteenth century that he came to buy the very Italian paintings that collectors like Andrew Mellon and Joseph Widener had shunned.

In 1939 Samuel Kress decided to donate his collection to the National Gallery of Art, and when it opened two years later it owned 375 paintings and 18 sculptures donated by Kress. At the dedication on March 17, 1941, he expressed his hopes for the collection:

> In forming my collection I have in mind to provide for the study and enjoyment of the public, as complete a representation as possible of the Italian School of painting and sculpture of quality. I have endeavored to acquire the best examples of the most representative masters of this important school, beginning with the thirteenth century painters, Giotto and Duccio, and extending through the great periods in Florence, Siena, Umbria, Venice, northern Italy, and ending with the Venetians of the eighteenth century. I felt that by so concentrating, I would be able to make the greatest contribution for comprehensive study and understanding of the school which really gave the earliest fundamental inspiration and also maintained superior quality in art throughout the Renaissance period.

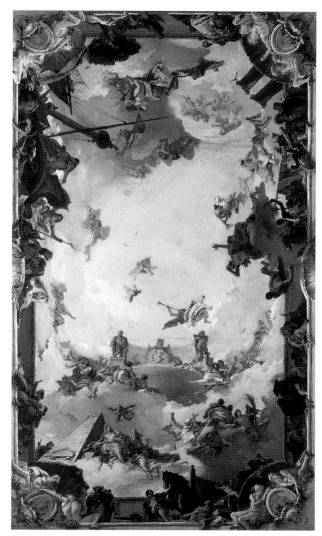

fig. 4 Giovanni Battista Tiepolo. *The World Pays Homage to Spain.* c. 1761/62. Oil on canvas, 71½ x 41⅛ in. (181 x 104 cm). National Gallery of Art, Washington, Samuel H. Kress Collection

A large share of credit for the catholicity of the Kress Collection in its early years is due to Stephen S. Pichetto (1888–1949), one of the most prominent American restorers of his generation. Born in New York, Pichetto graduated from City College and studied at the Art Students League. At an early age he began work as a picture restorer and spent several years in Europe studying the methods then used to restore Old Master paintings. He worked for the art trade, including Duveen, and in 1928 he was named consultative restorer to the Metropolitan Museum of Art, although he had already worked for the museum for a long period. Pichetto served as the Metropolitan's principal technical adviser and conservator well into the 1940s, responsible for the cleaning, lining, varnishing, and frame restoration of the European and American paintings. He

was named consultant restorer of paintings for the National Gallery in 1939 and undertook a great deal of work for the gallery over the years, particularly on the Kress pictures.

Kress first employed Pichetto in 1928 to examine and appraise three paintings he had recently purchased from Contini. Shortly thereafter he became Kress's principal restorer and treated the collection in a studio in the Squibb building on Fifth Avenue with the assistance of a large staff of specialists. Pichetto was made a trustee of the Samuel H. Kress Foundation in 1936; on January 1, 1947, he was appointed curator of the Samuel H. Kress Collection at the National Gallery of Art. His role in raising the standards of the collection was critical because, in John Walker's words, "shrewd as [Samuel Kress] was in buying for his stores, in buying works of art, his innocence remained astounding."[16] Pichetto's increasing influence in Kress's art affairs was no doubt responsible for the purchases from Duveen in 1937, and his role in the formation of the collection continued to expand until he eventually edged out Contini as Kress's main counsel and arbiter for purchases.[17]

Pichetto's role in the formation of the Kress Collection was significant in another way: it was he who provided continuity in the 1940s when Samuel Kress, then in his eighties, fell ill. After 1946, when Kress was completely bedridden, responsibility for oversight of the collection passed to his younger brother Rush, who shared Sam's hopes for the collection. As he wrote to Contini on April 17, 1947, "I might state that I am putting in much of my time in an endeavor to complete what my brother started out to do in the acquisition of such masterpieces as will strengthen any of the periods of the past seven hundred years which might at this time be available."

In John Walker's opinion Rush Kress was a more astute collector than his brother and deserves credit for transforming the collection in quality, focus, and scope: "With his ascendancy, the really great acquisitions for the Kress Collection began. Between 1946 and 1956, virtually every important painting and sculpture was offered to the Kress Foundation, and in those two decades Rush Kress spent approximately $25 million buying for the National Gallery. The same paintings and sculpture, if they could be bought today [1974], would cost over $100 million."[18]

Continuing Samuel's initiatives Rush Kress broadened the collection to include French, Flemish, Spanish, Dutch, and German art: his first major purchase was *The Death of Laocoön and His Sons* by El Greco (cat. 9) for the National Gallery in 1946. Equally important, Rush Kress initiated

efforts in the late 1940s to address the quality of the collection. In a letter to Contini of September 6, 1946, he wrote: "We are not interested in quantity at this time but only in quality which will be comparable with the best in the Samuel H. Kress Collection in the National Gallery in Washington." Early the following year he wrote again to Contini, announcing, "We have recently made some very valuable acquisitions of great paintings which will naturally strengthen my brother's collection and as the number is large we are now primarily interested in complying with his specific instruction as to improving the quality by the addition of outstanding masterpieces." In April 1947 Kress dispatched Pichetto, Alfred Frankfurter, and the New York dealer Félix Wildenstein to examine the Kress Collection in the National Gallery. A memorandum of April 25, 1947, records their method of evaluating the paintings: Fetti's *Parable of Lazarus and the Rich Man*, for example, was rated a "B" by Wildenstein, and "B+" by Frankfurter and Pichetto. Bernardo Cavallino's *Sacrifice of Noah*, now attributed to Antonio de Bellis (now in The Museum of Fine Arts, Houston), was judged a "B" by Pichetto and Wildenstein, but rated an "A" by Frankfurter. Crespi's *Lucretia Threatened by Tarquin* was assigned a "B+" by Wildenstein and an "A" by Pichetto and Frankfurter. Each thought the Caravaggio *Still Life*, then considered autograph, to be of the highest possible quality and importance.

Until about 1950 scholarly appraisal of the collection consisted almost exclusively of certificates of authenticity written by Roberto Longhi, Mason Perkins, Giuseppe Fiocco, and other scholars and experts resident in Italy to whom Contini paid a fee for their opinions. The practice of paid expertise is generally in disrepute today, but even in the early 1950s the Kress Foundation was criticized for attributions of its pictures "redolent of so-called 'expert's' certificates."[19] In an effort to raise the credibility of the collection, Rush Kress appointed the art historian William E. Suida (1877–1959) as the foundation's librarian and research curator on October 15, 1947. A professor at the Universität Graz, Austria, and former director of Steiermärkisches Landesmuseum Joanneum in that city, with affiliations to the Kunsthistorisches Institut in Florence, Suida was a distinguished scholar and connoisseur. An authority on Leonardo da Vinci, Titian, Raphael, Giorgione, and other Italian Renaissance masters, Suida also loved passionately Italian painting of the Baroque, which he wrote about in the Austrian art periodical he founded, *Belvedere*, and in the catalogues for exhibitions such as "Italienische Barockmalerei," which he organized for the Galerie Sanct Lucas in Vienna in 1937.[20] He fled Austria under the Nazi regime in 1939 and by way of England came to America,

where he taught at Queens College, New York. Suida became a passionate advocate in this country for Baroque art, writing for example the first catalogue of the paintings at the Ringling Museum.[21] Suida had been familiar with the Kress collection since 1940, when he published selections of it in the German art periodical *Pantheon*,[22] and he possessed the proper scholarly credentials to provide intellectual respectability to the Kress Foundation's efforts to evaluate and document its holdings. In the 1950s it was Suida who produced most of the catalogues of the paintings and sculptures in Washington and in the regional museums.

Kress dispatched Suida to Washington to vet the Kress paintings in the National Gallery, and on December 10, 1947, Suida and Pichetto produced a memorandum for Rush Kress that rated works in the collection on a scale of A to C. The largest number of paintings, 396, came from Contini, but of these only 29 were considered "A" quality; the majority were judged merely as "B" level. Duveen Brothers had by then sold the foundation 108 paintings, of which 71 were judged to be of the finest quality and all but four of the remainder were rated as "B+." The purchases from Wildenstein & Co. were judged even higher: of the twenty-four (mostly French) paintings sold to the Kress Foundation, all but three were considered to be of "A" quality; the others were rated "B+." Of the entire 606 paintings in the collection, Pichetto and Suida judged one-quarter of the works, 152, to be of premier quality.

Since taking over his brother's art affairs, Rush Kress had for some time been pondering the final disposition of the Kress Foundation's art collections, and he charged Pichetto and Suida with creating a plan for its future growth and development. Their proposal, detailed in a memorandum prepared by Suida on February 23, 1949, placed the main emphasis upon the Kress Collection in the National Gallery, which would become "the most comprehensive and complete demonstration of Italian art, from 1200 to 1800, existing in the world." The collection was believed to represent so completely the principal Italian masters of the thirteenth through the sixteenth century, and acquisitions by major artists not in the collection—Masaccio, Uccello, Pollaiuolo, or Parmigianino, for example—were thought to be unattainable. Nonetheless, Suida argued, Italian Renaissance painters of the second rank—in his opinion, Barna da Siena, Lorenzo di Credi, Sofonisba Anguissola, Rosso Fiorentino—could still be represented with major examples, and seventeenth- and eighteenth-century Italian paintings presented an exceptional market opportunity: "Seventeenth century painting in Italy only recently has regained the full interest it deserves. It is not too late to form a collection of exquisite examples of Seicento painting.

I dare to hope that, within the Samuel H. Kress Collection, not only the most complete but also the most beautiful collection of Italian Baroque painting will be formed. Here we have the rare advantage to be able to select only la crème de la crème out of a great number of items which, eventually, will be available."[23] Future purchases "will depend more on the absolute quality of the single painting available, than on the [artists'] names. . . . This procedure is the more justified as within the last quarter of a century, even, some painters of outstanding quality have been rediscovered, and some more may await their resurrection as soon as careful research is focused on them." Suida noted that with the acquisition of pictures by Albani, Annibale Carracci, Lavinia Fontana (cat. 6), Strozzi, Fetti, Rosa, and Tanzio, the collection "already owns valuable elements to gradually build up the most complete Baroque collection existing in any museum." Suida's desiderata were ambitious, reflecting his knowledge of seventeenth-century Italian painting and the importance—taken for granted today—of painters like Lodovico Carracci, Lanfranco, Guido Reni, Baciccio, Pietro da Cortona, and Orazio Gentileschi. Attached to the memo were extensive lists, organized by regional school, of artists deemed indispensable to a comprehensive collection of Baroque pictures.

In 1947 the Kress Collection was far richer in examples of eighteenth-century than of seventeenth-century Italian painting, particularly the work of Venetian painters like Canaletto, Bellotto, Guardi, Longhi, Tiepolo, and Marco and Sebastiano Ricci. Suida believed that "relatively little" could be added in the eighteenth century, "save for the opportunity to acquire some exceptionally beautiful work." Yet, following Suida's explicit recommendations, the Kress Foundation further enriched its settecento collection in the 1950s with paintings by Pompeo Batoni, *The Triumph of Venice* and *William Fermor* (cats. 45, 46); Placido Costanzi, *Jacob and Laban's Daughters* (Pomona College, Claremont, California); and Michele Rocca, *The Finding of Moses* (Samuel H. Kress Foundation, New York).

On January 20, 1949, the foundation suffered a serious blow when Stephen Pichetto died unexpectedly of heart failure. Pichetto had played an essential part for more than twenty years in the formation and care of the Kress Collection, and finding a successor was a matter of dire importance. Rush Kress received advice on the matter from several quarters, not least the New York art trade, whose interests would inevitably be affected by his choice. In the end, it was Contini who prevailed, suggesting Mario Modestini (b. 1907), "without exaggeration the finest restorer in the world," as the ideal replacement for Pichetto.[24]

The son of a restorer of frames and polychrome sculpture, Modestini was self-taught and in his early twenties had established a restoration studio in Rome. In 1931 he had the great fortune to restore the pictures belonging to Prince Don Gerolamo Rospigliosi, a collection of more than two hundred works by such Baroque artists as Domenichino, Carlo Maratta, Santi di Tito, and Nicolas Poussin, that was sold in Rome the following year.[25] Modestini had also worked for private collectors, dealers, and museums, including the Galleria Nazionale d'Arte Moderna, Rome. A gifted and sensitive connoisseur of Italian Old Master paintings of all periods, he knew the field and the art market as well as anyone; and this knowledge, coupled with his technical skills, made him a brilliant choice as the foundation's curator. Modestini was invited to New York in early 1949 and as a trial asked to clean a Sienese quattrocento panel by Paolo di Giovanni Fei (*Assumption of the Virgin*, National Gallery of Art, Washington) in his room at the Plaza Hotel. He was promptly offered the position, and within a few months had established a studio in the offices of the foundation at 221 West Fifty-seventh Street. Although Modestini did not close his studio, "La Palma," on the Piazza Augusto Imperatore in Rome and fully transfer his operations to New York until 1951, his presence was felt immediately, and his arrival ushered in the heyday of the Baroque acquisitions by the foundation.

In March 1949 Suida, Modestini, and Gualtiero Volterra, an associate of Contini's who had been involved in the sales to Kress from the beginning, visited the National Gallery to evaluate once more the Kress Collection on deposit there and to devise a plan for its future development. "The sublime goal," Suida reiterated in a memorandum dated March 24, 1949, "is to create the most complete collection of Italian art existing in the world." Further desiderata were listed—a work from Correggio's maturity, for example, or a mythological composition by Titian—as well as the need to add two or three galleries of Italian Baroque paintings.[26] Suida also noted the large number of paintings under consideration by the foundation at the time of Pichetto's death and urged an orderly procedure to present them to Rush Kress and the foundation's officers.

Suida returned to the National Gallery in May to examine the Kress paintings currently on view with John Walker and Fern Rusk Shapley, the National Gallery's curator of paintings. In a summary of his visit Suida stated that the decision to keep or eliminate Kress pictures on deposit at the National Gallery was to be made according to the criteria of quality, condition, historical importance, and worthiness of inclusion in "the most select collection in the world." How-

ever lofty in principle Suida's criteria may have been, disagreement arose almost immediately between the National Gallery and the Kress Foundation's staff over the emphasis to be given to Baroque art in the collection. The first dispute involved the acquisition of additional seventeenth- and eighteenth-century Italian paintings from Contini.

The Italian art dealer, who had been prevented by the war from negotiating purchases with the foundation, understandably jumped at the opportunity to expand the foundation's collection of Baroque pictures and played to the enthusiasm of Suida and Modestini for such works. Writing from Florence to Rush Kress on May 21, 1949, he reported that in recent months, "I have dedicated myself to buying up the few good frames that have turned up and also a few pictures of the Italian Baroque which are missing in your collection." Later that year he sold the foundation twenty-one paintings for $450,000, including two major Baroque works: Annibale Carracci's *Venus Adorned by the Graces* (National Gallery of Art, $7,100); and Domenichino's *The Madonna of Loreto appearing to Saint John the Baptist, Saint Paterniano, and Saint Anthony Abbot* (North Carolina Museum of Art, $7,100; each bought by Contini from Herbert Cook for $1,000).

Contini proposed additional acquisitions and early the following year, on February 8, 1950, wrote Kress: "Since my return from the United States, I have been working systematically and continually and with the only view in mind of the completion of the Kress gallery. The results have exceeded all my expectation and I think I will surprise you by showing you a group of works which represent the best which could still be found in the field of high Italian art. Practically it will fill every still existing gap in the Kress collection, and should make of it not only the greatest collection in the world but the most complete ever assembled in History." Contini assembled a remarkably diverse group of pictures, including Baciccio's *Thanksgiving of Noah* and *Abraham's Sacrifice of Isaac* (cats. 33, 34) and Tanzio's *Rest on the Flight into Egypt* (cat. 16) in the present exhibition, which he sold to the foundation in May 1950.[27]

John Walker opposed these (and almost all other) purchases from Contini on the grounds that none of the paintings was of outstanding quality. He had always disparaged the Kress approach to collecting as "stamp collecting" and in his autobiography, *Self-Portrait with Donors*, argued the "merit of the single masterpiece" against the "mass purchases" advocated by the foundation's staff. "They were in my opinion unduly acquiescent in Count Contini's high valuation of his minor Italian pictures."[28] The foundation acquired 162

pictures from Contini in three separate sales in 1949 and 1950, and of these Walker found only 17 up to the standards of the National Gallery of Art.

Undeterred, Suida continued to stress the importance of expanding the Italian Baroque collection. The moment was propitious because the 1950s were a golden age for acquiring Baroque paintings in America; never before (or since) were they so cheap and plentiful. The social, political, and economic upheavals of World War II resulted in the dispersal of many great aristocratic collections, particularly in England,[29] and suddenly large numbers of seventeenth- and eighteenth-century Italian paintings were available in the London art market. To be sure, since the 1930s the

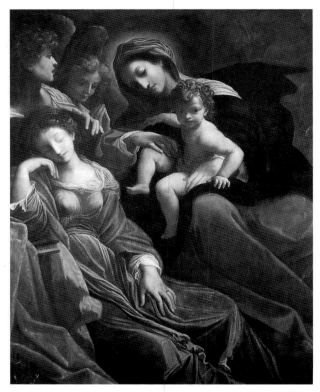

fig. 5 Lodovico Carracci. *The Dream of Saint Catherine of Alexandria*. c. 1590. Oil on canvas, 54⅝ x 43½ in. (138.8 x 110.5 cm). National Gallery of Art, Washington, Samuel H. Kress Collection

English had shown strong interest in the Italian seicento—Sir Ellis Waterhouse, the art historian and director of the Barber Institute of Fine Arts in Birmingham, had written *Roman Baroque Painting: A List of the Principal Painters and Their Works in and around Rome* in 1937, together with a stream of articles and exhibition reviews on painting of the period; Anthony Blunt, the influential Courtauld Institute professor, was sympathetic to Italian Baroque art; and Sir Denis Mahon had been collecting paintings by

Guercino and his contemporaries since the 1930s and had published an immensely influential book on Baroque painting, *Studies in Seicento Art and Theory*, in 1947.

What really fired enthusiasm for the Italian Baroque, however, was the availability of fine works by its neglected masters that could be acquired for a few hundred pounds or less. Jack Baer, a prominent London dealer for nearly a half century, recalled recently the extraordinary bargains available at the time he began his career in the late 1940s, when "masterpieces of the seventeenth century could be bought for £40 [$160], pictures that are now enormously famous."[30] At the Earl of Ellesmere sale at Christie's, London, October 18, 1946, paintings by the Carracci, Domenichino, and Guido Reni, artists who a century earlier were revered in England as the flowers of the seicento, sold for prices that are scarcely believable today. *A Vision of Saint Francis* on copper by Annibale Carracci (formerly Sir John Pope-Hennessy collection; now National Gallery of Canada, Ottawa)[31] fetched £23 2s ($92). Domenichino's *The Way to Calvary*, a small masterpiece on silvered copper of around 1610 (formerly Pope-Hennessy collection; now J. Paul Getty Museum, Malibu), brought £42 ($168). A fine, late landscape by Domenichino (Sir Denis Mahon, London) sold for £157 10s ($630).[32] And one of the finest Baroque pictures in the Kress Collection, Lodovico Carracci's *The Dream of Saint Catherine of Alexandria* (*fig. 5*), acquired from Contini in 1950, brought only £52 10s ($210) at the Ellesmere sale.

In the early 1950s the prices of Italian seicento pictures continued to fetch exceptionally little in relation to their artistic quality and historical importance. At the Ashburnham sale in 1953, for example, Baer wanted to buy a Francesco Albani *Baptism of Christ*, which had an extremely rare French frame made for the duc d'Orléans. He went to the frame dealer F. A. Polak and asked how much he would pay for it. Polak offered £150, so Baer bought the picture for £140 and sold the frame, for a profit of £10. Afterward Sir John Pope-Hennessy (formerly director of the Victoria & Albert Museum and the British Museum and consultative chairman of European paintings at the Metropolitan Museum of Art, New York) phoned Baer to see if he could buy the painting, which he did, minus the frame, at an additional 10 percent profit for the dealer.[33]

Buying in London, dealers like Julius Weitzner, David Koetser, E. and A. Silberman, Frederick Kleinberger, Nicholas Acquavella, Frederick Mont, and Oscar Klein brought Baroque paintings to New York for sale. There several inspired collectors realized the extraordinary oppor-

tunity before them, and around 1950 Walter Chrysler, Jr., Luis Ferré, Paul Ganz, Robert and the late Bertina Suida Manning, and Dr. Bob Jones, Jr., all began to form the collections with which their names are synonymous. Dr. Jones, for example, bought history paintings with religious subjects for the Gallery of Sacred Art he was forming at Bob Jones University in Greenville, South Carolina—for a few hundred dollars each. Shrewdly seeking the advice of scholars and connoisseurs like Federico Zeri, Alfred Scharf, Carlo Volpe, and Suida, Jones assembled in a very short time one of the major collections of Italian Baroque paintings in America.[34] Public institutions, notably the North Carolina Museum of Art in Raleigh, also bought advantageously in a market where in 1950 works of the caliber of Bernardo Bellotto's pair of complementary views, *Dresden with the Frauenkirche*, 1747, and *Dresden with the Hofkirche*, 1748, could be acquired for $10,000.[35] The result was that by the mid-1960s the Italian seventeenth century could be illustrated in great detail from American collections, and individual exhibitions of such narrow compass as Bolognese, Florentine, Genoese, and Venetian painting of the seicento could be assembled largely from local resources.[36]

The triumvirate responsible for the Kress Foundation's acquisitions in the 1950s consisted of Modestini, Suida, and Guy Emerson (1886–1969), a former banking executive and well-known amateur ornithologist, who had been appointed trustee and vice president of the foundation in 1949 and who later served as its art director and art director emeritus. The group reviewed the paintings on the market and made recommendations for purchase to Rush Kress and the foundation's trustees. The following account illustrates the usual procedure. During the last months of 1952 a number of paintings were offered to the foundation by Frederick Mont, Wildenstein & Co., M. Knoedler & Company, Julius Weitzner, Paul Drey, French and Company, Duveen Brothers, and David M. Koetser. About the latter (from whom the foundation had previously purchased several important pictures), Emerson wrote to Rush Kress on January 13, 1953:

> David Koetser is younger than most of the dealers, but Modestini and Suida feel that he knows and loves paintings to a far greater degree than most of the dealers. He has just returned from six months in Europe and brought with him twenty-two paintings which Modestini, Suida, and I saw last week. He offers the lot to us for $173,000. These paintings are mostly in what is known as the Baroque period, the seventeenth and early eighteenth centuries. We all feel that the paintings in this group

would add greatly to the color, variety, and popular interest of the Kress collection. The special interest of Mr. Berenson and Mr. Walker stops short of this school of painting. Modestini feels very strongly that our Collection would be rounded out, completed and enriched by having at least two good Baroque rooms. He points out that these paintings are becoming rare. They are beginning to be appreciated and known to the public and to the dealers. He feels that the group that Koetser is offering us could probably not be repeated in the same quality and degree. Modestini also feels convinced that these paintings which are offered to us for around $8,000 each will certainly be worth, on the market, three, four or five times that within the next several years. Of course, Mr. Walker will see the pictures and will speak for himself. But the recommendation which Professor Modestini, Dr. Suida and I make to you is that you give very serious consideration to the importance of adding a number of these pictures to our Collection. We feel, if Walker doesn't want them now, he is certain to want them later, and in the meantime a number of them could hang in 1020 [Fifth Avenue, Kress's penthouse apartment] or be kept at Huckleberry Hill [the Kress Foundation conservation laboratory and warehouse established in 1951 near Scranton, Pennsylvania], if we do not decide to assign them to regional galleries which, of course, would be very happy to have them.

Rush Kress was evidently fonder of Baroque paintings, which he called "bucolic pictures," than his brother, but he shared Samuel's enthusiasm for a bargain,[37] so these unfashionable, and inexpensive, paintings were doubly appealing. The foundation purchased the majority of the pictures offered by Koetser at this time, including Batoni's *William Fermor* (cat. 46); Orazio Gentileschi's *Portrait of a Young Woman as a Sibyl* (cat. 14); Francesco Guardi's *View of the Grand Canal and the Dogana, Venice* (Columbia Museum of Art, South Carolina); Alessandro Magnasco's *The Supper of Pulcinella and Colombina* and *Pulcinella Singing with His Many Children* (cats. 49, 50); Sebastiano Ricci's *The Battle of the Lapiths and Centaurs* (*fig. 6*); Sebastiano and Marco Ricci's *Memorial to Admiral Sir Clowdisley Shovell* (National Gallery of Art, Washington); Domenico Tiepolo's *The Minuet*, now thought to be a copy after his father (New Orleans Museum of Art); Gaspare Traversi's *The Arts—Music* (cat. 52) and *The Arts—Drawing*; and an anonymous eighteenth-century Venetian *Landscape with the Rest on the Flight into Egypt* (The Museum of Fine Arts, Houston).

It is not easy to explain why only two works among so many of great quality and distinction ended up in the National Gallery of Art. From the moment of Samuel Kress's initial

gift to the National Gallery in 1939, he endorsed the principle of exchanges to improve the quality of the collections on view in Washington. For twenty years—from the opening of the Kress Collection galleries in 1941, until the presentation of the final Kress exhibition, "Art Treasures for America," in 1961, following the final distribution of the collection to the regional galleries—paintings had been delivered to Washington, exhibited at the National Gallery, and either retained for its collections or returned to New York for dispersal to one of the regional galleries. The result is a superlative collection of Italian Renaissance paintings in Washington (although occasionally one or another of the regional museums received works that would be a centerpiece in the installations of the National Gallery today, like the North Carolina Museum of Art's so-called Peruzzi Altarpiece by Giotto and his workshop, believed to have been painted for the Franciscan church of Santa Croce in Florence about 1322).[38]

Among the Italian Baroque and eighteenth-century paintings, the National Gallery kept only about forty Kress works, which in the aggregate form an unimpressive and uneven collection. It is too conspicuous to ignore the absence in Washington of works by so many of the major figures of the Italian seicento—Domenichino, Caravaggio and his followers, Guido Reni, Pietro da Cortona, Giovanni Benedetto Castiglione, Pier Francesco Mola, Salvator Rosa, Baciccio, and Carlo Maratta—or any significant representation of the regional schools like the Florentine (Santi di Tito, Cigoli, or Carlo Dolci) or the Lombard (Cerano, Morazzone, or Procaccini). Worse, paintings by many of these very artists were exhibited in the Kress galleries in Washington for years before being returned to the Kress Foundation, often in exchange for Renaissance works. Many of the paintings that were refused had been acquired by Suida and his colleagues explicitly for the Baroque collection they hoped to form at the National Gallery, including Cecco Bravo's *Angelica and Ruggiero* (Samuel H. Kress Foundation, New York); Castiglione's *Allegory* (Nelson-Atkins Museum of Art, Kansas City); Baciccio's *Abraham's Sacrifice of Isaac* (cat. 34); Giovanni Sebastiano Mazzoni's *Sacrifice of Jephthah* (Nelson-Atkins Museum of Art, Kansas City); Ricci's *Battle of the Lapiths and Centaurs* (*fig. 6*); and Bellotto's *Entrance to a Palace* (cat. 43).

John Walker, as chief curator from 1938–56 and director from 1956–69, played a critical role in the selection of the Kress paintings for the National Gallery. A disciple of Bernard Berenson, Walker shared wholeheartedly his mentor's disdain for the Baroque, and his writings frequently reflect Berenson's position in *Italian Painters of the*

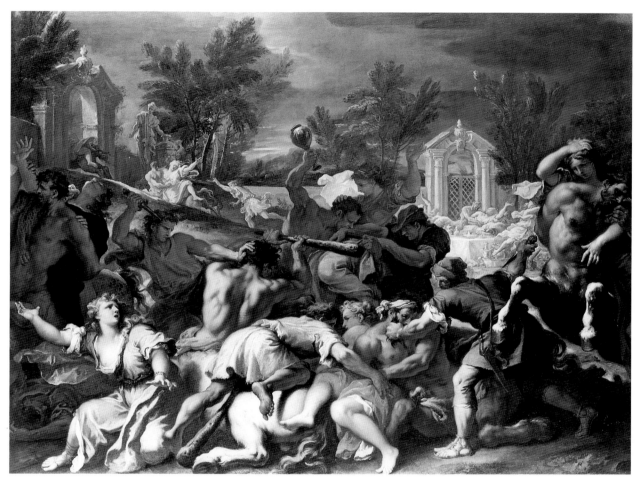

fig. 6 Sebastiano Ricci. *The Battle of the Lapiths and Centaurs*. c. 1705. Oil on canvas, 54 ½ x 69 ⅝ in. (138.5 x 176.9 cm). High Museum of Art, Atlanta, Samuel H. Kress Collection

Renaissance, which concluded with a chapter on painting of the seventeenth and eighteenth centuries entitled "The Decline of Art."[39] In the catalogue of the exhibition of paintings and sculpture acquired by the Kress Foundation between 1945 and 1951, Walker wrote of Italian painting after the Renaissance: "Though the fire of creation was dying down in Italy, a last afterglow is discernible in eighteenth-century Venice."[40] Walker's record of acquisitions—the most enduring legacy a curator leaves behind—was distinguished, particularly in Renaissance paintings and sculpture, but he has been criticized for failing to create a great collection of Baroque pictures at the National Gallery.[41]

Among the seventeen Kress Italian Baroque paintings in the National Gallery's 1951 tenth-anniversary exhibition, for example, Walker kept several important works for the permanent collection, including Lodovico Carracci's *The Dream of Saint Catherine of Alexandria*; Annibale Carracci's *Landscape* and *Venus Adorned by the Graces*; and Tiepolo's *Apollo Pursuing Daphne*. He also properly

insisted upon returning to the foundation during the following decade mediocre works by a variety of artists. But his decision to reject Giovanni Antonio Pellegrini's *Rebecca at the Well* (later destroyed by fire), an autograph version of the original in the National Gallery, London, or the Bellotto *Entrance to a Palace* is inexplicable except on the grounds of prejudice against later Italian painting.

Walker could also have encouraged the Kress Foundation to acquire more Baroque pictures among those on the market in the 1950s. On October 3, 1950, he visited Wildenstein & Co. with Suida, Modestini, and Emerson to examine a group of pictures offered to the foundation. These included Antoine Watteau's *Ceres (Summer)* and Pieter Jansz. Saenredam's *Cathedral of Saint John at 's-Hertogenbosch* (both National Gallery of Art, Washington); Primaticcio's *Ulysses and Penelope* (Toledo Museum of Art); Valentin de Boulogne's *Musical Party* (private collection; *fig. 7*); and Velázquez's *Portrait of a Man (The "Pope's Barber")* (private collection, New York), among other, less important pictures.

There is no gainsaying the decision to acquire the Watteau and Saenredam, each of which is essential to the National Gallery's collections of French and Dutch painting. Walker also wanted the Primaticcio, one of the finest pictures by the founder of the Fontainebleau School,[42] but for some reason it was not purchased. The Valentin *Musical Party*, a superb work painted in Rome by the greatest French Caravaggesque master,[43] is by virtue of its quality, provenance, and subject equal in importance to these other pictures and is without parallel in the National Gallery collections. Walker's comments in an undated memo declining interest in the work (which hung for months in Suida's office at the Kress Foundation) are therefore revealing:

> This painting seemed to me of greater importance to the Collection when I made my report on February 23, 1950, than it does today. In the Contini acquisitions are many very fine seventeenth-century paintings, and my advice would be to decide on the distribution of this category of pictures in the Kress Collection before adding additional canvasses. Moreover, with the recent purchases from New York dealers, I think you will find that the Collection is already exceptionally rich in Baroque painting. This does not mean that I think less highly of the picture by Valentin than I did, but rather that its usefulness is not as great today as it was six months ago.

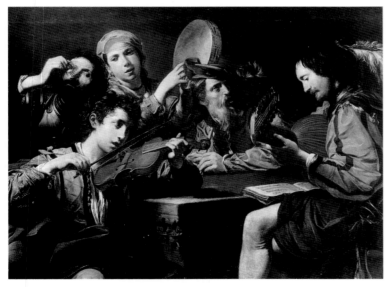

fig. 7 Valentin de Boulogne. *Musical Party*. c. 1620. Oil on canvas, 44 x 57¾ in. (111.7 x 146.5 cm). Private collection

Walker's reponse to the Velázquez portrait, generally considered to be an outstanding work,[44] was similarly blasé: "Any authentic Velázquez is a great addition to any collection of paintings. This picture seems to me authentic, but I would like to see X-rays and study it further in better light than was possible [in Rush Kress's bedroom] at 1020."

John Walker's greatest mistake—by his own admission—was the failure to acquire Caravaggio's *Saint John the Baptist*, now in the Nelson-Atkins Museum of Art (*fig. 8*).[45] In his autobiography Walker devoted a page to the importance upon his career of his wife, Margaret, and her "remarkable eye for works of art." "I wish I had always followed her advice," he wrote. "The most important picture I did not acquire when I might have, a Saint John the Baptist by Caravaggio, now in Kansas City, I lost when I ignored her recommendation. The picture had once belonged to her relatives in Yorkshire, and I thought she was prejudiced. I made a mistake which still haunts me."[46] His regret is understandable, but the account is puzzling because it implies that Suida, Modestini, and Emerson were indifferent to the painting when in fact they were eager to acquire it for the Kress Collection at the National Gallery of Art.

The picture was brought to Modestini's attention in 1952 by Theodore Rousseau, curator of paintings at the Metropolitan Museum of Art, to whom it had been offered by the London art dealer Geoffrey Agnew. The Metropolitan had been considering the painting, which was widely admired following its appearance the previous year in the Caravaggio exhibition in the Palazzo Reale in Milan—but the museum decided instead to acquire a recently discovered multifigured composition by the artist, *The Musicians*.[47] When the Metropolitan Museum relinquished its interest in the painting of the Baptist, it was delivered to the Kress Foundation's offices on West Fifty-seventh Street.

The painting was X-rayed and examined, and Emerson, Modestini, and Suida were elated at the prospect of acquiring it. Walker went to New York to examine the picture, but for reasons unknown, he declined it for the Kress Collection at the National Gallery. Sadly, in this instance Walker refused to heed the opinion of Berenson, who in his 1951 book on Caravaggio identified the Saint John as superior to and the probable original of a version in the Museo e Gallerie Nazionali di Capodimonte, Naples.[48] The painting was returned to London, but Modestini continued to fret over its loss and implored Rush Kress to reconsider the decision. Kress wandered into Modestini's studio at the foundation late one afternoon in the summer as he was leaving his office, and the two discussed the painting again. Modestini pleaded that an extraordinary opportunity was being lost and persuaded Kress to allow him to offer Agnew's $60,000, 20 percent below the asking price. When Modestini reached Geoffrey Agnew in London and presented the foundation's offer, he learned that Laurence Sickman, vice-director of the Nelson Gallery, had purchased the painting a few days before on August 8, 1952.

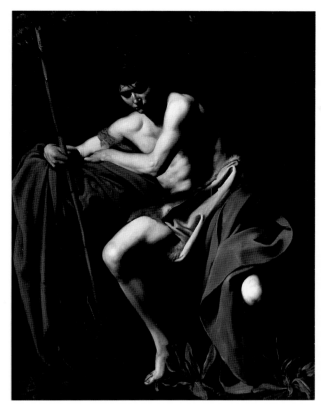

fig. 8 Michelangelo Merisi da Caravaggio. *Saint John the Baptist.* 1604/5. Oil on canvas, 68¼ x 52 in. (173.4 x 132.1 cm). The Nelson-Atkins Museum of Art, Kansas City, Missouri

In short, the National Gallery during the 1950s could have selected for its walls almost any of the Italian Baroque paintings on the market. Walker's disinclination to support the foundation in this area and to bolster the Baroque holdings of the Kress Collection in Washington seems especially vexing today when the prices of such pictures have made them almost prohibitively expensive. Suida, Modestini, and Emerson were not dissuaded by Walker, however, and continued to acquire Italian Baroque pictures for the foundation. The present exhibition brilliantly validates their conviction, and what Washington lost, other cities across America gained.

The Kress Foundation's success in assembling such an ambitious collection of seventeenth- and eighteenth-century Italian paintings is obscured today by its generosity in scattering them throughout the United States. No one, except possibly Mario Modestini and Robert Manning, assistant curator of the collection from 1950 to 1961, has ever seen the whole of the Kress Collection; and certainly no one has ever seen the whole of it together. Only in Fern Rusk Shapley's catalogue of the later Italian paintings[49] can one grasp the breadth of subject matter and variety of forms of the Baroque pictures—history paintings, land-

scapes and view paintings, genre paintings, still lifes and portraits, altarpieces, easel pictures, *modelli*, and *bozzetti.* From the beginning, Samuel Kress dispersed his collection to museums, universities, colleges, and churches in states served by S. H. Kress & Co. stores. Between 1929 and 1939 seventy-four works, including a number of Italian seventeenth- and eighteenth-century pictures, were given or lent to thirty-one different institutions. A remarkable example is one of the five compositions painted by Giovanni Battista Tiepolo around 1750 for the decoration of a room in the Palazzo Barbaro, Venice, the *Offering by the Vestals to Juno* (*fig. 9*). Kress purchased the painting from Contini in 1931 and the following year donated it to the Atlanta Art Association. (Ironically, in 1937 he acquired from Agnew's a second painting from the same room in the Palazzo Barbaro, *Scene from Ancient History*, which was given to the National Gallery of Art.) As a result of Kress's propensity to share his purchases, the collection of later Italian paintings has never been appreciated in its entirety. Even if countless visitors to the Metropolitan Museum of Art, New York, have admired Pietro Longhi's exceptional conversation piece, *The Meeting* (bought by Kress from the estate of Henry Walters in 1936, and donated to the Metropolitan later that year), how many have ever seen a brilliant pair of oil sketches by Gaspare Diziani, *The Adoration of the Magi* and *The Adoration of the Shepherds* (*figs. 10, 11*), that Kress acquired from Contini the same year and gave the following year to Wesleyan College in Macon, Georgia?

Among the experiences that shaped Kress's thoughts on the collection he was building, and its eventual dispersal, was the response of the American public to a traveling exhibition of his Italian pictures. From 1932 to 1935 "An Exhibition of Italian Paintings lent by Mr. Samuel H. Kress" traveled to twenty-four American cities, from Atlanta to Portland.[50] Kress's purpose, as he wrote in the introduction to the accompanying catalogue, was to encourage "a more cultured understanding of art" through the opportunity of viewing a characteristic and comprehensive group of Italian paintings. Kress himself selected the contents of the exhibition, which began with works of the early Renaissance in Florence and Siena by Agnolo Gaddi, Neri di Bicci, and Pietro Lorenzetti and continued through the seventeenth and eighteenth centuries with paintings by Sebastiano Ricci, Canaletto, Panini, and Guardi. Few cities on the itinerary possessed appreciable public or private collections of Old Master paintings of any sort, much less works of the later Italian schools, so the presence of such paintings in the exhibition was a revelation to people in these cities. Gratified by the public response to his collection—three thousand

visitors attended the opening of the exhibition in New Orleans in 1933, for example—Kress resolved to share his paintings with an even wider public. In the 1930s Kress lent his eighteenth-century Venetian paintings to a variety of exhibitions in Chicago, Dayton, New York, San Francisco, and Paris.

Rush Kress and the foundation's staff were committed to Samuel Kress's program for sharing his art collection, and in the late 1940s they began to focus closely on its distribution to museums beyond the National Gallery. A meeting

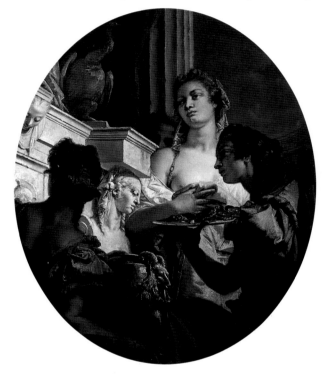

fig. 9 Giovanni Battista Tiepolo. *Offering by the Vestals to Juno.* c. 1749–50. Oil on canvas, 56⅞ x 44⅜ in. (144.5 x 112.7 cm). High Museum of Art, Atlanta, Samuel H. Kress Collection

of May 18, 1948, was devoted to the subject, and a memorandum entitled "Samuel H. Kress Collection: Art Research Work Analysis to Be Done" noted that the regional gallery program called for thirty-three institutions to receive a total of ninety-two works. Two years later, when the staff projected their activities for the coming year in a memorandum of January 10, 1950, the regional museums and galleries were again at the forefront of the foundation's concerns: "The only way to make these regional galleries a success is to give to each of them its own character, significance, and importance, otherwise there will always be the feeling that the outstanding works of art have gone to the National Gallery, while the regional galleries must be satisfied with secondary pieces." The foundation envisioned eighteen to twenty regional Kress collections, with the character of each to be

defined along thematic lines appropriate to their destinations. Thus San Diego and Houston, following discussions with their directors, were to receive collections featuring Spanish art and portraiture, respectively. Other regional collections would be organized along similar lines, and the foundation's staff intended to retrieve works that Samuel Kress had distributed in the 1930s and exchange them for objects according to the new scheme—Pichetto had long wanted to unite the Tiepolo oval in Atlanta with the companion painting in Washington, for example. This plan was abandoned, however, and the regional museums received Kress collections according to much more practical criteria.

The selection and distribution of the collections to the regional museums occupied the foundation's staff and officers throughout the 1950s. Negotiations and exchanges among the institutions were lively, and it is not generally realized how often paintings were moved from one collection to another until the final distribution was made in 1961.[51] Selections for the regional collections were accomplished in various ways. Some of the local directors, like Walter Heil at the M. H. de Young Memorial Museum in San Francisco, both energetically proposed works on the market to the foundation and solicited specific paintings from the Kress holdings.[52] (One example in the present exhibition is *The Empire of Flora* by Tiepolo [cat. 48], purchased by the foundation in 1952, which John Walker rejected for Washington and Heil ardently sought for San Francisco.) In other instances the museums were the passive, serendipitous recipients of the foundation's generosity. In almost every one of these museums, it should be emphasized, the institution derived indirect benefits from the gift. The Museum of Fine Arts, Houston, installed climate controls for the first time, to accommodate the Kress paintings; San Francisco added a new wing; and for others the standards of care for their collections were significantly improved with the assistance and advice of the Kress Foundation.

One surprising feature of the Kress Collection as it exists today is the extraordinary number of fine paintings in relatively provincial cities across the nation. The El Paso Museum of Art, for example, appears at first glance an unlikely place to find such fine Italian pictures as those by Lavinia Fontana (cat. 6), Canaletto (cats. 40, 41), and Bellotto (cat. 43) in the present exhibition and others by Strozzi, Magnasco, Crespi, and Rotari.[53] One explanation is that in 1958 the S. H. Kress & Co. store in El Paso led all the 262 Kress stores with sales of $3,263,703 (the flagship New York store at 444 Fifth Avenue was second, with $3,015,060).[54] Another is that Robert Manning, himself a Texan, made the selection of paintings for El Paso.

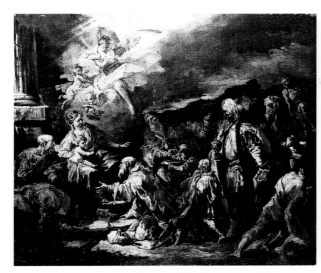

fig. 10 Gaspare Diziani. *The Adoration of the Magi.* c. 1750. Oil on canvas, 15¾ x 19¾ in. (40 x 50.2 cm). Wesleyan College, Macon, Georgia, Samuel H. Kress Collection

fig. 11 Gaspare Diziani. *The Adoration of the Shepherds.* c. 1750. Oil on canvas, 15¾ x 19¾ in. (40 x 50.2 cm). Wesleyan College, Macon, Georgia, Samuel H. Kress Collection

The North Carolina Museum of Art in Raleigh also received important Baroque and later Italian paintings from the Kress Foundation, but by quite different means than the other regional galleries. In 1943 Robert Lee Humber (1898–1970), a North Carolina lawyer and state senator, approached Samuel Kress about assisting with efforts being made to found an art museum for the state; and in 1947 Kress agreed to provide a million dollars, on the condition that neither his name nor that of the Samuel H. Kress Foundation be disclosed and that his commitment remain verbal in order to avoid solicitation from other states in which he operated five-and-dime stores. Humber accepted these terms, and the agreement served as the basis for the legislative action of 1947, when the North Carolina General Assembly conditionally appropriated a million dollars to the North Carolina State Art Society for the purchase of Old Master paintings, contingent upon the sum's being matched by private donations. In 1951 the state permitted the required matching gift to be made in works of art, and the Kress Foundation agreed to include Raleigh in its program for endowing regional museums throughout the United States with paintings and sculpture from the collection and to present the museum with "outstanding Italian Renaissance Art and other similar paintings of a value of at least one million dollars." Between 1958 and 1961, following negotiations and exchanges, the number of paintings in the Kress gift was increased to seventy-three, and two sculptures were added, making the Kress Collection in Raleigh the largest and most important of any except that given to the National Gallery.[55] The Italian Baroque paintings in Raleigh, which were selected by Modestini and Carl Hamilton, a New York

dealer and collector and friend of Rush Kress and Humber, are among the most important in the Kress Collection. They include Massimo Stanzione's powerful and arresting *Assumption of the Virgin* (cat. 17), one of the most important Neapolitan Baroque paintings in America; two very different canvases by Magnasco, each of unusually fine quality (cat. 49); Batoni's large and ambitious *Triumph of Venice* (cat. 45); and a masterpiece of northern Italian genre painting by Ceruti (cat. 51), all in the present exhibition, as well as the altarpiece by Domenichino for Fano, a town on the east coast of Italy where the artist worked in 1618–19.

Relations between the Kress Foundation and the intended recipients of its largesse were not always smooth, as illustrated by an incident involving the Philadelphia Museum of Art. In 1950 the museum was given twenty-five Italian paintings of the sixteenth, seventeenth, and eighteenth centuries in celebration of its Diamond Jubilee. The paintings, accepted by the museum's president, R. Sturgis Ingersoll, installed in three galleries, and published by Suida in an issue of the *Philadelphia Museum Bulletin*,[56] varied in quality and importance but included one great Renaissance work, *The Nativity* by Perino del Vaga (now National Gallery of Art), and several fine Baroque paintings: Sebastiano Ricci's *Finding of Moses* and *Jephthah and His Daughter* (cats. 37, 38); Tiepolo's *Queen Zenobia Addressing Her Soldiers* (National Gallery of Art, Washington); and Batoni's *Richard Aldworth Neville, Lord Braybrooke* (High Museum of Art, Atlanta). There was widespread criticism about the attribution of one of the paintings, however, a *Saint Sebastian* assigned by Suida to Raphael (now thought to be a follower

fig. 12 Guido Cagnacci. *David with the Head of Goliath.* c. 1650. Oil on canvas, 50⅜ x 38 in. (128 x 96.5 cm). Columbia Museum of Art, South Carolina, Samuel H. Kress Collection

of Perugino; New Jersey State Museum, Trenton),[57] which led the museum's curators to doubt the importance of the entire group of Kress paintings. In 1953 the Philadelphia Museum returned the paintings to the foundation, much to the distress of Rush Kress. In a letter to Contini of June 29, 1953, Kress wrote, "We have more minor and secondary paintings accumulated, consequently it is not advisable for us to consider any that are not acceptable to the National Gallery of Art as the remaining museum directors are becoming more particular in their selections and the paintings were returned recently by the Philadelphia Museum of Art, which we had placed on loan at their assiduous request; this included several from the Cook Collection [sold to the foundation by Contini]."

Kress had written to Contini earlier that year cautioning him about the foundation's increasing selectivity. One hundred paintings had been reserved from ten dealers, and Walker was coming from Washington "to check a very limited number of same for our consideration as there are very few which we will consider at this time. I am going into this most definitely as we will not make many further

investments in art after the coming year." In fact, the foundation continued to acquire, but the days of wholesale buying were over and the pictures were acquired more selectively and slowly. The *Group Portrait*, formerly attributed to Ubaldo Gandolfi (Fine Arts Museums of San Francisco), came from Aram Gallery, New York, in 1954. Guercino's portrait *Cardinal Francesco Cennini* (National Gallery of Art, Washington) was bought from Koetser; the Stanzione *Assumption of the Virgin* from Rosenberg & Stiebel, New York; and Guido Cagnacci's *David with the Head of Goliath* (*fig. 12*) from Jacques Seligmann, New York, all in 1955. And the Batoni *Triumph of Venice* (cat. 45) was acquired from a private consortium of dealers trading as the International Financing Company, Panama City, in 1957. With the acquisition of a group of nine paintings from Koetser in 1957 for $230,000, the last major Kress purchase, the Kress's Baroque collection was complete; this purchase included the Ceruti (cat. 51) and the Canalettos (cats. 40, 41) in the present exhibition, and another, especially poetic landscape by Canaletto, *The Porta Portello, Padua* (National Gallery of Art, Washington), produced after his visit to the mainland around 1741.

The earnings of S. H. Kress & Co. stores began to decline significantly in the late 1950s, and, as Rush Kress began to feel the effects of his age, the new management of the Kress Foundation decided to end its art acqusitions. But the taste for Italian Baroque paintings that had developed so strongly around 1950 continued into the next decade and in fact surged in the 1970s and 1980s. Art historians, museum curators, collectors, and dealers became even more infatuated with this long-neglected period. The lack of first-class examples in most major museums outside Italy, and the awareness of these lacunae, combined with the availability of Baroque pictures in private collections old and new, created an enormous demand for Baroque and eighteenth-century paintings and for exhibitions on the subject.[58] The result was a vigorous and active market as American museums avidly bought works by practically unknown artists like Giulio Cesare Procaccini, the prices of which rose to hundreds of thousands of dollars. During the Baroque boom painters like Guido Reni, for example, recovered much of the esteem—and market appeal— with which they had been regarded by dealers and collectors in the age of Reynolds, and museums in Toledo, Los Angeles, Edinburgh, Manchester, and elsewhere vied for his paintings. Reni's prices continued to rise until *David with the Head of Goliath*,[59] a version of a painting in the Louvre, brought an astonishing $2,838,000 at Sotheby's in 1985. Baroque pictures were now bought and sold in a

new sphere entirely—the world of Big Business—and
the 1950s, when the Kress Foundation bought Sebastiano
Riccis for $12,000 and Strozzis for $8,000, seem to have
belonged to another era altogether.

In 1961 the Kress Foundation gathered a selection of its
best pictures in Washington one last time at the National
Gallery before dispersing them across the land. There,
Samuel Kress's "Treasures for America," which he had
begun gathering nearly forty years before, were admired
by the art world. One of the great surprises of the exhi-
bition was the strong presence of the Baroque in pictures
of quality and real distinction, an achievement poetically
celebrated by the critic Thomas Hess:

> When you leave the fields of Greatness and of Old
> Italy, the record of the Kress Foundation is more impres-
> sive. It has a flair for the seventeenth- and eighteenth-
> century Italians; for the smokey, twisted, fleshy poetics
> of Giuseppe Bazzani (*Saint Thomas*, from Tucson);
> for Tanzio da Varallo's gesticulations in slow tobacco-
> colored light (*Saint John the Baptist*, from Tulsa); for the
> traffic-jam operatics and erotics of Mazzoni (*Jephthah*,
> from Kansas City); for the psychotic social comment of
> Traversi (*Music*, from Kansas City). It is a wonderful
> thing to have a noble, full-scale Baroque composition
> by Massimo Stanzione in Raleigh, N.C.; a young tour-
> ist could find more genius here, in the dying style of
> Caravaggio, than in many pretentious star-named objects.
> A Canaletto landscape of Padua (National Gallery)
> balances the tones of salt air, sea, sun, soft stone on a
> diamond point of vista. His organic balance hardens in
> Bellotto's northern cityscape (from Houston), but a true
> document is achieved with the coarser material.[60]

I am grateful to Marilyn Perry, President of the Samuel H. Kress Foundation, for permitting me to examine the foundation's archives during the preparation of this article and to the staff of the foundation, particularly Gail Bartley, archivist, for their kind assistance. I learned a great deal about the Kress Collection and its formation from Robert L. and the late Bertina Suida Manning, Mario Modestini, Stanley Moss, and Spencer Samuels. For assistance with various aspects of this essay I am also grateful to Julian Agnew, Jack Baer, Joseph Baillio, Tam Curry, David Steel, and Eliot Rowlands. All uncited references are to correspondence, memoranda, and other material in the Kress Foundation archives. For references to the Italian paintings in the Samuel H. Kress cited herein, see Shapley 1973 and 1979.

1. For an excellent survey of attitudes toward Italian seventeenth- and eighteenth-century painting in America during the past two centuries see George Hersey, "The Critical Fortunes of Neapolitan Painting: Notes on American Collecting," in New Haven 1987–88, 69–80.

2. Hans Tietze, "Introduction," in Baltimore 1944, 5.

3. On the modern resuscitation of the Italian Baroque see Rudolf Wittkower's introduction to Detroit 1965, 11–13.

4. The first twentieth-century collection of Italian Baroque paintings was formed by Henry Walters of Baltimore, when he acquired the entire collection of Don Marcello Massarenti, a Roman priest, in 1902. This collection comprised Greek, Etruscan, and Roman antiquities, medieval and Renaissance bronzes, ivories, and furniture, and Old Master paintings from various European schools, including a large number of Italian seventeenth- and eighteenth-century pictures (see Zeri 1976).

5. Peter Tomory, "John Ringling the Collector," in Sarasota 1976, ix–xiii.

6. Jean K. Cadogan, "Introduction: The Formation of a 'Small but Distinguished Collection,'" in Hartford 1991, 13, quoting a letter of November 19, 1929. Cadogan's essay is important for its discussion of both the early reception of Baroque art in the United States and the role Austin played in its acceptance (see also Sarasota 1958 and Denys Sutton, "A Voyage of Discovery," in New York 1981, 7–10).

7. Walker 1974, 143; *Life* 1953, 148.

8. The principal published source for the activities of Contini is de' Giorgi 1988. A scholarly biography of Contini does not exist. The sources for his activities as a collector and art dealer include unpublished letters in the Kress Foundation archives; the manuscript, if extant, of Contini's unpublished memoirs, detailing his relations with the Kress family (mentioned in a letter to Rush H. Kress of February 1, 1953, in the foundation archives); unpublished papers with the Contini family in Florence and papers at the Fondazione Roberto Longhi, Florence; and interviews with scholars, associates, and dealers who knew Contini, including Federico Zeri, Mario Modestini, and Stanley Moss.

9. Walker 1974, 144.

10. Although Kress began to acquire pictures from dealers other than Contini in 1936, his first major purchase from another source was a group of twelve paintings bought from Joseph Duveen on April 12, 1937, for $880,000. Kress continued, however, to buy almost exclusively from Contini until about 1940; in 1936–39, for example, his purchases from the Italian dealer amounted to $1,256,000.

11. Behrman 1972, 171.

12. Behrman 1972, 203.

13. Frankfurter 1932, 7.

14. For Ruskin, see Hersey in New Haven 1987–88, 72–75.

15. Comstock 1939, 150.

16. Walker 1974, 142–43.

17. Behrman 1972, 181–82.

18. Walker 1974, 140.

19. For Contini's use of experts see Walker 1974, 136; for criticism of the practice and reliance on inflated "authentications" see Frankfurter 1951, 63. A decade later Thomas Hess continued to criticize "the happy-go-lucky methods of attribution and restoration practiced by the Foundation" (Hess 1960, 35), although in fact the Kress conservation program was as sophisticated and advanced as any at the time.

20. Vienna 1937.

21. Sarasota 1949.

22. Suida 1940, 273–83.

23. In a memorandum of September 8, 1948, Suida described his intention to designate the individual galleries in the National Gallery according to the outstanding masters or schools represented therein. For example, Gallery 34 was to be called the "Caravaggio Gallery," on the basis of the *Still Life* then thought to be an autograph work by the Lombard master; Gallery 37 was the "Tiepolo Gallery," "called with the name of the greatest and most versatile master of the Venetian Settecento," and so forth.

24. Contini, upon learning of Pichetto's death, wrote immediately to Rush Kress on January 23, 1949, saying, "I have in mind a solution that might be ideal from every point of view. . . . The only person, in my knowledge, with *all* the necessary qualities." In a letter of February 9, 1949, Contini wrote: "This man has the temperament of a Master. His technical and artistic knowledge and his ability to inculcate into others love and care in their work make him substantially quite unique. In confidence and for your personal use I want to tell you that I consider Modestini without exaggeration the finest restorer in the world. Take care of him and try to help him as far as possible but do not tell him how highly I think of him, as it might turn his head a little." Contini continued to reassure Kress of his choice and wrote on February 8, 1950: "I am more and more convinced that he is really the greatest restorer of Italian art in the world."

25. See Sestieri 1932.

26. Suida also discussed plans for two Kress "study galleries" in the National Gallery that would "introduce the visitor to a deeper understanding of the historical and iconographical significance of works of art" and complement the handbook of religious symbolism proposed by Rush Kress as an aid to the understanding of Christian art (George Ferguson, *Signs and Symbols in Christian Art* [New York, 1954]).

27. Contini presented the paintings to the foundation in discrete groups, such as portraiture (Pompeo Batoni, *Richard Aldworth Neville, Lord Braybrooke*, High Museum of Art, Atlanta), religious painting (Luca Giordano, *Deposition of Christ*, Philbrook Museum of Art, Tulsa), Venetian painting (Canaletto, *View of the Grand Canal*, Birmingham Museum of Art), and so forth.

28. Walker 1974, 152–53. In fairness to Walker, a number of the paintings Contini sold to the Kress Foundation in 1949 and 1950 and exhibited at the National Gallery in the 1950s are studio or workshop products, including several by Tiepolo (*Sacrifice of Iphigenia* and *Circumcision of the Children of Israel*, University of Arizona Museum of Art) and Canaletto (*Bacino di San Marco*, Seattle Art Museum).

29. For example, in 1946 Christie's alone auctioned Old Master paintings from the collections of Lords Brocket, Hillingdon, Kinnaird, and Moyne; Viscount Rothermere; the Marchioness of Ailsa; the Earls of Crawford and Balcarres, Ellesmere, and Lauderdale; the Dukes of Buccleuch, Hamilton, Montrose, and Newcastle, among others.

30. Moore 1990, 68. In the mid-1940s one British pound equaled four American dollars; in 1948 the exchange was £1 = $2.80.

31. Posner 1971, II, 43 no. 99, pl. 99a.

32. Spear 1982, I, 172 no. 36; and 2:pl. 34; I, 302 no. 110; and II, 386.

33. Moore 1990, 68.

34. See Pepper 1984 and Raleigh 1984.

35. Raleigh 1992, reproduced 200–201.

36. See Detroit 1965 and New York 1969 and the exhibitions on the regional Italian schools organized by Robert Manning at Finch College in New York; for example, New York 1962 and New York 1964–65.

37. The Kress Foundation archives are filled with examples of Kress's satisfaction in buying paintings advantageously. In a letter of February 7, 1952, to Contini discussing recent acquisitions, he was particularly pleased that several were acquired "at the right prices." One painting, bought recently for $82,500, had been acquired by the seller twenty years earlier for $240,000; another painting had cost only $60,000, and Kress discovered to his delight that a similar work had sold recently for $320,000.

38. Raleigh 1992, reproduced 158–59.

39. Berenson 1952, 203: "The Mannerists, Tibaldi, Zuccaro, Fontana, thus quickly give place to the Eclectics, the Caracci, Guido, and Domenichino. Although counting many a painter of incontestable talent, and some few who, in more favouring circumstances, might have attained to greatness, yet taken as a school, the latter are as worthless as the former, understanding as little as they that art will only return with form and movement and that, without them, it is mere pattern."

40. John Walker, "Introduction," in Washington 1951, 13.

41. Mario Modestini, in an interview with Gail Bartley on February 2, 1991, for the Kress Foundation archives, said of Walker: "He occasionally wanted pictures not good enough that had been recommended by Bernard Berenson. Walker rejected all the Baroque pictures we had at the time and today they are sorry because these paintings are in the regional museums."

42. Toledo 1976, 131–32 pl. 15.

43. Mojana 1989, 116 no. 32, reproduced 117. The painting had been in the collections of M. Forest de Nacré; the Duc d'Orléans; the Duke of Bridgewater; the Marquess of Stafford; and the Earl of Ellesmere, by whom it was sold at Christie's, October 18, 1946, lot no. 162.

44. New York 1989–90A, 236–39 no. 33. Another Velázquez Walker discouraged the foundation from acquiring was the beautiful study for the head of Apollo in the *Forge of Vulcan* in the Museo del Prado, Madrid (New York 1989–90A, 116 no. 12).

45. New York 1985, 300–303 no. 85; a complete account of the painting will be published in the forthcoming catalogue of the European paintings in the Nelson-Atkins Museum of Art; vol. I, Italian school, by E. W. Rowlands.

46. Walker 1974, 34.

47. New York 1985, 228–35 no. 69.

48. Berenson 1951, 33 fig. 46: "Altre varianti esistono di seminudi in figura di Battista: una sola merita d'essere mentovata qui. Ne abbiamo due versioni, una a Napoli, l'altra—superiore e probabilmente l'originale —in vendita sul mercato londinese (la riproduce Longhi in *Proporzioni*, 1, figura 18)." In the 1953 English translation (32 fig. 54) the passage reads: "There exist other treatments of the semi-nude as Baptist. Only one deserves mention here. It is represented by two versions, one at Naples and the superior one, the probable original now in the Museum of Kansas City."

49. Shapley 1973.

50. For example, Memphis 1932–33.

51. See Guy Emerson's introduction to Washington 1961–62, xii–xiii.

52. See Fried 1978, 43.

53. For the fifty-one Italian, Spanish, and French paintings and sculptures in El Paso's Kress Collection, see El Paso 1961.

54. "We Remember Kress," edited by James S. Hudgins, unpublished, n.d., 397.

55. Edgar Peters Bowron, "The North Carolina Museum of Art and Its Collections," in Raleigh 1992, xiii, xx, xxi.

56. Suida 1950, 1–23.

57. Shapley 1968, 100 fig. 241.

58. As observed by Julian Agnew in the introduction to London 1981A, 8.

59. Washington 1986–87, 517–19 no. 185.

60. Hess 1960, 55.

Sebastiano Luciani, called **SEBASTIANO DEL PIOMBO**

Venice (?) c. 1485–1547 Rome

Portrait of a Humanist

⟶⟨◈⟩⟵

Sebastiano's sixteenth-century biographer Giorgio Vasari provides only sketchy information about the artist's early life and career in Venice. Training first in the studio of Giovanni Bellini, Sebastiano was then drawn into the artistic orbit of Giorgione da Castelfranco, as was his contemporary Titian (see cat. 2). Sebastiano's earliest documented works, the organ shutters in the church of San Bartolomeo al Rialto, painted between 1507 and 1509, demonstrate his brilliant appropriation of Giorgione's novel vocabulary of illusionism, subordinating line in favor of color and tonal lighting effects. The maturation of Sebastiano's personal style, however, took place in Rome rather than Venice.

Traveling in the entourage of the Sienese banker Agostino Chigi, Sebastiano departed for Rome in the summer of 1511. He arrived in the Eternal City at a fortuitous moment, when the artistic genius of Michelangelo and Raphael was matched by the abundant patronage of the papacy and wealthy private individuals such as Chigi. Sebastiano's first commission in Rome came from Chigi, whose suburban villa, later named the Farnesina, was being decorated under the supervision of the architect Baldassare Peruzzi. Both Sebastiano and Raphael contributed to decoration of the villa's loggia. Today viewed in direct juxtaposition to Raphael's Galatea, Sebastiano's design and execution of the fresco Polyphemus are relatively unsuccessful; neither the fresco medium nor the mythological subject matter suited the young Venetian's talents. Subsequent realization that his own artistic tastes were more in keeping with the monumentality and grandeur of Michelangelo than with the illusionistic colorism of Venice led Sebastiano in a new direction and secured his position in Rome.

Sebastiano's lengthy relationship with Michelangelo lasted from 1513 to the 1530s. Their friendship is documented by letters the two artists exchanged beginning in 1516, as well as in Vasari's commentary. Their artistic collaboration is recorded in a number of Sebastiano's paintings, including his Pietà of 1515 in the Museo Civico, Viterbo, and the Raising of Lazarus of 1517–19, now in the collection of the National Gallery, London. In response to Michelangelo, who often provided Sebastiano with compositional ideas and/or drawings, Sebastiano achieved a powerful personal style capable of investing his religious figures with monumentality and sober dignity.

c. 1519
Oil on wood mounted on masonite,
53 x 39¾ in. (134.7 x 101 cm)
National Gallery of Art, Washington 1961.9.38
Exhibited in Seattle and San Francisco only

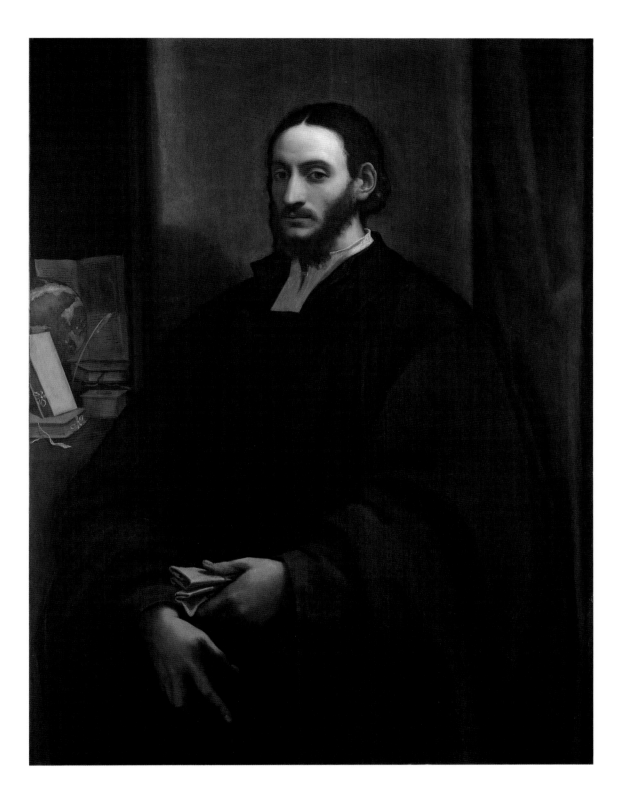

SEBASTIANO DEL PIOMBO, *Portrait of a Humanist*

This new approach affected Sebastiano's portraits as well, and he proved an innovator in that field. His early Roman portraits combined elements from the portrait traditions of both Venice and Rome, particularly as manifest in the recent works of Raphael. Prior to his stylistic alignment with Michelangelo, Sebastiano had already created a number of novelties in the portrait genre, such as the complex grouping in the 1516 painting Cardinal Bandinello Sauli, Two Secretaries, and Two Geographers, *also in the Kress Collection of the National Gallery of Art, Washington. The figures in Sebastiano's later portraits assumed even greater monumentality and stature. Upon Raphael's death in 1520, Sebastiano was unrivaled as the leading portraitist in Rome.*

After the sack of Rome in 1527 Sebastiano left the city briefly, joining the papal court in Orvieto and traveling on to Venice. He returned to Rome in 1529, where he lived until his death in 1547. Sebastiano's last works, however, date from the late 1530s. His artistic activity decreased markedly after 1531, when Clement VII appointed him keeper of the papal seals and he took holy orders. His nickname, del Piombo, refers to the seals, which were made of lead (piombo).

Portraiture is an ancient art form that celebrates the individual. Each portrait artist is presented with the identical formal problem: how to present in concentrated focus the physical presence and specific appearance of a human subject. The essence of the portrait is the topography of the human face; however, the realization of the sitter's features can be achieved in varying degrees of realism. Similarly, information about the sitter's social or professional status can be provided through the elaboration of costume and/ or setting. Achieving ever more illusionism, the Italian portrait genre evolved steadily during the course of the Renaissance. Sir John Pope-Hennessy described this evolution toward greater realism as:

> the story of how eyes cease to be linear symbols and become instead the light-reflecting, light-perceiving organs we ourselves possess; how lips cease to be a segment in the undifferentiated texture of the face, and become instead a sensitized area through whose relaxation or contraction a whole range of responses is expressed; how the nose ceases to be a fence between the two sides of the face, and becomes instead the delicate instrument through which we breathe and smell; and how ears cease to be repulsive Gothic polypi emerging from the head, and become instead a kind of in-built receiving set whose divine functions compensate for its rather unattractive form.[2]

The achievements of Italian artists working in the portrait idiom in the sixteenth century are represented in the present exhibition by superb works by Sebastiano del Piombo and Titian (see cat. 2). In this masterful *Portrait of a Humanist*, it is clear that Sebastiano has scrutinized the sitter's facial features, but it was not simply a realistic description of the physiognomy that the artist sought to achieve. He also explored the temperament of the sitter, investing the figure's dark features with an intense, contemplative expression. Sebastiano relied on various formal devices to accentuate this somber mood, including turning the figure away from the light source, so that half of the face is thrown into shadow. The subdued color scheme of costume and background, developed in tones of black, gray, and green, further enhances the picture's sobriety. In addition the expansive dimensions of the figure itself, as suggested by the voluminous cloak and Mannerist exaggeration of figural proportions, imbue the sitter with unprecedented dignity and stature. We sense we are in the presence of a cool cerebral personality of unwavering conviction.

Although the identity of the subject of this compelling portrait has not been established with any certainty, the books, globe, and writing equipment displayed next to the figure allude to the pursuits of a learned man. In several exhibitions of the nineteenth and early twentieth centuries, the picture was published as representing Count Federigo da Bozzolo,[3] an unlikely identification, since he made his career as a soldier not a scholar. More recently it has been proposed that the portrait depicts the poet Marcantonio Flaminio, an intimate of the intellectual circles Sebastiano

frequented in Rome.[4] Even without benefit of a specific name, the essential nature of the sitter has been conveyed by Sebastiano in this image of a man who looks out at us somewhat aloofly, yet holds our gaze unflinchingly.

L.F.O.

1. For complete early bibliography see Shapley 1979, 424–25.

2. Pope-Hennessy 1963, 3.

3. See Shapley 1979, 424 n. 1.

4. Hirst (1981, 102 n. 51) made this identification on the basis of a convergence of biographical information, which places both Flaminio and Sebastiano in the same circles, in combination with a profile portrait of Flaminio with somewhat generic features on a sixteenth-century medal.

Tiziano Vecellio, called **TITIAN**

Pieve di Cadore 1488/90–1576 Venice

Ranuccio Farnese

⎯⎯⎯⎯⎯◦◖◗◦⎯⎯⎯⎯⎯

*Disagreement between Titian's principal biographers, Lodovico
Dolce and Giorgio Vasari, has led to confusion regarding the specifics of the master's early
life and training. However, it has been generally assumed that Titian arrived in Venice
at an early age, apprenticed to the mosaicist Sebastiano Zuccato. He subsequently entered
the studio of Gentile Bellini and then trained under Gentile's more progressive brother,
Giovanni Bellini. However, it was the younger Giorgione da Castelfranco (b. 1476/78), prob-
ably also a student of Giovanni, who most profoundly influenced Titian's stylistic de-
velopment. Their creative temperaments were well matched; each would pursue the artistic
implications of Giovanni's movement away from an insistence on line* (disegno), *character-
istic of quattrocento painting, in favor of a growing pictorial importance for color* (colore).
*On this line of artistic evolution are predicated all of the great achievements of sixteenth-
century Venetian painting.*

*Titian's public career began in 1508, when he painted the frescoes
of the side facade of the Fondaco dei Tedeschi, the German merchants' quarters in Venice, a
project supervised by Giorgione, who executed the frescoes on the principal facade. Titian's
meteoric rise to prominence was aided by a sequence of events that left him without rival
on the Venetian art scene: Giorgione's premature death in 1510, Sebastiano del Piombo's
(see cat. 1) departure for Rome in 1511, and the death of Giovanni Bellini in 1516. Appointed
Painter to the Republic that same year, Titian dominated the city's artistic life for the next
sixty years.*

*The unrivaled richness of color and conception characteristic of
Titian's creative genius was revealed in the enormous* Assumption of the Virgin *installed
over the high altar in Santa Maria Gloriosa dei Frari, Venice, in 1518. Discarding the
comparatively dry, cerebral approach of the Renaissance, Titian creates the fully animated,
luminous, and luxuriously colored world of the Venetian High Renaissance. In the equally
innovative* Pesaro Madonna, *begun in 1518 and hung in the Frari in 1526, Titian aban-
dons the conventional planar symmetry and builds up his composition in striking diagonals,
both into space and across the pictorial surface. These startling innovations, coupled with*

1542
Oil on canvas, 35 ¼ x 29 in. (89.7 x 73.6 cm)
Signed at right below shoulder: *TITIANVS F*
National Gallery of Art, Washington 1952.2.11
Exhibited in Raleigh and Houston only

PROVENANCE
Commissioned by Andrea Cornaro, bishop of Brescia, for
Girolama Orsini, the sitter's mother, 1542; Farnese collec-
tion, Rome, 1542 (recorded in Van Dyck's Italian sketch-
book of the 1620s, now collection of the Duke of Devonshire,
Chatsworth; cited in Farnese inventory of 1653); Farnese
collection, Parma, by 1680 (cited in inventories of 1680,
1708, and 1725); probably Farnese collection, Naples,
1734–1885;[1] Sir George Donaldson, London, by 1885; Sir
Francis Cook, 1st Bart., Doughty House, Richmond, Surrey,
1885–1901; by descent to his son, Sir Frederick Lucas
Cook, 2nd Bart., by 1901; by descent to his son, Sir Herbert
Frederick Cook, 3rd Bart., London, by 1920; with Count
Alessandro Contini-Bonacossi, Florence, by 1948; Samuel
H. Kress Collection, New York, 1948 (K1562); on loan
to the National Gallery of Art, 1950–52; gift of the Kress
Foundation to the National Gallery of Art, 1952.

SELECTED EXHIBITIONS
Leningrad 1976; London 1983–84, no. 121; Venice 1990–91,
no. 33; Colorno 1994.

SELECTED REFERENCES[2]
Washington 1951, 114; Aretino 1957, I, 129–31; Wethey
1969–75, II, 28, 98–99 no. 31; Shapley 1968, 182–83;
Shapley 1979, 483–85; Bertini 1988, 41, 57, 62, 89.

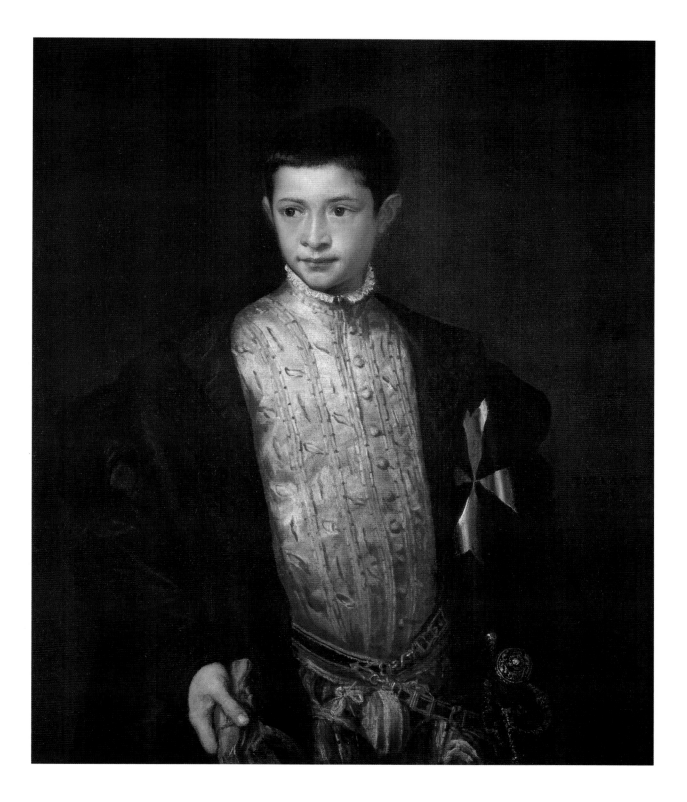

TITIAN, *Ranuccio Farnese*

his painterly technique, provided models not only for his contemporaries but for artists as diverse as El Greco (see cats. 8, 9), Rubens (see cats. 11, 12), and Van Dyck (see cat. 13) in the next century.

Recognition and patronage rapidly followed the Frari successes. Titian worked for a succession of important patrons in Venice and beyond, including the courts at Urbino, Ferrara, Mantua, and the Vatican. Invited to the Papal Court by Cardinal Alessandro Farnese, Titian went to Rome in 1545, returning to Venice the following year. For his Farnese patrons, he created a number of outstanding works, including the Danaë *(Capodimonte, Naples) of 1544, and the portrait* Paul III between His Nephews Alessandro and Ottavio *(Capodimonte, Naples). The greatest personal honors, however, came from the Hapsburg ruler Charles V, Holy Roman Emperor, who had ennobled the artist in 1533 with various titles, including Count Palatine and Knight of the Golden Spur. Titian visited the emperor's court in Augsburg in 1548, when he painted the commanding equestrian portrait* Charles V at Mühlberg *(Prado, Madrid), and again in 1550–51. At this time Titian met Charles's son and heir, Philip II of Spain, who would become the great patron of Titian's later years. For him Titian would paint imperial portraits and a series of mythologies, including* The Rape of Europa *(Isabella Stewart Gardner Museum, Boston) of 1562.*

Titian's evolving technique departed ever further from the tight linearity of the fifteenth century, liberating color, lighting effects, and brushstrokes from their previous subservience to contour. His early works are imbued with a rich chromatic vibrance, which is lessened in the 1540s, when greater pictorial unity is achieved through subtler gradations of tone. His palette darkens and is accompanied by an increasingly loose application of the paint in broader brushstrokes. Although a gradual evolution, the process resulted in Titian's very late style, celebrated for its great expressive power.

Few artists have moved the art of their school as precipitously as did Titian, whose elevated social status, unprecedented except for his contemporary Michelangelo, accorded him a degree of influence appropriate to his inexhaustible genius. Always highly valued, his paintings have continued to be a point of reference for artists in every subsequent century. Titian died in 1576, a victim of the plague.

Titian was among the first Italian painters to turn serious attention to the portrayal of children. Previously, children had rarely had been the focus in portraiture, appearing most often as secondary figures within a group portrait or narrative context. Though occasionally individualized, as in Mantegna's *Camera degli Sposi* (Bridal Chamber) in the Ducal Palace, Mantua, children as a rule had been portrayed with only the most generalized facial features. The painting exhibited here, one of several portraits of children painted by Titian in the 1540s, demonstrates his novel accomplishments in this field.

Completed by 1542 this popular image[3] represents Ranuccio Farnese (1530–1565), the twelve-year-old grandson of Pope Paul III Farnese. The gifted son of Girolama Orsini and Pierluigi Farnese, the Duke of Castro and later

Duke of Parma and Piacenza, Ranuccio received the full benefits of education and rapid advancement that his powerful family could provide. Ranuccio wears on his coat the insignia of the Knights of Malta, the Maltese cross, signifying his recent appointment as Prior of San Giovanni dei Forlani in Venice, an important property of the order. This position, conferred when the boy was only twelve, was followed by the cardinalship of Santa Lucia in Sicily at the age of fifteen and shortly thereafter the cardinalship of Sant'Angelo in Foro Piscium. Before his early death in 1565

fig. 1 Titian. *Ranuccio Farnese* (detail of cat. 2)

other significant posts within the Church hierarchy were conferred upon him, including the bishoprics of Bologna, Ravenna, and Naples.

The Kress portrait of Ranuccio is discussed in a letter written to Cardinal Alessandro Farnese, Ranuccio's older brother, from Gianfrancesco Leoni on September 22, 1542. This document reveals that Titian, who had solicited the patronage of the Farnese family as early as 1539,[4] had occasion to paint Ranuccio's portrait when the boy came to Padua to study in 1541, under the guardianship of Leoni and Andrea Cornaro, Bishop of Brescia. Leoni begins the letter, "You undoubtedly know that the Bishop of Brescia is preparing to return to Rome, and he will bring with him a portrait of the Prior [Ranuccio] which he has had done by the divine Titian, for presentation to the Duchess [Ranuccio's mother, Girolama Orsini], in which Titian's excellence is to be admired, especially since he executed it partly in the presence of the sitter and partly in his absence."[5]

Titian's *Ranuccio Farnese* is remarkable on several levels, but most immediately apparent are its brilliant technique and shimmering color. Note also how the artist has disrupted the conventional frontality: Ranuccio is posed at a slight angle to the picture plane, his head turned in the opposite direction. With additional subtle adjustments, such as allowing the linear pattern of the boy's doublet to deviate from the vertical axis, the artist eases the traditional formality of the portrait format and invests the image with a sense of movement, changes particularly appropriate in the portrayal of a child. Titian's unprecedented acuity captures those physical qualities of youth that are so difficult to render, such as the freshness of the skin, not simply soft but also luminous (*fig. 1*). Simultaneously, Titian conveys the inherent contradiction in the age of the boy and the weighty responsibilities that his various posts entail. Dressed in the trappings of position and authority, Ranuccio nonetheless exhibits a boyish innocence and spirit, which prevail in this perceptive characterization.

L.F.O.

1. The portrait was probably taken to Naples along with other Farnese treasures when, in 1734, Don Carlos of Bourbon, son of Philip V of Spain and Elisabetta Farnese, gave up the Duchy of Parma to become King of Naples.

2. For complete early bibliography, see Wethey 1969–75, II, 99, updated in Venice 1990–91, 244 no. 33.

3. Other versions of the Kress portrait exist, including a copy in the Gemäldegalerie Staatliche, Berlin, and a copy formerly in the collection of Mr. Brauer of Florence; for a discussion see Wethey 1969–75, II, 99. The image, extended to a full-length figure, is incorporated into the decorations at the Farnese villa in Caprarola, built between 1547 and 1559. In a fresco designed by Taddeo Zuccaro, Ranuccio witnesses the 1535 ceremony in which his father, Pierluigi Farnese, received the baton of commander-in-chief of the papal forces from his father, Pope Paul II (illustrated in Kelly 1939, pl. IIB).

4. Through the intercession of his friend Aretino, a noted art theorist and man of letters, Titian had offered to paint the portrait of Paul III; see Aretino 1957, I, 129–31.

5. Fabbro 1967, 3.

PARIS BORDON

Treviso 1500–1571 Venice

Paris Bordon, the son of a saddler, was baptized on July 5, 1500, in Treviso, sixteen miles north of Venice.[7] Following the death of his father in 1507, Bordon and his mother moved to Venice to live with her relatives, the aristocratic Gradenigo family. Bordon was therefore raised in an affluent environment and received a nobleman's education. Vasari, whose biography of the artist was probably based directly on Bordon's own recollections, says that Bordon first studied for a few years under Titian (see cat. 2) but, finding the latter to have little interest in teaching his pupils, set himself to studying the paintings of Giorgione.[8] The works of both artists exerted a strong and enduring influence on Bordon. In 1521 the city government of Treviso commissioned Bordon to paint a depiction of Noah and the animals entering the ark, a work that was considered by contemporaries to be the equal of a painting by Titian that hung nearby. During the early 1520s Bordon executed numerous frescoes to adorn the facades of Venetian houses, and he soon began to take on more substantial commissions. Vasari lists numerous altarpieces, frescoes, mythological works, and portraits painted by Bordon in and around Venice during this time.[9]

Bordon's activity soon spread beyond the Veneto, and, as a result, the influences upon his stylistic development became increasingly diverse. In 1525–26 he was working in Lombardy, where he would have seen the works of Pordenone and Moretto de Brescia; the monumentality and straightforward naturalism that characterize their works resonate throughout Bordon's mature oeuvre. Vasari records that in 1538 Bordon was called to France by King Francis and that while there he executed paintings of diverse subjects—altarpieces, mythologies, and many portraits—for the king and other distinguished patrons, such as the king of Poland and the cardinal of Lorraine, as well as for clients in Flanders.[10] If this trip did occur, Bordon's stay must have been rather brief, since his presence in Venice is documented on April 10, 1538, and June 2, 1539.[11] During the 1540s and 1550s he worked for other notable patrons, including the wealthy Fugger family at their court in Augsburg,[12] and Carlo da Rho in Milan.[13] There is some documentary evidence indicating that Bordon was back in France, in the service of Francis II, between 1559 and 1561.[14] Aside from this last trip to France, Bordon's later activity seems to have been concentrated in and around Venice, where he died at his house in January, 1571.[15]

3

Perseus Armed by Hermes and Athena

c. 1540–55
Oil on canvas, 41 x 60¾ in. (104.3 x 154.3 cm)
Signed indistinctly between Perseus and Athena: O[pera]. PARIDIS BORDON
Birmingham Museum of Art, Alabama 61.117

PROVENANCE
Edward Solly, London, by 1838, until 1847;[1] his sale, Christie's, London, May 8, 1847, lot no. 17; bought by "Captain Barrett"; Sir Francis Cook, 1st Bart., Doughty House, Richmond, Surrey, by 1868, until 1901;[2] by descent to his son, Sir Frederick Lucas Cook, 2nd Bart., 1901–20;[3] by descent to his son, Sir Herbert Frederick Cook, 3rd Bart., London, 1920–39;[4] by descent to Sir Francis Cook, London, by 1939, until at least 1947;[5] with Count Alessandro Contini-Bonacossi, Florence, after 1947; Samuel H. Kress Foundation, New York, 1949 (K1631); on loan to the Birmingham Museum of Art, 1951–59; gift of the Kress Foundation to the Birmingham Museum of Art, 1959.

SELECTED EXHIBITIONS
Leeds 1868, no. 51;[6] Leamington 1947, no. 57; Washington 1961–62, no. 10; London 1983–84, no. 20.

SELECTED REFERENCES
Waagen 1838, II, 193; Robinson 1868, 22–24 no. 19; Bailo and Biscaro 1900, 147–48 no. 69; Cook 1903, 20 no. 65; Cook 1907, 28 no. 90; Cook 1913–15, 1, 187 no. 161; Cook 1932, 54 no. 161 (275); Graves 1913–15, I, 81; Venturi 1928, 1033; Birmingham 1959, 80–82; Canova 1961, 88 n. 58; Canova 1964, 59, 75; Shapley 1973, 36–37; Treviso 1984, 43, 78; Béguin 1985, 15–16, 26 n. 51; Canova 1985, 145–46; Grabski 1985, 208.

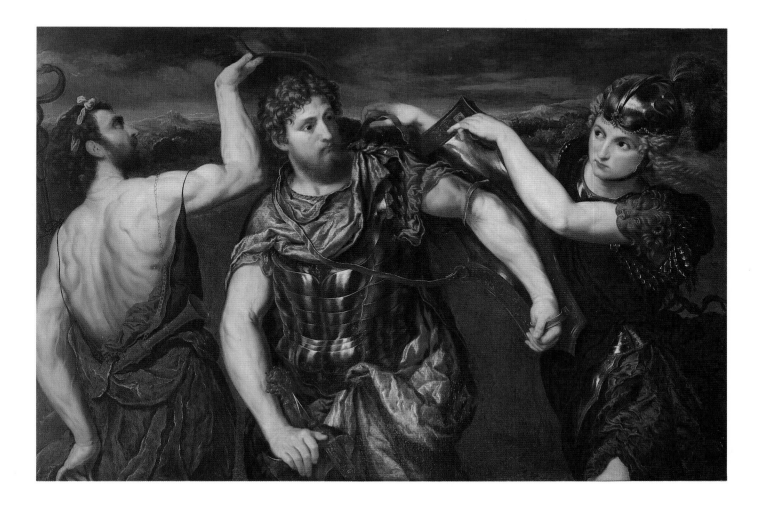

BORDON, *Perseus Armed by Hermes and Athena*

Bordon's exposure to a variety of styles—through his training and lengthy sojourn in Venice, his travels, and his sophisticated patrons—enabled him to create a charming, lyrical style that was obviously appreciated by his discriminating clientele. Although he was not a highly original artist, his ample gifts as a colorist and the marvelous fluidity of his brushwork are notably evident in the wide range of portraits and historical subjects he painted, particularly in his stylized, portraitlike depictions of courtesans and in his elegant interpretations of allegorical and mythological themes.

The subject and meaning of this painting have been debated since the work first came to the attention of scholars in the nineteenth century. The subject has been variously identified as Mercury (Hermes) and Bellona (the goddess of war) arming Mars, as a young hero armed by Bellona and Mercury, or as Perseus armed by Athena and Hermes.[16] The latter identification seems the most logical, particularly in light of the prominence given the accoutrements with which the center figure is being armed. According to ancient mythology, Perseus, the son of Zeus and Danaë, was tricked into giving his prospective stepfather the head of Medusa as a wedding present. Medusa was one of three fearsome Gorgons, monsters with snakes instead of hair; any person who looked at them was turned instantly to stone. Perseus was aided in his quest to secure Medusa's head by Hermes and Athena. Hermes gave him a sword with an indestructible blade capable of slicing through Medusa's armorlike

fig. 2 Paris Bordon. *Venus, Mars, Cupid, and Flora*. c. 1545–55. Oil on canvas, 43⅜ x 69¼ in. (110 x 176 cm). Kunsthistorisches Museum, Vienna, no. 120

scales. Athena gave the hero her highly polished shield in whose mirrorlike surface Perseus would be able to see Medusa's reflection, thus enabling him to carry out his task without having to look directly upon the face of the Gorgon. Mercury also helped Perseus obtain a magic helmet that rendered its wearer invisible. With the aid of these magical tools, Perseus accomplished his seemingly impossible quest.[17] The figure of Perseus may well be a portrait of a patron who wished to commemorate his military prowess and the intellect and cunning that lay behind it, but attempts to identify the figure as a specific person have met with little agreement among scholars.[18]

The work is closely related to a number of allegorical mythologies by Bordon, including *Vulcan and Thetis* in the Kress Collection at the University of Missouri, Columbia (*fig. 1*); *Jupiter and Io* (Konstmuseum, Göteborg); *Flora, Venus, Mars, and Cupid* (Hermitage, St. Petersburg); and *Venus, Mars, Cupid, and Flora* (*fig. 2*) and *Two Lovers in the Guise of Mars and Venus Crowned by a Victory*, both in the Kunsthistorisches Museum, Vienna.[19] Common to all of these paintings, but particularly noteworthy in the *Perseus*, is the balletic interplay of the arms of the figures: the position of Hermes' lowered left arm parallels Perseus's right arm, while the hero's left arm forms a counterpoint to Athena's limbs. Bordon raises this elaborate, rhythmic

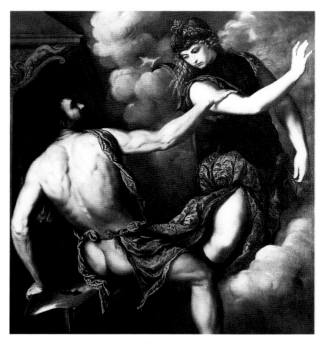

fig. 1 Paris Bordon. *Vulcan and Thetis*. c. 1550. Oil on canvas, 54⅞ x 50¼ in. (139.4 x 127.7 cm). University of Missouri, Columbia, Samuel H. Kress Collection

interplay to an even more sophisticated level, calling attention to the highly polished surface of the shield by using the reflection of Perseus's arm to create the illusion that the shield is transparent, seeming to reveal the entire length of Athena's right arm.[20] Additional similarities between the *Perseus* and these other paintings, all hallmarks of Bordon's mature style, include the use of harsh, artificial colors; the meticulous, painterly rendering of the draperies, armor, and accoutrements such as pearls, chains, and jewels; and the elaborately coiffed blond tresses of the female figures.

These qualities, and the sophisticated subject matter, suggest that these works were painted for a highly cultured, aristocratic clientele. Consequently they have been variously dated to the time of Bordon's activity in the service of the Fugger family and of Carlo da Rho, that is, from the 1540s to the mid-1550s, and this is the most likely period to which the Birmingham painting can be assigned.[21]

D.S.

1. The painting was recorded in Solly's collection by Waagen 1838, II, 193; it was sold for £39.18 at Christie's, London, May 8, 1847, together with the rest of the Italian pictures in Solly's possession at the time of his death.

2. Robinson 1868, 22–24 no. 19. Recorded in Sir Francis Cook's collection by Bailo and Biscaro 1900, 147–48 no. 69; Cook 1913–15, 187 no. 161, notes that it was in the Cook collection by 1868.

3. Cook 1907, 28 no. 90; Cook 1913–15, 187 no. 161.

4. Cook 1932, 54 no. 161 (275).

5. The work was still in the Cook collection when it was exhibited at the Royal Leamington Spa Art Gallery July 28–August 30, 1947, and September 21–November 15, 1947. It therefore must have been purchased by Contini-Bonacossi sometime between late 1947 and 1949, when it was acquired by the Kress Foundation.

6. Graves 1913–15, I, 81.

7. The most recent and comprehensive account of Bordon's life is Canova in Treviso 1984, 28–50. The two most informative early discussions of Bordon's life and oeuvre are Vasari's account, appended to his life of Titian (1568/1878–85, VII, 461–66), and Ridolfi's biography (1648/1914–24, I, 229–35), which is little more than a listing of his works. Many of the documents relating to the artist's life and career were published by Bailo and Biscaro in their seminal 1900 monograph; the most comprehensive and up-to-date compilation of these documents appears in Treviso 1984, 123–40.

8. Vasari (1586/1878–85, VII, 461–62) describes Bordon as "the artist who has most successfully imitated Titian."

9. Vasari 1586/1878–85, VII, 462–64. Although many of Bordon's works are signed, very few of them are dated or datable, making it difficult to analyze the chronological development of his style; see Canova 1985, 137–57. For two discussions of his early style, see Canova 1964, 4–15, and Treviso 1984, 28–34.

10. Vasari 1586/1878–85, VII, 464.

11. The documents recording Bordon's presence in Venice are published in Treviso 1984, 131 nos. 24, 26.

12. Canova (in Treviso 1984, 40–41) dates the period of Bordon's service for the Fuggers between 1540 and 1543; Garas (1985, 71–78) proposes dating this period sometime between 1550 and 1560.

13. See Canova in Treviso 1984, 46–48; Canova 1985, 148–51.

14. For discussions of the issue of Bordon's trip(s) to France, see Canova 1961, 77–88; Canova, in Treviso 1984, 41, 48–50; Béguin 1985, 9–27; and Canova 1985, 138–43.

15. The archival notice of Bordon's death is published in Canova 1964, 71, and Treviso 1984, 140 no. 60.

16. Waagen (1838, II, 193) describes the subject as "Perseus armed by Minerva and Mercury"; in the 1847 catalogue of the Solly sale (May 8, 1847, lot no. 17) the painting was described as "Perseus Attended by Minerva and Mercury, who are arming him." In 1868 Robinson (1868, 22) identified the subject as "Mercury and Bellona arming Mars"; this identification was followed by Bailo and Biscaro (1900, 147). In her monograph on Bordon, Canova (1964, 75) lists the painting as a "warrior armed by Mercury and Minerva," while Shapley (1973, 36–37) describes the subject as "a young hero armed by Bellona and Mercury." In more recent discussions of the painting (London 1983–84, 157 no. 20; Treviso 1984, 43, 78; Béguin 1985, 15–16, 26; Canova 1985, 145–46), the subject has been listed as "Perseus armed by Mercury and Minerva"; Grabski (1985, 208) identifies it as "Perseus armed by Mercury and Minerva (or Bellona)." The Greek forms of the names of the god and goddess are used here since the myth is Greek in origin (see n. 17 below).

17. Various parts of the story of Perseus and Medusa are found in a poem by the sixth-century B.C. lyric poet Simonides of Ceos, in Ovid's *Metamorphoses* (IV, 765–86), and in Apollodorus's *Bibliotheca*, II, 34 ff.; a basic modern account based on these various sources appears in *Mythology* by Hamilton (1942, 141–46).

18. Athena was the goddess of wisdom, and in a military context (as she is depicted in Bordon's painting) she embodies military strategy. Hermes' resourcefulness, cunning, and tactical abilities were emphasized frequently in mythology, especially so in the story of Perseus. Canova (in Treviso 1984, 43) suggests that the two figures in the painting symbolize "the necessity that valor in arms should be accompanied by astuteness and prudence."

Robinson (1868, 23–24 no. 19) identifies the central figure as a portrait of Ottavio Farnese (1525–86), the grandson of Pope Paul III and the brother of Ranuccio Farnese (see cat. 2), who was the commander of the papal troops that fought against German Protestant forces in the late 1540s. This identification was seconded by Bailo and Biscaro (1900, 147–48), who note that the figure had also been identified as Cardinal Alessandro Farnese (1520–89), another grandson of Paul III. This identification, however, has found little support among later scholars (Cook 1913–15, 187), primarily because the figure bears little resemblance to other known portraits of either Ottavio or Alessandro Farnese, such as Titian's portrait of Paul III and Alessandro and Ottavio Farnese in the Museo di Capodimonte, Naples. Robinson (1868, 23–24 no. 18) also notes that the female figure in the painting closely resembles the subject of the *Portrait of a Young Woman* in the National Gallery, London, who appears in several works by the artist.

19. All of the paintings, except for the Göteborg *Jupiter and Io*, are illustrated in a three-page spread in Canova's 1985 essay (146–48). *Jupiter and Io* is discussed and illustrated in Treviso 1984, 108–9 no. 35. *Jupiter and Io* is very probably the work that Vasari mentions (1568/1878–85, VII, 464) as having been painted for the Cardinal of Lorraine while Bordon was in France, thus in 1538–39 or 1559–61. The other works, as well as the Bordon portrait cited in n. 18 above, have generally been dated to the period c. 1545–55.

20. The compositional rhythm created by the similar and contrasting juxtapositions of the arms, as Józef Grabski notes (1985, 208–9), parallels the elaborate syntactical constructions of the poetry of Francesco Petrarch and Bordon's influential Venetian contemporary, Pietro Bembo. For a discussion of the complex issue of "bembismo" and "petrarchismo," see the introduction by Giulio Ferroni in *Poesia italiana del Cinquecento*, Milan, 1978, vii–xxvi; and Weinberg 1961.

21. For the different datings assigned to Bordon's activity for the Fuggers, see n. 12 above.

Paolo Caliari, called **VERONESE**

Verona c. 1528–1588 Venice

Veronese is regarded as one of the greatest painters of color and light and, together with Titian (see cat. 2) and Jacopo Tintoretto, is considered one of the most important Venetian painters of the sixteenth century. His works in oil and fresco, in formats ranging from easel paintings to epic-scale works nearly twenty by forty feet, are distinguished by a seemingly effortless and highly varied technique and, above all, by the exquisite, iridescent chromatic harmonies achieved through the rendering of the effects of light and atmosphere on color. Veronese was a profoundly influential artist, not only for later Venetian painters such as Sebastiano Ricci (see cats. 37, 38), Tiepolo (see cats. 47, 48), and Guardi (see cat. 39), but also for an array of distinguished colorists, including the Carracci, Watteau (see cat. 36), Delacroix, Turner, Cézanne, and Matisse.[5]

Paolo's nickname was derived from his birthplace of Verona; in early documents his surname is listed as "Spezapreda" and "Caliari."[6] He is described as a painter ("depentore") in a document of 1541, the same year in which he is recorded as an assistant ("discipulus seu garzonus") to the Veronese painter Antonio Badile.[7] Veronese's earliest works, dating from circa 1548, reflect his provincial training in Verona as well as the influence of northern Italian artists like Domenico Brusasorci, Moretto da Brescia, Giulio Romano, Correggio, and Parmigianino. Sometime between 1553 and June 1555, Veronese settled in Venice, which remained his home for the rest of his life. From the mid-1550s on, he was one of the two preeminent painters in Venice (Tintoretto was his only real rival). He executed a stream of commissions for altarpieces, ceiling paintings, large-scale frescoes, and portraits from ecclesiastical, civic, and private patrons in and around Venice. In 1573 he was summoned before the Inquisition in Venice to answer questions concerning the lack of decorum displayed in certain details in a huge Last Supper he had painted for the convent of Santi Giovanni e Paolo (now in the Galleria dell'Accademia, Venice).[8]

Beginning in the early 1560s, Veronese maintained an extensive workshop, which included his brother Benedetto and eventually his sons Carletto and Gabriele, his nephew Alvise Benfatto del Friso, and Francesco Montemezzano. There exist several paintings signed by "the heirs of Paolo Caliari Veronese," indicating the continued activity of the workshop for some ten years after Veronese's death, on April 19, 1588.[9]

4

The Baptism of Christ

c. 1550–60
Oil on canvas, 33 ¾ x 46 in.
(85.7 x 116.9 cm)
North Carolina Museum of Art, Raleigh
60.17.47

PROVENANCE
Possibly Don Giuseppe Colonna, Principe di Galatro, Palazzo Stigliano, Naples, by 1688;[1] Lord Heytesbury, Wiltshire, by 1828; Heytesbury family, by descent, until 1926; sold, estate sale of Margaret Lady Heytesbury, Heytesbury House, by Hampton and Sons, London, April 30, 1926, lot no. 1322 (as Lucini); with Colnaghi, London; sold to H. M. Clark, London, May 7, 1926; with Count Alessandro Contini-Bonacossi, Florence; Samuel H. Kress, New York, 1935 (K388); on loan to the National Gallery of Art, Washington, 1941–59;[2] gift of the Kress Foundation to the North Carolina Museum of Art, 1960.

SELECTED EXHIBITIONS
British Institution, London, 1828, no. 157;[3] British Institution, London, 1866, no. 54;[4] San Francisco 1938, no. 74; Seattle 1938; Baltimore 1938–39; San Francisco 1939, no. 58; Dayton 1939–40; New York 1940, no. 22; Washington 1941, no. 323; New York 1967, no. 29; Birmingham 1972, 19; Washington 1988–89, 73–74 no. 39, 84.

SELECTED REFERENCES
Waagen 1857, 386; Graves 1913–15, IV, 1575–76; Hadeln 1926, 104–6; Osmond 1927, 56, 112; Fiocco 1934, 122; Berenson 1957, I, 139; Raleigh 1960, 96; Marini 1968, no. 5; Crosato Larcher 1968, 221; Morassi 1968, 31, 37; Shapley 1973, 43; Pignatti 1976, I, 15–16, 103–4 no. 4; Cocke 1977, 786–87; Goldner 1981, 114, 116; Cocke 1984, 294; Pallucchini 1984, 51, 165 no. 12; Rearick 1988, 102; Cocke 1989, 62; Pignatti and Pedrocco 1991, 31 no. 11.

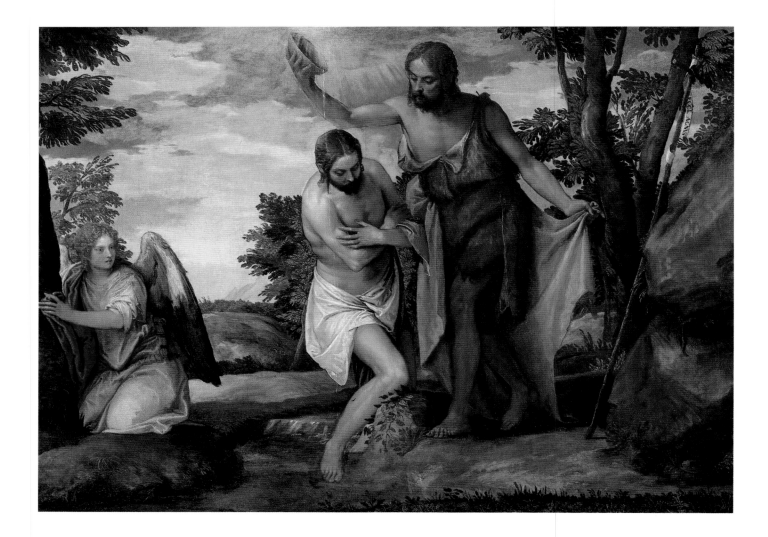

Veronese depicted the theme of Christ's baptism in the Jordan River numerous times, from the version at Braunschweig of circa 1548–49, one of his earliest surviving works, to the preparatory studies (*fig. 1*) made about February 1588, a little more than two months before his death.[10] The Raleigh and Braunschweig versions are the only two in which Veronese utilized an untraditional horizontal format. Rearick noted that the size of the Raleigh canvas is one that Veronese often used for works intended for private chapels or sacristies.[11]

As seen in the Raleigh painting, the landscape setting Veronese typically depicted in his *Baptism*s more closely resembles the northern Veneto than the Holy Land. The landscape here is lush and verdant, a terrestrial paradise—an appropriate setting for the first public revelation of Christ's divinity on earth. In nearly all of Veronese's depictions of the subject, angels are the only witnesses of Christ's baptism.[12] Here only a single angel attends, kneeling in adoration; the attending cherubim and the dove of the Holy Spirit found in most of Veronese's *Baptism*s have been omitted.[13] It is somewhat surprising that Veronese, whose own words document his predilection for adding auxiliary figures to his compositions, never enriched his *Baptism*s by including some of the "multitude" who came from Jerusalem and Judea to be baptized by John, as mentioned in the gospel accounts.[14] In a departure from most earlier depictions of the theme, Veronese represented Christ kneeling rather than upright. This is iconographically significant, as it emphasizes Jesus' humble and obedient submission to the will of God through this act of purification, even though he himself was without sin.

There has been significant disagreement concerning the dating and, to a somewhat lesser extent, the attribution of the Raleigh *Baptism*. Because relatively few of Veronese's paintings are dated, or reliably datable, and he worked in several different styles concurrently, it is difficult to date a work on the basis of its stylistic relation to another datable work. The Raleigh *Baptism* has been dated anywhere from 1551, as one of Veronese's earliest works, to 1587–88, as one of his very last works; several writers have also suggested a dating to the early or mid-1560s.[15] The scholars who have placed the work late in Veronese's career have done so on the basis of similarities between it and a sheet of preparatory studies for a *Baptism* that are drawn on the back of a letter dated February 4, 1588 (*fig. 1*); these studies have also been linked to two late *Baptism*s signed by the "Haeredes Paoli."[16] The attribution of the painting has also been the source of scholarly contention. Most scholars have accepted the work as autograph, but some have argued that the painting is a product of the artist's workshop.[17]

The Raleigh *Baptism* exhibits two qualities in particular that support an attribution to Veronese himself as well as an early dating for the painting. As in other early works by the artist, the *Baptism* displays a certain awkwardness in the poses of the figures and in their disposition within the composition.[18] For example, Christ's exaggerated contrapposto has a labored, studied quality, and from the visible pentimento it is obvious that Veronese struggled with the placement of the figure's right leg.[19] Furthermore, there is the Baptist's awkward pose and the unnatural way in which he grasps his cloak. The pose of the angel is similarly mannered, and its isolation at the edge of the composition distracts the viewer's attention from the central figures. Such inconsistencies are seen in a number of Veronese's early works, where individual figures (and occasionally small groups of figures) appear as separate units inserted into the compositions, rather than being completely integrated into them.

The handling of color also argues compellingly for placing the Raleigh *Baptism* among Veronese's autograph early works. His prodigious talent as a colorist began to emerge

fig. 1 Paolo Veronese. *Four Studies for a "Baptism of Christ."* c. 1588. Pen and brown ink and brown wash on ivory laid paper, 7⅞ x 7 in. (200 x 180 mm). Fogg Art Museum, Cambridge, Massachusetts, Gift of Denman W. Ross 1924.101

in the early 1550s, after his encounter with Emilian and Venetian art. The luminous and delicate play of light and color, especially evident in the angel's garments and Christ's loincloth, betray the study of Correggio and Bellini and, in some ways, anticipates Veronese's works of the 1560s. The more audacious and highly sophisticated chromatic inter-

relationships Veronese was to achieve in his maturity are only hinted at in the Raleigh *Baptism*. Nevertheless, the freshness and sensitivity with which the work is painted set it apart from the more labored handling that characterizes paintings by Veronese's assistants and followers.

D.S.

1. The provenance reference to the Palazzo Stigliano may have come from Lord Heytesbury; the source for the reference is not listed in the modern literature on the painting. There was a *Baptism* by Veronese listed in an inventory of the Palazzo Stigliano in Naples made on November 17, 1688, by the artist Luca Giordano (see Colonna di Stigliano 1895, 31 no. 44): "Un altro di palmi 4 e 5 con cornice in[dora]ta, il battesimo di S. Gio. Batt[ist]a, et Angioli, mano di Paolo Veronese [lire] 200." (Another painting of 4 x 5 *palmi*, with a gilt frame, the baptism of St. John the Baptist, by the hand of Paolo Veronese, 200 [lire].) There are two problems with identifying this painting as the Raleigh *Baptism*. The measurements given in the inventory are rounded off to the nearest *palmo* (approximately 26.4 cm), and thus the dimensions of the Stigliano painting are approximately 105.6 x 132 cm, versus the present-day dimensions of 85.7 x 116.9 cm. There are three possible explanations for this discrepancy: 1) The measurements are only approximate, "sight" measurements; Ribera's *Silenus*, now in the Museo di Capodimonte in Naples, is probably identical with the *Bacco* listed in the same inventory (no. 1) as measuring 8 x 10 *palmi* (211.2 x 264 cm), and its dimensions are actually 185 x 229 cm. 2) The measurements include the frame—the present frame on the painting measures 105.4 x 136.5 cm. 3) The painting has been cut down (see n. 13 below). The other problem has to do with the "Angioli" (angels) described by Giordano; the Raleigh *Baptism* has only one angel. It is possible that Giordano simply made a mistake; or perhaps there were some cherubim in the radiant "glory" above Christ's head that were cut off during the possible truncation of the work. Tom Willette generously provided the reference to the Colonna-Stigliano inventory.

2. Washington 1941, 212–13, as Veronese, possibly 1587–88; see Shapley 1973, 43, under "Provenance."

3. Graves 1913–15, IV, 1575.

4. Graves 1913–15, IV, 1576.

5. See Rosenthal 1981, 185 n. 1.

6. In an *anagrafo* (census register) made in the spring of 1529 (Pignatti 1976, I, 251, doc. 1), Paolo, the grandson of "Piero spezapreda" and the son of Gabriele, is listed as one year old; although *anagrafi* are not always reliable evidence for determining ages, there is less possibility for serious error concerning the age of an infant. The obituary of Veronese's death on April 19, 1588, lists his age as sixty. *Spezapreda* is best translated as stonemason or stonecutter (not sculptor, as many earlier biographers have stated); it is possible that this was simply the profession of Veronese's grandfather, father, and brother, rather than a surname, although in a document of 1553 (Pignatti 1976, I, 251 doc. 5), Veronese signed his name "Paullo spezapda." The surname Caliari may have been taken from a noble patron; the artist used it regularly from at least as early as 1555 (Pignatti 1976, I, 251 doc. 8), and it is also used as the surname of his brother and

sons. By 1555 he was signing works "Paulo Vero[nese]" (Pignatti 1976, I, 110 no. 45), and he continued to use Caliari and Veronese as surnames throughout his life.

7. Pignatti 1976, I, 251 docs. 2–4.

8. See Fehl 1961, 325–54, wherein the full text of the record of Veronese's interrogation is reprinted, with annotations. An English translation of the text appears in Holt 1947, 245–48. Veronese's responses to his inquisitors provide interesting insight into his attitude toward his profession and his approach to painting; see n. 14 below.

9. For Veronese's workshop see Ridolfi 1648/1914–24, I, 353–62; Caliari 1888, 177–86; Tietze and Tietze-Conrat 1944, 165–66, 191, 352–54; and Brown 1989, 111–24. Luciana Crosato Larcher has studied the works of Benedetto, Carletto, Gabriele, Alvise, and Montemezzano in a series of articles published in *Arte veneta* (1964, 1967, 1969, 1972, 1976).

10. Pignatti (1976) catalogues thirteen *Baptisms* as by or attributed to Veronese or his studio and cites at least nine other lost versions attributed to the artist in pre-1850 sources. The extant versions are all illustrated in Goldner 1981. The Braunschweig version is discussed by Pignatti (1976, I, 103 no. 3). The preparatory studies, which are probably related to an altarpiece that was ultimately painted and signed by "the heirs of Paolo Caliari Veronese," have most recently been discussed by Goldner (1981, 116–26) and by Rearick, in Washington 1988–89, 201 no. 104, and 202–3 no. 105.

11. Rearick, in Washington 1988–89, 84.

12. Veronese's *Baptism* in the church of the Redentore, Venice (Pignatti 1976, I, 123 no. 114, figs. 352–54), includes portraits of the donors, Bartolomeo Stravazino and his son Giovanni, who are rather awkwardly inserted in the lower right corner of the painting.

13. The painting appears to have been reduced along all four sides; the extent of the reduction cannot be determined. The rather awkward truncation of the tree on the left and the foliage in the top corners, and the absence of the "gloria," including the dove of the Holy Spirit, indicate that the reduction in the size of the canvas may have been fairly substantial. A note in the files in the North Carolina Museum of Art indicates that Mario Modestini, the Kress Foundation conservator, removed some later additions that had enlarged the canvas to 34½ x 47⅝ in.

14. The record of Veronese's interrogation before the Inquisition (cited in n. 8 above) quotes the artist as justifying the inclusion of auxiliary figures in his paintings on the grounds that "we painters take the same license the poets and jesters take." He also states that another figure to which the Inquisition took exception had been included "for ornament, as is customary," and that "if in a picture there is some space to spare I enrich it with figures according to the stories." The crowds of people John baptized are described in three of the gospel accounts (Matthew 3:5–6, Mark 1:5, Luke 3:32); Luke's account states, "When all the people were being baptized, Jesus was baptized too."

15. Marini (1968), Pignatti (1976), and Pallucchini (1984) (see *Selected References* above) all place the *Baptism* among Veronese's earliest works. Those scholars who propose a very late dating include Cocke (1977, 786–87) and the compiler of *National Gallery of Art, Preliminary Catalogue of Paintings and Sculpture* (Washington 1941); Rosand (in Birmingham 1972, 19) suggested a dating of "on or before 1548 or just before his death." A dating in the 1560s is suggested by Hadeln (1926), Fiocco (1934), Rearick (in New York 1967 and Washington 1988–89), Morassi (1968), Shapley (1973), and Goldner (1981).

16. See Washington 1988–89, no. 105. The scholars (cited in n. 15 above) who place the work late in Veronese's career do so because of its similarity to the Fogg sheet.

17. The *Baptism* has been accepted as an autograph work by Waagen (1857); Hadeln (1926); Osmond (1927); Fiocco (1934); Longhi, Van Marle, Perkins, Suida, and Venturi (in written opinions); Berenson (1957); Morassi (1968); Marini (1968); Crosato Larcher (1968); Rosand (in Birmingham 1972); Pignatti (1976); Pallucchini (1984); and Rearick (in New York 1967 and Washington 1988–89). Those who consider it a studio work include Tietze and Tietze-Conrat (in written opinion), Shapley (1973), Goldner (1981), and Cocke (1984, 1989). Cocke (1984, 294 n. 10) suggests an attribution to Veronese's nephew and assistant Alvise del Friso on the basis of what he perceived to be similarities between the *Baptism* and Alvise's *Saint Nicholas in Glory* from the church of San Nicolò dei Mendicoli (Cocke 1984, fig. 51). To the present writer, the quality of the *Saint Nicholas*, which is one of Alvise's best works, falls far below that of the Raleigh *Baptism*, making the attribution of the latter to Alvise untenable.

18. Similar qualities distinguish the Braunschweig *Baptism* and the *Madonna Enthroned with Saints and Donors* in the Museo di Castelvecchio, Verona (Pignatti 1976, I, 103 nos. 1, 3; II, pls. 1, 4); both are usually dated c. 1548–49, among his earliest works.

19. X-radiographs indicate that the artist also slightly altered the position of the Baptist's feet.

Domenico Robusti, called TINTORETTO

Venice c. 1560–1635 Venice

Following family tradition, Domenico was called Tintoretto after his
grandfather's profession of dyer (tintore).[3] Together with his younger brother, Marco, and
his sister Marietta, Domenico was trained in the studio of his father, Jacopo, where he
worked for almost twenty years. He assisted Jacopo on numerous commissions, including
the latter phases of the decoration of the Scuola di San Rocco (1576–87) and works
painted for the Scuola de' Mercanti (c. 1592–94) and San Giorgio Maggiore (1593–94).[4]

In 1577 Domenico joined the Venetian artists' guild, which indicates
that he was painting independent works by this date; his seventeenth-century biographer
Ridolfi records that the artist "acquired much fame with portraits in his youth."[5] In 1586
he became a member of the Scuola di San Marco, one of the foremost charitable confrater-
nities in Venice, and executed several paintings for the Scuola's headquarters.[6] When Jacopo
died in 1594, Domenico took over his father's workshop and gained the responsibility for
completing Jacopo's unfinished commissions.

The nearly twenty years that Domenico spent as his father's chief assis-
tant enabled him to master the style that had made Jacopo one of the foremost artists in
Venice after Titian's death in 1576. As a result, when his father died, Domenico was in
great demand and received numerous commissions from patrons in Venice and throughout
northern Italy. In 1598 he traveled to Ferrara for the marriage of Margaret of Austria to
Philip III of Spain, where he painted a portrait of the queen, who four years later sat for
the portrait by Juan Pantoja de la Cruz included in the exhibition (see cat. 10). Immedi-
ately thereafter Domenico accompanied Duke Vincenzo Gonzaga to his court at Mantua,
where he completed several devotional works and portraits. It was in the field of portraiture
that Domenico achieved his greatest success. Ridolfi lists dozens of illustrious personages
who had their likenesses painted by the artist and wrote that "every worthy subject and
every lady of the time wished to be made famous by Domenico's brush."[7]

Over his lengthy career Domenico executed altarpieces and frescoes
for many of the most important churches and confraternities in Venice. According to
Ridolfi, the artist most preferred to paint subjects based on the literary works of ancient
and modern poets.

5

Tancred Baptizing Clorinda

c. 1581–95
Oil on canvas, 66⅛ x 45 in. (168 x 114.3 cm)
The Museum of Fine Arts, Houston 61.77

PROVENANCE
R. Langton Douglas, London; Mr. and Mrs. Frank G.
Logan, Chicago, by 1923;[1] their sale, Kende Galleries at
Gimbel Brothers, New York, February 1, 1945, lot no. 170;
with Hirschl and Adler, New York, by 1955; Samuel H.
Kress Foundation, New York, 1957 (K2171); on loan to The
Museum of Fine Arts, Houston, by 1958; gift of the Kress
Foundation to The Museum of Fine Arts, Houston, 1961.

SELECTED EXHIBITIONS
On loan to the Art Institute of Chicago, by 1925 (as Jacopo
Tintoretto);[2] San Francisco 1938, no. 65 (as Jacopo);
New York 1939, no. 10 (as Jacopo); New York 1939A, no. 380
(as Jacopo).

SELECTED REFERENCES
Hadeln 1924, 156–57, 161 (as Jacopo); Fischkin
1925, 59–60 (as Jacopo); Pittaluga 1925, 264 (as Jacopo);
Venturi 1933, III, no. 552 (as Jacopo); Tozzi 1937, 26, 29
(as Domenico); Borenius 1939, 138; Coletti 1940/1944, 44
(as Jacopo); Bercken 1942, 107 n. 63 (as Jacopo); Tietze
1948, 348 (as Domenico); Argan 1957, 217–19; Maxon 1957,
2 n. 9 (as Jacopo); Tozzi Pedrazzi 1960, 387, 391 (as
Domenico); De Vecchi 1970, 130 no. 274 (as Jacopo and
studio); Shapley 1973, 61–62 (as Domenico); Pallucchini
and Rossi 1982, 245 no. A45 (as Domenico).

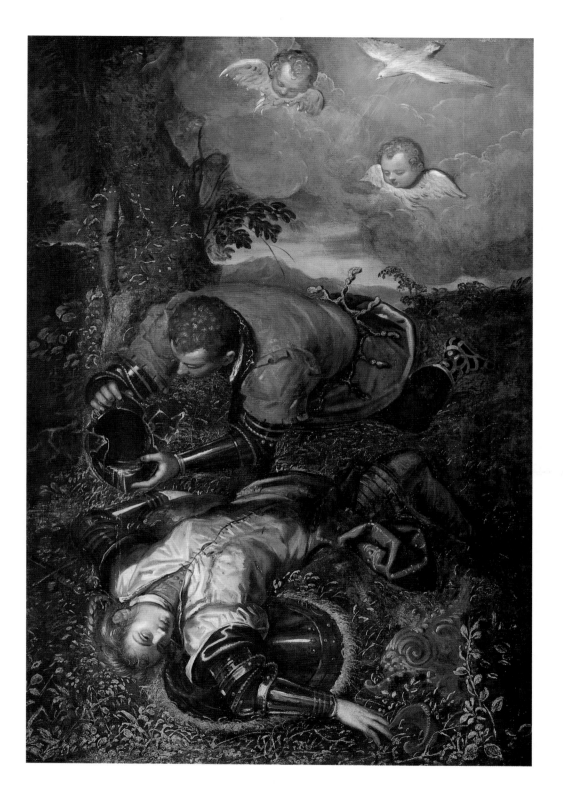

TINTORETTO, *Tancred Baptizing Clorinda*

Ridolfi reports that at the age of seventy-four Domenico suffered a stroke and lost the use of his right hand. The biographer goes on to say the artist continued to paint with his left hand, "but with little success."[8] He died on May 17, 1635.

Despite his long and successful career, Domenico has never been considered outside the looming shadow of his illustrious father, against whose works his own efforts have been judged as weaker and derivative. There exists only a handful of studies devoted solely to Domenico, and there has been no comprehensive examination of his life and works.[9] This situation has greatly hindered a clearer appreciation of his artistic gifts—amply evident in works like the one discussed below—and the important role he played in the continuation of Jacopo's influence upon Venetian painting, which lasted well into the seventeenth century.

The subject of Tintoretto's painting is taken from Torquato Tasso's epic poem *Gerusalemme liberata*, the most important literary work of the late Renaissance. Tasso's narrative centers around the actions of the Christian army during the First Crusade (A.D. 1099) in the months preceding the recapture of Jerusalem from the Saracens. The poet embellished this historical framework with numerous romantic and supernatural episodes, revealing his particular genius for conveying the ineffable emotional and spiritual states of mind that distinguish the poem. The *Gerusalemme liberata* combines the narrative and literary structure of classical epic poetry, the lyrical fantasy of chivalric romance literature, and the fervent pietism of the Counter-Reformation. Completed about 1575 and published six years later, the work was an immediate—albeit controversial—success and was soon translated into several languages. Tintoretto was, in effect, illustrating a scene from a best-seller of his time.

Domenico's decision to illustrate a subject from contemporary literature is hardly surprising in view of the popularity of Tasso's poem and the artist's predilection for depicting literary themes. According to Ridolfi, Domenico "delighted in composing verses," was "filled with ideas to which he gave expression in many historical, poetical, and moral themes, having devoted some time of his youth to the study of literature," and painted subjects from the poetic works of Ludovico Ariosto and Giambattista Marino.[10] In addition to the Houston painting, Domenico illustrated episodes from Tasso's poem on other occasions. An oil sketch in the Rhode Island School of Design Museum of Art (*fig. 1*) depicts a battle scene from the ninth canto of the poem, in which the Christian knight Guelpho wounds Clorinda.[11] The archangel Michael appears in the sky above the earthly combatants and routs the demons who were assisting the

fig. 1 Domenico Tintoretto. *Guelpho Wounding Clorinda.* Oil on canvas, 28 x 16½ in. (71.1 x 41.9 cm). Rhode Island School of Design Museum of Art, Providence 53.122

Saracens. Three oil sketches in the British Museum (one of which is reproduced in *fig. 2*) probably depict Tancred and Clorinda triumphantly routing their opponents on the battlefield.[12]

The Houston painting depicts the aftermath of a nocturnal duel between Tancred, a Christian knight, and a Saracen opponent who, unknown to Tancred, is his beloved, the princess Clorinda. An underlying theme of Tasso's poem, the often tragic consequences of irreconcilable religious differences, is sensitively expressed in this episode. Tancred mortally wounds Clorinda, who, still unrecognized by Tancred, implores him to baptize her:[13]

> Friend, thou hast won; I pardon thee; nor save
> This body, that all torments can endure,
> But save my soul; baptism I dying crave,
> Come, wash away my sins with waters pure.—
> His heart relenting nigh in sunder rave,
> With woeful speech of that sweet creature;
> So that his rage, his wrath, and anger died,
> And on his cheeks salt tears for ruth down slide.
>
> (Canto XII:66)

The knight rushes to a nearby stream ("runnel") and fills his helmet with water in order to grant his opponent's final request. He removes the visor ("beaver") from her helmet and at that moment recognizes his beloved:

> With murmur loud from the mountain's side
> A little runnel tumbled near the place,
> Thither he ran and filled his helmet wide,
> And quick return'd to do that work of grace:
> With trembling hands her beaver he untied,
> Which done, he saw, and seeing knew her face,
> And lost therewith his speech and moving quite;
> O woeful knowledge! ah unhappy sight!
>
> He died not, but all his strength unites,
> And to his virtues gave his heart in guard;
> Bridling his grief, with water he requites
> The life that he bereft with iron hard:
> And while the sacred words the knight recites,
> The nymph to heav'n with joy herself prepar'd;
> And as her life decays her joys increase;
> She smil'd and said—Farewell! I die in peace.—
>
> As violets blue 'mongst lilies pure men throw,
> So paleness 'midst her native white begun.
> Her looks to heav'n she cast; their eyes, I trow,
> Downward for pity bent both heav'n and sun.
> Her naked hand she gave the knight, in show
> Of love and peace; her speech, alas! was done.
> And thus the virgin fell on endless sleep.
> Love, beauty, virtue, for your darling weep!
>
> (Canto XII:67–69)

fig. 2 Domenico Tintoretto. *Scene from the 'Gerusalemme liberata.'* Oil on paper, 7⅜ x 9⅙ in. (188 x 233 mm). Trustees of the British Museum, London 1907-7-17-81

The sacramental nature of Tancred's baptizing of Clorinda is emphasized in the painting by the inclusion of the dove of the Holy Spirit and a pair of cherubim who look down upon the scene. Their presence is not mentioned in Tasso's poem but instead derives from scriptural accounts (and earlier pictorial representations) of Christ's baptism (see cat. 4).

Although his painting is essentially faithful to Tasso's text, Tintoretto focuses on the dramatic elements of the episode rather than the sentimental aspects emphasized by the poet. The vertical format compresses the composition, compelling the artist to arrange the figures (albeit somewhat awkwardly) in the sort of dramatic poses that are typically found in the mature works of his father, Jacopo. The compositional viewpoint is striking; the spectator looks down on the bleeding figure of Clorinda, whose headlong pose creates the impression that she has fallen at the feet of the viewer. The figures and the surrounding landscape are bathed in a strong, supernal light that allows Domenico to depict a range of luministic effects and to enliven the work—in a manner quite similar to his father's—through an array of vigorously painted highlights shimmering across the surfaces of the silks, armor, skin, hair, foliage, and water. The light also conveys the spiritual connotation that, through Tancred's work of grace, Clorinda's death is transformed into the dawn of her salvation and eternal life.

The chronology of Domenico's oeuvre is problematic, and any dating advanced for an undocumented work like the *Tancred Baptizing Clorinda* must be considered hypothetical. Nevertheless, the stylistic evidence argues compellingly for placing the work relatively early in the artist's career,

when the influence of his father was most pronounced. The extraordinary freshness and vigor of the brushwork and the bold composition support this hypothesis, since these qualities are frequently absent from the works Domenico painted after Jacopo's death in 1594. The subject matter also argues for an early dating, since it seems likely that given Domenico's literary interests, he would be among the vanguard of artists who illustrated Tasso's poem following its publication in 1581. This date furnishes a *terminus post quem* for the picture, which was probably executed before Jacopo's death.

The composition was augmented by two strips of canvas, each approximately four inches wide, added along the left and right sides. It is possible that these additions were made by Domenico himself, for they are integral to the composition, helping to establish the figures' positions in space. Wyld's 1989 technical examination indicated that the brushwork and the pigments used in these areas are consistent with the rest of the painting.[14]

D.S.

1. In the catalogue to this sale, the work was described as "one of America's most famous paintings." It was sold for $41,000. Josephine Hancock (Mrs. Frank) Logan was a remarkable patron of the arts in Chicago. In 1917 she and her husband established a fund for the awarding of prizes and the acquisition of contemporary works for the Art Institute. She gradually became disenchanted, however, with "the trend of so-called Modernism," which she felt was dominated by "the new French art influence." She began a crusade "to help rid our museums of modernistic, moronic grotesqueries that were masquerading as art"; she called this crusading movement "Sanity in Art," and published a remarkable manifesto of the same name in 1937.

2. See Fischkin 1925, 59–60.

3. Domenico's death notice (*necrologio*) from the parish of San Marcilian (Tozzi 1933, 299–300), which is dated May 17, 1635, lists his age as seventy-five, which would make the year of his birth 1559 or 1560. Zanetti (1771) gives his date of birth as 1562. Most later writers use the date 1560. The most important early source for Domenico's life and works is Ridolfi, whose biography of the artist (1648/1914–24, II, 257–63) was recently translated into English by Catherine and Robert Enggass (Ridolfi 1648/Enggass 1984, 87–94).

4. For Domenico's work in the Scuola di San Rocco, see Pallucchini and Rossi 1982, 88, 100; in 1602 Domenico was paid for restoring the *"Piscina Probatica"* in the Sala Superiore of the Scuola; see Rossi 1977, 260–61.

5. Ridolfi 1648/1914–24, II, 260.

6. See Tozzi Pedrazzi 1964, 73–89.

7. Ridolfi 1648/1914–24, II, 261.

8. Ridolfi 1648/1914–24, II, 262.

9. Aside from Ridolfi's biography, the most useful studies devoted to Domenico are: Venturi 1929, 652–53, 656–76; Tozzi 1937, 19–31; Tozzi Pedrazzi 1960, 386–96; and Tozzi Pedrazzi 1964, 73–88. Pallucchini and Rossi's 1982 monograph on Jacopo catalogues and illustrates numerous works by Domenico that were once attributed to Jacopo.

10. Ridolfi 1648/1914–24, II, 262; Ridolfi 1648/Enggass 1984, 93.

11. Maxon 1953, 1–3.

12. Tozzi 1937, 26–27, 29.

13. The verses quoted here are taken from Sir Thomas Fairfax's 1600 translation (Tasso 1581/1962, 313–14).

14. According to notes taken by Carolyn Wilson, Adjunct Curator for Renaissance Art at The Museum of Fine Arts, Houston. Dr. Wilson is writing the catalogue of the Renaissance paintings at Houston and shared with me her observations on Tintoretto's painting.

LAVINIA FONTANA

Bologna 1552–1614 Rome

———

Lavinia Fontana was baptized in Bologna on August 26, 1552. She received her artistic training from her father, Prospero (1512–1597), a successful Bolognese painter who had also worked for a number of years in Rome and Florence. Many of her earliest paintings, which date from the early to the mid-1570s, are small devotional panels, painted in a style based on her father's works. These are characterized by an eclectic synthesis of Tuscan-Roman models and of the works of Emilian artists like Antonio Correggio, Francesco Parmigianino, and Denys Calvaert, who had studied with Prospero in the early 1560s.[1] These small panels, and even the larger works from her early period, have a precision and a jewel-like quality that call to mind manuscript illuminations or miniatures.

During the 1570s Lavinia established herself as a successful portraitist. Her portraits, like her religious paintings, reflect the transition between the artificial maniera *style of the mid-sixteenth century and the more naturalistic style contemporaneously being developed in Bologna and Emilia. On the one hand, her portraits have an aristocratic elegance and emotional coolness that are rooted in late Mannerist portraiture. Yet, on the other hand, they convey an emotional sensitivity, humanity, and psychological depth that reveal the influence of Sofonisba Anguissola, whom she knew and admired, and an awareness of the stylistic reform of painting advocated in Bologna by Lodovico, Annibale, and Agostino Carracci. These qualities, as well as her meticulous attention to details of costume and accessories, secured her reputation as one of the leading portraitists of the Emilian aristocracy during the last quarter of the sixteenth century.*

In 1577 Lavinia married the painter Severo Zappi, with whom she had eleven children, and thereafter she included his surname in her signature.[2] By the mid-1580s her stature as an artist had increased to the point where she began to receive commissions for public altarpieces.[3] Her fame spread abroad, and in 1589 Philip II reportedly paid her the very substantial sum of 1000 ducados for an altarpiece for the Escorial. In 1604 she traveled to Rome, where she executed a Martyrdom of Saint Stephen *for the basilica of San Paolo fuori le Mura.[4] The last years of her artistic activity in Rome are not particularly well documented. She apparently had no pupils other than her daughter, Laodamia, who died at the age of sixteen.*

6

Angels Supporting the Body of Christ

———⊂◉▩◉⊃———

1576
Oil on wood, 15¾ x 11⅞ in. (40 x 30.2 cm)
Inscribed on tablet, lower left:
LAVINIA/FONTANA/VI[RG]O/FACIEBAT/1576
El Paso Museum of Art 1961.2/32

PROVENANCE
With Julius Weitzner, New York; Samuel H. Kress, New York, 1945 (K1402); on loan to the National Gallery of Art, 1945–51; gift of the Kress Foundation to the El Paso Museum of Art, 1961.

SELECTED EXHIBITION
Indianapolis 1954, no. 35.

SELECTED REFERENCES
El Paso 1961, no. 32; Shapley 1973, 71; Fortunati Pietrantonio 1986, II, 727–28, 741; Cantaro 1989, 32–33, 70–71 no. 4a. 11; Winter Park 1991, 24.

FONTANA, *Angels Supporting the Body of Christ*

Lavinia enjoyed the most successful career of any woman artist prior to Vigée Le Brun (see cat. 54) and was cited at least briefly by most of the important seventeenth-century biographers of artists. She was generally ignored by later writers, however, and was spared from complete obscurity only by the noteworthy aspect of her gender. Her deserved rediscovery is a relatively recent phenomenon; the earliest monographic study of her life and art did not appear until 1940. There was a rekindling of interest in her work during the 1970s, when a number of female artists were studied by art historians, but a reasonably complete picture of her life and oeuvre did not emerge until 1989, when the first catalogue raisonné of her work was published.[5]

The theme of the angelic pietà, while not recorded in the Bible, became popular in fifteenth- and sixteenth-century art, particularly in Italy after the Council of Trent (1545–63). Representations of the theme probably derived from devotional images of Christ as the Man of Sorrows (from Isaiah 53:3–5) and perhaps from representations of the Mass of Saint Gregory the Great, where the body of the crucified Christ, his wounds prominently displayed, surrounded by the instruments of his Passion, appeared to the saint as he was celebrating mass.[6] Earlier Italian representations of the theme usually included more of a narrative context closely relating to the pietà, the deposition from the cross, or the entombment of Christ; in these works angels support Christ's body at his tomb, and Golgotha, the site of the Crucifixion, is sometimes included in the background.[7] In many Italian Counter-Reformation images, the theme is taken out of a narrative context, and the imagery becomes more strictly devotional. The thematic emphasis of these works is more contemplative, their primary purpose being to encourage the viewer to come to repentance by meditating on the eternal significance of Christ's suffering and sacrifice. In this context, it is worth noting that Gabriele Paleotti, who became archbishop of Bologna in February 1576, the year in which Fontana's work was painted, asserted that religious paintings ought to serve as "mute preachers, a book for the populace . . . images that breathe piety, modesty, sanctity, and devotion . . . and penetrate into us with a greater force than words."[8]

The small format of Fontana's painting suggests that it was intended for private devotion, for which its subject and composition are well suited. The lifeless body of Christ, supported by two wingless angels, is placed in the center of the composition. Other angels, holding instruments of Christ's Passion—the cross, the column to which he was bound during his flagellation, and the nails used in the Crucifixion—are arranged in a tight arc around Christ. Other instruments of the Passion—the cords with which

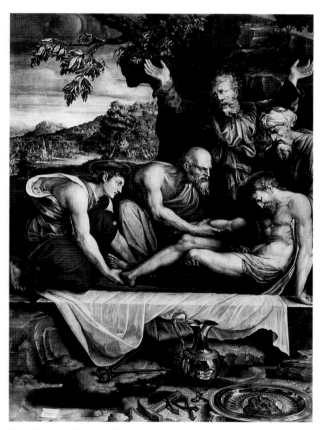

fig. 1 Prospero Fontana. *The Deposition of Christ*. Oil on wood, 99½ x 71⅜ in. (253 x 182 cm). Pinacoteca Nazionale, Bologna

Christ was whipped and the crown of thorns—are placed on the ground in the foreground so that nothing comes between the viewer and the body of Christ, intensifying the devotional aspect of the image. The forceful diagonals of the cross and column focus the viewer's attention on the body of Christ. Although the scene is set in a landscape, and Christ's body is placed on what may be a sarcophagus, any narrative context is secondary; the landscape serves primarily as a dark backdrop against which the luminous figures stand out prominently.

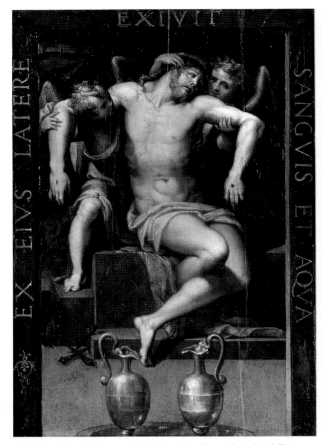

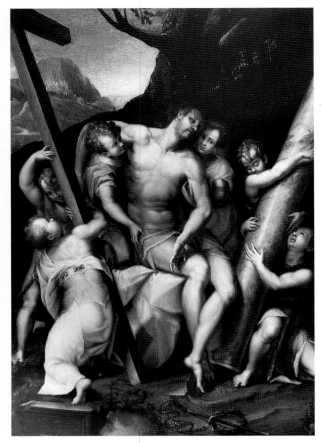

fig. 2 Attributed to Lorenzo Sabatini or Bartolomeo Cesi. *Dead Christ Supported by Angels*. Oil on wood, 15 ¾ x 10 ⅝ in. (40 x 27 cm). Pinacoteca Nazionale, Bologna 630

fig. 3 Lavinia Fontana. *Angels Supporting the Body of Christ, with Symbols of the Passion*. 1581. Oil and tempera on wood, 14 ¼ x 10 ⅝ in. (36.2 x 27 cm). Cornell Fine Arts Museum, Rollins College, Winter Park, Florida 36.30.P

The painting, signed and dated 1576, is one of Fontana's earliest documented works, and it is distinguished by the jewel-like luminosity and the miniaturist handling and attention to detail that characterize many of her early paintings. The precise rendering of the plants and flowers recalls botanical illustrations, and it is documented that Ulisse Aldrovandi, who amassed a huge collection of botanical specimens and many paintings and drawings of plants, was a close friend of Prospero and Lavinia Fontana, and that they frequently visited Aldrovandi's home.[9]

As would be expected in an early work, the El Paso painting reveals the stylistic influence of her father, Prospero, and the artists who in turn had profoundly influenced his style. Compositionally the work is indebted to Prospero's *Deposition* (*fig. 1*), which features a similar dark landscape backdrop and the implements of Christ's Passion and burial in the foreground.[10] The pose of Christ recalls Michelangelo's famous *Deposition* (Duomo, Florence), and the three central figures are compositionally very similar to those in a painting (*fig. 2*) that has been attributed to one of Lavinia's Bolognese contemporaries, either Lorenzo Sabatini or Bartolomeo Cesi. The angels supporting the cross and column recall their counterparts in the lunette of Michelangelo's *Last Judgment* in the Sistine Chapel; the pose of the angel on the left, supporting the upper part of the cross, may have been derived from the figure of the archangel Gabriel in Prospero's *Annunciation* (Brera, Milan), which was painted about 1570–71, when Lavinia would have been working in her father's studio.[11]

A somewhat truncated autograph replica of the painting (with slight variations) is in the collection of the Cornell Fine Arts Museum at Rollins College (*fig. 3*).[12]

D.S.

1. The most thorough studies of Fontana's life and artistic development are Fortunati Pietrantonio 1986 (II, 727–35) and Cantaro 1989 (5–54). Galli (1940, 107–25) published much of the significant documentation relating to Fontana's biography and oeuvre; also see Cantaro 1989, 302–18.

2. Before 1577 she usually signed her works "LAVINIA PROSPERI FONTANAE," occasionally with "FILIA" and/or "VIRGO" included. After her marriage she signed her works as "LAVINIA FONTANA DE ZAPPIS" or a variant thereof.

3. Lavinia's *Multiplication of Loaves and Fishes*, painted for one of the altars in the Bolognese church of Santa Maria della Pietà, has been dated circa 1583 (Cantaro 1989, 115 no. 4a. 40). The *Assumption of the Virgin with Saints*, painted for the altar of the chapel in the Palazzo Comunale, Imola (Cantaro 1989, 124–25 no. 4a. 45), is signed and dated 1584.

4. The *Martyrdom of Saint Stephen* (Cantaro 1989, 208–9 no. 4a. 97), which was destroyed in the fire that swept San Paolo fuori le Mura in 1823, is described in unflattering terms by Baglione (1642, 143–44; reprinted in Cantaro 1989, 321) but is mentioned favorably or without additional comment by other seventeenth- and eighteenth-century writers such as Mancini, Toti, Celio, Titi, and Oretti (Cantaro 1989, 319–28 nos. 5b. 3, 5b. 5–6, 5b. 9–10, 5b. 16). Baldinucci (reprinted in Cantaro 1989, 325–26 no. 5b. 13) notes that the painting was not favorably received.

5. Galli 1940; Tufts 1974; Los Angeles 1976–77; Ghirardi 1984; Fortunati Pietrantonio 1986; Cantaro 1989.

6. For the development of the theme and its iconography see Schiller 1972, II, 215–19; and Mâle 1932/1951, 288–89.

7. As, for example, Mantegna's circa 1490 painting in the Statens Museum for Kunst, Copenhagen (Tietze-Conrat 1955, pl. 134).

8. Paleotti, *Discorso intorno alle imagini sacre e profane*, Bologna, 1582, 2: Chap. 52; reprinted in Barocchi 1960–62, II, 497.

9. For Aldrovandi's "museum," see the essay by Giuseppe Olmi and Paolo Prodi, "Art, Science, and Nature in Bologna Circa 1600," in Bologna 1986–87, 213–35, esp. 218–24. For Aldrovandi's friendship with Prospero and Lavinia, see Malvasia 1678/1841, I, 174. Aldrovandi and Paleotti were also close friends; see Olmi and Prodi in Bologna 1986–87, 224–26.

10. For Prospero's *Deposition* see Fortunati Pietrantonio 1986, I, 341–42, 357; and Cantaro 1989, 71.

11. For Prospero's *Annunciation*, see Bologna 1986–87, 137–38 no. 47.

12. For the Rollins College version, see Winter Park 1991, 24–25 no. 12. The painting bears Lavinia's signature and a date of 1581, but at least one of these elements is probably by a later hand, since the signature is of a form not used by the artist after her marriage in 1577. For a discussion of the different signatures used by Lavinia, see n. 2 above.

LEANDRO BASSANO (Leandro dal Ponte)

Bassano 1557–1622 Venice

Born on June 10, 1557, Leandro was from the third generation of a distinguished family of artists from Bassano del Grappa, a town located some forty miles northwest of Venice, from which the dal Ponte family derived its better-known surname.[5] Although his grandfather Francesco dal Ponte the Elder (c. 1475/78–1539) was a minor artist, Leandro's father, Jacopo (c. 1510–1592), and his brothers Francesco (1549–1592), Giambattista (1553–1613), and (to a significantly lesser extent) Girolamo (1566–1621) were all successful artists in their own right. Leandro received his artistic training in Jacopo's prosperous studio where he worked alongside his father and brothers, helping to meet the constant demand for biblical and genre scenes by the Bassano. When Francesco left the studio to pursue an independent career in Venice about 1577–78, Leandro became Jacopo's chief assistant, assuming an increasingly greater responsibility for the actual execution of paintings that left the studio.

Leandro's own independent career seems to have begun about 1574. During the late 1570s and early 1580s he traveled frequently between Bassano and Venice, eventually settling in the latter city sometime between 1584 and 1588; his name appears on the rolls of the Venetian painters' guild between 1588 and 1621. During his first years in Venice he seems to have executed both religious subjects and portraits, but he increasingly concentrated on the latter, for which there was great demand in Venice, and it was in this field of painting that he achieved his greatest success. Sometime between 1595 and September 1596 Leandro was knighted by Doge Marino Grimani, and afterward he usually added the title "Eques" (knight) to his signature.

In addition to the many portraits he painted during the early seventeenth century, Leandro continued to execute civic, ecclesiastical, and private commissions in and around Venice. The seventeenth-century biographer Ridolfi describes Leandro as a highly successful artist and a man of many talents, given to singing and playing the lute. Ridolfi paints a vivid picture of the artist walking through Venice "displaying grandeur and splendor in every action," accompanied by his pupils, one carrying his gilded rapier and another his notebook.[6] Following a lengthy illness, Leandro died on April 15, 1622, and was buried amid great ceremony in the Venetian church of San Salvatore.

7

The Last Judgment with the Saints in Paradise

———⟳———

c. 1595–1605
Oil on copper, 28 x 19 in. (71.1 x 48.3 cm)
Signed, lower right: LEANDER A PONTE BASS. EQVES. F.
Birmingham Museum of Art, Alabama 61.114

PROVENANCE
Possibly Bernardo Giunti, Venice and Florence, before 1648;[1] M. de Bertillac;[2] Philip, Duc d'Orléans, Palais Royal, Paris, as early as 1737; Louis-Philippe-Egalité, until 1792; sold by him to Vicomte Édouard de Walkuers, Brussels, 1792; sold by him to Laborde de Méréville, 1792; sold by him to Jeremiah Harmann, London; with a consortium consisting of the Duke of Bridgewater, the Earl of Carlisle, and the Earl Gower, 1798–99;[3] Francis, 3rd Duke of Bridgewater, London, until 1803; his nephew, Lord Gower, later 2nd Marquess of Stafford, Cleveland House, London, until 1833;[4] his son, Lord Francis Leveson-Gower (later Egerton), 1st Earl of Ellesmere, Bridgewater House, London, until 1857; by descent to the 5th Earl of Ellesmere, until 1846; his sale, Christie's, London, October 18, 1946, lot no. 53; with S. Hartveld Galleries, New York; with Paul Drey, New York; with Julius Weitzner, New York; Samuel H. Kress Foundation, New York, 1947 (K1431); gift of the Kress Foundation to the Birmingham Museum of Art, 1961.

SELECTED EXHIBITIONS
London 1798–99, no. 7; Indianapolis 1954, no. 55.

SELECTED REFERENCES
Ridolfi 1648/1914–24, II, 168; Britton 1808, 94 no. 86; Ottley 1818, II, no. 31; Buchanan 1824, I, 138; Westmacott 1824, 192 no. 86; Young 1825, I, 72–73 no. 95; Jameson 1844, 96; Waagen 1854, II, 487; Stryienski 1913, 157 no. 107; Arslan 1960, I, 266; Shapley 1973, 48; Cohen 1983, 40, 42–43.

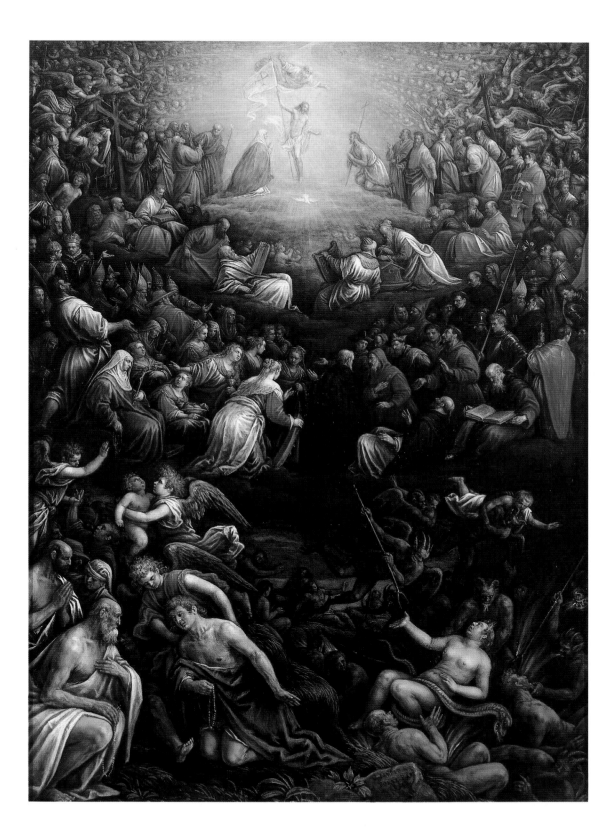

BASSANO, *The Last Judgment with the Saints in Paradise*

Bassano's painting depicts the triumphant second coming of Christ on Judgment Day. According to Christian thought, there are two aspects of this second coming: the judgment of the living and the dead, and the eternal glorification of Christ in heaven by the saved, the blessed "saints." Both of these aspects are illustrated in this marvelous copper. Through his sophisticated handling of light and color and through compositional means Bassano does ample justice to this grandest of themes in Christian art—the culmination of God's plan for mankind as outlined in the Bible—conveying both a sense of the glory of paradise and the drama of eternal judgment. That he is able to do so while working on such a small scale testifies to his skill and sensitivity as an artist, which become increasingly evident as one studies this painting.

The elect in heaven are bathed in a golden light that radiates from the Holy Trinity. The bright colors of the robes worn by the figures closest to the Trinity and their circular arrangement call to mind the rainbow surrounding Christ mentioned by the Evangelist John in Revelation 4:3. Light and color are also used to suggest the vast amplitude of heaven, for the light that reaches the second tier of the elect appears dimmer and softer, indicating the greater distance of these figures from the Trinity. This diminished intensity is also conveyed through the colors of the garments worn by the saints in this group, which are predominantly brown and black, although the artist enlivens this subdued area of the composition with flashes of color and light reflecting off the silks and armor worn by a few of the saints. In contrast to the more even handling of light in the upper part of the composition, in the lower portion the artist uses stronger contrasts of light and dark, heightening the drama of judgment taking place there. The luminosity of the work and the jewel-like quality of the colors, which are even more apparent following the recent cleaning of the painting, are due in part to the highly polished copper support upon which Bassano painted.

To do justice to so grand a theme on so small a scale requires great compositional skill and discipline. Scenes of the worshipful elect in paradise were popular in Italy during the sixteenth and seventeenth centuries, especially in dome and ceiling frescoes in churches, where the circular architecture of the dome or the extensive field of the ceiling enabled artists to suggest illusionistically the immense magnitude of heaven. Bassano conveys the unlimited vastness of paradise through the great host of figures arranged in rows and tiers as if witnessing (and participating in) a divine performance in a heavenly amphitheater. The depth of space is also communicated through the dif-

ferent scales of the figures, from the almost microscopic heads of the angels behind and above Christ, through the larger Old Testament prophets and the saints in the next two tiers, which are to be understood as being situated farther from the Trinity and closer to the picture plane, to the more substantial figures on earth below who nearly extend into our own space (note the protruding knee of the figure in the lower left corner). Bassano also suggests the universality of the judgment taking place below on earth by opening up the center of the foreground, allowing the viewer to see into the distant background, where the judgment is also dispensed.

The clarity and precision of Bassano's depiction of the elect and their disposition according to a general celestial hierarchy, with the most prominent saints and prophets placed closest to the Trinity, make it possible to identify a number of the figures. It goes without saying that in Bassano's day a far greater number would have been identi-

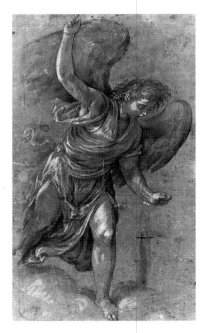

fig. 1

Attributed to Jacopo Bassano. *Angel*. 1569. Brush and bister wash, heightened with white, over black chalk, on brown paper, 21⅛ x 12⅞ in. (537 x 327 mm). The Governing Body, Christ Church, Oxford, inv. 1416

fiable. Although this task is more difficult for us today, it is nevertheless an interesting exercise, one that the artist clearly intended the viewer to undertake, for many of the saints are shown with their iconographic attributes, and the features of the few secular figures are carefully rendered.

Among the elect on the left side of the composition (*fig. 2*) are: the Virgin Mary; Joseph, holding the miraculously blooming rod that distinguished him as God's chosen husband for Mary; a group of apostles, including Peter, who holds the keys to the kingdom of heaven, and Andrew with the cross; and the archangel Michael, holding the sword

fig. 2 Leandro Bassano. *The Last Judgment with the Saints in Paradise* (detail of cat. 7)

fig. 3 Leandro Bassano. *The Last Judgment with the Saints in Paradise* (detail of cat. 7)

and scales. Below Michael (from left to right) are: Roch, wearing the hat and carrying the staff of a pilgrim; Sebastian, clad in a loincloth; the Evangelists Mark and John; and Moses, holding the tablets of the Law. Below them are distinguished secular and ecclesiastical personages, including Marino Grimani, the reigning Doge of Venice, who had knighted Leandro shortly before this work was painted; the Holy Roman Emperor Rudolf; numerous cardinals, bishops, and popes, including Blaise, wearing a bishop's miter and holding a metal comb, the instrument of his torture, and the four doctors of the Western church— the bishops Augustine and Ambrose, Jerome in a cardinal's hat and robes, and Pope Gregory the Great, wearing a papal tiara.[7] Just below Roch and Doge Grimani is a figure, wearing a cruciform decoration, who is probably Leandro himself.[8] In the register below the bishops is a group of predominantly female saints, many bearing the attributes of their torture or martyrdom, including (moving left from the center): Catherine, holding the spiked wheel; Apollonia, holding pincers; Justina of Padua, her breast pierced by a sword; Barbara, holding a chalice with a wafer; Agatha, holding a salver bearing a pair of breasts; Lucy, holding a pair of eyes; a woman dressed in the habit of a Dominican

nun, holding a crucifix and rosary, perhaps Catherine of Siena; Christopher, the gigantic male figure holding a palm branch; and Veronica, holding the *sudarium* with which she wiped the sweat from Christ's face as he bore his cross to Calvary.

Among the elect on the right side (*fig. 3*) of the composition, behind the kneeling figure of John the Baptist, are a group of apostles, including Paul, holding a book and the sword of his martyrdom; Stephen, the first martyr of the Christian church, the rock on his head an allusion to his death by stoning; Lawrence, holding the grill upon which he was martyred; and a figure carrying a pilgrim's staff, probably James the Greater. Below them in the center are grouped David holding a harp, a reference to his authorship of the Book of Psalms; Noah with a model of the ark; and the Evangelists Matthew and Luke. Prominent among the male saints below them are (from the center, moving right): the aged Francis of Paola, wearing a brown habit; Peter Martyr, in a Dominican habit, the bleeding wound on the back of his head alluding to his martyrdom; Francis of Assisi in the robes of the monastic order he founded; two figures in armor, one, perhaps Martin of Tours, holding a

red cloak, the other, bearing a lance, may be Jude or Longinus; Antony of Padua, holding lilies; Nicolas of Myra, with a salver surmounted by three gold balls, alluding to his acts of charity; and another sainted knight who holds a banner, perhaps Victor or George.

In spite of its small scale, the *The Last Judgment with the Saints in Paradise* is one of Leandro's most ambitious works. Like many of Leandro's religious paintings, it derives in part from a composition by his father, in this instance the *Paradise* altarpiece in Bassano (*fig. 4*), which Leandro himself may have had a major role in painting.[9] Leandro borrowed several of the figures of the elect directly from this source. Also related to both the altarpiece in Bassano and the Kress painting is the *Virgin Mary before the Trinity in Paradise* in the Prado, traditionally attributed to Leandro but assigned by Rearick to Leandro's brother Giambattista. A drawing at Christ Church, Oxford (*fig. 1*), which has been variously attributed to Jacopo, Francesco, or Leandro, appears to be the source for the figure of the archangel Michael in the upper left part of the composition (see *fig. 2*).[10]

The inclusion of the word "EQVES" in the signature (and the decoration worn by the artist himself in the Birmingham painting) indicates that it was painted after 1595–96, when Leandro received his knighthood, while the presence of

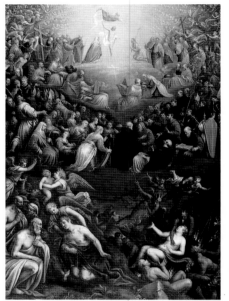

fig. 5

Leandro Bassano. *Paradise and the Last Judgment*. c. 1595–1605. Oil on panel, 28¾ x 20 in. (73.2 x 51 cm). Trafalgar Galleries, London

Doge Grimani suggests that it was probably painted sometime before 1605, when Grimani's term as doge expired. The precise, miniature style of this painting may have influenced Johann Rottenhammer and Adam Elsheimer, both of whom arrived in Venice in the late 1590s, and both of whom painted similar compositions on copper.[11]

Another, very similar version of Leandro's composition is currently on the London art market (*fig. 5*).[12] It appears probable that the London painting is the earlier of the two paintings, because it features a graphically rendered vignette of a demon clawing the breast of one of the damned figures. It would seem probable that the violence in the Kress painting would have been "toned down" in deference to the wishes of a client who had seen the first version.[13] It is likely that one of these two paintings was the "Paradisio con piccole e diligenti figure" cited by Ridolfi in 1648 as being in the possession of the Venetian collector Bernardo Giunti who, Ridolfi says, had taken the painting to Florence. The Kress painting's long and distinguished provenance— it passed through some of the most notable collections assembled in Europe during the eighteenth and nineteenth centuries—is indicative of its quality and the esteem in which it has long been held.

D.S.

fig. 4 Jacopo Bassano and Leandro Bassano. *Paradise*. c. 1580. Oil on canvas, 93⅓ x 61 in. (237 x 155 cm). Museo Civico, Bassano del Grappa

I gratefully acknowledge the counsel and assistance of Roger Rearick and Donna Antoon in the preparation of this entry.

1. Ridolfi 1648/1914–24, II, 168.

2. Young 1825, I, 72 no. 95; Stryienski 1913, 157 no. 107.

3. The provenance of the Duc d'Orléans collection and the history of its dispersal are discussed in Buchanan 1824, I, 11–21. The sale of the Bassano *Last Judgment* to the Duke of Bridgewater for 100 guineas is recorded in Buchanan 1824, I, 138.

4. Britton 1808, 94 no. 86; Ottley 1818, II, no. 31; Young 1825, I, 72–73 no. 95.

5. The most up-to-date and comprehensive biography of Leandro is Livia Alberton Vinco da Sesso's entry in the *Dizionario biografico degli Italiani* 32 (1986): 188–92, which also includes bibliographic references. Ridolfi's short biography (1648/1914–24, II, 165–71) is the most useful early account of Leandro's activity.

6. Ridolfi 1648/1914–24, II, 170.

7. Leandro's portrait of Doge Grimani, painted about the same time as the Kress *Last Judgment*, is in Dresden (illustrated in Cohen 1983, 40 fig. 1), as is Leandro's pendant portrait of Grimani's wife, Morosina Morosini.

8. This hypothesis is based on the close similarities between his features and those of Leandro's self-portrait in the Uffizi (inv. no. 1819). The cruciform medallion worn by the figure is very probably the decoration that Leandro was awarded by Doge Grimani in 1595–96.

9. For a discussion of the *Last Judgment* altarpiece, see Bassano del Grappa 1992–93, 544 no. 123. In an essay for the same catalogue Rearick (157) notes that the painting, based on Titian's *Gloria* (Museo del Prado, Madrid), was intended as a compositional model for the benefit of Francesco, who was at that time (c. 1582) competing for the commission for a *Paradise* mural for the Sala del Maggior Consiglio in the Palazzo Ducale. The commission was ultimately awarded to Francesco and Paolo Veronese, but the death of the latter resulted in the commission ultimately being given to Jacopo Tintoretto. Rearick ascribes the composition of the *Paradise* mural to Jacopo Bassano but notes that the actual execution was a collaborative effort, with Leandro being responsible for the greater share.

10. Byam Shaw 1976, I, 202 no. 752; also Bassano del Grappa 1992–93, 494 no. 99. Rearick (1962, 531) hypothesized that the drawing was "a *ricordo* . . . to preserve the motif for future reference and repetition" made after an Archangel Gabriel now in a private collection in Baltimore (Rearick 1962, fig. 16). Leandro's use of this drawing some thirty years later validates Rearick's hypothesis.

11. Rottenhammer came to Venice in 1596 in order to study the works of the great Venetian masters, and one of the first works he painted after his arrival bears the inscription "a imitazione di Giacobo da Ponte dipinse." Rottenhammer's *Coronation of the Virgin* (oil on copper, 37 x 25 ⅕ in.) in the National Gallery, London (Cohen 1983, 43 fig. 6), bears compositional and stylistic similarities to Leandro's *Paradise*. The Bassano were an important influence on Elsheimer; for a somewhat similar composition by Elsheimer, the *Exaltation of the Cross* (oil on copper, 19 x 13 ¾ in.) in the Städelsches Kunstinstitut, Frankfurt, see Cohen 1983, 43 fig. 7.

12. Cohen 1983, 40–43 no. 15.

13. Cohen 1983, 43.

Doménikos Theotokópoulos, called **EL GRECO**

Candia 1541–1614 Toledo

8

*Saint Francis Venerating
the Crucifix*

————◦◉◦————

c. 1600
Oil on canvas, 58 x 41½ in.
(147.3 x 105.4 cm)
The Fine Arts Museums of San Francisco
61.44.24

PROVENANCE
Possibly private collection, southern Spain, by 1614;
private collection, France; H. F. Frankhauser, Basel; with
Rosenberg and Stiebel, Inc., New York, before 1953; Samuel
H. Kress Foundation, New York, 1953 (K1971); on loan to
the M. H. de Young Museum, 1955–61; gift of the Kress
Foundation to the M. H. de Young Memorial Museum, later
The Fine Arts Museums of San Francisco, 1961.

SELECTED EXHIBITIONS
Washington 1961–62, no. 41; Seattle 1962, no. 67; Portland
1967–68, no. 23.

SELECTED REFERENCES
San Francisco 1955, 70; Gudiol 1962, 202; Wethey 1962,
II, 121–22 no. 219; Eisler 1977, 194–95; Manzini and Frati
1969, 108 no. 102a.

El Greco was born in Candia, the capital of Crete, a Greek island long under Venetian rule. In acknowledgment of this heritage, he always signed his paintings with his given name spelled in Greek letters. He sometimes embroidered this further with Kres, meaning "Cretan." However, El Greco (meaning "the Greek" in Spanish) was destined to be the most potent artistic personality working in sixteenth-century Spain, and thus he became known as one of the greatest artists of the Spanish school.

El Greco's early artistic approach was molded by Crete's conservative Byzantine tradition of icon painting, characterized by figural distortions, spatial abstractions, and vivid coloration. His manner of execution broadened with exposure to Italian art, most particularly during a stay in Venice, where he is documented as having been in 1568. The model of Venetian High Renaissance works by Titian (see cat. 2), Tintoretto, Veronese (see cat. 4), and the Bassano family provided El Greco with a new sense of convincing figural proportions and pictorial space, coupled with a more painterly technique.

Documented in Rome in 1570, El Greco gained entrée to the influential enclave of Cardinal Alessandro Farnese through an introduction from the miniaturist Giulio Clovio. El Greco, well educated himself, would find support among similar groups of scholars, theologians, and connoisseurs throughout his career; and in the tradition of Michelangelo, Raphael, and Leonardo, El Greco considered himself not an artisan but a learned artist worthy of such company.

Although accepted as a miniaturist into the Academy of Saint Luke in 1572, El Greco failed to secure recognition and patronage in Rome beyond the Farnese circle. Most likely for this reason and because he hoped to share in the generous patronage with which Philip II was completing the monastic and palatial complex at El Escorial, El Greco quit Rome, arriving in Spain by 1577. Possibly stopping first in Madrid, he settled in Toledo. He probably carried with him letters of introduction from Luis de Castilla, another frequenter of the Farnese Palace. El Greco's first significant patron in Spain was Diego de Castilla, Luis's father and dean of the Toledo cathedral chapter. By 1582 El Greco had completed three important Spanish commissions for the cathedral of Toledo, the convent of

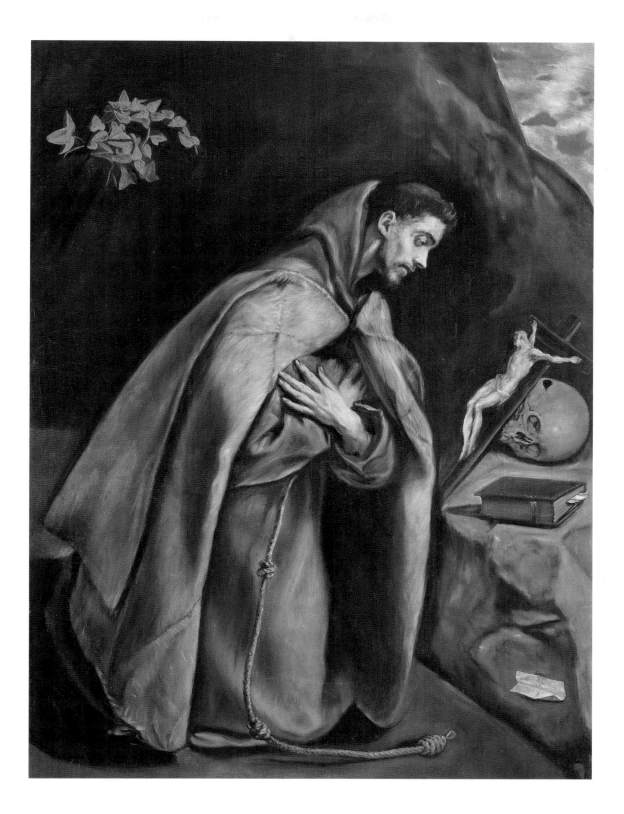

EL GRECO, *Saint Francis Venerating the Crucifix*

Santo Domingo al Antiguo, and the church of El Escorial. The projects for both the cathedral and the king ended disastrously in controversy over payment and, more important, over the decorum of El Greco's rendition of the religious subjects. These two proceedings established a pattern for El Greco's Spanish career wherein he repeatedly challenged the results of the Spanish tasación (valuation).[1] Nonetheless, his artistic reputation established, El Greco was never without major commissions from the learned clergy of the great religious institutions of the archdiocese of Toledo. And in a series of masterpieces, El Greco's highly idiosyncratic style is perfectly wed to the emotional intensity of the Counter-Reformation. Religious works predominate his oeuvre; however, El Greco was also a masterly portraitist. Failing to secure royal patronage at the court in Madrid, El Greco continued to work in Toledo until his death in 1614.

In 1961 the citizens of San Francisco accepted this moving image of the city's namesake from the Kress Foundation. No other saint figures as prominently in the works of El Greco as Saint Francis of Assisi (b. 1181/82), the gentle poet and mystic who was canonized two years after his death in 1226. He founded the Franciscans, one of the three great mendicant orders of the Catholic Church.[2] This brotherhood relied on begging for its subsistence, preaching and living among the poorest members of their congregation. More than 120 paintings depicting Saint Francis have been ascribed to El Greco and his workshop, evidence of the great market for devotional images of this popular saint. In El Greco's time Toledo boasted ten Franciscan communities: seven convents and three monasteries. El Greco himself lived in the vicinity of the important monastery dedicated to the Franciscan San Juan de los Reyes. The great popularity of the Italian-born Saint Francis was not, however, a uniquely Spanish phenomenon; the saint enjoyed particular veneration in his native Italy, as well as in El Greco's Crete.

Christened Giovanni Bernardone, Francis was the son of a wealthy Umbrian cloth merchant. Taught to speak French at an early age, which was unusual for the time, he became known as Francesco (Francis), the "Frenchman." As a profligate youth he was given to wild extravagance and delighted in expensive, showy clothing. After a series of sobering events and visions, however, Francis renounced the worldly possessions of his social station.[3] He fervently embraced poverty and humility, his life newly governed by a self-effacing love for Jesus. According to Saint Bonaventure's commentary on the life of Saint Francis, this love was the medium through which Francis became miraculously linked with Christ, both spiritually and physically, as evidenced by the stigmata, the mystical implantation of Christ's five wounds on Saint Francis's body.[4]

The various historical events of Saint Francis's life occupied artistic interest until the mid-sixteenth century when the requirements of the Catholic Counter-Reformation called for new Franciscan imagery. In its campaign against further defections to Protestantism, the Roman Church called on the visual arts to reassert the power and efficacy of the mysteries of the Catholic faith, including the veneration of saints. Thus the objective, narrative approach was superseded by a novel iconography that emphasized the saint's mystical experiences.

The Kress painting exemplifies one of El Greco's numerous interpretations of the ascetic saint in meditation.[5] The present composition follows the "Cuerva" type, named after an earlier painting by El Greco that remained in the Convento de Carmelitas (Carmelite Convent) in Cuerva, Toledo, until 1940.[6] Consistently accepted by scholars as autograph, the Kress *Saint Francis* is the largest of the Cuerva compositions and the handsomest painting of this type known today.

Following convention,[7] El Greco depicts Saint Francis in a patched, hooded cloak worn over the coarse gray-brown tunic of the order. As shown, the Franciscan habit also includes a knotted cord used as a belt; this Saint Francis likened to the halter or bridle of a beast, symbolic of the spirit's subjugation of the body. Typical of the new Counter-Reformation imagery, however, it is not one of the specific events in the life of the holy man that El Greco depicts but rather an exploration of the psychology of religious fervor as induced through meditation. Here, as in El Greco's best works, technique is wed to content. The austerity of the rocky setting and the subdued color scheme reiterate the saint's ascetic character and help to focus attention on the intensity of his meditative state centered on the figure of

the crucified Christ. The nervously rendered but beautiful hands of the saint, as yet unmarked by Christ's wounds, are crossed over his chest in a gesture of supplication that forms the center of the image.

In this sparse canvas the complexity of the Catholic belief in the cycle of redemption is eloquently portrayed. The fall of man from grace in the Garden of Eden, as represented by Adam's skull against which the crucifix leans, necessitated a sacrifice of such moment that only the death of God's own son, Jesus, could make adequate atonement. The inclusion of the ivy vine, however, a traditional symbol of immortality, symbolizes the ascendancy of the virtuous human soul. And the model of Saint Francis provides the link between all of these symbols, suggesting that through meditation and spiritual surrender we, too, can approach God and experience his love.

L.F.O.

1. Through this process a panel of jurors, representing both the artist and the client, determined the price that an artist was to be paid for a work of art, not at the time the commission was granted but when it was completed.

2. Provisionally approved by Pope Innocent III, the order of the Franciscans was officially sanctioned by Pope Honorius III in a papal bull in 1223.

3. Details of the life of Saint Francis first were described in the two *Lives* written by Thomas de Celano in 1228 and 1248.

4. A biography of Saint Francis with a commentary on Celano was written in 1260–62 by the Franciscan theologian Saint Bonaventure (1221–1274), who as a sickly baby had been laid at Saint Francis's feet to be blessed. The accounts of Celano and Bonaventure were augmented by the *Fioretti* (Little Flowers), a fourteenth-century compilation of popular legends about the life of Saint Francis first printed in the vernacular in Milan in 1477.

5. El Greco created several different compositional types representing Saint Francis meditating. See Gudiol 1962, 195–203.

6. That work is now in the Museo de Bellas Artes, Bilbao. Camón Aznar (1950/1970, nos. 570–88) lists nineteen versions of the "Cuerva" type by El Greco and his followers.

7. For a general review of how Saint Francis has been represented in art, see Réau 1955–59, III, pt. 1, 516–35; for Franciscan imagery after the Council of Trent, see Mâle 1932/1951, 171–78, 478–95; and Askew 1969.

Doménikos Theotokópoulos, called EL GRECO

Candia 1541–1614 Toledo

*The Death of Laocoön
and His Sons*

———◁◫▷———

c. 1610–14
Oil on canvas, 54⅛ x 67⅞ in.
(137.5 x 172.4 cm)
National Gallery of Art, Washington
1946.18.1

PROVENANCE
Probably in the artist's possession at his death in 1614;[1]
probably his son, Jorge Manuel Theotocópuli, Toledo, in
1621; Duques de Montpensier, Palacio San Telmo, Seville;
the Infante Antonio María Felipe Luis de Orleáns, Duque
de Montpensier (1824–1890), Seville; his son, the Infante
Don Antonio de Orleáns, Duque de Galliera, Sanlúcar de
Barremada, Cadiz, 1908; with Durand-Ruel, Paris, by 1910;
with Paul Cassirer, Berlin, by October 1915; Edward Fisher,
Basel and Berlin, by 1923; his ex-wife, Eleanora Irme von
Jeszenski von Mendelsohn, Berlin, by 1926; on loan to the
Kunstmuseum Basel, 1923–30; Prince Paul of Yugoslavia,
Belgrade, Johannesburg, and Paris, by May 1934; on loan to
the National Gallery, London, May 1934–December 1935;
stored at the National Gallery of Art, Washington, during
World War II; with M. Knoedler & Co., New York, 1946;
Samuel H. Kress Foundation, New York, 1946 (K1413); gift
of the Kress Foundation to the National Gallery of Art, 1946.

SELECTED EXHIBITIONS
Munich 1910; Athens 1979–80; Madrid 1982–83, no. 56;
on loan to the State Hermitage Museum, Leningrad, 1989;
on loan to Muzeum Czartoryski, Krakow, 1992.

SELECTED REFERENCES[2]
Montpensier 1866, 44 no.155; Förster 1906, 174–75;
Cossío 1908, 357–63 no. 162, 579 (1972 ed., 207–11 nos.
385, 397); Kehrer 1914, 85–87; Kehrer 1926, 96–97; Saxl
1927–28, 95–96; Mayer 1931, 138–39; Capdevila 1936,
91; Cook 1944, 261–72; Camón Aznar 1950/1970, II, 815,
883, 918, 924 no. 684, 997, 1292, 1376; Guinard 1956,
102–6; Wethey 1962, I, 50–51, 61, 63, II, 83–84 no. 127;
Palm 1969, 129–35; Vetter 1969, 295–98; Palm 1970,
297–99; Waterhouse 1972, 114; Finley 1973, 89; Walker
1974, 144–46; Lafuente Ferrari and Pita Andrade 1975,
61, 73–74, 114, 136–37 nos. 145, 162; Davies 1976, 10, 16;
Eisler 1977, 195–201; Rogelio Buendía 1983, 42–46;
Moffitt 1984, 44–60; Kitaura 1986, 85–91; Brown and
Mann 1990, 60–67.

A masterpiece of El Greco's last years, the Laocoön is one of his most extraordinary paintings and certainly one of the most important works in the Kress Collection. A compelling, enigmatic picture, it continues to provoke more questions than it answers. The subject— the death of the Trojan priest Laocoön and his sons—is easily recognizable, yet the meaning and context of the work, and even the identification of some of the figures, are far from certain. Although it is the artist's only extant painting of a pagan theme, its subject probably carried religious overtones. The events represented in the painting took place during the Trojan War (c. 1200 B.C.) before a crowd of horrified onlookers outside the gates of Troy, but El Greco transports the scene to the suburbs of seventeenth-century Toledo, where the only witnesses are a pair of enigmatic nude figures. At first glance, the picture appears finished, yet it is likely that the artist was still making significant adjustments to the two figures at the right side of the composition when he ceased work on the painting.[3] These ambiguities only enhance the powerful spell the picture has cast over viewers since it first came to the public's attention early in this century.

The best-known account of Laocoön's death is found in the second book of Virgil's *Aeneid*, wherein Aeneas describes the fall of Troy through a clever ruse planned by the Greek forces that had unsuccessfully lain siege to the city for ten years. The Greeks constructed a huge wooden horse and secreted several of their number inside. Over the objections of Laocoön, one of their priests, the Trojans pulled the horse inside the city walls. While the Trojans slept, the Greek warriors slipped out of the horse, opened the gates to their comrades who had stealthily returned by sea from their nearby hiding place, and together they burned and sacked the city.

El Greco's painting depicts one of the most dramatic episodes in the story. Upon discovery of the horse, Laocoön had passionately warned his countrymen against bringing it inside the city walls and had flung a spear at the flanks of the horse.[4] Later, as Laocoön prepared a sacrifice to Neptune, a pair of huge serpents emerged from the sea, attacked and killed the priest and his sons, and then slithered into the city and coiled at the feet of a statue of Athena. The Trojans were convinced that this action represented the goddess's retribution for Laocoön's having thrown his spear at the horse, and they dragged the huge wooden beast into the city.[5]

Rather than a straightforward visual narration of an episode from literature, the *Laocoön* is first and foremost a demonstration of El Greco's vivid imagination and stunning technical virtuosity. The artist has distilled the story to its essential figural elements. The crowds of appalled spectators described in the ancient accounts have been eliminated in the painting; the only witnesses to the struggle are a pair of figures whose discrete position and somewhat detached attitudes suggest that they may be divine personages.[6] Other than the serpents, the only narrative detail is the horse—disconcertingly lifelike for a wooden construction—which occupies a prominent, if spatially ambiguous, position near the center of the composition (*fig. 4*).

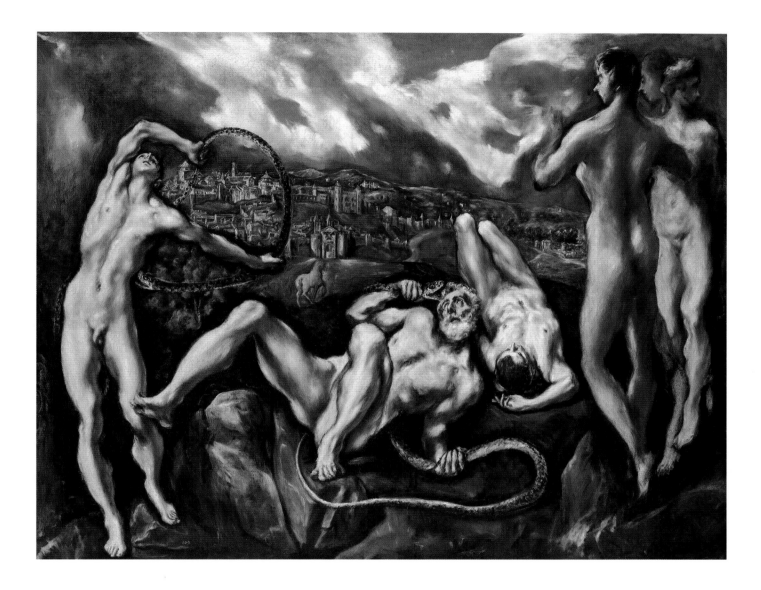

EL GRECO, *The Death of Laocoön and His Sons*

Like many of El Greco's late works, such as the *Fifth Seal of the Apocalypse* (Metropolitan Museum of Art), the *Laocoön* abounds with sophisticated, if disquieting, contrasts—both conceptual and technical—creating an exquisite tension

fig. 1 El Greco. *The Death of Laocoön and His Sons* (cat. 9 before 1955 restoration)

that results from the artist's decision to reject conventional illusionism in favor of a subjective pictorial space. Although it is a scene of death, the picture pulsates with an animating rhythm established by the vigorous surface pattern El Greco creates through his deliberate, contrapuntal arrangement of the figures. Presented in a tableau across a shallow stage, they dominate the work through their size and prominence in the foreground, though their place within the composition is ambiguous; the figures on the right do not so much stand within the landscape as hover on the surface of the painting. Instead of establishing the illusion of distant background space, El Greco flattens the landscape and sky into overlapping screens. The flamelike forms who frame the scene contrast markedly with the abrupt, angular diagonals of the sprawling figures in the center. The pale, insubstantial bodies, raked by a cold, "quivering stormlight,"[7] are set against a dark backdrop or silhouetted against vaporous black outlines. The resulting tonal contrast thrusts the figures forward and renders them two-dimensional, an illusion that is further enhanced by the play of flickering shadows and highlights across the bodies that serve not so much to model the figures as to enliven the surface of the work. El Greco masterfully conveys the turbulent drama of the story through his treatment of the figures and the darkened sky and portentous clouds, which descend to earth as if poised to engage the contorted forms, reflecting the terrible divine wrath visited upon them.

Many hypotheses have been put forward concerning the genesis of El Greco's *Laocoön* and its iconological context. The work may have been painted at the request of a client, perhaps a member of the circle of humanists with whom the artist associated in Toledo. No other mythological subject by El Greco survives, which suggests that it was a commissioned work or at least that there were probably unusual circumstances behind its creation. The probable presence of this painting—and two other versions of the same theme —among the possessions listed in the inventory of the El Greco's estate may indicate that it was not executed for a specific patron, or, possibly, that the patron refused the work. It is also possible that the artist painted the *Laocoön* for himself alone. We know that El Greco was a learned man and was part of humanist circles in Rome and Toledo and that he possessed an extensive library and wrote theoretical treatises on art.[8] The theme of Laocoön's death was only rarely illustrated in art,[9] although it was dramatically brought to the attention of the art world following the discovery in Rome in 1506 of the celebrated ancient marble group representing the death of Laocoön and his two sons (*fig. 2*). El Greco must have known this sculpture firsthand, since he had incorporated motifs from it in some of his earlier pictures.[10] Yet it seems unlikely that his *Laocoön* was painted merely as an homage to the ancient work. Although the latter influenced the painting—not least in the surface rhythm generated in the marble by the frieze-like presentation of the figures—the Kress picture represents an unprecedented and idiosyncratic interpretation of the subject.[11] Eisler makes the compelling suggestion that the painting may also represent El Greco's response to the Renaissance theoretical debate over the relative merits

fig. 2

Agesandros, Polydoros, and Athenodoros of Rhodes. *Laocoön and His Sons*. Probably 1st century A.D. Marble, height 84 in. (210 cm). Vatican Museums, Rome

of painting and sculpture. Citing the artist's self-declared superiority over Michelangelo, Eisler writes, "El Greco could have meant his canvas as a triumph of painting over the sculpture of antiquity and the Renaissance."[12]

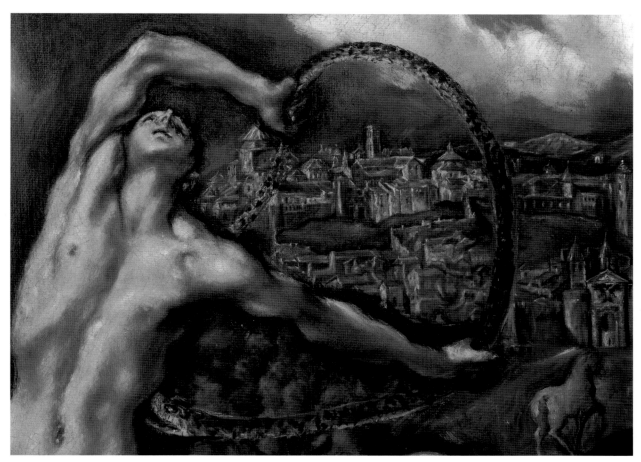

fig. 3 El Greco. *The Death of Laocoön and His Sons* (detail of cat. 9)

The story of Laocoön could also have had a particular iconological meaning for the artist or the work's patron. The fact that El Greco set the scene against the backdrop of Toledo (*fig. 3*) rather than Troy argues strongly in favor of a direct connection between the subject of the painting and the city that was the artist's adopted home for nearly forty years.[13] Some scholars have pointed to contemporary religious events in Toledo, which was the most powerful archdiocese in Spain at the time, as a possible source for the genesis of the painting. Waterhouse thought that the painting may have referred to a conflict between conservative and progressive ecclesiastical factions in Toledo, and that Laocoön and his sons represented elements within the Toledan Church who warned against the reforms sweeping through the Catholic church.[14]

A pre-Virgilian account of the story and ancient commentaries of the *Aeneid* have also been proposed as sources for the painting. In 1908 Cossío suggested that El Greco based his work on an earlier version of the story by Arctinus of Miletus.[15] Arctinus wrote that Laocoön was a priest of Apollo, who demanded that those in his service remain chaste, and that Laocoön's death was a punishment for his having married and fathered children. Eisler proposes that El Greco could have known the ancient commentaries on the *Aeneid* by Hyginus and Servius, who also cited Apollo's displeasure at Laocoön's failure to remain chaste as the reason for the death of the priest and his sons.[16] These non-Virgilian versions of the Laocoön story could have provided an ancient precedent for the Counter-Reformation Church's insistence that the clergy adhere to their vows of chastity. In the eyes of the Church, the failure of priests to submit to its authority weakened its defense against the corrupting influence of Protestant beliefs.[17]

Many writers have suggested that El Greco painted Laocoön as a Christian martyr in classical guise; to one, the expression on Laocoön's face represents his final appeal to God and his confidence in divine mercy.[18] In the context of this interpretation, it is worth noting that while the head of Laocoön (*fig. 4*) is clearly indebted to the Vatican sculpture (*fig. 2*), his expressive features relate more closely to those of El Greco's *Saint Peter in Tears* (Nasjonalgalleriet, Oslo).[19]

The circumstances surrounding the painting's purchase by the Kress Foundation are noteworthy.[20] The *Laocoön* marked a watershed in the acquisition strategy of the foundation under the leadership of Rush Kress, who succeeded

fig. 4 El Greco. *The Death of Laocoön and His Sons* (detail of cat. 9)

his brother in 1946. Moving beyond Samuel Kress's original goal of collecting a representative example of the work of every important Italian artist, the foundation redirected its considerable resources toward broadening the collection through the acquisition of masterpieces by Dutch, Flemish, French, German, and Spanish artists as well. The *Laocoön* was Rush Kress's first purchase. It had belonged to Prince Paul of Yugoslavia, at the time a prisoner of the British in South Africa, who had sent the painting to Washington for safekeeping during World War II. Realizing that the prince's unfortunate circumstances might have left him financially pressed, John Walker, the curator of the National Gallery of Art, advised Kress that the situation presented a unique opportunity for the foundation to acquire one of the most important works of art still in private hands. The director of the National Gallery of Art, David Finley, cabled the prince, received an affirmative answer, and El Greco's masterpiece was secured for the National Gallery's Kress Collection.

D.S.

1. Three paintings depicting Laocoön, one large and two small, were listed in the 1614 inventory of El Greco's estate. They were recorded also in the 1621 inventory of the artist's son Jorge Manuel. It generally is believed that the Kress painting was one of the smaller versions; the other two paintings have been lost. See Brown and Mann 1990, 64 nn. 1, 2.

2. An exhaustive list of bibliographic references appears in Brown and Mann 1990, 66–67.

3. When the *Laocoön* was cleaned in 1955, overpainting added after El Greco's death (see *fig. 1*) was removed, revealing the third head and an additional leg that are visible today. These additions were generally interpreted as reflecting an alternative pose of the female figure who turns away from the horrific scene, or possibly a third figure, but it was plausibly suggested (in Lafuente Ferrari and Pita Andrade 1972) that the additions instead indicated the original position of the male figure, which has a similar profile.

The Kress painting might have been a study for one of the larger versions described in the 1614 and 1621 inventories (see n. 1 above), and the artist may have put the present work aside when he had resolved the complex composition to his satisfaction. The disconcerting extra appendages would have been painted out before the *Laocoön* was sold as a finished work.

4. *Aeneid*, II, 40–53 (Virgil/Fitzgerald 1981, 34–35):

> Next thing we knew, in front of everyone,
> Laocoön with a great company
> Came furiously running from the Height,
> And still far off cried out: "O my poor people,
> Men of Troy, what madness has come over you?
> Can you believe the enemy truly gone?
> A gift from the Dannaans, and no ruse?
> Is that Ulysses' way, as you have known him?
> Achaeans must be hiding in this timber,
> Or it was built to butt against our walls,
> Peer over them into our houses, pelt
> The city from the sky. Some crookedness
> Is in this thing. Have no faith in the horse!
> Whatever it is, even when Greeks bring gifts
> I fear them, gifts and all."
> He broke off then
> And rifled his big spear with all his might
> Against the horse's flank, the curve of belly.
> It stuck there trembling, and the rounded hull
> Reverberated groaning at the blow.

5. *Aeneid*, II, 199–234 (Virgil/Fitzgerald 1981, 40–41):

> And now another sign, more fearful still,
> Broke on our blind miserable people,
> Filling us all with dread. Laocoön,
> Acting as Neptune's priest that day by lot,
> Was on the point of putting to the knife
> A massive bull before the appointed altar,
> When ah—look there!
> From Tenedos, on the calm sea, twin snakes—
> I shiver to recall it—endlessly
> Coiling, uncoiling, swam abreast for shore,
> Their underbellies showing as their crests
> Reared red as blood above the swell; behind
> They glided with great undulating backs.
> Now came the sound of thrashed seawater foaming;
> Now they were on dry land, and we could see

Their burning eyes, fiery and suffused with blood,
Their tongues a-flicker out of hissing maws.
We scattered, pale with fright. But straight ahead
They slid until they reached Laocoön.
Each snake enveloped one of his two boys.
Twining about and feeding on the body.
Next they ensnared the man as he ran up
With weapons: coils like cables looped and bound him
Twice round the middle; twice about his throat
They whipped their back-scales, and their heads towered,
While with both hands he fought to break the knots,
Drenched in slime, his head-bands black with venom,
Sending to heaven his appalling cries
Like a slashed bull escaping from an altar,
The fumbled axe shrugged off. The pair of snakes
Now flowed away and made for the highest shrines,
The citadel of pitiless Minerva,
Where coiling they took cover at her feet
Under the rondure of her shield. New terrors
Ran in the shaken crowd: the word went round
Laocoön had paid, and rightfully,
For profanation of the sacred hulk
With his offending spear hurled at its flank.
"The offering must be hauled to its true home,"
They clamored. "Votive prayers to the goddess
Must be said there!"
So we breached the walls
And laid the city open.

6. For a summary of the various identifications of these figures that have been proposed by scholars, see Madrid 1982–83, 257; and Brown and Mann 1990, 61–62, 65 nn. 28–32.

7. Goldscheider 1938, 16.

8. Wethey 1962, I, 4; Brown, in Madrid 1982–83, 110.

9. Pigler (1956, II, 34) records only fourteen paintings and drawings of the subject dating from the late fifteenth to the late eighteenth century.

10. Kitaura (1986, 85–91) mentions earlier paintings by El Greco that include borrowings from the *Laocoön* sculpture. Eisler (1977, 196) also noted that the sculpture was studied carefully by Venetian painters and sculptors with whose works El Greco would have been familiar.

11. Förster 1906, 175; Brown and Mann 1990, 62, 65 n. 34. Other possible stylistic sources for the painting, aside from the marble *Laocoön*, are discussed by Eisler (1977, 196–97); Brown, in Madrid 1982–83, 257; and Moffitt (1984, 46–49).

12. Eisler 1977, 197.

13. Another possible explanation for El Greco's substitution of Toledo for Troy was raised by Davies (1976, 16), who notes an old Spanish legend that the city of Toledo had been founded by two descendants of the Trojans, Telemon and Brutus.

14. Waterhouse 1972, 114. Davies (1976, 16) suggested that the painting was commissioned in homage to Bartolomé Carranza de Miranda, the reformist sixteenth-century archbishop of Toledo who died in 1576 after having been imprisoned by the Inquisition for seventeen years on charges of espousing heretical ideas in his writings.

For a discussion of Toledo's ecclesiastical preeminence in sixteenth- and seventeenth-century Spain and its important role in the dissemination of the Counter-Reformation doctrines of the Council of Trent, see Richard Kagan's essay, "The Toledo of El Greco," in Madrid 1982–83, 35–73, esp. 52–61.

15. Cossío 1908/1972, 357–63; Eisler 1977, 198–99.

16. Eisler 1977, 196.

17. Carranza (see n. 14 above) himself wrote that a priest's failure to remain chaste was a sacrilege and strongly urged that transgressors be punished with death. See Brown and Mann 1990, 61.

18. Camón Aznar 1950/1970, II, 920–24. Ironically, sixteenth-century art theorists had recommended that the *Laocoön* sculpture be used as a model for depicting the sufferings of Christ and Christian martyrs; see Kehrer 1939, 103–4; and Moffitt 1984, 44–60.

19. The *Saint Peter in Tears*, painted about the same time as the *Laocoön*, is illustrated in Wethey 1962, I, pl. 313. Several writers have also noted the similarity between Laocoön's features and those of the contemporaneous *Saint Peter* in the sacristy of the Escorial (Wethey 1962, I, pls. 3, 4).

20. The account given here is derived from Walker 1974, 144–46.

JUAN PANTOJA DE LA CRUZ

Valladolid 1553–1608 Madrid

Born in Valladolid in 1553, Pantoja studied with one of Philip II's court painters, Alonso Sánchez Coello, best known for his elegant portraits of the royal family. Pantoja is assumed to have succeeded his teacher as court painter to Philip II after Sánchez Coello's death in 1588, but his first documented paintings for the court date from 1596, leaving an eight-year period in some obscurity.[3] After Philip II's death in 1598 the artist retained his position under Philip III, whom he served until his own death in 1608. Most of Pantoja's efforts were devoted to painting formal state portraits of the monarchs and their family, for export to other European courts, primarily in England and Flanders. Dynastic concerns were also behind the creation of some unusual and seemingly intimate portraits, including the visibly pregnant Queen Margaret and posthumous depictions of her daughter Maria, who died in infancy, all done in 1603. Besides court portraiture, for which he is best known, Pantoja's other duties included drawing up an inventory and appraising the art collection of Philip II, restoring paintings that had been damaged in the fire of the royal palace El Pardo in 1604 as well as making copies of those that had been ruined, and creating heraldic decorations. As a court artist he was expected to leave his home in Madrid and follow the court when necessary. In the years 1602 to 1606 Pantoja was variously in Madrid, Valladolid (where the court was centered until 1606), Lerma, and the royal monastery at El Escorial. A number of religious subjects by Pantoja survive, some of which incorporate royal portraits among the principal participants.[4] He also painted pictures for private clients.

Within the Spanish tradition of court portraiture, Pantoja's many depictions of the royal family occupy an interesting place between the closely observed likenesses by his predecessors Antonis Mor and Sánchez Coello and the loosely painted, psychologically penetrating portraits by Diego Velázquez that dominated the field from 1623 until his death in 1660. Pantoja's paintings stylize portraiture of the previous generation, presenting sharp silhouettes of figures that contrast strongly with the plain backgrounds against which they are set. His flat, abstract style complements the stiff fashions of the Spanish court, which were designed to display wealth and magnificence rather than the human form beneath the garments. Art historians have traditionally viewed Pantoja's

10

*Margaret of Austria,
Queen of Spain*

———◦◦◦◦———

1605
Oil on canvas, 80⅛ x 40⅛ in.
(205.2 x 101.9 cm)
Signed at lower left: *Ju^es Pantoja de la ✝.
Facieba[t] Vallesolito 16[0]5*
The Museum of Fine Arts, Houston 61.66

PROVENANCE

Commissioned by Margaret of Austria, given to Don Antonio de Toledo, Count of Alba, along with portrait of King Philip III, after November 25, 1604 (possibly);[1] John Stuart, 6th Earl of Darnley (d. 1896), Cobham Hall, by 1854–96; by descent to Edward Henry Stuart, 7th Earl (d. 1900), 1896–1900; by descent to Ivo Francis Walter, 8th Earl (d. 1927), 1900–1925; his sale, Christie's, London, May 1, 1925, lot no. 14; with Colnaghi, London, 1925; with M. Knoedler & Co., New York, 1925; Otto Kahn, New York, 1925–49; with Duveen Brothers, London, 1949; Samuel H. Kress Foundation, New York, 1949 (K1662); on loan to The Museum of Fine Arts, Houston, 1953–61; gift of the Kress Foundation to The Museum of Fine Arts, Houston, 1961.[2]

SELECTED REFERENCES

Kubler and Soria 1959, 207; Kusche 1964, 153 no. 22; Eisler 1977, 202–3; Shackelford and Vaughn 1987, 6.

106

PANTOJA, *Margaret of Austria, Queen of Spain*

formulaic portraits as apt expressions of the negative qualities of Philip III's twenty-three-year reign, which had no examples of lasting artistic splendor comparable to those of either his father Philip II or his son Philip IV. During his lifetime, however, Pantoja was celebrated as a master illusionist, able to "breathe life and soul into a mute face," according to the great court poet Lope de Vega.[5] After Pantoja's death, Lope classified him and his recently deceased contemporaries Carducho and Caravajal with Apelles, Zeuxis, and "Cleoneo," classical artists of legendary renown.[6]

Kusche has identified the Kress painting as one of a pair that was finished by November 1604. In his records of orders from the queen, Pantoja described two portraits as follows: "And on 25 November 1604 two full-length portraits of the King and Queen, our majesties, the King in armor and with white stockings and with a baton in his hand and Her Majesty with a white dress, bonnet, jewels and table. Her Majesty had them made for Don Antonio de Toledo, Count of Alba de Aliste, to whom I delivered them in Valladolid. I have a receipt for it. 2,200 reales."[7] Kusche published as the pendant a painting of approximately the same size in the Banco de España, London (*fig. 1*), showing Philip III and conforming to the artist's written description. Both paintings had been part of the Darnley Collection and were first separated when the Houston painting was sold in 1925.[8]

While the images match the written description, the dates on the paintings do not agree with Pantoja's account. The date on the portrait of Philip III is 1605: according to Pantoja's own record, he delivered the two portraits by November 25, 1604. Kusche appears to believe that the two are the pendants mentioned in the document, but she does not come to terms with the discrepancies between the dates.[9] In the Houston painting, the date, which is abraded and difficult to read, has variously been read as "1604" (Kusche and Eisler) and "1606" (curatorial files at Houston). Although the third digit is missing, the final digit conforms to an early-sixteenth-century "5," and it is safe to assume that the date is 1605. Two other full-length portraits of King Philip published by Kusche show him in the same type of costume described in Pantoja's entry: armor, white stockings, and carrying a baton.[10] Nor is the written description of Margaret's costume so specific as to be decisive. It remains a possibility that the Darnley portraits, certainly a pair, are indeed the paintings described in the document quoted above; but they may also belong to a group of royal portraits by Pantoja that do not correspond to any published documentary source.[11]

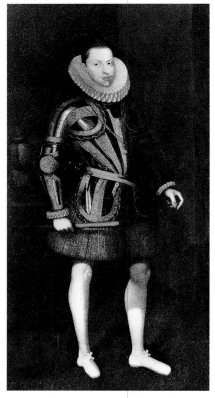

fig. 1

Juan Pantoja de la Cruz. *Philip III of Spain*. 1605. Oil on canvas, 82 11/16 x 39 3/8 in. (210 x 100 cm). Banco de España, London

Margaret of Austria (1584–1611) was the daughter of the Archduke Charles of Inner Austria and Mary of Bavaria. She married her distant relative Philip III in 1598, the year he became king. By her death at the age of 27, Margaret had given birth to eight children, of whom five survived to adulthood; her third child, born in 1605, would become Philip IV. As painted by Pantoja, her full lips and prominent jaw are unmistakable Habsburg characteristics; the face, however, is effectively overwhelmed by her stiffly erect figure, shown full-length and displaying the severe splendor of Spanish royal dress.

Spanish courtly fashion remained virtually unchanged from the mid-1550s to the end of the reign of Philip III, in 1621.[12] Both men and women were encased in stiff, heavily

embroidered materials, adorned with an array of jewels and jeweled fasteners. Here Margaret wears a white damask *saya entera*, the one-piece dress with tightly fitted bodice

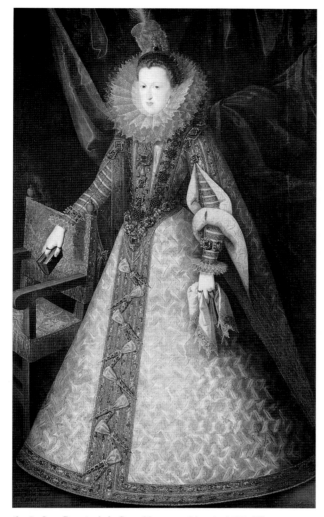

fig. 2 Juan Pantoja de la Cruz. *Margaret of Austria*. 1606. Oil on canvas, 80⁹⁄₁₆ x 48 in. (204 x 122 cm). Museo del Prado, Madrid

and full skirt that was the basic feminine garment. The rounded sleeves (*mangas redondas*) are slit at the elbow to expose closely fitting, embroidered undersleeves trimmed with lace. At her throat is a cartwheel ruff, which had become fashionable in the 1590s. It is so heavily starched that it pushes forward Margaret's heavy pearl earring, and the ruff's sheer, spiky edges contrast with the milky solidity of the queen's face. She also wears a jeweled diadem topped with white plumes (the same headdress appears in *fig. 2*). The queen's bodice and epaulets are studded with clusters of jewels, and she wears a heavy belt encrusted with pearls and cut gems. Suspended above a double strand of pearls is a large pendant known as the *joyel rico* or the *joyel de los Austrias*, which is frequently seen in portraits of Margaret.[13]

Visible on her left sleeve and running down the front of her skirt are jeweled clasps called *puntas*, made of gold and tied with ribbons. Margaret's ungloved hands are adorned with rings.

Pantoja's full-length portrait of Queen Margaret dated 1606, now in the Prado (*fig. 2*), closely resembles the Houston portrait. The Prado picture has a greater sense of space, however, as the artist placed the queen before billowing drapery and turned her chair at an angle to the picture plane. In the Houston painting the effect is of unrelieved flatness: the cloth-covered table is placed parallel to the picture surface so that it does not animate the space but instead contributes to a sense of overall pattern. Although the queen is seen at a three-quarter angle, her stiff costume flattens the figure and we read a silhouette rather than a turning, three-dimensional form.

While the impulse to abstraction is heightened by the conventional appearance of Spanish formal costume, this type of ritualized state portrait, where the brief flicker of an individualized face is subordinated to the trappings of wealth and power, was an international fashion in the sixteenth century. From Lucas Cranach the Elder to Hans Holbein the Younger, from Titian to Antonis Mor, artists worked with a relatively inflexible full-length model to portray courtly personages all over Europe.[14] In the case of Spanish portraiture, it would take the arrival of as decisive and original a personality as Peter Paul Rubens to change the expectations of a noble portrait. His visit to Spain in 1603–4 introduced artists and patrons to a new dynamism and an integration of sitter, costume, and setting that heralded an important departure in Spanish portraiture (see cat. 11). It has been suggested that in his last years Pantoja himself was influenced by Rubens;[15] however, no sign of outside influence is apparent in this portrait, which is still closely bound to conventions of Spanish court portraiture.

Kusche calls the Houston painting "probably the most beautiful portrait of Margaret."[16] Eisler, on the other hand, suggests the possibility of workshop participation.[17] The surface of the painting is abraded; glazes on the red tablecloth are missing, and the damask pattern in Margaret's white dress has largely been lost. These signs of wear, along with an old lining, exaggerate the effect of flatness and may have contributed to Eisler's negative assessment.

C.I.

I am very grateful to Sarah Schroth for her comments on an early draft of this entry.

1. See discussion at the beginning of this cat. entry.

2. Information supplied by the Getty Art History Information Program, the Provenance Index, in curatorial file, The Museum of Fine Arts, Houston.

3. Kusche 1964, 25–26. Pantoja did paint some portraits of noble sitters in 1593 and 1599; see Kusche 1964, nos. 27, 28, 36, 37.

4. His *Annunciation* of c. 1605 shows Queen Margaret as the Virgin and her daughter Anne in the guise of the angel Gabriel; illustrated in Madrid 1990, 39. In 1603 Pantoja painted a *Birth of the Virgin* with Margaret's mother, Maria of Bavaria, as one of the figures bathing the newborn; she is attended by two of her daughters; illustrated in Madrid 1990, 40.

5. "Juan de la Cruz que si criar no pudo/Dió casi vida y alma a un rostro mudo." Lope de Vega, "Hermosura de Angelica," 1602, reprinted in Kusche 1964, 9. Compare with Lope's remarks about Juan van der Hamen y León, cat. 18.

6. "Al pie de un lauro tres sepulcros veo/Apeles yace aqui, Zeuxis, Cleoneo/Juan de la Cruz, Caravajal, Carducho/murieron ya, que fúnebre trofeo/muerte cruel más no te alabes mucho." Lope de Vega, prologue to "Viaje del alma," reprinted in Kusche 1964, 10. While Apelles and Zeuxis are familiar names, "Cleoneo" probably refers to the vase painter of the fifth century B.C., Cimon of Cleonae.

7. "Más, en 25 de nobiembre de 1604, dos retratos enteros del Rey y Reyna Nuestros Señores, el Rey armado y calças blancas, con vn bastón en la mano y Su Magestad con saya entera blanca, gorra y joyas y bufete; que Su Magestad mandó hacer para don Antonio de Toledo, Conde de Alba de Aliste a quien los entregué en Valladolid y tengo certificación dello—2U200 reales"; see Kusche 1964, 238. The document was originally published by R. de Aguirre, *Boletín de la Sociedad Española de Excursiones* 30 (1922): 17–22.

8. According to records at the Getty Provenance Index, the portrait of Philip III was first sold from the Darnley Collection at Sotheby's, London, on July 22, 1957 (lot no. 351).

9. She writes, "The question is whether the picture of Philip III, which hung together with the picture of Margaret [Houston] in Cobham Hall, is, despite the obvious old signature 1605, the original pendant" and then dates the painting "1604 or 1605" (Kusche 1964, 146). Not having seen the portrait of Philip, it is impossible for me to judge how accurately Kusche read the inscription.

10. See Kusche 1964, pls. 6, 8.

11. See, for example, Kusche 1964, nos. 6, 7, 10, 20, 24, 25.

12. For a useful summary of Spanish royal costume during this period see Carmen Bernis, "La Moda en la España de Felipe II a través del Retrato de Corte," in Madrid 1990, 65–111.

13. The pendant, created for the royal family at the beginning of the seventeenth century, was made up of a squared diamond called the "Estanque," and a 58½-carat pearl known as the "Peregrina" (Muller 1972, 52–53). Pantoja depicted the splendid jewel more than once in official portraits of the queen and may have created a detailed preparatory study of it to keep on hand; in the inventory of his possessions at his death

were two canvas paintings showing only jewels (Kusche 1964, 261, and Muller 1972, 54). In 1972 a pearl believed to be the Peregrina was in the collection of Elizabeth Taylor (Muller 1972, 178–79).

14. Campbell (1990) addresses some of these issues in his interesting account of European portrait types during the Renaissance.

15. Brown 1991, 97.

16. Kusche 1964, 77.

17. Eisler 1977, 203. Soria (in Kubler and Soria 1959, 207) does not discuss the quality of the Houston picture but does state that the portrait of Queen Margaret at Buckingham Palace was the best of the full-length

PETER PAUL RUBENS

Siegen 1577–1640 Antwerp

Peter Paul Rubens was born in Siegen, near Cologne. As a Calvinist, his father, a prominent jurist and alderman, had been forced in 1568 to uproot his family and flee the Catholic city of Antwerp. After his father's death in 1587, his mother took the family back to Antwerp, where Peter Paul received a brief education, learning Latin and some Greek and acquiring a lifelong enthusiasm for classical literature. Rubens received his artistic training from Antwerp painters Tobias Verhaecht, Adam van Noort, and Otto van Veen and became a member of the Antwerp Guild of Saint Luke in 1598. In 1600 the young artist went to Italy, stopping first in Venice, where he saw paintings by Titian (see cat. 2), Veronese (see cat. 4), and Jacopo Tintoretto, all of whom remained important influences on him. Soon after, he became attached to the court of the Duke of Mantua, Vincenzo Gonzaga, in whose service he remained for eight years. During that time Rubens traveled to Florence and Rome, where he copied ancient sculpture and paintings in masterly drawings for his own pleasure and for incorporation into later projects. In 1603 Rubens was sent to the court of Philip III of Spain on the first of many diplomatic missions in the service of his patron. He impressed the king's favorite, the Duke of Lerma, with a brilliant equestrian portrait (Prado, Madrid) but turned down the duke's offer to become court painter. Returning to Italy in early 1604, the artist spent the next years in Mantua, Venice, and Rome, undertaking commissions for the Gonzaga family and for ecclesiastic patrons. In 1606 he accompanied the Duke of Mantua to the cosmopolitan port city of Genoa, which impressed him with its stately domestic architecture and provided him with numerous portrait commissions by members of the local aristocracy (cat. 11).

Rubens returned to Antwerp in late 1608, never to revisit the country that had played such an important role in his artistic formation and to which he felt great personal attachment. He was given the title of court painter to the sovereigns of Flanders, the Archduke Albert and the Infanta Isabella Clara Eugenia, an arrangement that left him free to live in Antwerp, away from the court at Brussels, and to accept other commissions. In the decade following his return, Rubens created large altarpieces for several local churches. He also designed a set of tapestries ordered by two Genoese patrons. In order to meet the demand for the many commissions that came to the now-famous artist, Rubens established an extensive studio system. He employed still-life and animal specialists to

11

*Marchesa Brigida
Spinola Doria*

———◦⟋⟋⟋◦———

1606
Oil on canvas, 60 x 38⅞ in. (152.2 x 98.7 cm)
Inscribed on verso: BRIGIDA SPINOLA
DORIA Å Sal. 1606. Aet. svae. 22.
P.P. RUBENS ft.
National Gallery of Art, Washington 1961.9.60
Exhibited in Seattle and San Francisco only

PROVENANCE
Marchese Giacomo Massimiliano Doria (first husband of the sitter), Genoa, 1606; Giovanni Vincenzo Imperiale (second husband of the sitter), Genoa, 1661 (possibly);[1] Francesco Maria Imperiale (stepson and son-in-law of the sitter) (possibly);[2] Rati Opizzone, Turin;[3] General Sir John Murray, Clermont, Fifeshire, Scotland; sold by T. Murray to Sir Thomas Lawrence, London, 1830; Simon Horsin-Déon, Paris, 1848; J. Pariss; sale, Christie's, London, February 4, 1854, lot no. 76 (bought in); with C. J. Nieuwenhuys, London; his sale, Christie's, London, July 17, 1886, lot no. 92, sold to Charles Wertheimer; Bertram W. Currie, Minley Manor, Hampshire; sale, Christie's, London, April 16, 1937, lot no. 116, sold to Goldschmit; with Duveen Brothers, New York, by 1953; Samuel H. Kress Foundation, New York, 1957 (K2187); gift of the Kress Foundation to the National Gallery of Art, 1961.

SELECTED EXHIBITIONS
London 1950, no. 55; London 1953–54, no. 180; Washington 1961–62, no. 81; Antwerp 1977, no. 7; Cologne 1977, I, no. 91; Sarasota 1980–81, no. 60; Padua 1990, no. 23; Boston 1993–94, no. 8.

SELECTED REFERENCES
Horsin-Déon 1851, 34, 35; Rooses 1886–92, IV, 273 no. 1064, and V, 350; Bauch 1924, 190; Burchard 1929, 321–24; Valentiner 1946, 155 no. 5; Goris and Held 1947, 26 no. 2; Seymour 1961, 144, 215; Müller Hofstede 1965, 94–96, 110–11, 139, 141, 142; Jaffé 1969, 26; Eisler 1977, 101–3; Huemer 1977, 35–39, 169–72; Jaffé 1977, 76; Biaviati 1977–78, 150–52, 153; Washington 1985–86, 559; Washington 1990–91, 174, 176.

111

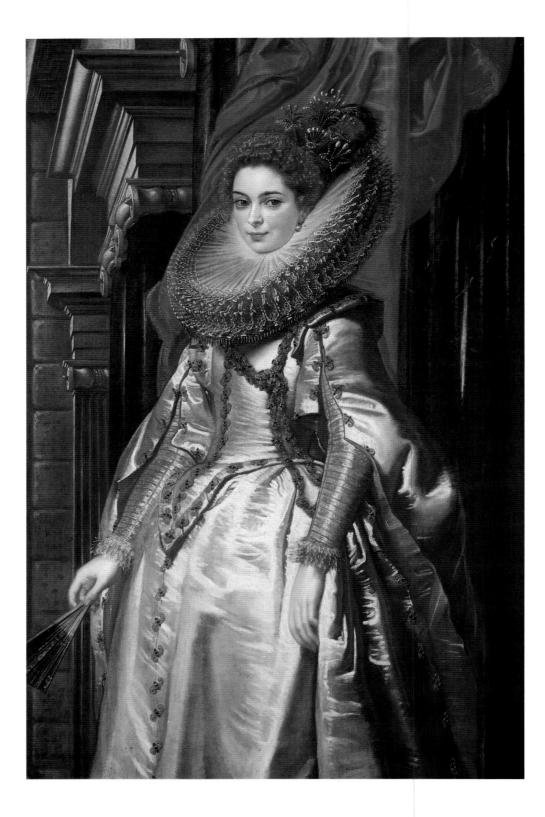

RUBENS, *Marchesa Brigida Spinola Doria*

insert appropriate details while he executed the figures and setting. In addition the work-
shop was often given the task of executing final compositions based on Rubens's prelimi-
nary drawings or grisaille panels and colored oil sketches. This efficient solution meant
that in 1620 Rubens could take on the ambitious project of decorating the Jesuit church in
Antwerp (cat. 12), which called for thirty-nine large ceiling paintings, and deliver the fin-
ished works in less than one year, a feat well beyond the powers of an artist working alone.

The next years brought numerous important international commis-
sions, particularly a cycle of paintings commissioned by Maria de' Medici in France, tapestry
designs for Isabella Clara Eugenia, and ceiling decorations for the Banqueting House
at Whitehall for Charles I of England. Rubens's court duties ended with the death of the
infanta in 1633, but he continued to paint for himself and for an international clientele
until his death in 1640.

The quintessential "noble artist," Rubens was admired in his lifetime
as much for his erudition and personal grace as for his artistic skill. As a painter, he demon-
strated a versatility and ingenuity when treating varied subject matter—religious and
classical themes, allegories, portraits, landscapes—that elevated his chosen profession.
His closest follower was his gifted pupil Anthony van Dyck (see cat. 13), but because of the
international scope of activity throughout Rubens's career his impact also continued to
be felt long after his death in many parts of Europe, including Spain, England, and
France. His paintings enjoyed an especially potent revival among such eighteenth-century
French masters as Fragonard and Watteau (see cat. 36).

During the early part of his eight-year Italian sojourn, Rubens primarily painted large religious altarpieces with multifigured compositions, establishing himself as the equal of his Italian colleagues in *invenzione*. In Genoa, however, where he spent the year 1606–7, he received a different challenge: portrait commissions from leading Genoese families, of which a reasonable number still exist.[4] The *Marchesa Brigida Spinola Doria* is the only surviving portrait from this period to depict a standing female figure. The young woman stands erect, her body facing left but her face turned toward the viewer. She wears a heavy satin dress that shimmers under the strong light. The huge cartwheel ruff sets off her pearly face and fine curls of reddish hair, adorned with a plumed ornament set with pearls. Looming behind her are the massive architectural forms of an imposing early Baroque facade, their severity broken by a cascade of swirling red drapery that sets off the glowing figure of the sitter.

The painting was cut down on all sides in the second half of the nineteenth century, but Rubens's original composition survives in several forms: a lithograph published in 1848 that records the original inscription and date,[5] an original preparatory drawing, and a drawing by an unknown artist that was copied after a more finished working sketch by Rubens. Rubens's own preliminary sketch (*fig. 1*), which used a stand-in for the marchesa, established the basic composition, depicting the young woman on the porch of a steeply foreshortened villa. At the lower left a low balustrade supports a potted plant and provides a distant view of foliage. Rubens's color notations for the drapery behind the figure and other details are evident.[6]

In the next working drawing (*fig. 2*), Rubens more closely integrated figure and setting by extending the space in front of the figure (a second model was used) and by pushing the balustrade farther into the background.[7] Now the figure

stands firmly within the setting, decorously aloof from the viewer. This adjustment was retained in the final version, recorded in the 1848 print (*fig. 3*), which also includes a rainbow in the sky. In its current reduced state, the Doria

fig. 1

Peter Paul Rubens. Study for *Marchesa Brigida Spinola Doria*. c. 1606. Pen and wash over black chalk on paper, 12⅜ x 7¼ in. (315 x 185 mm). Pierpont Morgan Library, New York

portrait is probably more intimate than the artist intended. The solidity of the architecture is unrelieved even by a sliver of sky. Originally one-quarter taller and wider than it is now, the portrait would have been spectacularly rich and imposing, with the dignified effect softened only by the pliant smile of the young marchesa.

The portrait as originally designed signals a dramatic departure from the fifty-year-old dominant type of European court portraiture (see cat. 10), which Rubens knew

fig. 2

Anonymous copy, after Peter Paul Rubens. Study for *Marchesa Brigida Spinola Doria*. c. 1606. Brush drawing on paper, 13⅜ x 7⁷⁄₁₆ in. (345 x 189 mm). École des Beaux-Arts, Paris

well through Venetian art, his fellow court painter at Mantua, the portraitist Frans Pourbus the Younger, and his encounter with Spanish court painting in 1603. Innovations are numerous. The female figure, traditionally shown in an interior setting, here holds her own outside, standing before an imposing facade. While Rubens has not abandoned one of the primary aims of court portraiture—to display the opulence and richness of the sitter's garments—he has not sacrificed the individuality of the person who inhabits the magnificent dress. The face of Brigida Spinola Doria is alert and lively, not an impervious mask; and it is easy to imagine a living body breathing within the dress, whose basic design is not markedly distinct from the one seen in Pantoja's portrait (see cat. 10) but whose effect could not be more different.

Rubens was greatly taken with Genoese domestic architecture and illustrated a book, *Palazzi di Genova*, published in Antwerp in 1622. His decision to prominently display an architectural facade within a portrait is less surprising than the way he chose to depict it. Rather than present it frontally,

fig. 3

Pierre Frédéric Lehnert, after Peter Paul Rubens. *Marchesa Brigida Spinola Doria*. 1848. Lithograph

creating a monotonous pattern along the picture surface, he has shown it receding precipitously. This arrangement gives unprecedented dynamism to the relationship between sitter and setting. The tall, stately figure of the marchesa seems almost to be an extension of the marble columns; yet the contrast of her shimmering, rounded form with their cold severity makes her seem all the more lifelike.

Rubens's treatment of light also contributes to the lively interplay between foreground and background. The strong light that casts brilliant, slashing reflections on Brigida

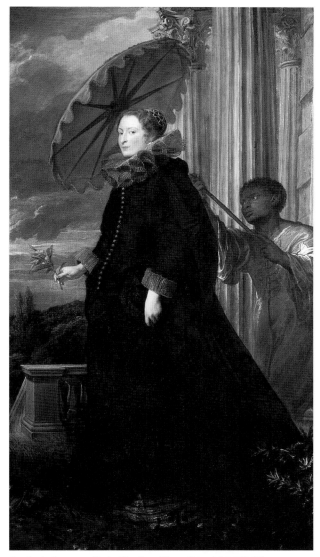

fig. 4 Anthony van Dyck. *Marchesa Elena Grimaldi*. 1623. Oil on canvas, 97 x 68 in. (246 x 173 cm). National Gallery of Art, Washington, Widener Collection

Spinola Doria's silvery dress—reminiscent, as many have pointed out, of the swift brushwork of Tintoretto—also strikes the architecture behind her. The margin of sky that originally showed on the left (*figs. 2, 3*) was filled with billowing, light-struck storm clouds, punctuated by the calming rainbow visible above the urn. Rubens employed a similarly dramatic treatment of the transience of nature's moods in the background of the equestrian portrait of Giovanni Carlo Doria (c. 1606–7, Palazzo Vecchio, Florence).[8]

The impact of Rubens's invention was felt again seventeen years later, when his former assistant Anthony van Dyck was in Genoa and was commissioned to paint a new genera- tion of the city's leading citizens. In a splendid portrait also in the National Gallery of Art (*fig. 4*), Van Dyck posed Marchesa Elena Grimaldi in a way that can only be seen as a quotation of Rubens's Spinola Doria. Consciously emu- lating his former master, Van Dyck sought to surpass him by painting the figure in mid-stride and gracefully breaking free of her environment.[9]

Brigida Spinola Doria, born in Genoa in 1583, married her cousin Giacomo Doria in the summer of 1605, leading to speculation that this picture may have been commissioned to commemorate her marriage, and that it might have had a pendant showing her husband.

C.I.

I am grateful to Marjorie Elizabeth Wieseman for sharing her research on this painting with me.

1. In the 1661 inventory of the collection of Gianvincenzo Imperiale a *"Ritratto de Donna in piedi"* (full-length portrait of a woman) is men- tioned, but unfortunately the description is not precise enough to clearly associate it with the Washington painting.

2. An undated note by W. J. Bankes, published by Michael Jaffé in Washington 1985–86, 559, refers to the Washington painting as being "a present from the head of the Family Imperiali to his (the Chevr's) father- in-law when the Imperiali was quitting the palace in Campetto."

3. The description cited in n. 2 above mentions the painting owned by "Chev Rati Opizzone, conseiller d'Etat à Turin."

4. The two most thorough articles on Rubens's Genoese portraits are Burchard 1929 and Müller Hofstede 1965. Huemer (1977, 35–39, 169–72) discusses them in the context of Rubens's other portraits.

5. The inscription in the lower left corner of the print, "BRIGIDA SPIVOLA DORIA/ANN: SAL: 1606./ÆT.SVÆ.22," may have reproduced an inscription originally on the front of the painting. A similar inscription, with the addition of the artist's name, is found on the reverse.

6. The curtain is labeled *root* (red) and the cornice *hout* (wood), and *gaudt* (gold) is written below the first capital.

7. As Müller Hofstede (1965, 110–11) points out, the drawing clearly follows a preliminary sketch rather than the completed painting; the dress is not fully adorned with the variety of jewels that are found in the finished painting, and the model (who does not share the marchesa's facial features) wears no hair ornament. Held (1959/1986, 78 no. 29) nevertheless believes the drawing is a copy of the finished painting. The drawing was exhibited as an original by Rubens in Cologne 1977, no. 40.

8. In connection with this device, Huemer (1977, 43) cites Rubens's awareness of Stoic philosophy, specifically, the idea of the "constancy of the individual in the face of the storm."

9. Susan Barnes, in Washington 1990–91, 174–76, thoughtfully analyzes the relationship of Van Dyck's portrait to Rubens's model.

PETER PAUL RUBENS

Siegen 1577–1640 Antwerp

This panel, a view of the Last Supper seen from below, was one of Rubens's designs for a series of ceiling paintings for the new Jesuit church in Antwerp. The commission was the artist's first major ceiling project; along with the new church it was powerfully symbolic of Antwerp's turn back toward Catholicism in the early seventeenth century.

Emerging from the religious and social unrest initiated almost a century earlier by the Protestant Reformation, Antwerp became a bastion of Catholic Counter-Reformation thought under Spanish rule. The Catholic Church poured money into construction of churches and commissioned large altarpieces to put a public face on its renewed power. No project was more prominent than the building of a church dedicated to Ignatius of Loyola, founder of the Jesuits, who had not yet been canonized. The new Jesuit church (now Saint Charles Borromeo), built during the second decade of the seventeenth century, was the first important Baroque building in a city steadfastly devoted to the Gothic style. Under the guidance of architect Pieter Huyssens, the building paid tribute to classical and Early Christian architecture and made liberal use of costly marble and gold to achieve an effect of permanence and visual splendor. It is possible that Rubens, Antwerp's leading artist, played a role in designing architectural decoration for the building.[3] By 1618 he had completed two great altarpieces, the *Miracles of Saint Francis Xavier* and the *Miracles of Saint Ignatius of Loyola* (both Kunsthistorisches Museum, Vienna), setting the highest standard of decoration for the magnificent new edifice.

Three years later, as the building was nearing completion, Rubens undertook another significant project for the church: thirty-nine ceiling paintings to be installed on two levels in the side aisles. In a contract dated March 29, 1620, the artist agreed to produce all thirty-nine paintings within less than a year even though the list of subjects had not yet been completed. The contract specified that the actual execution of the ceiling paintings be left to Anthony van Dyck (see cat. 13) and other studio assistants, but that Rubens would supply the original designs in the form of small oil sketches (actually referred to as *kleyne afteekeningen*, or small drawings) and would touch up the finished paintings as deemed necessary. The Seattle painting is one of these sketches. As the only part of the ceiling project by the master's own hand, the sketches would have had unique prestige and value. They served as guides for Rubens's workshop, plans for patron approval, and studio models for future projects.[4] In the case of the Jesuit church, the oil sketches have further significance, constituting the major evidence for the project as a whole, as the church was struck by lightning and suffered a disastrous fire on July 18, 1718. Within a few hours the main body of the church with Rubens's great series was completely destroyed. Today, in reconstructing the appearance of the ceiling paintings, we can consider two drawings, five monochrome oil sketches on panel, twenty-four colored oil sketches, and drawings and engravings made after the finished paintings.[5]

The Last Supper, surprisingly absent from the original list of subjects, was incorporated into the north gallery following the Old Testament story of Abraham and Melchizedek, which the Church viewed as a prefiguration of the Eucharist, the central subject of the

12

The Last Supper

⎯⎯⎯⎯⎯◈⎯⎯⎯⎯⎯

1620
Oil on oak panel, 16⅞ x 17 in.
(43.8 x 44.1 cm)
Seattle Art Museum 61.166

PROVENANCE
Simon de Vos, before June 16, 1662 (possibly);[1] with Guilliam I Forchoudt, Antwerp (possibly);[2] Jacques de Roore, sold with six other *modelli* from series (lot nos. 39–45), The Hague, September 4, 1747, lot no. 45; bought by Anthonis and Stephanus de Groot, sold with six other *modelli* from series (lot nos. 1–7), The Hague, March 20, 1771, lot no. 4; bought by Abelsz.; Jacques Clemens, sold Ghent, June 21, 1779, lot no. 232; Supertini and Platina, sale Brussels, September 19, 1798, lot no. 150 (apparently bought in); Pauwels, sold Brussels, August 25, 1814, lot no. 108; Robert Saint-Victor, sold Paris, November 26, 1822, lot no. 29; bought by Roux; Marquise d'Aoust, sold at Galerie Georges Petit, Paris, June 5, 1924, lot no. 78; Francesco Gentili di Giuseppe, Paris, sold prior to Gentili di Giuseppe sale, Paris, April 23, 1941; with Frederick Mont and Newhouse Galleries, by 1953–54; Samuel H. Kress Foundation, New York (K1997); on loan to Seattle Art Museum, 1954–61; gift of the Kress Foundation to Seattle Art Museum, 1961.

SELECTED EXHIBITIONS
Rotterdam 1953–54, no. 34; Cambridge 1956, no. 32; Washington 1961–62, no. 80; Washington 1983–84, no. 14; New York 1989, no. 33.

SELECTED REFERENCES
Rooses 1886–92, I, 25 no. 8; Puyvelde 1947, 26–28; Jaffé 1954, 54, 57; Seattle 1954, 60–61; Martin 1968, 81–83, 198 no. 8; Held 1980, 35, 36–37, 49–50, 468 no. 22.

RUBENS, *The Last Supper*

Last Supper. Flanking *The Last Supper* on the other side was *Moses in Prayer between Aaron and Hur*, a less common subject also considered to be symbolically associated with the mass.[6] Rubens often enforced these typological associations through formal parallels: for example, the figures of Christ and Saint Peter in the *Last Supper* echo the poses of the protagonists in the *Meeting of Abraham and Melchizedek*.[7]

The story of the Last Supper is recounted in all four Gospels: Christ and his twelve disciples gathered in Jerusalem to celebrate the Jewish feast of the Passover. During the meal Christ announced that one of the twelve would betray him. Then Christ blessed the bread and wine and distributed them among the disciples. Christ's actions and words—"This is my body which is given for you: this do in remembrance of me. . . . This cup is the new testament in my blood, which is given for you" (Luke 22:19, 20)—established the Eucharist, the central sacrament of the Christian Church.

In the Seattle sketch, Christ and his followers are seated in a room with an oculus showing the sky above the heads of the figures.[8] The octagonal shape of the picture compresses the postures of the figures and contributes to the intensity of their interaction. Christ, wearing a brilliant coral mantle

fig. 1 Christian Benjamin Müller, copy after Peter Paul Rubens. *The Last Supper*. Red chalk and gray wash on paper, 7½ x 11⅞ in. (190 x 300 mm). Stedelijk Prentencabinet, Antwerp

over a blue-gray robe, is seated next to John the Evangelist on a rug-draped bench at the right side of the round table.[9] Shown in profile, he leans toward his followers, holding the bread in one hand and the chalice in the other. The six dis-

fig. 2 Peter Paul Rubens. *The Last Supper* (cat. 12, with original margins and showing later addition at top)

ciples facing Christ watch him closely, with Peter, whose straining posture echoes Christ's own, most prominent in a yellow mantle and blue robe. The disciple behind him, in dark green and a white mantle, rises to his feet and lifts a hand to his chest in reaction to Christ's words. On a step below the table is a still life of a large ewer and covered bread basket, a further reminder of the Eucharistic significance of the scene. The emotional responses of the disciples have been interpreted as reactions to Christ's announcement of impending betrayal.[10] However, the absence of Judas and the placement of the final painting between two Old Testament scenes containing Eucharistic symbolism suggest that the responses are to the institution of the Eucharist itself, an emphasis consistent with the prominence of the sacraments in Counter-Reformation thought and practice.[11] In the drawing by Müller after the finished painting (*fig. 1*), we see that the number of disciples was eventually reduced from seven to four.[12] This reduction opens up the pictorial space and permits Christ's right hand to be silhouetted against the background. Rubens thus condensed Christ's last appearance to his twelve disciples into an intense exchange between Jesus and a handful of his followers. As in several of his other ceiling designs for the Jesuit church, the artist sacrifices narrative detail for the sake of thematic clarity.[13]

As noted by Held, Rubens appears to have begun the sketch with the notion that it would follow a square format, since the edges of the ewer and the steps continue into the margins (*fig. 2*).[14] Shortly afterward, however, he added

the oblique lines in the corners to make the composition octagonal and concentrated his efforts within the newly designated border. The swift and dazzling brushwork, already evident in his 1606 portrait of the Marchesa Brigida Spinola Doria (cat. 11), here becomes more fluid, with no sharp edges. As in so many of Rubens's oil sketches, his powerful and convincing illusionism is achieved through the application of paint in layers so thin that the coarse vertical streaks of the ground preparation show through.

C.I.

1. Suggested by Martin 1968, 83. A sketch by Rubens of a Last Supper was sold by Simon de Vos to art dealer Guilliam I Forchoudt, but there is no way of confirming that it was the Seattle sketch.

2. See n. 1 above.

3. Baudouin 1977, 143–55.

4. The contract gave Rubens the option of turning over all thirty-nine oil sketches to the Jesuit Superior upon completion of the project or of executing, with no studio assistance, a painting for one of the four side aisles of the church. Rubens chose the latter alternative. Martin 1968, 38.

5. See Martin 1968, 44–53, for an account of the various copies that were made.

6. The elevation of Moses' arms by Aaron and Hur was likened to the priest's elevation of the host during the mass. Held 1980, 36–37.

7. Martin 1968, 80, 198.

8. Eisler interpreted the setting as faithful to the biblical description of an "upper room" (Mark 14:12–16, Luke 22:7–13); Martin (1968, 80–81) interprets the oculus as a wall window, comparing it with Rubens's earlier treatment of the theme (1614) in the *Missale Romanum*. Rubens's drawing and engraved design for the *Missale Romanum* share the following elements with the Seattle sketch: illumination by oil lamps, a curtain suspended from the ceiling, and the placement of Christ, shown in profile, to one side rather than at the center; see Müller Hofstede 1974, 133–35, fig. 1, pl. 5. Müller Hofstede (followed by Held 1980, 50) also cites the influence of a Last Supper composition by Rubens's teacher Otto van Veen, which includes a round table, an oil lamp chandelier, and a similar still life. Another possible model, using illusionistic foreshortening within a similar setting, is the octagonal ceiling fresco by Giulio Romano for the Palazzo del Te in Mantua, *Psyche Served by Unseen Hands*, which the artist would have known from his time in that city. See Martin 1968, 81; Wheelock in Washington 1983, no. 14. The painting is reproduced in Signorini 1983, 45.

9. Egbert Haverkamp-Begemann, in Rotterdam 1953–54, 59, related the round table to Early Christian practice.

10. Eisler 1977, 107.

11. Judas, identified through his isolated placement and violently troubled facial expression, is clearly indicated in two other *Last Supper* compositions by Rubens (drawing, c. 1614, collection Professor Peter Kröker, Murnau; engraved by Theodoor Galle for the *Missale Romanum*, 1614 [see Müller Hofstede 1974 for a discussion of these works]; and Brera,

Milan, 1631–32; sketches Pushkin Museum, Moscow, and private collection, New York; see Held 1980, 467–69, pls. 334, 335). Emphasis on Eucharistic associations are noted by Martin 1968, 80; Held 1980, 50; and Wheelock, in Washington 1983, no. 14.

12. The same change is evident in drawings by De Wit. See Martin 1968, figs. 50, 51.

13. See, for example, *The Raising of the Cross* (Martin 1968, fig. 62) and *The Ascension of Christ* (Martin 1968, fig. 80).

14. Held 1980, 35. The panel was enlarged at an unknown date, when a strip of 2 11/16 inches was added to the top to make the composition nearly square.

ANTHONY VAN DYCK

Antwerp 1599–1641 London

Anthony van Dyck was born in Antwerp on March 22, 1599, the seventh child of a prosperous Catholic cloth merchant, Frans van Dyck, and his second wife, Maria Cuypers, known for her skill in embroidery. At the age of ten Anthony apprenticed to a local painter, Hendrick van Balen, dean of the Antwerp Guild of Saint Luke. This association was less fruitful for the young artist than his subsequent relationship with Antwerp's leading artist, Peter Paul Rubens (see cats. 11, 12). Scholars once believed that Van Dyck had set up independent practice by 1615–16, but it is more likely that he was a pupil in Rubens's studio at this time.[1] After joining the painters' guild in 1618, he remained with Rubens, who in April 1618 referred to him as "the best of my pupils."[2] After collaborating with Rubens on cartoons and paintings for the Decius Mus tapestry series (1616–18) and executing some of the ceiling paintings from Rubens's designs for the Jesuit church in Antwerp in 1620, Van Dyck traveled to England, where he stayed until February 1621. There he painted commissions for certain members of the court and was paid £100 on February 16, 1621, by King James I as a reward for "special service."[3] Two weeks later Van Dyck left England, armed with a royal travel pass secured for him by the collector the Earl of Arundel.

In the fall of 1621, after a brief stopover in Antwerp, Van Dyck set off for Italy, where he spent the next six years. Though he saw all variety of ancient and contemporary art, it was the paintings of the great Venetian Titian (see cat. 2) that would remain of paramount importance to Van Dyck. Titian's influence hovers behind the poetic feeling, lush colors, and supremely fluid paint handling of Van Dyck's mythological and religious paintings. While in Italy Van Dyck spent most of his time in the port city of Genoa, working for the wealthy clientele who had employed Rubens earlier in the century. Returning to Antwerp in late 1627, Van Dyck became the leading portraitist of the southern Netherlands, helped by his considerably refined artistic skills and by the virtual abandonment of portraiture by Antwerp's leading painters Rubens and Jordaens, who preferred to create more prestigious history paintings. Van Dyck served the Infanta Isabella Clara Eugenia, governor of the southern Netherlands, as court painter from 1630 to her death in December 1633.

In early 1632 Van Dyck returned to London at the invitation of the new king, Charles I, who knighted the artist on July 5 of that year. Van Dyck painted many

13

Queen Henrietta Maria with Sir Jeffrey Hudson

�völgy⟨———⟩

Probably 1633
Oil on canvas, 86 ¼ x 53 ⅛ in.
(219.1 x 134.8 cm)
National Gallery of Art, Washington
1952.5.39
Exhibited in Raleigh and Houston only

PROVENANCE
Earls of Bradford (Newport family); by descent to Thomas, 4th Earl of Bradford (d. 1762); by descent to his sister, Diana, Countess of Mountrath, widow of Algernon Coote of Ireland, 6th Earl of Mountrath; by descent to their son Charles Henry, 7th and last Earl of Mountrath (d. 1802); Joseph Dramer, 1st Earl of Dorchester (d. 1798); by descent to Henry John, 3rd Earl of Portarlington (d. 1889), Emo Park, Queens County, Ireland; by exchange in 1881 to Thomas George, 1st Earl of Northbrook (d. 1867); by descent to Francis George, 2nd Earl of Northbrook, Stratton, Micheldever, Hampshire, until 1927; with Duveen Brothers; bought by William Randolph Hearst, San Simeon, California; with M. Knoedler & Co., New York; Samuel H. Kress Foundation, New York, 1952 (K1911); gift of the Kress Foundation to the National Gallery of Art, 1952.

SELECTED EXHIBITIONS
London 1887, no. 15 or 35; London 1927, no. 146; Detroit 1929, no. 42; San Francisco 1939, no. 92; New York 1941, 29; Berlin 1980, no. 9; Washington 1990–91, 56 no. 67.

SELECTED REFERENCES
Weale 1889, 92 no. 130; Cust 1900, 108, 265 no. 24; Schaeffer 1909, 307; Valentiner 1930, I, 47; Glück 1931, 44; Puyvelde 1950, 172; Washington 1956, 70 no. 24; Vey 1962, 380 no. 206; Jaffé 1965, 43, 46; Eisler 1977, 116–18; Brown 1982, 180; London 1982–83, 21, 22; Larsen 1988, I, 296, 298, II, no. 864; New York 1991, 220.

VAN DYCK, *Queen Henrietta Maria with Sir Jeffrey Hudson*

formal and informal portraits of the king and of Queen Henrietta Maria, and disarmingly
natural observations of their children. His clientele consisted almost wholly of the nobility
and aristocracy, with whom the refined and sophisticated artist was socially at ease.

While Van Dyck's exalted reputation as one of the finest and most in-
fluential portraitists in Europe has never flagged, his religious and mythological subjects
have not been fully appreciated until recently. Indeed, there are indications that toward
the end of the artist's life he would have preferred to undertake ambitious decorative and
historical projects than fulfill the constant demand for portraits.[4] Circumstances and,
finally, illness prevented Van Dyck from realizing these ambitions; he died on December 9,
1641, at the age of forty-two. He left an oeuvre of about nine hundred works of art, and a
rather romantic image of an emotional, high-strung cosmopolitan at home in the glamor-
ous world of the Stuart court before its demise. It can be said with no qualification that he
utterly transformed British portrait painting, his influence seen most potently in the paint-
ings of Lawrence, Lely, and Gainsborough.

Having devised some basic formats for full-length portraiture during his six years in Genoa, Van Dyck approached his English commissions with a repertoire of devices and solutions that would please his clientele and preserve his already established reputation. In contrast to the stiff likenesses of his predecessor as court painter, the Dutch artist Daniel Mytens, Van Dyck portrayed tall, elegant figures capable of graceful, fluid movement and shown against evocative settings.[5] In this portrait of the twenty-four-year-old queen of England, Henrietta Maria, artful manipulation is lightly cloaked under the guise of naturalism. Van Dyck has given the petite queen added stature by elongating her body and by including in the picture Sir Jeffrey Hudson, a dwarf who had been presented to the queen shortly after her marriage to Charles I.[6] Henrietta Maria commands the viewer's attention with her rich blue dress and steady, appealing gaze. As in Van Dyck's Genoese portraits,[7] the stately figure conveys a sense of implied motion: her head is at a slight angle to her body and, with hand poised to lift her skirt, she seems about to step down the stone stair and out of the picture. The energetic figure of Sir Jeffrey Hudson, clad in red velvet and balancing a lively monkey on his left arm, contributes a further animating element.[8] Leaning forward, he seems eager to lead his mistress to more amusing recreations. The lively force of this figure is balanced on the right by solid architectural forms draped with gold brocade, in which the queen's crown is nearly hidden. Henrietta Maria turns away from these reminders of protocol, her informal black hat declaring her leisurely intentions.

Van Dyck characteristically has rendered the other details of setting in neutral tones to emphasize the high-key figures. An unruly plant emerges from the shadows at the bottom right, while a potted orange tree has a prominent position near the head of the queen. Wheelock has suggested that it may be related to Henrietta Maria's interest in gardens, as well as a possible allusion to her patron saint, the Virgin Mary.[9]

Henrietta Maria, the youngest daughter of Henry IV and Maria de' Medici of France, married the Protestant Charles I in 1625 on conditions set forth by the pope: she must be able to keep her Catholic faith, raise her children as Catholics, and be a guardian for Catholics in England.[10] By all accounts the royal marriage was happy and fruitful, with the queen giving birth to six children. Royal portraiture by Van Dyck certainly contributed to the reputation of harmony between the royal couple.[11] The appealing image of demure, porcelain beauty that pervades Van Dyck's portraits of the queen idealized her features to some degree: the king's niece, already familiar with Van Dyck's portraits of the queen, noted with surprise on meeting her for the first time in 1641 that she was "a little woman with long lean arms, crooked shoulders, and teeth protruding from her mouth like guns from a fort."[12]

For all his extraordinary ability to create moving psychological portraits of his sitters, Van Dyck's depictions of the English royal couple are necessarily less revealing. In many paintings of the queen we encounter the same lovely and serene being, her pale visage framed by curled tendrils of

hair, her large eyes gazing at the spectator, and her mouth caught in a half-smile.[13] It has been plausibly suggested by Millar that several images of the queen could be based on a single sitting for Van Dyck, so that the artist could simply change gestures and details of clothing as demanded by the commission.[14] In the case of the queen, whose likeness was consistently idealized, dependence on an artistic formula rather than a live model would have made practical sense.[15]

fig. 1

Anthony van Dyck. *Costume Study for Queen Henrietta Maria with Sir Jeffrey Hudson.* 1633. Black chalk with white chalk highlights and touches of red and blue chalk on blue paper, 16½ x 10⅛ in. (419 x 257 mm). École des Beaux-Arts, Paris

A contemporary account of Van Dyck's typical working day describes an idiosyncratic routine in which the artist would meet numerous sitters every day at his studio for only an hour each. Van Dyck would sketch the face on canvas and draw the figure with black and white chalk on a blue or gray paper.[16] Such a drawing exists for the present painting, a costume study of the sumptuous hunting dress (*fig. 1*). The queen's head and the contours of the plumed hat are barely indicated. The artist has sketched in details of the final composition—curtain, column, Sir Jeffrey Hudson, urn with orange tree—but what clearly interested him was her dress with its shimmering, varied reflections of light. The final painting closely follows the basic design of the drawing; the queen's left hand is prominent in both mediums, touching her dress and creating a bright vertical highlight to vary the shades of blue along the skirt.

At least three double portraits of the queen with Sir Jeffrey Hudson had been commissioned in 1628 from Daniel Mytens for presentation as gifts to friends of the king and queen.[17] In 1633 Van Dyck was paid £40 for a double portrait of the two, which was given by the king to Thomas Wentworth (Wentworth Woodhouse, South Yorkshire).[18] That picture, identical to the Kress painting, was thought to be the primary version until Valentiner pointed out the superi-

ority of the Kress canvas; considering that the Wentworth Woodhouse painting must then be a replica of the Kress picture, scholars have assumed a date of 1633 for both pictures.[19] A later copy also exists, painted by Charles Jervas (1675–1739) and preserved at Petworth.

C.I.

1. See Roland 1984. Van Dyck did, however, sign and date a portrait in the year 1613; see Washington 1990–91, 80 no. 1.

2. Quoted by Millar in London 1982–83, 10.

3. Hookham Carpenter 1844, 9.

4. Millar in London 1982–83, 34–35. See also the sketch for a tapestry showing Charles I and the Knights of the Garter in Procession (Washington 1990–91, no. 102), planned, but not carried out, for the Banqueting House at Whitehall.

5. See Zirka Zaremba Filipczak, "Reflections on Motifs in Van Dyck's Portraits," in Washington 1990–91, 59–68.

6. For Jeffrey Hudson, see Wheelock in Washington 1990–91, 262, 264.

7. See cat. 11, *fig. 4.*

8. The monkey, named "Pug," was owned by the queen and reportedly was Sir Jeffrey Hudson's constant companion (Eisler 1977, 116). Wheelock, in Washington 1990–91, 264, argues for an allegorical meaning of the queen's gesture, symbolizing the restraint of passion.

9. Wheelock in Washington 1990–91, 264–65. The orange tree is a traditional Christian symbol of chastity and purity associated especially with the Virgin Mary, as Eisler points out (1977, 117 n. 2).

10. It has been suggested, most recently by Wheelock, in Washington 1990–91, 248, that Van Dyck's Catholicism would have made it easy for the queen to accept him not only as royal painter but as a social acquaintance.

11. See, for example, the double portrait of Charles I and Henrietta Maria, 1632, Státní Zámek, Kroměříz, the Czech Republic (Washington 1990–91, no. 60).

12. Millar in London 1982–83, 27; Larsen 1988, I, 298.

13. See, for example, Larsen 1988, II, nos. 862, 863, 867.

14. Millar in Washington 1990–91, 56. He compares the depiction of the queen in the Kress portrait with a portrait in the collection of the Earl of Radnor, Longford Castle, Wiltshire (his fig. 8).

15. Exceptions to the formulaic presentation of the queen are the closely observed frontal and profile views painted by Van Dyck to furnish the sculptor Bernini, from whom the queen wanted to order a portrait bust. See Washington 1990–91, no. 82.

16. Description by Everhard Jabach to Roger de Piles, quoted by Christopher Brown in New York 1991, 34–35.

17. Eisler 1977, 116–17; Cust 1911, 86–89.

18. The Van Dyck document was published in Hookham Carpenter 1844, 75–76.

19. See Eisler 1977, 117, for a full account of the two pictures and critical opinions of them.

ORAZIO GENTILESCHI

Pisa 1563–1639 London

Orazio was baptized in Pisa on July 9, 1563. His early training is undocumented beyond the artistic environment of his family (his father, Giovanni Battista Lomi, was a goldsmith, and his brother, Aurelio, was a competent painter). By his own accounts,[1] Orazio arrived in Rome around 1576–78, and there adopted the name Gentileschi from his maternal uncle, a Captain of the Guards at the Castel Sant'Angelo. Orazio's early works, awkward in both conception and execution, are based on the late Roman Mannerist style of artists such as Cesare Nebbia. Nothing in them prepares for his subsequent emergence as one of the most interesting and skillful painters working in Rome during the early seventeenth century. The break with this early style came around 1600, when Orazio, along with the rest of Rome's artistic community, was confronted with the innovations of the painter Caravaggio. Caravaggio's vocabulary of visual and emotional realism, enacted by figures of physical substance and weight, aided Orazio in the discovery of his own artistic temperament. Gentileschi's style moved toward a more realistic mode, and his compositions are peopled by fewer, relatively larger figures pressed close to the pictorial surface and illuminated by dramatic lighting before a darkened background. However, Orazio tempered the principles of Caravaggesque naturalism with his own artistic sensibilities, which reflect his Tuscan beginnings. Monumentality and clarity of form are coupled with an insistence on the decorative beauty of line, both in defining contours and in establishing drapery rhythms. Gentileschi understood the expressive implications and poetic potential of Caravaggio's approach, and his mature works are imbued with a poetry and formal elegance that have no precedent in the work of Caravaggio himself.

Documents track Orazio's early career from inauspicious beginnings as one of a host of painters decorating the Vatican Sistine Library in 1588–89, through a series of fresco designs and altarpieces in churches in Rome and beyond. In 1612 Orazio successfully brought suit against the artist Agostino Tassi for the rape of Orazio's daughter Artemisia. The year following the trial proceedings, Orazio left Rome, spending most of the years from 1613 to 1619 in the Marches, working principally in Fabriano, probably visiting Florence in 1615–16, and returning to Rome only intermittently. By 1621 Gentileschi had quit Rome permanently, moving first to Genoa and working subsequently for the courts in

Portrait of a Young Woman as a Sibyl

—⎯⎯⎯⎯⎯⎯⎯⎯

c. 1620
Oil on canvas, 32 ⅛ x 28 ¾ in. (82.5 x 73 cm)
The Museum of Fine Arts, Houston 61.74

PROVENANCE
Private collection, England (sale, Christie's, London, June 22, 1951, lot no. 88, as Artemisia Gentileschi); bought by Jeffery Tooth; with David M. Koester, New York, by 1953; Samuel H. Kress Foundation, New York, 1953 (K1949); gift of the Kress Foundation to The Museum of Fine Arts, Houston, 1953.

SELECTED EXHIBITIONS
Washington 1961–62, no. 33; Providence 1968–69, no. 4; Cleveland 1971–72, no. 31.

SELECTED REFERENCES
Houston 1953, pl. 18; Moir 1967, I, 75 n. 22; Shapley 1973, 83–84; Bissell 1981, 187 no. 60; Houston 1981, 48 no. 88.

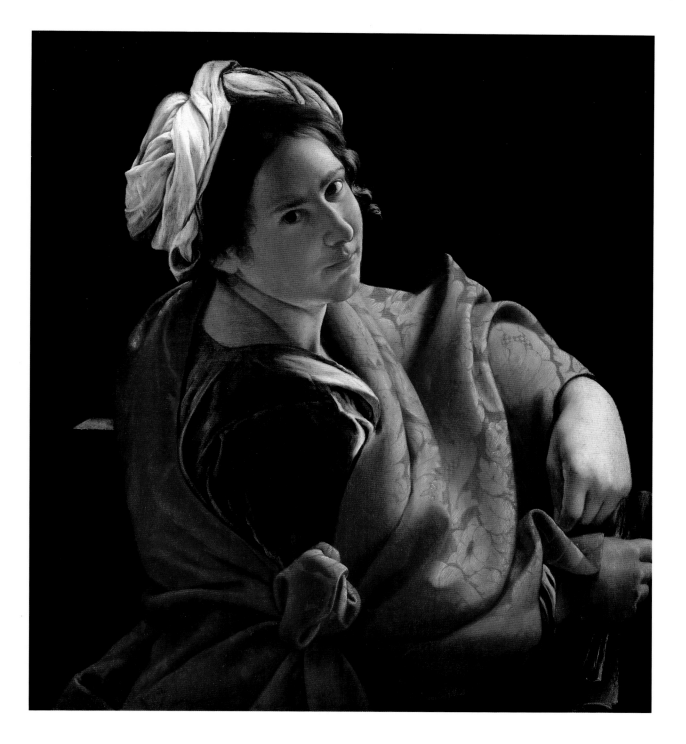

GENTILESCHI, *Portrait of a Young Woman as a Sibyl*

Turin (1623), Paris (1624–25), and London (1625–37). Because of this movement, Orazio figured prominently in the dissemination of the Caravaggesque idiom. Although Artemisia was his closest follower, Orazio's very personal and poetic interpretation of early Baroque naturalism also had a significant impact on the artists of northern Europe.

The Houston painting displays the skills of Orazio Gentileschi at their most evocative. Every nuance of light and color, every adjustment to the sitter's pose and to the arrangement of the draperies has been calculated to achieve an image of immediacy and intimacy, without compromising the grace and dignity of the figure. In common with Orazio's best works, the *Sibyl* exhibits the artist's preoccupation with the expressive potential of the draperies. Here they define and amplify the human form; they are not, however,

fig. 1

Jérôme David. *Portrait of Artemisia Gentileschi.* c. 1625–30. Engraving, 5¼ x 3⅛ in. (133 x 80 mm). Trustees of the British Museum, London

relegated to a secondary role. The artist's intense fascination with the linear rhythms, general textures, surface patterns, and deep bunching of the various fabrics is exploited by the soft light. Also characteristic of Orazio is the predilection to make all compositional elements conform to the picture plane. Consequently, although the sibyl's shoulders are angled into space, her face, back, and arms strain to remain parallel to the pictorial surface, and the drapery lines are instrumental in accomplishing this planarity.

The young woman, holding a scroll and leaning against a slab inscribed with hieroglyphics, has been identified in modern scholarship as a sibyl, specifically the Libyan sibyl.[2] In ancient Greek literature and legend, a sibyl was a woman with the gift of prophecy, a teller of truths. Initially mentioned in the writings of the Greek philosopher Hera-

clitus, Sibylla was given as the name of a specific woman from Asia Minor. By the first century B.C., the Roman writer Varro records ten sibyls, each linked to a famous oracular shrine of the ancient world, such as Delphi. Associated with Egypt and North Africa, the Libyan sibyl was described by Pausanias as the first woman to chant oracles. Of divine origin, she was the daughter of Zeus by Lamia, who was herself the daughter of Poseidon. Seen as prefiguring the prophets of the Old Testament, the pagan sibyls entered the repertoire of Christian art.[3] The most famous representation of the Libyan sibyl is Michelangelo's beautiful, melancholy woman of heroic proportions on the ceiling of the Sistine Chapel.

During the Baroque period sibyls appeared frequently in painting. But comparison with contemporary examples reveals Orazio's interpretation as unique in its robust and palpable realism.[4] The crucial element in his approach is, of course, the direct confrontation of nature. In Orazio's completed paintings, however, he downplays the anecdotal and minute details such as surface textures without sacrificing the convincing presence of his human subject. In addition, the Houston sibyl seems to turn to engage the viewer. She establishes eye contact with us and seems to lean almost into our own space. The result is an image of compelling proximity.

The dating of this painting is problematic. Through documentary or internal evidence, a general chronology of Orazio's oeuvre can be established. Charting a straight evolution is not possible, however, because he did at times revert to earlier trends in his stylistic development. The Houston *Sibyl* has been put forward as an example of this tendency.[5] The weight of scholarly opinion places the picture around 1620–26.[6] But its pronounced illusionism suggests irresistibly that the work belongs earlier in Orazio's career, during the early teens.[7]

Another point of controversy concerning this work is whether or not his daughter, Artemisia (1593–1652), was Orazio's model. Although this idea has been dismissed by some,[8] similarities between accepted contemporary portraits of Artemisia and the physiognomy of the Houston *Sibyl* are strong enough to merit reconsideration. In determining what Artemisia actually looked like, two works are

of particular note: an engraving by Jérôme David (*fig. 1*), believed to be after a self-portrait drawing by Artemisia, and a seventeenth-century portrait medallion of her (*fig. 2*).[9] Both likenesses share what must have been her

essential characteristics: high forehead, fleshy face, small full mouth, and a small but prominent chin with a cleft. On the basis of these images, Levey further accepted as Artemisia's portrait a figure (*fig. 3*) from the ceiling fresco in the Casino of the Muses in the Quirinal Palace, designed by her father and Agostino Tassi in 1611–12 for Cardinal Scipione Borghese.[10] Born in 1593, Artemisia would have been in her late teens at the time of this commission, which seems appropriate to the image.

The facial features of the Houston *Sibyl* are strikingly comparable to those of all of these other figures. Even taking into account the artistic practice of repeatedly utilizing one

fig. 3 Orazio Gentileschi and Agostino Tassi. *Musical Concert Sponsored by Apollo and the Muses*, detail of Artemisia Gentileschi (?). 1611–12. Fresco. Casino of the Muses, Quirinal Palace, formerly the Palazzo Pallavicini-Rospigliosi, Rome

ideal type, the similarities cannot be ignored. The posing of his daughter as the model for the *Sibyl* could explain the tender mood of the picture and the sense of familiarity that exists between the figure and viewer. Furthermore, whether the Houston *Sibyl* dates from 1613–14 or from the 1620s, to cast Artemisia in the role of a sibyl would have had poignant associations for both father and daughter. For during the rape trial of 1612, in order to prove the veracity of her testimony, Artemisia voluntarily submitted to a type of torture in which metal rings are tightened about the fingers by a set of cords.[11] This particular device for extracting the truth was called "the sibyls" (*sibille*).

L.F.O.

1. On documentation of Orazio's early years see Bissell 1981, 1–10.

2. For a review of the literature see Bissell 1981, 187.

3. For the depiction of the sibyls in Christian art, see Réau 1955–59, II, pt. 1, 420–30.

4. See, for example, works by Domenichino (Galleria Borghese, Rome) and Reni (Collection of Sir Denis Mahon, London).

5. Pepper 1983, 699.

6. For a review of arguments on the painting's date, see Bissell 1981, 187, and Shapley 1973, 84.

7. Shapley 1973, 84.

8. Cleveland 1971–72, 103; Bissell 1981, 187.

9. Levey 1962, 79–81.

10. Levey 1962, 79–80. This identification is also supported by Bissell (1981, 28) and Garrard (1989, 19–20). See also Roberto Contini's discussion in the catalogue of the 1991 Artemisia exhibition in Florence (Florence 1991, 128).

11. See Garrard 1989, 403–87, for the text of the trial proceedings.

Antonio d'Errico (Enrico), called **TANZIO DA VARALLO**

Riale di Alagna c. 1575/80–1635 Varallo

Tanzio's provincial origins in a tiny German-speaking alpine area of
northeastern Piedmont colored his artistic approach throughout his career. Less than forty
kilometers from Protestant Switzerland, the Valsesia (Sesia River valley) was the front line
against further incursions of Protestantism into Catholic Italy. Characterized by a certain
crude realism, almost medieval in spirit, Tanzio's works manifest the vernacular religious
piety of this region, which is best illustrated by a series of pilgrimage sites, called sacri monti,
unique to Piedmont and Lombardy.[1] Tanzio, with his brothers Melchiorre, a fresco painter,
and Giovanni, a sculptor and stucco worker, contributed to the decoration of several chapels
in the Sacro Monte above Varallo, the most ancient and significant sanctuary of this type.[2]

Tanzio emerged as a mature artist working in Varallo Chapel XXVII,
depicting Christ before Pilate, where he is documented in 1616–17. Prior to that time little
is known about his life and artistic training. Contemporary records note that the family
had moved to Varallo by 1586. And in a document of 1600, Tanzio and Melchiorre were
granted judicial permission to travel outside the district of Valsesia in order to practice their
craft and to attend the Jubilee of Pope Clement VIII in Rome. Tanzio probably did reach
Rome before traveling on to Abruzzi, where documented works place him prior to 1616,
and Naples.

By 1616 Tanzio was again in Varallo. Completing the Christ before
Pilate the following year, Tanzio undertook the frescoes for Sacro Monte Chapel XXXIV,
depicting Pilate Washing His Hands. There Tanzio worked in tandem with his brother
Giovanni, who was responsible for the freestanding terra-cotta figures. During 1628–29
the pair collaborated again in Chapel XXVIII, which depicts Christ before Herod. Stylis-
tically, Tanzio's Varallo frescoes echo the dramatic realism of Gaudenzio Ferrari, whose
chapels at the Sacro Monte provided a powerful model for all subsequent artists.

Other stylistic influences are discernible throughout Tanzio's career.
It is evident that Tanzio studied the works of Caravaggio and his followers, including
Orazio Borgianni and Orazio Gentileschi. The exaggerated figural poses and acrid colors
in Tanzio's works of the late 1620s reveal the influence of his Milanese contemporaries,

15

*Saint John the Baptist in the
Wilderness*

———⟨∞⟩———

c. 1625
Oil on canvas, 63¾ x 43¾ in.
(162 x 111.1 cm)
The Philbrook Museum of Art, Tulsa 44.2

PROVENANCE
Cav. Enrico Marinucci, Rome, by 1936 (as Dosso Dossi);
with Count Alessandro Contini-Bonacossi, Florence, before
1939 (as Velázquez); Samuel H. Kress Foundation, New
York, 1939 (K1223); gift of the Kress Foundation to The
Philbrook Museum of Art, 1943 (as Tanzio).

SELECTED EXHIBITIONS
El Paso 1940–41; Turin 1959–60, no. 13; Washington
1961–62, no. 91; Detroit 1965, no. 140; New York 1967,
no. 34; Denver 1971, 16–17; Milan 1973, II, no. 162.

SELECTED REFERENCES
Longhi 1943, 53 n. 66; Tulsa 1953, 62; Mallè 1961, 257;
Shapley 1973, 80; Tulsa 1991, 20–21; Townsend 1991,
33–34 no. 33.

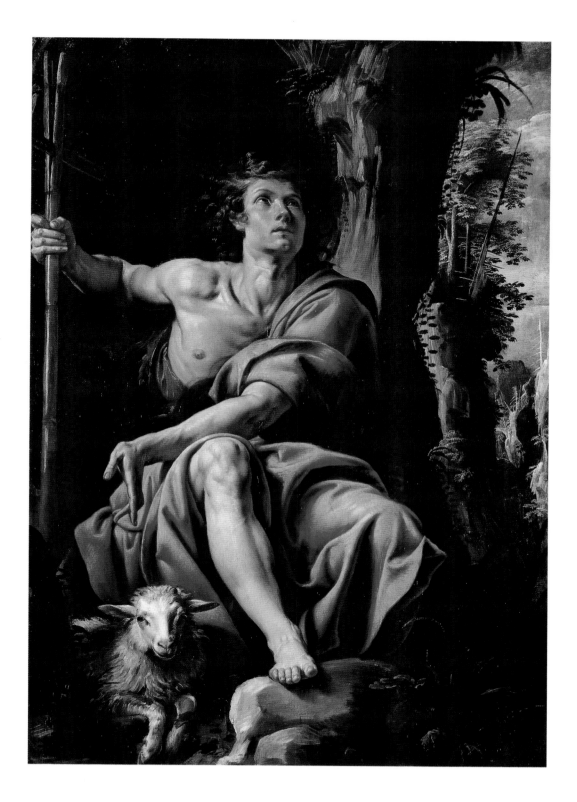

TANZIO DA VARALLO, *Saint John the Baptist in the Wilderness*

particularly Pier Francesco Mazzucchelli (called Morazzone), who had also worked in
the sanctuaries of Varallo, and Giovanni Battista Crespi (called Cerano). However, Tanzio
always grafted these external influences to the indigenous artistic vocabulary of brutal
realism and fervent piety.

The small number of surviving works attributed to Tanzio suggests
that his output was rather limited, composed principally of religious works, although sev-
eral portraits exist. Other commissions included frescoes in the Chapel of the Guardian
Angel in the church of San Gaudenzio, Novara, dated 1629, and in the Milanese churches
of San Antonio and Santa Maria della Pace. Tanzio also executed altarpieces for many
provincial religious institutions throughout the Valsesia, such as the Virgin Adored by
Saint Carlo Borromeo and Saint Francis *for the Oratory of San Carlo at Sabbia (now in*
the Pinacoteca, Varallo), installed by 1628, and the Saint Roch, *dated 1631, painted for*
the parish church in Camasco. These paintings are conventional in both subject matter and
composition, for although Tanzio had traveled widely enough to have seen the stylistic
innovations of the emergent Baroque he maintained the symmetry and hieratic formality
typical of the art of his native region. This deliberately archaizing style was well suited to
the provincial nature of the communities where he worked during the remainder of his
career. He died in Varallo in 1635.

The Tulsa painting is Tanzio's most elaborate development of the theme of John the Baptist.[3] Imposing in scale and compelling in its intense religious sentiment, the canvas was probably designed for installation in a church interior. Diverse stylistic currents come together in *Saint John the Baptist in the Wilderness*, revealing Tanzio's interest in and exploration of the artistic vocabulary of others. Simultaneously in evidence are Mannerist affectations of pose and gesture,[4] and a Caravaggesque display of the potential of dramatic lighting effects to render the painted image fully three-dimensional.[5] The combination of these disparate qualities in a composition at once artificial and realistic have made dating the Tulsa painting problematic. Some scholars have proposed a date early in Tanzio's career, shortly after his return from Rome, when the impression of Caravaggio and his followers would have been still fresh; others suggest persuasively a date well into the 1620s, when the impact of Tanzio's Milanese contemporaries is strongest in his work.[6]

John the Baptist is one of the most familiar figures in Christian art.[7] Considered the last of the Old Testament prophets and the first of the New Testament saints, John holds a pivotal place in the unfolding of Christianity; he is the link between the era under Hebraic law and the era of grace initiated by the incarnation of Christ. With the proclamation "Behold the Lamb of God!" John the Baptist announced the beginning of Jesus' public ministry, culminating in the crucifixion and resurrection that were to secure the redemption of mankind. Consequently the Baptist is accorded the highest rank among the Catholic hierarchy, second only to the Virgin Mary herself. And with the Virgin, it is John the Baptist who acts as intercessor on mankind's behalf at the Last Judgment (see cat. 7).

The roles of John the Baptist as the direct forerunner and witness to Christ take shape as the four Gospel accounts are pieced together.[8] In the fifteenth year of the reign of Tiberius Caesar, John went into the desert of Judea and preached the coming of the Messiah. This was seen as a fulfillment of Isaiah (40:3), foretelling "The voice of him that crieth in the wilderness. Prepare ye the way of the Lord." The Gospel according to Saint Mark reads:

> John did baptize in the wilderness, and preach the baptism of repentance for the remission of sins.

> And there went out unto him all the land of Judea, and they of Jerusalem, and were all baptized of him in the River Jordan, confessing their sins.

And John was clothed with camel's hair, and with a girdle of a skin about his loins; and he did eat locusts and wild honey;

And preached, saying, There cometh one mightier than I after me, the latchet of whose shoes I am not worthy to stoop down and unloose.

I indeed have baptized you with water; but he shall baptize you with the Holy Ghost. (Mark I:4–8)

In the sixteenth and seventeenth centuries, the image of John the Baptist was particularly popular with Catholic reformers anxious to reassert the validity of those traditions and sacraments (rites conferring grace on the participants) attacked by Protestants. Generally the Protestant sects recognized only two sacraments: baptism and communion. Among the sacraments they repudiated are penance and the Catholic Church's insistence on the formal rite of confession. Because the Gospel accounts of John the Baptist provided unequivocal biblical authority for both the Catholic sacraments of baptism and penance, depictions of the Baptist figured widely in Counter-Reformation imagery. In addition, John's evangelical zeal could be seen as a precedent for the Roman Church's own missionary efforts.[9]

Following traditional artistic license, Tanzio removes the Baptist from the deserts of Judea, here situating the solitary figure in a rugged alpine landscape. The harsh austerity of life in the wilderness is suggested by both the rocky terrain and the lean form of the Baptist, whose finely etched contours are silhouetted against the mouth of a cave. Striking light/dark contrasts further accentuate outlines, musculature, and gestures, giving the figure a pronounced sculptural effect. As portrayed, the Baptist is a stark figure. The directness with which Tanzio renders the scene mirrors the intensity of the Baptist's spiritual energy. By formal means, including the rhythmic alternation of darks and lights, the curving folds of vibrantly colored cloth, and the opposing directional forces of the figural pose, the pictorial surface is animated. But the Baptist's animation comes from within, the result of his communion with God: "The word of God came unto John the son of Zacharias in the wilderness" (Luke 3:2). And it is this intense, but internalized, drama that the Baroque artist makes visible.

L.F.O.

1. These mountain sanctuaries re-create individual religious events, such as the crucifixion of Christ, in the form of *tableaux vivants*. In each chapel life-size terra-cotta figures, naturalistically sculpted and painted and fitted with real hair and glass eyes, are posed before illusionistically frescoed walls that set the scene. The most important *sacri monti* are Varese, near Como, begun in 1604, with fourteen chapels illustrating the mysteries of the rosary; Orta San Giulio, begun in 1592, with twenty chapels dedicated to the life of Saint Francis; and Varallo, with forty-four chapels reconstructing scenes from the life of Christ.

2. The Sacro Monte at Varallo was begun in 1486 by the Blessed Bernardino Caimi, a Franciscan friar who in 1477 had been guardian of the Holy Sepulchre in Jerusalem. In the seventeenth century, under the patronage of Carlo Borromeo, Archbishop of Milan (canonized in 1610), Caimi's plan to re-create the holy places of Palestine on the mountain above Varallo was revived.

3. In 1987 a canvas representing the figure in three-quarter length entered the collection of Allen Art Museum, Oberlin College, Oberlin, Ohio. A second painting, of a bust-length figure, appeared on the art market during the 1980s, first in London (London 1981, no. 4) and later sold by Finarte in Milan (see Bona Castellotti 1985). Both of these works have much smaller dimensions than the Tulsa painting and were obviously created as private devotional pictures. Yet another version is recorded by Reinach (1905–23, III, 594); this also depicts a bust-length figure, but with a completely different positioning of the arms and placement of the lamb than appear in either the Oberlin picture or that formerly with Finarte.

4. Note not only the tight complexity of the pose but also the manner in which the drapery folds reiterate and accentuate the position and elongation of the fingers of the Baptist's left hand. The compressed figural pose used here reappears with little variation in the third painting by Tanzio in the Kress Collection, *Saint Sebastian* (Bowron essay, *fig. 1*) in the National Gallery of Art, Washington. It is extraordinary that the Kress Collection should include three superb paintings by this very rare artist.

5. It is important to note, however, that Caravaggio and Tanzio shared a common background, trained in the artistic traditions of northern Italy. This included not only a provincial emphasis on realism, coupled with deep religious sentiment, but also a predilection for tenebroso lighting effects, as developed in the late-sixteenth-century works of Antonio Campi and Luca Cambiaso.

6. See Tulsa 1991, 20; Townsend 1991, 33; for arguments favoring a date of c. 1625–29, see Detroit 1965, 128; Denver 1971, 16; Milan 1973, II, 63; Shapley 1973, 80; Caramellino in *Dizionario enciclopedico Bolaffi dei pittori e degli incisori italiani* 1 (1976): 203.

7. Réau 1955–59, II, pt. 1, 431–63.

8. Matthew 3:1–17; Mark 1:1–14; Luke 3:1–19; John 1:6–36.

9. The Jesuit Order in particular went out into the world, bringing Catholicism to the inhabitants of Asia and the New World.

Antonio d'Errico (Enrico), called **TANZIO DA VARALLO**

Riale di Alagna c. 1575/80–1635 Varallo

*The Rest on the Flight
into Egypt*

————◦✦◦————

The bucolic subject of *The Rest on the Flight into Egypt* has long been favored by European artists. Gaining popularity in the sixteenth century, when landscape emerged as a subject in its own right, the theme provided an opportunity for the artistic investigation of natural phenomena within the context of a religious painting. The biblical source for the subject is Matthew 2:13–14. Joseph, father of Jesus, is warned in a dream that King Herod, hoping to destroy the child called the "King of the Jews" by the three wise men, had ordered the murder of all the small children in Bethlehem. Joseph arose "and took the young child and his mother by night, and departed into Egypt." No further mention of the journey appears in the Bible, but the tale was greatly embroidered by the Pseudo-Matthew (Chapters XVIII–XXIV) in the Apocrypha and later in the *Golden Legend*. The commentary follows the Holy Family into exile, from Bethlehem supposedly beyond Heliopolis (Hermopolis) to the village of Sotinen in Egypt. This journey of about four hundred miles would have taken many weeks on foot.

According to the apocryphal accounts, on the third day the travelers stopped to rest in the shade of a palm tree. Mary, particularly weary and hungry, noticed that the palm bore dates and asked Joseph to get the fruit for her. Joseph, himself more concerned about their dwindling supply of water, answered that he was surprised she requested this, because the fruit was high out of reach. At this moment the infant instructed the palm tree to bend down so that his mother could pick the dates. The palm obliged. Then Jesus asked the tree to uncover the spring that was concealed beneath its roots, so that they could quench their thirst. This the palm also did, and a limpid pool of fresh water appeared. In the Houston painting, Tanzio follows a long artistic tradition, providing as well more practical solutions for the manner in which food and drink were secured: two figures gather the fruit from the palm tree in the background, and the Holy Family sits along the banks of a stream.[1]

The Houston painting exemplifies Tanzio's idiosyncratic blend of realistic and schematized elements. For example, while the figural details are handled with great directness, the landscape backdrop is handled in a very artificial fashion.[2] In addition, the integration of the compositional parts is only partially successful. Transitions between foreground and background are not developed gracefully or convincingly; similarly the figures appear situated before, not within, the landscape. Exhibiting a provincial synthesis of progressive and *retardataire* elements, the painting does not produce the pictorial unity that is a hallmark of Baroque art. Nonetheless the picturesque subject matter, coupled with Tanzio's treatment of the figures and the psychological interplay between them, produces an image of great appeal.

A red chalk preparatory drawing (*fig. 1*) exists for the figure of Joseph. While he is cast as a much younger man in the painting, in both works Joseph's expressive pose and furrowed brow suggest a man tired and disgruntled, or at least preoccupied. Even if his exact mood is somewhat difficult to determine, the look on his face is quite remarkable. Tanzio captures an expression truthful in its humanity and, for a figure depicting the earthly

c. 1630
Oil on canvas, 22¼ x 27⅞ in.
(56.5 x 70.8 cm)
The Museum of Fine Arts, Houston 61.69

PROVENANCE
Professor Zobali, Venice; Count Alessandro Contini-Bonacossi, Florence, before 1950; Samuel H. Kress Foundation, New York, 1950 (K1773); on loan to The Museum of Fine Arts, Houston, 1953–61; gift of the Kress Foundation to The Museum of Fine Arts, Houston, 1961.

SELECTED EXHIBITIONS
Turin 1959–60, no. 26; Washington 1961–62, no. 91; Providence 1968–69, no. 19; Milan 1973, no. 161.

SELECTED REFERENCES
Houston 1953, pl. 19; Moir 1967, I, 263 n. 35, II, 110; Shapley 1973, 80.

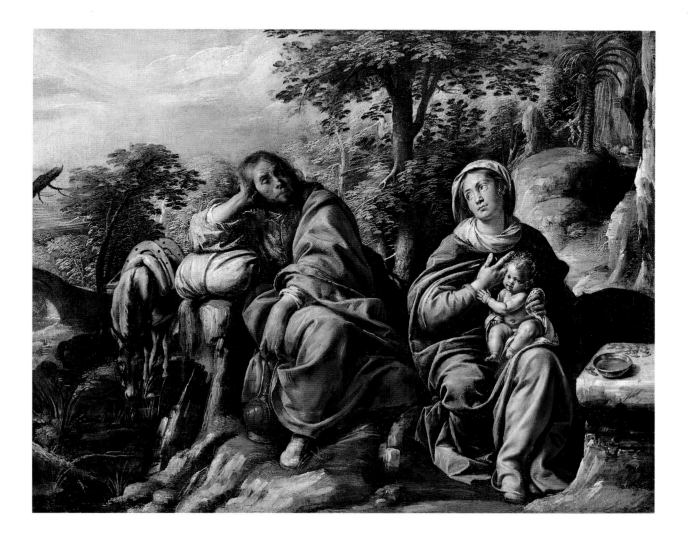

TANZIO DA VARALLO, *The Rest on the Flight into Egypt*

fig. 1 Tanzio da Varallo. *Saint Joseph*. c. 1630. Red chalk on paper, 12 ⅝ x 9 ⁷⁄₁₆ in. (320 x 240 mm). Pinacoteca, Varallo

father of Christ, unprecedented in its negativity. Similarly unusual is Mary's rather peculiar glance. Although enigmatic, the veracity of these expressions testifies to the artist's powers of observing the realities of human nature; they also continue the tradition of realism found in the sanctuaries of Varallo. Such novelties of emotional realism and informality, combined with the painting's relatively small scale, dictate that the work must have been produced for a private audience.

L.F.O.

1. Frequently in representations of the Rest on the Flight, angels accompany and aid the Holy Family on its journey, and it is they who gather the dates from the tree. Here, however, the wispy figures in the background do not appear to have wings.

2. The handling of the landscape in this picture is very close to the schematic approach of northern European landscape painters such as Jan Bruegel the Elder and Paul Bril, both of whom worked extensively in Italy. Numerous superb landscapes by them were included in Federico Borromeo's donation of his art collection to the city of Milan in 1618, forming the Pinacoteca Ambrosiana.

MASSIMO STANZIONE

Orta di Atella (Naples) 1585–1656 Naples

One of the most gifted and influential artists of the early Neapolitan Baroque, Stanzione decided to become a painter only at the age of eighteen, after previously devoting himself to the study of music and the humanities.[4] His formal artistic training began about 1605–10 in the studio of the Neapolitan painter Fabrizio Santafede, where his initial efforts were in the area of portraiture.[5] Stanzione's eighteenth-century biographer, De Dominici, noted that he also frequented an informal "Academy of the Nude," where he drew from live models.[6]

By 1617 four of Stanzione's paintings (now lost) had been praised in poetic works, and in October of that year he was in Rome, painting an altarpiece for the church of Santa Maria della Scala; he would have been working there at the same time as Caravaggio's Roman followers Gerrit van Honthorst (see cat. 22) and Carlo Saraceni.[7] De Dominici wrote that while in Rome Stanzione studied the works of Annibale Carracci and his Emilian followers, in particular Guido Reni. Stanzione was the only artist of his day who was able to combine the narrative clarity of the Emilian painters—Carracci, Reni, and, later on, Domenichino—with the more painterly qualities and expressive use of chiaroscuro characteristic of Caravaggio's Roman and Neapolitan followers, such as Valentin de Boulogne, Jusepe de Ribera, and Giovanni Battista Caracciolo.

During the 1620s Stanzione made several trips from Naples to Rome.[8] His motives were not purely artistic, however; he was also actively seeking to advance his social standing. He was successful in this endeavor, for between 1621 and 1627 he was inducted into three papal and dynastic orders.[9] He subsequently signed many of his works "EQUES MAXIMUS," and became known throughout Europe as "Cavaliere Massimo."

Around 1630 Stanzione established himself permanently in Naples, which at that time was the second-largest city in Europe, after Paris. About this time Artemisia Gentileschi, the talented daughter of Orazio Gentileschi (see cat. 14), moved to Naples, and, according to De Dominici, "the freshness of her beautiful coloring was so suited to [Stanzione's] genius that he set himself to imitate it."[10] In 1631 Domenichino arrived in Naples, followed three years later by his Emilian compatriot Giovanni

17

The Assumption of the Virgin

c. 1630–35
Oil on canvas, 108½ x 74⅝ in.
(275.6 x 189.6 cm)
North Carolina Museum of Art, Raleigh
60.17.52

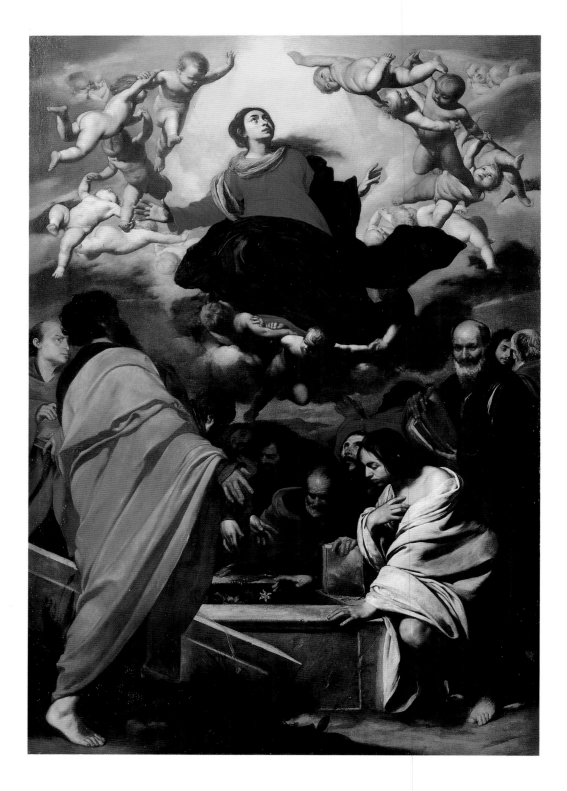

STANZIONE, *The Assumption of the Virgin*

Lanfranco; these artists, whose works Stanzione would have already encountered in Rome during the 1620s, further influenced his stylistic evolution. By this time Ribera was his only serious artistic rival in Naples.

In the 1630s the naturalistic impulses that underpinned Stanzione's early paintings began to diminish, and he developed an increasingly idealizing pictorial style based upon a highly personal reinterpretation of the Neapolitan works of Domenichino and Reni.[11] His refined, graceful works from this period earned him the sobriquet "the Neapolitan Guido." In 1633 he painted the frescoes for the vault of the church of Santi Marcellino e Festo, and during the second half of the 1630s he executed several other major commissions, including his most famous work, the Pietà *for the Certosa of San Martino.*

During the 1640s Stanzione and his pupils continued to dominate the artistic scene in Naples, as attested by a steady stream of prestigious private and ecclesiastical commissions for oil paintings and frescoes. The idealism of his compositions of the later 1630s continued unabated in projects like the vast fresco cycle for the Theatine Order in the church of San Paolo Maggiore, begun in 1642, and the frescoes for the chapel of San Giacomo della Marca in the church of Santa Maria la Nova, finished in 1646. The participation of assistants and the effort of meeting the great demand for his paintings may partially account for the noticeable decline in the quality of Stanzione's works of the late 1640s and early 1650s. De Domenici records that Stanzione fell victim to the plague that swept Naples in 1656, killing approximately half of the city's inhabitants.[12]

Stanzione's art brought together the two most important stylistic impulses of the early Baroque, Caravaggism and Emilian-Roman classicism. To a greater degree than any other artist of his generation, he was responsible for modernizing Neapolitan painting during the second quarter of the seventeenth century. Although by the time of Stanzione's death, the innovative, fully Baroque style of Luca Giordano was beginning to revolutionize painting in Naples, Stanzione's style continued to exert a significant influence on artists in the provincial towns around Naples and in Apulia well into the second half of the century.[13]

The Raleigh *Assumption of the Virgin* is Stanzione's earliest large-scale, multifigured masterpiece, the type of altarpiece that transformed Neapolitan painting during the 1630s and secured his position as one of the foremost painters in Naples. It is a major landmark in the history of Neapolitan Baroque painting, epitomizing the kind of religious art created in the wake of the Counter-Reformation that sought to move the worshiper emotionally and spiritually and inspire greater devotion.

When the *Assumption* first came to the attention of scholars in the late nineteenth century, it was attributed to the Spanish master Alonso Cano (1601–1667). The attribution to Stanzione was first suggested by Herman Voss in 1910 and has generally been accepted by later scholars.[14] The earlier attribution may have been suggested by the probable Spanish provenance of the painting. It was first recorded in 1885, when it was sold from the collection of Henry Wellesley, who had inherited the collection of paint-

ings formed by his father between 1810 and 1822, when the latter was the British envoy and ambassador to Spain. The painting's monumental scale indicates that it was designed as an altarpiece, but the absence of any reference to it in the major seventeenth- or eighteenth-century Neapolitan sources suggests that it was not painted for a church either in the city or in the surrounding provinces. Naples was under Spanish rule at the time, and Stanzione's connections with the Spanish court—he had just completed a series of paintings for Philip IV—support the hypothesis that the *Assumption* originally may have been destined for Spain.[15] The *Assumption* has generally been dated to the late 1620s.[16] The palette and brushwork, however, share closer stylistic affinities with Stanzione's paintings of the early 1630s, such as the oil paintings for the chapel of San Bruno in the Certosa di San Martino. This date also accords well

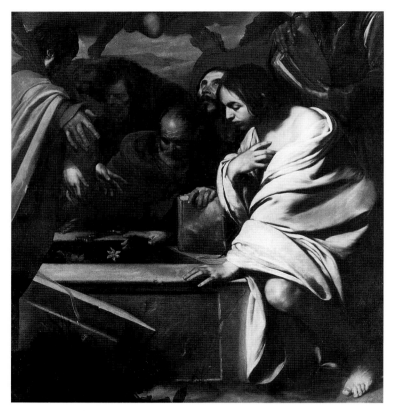

fig. 1 Massimo Stanzione. *The Assumption of the Virgin* (detail of cat. 17)

with the blend of naturalism and idealism, of both Caravaggesque and Emilian elements, the latter being most apparent in the composition and in the putti, which betray Stanzione's study of Domenichino's works.

The painting represents the assumption of the Virgin Mary into heaven, a subject not found in the canonical Gospels, deriving instead from apocryphal accounts of the third

or fourth century. The story was included in Jacobus de Voragine's thirteenth-century *Golden Legend*, a source frequently used by Renaissance and Baroque artists. On the third day after Mary's death, the apostles were gathered around her tomb, when, in Voragine's words, "she came glorious from the tomb and was assumed into the heavenly bridal chamber, a multitude of angels with her."[17] The term "assumption" refers to the fact that the Virgin was borne up to heaven by angels, in contrast to Christ, who ascended into heaven through his own divine power. The Assumption, a popular subject for artists of the twelfth and thirteenth centuries, enjoyed renewed popularity as a Counter-Reformation theme during the late sixteenth and seventeenth centuries.

In the lower half of Stanzione's composition, the twelve apostles are gathered around the Virgin's tomb (*fig. 1*). Confronted with the empty, flower-filled sarcophagus and Mary's heavenward ascent, they express attitudes of reverence, puzzlement, and rapt amazement. Although the artist has carefully individualized their features—a legacy of his activity as a portraitist—only a few of the apostles can be identified. The balding figure kneeling over the tomb in the center of the composition is Peter; resting on the edge of the sarcophagus is his attribute, a golden key.[18] The youthful apostle on the right, whose white cloak is a breathtaking example of Stanzione's painterly technique, is probably John the Evangelist, who according to apocryphal tradition wrote the earliest account of the Assumption. His counterpart on the left side, clothed in an ocher robe, may be Thomas, who doubted the bodily assumption of the Virgin until she cast down to him the girdle that bound her robes; the beltlike article draped over the tomb next to him may be this girdle.

The figure of the Virgin (*fig. 2*), bathed in a golden light, hovers over the apostles. As she leaves the world behind, her hair streams out behind her, and her eyes are raised and her arms outstretched in rapturous contemplation of her heavenly destination. She is accompanied and borne upward by an extraordinary ring of acrobatic putti.

Stanzione employs a variety of technical and compositional means to make the event a tangible experience for the worshiper. The open center of the composition provides clear access to the dual iconographic focal points, the Virgin's empty tomb and her bodily assumption into heaven. The bearded apostle on the right directly engages our eye. The gestures and gazes of some of his companions lead us down to the empty tomb while, simultaneously, the ocher cloak of the apostle on the left and the upturned faces of

other apostles sweep our eyes aloft to the ascending figure of the Virgin. The faithful viewer shares in her ecstatic transport, for her destination is the ultimate destination of all Christian believers.

Stanzione is careful to distinguish, as well as link, the earthly and heavenly realms. His careful individualization of the apostles' features and their credible weight and mass imbue them with a believable naturalness that binds them to this world. In most of the lower part of the composi-

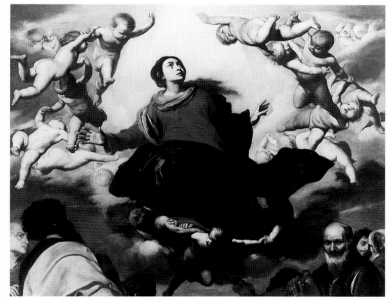

fig. 2 Massimo Stanzione. *The Assumption of the Virgin* (detail of cat. 17)

tion the light is muted, the colors deeper. The sky behind and just above the apostles is a deep, crepuscular blue. The dense crowding of the apostles also serves to visually ground them. In marked contrast, the upper part of the composition (*fig. 2*) is all golden light and dynamic motion. The concatenation of frolicsome putti is a technical tour de force, revealing the full measure of the artist's virtuosic compositional abilities. The Virgin's upward course is emphasized by her gaze and gesture and by her billowing gown. In addition, two ascending triangles—one formed by her body and the two strongly illuminated apostles in the foreground below, the other created by her upper torso and outstretched arms and culminating in the hands of the uppermost putti—reinforce this vertical impulse.[19]

The transition between the two realms is accomplished by the figure of the putto beneath the Virgin, at the exact center of the composition. His lower body is enveloped in earthly shadow, while his shoulders and the top of his arms are strongly illuminated by the heavenly light. Another link, spiritual as well as compositional, is established by

the apostle in the right background. His hands joined in prayer, this figure symbolizes the power of prayer as a potent mediation between heaven and earth and alludes to the Virgin's role in Catholic theology as a heavenly intercessor on behalf of humankind.

The Kress *Assumption of the Virgin* is one of the most important Baroque altarpieces in America. A visually stunning work, carefully composed and dazzlingly painted—qualities that are even more readily apparent thanks to a recent conservation treatment—it reveals the full abilities of this vastly underrated artist at the height of his powers. Far removed from the fervent religiosity of the Catholic Counter-Reformation, when the aim of artists (and their patrons) was to create altarpieces that would edify and spiritually move the worshiper, the twentieth-century viewer tends to respond to this type of work on a purely aesthetic level. Yet, standing before it today, one experiences something of the transporting effect that the painting must have had upon a seventeenth-century worshiper encountering it above an altar in a candle-lit church.

D.S.

I am grateful to Thomas Willette for reading a draft of this entry and for sharing with me his observations concerning Stanzione and the *Assumption*.

1. Shapley (1973, 95–96) conflates Stanzione's painting with an *Immaculate Conception* that was also attributed to Cano when it was in Sir Francis Cook's collection. J. Charles Robinson had acquired the *Immaculate Conception* in Granada and sold it to Cook in 1868, the year in which the latter lent it to an exhibition in Leeds.

2. Cook 1903, 22 no. 6, as Cano; Cook 1905, 14, as Cano; Cook 1907, 21 no. 6, as Cano; Cook 1913–15, III, 152 no. 514, as Cano, or possibly Stanzione.

3. Cook 1932, 63 no. 514, as "Stanzioni."

4. The most important biographical source for Stanzione is Bernardo De Dominici's complex *vita* (De Dominici 1742–45, III, 44–69). The best and most thorough study on the artist's life and works is the comprehensive monograph and catalogue raisonné by Sebastian Schütze and Thomas Willette, published in 1992, which includes a discussion of De Dominici's work and an annotated version of his biography of Stanzione.

5. De Dominici 1742–45, III, 45; see also Schütze and Willette 1992, 16, 176 nn. 5, 6, and 264–65 nos. D22, D25–D29.

6. De Dominici 1742–45, III, 45; Schütze and Willette 1992, 176 n. 7.

7. For Stanzione's *Saint Andrea Corsini* altarpiece for Santa Maria della Scala, see Schütze and Willette 1992, 41, 261–62 no. D14. The Cavaliere d'Arpino and Cristoforo Roncalli (Il Pomarancio) were also working at Santa Maria della Scala during this period.

8. It was long believed that Stanzione made just two lengthy sojourns to Rome, in about 1617–18 and 1625–30. It now seems clear, however, that he made numerous trips between Naples and Rome from 1617 to 1630; see Schütze and Willette 1992, 41, 45, 53, 56, 57.

9. Schütze and Willette 1992, 45, 49, 52–53. In 1621, upon the recommendation of the Spanish ambassador to the papal court, Stanzione was made a "Cavaliere del Speron d'Oro" (Knight of the Golden Spur) by decree of Pope Gregory XV. Sometime before March 1625, he was inducted into the dynastic "Sacro Militare Ordine Constantino di San Giorgio." Finally, in 1627 Pope Urban VIII awarded Stanzione the title of "Cavaliere di Gesù Cristo." Stanzione's receipt of these titles would certainly have enhanced his prestige as an artist and would have enabled him to stand on more equal footing with his aristocratic patrons. A good overview of seventeenth-century Neapolitan society is found in Giuseppe Galassi's essay, "Society in Naples in the Seicento," in Washington 1983, 24–30.

10. De Dominici 1742–45, III, 45. De Dominici erred in placing Gentileschi's arrival in Naples to a date very early in Stanzione's career rather than around 1629–30; see Schütze and Willette 1992, 176 n. 10. Stanzione and Gentileschi both worked on the series of paintings depicting scenes from the life of Saint John the Baptist, painted about 1630 for Philip IV's Hermitage of Saint John (located on the grounds of the Buen Retiro palace in Madrid), and now in the Prado; see Schütze and Willette 1992, 200–202 no. A30.

11. Schütze and Willette 1992, 69–78.

12. De Dominici 1742–45, III, 66–67; the author also quotes from Paolo de' Matteis's notes on Neapolitan artists, which state that Stanzione died "nel contaggio dell'anno 1656." The 1656 epidemic is believed to have claimed the lives of a number of Neapolitan artists, including Bernardo Cavallino, Aniello Falcone, Francesco Fracanzano, Pacecco de Rosa, Giovanni Do, and Agostino Beltrano.

13. The perpetuation of Stanzione's influence in Apulia and in the Neapolitan provinces was due primarily to his pupil Francesco Guarino, who worked at the court of Ferdinando Orsini at Gravina di Puglia in Apulia; his pupil Pacecco de Rosa, who painted numerous works for the provincial towns around Naples; and to the works of their followers.

14. The only alternative attribution, to Stanzione's pupil Francesco de Rosa (Pacecco de Rosa), has not been given serious credence, for the extraordinary technical virtuosity seen in the painting substantially exceeds de Rosa's comparatively modest abilities.

15. Schütze and Willette 1992, 195.

16. Ferdinand Bologna (in Salerno 1954–55, 56) dates the painting to the 1620s; Leone de Castris (1986, 178) and Lattuada (1988–89, 233, 235) date it to the last years of that decade. Spinosa (oral communication) suggests a dating of about 1632–33.

17. Voragine c. 1295/1969, 454.

18. The key is a reference to Christ's charge to him, recorded in Matthew 16:19: "I will give you the keys of the kingdom of heaven."

19. At some point after the *Assumption* left Stanzione's studio and before it was acquired by the Kress Foundation, strips of canvas were added to the top (6 cm), left (6 cm), and right (3 cm) edges of the painting, and approximately 6 or 7 cm were removed from the bottom edge. The additional canvas along the top edge diminishes the original effect of the heavenly "entranceway" between the outstretched hands of the putti. The illustrations reproduced here have been cropped to eliminate these later additions.

Juan van der Hamen y León

Madrid 1596–1631 Madrid

During his short lifetime, Van der Hamen was among the most illus-
trious painters active in the flourishing capital city of Madrid. Working amid a prestigious
group of intellectuals, the artist achieved fame and respect above all for his still lifes,
a genre that was then quite new. He was born in Madrid in 1596 to Juan van der Hamen,
who had moved to Spain from Brussels at least ten years before, and his half-Flemish,
half-Spanish wife, Dorotea Bitman Gómez de León.[2] Both parents claimed noble ancestry,
and the elder Van der Hamen was a member of the Burgundian Guard of the King, a
position that his son also would hold later.

As Jordan has shown, Van der Hamen's brief career must be seen in
the context of this courtly atmosphere. His paintings were prized not only by royalty but
also by the leading collectors of the day, such as the Marquis of el Carpio and the Marquis
of Leganés. Although nothing is known of Van der Hamen's training, which is assumed to
have taken place in Madrid,[3] he was paid to execute "a picture of fruit and game" for the
royal palace of El Pardo in 1619.[4] This commission was followed by a decade of activity
in which Van der Hamen refined Spanish still-life conventions and made ground-breaking
contributions of his own. Van der Hamen was respected for possessing a multitude of
talents befitting a learned artist, as a tribute written shortly after his death demonstrates:

> Juan de Vanderhamen y León, among the most celebrated painters of our
> century, because in drawing, in painting, and in narrative works he exceeded
> Nature herself: aside from being unique in his art, he wrote extraordinary
> verses, with which he proved the relationship that exists between Painting and
> Poetry; he died very young, and from what he left us in fruits, as well as in por-
> traits, and large canvases, it obtains that if he were living, he would be the
> greatest Spaniard of his art.[5]

These skills, along with his noble lineage and membership in the royal Burgundian Guard,
would have made Van der Hamen a natural choice for the position of painter to the king.
But when a committee of the three court painters, Vincencio Carducho, Eugenio Cajés, and
the young Diego Velázquez, was designated to select an artist from among twelve candi-
dates for an open position, Van der Hamen did not make the final cut. Brown has plausibly
speculated that professional jealousy on the part of Velázquez might have helped to exclude
Van der Hamen, who was certainly qualified for the job.[6]

18

Still Life with Fruit and Glassware

———⊙⊛⊙———

1626
Oil on canvas, 33 x 44 ⅜ in.
(83.8 x 113.4 cm)
Signed and dated lower left: *Ju vander
Hammen fa[t] 1626*
The Museum of Fine Arts, Houston 61.78

PROVENANCE
Marquis of Leganés, Madrid (d. 1655), before 1655 (inv.
no. 353);[1] with Victor Spark, New York, 1950; with David
M. Koetser, New York; Samuel H. Kress Foundation, New
York, 1957 (K2176); on loan to The Museum of Fine Arts,
Houston, 1953–61; gift of the Kress Foundation to The
Museum of Fine Arts, Houston, 1961.

SELECTED EXHIBITIONS
Paris 1952; Fort Worth 1985, no. 16.

SELECTED REFERENCES
Longhi 1950, 39; Bergström 1963, 25–26; Jordan 1964–65,
63, 66, 68; Bergström 1970, 35–36; Angulo Iñíguez 1971,
29, fig. 8; Eisler 1977, 205–6; Sterling 1981, 60, 69, pl. 64;
Houston 1981, 48–49; Houston 1989, 136–37; Brown and
Mann 1990, 86.

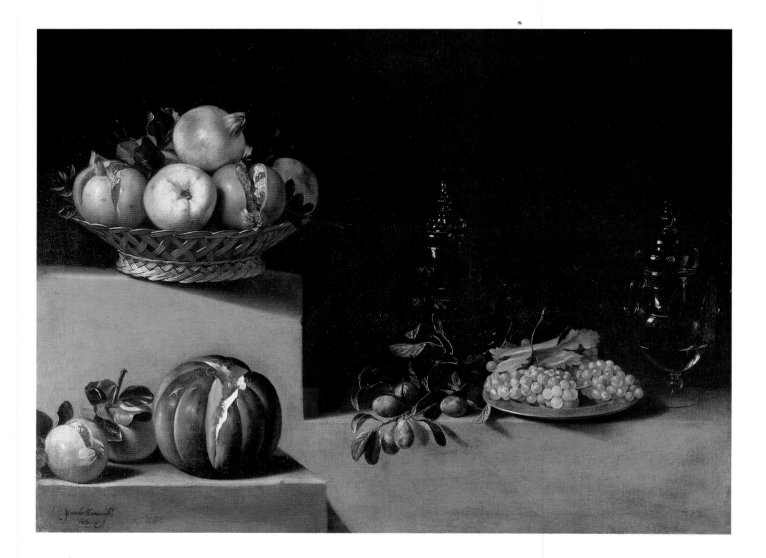

VAN DER HAMEN, *Still Life with Fruit and Glassware*

Reminiscences of abundant Flemish still lifes, such as those painted

by Frans Snyders, occasionally may be found in Van der Hamen's works, but more funda-

mentally influential were the starkly lit, abstract arrangements of ordinary fruits and

vegetables by his Spanish predecessor Juan Sánchez Cotán. Van der Hamen transformed

this model by infusing his own still lifes with monumental grandeur and a courtly elegance.

The accomplishments of later Spanish still-life painters such as Zurbarán and Meléndez

are unthinkable without his precedent. Several religious subjects and genre pictures by

Van der Hamen's hand also survive, as do a handful of portraits of court personages, where

the use of stark lighting endows the figures with as powerful a physical presence as that

found in the flowers and fruits of his more celebrated still lifes.

Still-life painting most fascinated its early enthusiasts in Spain by offering artists the opportunity to demonstrate their ability to rival nature itself. Using ordinary objects for their subjects, painters depended on skill and ingenuity to create arrangements that might fool the eye with their lifelikeness. Artists also engaged in self-conscious emulation of the painters of antiquity, about whom telling anecdotes alone survived.[7] This sanction of the classical past gave sheen to subject matter that would otherwise have been considered unworthy of an artist's attention. Unhampered by the rules of decorum governing more traditional themes from religion or history, this new field was an arena where artists could explore current issues of naturalism, illusionism, and the concept of the superiority of art over nature. Some artists included human figures preparing or selling food; these works, gathered under the Spanish term *bodegón*, are as closely related to genre paintings as to still lifes.[8] Other artists presented straightforward— but not necessarily naturalistic—arrangements of fruits and vegetables. The most important contributor of the first generation of Spanish still-life painters was Juan Sánchez Cotán of Toledo, whose stark compositions strongly influenced Van der Hamen. Van der Hamen's earliest still lifes often are symmetrically arranged, with a single row of fruit-filled vessels along a stone ledge. Distances between objects are precisely modulated to create a harmonious, balanced composition, held together by energetic tension. These compositions are strongly lit from above and the left, creating a minimal but stately drama—the emergence of the rounded, heavy forms from darkness into the blazing light. Other early paintings show some departures from the established style. In the *Still Life with Sweets* of 1622 from Cleveland (*fig. 1*), Van der Hamen arranged a group of mostly rectangular objects with architectonic rigor and precision. The wooden box does double duty as both object and support for other objects, creating two levels of display.

This device disrupts the artist's customary symmetry but enlivens the upper part of the canvas and multiplies the interrelationships among the objects.

Van der Hamen continued to experiment in the Houston canvas of 1626, *Still Life with Fruit and Glassware*, where an extraordinary departure from his customary format yields a still life of unprecedented grandeur. Here he replaces the single display surface with a system of ledges that both mount vertically and recede into depth. Predictable standards of balance and proportion are flouted as the artist weights the left side of the composition with the replete forms of pomegranates, quinces, and melon.

fig. 1 Juan van der Hamen. *Still Life with Sweets*. 1622. Oil on canvas, 22¾ x 38¼ in. (58 x 97 cm). The Cleveland Museum of Art, John L. Severance Fund 80.6

Brilliantly lit and warmly colored, these heavy fruits dominate the cool hues and delicate forms of the purple plums, white grapes, and three glass vessels that emerge from the deep shadows on the middle ledge. The amplitude of space that comes from the greater distance between the viewer and the majestic, dignified display is unique in Van der Hamen's work to this time. Yet the artist maintains his habitual rigorous adherence to the picture plane, meticulously arranging objects parallel to the surface and from a

fixed point of view. Only the elegant branch of plums extends beyond the ledge and offsets the strict containment of forms. This sensitive detail mediates the space between the foreground and middle ledges and helps to preserve pictorial unity.

Although issues of compositional complexity and balance obviously occupied Van der Hamen before 1626, several scholars have attributed the ambitious multilevel format of the Kress canvas to the influence of Italian still lifes painted by Caravaggio's immediate followers.[9] Jordan suggested that the arrival of noted antiquarian and collector

fig. 2 Juan van der Hamen. *Still Life with Sweets and Pottery.* 1627. Oil on canvas, 33 ⅛ x 44 ⅜ in. (84.2 x 112.8 cm). National Gallery of Art, Washington, Samuel H. Kress Collection

Cassiano dal Pozzo and Roman patron Cardinal Francesco Barberini in Madrid that same year also might have played a part in the development of the new type.[10]

The ingenuity and subtlety with which artistic issues of balance, lighting, volume, and proportion are dispatched in a painting such as this have unquestionable intellectual appeal, and it was exactly the stimulating interplay of the intellect and the senses that made Van der Hamen's still lifes so popular in the sophisticated atmosphere of Madrid. An inventory number, "353," partially visible at the lower right of the Houston canvas, has been traced to the distinguished collection of the Marquis of Leganés.

In the Kress Collection at the National Gallery of Art is another stepped still life by the artist, signed and dated 1627, representing sweets and pottery (*fig. 2*). Because of similarities in setting and because they were first recorded together, the two paintings have often been considered

to be a pair.[11] Eisler, and following him, Jordan and Brown, maintained that since the compositions are oriented in the same direction they do not create a symmetrical pair but that it is possible they were meant to be part of a series of four, corresponding perhaps to the four seasons.[12]

C.I.

1. López Navio 1962, 285: "353. otra de *Vanderhamen*, del mismo tamaño, con frutas y granadas, membrillos, melones y ubas y unos bidrios, en 500." (353. another by Van der Hamen, of the same size, with fruits and pomegranates, quinces, melons and grapes and some glasses, at 500.) The Marquis owned eighteen paintings by the artist.

2. The most recent summary of Van der Hamen's life and career is by William B. Jordan in Fort Worth 1985, 103–24.

3. In a petition of 1615 by the painter, Van der Hamen claimed never to have left Madrid. Jordan in Fort Worth 1985, 105.

4. The painting was to be paired with two other works that had recently been purchased from the estate of the Cardinal of Toledo, an early collector of still lifes. Jordan in Fort Worth 1985, 106.

5. Juan Pérez de Montalván, *Índice de los ingenios de Madrid* (1633), fol. 11r, no. 215, translated by Jordan and quoted in Fort Worth 1985, 104.

6. Brown 1991, 138–40. The group of finalists included Antonio Lanchares, Félix Castelo, Angelo Nardi, and Pedro Núñez del Valle. See also Jordan in Fort Worth 1985, 113–14.

7. Francisco Pacheco, the important theorist of the mid-seventeenth century, cited a story by Pliny on the invention of still-life painting by the painter Pausias who, to win the love of a garland maker, created painted representations of flowers. Cited by Jordan in Fort Worth 1985, 8. Later, Pacheco mentioned the painter Peiraikos, who painted "humble things like barbershops, stalls, meals and similar things." Cited by Jordan in Fort Worth 1985, 15.

8. By the eighteenth century the term *bodegón* had come to be applied to Spanish still lifes in general.

9. Longhi 1950, 39; Pérez Sánchez in Madrid 1983–84, 49; Jordan in Fort Worth 1985, 132; Jordan (134) illustrates an interesting stepped still life, similar in many ways to the Houston picture, which he attributes to an anonymous Italian painter.

10. "It may not be just a coincidence that this dramatic change in style, which incorporated a compositional format with antique precedent, occurred in the very year that Cassiano dal Pozzo and Cardinal Francesco Barberini visited Madrid." Jordan in Fort Worth 1985, 132.

11. There is less evidence for the National Gallery painting having been part of the collection of the Marquis of Leganés; an inventory citation that describes similar subject matter differs significantly in the dimensions listed; they may have been recorded in error, but the absence of an inventory number on the painting makes it impossible to resolve the question.

12. Eisler 1977, 205–7; Jordan in Fort Worth 1985, 135; Brown in Brown and Mann 1990, 86.

PAULUS MOREELSE

Utrecht 1571–1638 Utrecht

Moreelse trained in Delft with the portrait painter Michiel van Mierevelt and in 1596 joined the Saddlers' Guild, which included painters.[1] Sandrart (1675) mentions that Moreelse traveled "to Rome," but since northern Italian art seems to have made a stronger impression on him than Roman painting, it may be that "Rome" here refers to Italy in general. Moreelse returned to Utrecht at least by 1602, the year he married. Two years later Van Mander referred to him as "an excellent portrait-painter."[2] Moreelse was in heavy demand as a portraitist for elite families in Utrecht and Amsterdam, and in the 1620s and 1630s he pleased this wealthy clientele with his fashionable, fluidly painted pastoral images (see cat. 22). In 1627 the provincial assembly of Utrecht selected a Shepherd and Shepherdess by him to be part of an official gift to Amalia van Solms, wife of the Stadholder Frederick Hendrick.[3] Moreelse's masterpiece in this vein is the luscious Vertumnus and Pomona (Museum Boymans-van Beuningen, Rotterdam). The overt sensuality of these paintings is absent in Moreelse's portraits of upstanding burghers, save for his delight in portraying the tactile properties of the luxurious garments they wore. As De Jonge notes, Moreelse's portrait style is notable for its concentration on the figure above all else; setting is rarely described, and backgrounds are generally unadorned.[4]

In 1611 Moreelse was a cofounder of the painters' Guild of Saint Luke in Utrecht, an offshoot of the Saddlers' Guild, and he served as dean numerous times between 1611 and 1619. Moreelse's administrative talents were also applied to civic matters through his membership on the town council beginning in 1618, a post that brought him into closer contact with leading Utrecht families whose portraits he painted; from 1627 to 1629 he served as alderman and was elected treasurer in 1637. Moreelse also had architectural expertise, erecting the Catharijnepoort and proposing plans to extend city boundaries, and he was instrumental in the foundation of the Utrecht University. Moreelse trained a number of students, the best known of whom was Dirck van Baburen.

19

A Member of the Strick Family

⟡

1625
Oil on canvas, 47⅞ x 38⅛ in.
(121.7 x 96.9 cm)
Inscribed upper right: *A° 1625 PM*
Allentown Art Museum, Pennsylvania
61.39.G

20

The Wife of a Member of the Strick Family

⟡

1625
Oil on canvas, 47⅞ x 38⅛ in.
(121.7 x 96.9 cm)
Inscribed upper left: *A° 1625 PM*
Allentown Art Museum, Pennsylvania
61.38.G

PROVENANCE
Sir William and Lady F. A. J. Hutt, Appley Towers, Isle of Wight; sold Christie's, London, June 20, 1913, lot no. 105; with Lewis and Simmons, London and New York; Asher Wertheimer, London; sold Christie's, London, June 18, 1920, lot no. 31; with F. Kleinberger and Co., New York, 1938; with M. Knoedler & Co., New York; with Levy Galleries, New York; Samuel H. Kress Foundation, New York, 1938 (K1133, *Member of the Strick Family*, and K1132, *Wife of a Member of the Strick Family*); on loan to Allentown Art Museum, 1960; gift of the Kress Foundation to Allentown Art Museum, 1961.

SELECTED EXHIBITIONS
San Francisco 1939, nos. 83, 84; Dayton 1939–40; Sarasota 1980–81, nos. 53, 54.

SELECTED REFERENCES
De Jonge 1938, 26, 89 nos. 77a, 77b; Allentown 1960, 108–11; Eisler 1977, 126–27; Ekkart and Nieuwenhuis 1994.

MOREELSE, *A Member of the Strick Family*

MOREELSE, *The Wife of a Member of the Strick Family*

Having made his reputation with bust-length portraits, Moreelse from 1625–28 used the three-quarter-length format seen here for paired portraits of married couples.[5] The works from this three-year period in which he employed the new type are the only examples of his conventional portraits in which Moreelse allowed any suggestion of setting to share the stage with his sitters. The Allentown portraits, in which the husband and wife face each other but direct their eyes toward the viewer, are typical of this period.

The subjects were identified in 1968, upon discovery of a contemporary copy of the man's head, bearing a four-line inscription and the coat of arms of the Strick family of Utrecht (*fig. 1*).[6] A similar coat of arms and a four-line inscription had been removed from the upper left corner of the Allentown male portrait.[7] The inscription on the copy names "Ian Strick" and describes the accomplishments of Johan Strick (1566–1604), secretary to the Provincial Council of Utrecht. Because Moreelse's Allentown painting, the source for the copy, is dated 1625, the inscription referring to Johan Strick can apply to the male figure shown only if it is a posthumous portrait. This is unlikely in view of the costume, which is consistent with fashions of the 1620s.

The portrait may be of one of Strick's three sons, although the eldest, Adriaan (1578–1623), and his wife, Cornelia, were too old to be the sitters in the Allentown paintings.

fig. 1

Anonymous artist. *A Member of the Strick Family*. After 1625. Oil on canvas, 26 ¼ x 21 ½ in. (66.6 x 54.5 cm). Private collection

More than twenty years later Johan (1583–1648) and his wife, Beatrix (1595–1655), were portrayed by the Utrecht artist Jan van Bijlert (*figs. 2, 3*). The lack of close resemblance between the pairs of portraits—especially the male ones—is not surprising given the aging of the sitters. The youngest son, Dirck Strick (1592–1633), and his wife, Henrica Ploos van Amstel, were identified as the subjects in 1968, but without full explanation.[8]

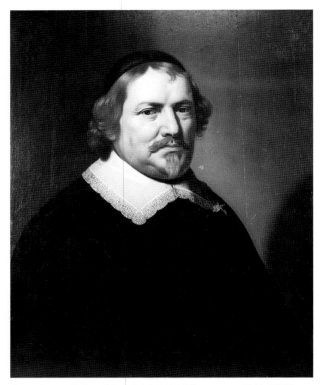

fig. 2 Jan van Bijlert. *Johan Strick*. 1647. Oil on canvas, 73 ⅛ x 22 ¾ in. (73.2 x 57.7 cm). Private collection

Two factors slightly favor the assignment of the son Johan as the sitter of the male portrait. First is the inscription on the copy (*fig. 1*), which identifies the figure as Ian (Jan, Johan) Strick. As we have seen, however, that inscription describes the family patriarch rather than one of his sons and as such is questionable as a tool for identification even though the two men shared the same first name. Second, of the sons who survived into adulthood, Johan Strick is the one who built the family manor house at Linschoten; his offspring became the "Strick van Linschoten" family, which retained possession of the portrait copy shown in *fig. 1*.

Whatever the exact identities of the sitters, there is no doubt that this sedate couple was consciously displaying their wealth by wearing lavishly expensive costumes.[9] Although the severe Spanish fashion for sober black garments that hid the figure still prevailed in the Netherlands, wealthy burghers found ways to adorn themselves within the narrow restrictions, embellishing fine black silks and satins with pattern and embroidery for a luxurious decorative effect. The husband wears a satin doublet beneath a padded *rockgen*, a jacket with trailing sleeves that was fashionable in the late sixteenth and early seventeenth centuries. A black cape gathered over his left arm and hanging stiffly at his side adds bulk and presence to the already

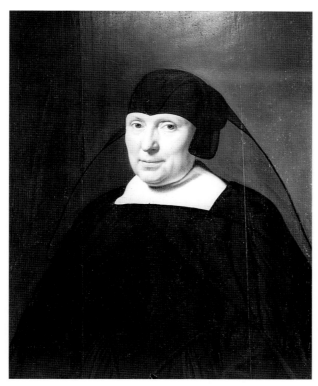

fig. 3 Jan van Bijlert. *Beatrix Gybels*. 1650. Oil on canvas, 28¹⁵⁄₁₆ x 23¼ in. (73.5 x 59 cm). Private collection

impressive figure. The glossy, somber costume is set off by crisp white accents: a loosely pleated ruff trimmed with fine bobbin lace, and starched, lace-bordered cuffs. His gauntlets are decorated with gold braid.

The wife also is garbed fashionably, in a damask dress with a matching *vlieger*—the open, sleeveless overgarment pinned in place at her waist. Her cambric cap and cuffs are trimmed with bobbin lace in an alternating fleur-de-lis pattern, and she wears a flamboyant cartwheel ruff. A scalloped stomacher embroidered with a floral motif in gold thread relieves the black expanse of her dress. Her gloves have scalloped cuffs also embroidered with flowers.

The presentation of the couple is well within the conventions of early-seventeenth-century portraiture. The minimal setting provides just enough information to enforce the sitters' traditional roles within society: the man stands assertively, hand on hip. On the table, his hat serves as a reminder of activity in the outside world of commerce. The woman, with her hand resting on a table, symbolically attaches herself to the world of the home.[10] The richly decorated gloves held by both husband and wife provide a unifying link between the figures and may be a marital symbol.[11]

C.I.

1. De Jonge 1938 is still the standard monograph on Moreelse and is the source for the biography presented here. Erik N. Domela Nieuwenhuis is preparing a doctoral dissertation on the artist. I am grateful for his comments on a draft of this entry.

2. Van Mander 1604/1936, 353.

3. See cat. 22 for more on this gift.

4. De Jonge 1938, 13, 62.

5. See De Jonge 1938, nos. 61–74.

6. F. G. L. O. van Kretschmar letter of October 22, 1968, on file at the Stichting Iconographisch Bureau and cited in Eisler 1977, 126, 127. The female portrait apparently had no coat of arms.

7. The remains of the shield and inscription are visible in an X-radiograph on file at the Photo Archives, National Gallery of Art, Washington (erroneously identified as an infrared photograph in Eisler 1977, 126 n. 1). I am grateful to Jerry Mallick of the National Gallery for making the photograph available to me.

8. See n. 6 above. No portraits of Dirck Strick or Henrica Ploos van Amstel are known, so it is impossible to confirm the identification based on visual evidence. I am most grateful to Mrs. Karen E. Schaffers-Bodenhausen, Director of the Stichting Iconographisch Bureau, for sharing her research on this complex question.

9. For general remarks on seventeenth-century costume in the Netherlands see the excellent essay by Du Mortier in Washington 1989–90, 45–60.

10. This traditional opposition between male/outside and female/inside was expressed in the placement of figures and in details of the domestic setting in the first great marriage portrait of the Northern Renaissance, Jan van Eyck's *Arnolfini Wedding* (National Gallery, London), as pointed out by Smith (1982, 45).

11. For marital symbolism of gloves and other garments, see Smith 1982, 72–81, and Bianca M. du Mortier, "Costume in Frans Hals," in Washington 1989–90, especially 47–48. See also Du Mortier 1984.

HENDRICK TER BRUGGHEN

Utrecht or The Hague 1588(?)–1629 Utrecht

Documentary evidence indicates that Ter Brugghen was born in either *Utrecht or The Hague, where his father held administrative posts with the Court of Utrecht and the Court of Holland.*[4] *Seventeenth- and eighteenth-century sources state that he was a pupil of the painter Abraham Bloemaert in Utrecht before traveling to Italy. This journey probably took place sometime around 1604, since near-contemporary sources record that Ter Brugghen lived in Rome for ten years and that he did not return to Utrecht until late 1614 or early 1615.*[5] *His earliest dated work is from 1616, around the time he is first listed as a member of the artists' guild in Utrecht.*[6] *There is some evidence that he may have made a second trip to Italy between 1619 and 1621.*[7] *By 1622 (and perhaps as early as 1620) he was working closely with the painter Dirck van Baburen, who had recently returned from Italy. Ter Brugghen enjoyed a successful career in Utrecht and the respect of his peers until his death on November 1, 1629.*[8]

Ter Brugghen was the first Dutch artist of his generation who went to Italy and returned with a style that was based on a personal interpretation of the manner of Caravaggio and the Roman Caravaggisti such as Bartolomeo Manfredi, Orazio Gentileschi (see cat. 14), and Carlo Saraceni, as well as other Italian masters like the Bassano.[9] *These Italian influences became more evident in his work following the return from Italy of his Utrecht colleagues Honthorst (see cat. 22) and Baburen around 1620. The impact of Caravaggio and his Roman and Utrecht followers is revealed in Ter Brugghen's use of half- or three-quarter-length figures set in a shallow space against a dimly lit or dark background, the manner in which his figures fill up nearly all the space in his compositions, and his understanding of the dramatic and emotional possibilities of light and shadow. However, this influence is almost always filtered through Ter Brugghen's understanding of northern artists like Lucas van Leyden, Aertgen van Leyden, Dürer, and Grünewald. The melding of these northern and southern idioms, together with Ter Brugghen's superior artistic skills, enabled him to create works that are unique in their delicate rendering of soft opalescent light and half-light, sensitive color harmonies, and subtly rendered facial expressions.*

21

David Praised by the Israelite Women

1623
Oil on canvas, 23 3/16 x 41 1/2 in.
(81.8 x 105.3 cm)
Inscribed at the bottom of the sheet
of music: *HTBrugghen 1623*[1]
North Carolina Museum of Art, Raleigh
60.17.66

PROVENANCE
Possibly Don Eugenio L. de Bayo, New York; possibly his sale, American Art Association, New York, December 12, 1928, lot no. 83 (as Gasper Pieter Verbrugghen, *The Concert*);[2] with Tomás Harris, London;[3] with Durlacher Brothers, New York, by 1946 (as Baburen); Samuel H. Kress Foundation, New York, 1948 (K1542); gift to the North Carolina Museum of Art, 1960.

SELECTED EXHIBITIONS
New York 1946, no. 14 (as Baburen); Dayton 1965–66, no. 3.

SELECTED REFERENCES
Pauwels 1951, 154; Longhi 1952, 55; Nicolson 1956, 107; Nicolson 1958, 41, 82–83 no. A50; Nicolson 1958A, 86 n. 2; Gerson 1959, 318; Raleigh 1960, 15–16, 134–35; Nicolson 1960, 469; Judson 1961, 347; Minott 1962; Slatkes 1965, 67 n. 44, 94, 153; Stechow 1965, 46–49, 61; Van Thiel 1971, 112, 137–38; Eisler 1977, 128–30; Nicolson 1979, 98; Utrecht 1986–87, 109–10; Boston 1992, 129.

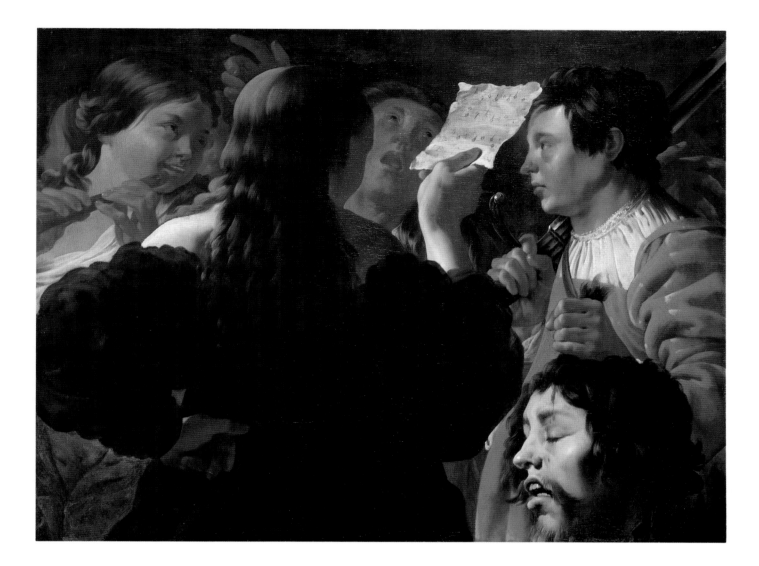

TER BRUGGHEN, *David Praised by the Israelite Women*

The theme of David being praised with song and music would have been particularly appealing to Ter Brugghen, who portrayed singers and musicians (including one paint-

fig. 1 Lucas van Leyden. *David Praised by the Israelite Women.* c. 1514. Engraving, 4⅛ x 3¼ in. (105 x 83 mm)

ing depicting the aged King David singing and playing a harp) in approximately one-third of his surviving works. The specific subject of this painting is derived from two passages in 1 Samuel (17:54, 18:6–7) that describe the joyful celebration of the Israelite women at David's triumph over the Philistines and their champion, the giant Goliath:

> David took the Philistine's [Goliath's] head and brought it to Jerusalem. . . . When the men were returning home after David had killed the Philistine, the women came out from all the towns of Israel to meet King Saul with singing and dancing, with joyful songs and with tambourines and lutes. As they danced, they sang: "Saul has slain his thousands, and David his tens of thousands."

The theme was popular with sixteenth- and seventeenth-century artists, who usually emphasized the pageantry of the celebration and the triumphant jubilation of David and the women.[10] In contrast to this tradition Ter Brugghen has rendered the theme in more sober terms, reducing his composition to four primary figures set against a dim, undefined background and giving David a thoughtful, even troubled expression. The celebratory nature of the episode has been replaced by a sense of foreboding, because this public praise of David only served to arouse King Saul's envy:

> Saul was very angry; this refrain galled him. "They have credited David with tens of thousands," he thought, "but me with only thousands. What more can he get but the kingdom?" And from that time on Saul kept a jealous eye on David. (1 Samuel 18:8–9)

Saul's subsequent persecution of David is chronicled throughout the rest of 1 Samuel.

Precedents for Ter Brugghen's depiction of David's pensive, brooding expression are found in earlier treatments of the theme that would have been familiar to him. One of these is Lucas van Leyden's engraving (*fig. 1*), executed about 1514.[11] As in Lucas's composition Ter Brugghen's figures wear early-sixteenth-century costumes, his thoughtful David shoulders Goliath's heavy sword, and the giant's carefully rendered head dangles from David's other hand.[12] The figure of David in Caravaggio's *David Holding the Head of Goliath* (Borghese Gallery, Rome), painted in Rome about 1605–6 (when Ter Brugghen was probably in the city), is characterized by a similar brooding attitude.[13] The head of Goliath in the Borghese painting was considered by early biographers to be a self-portrait of Caravaggio. More recent writers have proposed the same hypothesis for the Ter Brugghen painting, based on a perceived similarity between the features of his Goliath and those represented in a posthumous portrait of Ter Brugghen, engraved sometime before 1708 (*fig. 2*).[14]

fig. 2

Peter Bodart, after a lost drawing by Gerard Hoet I. *Portrait of Hendrick ter Brugghen.* Before 1708. Engraving

Ter Brugghen's skills as a storyteller and a composer are clearly evident in *David Praised by the Israelite Women.* He has purged the work of extraneous embellishment—including any indication of a setting—communicating the story in a kind of narrative shorthand through the subjects' expressions and gestures. The four main figures are tightly linked

across the shallow, spherical space by their gazes and gestures and by the play of light and shadow. Two others, only partly discernible, are crowded into the background, one turned toward her unseen companions outside of the composition. This congestion enables the artist to suggest the throng of celebrating women "from all the towns of Israel" described in the biblical passage. The tight circular nexus of figures may have been influenced by Dirck van Baburen's *Crowning with Thorns* (Rijksmuseum Het Catharijneconvent, Utrecht), painted about 1622, when Ter Brugghen and Baburen were working closely together and perhaps even sharing a studio.[15] The composition of *David* also relates to Ter Brugghen's *The Unequal Pair: Mercenary Love* (private collection), in which a background figure holding a glass and beaker closely corresponds to the woman with outstretched hands in the Raleigh picture.[16]

At least two other versions of the *David* are known.[17] At one time the Kress painting was misidentified as the work in the Muzeul Brukenthal, Sibiu, Romania, which is dated

fig. 3 Hendrick ter Brugghen. *David Praised by the Israelite Women.* Formerly Eugenio de Bayo Collection

1623.[18] The latter is clearly inferior in quality to the Kress painting, and legitimate doubts have been raised concerning the viability of its attribution to Ter Brugghen. Another version, in the Centraal Museum Utrecht, is a weak copy.[19] Nicolson cited still another version, formerly in the Eugenio de Bayo collection and sold in New York in December 1928 (*fig. 3*). It is quite possible that this work is identical with the Kress painting, which was consigned for sale in November 1928, according to an old label that was once attached to the verso.[20] If the two versions are one and the

same, then the Kress painting was the first picture by Ter Brugghen to come to America; even if this is not the case, at the time of its purchase by the Kress Foundation in 1948 it was one of the first paintings by the artist to be acquired for an American collection.[21]

D.S.

1. At some earlier time in the painting's history the signature was altered to read "Baburen," which partially explains the misattribution of the work when it was exhibited at Durlacher Brothers, New York, in 1946. The original signature was uncovered when the painting was cleaned in 1948. It should be noted that two other versions of the work (see nn. 18, 19 below) also once were attributed to Baburen.

2. Catalogue, American Art Association, New York, December 12, 1928, lot no. 83 (illustrated), as Gasper Pieter Verbrugghen, *The Concert* (*fig. 3*). The unexpected title derives from the fact that the head of Goliath had been painted out (or was possibly omitted altogether). The status of this painting is difficult to ascertain from the poor-quality illustration in the sales catalogue. It is possible, however, that the Kress *David* is identical with the De Bayo painting; an old label from the Kress painting indicates that it was consigned for sale on "11/20/28."

3. In a letter from the firm of Durlacher Brothers that is now in the North Carolina Museum's files, the London dealer Tomás Harris stated he had acquired the painting from the collection of Baron Brukenthal, Hermanndstadt, Romania. This is incorrect, since the Brukenthal version is still in the Muzeul Brukenthal, Sibiu, Romania; see n. 18 below.

4. Bok and Kobayashi 1985, 7–34. The evidence for the date of Ter Brugghen's birth is discussed in Houck 1899, 350–51, and is summarized in MacLaren and Brown 1991, I, 60, 62.

5. Sandrart 1675/1925, II, 308; Houbraken 1718, 1719, 1721, I, 133; summarized in MacLaren and Brown 1991, I, 60–61. In a document of 1615 (Bok and Kobayashi 1985, 25 doc. 17) Ter Brugghen and the artist Thijman van Galen testified that they had "exercised their art in Italy during some years [*gettelicke jaren*]." It does seem somewhat unlikely, however, that Ter Brugghen would have undertaken such a journey when he was only fifteen or sixteen.

6. The *Supper at Emmaus* (Toledo Museum of Art) and the *Saint Peter in Prayer* (Centraal Museum Utrecht) are both dated 1616. The document listing Ter Brugghen in the accounts of the Utrecht Guild of Saint Luke in 1616–17 is transcribed in Bok and Kobayashi 1985, 26 doc. 18.

7. Schuckman 1986, 7–22.

8. Tax and real-estate archival documents indicate that Ter Brugghen was a man of some wealth; see Bok and Kobayashi 1985, 11–12, 28–29. Some indication of Ter Brugghen's stature as an artist among his peers is provided by a statement traditionally attributed to Peter Paul Rubens, who while traveling in the Netherlands in 1627 is said to have commented that "looking for a painter [in Holland] he had found but one, namely Henricus ter Brugghen."

9. Longhi's 1927 article remains one of the best discussions of the influence of Italian art on Ter Brugghen.

10. More than sixty examples by sixteenth- and seventeenth-century artists are cited by Pigler (1956, I, 134–36). The Dutch people in the seventeenth century closely identified themselves with the people of Israel, and to them David personified their struggle against the "Goliath" of the Spanish monarchy; a lively discussion of this attitude appears in Schama 1987, 94–125. Eisler (1977, 129) notes that the artist Jacques de Gheyn played the role of the triumphant David in the Amsterdam *Rederijker's* pageant held in honor of Prince Maurits in 1594.

11. In addition to the print illustrated here (Bartsch 26), Lucas van Leyden made another version of the same theme that was copied in 1600 by Jan Saenredam (Bartsch 109), whose print, in turn, was copied by Pieter de Jode (Hollstein 1949–92, 10, 242 n. 63) and by C. van Sichem (Hollstein 1949–92, 10, 242 n. 66). In his review of Nicolson's monograph on Ter Brugghen, Judson (1961, 347 under A50) discusses several similarities between Lucas's print (Bartsch 26) and Ter Brugghen's painting. The massing of the women (one of whom sings from a sheet of music) and the position of the pensive figure of David in Saenredam's copy after Lucas's print are echoed in Ter Brugghen's composition.

12. Judson 1961, 347.

13. Illustrated and discussed in Friedlaender 1955/1972, 202–3 pl. 40.

14. See Minott 1962. There are two reasons why Minott's interesting and provocative hypothesis must be considered with caution. The first is the "distressingly posthumous" (as Nicolson described it) date of Bodart's engraving, which was based on a lost drawing probably dating from the 1690s or the early years of the eighteenth century. This drawing, in turn, may have been based on an earlier portrait, now lost, or perhaps on the recollections of Ter Brugghen's son Richard, who was only eleven years old when his father died; in either case, the relationship between Ter Brugghen's actual features and Bodart's engraving is tenuous at best. The equally tenuous second factor is that the similarity between the face depicted in Bodart's engraving and that of Goliath in the painting is a matter of personal judgment; the similarity is not particularly evident to this writer. Barry Hannegan (in a note in the North Carolina Museum's file) has suggested that "both David and the head of Goliath are based on the same model, whether that might or might not have been the artist." This similarity seems more generic—based on a Ter Brugghen type— than specific.

15. See Baburen's painting in Slatkes 1965, no. A17, fig. 16, 64, 94; also Utrecht 1986–87, 182–84 no. 35.

16. For the *Unequal Pair: Mercenary Love*, see Nicolson 1958, 94–95 no. A64; Utrecht 1986–87, 109–12 no. 14; and Boston 1992, 129–30 no. 16. The compositional similarities between this painting and the *David* are so strong that Nicolson (1960, 169) revised his original dating of the *Unequal Pair* from circa 1625–28 to a date closer to 1623. Nicolson noted that Ter Brugghen's *Unequal Pair* was closely related to two drawings that depict an old man in a turban offering money to a young woman; one of the two drawings (both of which are in the Rijksprentenkabinet, Amsterdam) is reproduced in Utrecht 1986–87, 109–10.

17. For a discussion of the multiple versions and copies of paintings by Ter Brugghen, see Nicolson 1957, 193–203.

18. Oil on canvas, 31½ x 40½ in., inv. no. 45; see Brukenthal 1964, no. 52, 17, illustrated; also illustrated in Schneider 1933, pl. 21b. The painting, which had been in the possession of the Brukenthal family before 1790, had previously been attributed to both Honthorst and Baburen before Longhi (1943, 57 n. 79) recognized it as a possible copy after a youthful work by Ter Brugghen. Nicolson (1958, 83 under no. A50, under "Literature") conflated this version with the Kress painting (see n. 9 above). Longhi (1952, 55) was the first to recognize the superior quality of the Raleigh painting.

19. Utrecht 1952, no. 8, pl. 26, as Baburen.

20. The De Bayo painting (see n. 2 above) was first noted by Nicolson. The possible identification of this painting with the Raleigh painting is hampered by the poor quality of the illustration in the sales catalogue, which is the only known reproduction of the picture. The only noticeable difference between the De Bayo painting and the present work is the absence of the head of Goliath, which simply could have been overpainted at an earlier date and uncovered sometime between 1928 and 1946. The old label on the verso has been detached from the canvas and is now in the curatorial file of the painting in the North Carolina Museum of Art.

21. The *Luteplayer* formerly in the Morris Kaplan collection in Chicago (Nicolson 1958, 110 no. B78) was purchased shortly after 1940, when it was exhibited at the New York World's Fair. The *King David Playing the Harp* (Nicolson 1958, 108–9 under no. A77) was acquired by the Wadsworth Atheneum in 1942. The sublime *Saint Sebastian Tended by Saint Irene*—a work offered to the Kress Foundation, which unfortunately declined to purchase it—was acquired by Wolfgang Stechow for the Allen Memorial Art Museum at Oberlin College in 1953. For the rediscovery of Ter Brugghen in this century and the collecting of his work in America, see Nicolson 1958, 39–42; and Stechow, in Dayton 1965–66, 7.

GERRIT VAN HONTHORST

Utrecht 1590–1656 Utrecht

Honthorst was born into a family of Utrecht painters and received his early training from Abraham Bloemaert (1564–1651). More significant for Honthorst's later career, however, was a ten-year sojourn in Italy, where the works of Annibale Carracci, Domenichino, and especially Caravaggio made a deep impression on the young artist. Honthorst worked in Rome for important church officials and private patrons, including the Marchese Vincenzo Giustiniani, the well-known collector and patron of Caravaggio. He earned the nickname "Gherardo delle Notti" for his dramatically lit nocturnal scenes.

Honthorst returned to Utrecht in 1620, married, and was registered in the painters' guild in 1622. He served as dean of the guild four times before 1630 and also formed a kind of academy to train artists. Along with two other Utrecht artists who had been to Italy, Hendrick ter Brugghen (see cat. 21) and Dirck van Baburen, Honthorst was responsible for disseminating the Caravaggesque style in the northern Netherlands. For most of his later career, however, Honthorst diluted the tenebrist manner of his early works and accommodated the more academic tastes of his many noble patrons, including Charles I of England, Christian IV of Denmark, and the Stadholder Frederick Hendrick of the House of Orange. In 1637, after years of court service, Honthorst was given the title of court painter to the stadholder. His later oeuvre is dominated by decorous history paintings and royal portraits.

22

*Shepherdess Adorned
with Flowers*

1627
Oil on canvas, 43 $\frac{7}{16}$ x 39 $\frac{13}{16}$ in.
(110.6 x 101.1 cm)
Signed on shepherdess's crook:
G v Honthorst fe 1627
Seattle Art Museum 61.156

PROVENANCE
Stadholder Frederick Hendrick, The Hague (possibly);[1] sale, C. Groeninx van Zoelen, Rotterdam, June 25, 1800, lot no. 23 (possibly);[2] sold to Van der Poll (possibly); Colonel Petrie Waugh, Brownsea Castle, Dorset, sold 1857;[3] Robert Kerley, Bournemouth, Dorset, sold April 24, 1885, lot no. 166; sale, Sotheby's, London, April 26, 1950, lot no. 124;[4] sold to Dr. Alfred Scharf, London; with Paul Cassirer, London, 1950; Grete Ring, London, by 1953 (d. 1953);[5] with Arcade Gallery, London, by 1954;[6] with M. Knoedler & Co., London and New York, 1954; Samuel H. Kress Foundation, New York, 1954 (K2059);[7] on loan to Seattle Art Museum, 1954; gift of the Kress Foundation to Seattle Art Museum, 1961.

SELECTED EXHIBITIONS
Indianapolis 1958, no. 83; Washington 1961–62, no. 44; Denver 1971, 88–89.

SELECTED REFERENCES
Nicolson 1952, 251; Seattle 1954, 58; Millar 1954, 39 n. 14; Judson 1959, 101, 191, 218–19 no. 142; Kettering 1983, 90, 93, 183; Utrecht 1993–94, 80, 177, 180, 182.

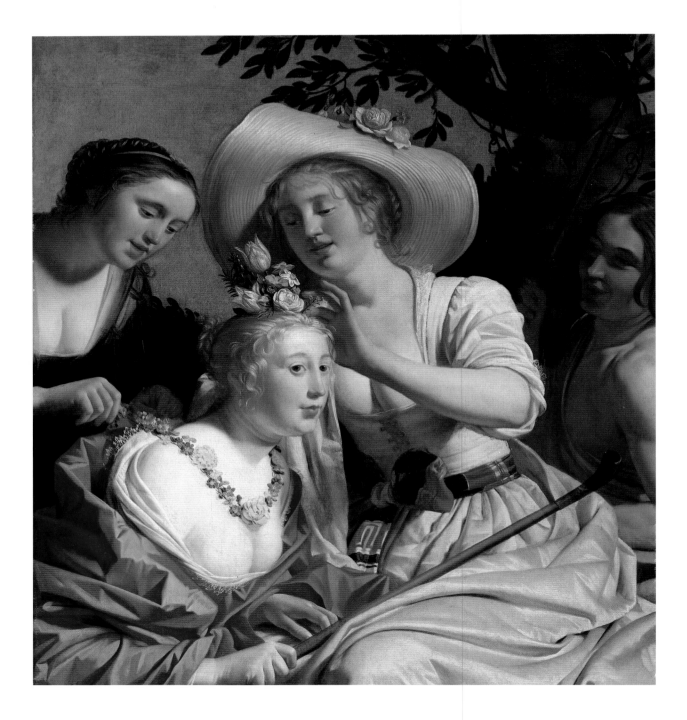

HONTHORST, *Shepherdess Adorned with Flowers*

The Arcadian movement, whose celebration of tranquil rural life was rooted in the works of such classical writers as Theocritus and Virgil, had been revived during the early Renaissance in the courtly centers of Italy, France, and England. In Italy, especially, the movement gained ground, and shepherds and shepherdesses became stock characters in romances and dramas that sought to contrast idealized bucolic situations with the corruption and artificiality of the city and court. Works such as Torquato Tasso's *Aminta* (1573) and Giovanni Battista Guarini's *Il pastor fido* (1590) had international resonance, providing subject matter for artists and inspiration for other writers. It was largely under the influence of works such as these that the first Dutch pastoral plays were written in the early seventeenth century.[8] Not surprisingly, the genre was heavily promoted by the aristocracy, who were familiar with pastoral art and literature through their close connections with other European royal houses. At the time of their marriage in 1625, the Prince of Orange, Frederick Hendrick, and Amalia van Solms seem to have shared a taste for the fashionable style. The provincial assembly of Utrecht acknowledged this by selecting two pastoral paintings for Amalia van Solms in 1627.[9] The stadholder and his wife did much to further the genre through their own collecting, refurbishing of court residences, and building and decorating campaigns, which frequently drew on pastoral imagery.

Pastoral art represented a restorative escape from everyday concerns and responsibilities and a relaxation of the strict moralizing that was otherwise prominent in much of Dutch art and literature of the period. Shepherds were idealized as closer to elemental nature, thus allowed to indulge natural sensuous desires and to freely pursue love and pleasure. These smiling, carefree characters occupied themselves with activities no more strenuous than making music or weaving flower garlands; and their world was considered to be pleasant, refreshing, sweet, and leisurely. In the Seattle painting, for example, two shepherdesses are occupied in adorning a third girl, who stares dreamily ahead as she loosely clutches her staff. A tanned, bare-chested shepherd is the laughing observer to the romantic ritual.

Pastoral paintings frequently carry erotic messages. Fruit and musical instruments, for example, are often cheerfully brandished by figures as coy sexual references (*fig. 1*). The low-cut costumes of many shepherdesses, which sometimes completely reveal their breasts, derive from a literary and visual tradition associating the figures with the courtesans of contemporary life.[10] While such specific associations may not finally explain the Seattle painting, its ample display of décolletage and the traditional significance of

the floral chaplet suggest an amorous theme. Floral wreaths plaited by shepherdesses were a staple of pastoral literature and art. Originally emblems of innocence, they took on sexual significance through popular custom: the willingness of a young woman to give up her virginity could be signaled by bestowing a flower wreath on her lover. In this way garlands came to be associated with both brides and pleasure seekers alike. In poetry and plays they are bestowed by lovers of both sexes.

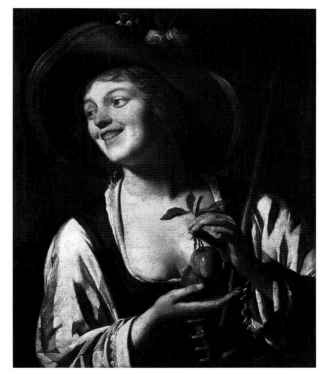

fig. 1 Gerrit van Honthorst. *Shepherdess*. 1626. Oil on canvas, 30⅝ x 25 in. (77.8 x 63.5 cm). Private collection, England

Honthorst presents a bucolic coronation not as an expression of love offered but as a ritual in preparation for love; the shepherdess's thoughtful expression and the gentle attention of her companions suggest that the girl is a bride (or is at least playing at being a bride).[11] The ivy twining around the tree was a familiar symbol of marital fidelity and further enforces the notion of romantic commitment.[12] As Kettering has discussed, these literary connections are general and do not appear to be specifically associated with a particular pastoral play or poem.[13] Honthorst and his Utrecht colleagues painted many half-length pastoral groups that have only the broadest literary allusions and that seem designed primarily for decoration.

The close-up view invites the eye to linger on the attractiveness of the figures and the contrast between smooth flesh and rustling taffeta and silk. A lovely dialogue between

pink and yellow is established in the costumes of the two principal shepherdesses. In the late working stages of the painting Honthorst added the yellow drapery that falls behind the face of the kneeling shepherdess to provide a more graceful backdrop for her head.[14] This drapery also creates pleasing golden reflections on her throat. Although the blond tonality of the picture is distinct from the coloration of Honthorst's earlier, darker period, the mastery of strong light and shadow, as well as the smooth brushwork, are legacies of his Caravaggesque training. The strong, oblique light lends a theatrical quality, and the laurel tree against the ocher ground resembles a painted backdrop

fig. 2 Gerrit van Honthorst. *Pastoral Scene*. 1629. Oil on panel, 44½ x 37⅜ in. (113 x 95 cm). Museum der bildenden Künste, Leipzig

more than a plausible outdoor vista. Such patent artificiality in a work that ostensibly celebrates natural rural life is fully consistent with the playful aspects of the pastoral genre as a whole.

A panel of 1629 in Leipzig (*fig. 2*) has often been considered in conjunction with the Seattle picture.[15] Though the two pastorals are painted on different supports they are close in size and format, with a tight pyramidal group of figures engaged in a single activity, in the case of the Leipzig picture singing and making music. The middle shepherdess is dressed similarly to the kneeling figure in the Seattle painting, and the multicolored shawl appears in both works. A third, related picture—an *Allegory of Spring* (Gallery Arnoldi-Livie, Munich)—was mentioned by Van den Brink.[16] The Seattle and Leipzig pictures are both candidates for the pastoral that was cited in the 1632 inventory of the living quarters of the stadholder and his wife.[17] The citation mentions a chimneypiece showing shepherdesses; because no shepherd is mentioned, Van den Brink suggested that the Leipzig picture was the more likely reference.[18] Inventories are rarely perfectly precise in their descriptions of subject matter, however, and the possibility that the Kress canvas is the work mentioned should not be dismissed. Whatever its original destination, the picture certainly was meant to be hung above eye level, a vantage point that imparts a greater degree of three-dimensionality to the scene and more clearly articulates the space among the figures.

C.I.

I am grateful to Dr. Peter van den Brink for reading an early draft of this entry.

1. The 1632 inventory of the stadholder's living quarters, cited in Kettering 1983, 183 no. 223, records the following work: "Eene schoorsteenmantel vergult op eenen rooden lacken gront, daerinne een stuck schilderie, verciert met harderinnekens door Honthorst gemaeckt" (a chimneypiece in gilt over red lacquer frame, with shepherdesses by Honthorst). It is possible that the entry refers to the Seattle work or to a similar pastoral scene in Leipzig; see text, last paragraph, and *fig. 2*.

2. The work is recorded as measuring 43 x 39 *duim* (116.1 x 105.3 cm) and is described: "Een Herderin, welcke als een Bruid met Bloemen word gesiert, door twee bevallige Speelgenoten, het welk een Herder met genoegen beschowd; dit Stuk is van een aangenaam coloriet" (A shepherdess who like a bride is decorated with flowers by two charming playmates, which a shepherd views with delight; this piece is of a pleasant color); quoted by Judson (1959, 218–19), who gives the lot no. as 32.

3. Judson (1959, 219) lists Brownsea Castle and Colonel Waugh as two separate owners.

4. Judson (1959, 219) and Eisler (1977, 131) cite Lady Phyllis Benton as the owner; but according to a note from the Getty Provenance Index in the curatorial file of the Seattle Art Museum, the sale was titled the Benson sale, and Benson lots were limited to nos. 127–31.

5. Judson 1959, 219; Eisler (1977, 131) lists her name with the Paul Cassirer Gallery as one owner; note from the Getty Provenance Index in the curatorial file, Seattle Art Museum.

6. Getty Provenance Index, note in curatorial file, Seattle Art Museum.

7. The painting was offered as a possible addition to the Seattle collection before it was purchased by the Kress Foundation; in a letter of May 12, 1954, to Seattle's director Richard E. Fuller, Guy Emerson of the Kress Foundation wrote, "I am struggling hard to complete the necessary work relative to our openings in Denver, Seattle and San Francisco. . . . I am enclosing a photograph of a painting by our old friend Honthorst which we all saw at Knoedler's last week and like very much. Mr. Kress thought that it ought to go to the National Gallery and Walker and Modestini felt that it was the best Honthorst they had seen in America. It is gay and fresh and full of color and life." A week later Emerson wired Dr. Fuller that the picture had been purchased and assigned to Seattle.

8. Theodore Rodenburgh's *Trouwen Batavier* (completed 1601–2, first published 1617) and Pieter Cornelisz. Hooft's *Granida* (written 1605, published 1615) are the first two pastoral plays by Dutch authors.

9. Kettering 1983, 1–2. See also cat. 19.

10. See, for example, Kettering 1983, figs. 12, 29, 31, 48. The immediate visual source for this association is the Venetian half-length portrait of courtesans, popularized by Titian and his contemporaries in the sixteenth century. See Kettering 1983, 52–55.

11. Suggested by Kettering (1983, 94).

12. De Jongh and Vinken 1961, 118–20, 125–27; Demetz 1958.

13. In one of the most famous pastoral plays, *Il pastor fido* (first published 1589), Guarini described an exchange of floral crowns between his protagonists Amarillis and Mirtillo, but the Seattle painting does not correspond with the narrative.

14. Because the oil medium becomes transparent over time, these forms have become visible again as a pentimento.

15. Kettering 1983, 90, 93, 183; Utrecht 1993–94, 180–82 no. 29.

16. Utrecht 1993–94, 177–79 no. 28.

17. See n. 1 above.

18. Utrecht 1993–94, 180–82.

JAN MIENSE MOLENAER

Haarlem c. 1610–1668 Haarlem

The Duet

———◦◦◦———

 The date of the artist's birth is not recorded, but a notarized document dated November 21, 1637, gives his age as about twenty-seven, implying a birth date of around 1610. Nothing is known of Molenaer's training, though it often has been suggested that he was a member of Frans Hals's workshop in Haarlem; the two painters certainly knew each other.[1] After his marriage to fellow artist Judith Leyster in June 1636, the couple moved to Amsterdam, where they probably stayed until 1648. From then until the artist's death, the Molenaer family lived variously in Haarlem, Heemstede, and Amsterdam. Real-estate transactions in these three cities comprise most of the references to the artist from the later period of his life. It was common for artists to support themselves through means other than their art, and this partly explains Molenaer's activity; but it also must have stemmed from his constant tendency to incur debts. Eight years after the death of his wife, on September 8, 1668, he drew up his will and died later that month. He was buried in the Groote Kerk in Haarlem on September 19. An inventory of Molenaer's belongings made on October 10, 1668, records a large collection of paintings.[2]

 Molenaer is known almost exclusively as a genre painter, although he often incorporated portraits in his early works, and he painted religious subjects in the mid- to late 1630s. A number of sophisticated allegories dealing with themes of love and vanity also date from the early part of that decade. This calculated, layered symbolism was not as prominent in his later oeuvre, which was dominated by chaotic scenes of rambunctious peasants that are more coarsely conceived and painted.

c. 1629
Oil on canvas, 26⅛ x 20½ in.
(66.4 x 52.1 cm)
Signed on foot warmer: *I. Molenaer*
Seattle Art Museum 61.162

PROVENANCE
Leroy M. Backus, Seattle; with D. Katz, Dieren, Netherlands, by 1938; with Schaeffer Galleries, New York, by 1948; Samuel H. Kress Foundation, New York, 1954 (K1998); on loan to Seattle Art Museum, 1954–61; gift of the Kress Foundation to Seattle Art Museum, 1961.

SELECTED EXHIBITIONS
Providence 1938–39, no. 31; Indianapolis 1958, no. 52; Allentown 1965, no. 50; Milwaukee 1966, no. 68; Philadelphia 1984, no. 77; Haarlem 1993, no. 29.

SELECTED REFERENCES
Seattle 1954, 66–67; Eisler 1977, 135–36.

MOLENAER, *The Duet*

In this early work Molenaer depicts a genial young couple engaged in a musical duet. While the young woman looks up from her recorder (*bekfluit*), her companion strums a theorbo,

fig. 1 Judith Leyster. *Self-Portrait*. c. 1633. Oil on canvas, 28⅛ x 25½ in. (72.3 x 65.3 cm). National Gallery of Art, Washington

a two-necked lute. The room is bare except for their chairs and a prominently placed foot warmer. By the absence of a detailed setting, the painting avoids the anecdotal quality of many genre pictures, which often present scenes from daily life in painstakingly described domestic interiors. Instead of presenting the viewer with a slice of life, Molenaer creates what is unmistakably a planned display, organized and lit with thoughtful precision and self-conscious élan. At the same time, the close cropping of the composition and the relaxed attitudes of the figures contribute to an unguarded and intimate quality.

These characteristics—the straightforward, close-up portrayal of full-length figures, painted with bravura and shown against a neutral, undefined background—are abundant in the pictures of Haarlem's greatest painter, Frans Hals. The appearance of many of these features in Dutch painting can be traced from the genre paintings of Caravaggio and his Italian followers to the Utrecht Caravaggisti (see cats. 21, 22) and then to artists working in other parts of the Netherlands. At the end of the 1620s, under the influence of these artists, Hals and his circle—his pupil Judith Leyster (who was to become Molenaer's wife in 1636), his brother Dirck, and Molenaer—began to paint pictures showing

half- or full-length figures in unembellished settings, making amused, even gleeful eye contact with the viewer, as though sitter and viewer were joined in conspiracy. These paintings have a sense of improvisation and immediacy; their loose, swift brushwork seems freed by the absence of complicated narrative demands. The saturated colors, sharp lighting, and stationary figures in *The Duet* are also found in Molenaer's *Two Boys and a Girl Making Music*, 1629 (National Gallery, London); the Kress picture probably dates from the same time.

In *The Duet*, Molenaer demonstrates an apparently off-hand, relaxed technique that belies his close attention to details and textures. The smooth wall and floor provide a foil for the briskly painted figures, which are pushed toward the viewer and strongly lit from the left. This powerful oblique light, which Hals also used to great effect, enables Molenaer to display his painterly virtuosity, for example, in his handling of the woman's shimmering green skirt with flashing yellow highlights. In addition to using fluid brushwork, the artist also scraped into the wet paint with a stiff instrument (probably the butt of his brush) to produce areas of fine texture.[3] Finally, in the man's red cape, Molenaer created shadows on the surface of the paint with crisply hatched black brushstrokes, imitating the manner of a draftsman or engraver.

Several scholars have proposed that the couple represents the painter and his future wife, the artist Judith Leyster.[4] The girl bears only a general resemblance to Leyster's cele-

fig. 2 Jan Miense Molenaer. *Artist's Studio*. 1631. Oil on canvas, 35⅓ x 50 in. (91 x 127 cm). Gemäldegalerie, Staatliche Museen Preußischer Kulturbesitz, Berlin

brated self-portrait in the National Gallery of Art, Washington (*fig. 1*), and the male figure can be compared with the grinning, identically garbed painter in Molenaer's *Artist's Studio*, 1631 (Gemäldegalerie, Berlin), a possible

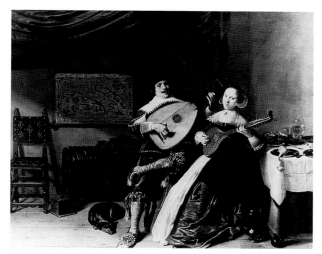

fig. 3 Jan Miense Molenaer. *The Duet*. c. 1635. Oil on panel, 17 x 20 in. (43.5 x 51.5 cm). Collection Peter Eliot, New York

self-portrait (*fig. 2*).[5] This romantic speculation must be tempered, however, by the recognition that the distinction between genre painting and portraiture is especially vague in Molenaer's oeuvre, in part because he was never the most penetrating of portraitists.[6]

Molenaer returned to the theme of the music-making couple several times in the 1630s (*fig. 3*), in part, no doubt, because of the popularity of the traditional association of harmonious love and the musical duet.[7] In his later compositions he devoted more attention to the relation between the figures and the setting. This shift in emphasis, along with the more refined costumes of the sitters, gives the paintings an effect of greater formality than found in the Seattle painting.

Eisler saw the foot warmer as an erotic symbol, but Sutton dismisses this suggestion as out of keeping with the cheerful attitudes of the sitters; he cautions that the commonplace object might have a more mundane meaning.[8] The frequent appearance of a foot warmer in a wide variety of genre scenes by Molenaer suggests that—like so many other objects—its meaning is fluid and depends on the context in which it is displayed. While the foot stove is conspicuous in this painting, it is not giving off heat and its function may be nothing more than it appears—a handy footrest.[9]

C.I.

1. A summary of biographical information, including the publication of some important documents, is found in Hofrichter 1989, 16–21, 81–103. See also the doctoral dissertation by Dennis P. Weller, University of Maryland, 1992 (Weller 1992). I am grateful to Dr. Weller for sharing some of his observations with me and to Dr. James A. Welu for his generosity in sharing prepublication material from the exhibition "Judith Leyster: A Dutch Master and Her World" (Haarlem 1993).

2. Hofrichter (1989, 87–103) transcribes the complete inventory and gives an English translation.

3. This scraping is evident in the hair of both figures, the edge of the man's ruff, the fur trimming the woman's jacket, and the plumes on the man's hat. Though the technique also was practiced by Hals, it is more commonly found in the work of Rembrandt (see cat. 25). See discussion of Hals's technique by Karin Groen and Ella Hendriks in Washington 1989–90, 109–27. For Rembrandt see Rembrandt Corpus 1982–89, I, 31.

4. W. R. Valentiner, quoted in Seattle 1954, 66, followed by Eisler 1977, 135. The inventory of belongings drawn up after Molenaer's death records "two portraits of Jan Molenaer and his wife" (Hofrichter 1989, 89), but this citation is too imprecise to link it with the Kress picture.

5. A similar broad-faced, smiling man appears in two of Leyster's extant works, *Concert*, c. 1631–33 (Hofrichter 1989, pl. IX), and *Carousing Couple*, 1630 (Hofrichter 1989, pl. VI), in which he also wears a nearly identical costume. What appears to be the same costume can also be seen in Leyster's *Serenade*, 1629 (Hofrichter 1989, pl. II).

6. Cynthia Kortenhorst-von Bogendorf Rupprath in Haarlem 1993, 286, cites other paintings that include what appears to her to be the same couple, whom she concludes are not Leyster and Molenaer; see her figs. 29b and 29c.

7. Weller (1992, 27) considers the two figures to represent the artist and his sister. See also Molenaer's *A Young Man Playing a Theorbo and a Young Woman Playing a Cittern*, National Gallery, London (MacLaren and Brown 1991, no. 1293).

8. Eisler 1977, 135–36; Sutton in Philadelphia 1984, 261.

9. Given the frequency with which it appears in Molenaer's paintings, the foot warmer may have been a studio prop. The same may be said for the chair with lion-headed finials and even the costumes of the two figures, all of which the artist and his future wife used in several other paintings (see Kortenhorst-von Bogendorf Rupprath in Haarlem 1993, 286, 288–89).

JAN HAVICZ. STEEN

Leiden 1625/26–1679 Leiden

Jan Steen, known above all for his witty genre scenes, was the son of a prosperous brewer. In 1646, at the age of twenty, Steen enrolled in the University of Leiden, but he probably stayed for only a short time since he joined the newly founded Guild of Saint Luke at Leiden in 1648. He studied with Nicolaes Knüpfer of Utrecht, Adriaen van Ostade in Haarlem, and, finally, the landscape painter Jan van Goyen in The Hague. Though Van Goyen's influence on Steen is not clearly evident, a personal association between the two men is certain, as Steen married the painter's daughter Margaretha in 1649. Shortly after their marriage, the couple settled in The Hague, where they appear to have stayed until 1654. That year, with the help of his father, Steen leased a brewery in the town of Delft, which failed after several years. From 1656–61 Steen settled his growing family at Warmond, near his hometown.

The years 1661–70, when the artist and his family lived in Haarlem, are generally considered to represent the peak of his production. It is during this period that his major genre themes (the Disorderly Household and As the Old Sing, So the Young Chirp) were fully developed, and his early style, dominated by browns and reds, gave way to a cool, satiny effect achieved through the use of thin layers of silvery pinks, blues, and grays. He showed no preference for a single size or support, being equally comfortable with small, highly finished paintings on wood or copper and large canvases. Following the death of his wife in 1669 and the death of his father in 1670, Steen moved his children to his father's house in Leiden. Another business venture, the opening of an inn in 1672, was a failure, and he seems to have confined himself to painting until his death in 1679.

Steen's paintings do not much resemble those of his contemporaries in either technique or approach to subject matter. Whether treating biblical themes or noisy genre scenes demonstrating popular proverbs and sayings, he presents them with idiosyncratic richness, inventiveness, and humor. Chaotic crowd scenes are often depicted as though onstage, and devices such as huge curtains and stock dramatic characters contribute to the theatrical character of his pictures. In a series of amusing, visual anecdotes (often posed by members of his own family), he moralizes without pontificating. The good-natured

24

"Soo de Ouden Songen"

———⊂◉⊃———

c. 1668[1]
Oil on oak panel, 17⅜ x 23⅞ in.
(44.1 x 60.6 cm)
Inscribed at lower left corner: *JSteen*;
on chandelier hanging from ceiling:
SOO D OVDE
Allentown Art Museum, Pennsylvania
61.60.G

PROVENANCE
M. le Chevalier Francottay; his sale, Paris, February 20, 1816, 10–12, lot no. 24 (as *Scène Familière*); M. le Chevalier Erard, Château de la Muette, Boulogne; sold to John Smith, London, 1828 (as *The Hurdy-Gurdy Player*); Baron Verstolk van Soelen, The Hague, 1833; Héris de Bruxelles, Paris, March 25, 1841; Lord Overstone, London, 1846; Sir Robert James Lloyd-Lindsay, Baron Wantage, London (as *Twelfth Night*);[2] by descent to Earl of Crawford and Balcarres 1920; with D. Katz, Dieren, Holland, 1936; Mr. and Mrs. D. Birnbaum, Ten Cate; David Bingham, Hartsdale, New York; with Schaeffer Galleries, New York; Samuel H. Kress Foundation, New York, 1957 (K2185); on loan to Allentown Art Museum, 1960; gift of the Kress Foundation to Allentown Art Museum, 1961.

SELECTED EXHIBITIONS
Manchester 1857, no. 770; London 1909, no. 31; Leiden 1926, no. 35; New York 1945, no. 35; Pittsburgh 1954, no. 40; Washington 1961–62, no. 88; Allentown 1965, no. 74.

SELECTED REFERENCES
Smith 1829–42, 16 no. 51; Van Westrheene 1856, 115–16 no. 71; Waagen 1857, supp., 143–44; Hofstede de Groot 1908–27, I, 34 no. 91; Martin 1954, 82 no. 66; Allentown 1960, 128–31; Eisler 1977, 151–52.

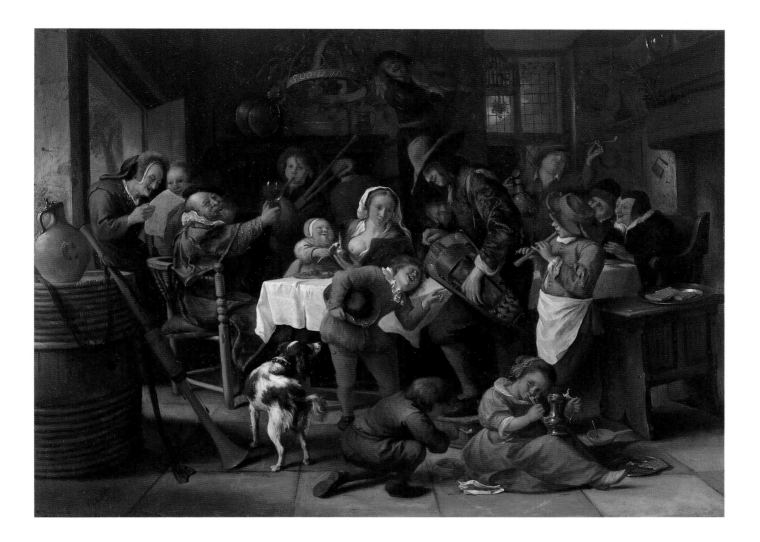

STEEN, *"Soo de Ouden Songen"*

mood of the pictures often appears at odds with the artist's serious intent, and he seems to have relished this contradiction, frequently including his own likeness, grinning or roaring with laughter at the folly of the characters and situations he has portrayed.

As prolific as he was (Hofstede de Groot attributed some eight hundred paintings to him), Steen was periodically in debt, moved often, turned unsuccessfully to other business ventures, and apparently left neither a workshop nor a significant group of followers after his death. Given the large size of his oeuvre, its unevenness of execution is not surprising, and the situation is complicated by forgeries of his work that began to appear already in the eighteenth century. A clear understanding of his output is hampered also by Steen's avoidance of dating his paintings, his frequent repetition of themes, and his ability to work in different idioms at any given time.

In a public house, several generations of merrymakers engage in a spontaneous concert, with singing, flutes, violins, bagpipe, and hurdy-gurdy contributing to a festive air. Although in the nineteenth century the picture was called *The Hurdy-Gurdy Player* because of the tall figure at the center,[3] there is, as usual in Steen's group scenes, no single focus. Rather, a compendium of human behavior is linked less by compositional devices than by shared activity and mood.

On the chandelier suspended from the ceiling the artist has inscribed a clue to the scene, the beginning of the popular aphorism "*soo de ouden songen/soo pijpen de jongen*" (as the old sing, so the young chirp). The proverb, given

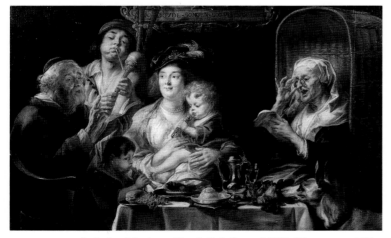

fig. 1 Jacob Jordaens. "*Soo de Oude Songen.*" 1638. Oil on canvas, 46¾ x 74⅞ in. (120 x 192 cm). Royal Museum of Fine Arts, Antwerp

renewed exposure by the widely read author Jakob Cats in his book *Spiegel van de oude en de nieuwen Tijd (Mirror of the Old and New Time)* (1632), urges adults to set a good example for the children who will inevitably follow their

lead.[4] References to gluttony, slovenliness, and immoderate drinking indicate that despite the clear enjoyment of all involved, the adults here are not setting a profitable example.

As in his numerous other versions of the theme (for example, in the Rijksmuseum, Amsterdam, and Gemälde-galerie, Berlin), Steen makes visual puns on the word *pijpen*, which means "to chirp" and "to pipe" and also refers to a pitcher's spout.[5] We see a little girl with the spout of a wine pitcher in her mouth, a boy playing a flute, a young bagpiper blowing on his instrument, and children playing with tobacco pipes—to the chubby baby at the table, the clay pipe is already a familiar plaything.[6] Typically, Steen brings members of his cast of characters into provocative eye contact with the viewer. The appealing, inviting smiles of children and adults make rejection of their behavior difficult. The irony of this dilemma is underscored by the chortling fiddler perched on a ladder at the rear of the room: it is a likeness of the artist himself, gleefully presiding over the display of human folly he has created.[7]

This humorous presentation of an essentially pessimistic theme—the stubborn persistence of human weakness—embodies the approach of Steen's sixteenth-century precursors Hieronymus Bosch and Pieter Bruegel the Elder. These Flemish artists gave visual form to popular literary themes such as the Ship of Fools (Bosch) and the Topsy-Turvy World (Bruegel), in which folly and vanity surpass logic and reason as motivators of human behavior. A more immediate and specific precedent for the Allentown picture is the work of the Antwerp master Jacob Jordaens, who had popularized the "Soo de Oude Songen" theme in paintings beginning from the late 1630s (*fig. 1*).[8] Jordaens presents the theme within the confines of its literal mean-

ing, showing older members of the group singing and two children and a young man blowing on various types of musical pipes.

A survey of Steen's large oeuvre reveals his ability to work in both a highly finished manner, where textures and light effects are carefully rendered, and a much looser, almost caricaturistic style, which conveys expression and personality with a few swift strokes. In this picture both styles coexist. The more fluid approach is seen in the two old women who flank the group of revelers and in the glimpses of landscape through window and doorway. Much more subtly rendered are other details—the earthenware jug at the left, illuminated by an unseen window, a plate of waffles at the right, an attentive dog, and the standing piper in the foreground, whose face is partially hidden by the brim of his red hat.[9] In these passages Steen reveals himself to be a master illusionist with an exquisite awareness of the poetic properties of light. The combination of styles in the picture balances lively, spontaneous animation with suspension of action, expressively supporting Eisler's characterization of the painting as "a complex fusion of gaiety and melancholy."[10]

C.I.

of the Twelfth Night and "Soo de Oude Songen" themes. Eisler (1977, 152) points out that the two artists could have met each other in 1649–51, when Jordaens was in The Hague.

9. This figure calls to mind the three-quarter-length depiction of a flute player by Hendrick ter Brugghen (Staatliche Kunstsammlungen, Kassel), which Steen could have known from his early sojourn in Utrecht.

10. Eisler 1977, 152.

1. Shapley (in Allentown 1960, 128) dates the painting c. 1668, comparing it with Steen's larger painting of the same theme in the Rijksmuseum, Amsterdam. The crowded, close setting and the warm palette dominated by browns and reds are found typically in Steen's small panel paintings of the late 1660s.

2. Cat. 1905, no. 220.

3. Smith 1829–42, 16 no. 51.

4. Jakob Cats, *Spiegel van de oude en de nieuwe Tijd* (1632); 1658 ed., 26.

5. Hofstede de Groot (1908–27, 34) lists fifteen examples of the subject in Steen's oeuvre.

6. Excessive use of tobacco, like indulging in drinking, was seen as a threat to the stability of upright Dutch society. See the enlightening discussion in Schama 1987, 193–201, 203–8.

7. Compare with his self-portrait as a lutenist in the Thyssen Collection, in Gaskell 1990, 163.

8. See also d'Hulst 1982, 168, 179–81. Another subject treated by both Jordaens and Steen is that of *The King Drinks*, which depicts an isolated moment within Twelfth Night festivities, also usually taking place in a crowded public setting. The jovial figure raising his rummer while grinning at the viewer in the Allentown painting can be compared with the king in paintings by Jordaens (d'Hulst 1982, 169, 140, 189), as well as in Steen's painting *The Way You Hear It Is the Way You Sing It* in the Mauritshuis (The Hague 1977, 227 no. 742), which conflates the imagery

Attributed to **Govert/Govaert Flinck**

Kleve 1615–1660 Amsterdam

Of the many artists who were associated with Rembrandt, Govert Flinck was one of his first pupils and the most successful. His ability to imitate the styles of the most fashionable artists of his day and to integrate these styles into his own manner enabled him to take over Rembrandt's position as the leading artist in Amsterdam during the 1640s and 1650s. Flinck's competently painted portraits, histories, and landscapes were designed to accommodate the tastes of his patrons and reveal little trace of the artist's personality. Yet, for this very reason, his paintings reflect the spirit and taste of Amsterdam in his time to a greater degree than the works of any of his contemporaries.

Born on January 25, 1615, Flinck was the son of the bailiff (tax collector) in the town of Kleve (Cleves), part of the Duchy of Brandenburg located near the German border. As a young man, Flinck spent his free time drawing, but his Mennonite father opposed his desire to become an artist because he disapproved of the bohemian life-style that artists reputedly led.[4] This situation changed dramatically, however, when the Mennonite preacher Lambert Jacobsz. came to Kleve. The upright Jacobsz. was also a painter, and around 1629–30 Flinck was allowed to study with him. In the early 1630s Flinck went to Amsterdam, where he became a protégé of Jacobsz.'s friend and fellow Mennonite Hendrick Uylenburgh, who ran a prosperous art studio that, at the time, was dominated by its resident prodigy, Rembrandt van Rijn.[5] A large portion of the activity in Uylenburgh's business was the production of originals, copies, and etchings by, after, and "in the manner of" Rembrandt, and therefore Flinck's early years in Amsterdam would have been spent working closely with Rembrandt.[6] His earliest biographer wrote that Flinck worked as an assistant under Rembrandt for about a year "in order to learn his manner of handling oils and his style of painting," but it is unclear whether this study would have taken place when both artists were working in Uylenburgh's studio or after Rembrandt set out on his own about 1635.[7] In any event, Flinck was soon able to imitate Rembrandt's style so successfully that some of his works were sold as Rembrandt originals.[8] By 1636, when he signed and dated several works, Flinck was probably working independently.

During the 1640s Flinck's career took off rapidly. Aided by his connections with Uylenburgh and wealthy patrons in Amsterdam, many of whom were

25

Young Man with a Sword

———⟨✦⟩———

c. 1633–36
Oil on canvas, 46 9/16 x 38 1/16 in.
(118.4 x 96.7 cm)
Signed and dated, upper right:
Rembrandt/1633
North Carolina Museum of Art, Raleigh
60.17.68

PROVENANCE
Major Archibald William Hicks Beach, Oakley Hall, Hampshire, before 1912–24; his son, William Guy Hicks Beach, Esq., 1924–32; his sale, Christie's, London, June 3, 1932, lot no. 62;[1] with D. Katz, Dieren, The Netherlands, 1933;[2] Mrs. J. C. Hartogh, Arnhem, The Netherlands, c. 1933;[3] sale, Van Marle and Bignell, The Hague, July 1, 1941, lot no. 20; Dr. Tietjen, The Netherlands; with Schaeffer Galleries, New York, 1956; Samuel H. Kress Foundation, New York, 1957 (K2184); gift of the Kress Foundation to the North Carolina Museum of Art, 1961.

SELECTED EXHIBITIONS
London 1912, 24 no. 81 (as Rembrandt, *Portrait of a Cavalier*, signed and dated 1635); Raleigh 1956, no. 7 (as Rembrandt); Indianapolis 1958, no. 8 (as Rembrandt); Washington 1961–62, no. 77 (as Rembrandt); Montreal 1969, 27, 64 no. 7 (as Rembrandt; but perhaps by Bol); Denver 1971, 74–75.

SELECTED REFERENCES
Graves 1913–15, III, 1017; Bredius 1935/1969, 548 under no. 25 (as Flinck); Van Gelder 1946, 26, 28 (as "one of Flinck's best works and earlier than 1636"); Richardson 1958, 288 (as Rembrandt); Vaughan 1961, 224–25; Emerson 1961, 828–29, 831; Wescher 1963, 13; Moltke 1965, 248 no. 180 (as "Not by Flinck. . . . Perhaps closely related to F. Bol."); Raleigh 1960, 138 (as Rembrandt); Haverkamp-Begemann 1969, 286 (as Flinck, 1640 or 1641); Judson 1969, 703 (as closer to Bol); Gerson 1973, 26 (as Flinck); Eisler 1977, 138–40 (as Circle of Rembrandt, *Ferdinand Bol in Picturesque Garb*); Sarasota 1980–81, under no. 6 (as possibly by Flinck); Blankert 1982, 172 no. R89 (as not by Bol); Sumowski 1983, V, 3098 no. 2079, 3210 (as Flinck); Rembrandt Corpus 1982–89, III, 595 (as "can most probably not be seen as coming [out] of Rembrandt's circle").

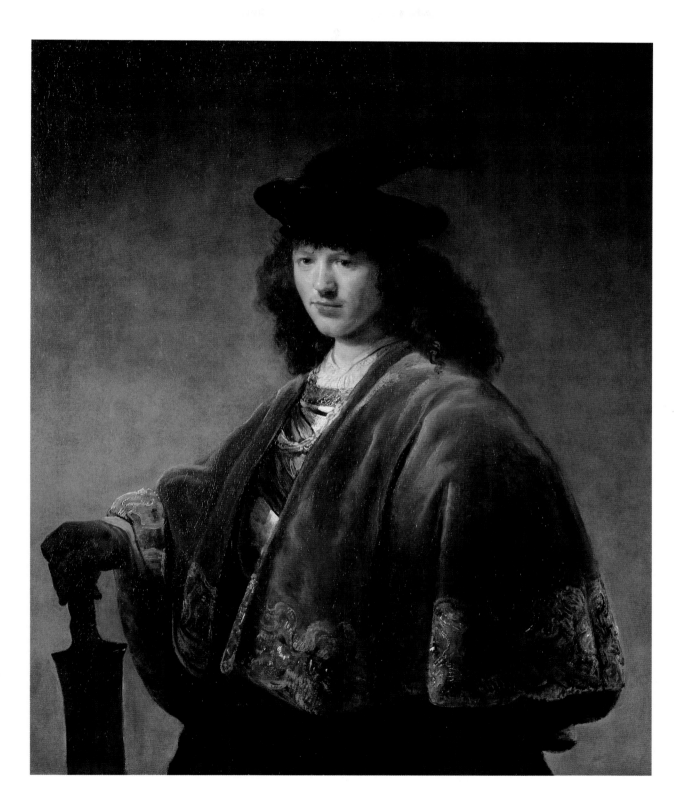

FLINCK, *Young Man with a Sword*

Mennonites like himself, he soon supplanted Rembrandt as the most fashionable artist in the city.[9] As the capital of the Dutch mercantile empire, Amsterdam became increasingly cosmopolitan during this period. This, together with the influx of Flemish and Italian art-works into the city, resulted in a growing sophistication of Flinck's patrons.[10] In response, Flinck gradually altered his early Rembrandtesque manner to a smoother, more courtly style that reflected, above all, the influence of Van Dyck (see cat. 13). A seventeenth-century connoisseur wrote that, compared to Rembrandt's portraits, Flinck's were "judged to be more felicitous in the exactness and in the pleasing quality of the portrayal."[11] Although his reputation was based primarily on his portraits, Flinck expanded his repertoire to include landscapes, allegories, and historical subjects. His success as an artist and his marriage to a wealthy young woman enabled him to build a splendid studio and to amass a substantial collection of art, exotic costumes, armor, tapestries, and weapons.[12]

In the 1650s Flinck achieved new heights of success through the patronage of Frederick Wilhelm, the Elector of Brandenburg; Prince Johan Maurits van Nassau; and a number of Amsterdam's politically influential families. Flinck also received several commissions from the city of Amsterdam, culminating in the 1659 contract for twelve paintings for the town hall, the most lucrative and prestigious commission of his day. Tragically, just as he was beginning to work on this project, he died of a fever on February 2, 1660.

Until thirty years ago, the *Young Man with a Sword* was enthusiastically attributed to Rembrandt with near unanimity.[13] The painting is closely related to a number of Rembrandt's works of the early 1630s, when Rembrandt was working for Hendrick Uylenburgh and beginning his own independent career. Chief among these works are the exotically garbed single figures (*tronies*) and fanciful portraits, such as the *Self-Portrait with a Poodle* (c. 1631; Musée du Petit Palais, Paris) and the *Bust of a Young Man in a Plumed Cap* (c. 1631; Toledo Museum of Art; *fig. 1*).[14] Especially striking is the relationship of the Raleigh painting to Rembrandt's 1634 etching, *Man with Plumed Cap and Lowered Sabre* (*fig. 2*), about which one recent scholar has noted: "This is not a portrait but a study of a pose, a gesture, and a costume. Pupils made copies of such figures which we might call travesty portraits."[15]

In the final analysis, however, it must be recognized that the similarities and relationships between the *Young Man with a Sword* and these works by Rembrandt are primarily superficial, and the attribution to the master has been rightly rejected by recent scholars. The Raleigh painting should still be considered, however, in the context of the works based on Rembrandt's prototypes that were being produced for the

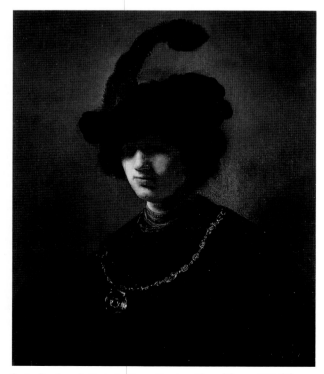

fig. 1 Rembrandt. *Bust of a Young Man in a Plumed Cap.* c. 1631. Oil on wood, 32 x 26 in. (81.2 x 66 cm). The Toledo Museum of Art 1926.24

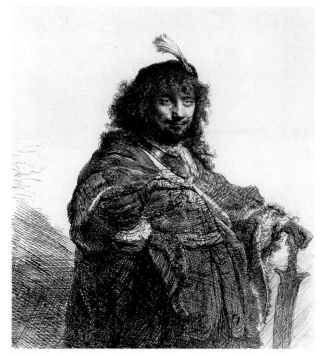

fig. 2 Rembrandt. *Man with Plumed Cap and Lowered Sabre.* 1634. Etching, 7¾ x 6⅜ in. (197 x 162 mm). Rijksprentenkabinet, Rijksmuseum, Amsterdam

art market in Uylenburgh's studio during the first half of the 1630s. Furthermore, there is compelling evidence that shortly after he left Uylenburgh in 1635, Rembrandt was actively engaged in selling works painted by his own pupils. A note written by Rembrandt about 1637 refers to the sale of works by his pupils Ferdinand Bol and Leendert van Beyren. Joachim von Sandrart, an artist who lived in Amsterdam from 1637 to around 1643, remarked that Rembrandt had "filled his house in Amsterdam with almost countless privileged children for instruction and learning, each of whom paid him 100 guilders annually, plus the profits from the paintings and copper-plate engravings they made, which ranged in value from 2 to 2500 guilders, beside what he earned with his own work."[16] Uylenburgh's and Rembrandt's practice of marketing Rembrandtesque works painted by the master's pupils and assistants explains, to a large degree, the existence of a substantial number of paintings executed in Rembrandt's style of the 1630s.[17]

The Raleigh painting bears the inscription "Rembrandt 1633" (*fig. 3*); it is possible that the last digit in the date may be a "5"; either year is a plausible date for the work. Technical examinations of the inscription indicate that it is of considerable age and may well be contemporaneous with the rest of the painting.[18] Given what is known about the commercial activities of the studios run by Uylenburgh

and Rembrandt, it is possible that the signature is contemporary, and that the *Young Man with a Sword* was originally sold as a signed and dated "Rembrandt."

The question then becomes: If Rembrandt didn't paint this picture, then who did? The two most plausible candidates proposed by scholars are Ferdinand Bol and Govert Flinck.[19] Bol, who was born in Dordrecht in 1616, seems to have entered Rembrandt's studio about 1637 and probably did not become an independent master until 1641.[20] The primary impetus for the attribution of the Raleigh painting to Bol has been a perceived similarity between the features of the young man and those of a number of reputed self-portraits by Bol, almost all of which are no longer considered to depict the artist.[21] Some scholars have also pointed to the similarities between the *Young Man with the Sword* (c. 1645–50; Dayton Art Institute) and the *Young Hunter* (c. 1650; Toledo Museum of Art), but these similarities are superficial, confined to the pose of the figures and the fact that they both derive from a Rembrandtesque "type."[22] The most logical dating for the Raleigh painting, about 1633–36 (see below), argues against an attribution to Bol, who probably had no contact with Rembrandt until around 1637 and whose earliest works date from four or five years later. Furthermore, Bol very rarely placed his figures against the type of undefined background seen in the Raleigh painting. The strongest evidence against attributing the *Young Man with a Sword* to Bol, however, is the vigorous, painterly style in which it is executed. Even in his earliest works, Bol applied paint in a thinner, smoother, and less emphatic manner than that which is evident in the Raleigh work, and his brushwork is even less pronounced in his mature works.

Far more compelling is the evidence supporting the attribution of the *Young Man with a Sword* to Govert Flinck, and a dating of circa 1633–36, a period during which he was

fig. 3 Govert Flinck. *Young Man with a Sword* (detail of cat. 25)

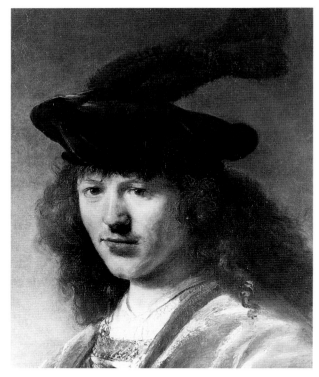

fig. 4 Govert Flinck. *Young Man with a Sword* (detail of cat. 25)

cises in the free application of paint; the buildup of impasto used for the rendering of the gold chain is merely suggestive of form rather than explicitly descriptive, as it is in Rembrandt's works. These characteristics are also evident in Flinck's Rembrandtesque works of around 1637–38, such as the *Young Man with a Feather Cap and Jewels* (1637; Hermitage, St. Petersburg), the *"Self-Portrait"* (1637; National Gallery, London), and the *Half-Length Figure of Rembrandt* (c. 1638; private collection, England), a work that has been reattributed by the Rembrandt Research Project to a member of Rembrandt's studio.[25] Yet, despite the similarities they share with *Young Man with a Sword*, these works display a greater assurance in handling, which indicates that they are somewhat later in date than the Raleigh painting.

In *Young Man with a Sword* Flinck was imitating the style of the foremost painter in Amsterdam in the 1630s, just as he was to later incorporate the styles of Van Dyck and Bartholomeus van der Helst in his fashionable portraits of the 1640s and 1650s. As one of the very earliest works of a budding provincial artist in his late teens, it is an impressive debut, painted with a freshness and exuberance that few of Rembrandt's pupils could match. A work of formidable presence, *Young Man with a Sword* displays the talent and promise of an artist who would soon become one of the most successful Dutch artists of his day.

D.S.

working closely with Rembrandt. It seems likely that after Rembrandt struck out on his own in 1635, Flinck took over the position of chief artist in Uylenburgh's studio. Thus Flinck would have had the primary responsibility for the production of Rembrandtesque paintings there until he began working independently around 1636. As would be expected, given his role in Uylenburgh's studio and his training under Rembrandt, a number of Flinck's earliest works are "fancy portraits" executed in a Rembrandtesque manner, including the so-called *Bust of Rembrandt* (Gemäldegalerie, Berlin). Long considered to be a work by Rembrandt, this painting has recently been reattributed to Flinck, with a dating of circa 1633.[23] It shares a number of stylistic, compositional, and technical similarities with the *Young Man with a Sword*. In both works the butt of the brush was used to delineate the hair (*fig. 4*), and further correspondences are evident in the underpainting, as revealed in X-radiographs.[24] One of Flinck's earliest extant paintings, the *Young Man with a Sword* displays (albeit in somewhat tentative form) many of the stylistic hallmarks of his works of the later 1630s. Chief among these qualities is the rich, painterly brushwork, which, characteristic of Flinck—and in marked contrast to Rembrandt—is essentially superficial and decorative. The features of the sitter are rendered through a vigorous scumble of paint that lacks firm anatomical structure. The gold chain and the embroidery of the cloak are essentially exer-

1. Three annotated catalogues from this sale, researched by Maria Gilbert at the Getty Provenance Index, indicate that the painting was purchased by "Wells." One of these copies has "(B.i.)," or "bought in,"— that is, not sold—next to Wells's name. "Wells" may possibly be identified as William Wells of Redleaf, Kent, England, who was putting together a substantial collection of paintings at the time. In any case, the painting was in the possession of Daniel Katz in 1933 (see n. 2 below), so it may well be the case that Wells subsequently decided against purchasing the painting.

2. The painting was listed as in Katz's possession when it was reproduced in *The Art News* 32, no. 8 (November 25, 1933): 13.

3. Van Gelder to W. R. Valentiner, January 16, 1957, curatorial files of the North Carolina Museum of Art: "the picture was bought by Katz ofr [for?] the Mrs. Hartogh Collection in Arnhem, long before the war."

4. Houbraken 1718, 1719, 1721, II, 19. Houbraken's biography of Flinck, the most complete early account of the artist's life, was based on information obtained from Flinck's son. A translation of key excerpts of Houbraken's biography appears in Schwartz 1985, 282. The most comprehensive study on Flinck is J. W. von Moltke's catalogue raisonné (Moltke 1965), but much new information concerning Flinck's early career and his patronage has since come to light (e.g., Schwartz 1985, 170–73 passim). Also see Sumowski 1983, II, 998–1151, and V, 3097–3101.

5. Schwartz 1985, 139–45.

6. Schwartz 1985, 139–42, 170–73, 177, 193–94.

7. Houbraken 1718, 1719, 1721, II, 20.

8. Houbraken 1718, 1719, 1721, II, 20. Flinck's role in producing paintings in the style of Rembrandt is discussed in the text of this entry. Flinck may have painted the version of Rembrandt's *Abraham Sacrificing Isaac* in the Alte Pinakothek at Munich (Moltke 1965, no. 6, pls. 4, 5), inscribed "Rembrandt verandert en overgeschildert" ("Rembrandt revised and repainted"), a work that is a near-exact replica of Rembrandt's 1635 painting in the Hermitage. Schwartz (1985, 177) also noted that there is a version (Moltke 1965, no. 22) of Rembrandt's circa 1635 *Samson Threatening His Father-in-law* in Berlin "that has long been attributed to Flinck." Schwartz (1985, 195–200) lists a number of inventories from 1637–39 that list works "after Rembrandt."

9. Schwartz 1985, 170–71.

10. Houbraken (1718, 1719, 1721, II, 21) wrote that "thanks to the importing of Italian paintings the eyes of the true connoisseurs were opened, and transparent [i.e., lighter] painting once again came into its own."

11. Sandrart 1675/1925, cited in Berlin 1991–92, 314.

12. Houbraken 1718, 1719, 1721, II, 20.

13. See above, under "Selected References."

14. For the Paris and Toledo paintings, see Rembrandt Corpus 1982–89, I, 373–82 no. A40, 383–90 no. A41.

15. Ben Broos, in The Hague 1990–91, 171. For Rembrandt's etching, see Münz 1952, II, 62–63 no. 48.

16. Sandrart 1675/1925, 203. Rembrandt's note, which appears on the verso of a chalk drawing now in Berlin, is discussed by Blankert (1982, 17).

17. See n. 8 above.

18. The painting was examined by Dr. A. M. de Wild on May 9, 1952. Dr. De Wild noted that microscopic examination of the inscription indicated that the paint surface of the inscription was level with the surface of the surrounding paint, that the pigment of the inscription exhibited the typical coarse-grained appearance of seventeenth-century pigment and was similar to that of the rest of the picture, and that the craquelure of the background surface continued unbroken through the brushstrokes of the inscription. A microscopic examination of the inscription, carried out in 1992 by David Goist, formerly the chief conservator at the North Carolina Museum of Art, confirmed De Wild's observations, although Goist observed that the inscription had probably been strengthened at some later date.

19. See above, under "Selected References." It is worth noting that Albert Blankert and J. W. von Moltke, authors of the most recent monographs on Bol and Flinck respectively, each rejected the attributions to the artists to whom their studies were devoted.

20. Blankert 1982, 17–18.

21. Blankert 1982, nos. 22, 60–65; The Hague 1990–91, 171–72.

22. For the Dayton and Toledo paintings, see Blankert 1982, nos. 68, 72, and The Hague 1990–91, no. 9.

23. Berlin 1991–92, 314–17 no. 60; Rembrandt Corpus 1982–89, III, no. C92.

24. Rembrandt used the butt of the brush to delineate the hair of his figures in a number of paintings, such as the c. 1628 *Self Portrait* in the Rijksmuseum (Rembrandt Corpus 1982–89, I, no. A14) and the 1635 *Samson Threatening His Father-in-law* in Berlin (Rembrandt Corpus 1982–89, III, no. A109). The cloak worn by the sitter in the Berlin painting is very similar to the one worn by the young man in the Raleigh picture. The X-radiograph of the so-called *Bust of Rembrandt*, published in Berlin 1991–92, 317, is very close to the X-radiograph of the Raleigh painting, which unfortunately does not reproduce very legibly, owing to the coarse weave of the canvas upon which the work is painted. The X-radiographs reveal that in the Raleigh and Berlin pictures the white lead underpaint is applied in short, choppy brushstrokes that frequently overlap one another quite abruptly. X-radiographs of Rembrandt's autograph works from the early and mid-1930s (e.g., Rembrandt Corpus, II, 379, 401, 441, 481, 513, 543, III, 135, 323, 337, 385, 399) indicate that he tended to apply the white lead underpaint more evenly in longer, more parallel brushstrokes than Flinck did.

25. For the Hermitage and London paintings, see Moltke 1965, nos. 226, 263. For the *Half-Length Figure of Rembrandt*, see Rembrandt Corpus 1982–89, III, no. C92.

ABRAHAM HENDRICKSZ. VAN BEYEREN

The Hague 1620/1–1690 Overschie

Banquet Still Life

———⟨◎⟩———

The son of a glassmaker, Abraham van Beyeren studied with Pieter de Putter (d. 1659), a specialist in fish still lifes in The Hague. Except for the years 1638–39, when he was in Leiden, Van Beyeren lived and worked in The Hague until 1657, and became a member of the painters' guild there in 1640. In 1657 he joined the painters' guild in Delft, where he lived before returning to The Hague in 1663. From 1669 to 1674 he was in Amsterdam. Then, after spending time in Alkmaar and Gouda, he moved in 1678 to Overschie, where he lived until his death, twelve years later. These many moves were probably related to the lack of financial success during his lifetime. Economic difficulties also have been offered as a reason for the variety of his specialties, a relatively unusual diversity for the time. Van Beyeren painted masterly fish still lifes (a natural subject for his broad brushwork and glistening visual effects), vanitas *still lifes, spirited seascapes, kitchen still lifes, and flower pieces.*

In 1651 Van Beyeren signed and dated his first pronk *(ostentatious or showy) still life (Kunstmuseum, Düsseldorf), a sumptuous array of luxury objects, expensive foods, and rich textiles. He continued to paint banquet pieces for the rest of his life, demonstrating his familiarity with the work of his great contemporary Jan Davidsz. de Heem (1606–1683/4). However, Van Beyeren's banquet still lifes are generally more loosely designed and painted than those of De Heem, and the objects within them are often less luxurious. Van Beyeren often did not date his paintings, but recent scholarship has suggested a chronology based on the repetition of objects and motifs within the pictures.[1]*

c. 1653–55
Oil on canvas, 42⅛ x 45½ in.
(102 x 105.6 cm)
Signed at left edge of table: AVB f
Seattle Art Museum 61.146

PROVENANCE
Francis Charles Hastings Russell, 9th Duke of Bedford (d. 1891), Woburn Abbey, Bedford, England, by 1890–91 (as Jan Weenix); by descent to George William Francis Sackville Russell, 10th Duke of Bedford (d. 1893), Woburn Abbey; by descent to Herbrand Arthur Russell Bedford, 11th Duke of Bedford (d. 1940), Woburn Abbey; by descent to Hastings William Sackville Russell Bedford, 12th Duke of Bedford (d. 1960); sale, Christie's, London, January 19, 1951, lot no. 7; bought by W. Sabin; with David M. Koetser, London and New York; Samuel H. Kress Foundation, New York, 1954 (K1986); on loan to Seattle Art Museum, 1954–61; gift of the Kress Foundation to Seattle Art Museum, 1961.

SELECTED EXHIBITIONS
Washington 1961–62, no. 8; New Orleans 1962, no. 18.

SELECTED REFERENCES
Seattle 1954, 64; Eisler 1977, 154–55.

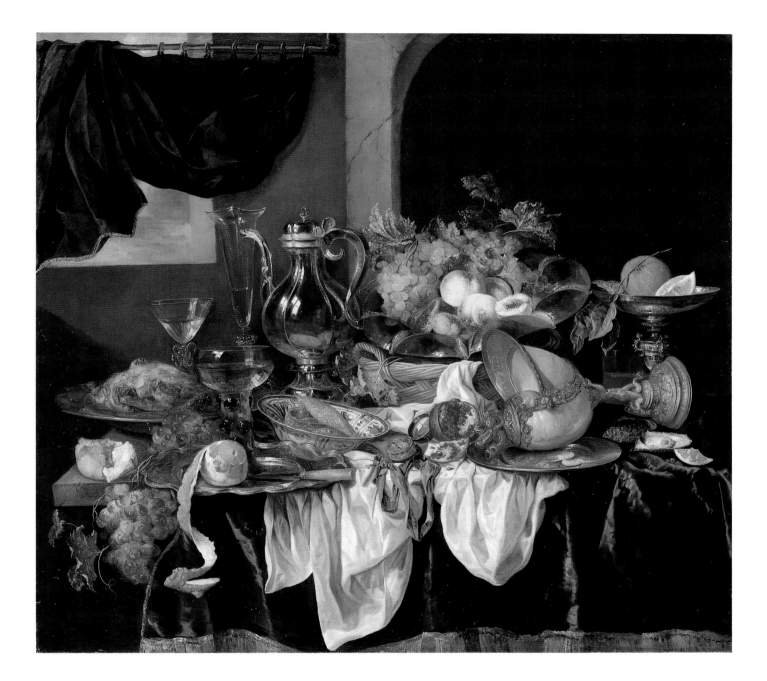

Van Beyeren, *Banquet Still Life*

fig. 1 Abraham van Beyeren. *Banquet Still Life* (detail of cat. 26)

Spread out on a table partly covered with a purplish velvet throw and a crumpled white cloth is a lavish array of expensive wares and appealing foods that challenges Van Beyeren's skills in rendering shimmering and moist surfaces. At the rear right, ripe peaches, green and red grapes, and a sliced fig overflow a silver *plooi* (pleated) platter. An orange and an orange wedge rest in the shallow bowl of a silver tazza to the right. Below, a nautilus cup in a gold mount with merman motifs—an object prized by seventeenth-century collectors—is tipped onto its side next to an open oyster and rests on a simple silver plate beside two pink shrimp. A split pomegranate mimics the shape of the open watch beside it, while to the left a blue and white bowl of Chinese export porcelain tilts unsteadily and holds candied orange peel, an expensive delicacy. A silver charger with scalloped edges supports a green *roemer* half-full of wine and a lemon[2] whose peel meanders over the edge of the tray that protrudes beyond the table. The lemon peel falls in a lazy curl, in marked contrast to the heavy bunch of red grapes suspended beside it. A half-eaten crust of bread anchors the left corner of the table and leads us to the plain silver serving dish bearing something resembling octopus. Two Venetian-style wine glasses and a tall silver wine ewer complete the display.[3]

The artist presents an abundance—almost an excess—of objects and foods with vividly rendered textures and lifelike colors designed to appeal to the viewer's appetites.

The many reflective surfaces magnify the opulence of the display and repeat colors that help to unify the picture. In addition, the reflections introduce an implicit contradiction in the artist's presentation. Although the table is placed before an open, draped window, this is clearly not the source of the bright light that plays on the shiny surfaces within the still life. Instead, reflections in the convex forms of some of the vessels indicate that light streams through a four-pane window typical of Dutch domestic architecture, significantly different in style from the pseudoclassical, unadorned stone architecture that forms the austere backdrop of the display. The contrast between the apparent setting and the reflected setting reveal a self-consciousness on the part of the artist that is borne out by further examination.

Close study of the picture in fact reveals the image of the artist at his easel, reflected in the surface of the wine ewer (*fig. 1*). By portraying himself at work, facing the laden table, Van Beyeren seems to establish his presence as an eyewitness and argues both for the veracity of his representation and for the superiority of his imitative skills.

Jan van Eyck's *Madonna of Canon Georges van der Paele* (1436, *fig. 2*), where the artist is seen reflected in the armor of Saint George, is the earliest example of an "incidental" reflection of the artist.[4] According to Brusati, Van Eyck here portrays himself as "witness and recorder of the scene" and at the same time calls attention to the astonishing illusionism achieved through his mastery of the tech-

fig. 2 Jan van Eyck. *Madonna of Canon Georges van der Paele.* 1436. Oil on panel, 47¹¹⁄₁₆ x 61¼ in. (122 x 157 cm). Groeningemuseum, Bruges

nique of painting in oils.[5] Van Beyeren's rendering similarly calls attention to his own command of the oil medium, but the artist's supposed direct observation of this still life is no more likely than Van Eyck's witnessing of the Virgin and Child surrounded by saints. Van Beyeren frequently painted

identical objects in exactly the same position, suggesting that he relied on stock drawings rather than life studies.[6] In other words, this seemingly spontaneous and closely

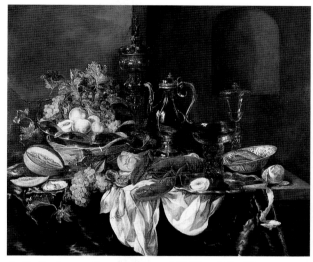

fig. 3 Abraham van Beyeren. *Banquet Still Life*. c. 1653. Oil on canvas, 38⅝ x 46⅜ in. (99 x 119 cm). Rijksdienst Beeldende Kunst, The Hague

observed composition is actually a pastiche of objects from his repertoire, some of which also appear in other paintings of the mid-1650s. A picture dated 1653 in Munich shows the nautilus shell cup, the silver tazza, the scallop-edged charger, and the *roemer* of the Seattle painting.[7] The silver ewer, *plooi*-platter in a straw basket, Chinese bowl, and watch are all seen in a painting from about 1653, now in The Hague (*fig. 3*).[8]

The closely placed, rounded forms, some of them tilted or toppled, push out toward the picture plane, inviting our visual consumption. In this picture Van Beyeren clearly celebrates the sensuous pleasures offered by the colorful array yet warns against overindulgence in earthly appetites. The pocket watch, a common article in banquet still lifes, is both a familiar *vanitas* motif, reminding of the transience of earthly life, and a symbol of temperance. The three wine glasses, isolated by their height from the near-chaos around them, are half-full, embodying another message of moderation.

C.I.

1. Segal 1988, 172–76.

2. Not an orange, as Eisler (1977, 155) writes.

3. Eisler (1977, 155) incorrectly identifies the ewer as a coffeepot.

4. Clara Peeters was the first important still-life painter to adopt a similar use of a self-portrait within her paintings, followed by Pieter Claesz. and Jan de Heem, among others. In banquet still lifes, Van Beyeren frequently portrayed his reflection at his easel. See Brusati 1990/91, 168–75, and Sullivan 1974, 277–78.

5. Brusati 1990/91, 174.

6. Sullivan 1974, 278.

7. The charger is also seen in Van Beyeren's first dated *pronk* still life, 1651, in the Kunstmuseum, Düsseldorf, Bentinck-Thyssen Collection, illustrated in Segal 1988, 173.

8. Other paintings that show the same Chinese bowl are a *Pronk Still Life with Roses*, 1654, Brod Gallery, London (illustrated in Segal 1988, 173), and perhaps the *Banquet Still Life* of 1655 in the Worcester Art Museum, illustrated in Sullivan 1974, 276. In a *Banquet Still Life* recorded as in the possession of Mr. Arthur Kauffmann and published in *The Burlington Magazine*, December 1952, pl. 16, the nautilus cup and silver tazza with oranges are shown in the same positions as in the Seattle painting, and an identical silver ewer is shown in reverse. Eisler (1977, 155) cites the inclusion of the ewer and nautilus cup and "several of the other props" in a painting from the S. Larsen-Menzel Collection, Wassenaar.

MELCHIOR D'HONDECOETER

Utrecht 1636–1695 Amsterdam

Melchior d'Hondecoeter came from a family of painters that
included his grandfather, the landscape painter Gillis d'Hondecoeter (d. 1638), and his
father Gysbert (1604–1653), with whom Melchior studied, who painted both landscapes
and scenes with birds. When Gysbert died, Melchior entered the studio of his uncle Jan
Baptist Weenix, a highly successful painter whose use of Italianate architecture and deco-
rative motifs was adopted by his nephew. Hondecoeter was active in The Hague in the
years 1659 to 1663, when he married and moved to Amsterdam. He remained there until
his death, on April 3, 1695.

Hondecoeter specialized in animal and bird paintings of all sizes,
both live subjects and game pieces showing trophies of the hunt, a popular aristocratic
activity in seventeenth-century Holland. Among his few documented paintings are commis-
sions from the Stadholder William III for his pleasure palaces at Soestdijk and Het Loo.
Hondecoeter established his style early and adhered to it throughout his long career, so it
is difficult to propose a precise chronology for undocumented paintings. His reputation
has suffered somewhat, partly because the subject matter he favored became unfashionable
and also because of the widespread existence of inferior imitations of his work. However,
his descriptive skills, bold coloring, and sense of drama help explain his popularity in the
seventeenth century.

27

Peacocks

⸺⟟⟟⟟⸺

1683
Oil on canvas, 74 ⅞ x 53 in.
(190.2 x 134.8 cm)
Signed and dated on parapet:
MD Hondecoeter Aº 1683[1]
The Metropolitan Museum of Art, New York
27.250.1

PROVENANCE
With Colnaghi, London; bought by H. M. Clark, November
3, 1926; sold to Count Alessandro Contini-Bonacossi,
November 3, 1926;[2] Samuel H. Kress, 1927 (KM–1); to
Metropolitan Museum of Art, 1927.[3]

SELECTED EXHIBITIONS
New York 1968, no. 41; Portland 1972.

SELECTED REFERENCES
Bulletin of the Metropolitan Museum of Art 23 (1928), 91–92;
Burroughs 1931, 167; Eisler 1977, 156; Sutton 1990, 128.

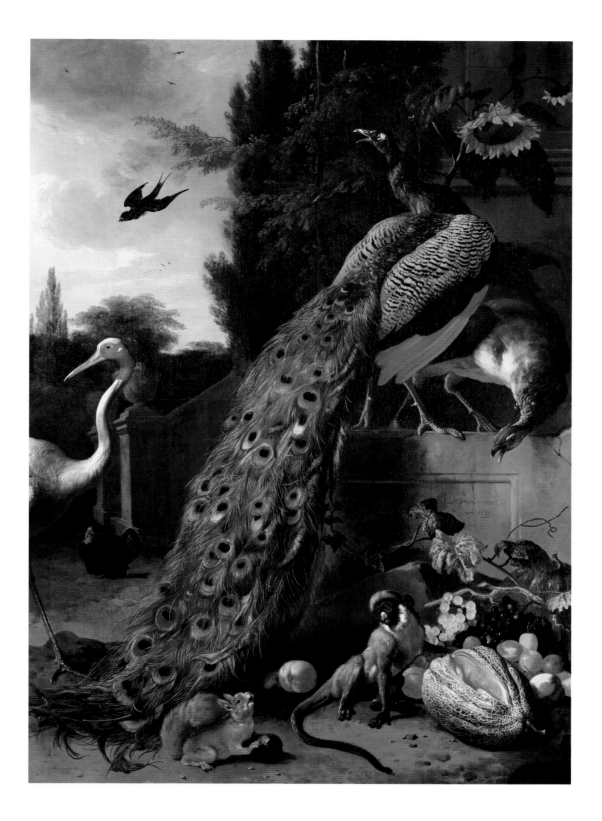

HONDECOETER, *Peacocks*

The picture shows an array of animals and fruits that are found in nature, but there is nothing natural about their presentation. The animals live not in the wild but in a man-made setting; creatures indigenous to different continents are shown together here and have been gathered for a specific purpose. In fact, fashionable seventeenth-century aristocrats often added game parks of exotic animals to their country estates. Precursors to today's public zoos, they aimed to preserve and maintain rare species as fascinating curiosities.

The Metropolitan composition is dominated by a peacock, whose magnificent tail cascades down the surface of the large painting. His contentious mate pokes her head out from behind him and appears to confront the red squirrel in the foreground. A squirrel monkey, stretched dramatically

fig. 1

Dutch school, 18th century. *Assembly of Birds with a Peacock.* Watercolor on paper, 19½ x 14⅜ in. (496 x 378 mm). Location unknown

fig. 2

Dutch school, 18th century. *Assembly of Birds with a Pelican.* Watercolor on paper, 19½ x 14⅜ in. (496 x 378 mm). Location unknown

within a still life of autumn fruits, completes the foreground. A crane abruptly enters at the left, while in the distance squats the ungainly, exotic American turkey.[4] These animals occupy the grounds of a park and roam freely among the Italianate architecture that is the only sign of human presence.

Paintings such as this were commissioned, often in series, to decorate country homes and to bring images of prized animal collections indoors. The works faithfully record the colorful plumage and markings of various species as well as characteristic animal behavior and are a nondidactic contrast to the sumptuous depictions of foods, flowers, and game that often carried sobering messages of life now stilled (see cat. 26). Moralizing is absent in these large decorative bird and animal paintings.[5] Still, some have seen literary associations in the behavior of the creatures that inhabit this fanciful world. Sutton, for example, has suggested mocking parallels with human behavior, and indeed there is a certain anthropomorphic quality to the postures and expressions of the foreground animals in the Metropolitan canvas.[6]

Eisler suggests that Hondecoeter's painting, with its autumnal still life and crumbling masonry, might have been part of a series showing seasonal subjects.[7] Another possibility —that it might be one of a pair—is raised by the existence of two watercolors with identical dimensions by an unknown artist. One watercolor exactly reproduces the gathering of the Metropolitan's painting (*fig. 1*) and the other shows a group of waterfowl (*fig. 2*).[8]

C.I.

1. Not "MDHoendecoeter," as transcribed in Eisler 1977, 156.

2. Information from Getty Art History Information Program, the Provenance Index, in curatorial file, Metropolitan Museum of Art, New York.

3. This is one of the first non-Italian paintings purchased by Samuel Kress, and he donated it almost immediately to the Metropolitan Museum, along with a trecento *Madonna and Child*. See *Bulletin of the Metropolitan Museum of Art* 23 (1928), 91–92.

4. The crane, painted out at an unknown date, was uncovered when the painting was cleaned in 1956 (Eisler 1977, 156). Haak (1984, 405) points out that Hondecoeter frequently truncated animals at the margins of his pictures.

5. In creating his decorative canvases Hondecoeter frequently reused animal poses and still-life motifs. The peacock and peahen were repeated in numerous compositions, including the *Peacocks and Ducks* in the Wallace Collection (cat. no. P64), and other paintings in private collections or on the art market (e.g., Christie's, New York, June 3, 1987, lot no. 122); see Ingamells 1992, 160, for further citations. According to Eisler (1977, 156), an identical monkey is found in a canvas signed and dated 1685 by Hondecoeter in a private collection in London.

6. Sutton 1990, 128.

7. Eisler 1977, 156.

8. Sale, Sotheby's, London, November 25, 1971, lot nos. 7 and 8, as "Dutch School, 18th century." Information in curatorial file, Metropolitan Museum of Art, New York. The pelican in the companion watercolor is based on the same model as one in a painting popularly known as *The Floating Feather*, Rijksmuseum, Amsterdam, no. A175.

EMANUEL DE WITTE

Alkmaar c. 1616–1691/92 Amsterdam

Emanuel de Witte, one of the greatest architectural painters of the seventeenth century, was the son of an Alkmaar schoolmaster and his wife. His early training was under the Delft still-life painter Evert van Aelst, and he joined the Alkmaar painters' guild in 1636. He was active in Rotterdam in 1639–40. The next year he settled in Delft, where his daughter was baptized in October 1641. There he joined the Guild of Saint Luke and married the mother of his child in 1642; he is recorded in Delft through the spring of 1651. Sometime after 1650, he turned from depicting historical themes to painting lofty church interiors, the subject that was to dominate the rest of his career. Though De Witte was long thought to be the pioneer in this specialization, his contemporary, the Delft painter Gerard Houckgeest, should be credited with a more seminal role than previously considered.[1]

By January 1652 De Witte was in Amsterdam, where he probably spent the rest of his life. He was in periodic financial difficulty and sometimes resorted to paying off his debts with paintings. The artist was said to have suffered from depression, and his death may have been a suicide. In the winter of 1691–92 his body, reportedly found with a rope around the neck, was fished from a canal that had been frozen since his disappearance eleven weeks before.

De Witte's church interiors are generally populated with figures and animals but have a hushed quality that comes with an unwavering reliance on light as a descriptive tool.[2] While his great contemporaries Pieter Saenredam, Gerard Houckgeest, and Hendrick van Vliet also created pristine, light-filled church views, their compositions are more analytical and less intuitive than those of De Witte. De Witte's painterly, even sketchy, approach gives his compositions a sense of immediacy, as well as an appreciation for the materials used, qualities that are seen also in the genre and market scenes he sometimes painted. By the time of his death the great period of Dutch architectural painting had passed, and he left no followers.

28

Interior of Protestant Gothic Church

c. 1670–74
Oil on oak panel, 19½ x 16½ in.
(49.7 x 42 cm)
Inscribed on lower left corner: *E De Witte*
Seattle Art Museum 61.176

PROVENANCE
Marion L. Sulivan, Lady Cosmo Bevan, Dorking, Surrey, England; Anne Beauclerk Dundas Dickson-Poynder, Baroness Islington; her sale, Sotheby's, London, June 20, 1951, lot no. 41A; with David M. Koetser, London and New York, 1951–54; Samuel H. Kress Foundation, New York, 1954 (K1988); on loan to Seattle Art Museum, 1954–61; gift of the Kress Foundation to Seattle Art Museum, 1961.

SELECTED REFERENCES
Seattle 1954, 70; Manke 1963, 107 no. 123; Eisler 1977, 148.

DE WITTE, *Interior of Protestant Gothic Church*

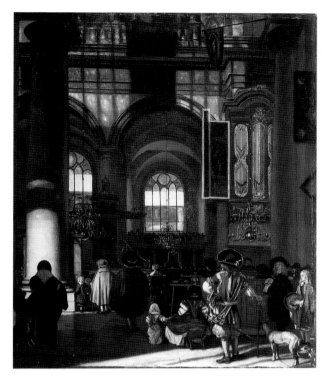

fig. 1 Emanuel de Witte. *Protestant Baroque Church*. 1674. Oil on canvas, 30¹³⁄₁₆ x 29¹⁵⁄₁₆ in. (79 x 69 cm). Wallraf-Richartz-Museum, Cologne

The viewer, positioned in the south side aisle of a Gothic church, sees a gathering of soberly dressed Dutch burghers turned toward the preacher in the wooden pulpit across the nave. The bright sunlight that slants through the clerestory windows on the south wall casts deep shadows on the floor and bathes other surfaces in warm light. The abstract and lively patterns of light on architecture fascinated Emanuel de Witte for the forty years that he painted church interiors.

Once the artist adopted the theme of architectural perspectives in the early 1650s, his stylistic development became "a steady refinement of visual effects" rather than a search for new challenges.[3] By the mid-1650s De Witte moved from the dynamic oblique views of his early efforts and began to arrange architectural forms parallel to the picture plane. His view might be down the length of a nave (*Imaginary Catholic Church*, Mauritshuis, The Hague) or, as in the Seattle picture, across it. The latter view allowed De Witte to develop the abstract patterns inherent in the architecture simply by shifting his viewpoint slightly to the left or right. In the Seattle painting, for example, the space is unevenly framed by two massive nave columns; the arch that links them continues out of sight. The head-on view collapses the broad, airy expanse of the nave—which another artist, such as Saenredam, would have considered the painting's central subject—and turns the composition into a pattern of repeating horizontals and verticals. These

repetitions divide the picture into blocks that recall the contemporary interiors of Delft painter Pieter de Hooch (1629–1684) or even the modern geometric compositions of Dutch artist Piet Mondrian (1872–1944). The patches of light and shadow further contribute to the richness of patterning across the painting's surface.

Though De Witte's vocabulary is dominated by rectilinear forms, the painting is full of visual incident and is neither rigid nor arid. To counter the many right angles, the artist provides an ample supply of curving forms, including the organ casing, brass chandeliers, lancet windows, nave arches, and triforium arcade. Moreover, De Witte imparts a sense of immediacy through the presence of living human beings and dogs (clearly tolerated in Dutch churches) and through the capture of transient light, which is recorded at the precise angle it happens to fall at a particular moment of a particular sunny day.

Determined to create a convincing semblance of architectural space by masterly and instinctive manipulation of a limited repertoire of forms and light effects, De Witte developed a skillful illusionism, all the more impressive since the church depicted in the Seattle painting was imaginary. After about 1660, for reasons that are unclear, the artist increasingly painted realistic but fictive church interiors in addition to depictions of existing churches.[4] Some of the details in the Seattle painting—the clerestory windows and

fig. 2 Emanuel de Witte. *Interior of Protestant Gothic Church* (infrared reflectogram assembly of cat. 28 with overlay)

triforium arcade, for example—are superficially similar to those found in De Witte's paintings of both the Amsterdam Oude Kerk and the Oude Kerk in Delft but vary enough to make either identification unlikely.[5]

De Witte commonly reused figures as well as architectural motifs. Manke pointed out that in the Seattle panel the artist duplicates the figure group from his painting in Cologne dated 1674, where the worshipers occupy a grand Baroque interior (*fig. 1*).[6] In an infrared reflectogram assembly of the Seattle painting (*fig. 2*),[7] it can be seen that De Witte originally included the dandyish cavalier seen from behind in the right foreground of the Cologne picture before painting him out and thereby opening up the foreground space.[8] The network of underdrawn lines visible in the architecture also demonstrates that, contrary to assumed practice, De Witte did labor to assure a proper perspectival rendering of the principal elements of the composition. Significantly, his ruled underdrawn lines correspond not to the contours of the forms themselves but to the spatial relationships among them.[9]

The painting should probably be dated close to the Cologne painting of 1674.[10] The imaginary subject and sketchy technique are typical of pictures produced during the last third of De Witte's long career. The blurred contours in areas of reflected light and the loose brushwork in the organ (which was not underdrawn) can be compared to late works by the artist dating from 1669 to 1685.[11]

C.I.

8. It may also be, as suggested by Walter Liedtke (oral communication), that the cavalier figure, typically shown wearing a red costume, would have been too dominant a color accent in the foreground of the notably muted picture. According to Michael Gallagher (oral communication), who cleaned the painting, his garments contain both red and blue.

9. Little is known about De Witte's working methods. Unlike Saenredam, he does not appear to have kept working sketches. Liedtke (1982, 93) speculates that De Witte sketched his composition directly onto the painting support rather than trace a perspective cartoon as was Saenredam's practice; the Seattle underdrawing demonstrates a desire to establish architectural relationships while leaving many of the actual details to be worked up in paint with no underdrawn preparation. The repetition of both architectural elements and figure groupings in De Witte's oeuvre suggests that he could have followed studio sketches (now lost) or finished paintings for these details.

10. Given De Witte's propensity to reuse figures, it is not necessary to assume that this painting depends on the design of the Cologne canvas.

11. See Manke 1963, fig. 81, dated 1678; and Liedtke 1982, fig. 91, dated 1669, and fig. 96, dated 1685.

1. See Wheelock 1977, 221–60; De Vries 1975, 27–28; and Liedtke 1982, 11–21.

2. See the perceptive discussion on De Witte's "subjective use of light" in Liedtke 1982, 78.

3. Liedtke 1982, 93.

4. See Liedtke 1982, 95, for discussion of the theme.

5. See Manke 1963, figs. 71, 81, 104, 108.

6. Manke 1963, 107.

7. With the technique of infrared reflectography, black underdrawing can be made visible, as well as painted forms that have been covered over by the artist (pentimenti). Areas of damage are also evident; in the Seattle painting, heat damage dating from 1962 is visible as a cluster of white dots concentrated within the central area of the picture. Infrared reflectography of the Seattle painting was undertaken in 1992, at the time of its cleaning, by Michael Gallagher of the J. Paul Getty Museum.

GERRIT ADRIAENSZ. BERCKHEYDE

Haarlem 1638–1698 Haarlem

Baptized on June 6, 1638, in Haarlem, Gerrit Berckheyde was the sixth child of a butcher and his wife. His older brother Job (1630–1693), a specialist in church interiors and genre scenes, may have been his first teacher, and the two brothers lived together in Haarlem throughout their adult lives. During the 1650s they traveled up the Rhine as far as Heidelberg. There they achieved a major goal of their voyage, securing royal patronage from Karl-Ludwig, Elector of the Palatinate. Shortly afterward, however, they returned to Haarlem, where Gerrit was admitted to the Guild of Saint Luke on July 27, 1660 (Job had been a member since 1654). His first signed and dated works are recorded in the following year.

Gerrit specialized in architectural views, a new subject in Dutch painting that occupied him throughout his career.[1] Although he occasionally painted architectural interiors, he is most closely associated with townscapes—especially views of Haarlem, Amsterdam, and The Hague. His topographically accurate depictions of the seventeenth-century urban scene are painted with a refined technique and subtle sense of color that makes Berckheyde's paintings among the most elegant to emerge from the Dutch Golden Age. The painter died on June 10, 1698, reportedly a victim of drowning.

29

The Fish Market and the Grote Kerk at Haarlem

c. 1675–80
Oil on oak panel, 17¾ x 16¾ in.
(45.2 x 42.6 cm)
North Carolina Museum of Art, Raleigh
60.17.69

PROVENANCE
Duc de Choiseul, Paris; his sale, Paris, April 1772, no. 79 (as Jan van der Heyden); A. Brondgeest, Amsterdam, c. 1827; Baron Lionel de Rothschild, 1854 (as Van der Heyden); Edmond de Rothschild, Exbury, Hants (Hampshire), 1946; with Harry G. Sperling, New York, 1947 (as Van der Heyden); with F. Kleinberger and Co., New York; Samuel H. Kress Foundation, New York, 1953 (K1966); gift of the Kress Foundation to North Carolina Museum of Art, 1960.

SELECTED EXHIBITIONS
Hartford 1947, no. 25; Allentown 1965, no. 5.

SELECTED REFERENCES
Smith 1829–42, V, 377, 409–10; Waagen 1854, II, 131; Hofstede de Groot 1908–27, VIII, 353 no. 81; Raleigh 1960, 140–41; Eisler 1977, 148–49; Lawrence 1991, 30, 39–40; Sutton 1992, 29.

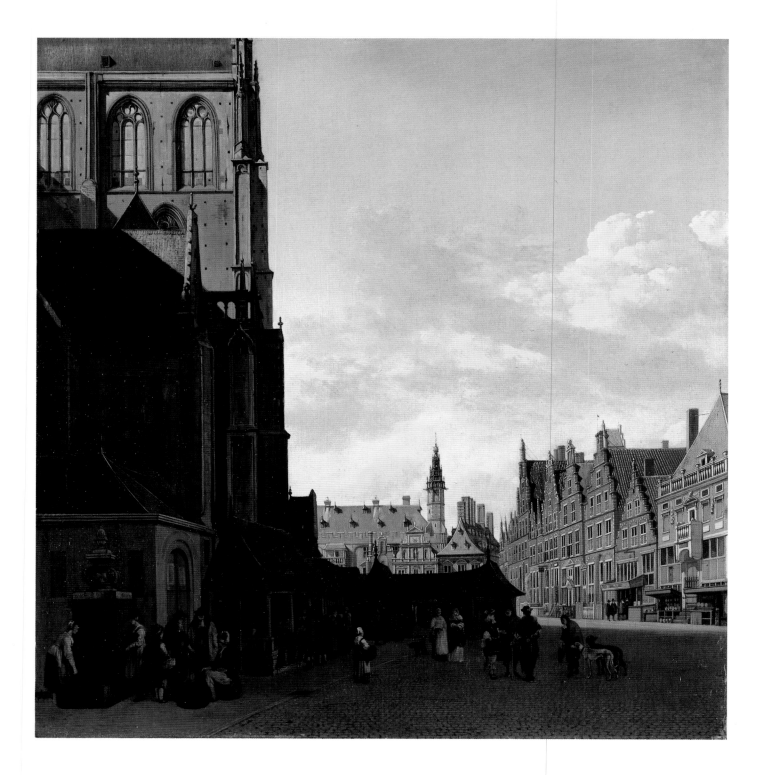

BERCKHEYDE, *The Fish Market and the Grote Kerk at Haarlem*

Berckheyde painted numerous views of his native town beginning in the late 1660s, and the monumental Grote Kerk (Great Church, founded as Saint Bavo's in the late fifteenth century), which dominated the Grote Markt (central marketplace), was the subject of most of his surviving views. He painted the site from a variety of viewpoints, always seeking a balance between solid buildings and the open spaces of the marketplace and sky, between civic architecture and the city's most prominent religious building. In this beautifully preserved painting, a deep shadow cast by the great Gothic church shades the fish market, where townspeople meet to shop and chat in the early morning. As in many of his paintings, Berckheyde presents a combination of imposing public buildings and human activity that gives a lively picture of daily life.

The Grote Markt was Haarlem's center of commercial and civic life, with its central fish and meat markets, the church, and the distinctive city hall, visible in the distant center of the Raleigh panel. Berckheyde's concentration on the depiction of orderly civic life—and the juxtaposition of different historical styles of architecture—has been seen as part of a self-conscious celebration of both distant history and recent prosperity within the young Dutch Republic.[2] In Haarlem itself, Samuel Ampzing's *Beschrijvinge ende Lof der Stad Haerlem* (*Description and Praise of the City of Haarlem*), 1628, praised some of the specific buildings that Berckheyde was to depict, for both their beauty and the lofty civic values they embodied.

Local pride is evident in this tranquil picture, but Berckheyde's use of abstraction in depicting the everyday scene is equally clear. The north transept of the Grote Kerk combined with the shadow cast across the foreground impose a bold L-shape on the painting and leave a nearly square patch of blue sky in the upper center and right. Offsetting this play between solid and void is the receding row of sunlit buildings, whose stepped gables and lively fenestration give them cheerful animation.

The North Carolina picture may belong to a series of innovative views Berckheyde painted of the Grote Markt in the early to mid-1670s.[3] In these works he strove to impose drama on the familiar setting, either through the use of columns or arches as framing devices (*The Grote Markt, Haarlem*, 1674, Fitzwilliam Museum, Cambridge, England) or through the manipulation of light and shadow (*The Grote Markt, Haarlem*, 1675, Musée des Beaux-Arts, Lyons). Although Berckheyde repeated the viewpoint of the Raleigh picture in *The Haarlem Fish Market* of 1692 (Frans Halsmuseum, Haarlem), his bold compositional experiments are generally confined to the relatively short earlier

period.[4] Unlike his contemporaries Emanuel de Witte (see cat. 28) and Jan van der Heyden, Berckheyde did not paint imaginary views of Dutch subjects;[5] the compositional innovations of the early 1670s are as close as he came to departing from the straightforward topographical description for which he is best known.

C.I.

1. For a good account of the development of town views in Dutch painting, see Amsterdam 1977.

2. See Liedtke 1979 and Lawrence 1991, as well as Schama 1987, 298.

3. Lawrence 1991, 37–40.

4. Haarlem 1969, no. 17. For illustration, see Amsterdam 1977, no. 106.

5. His paintings of Rhenish cities, especially Cologne, while partly based on drawings made during his early trip up the Rhine, include embellishments and inventions that are missing from his Dutch views.

SALOMON VAN RUYSDAEL

Naarden 1600/03–1670 Haarlem

The artist was born in Naarden in Gooiland and was originally named *Salomon de Gooyer (Goyer). However, both Salomon and his brother Isaack, also a land- scape painter, later took the name Ruysdael (sometimes signed "Ruyesdael") after the Castle Ruisdael (Ruisschendael), a landmark near Blaricum, their father's hometown. Except for limited travel, Salomon seems to have spent his entire active career in Haarlem, where he moved in 1616. He was received into the painters' guild in 1623 and held various offices in that body, including deacon in 1647.*

Seventeenth-century Haarlem was the center of a progressive school of landscape painters that had produced many early innovations in the development of the naturalistic Dutch landscape. Salomon followed in this tradition, and, with the exception of a few still-life paintings dating from his later years, his oeuvre is dedicated to the explora- tion of the landscape idiom. The work of Esaias van de Velde, who had worked in Haarlem from 1609 to 1618, was of particular importance to Salomon's early style. Van de Velde's direct representations of typically Dutch terrain formed the basis of the work of Salomon, Jan van Goyen (one of Van de Velde's former pupils), and Pieter de Molijn (whose own in- fluence is discernible in Salomon's work). These three younger artists were the principal exponents of the monochromatic Dutch tonal landscape, which occupied their interest until the 1640s. At that time their paintings began to exhibit more pronounced color and the forms became weightier and more substantial. Ruysdael's best works date from this class- ical period. He became a specialist in river scenery, featuring the waterways that were the commercial arteries within the Dutch Republic. With skillful variety, Salomon focused on the effects of light and atmosphere that fill his compositions, changing and qualifying the land, water, foliage, and cloud-filled sky. Salomon van Ruysdael died in 1670 and was buried in Saint Bavo's Church in his adopted Haarlem. The uncle of the more famous Jacob van Ruisdael, Salomon was the father of Jacob Salomonsz. van Ruysdael, who was also a landscape artist.

30

River View of Nijmegen with the Valkhof

———⌘———

1648
Oil on canvas, $40^{15}/_{16}$ x $56^{5}/_{8}$ in.
(104 x 143.8 cm)
The Fine Arts Museums of San Francisco
61.44.36

PROVENANCE
Count Stanislaus Potocki; his sale, Galerie Georges Petit, Paris, May 8, 1885, lot no. 47; bought by Petitpont, John Nicolson Gallery, New York; with Julius Weitzner, New York, 1951; Samuel H. Kress Foundation, New York, 1952 (K1888); on loan to the M. H. de Young Memorial Museum, 1655–61; gift of the Kress Foundation to the M. H. de Young Memorial Museum, later The Fine Arts Museums of San Francisco, 1961.

SELECTED EXHIBITIONS
New Brunswick 1983, no. 107; Tokyo 1992, no. 11; Canberra 1992–93, no. 10.

SELECTED REFERENCES
Stechow 1938/1975, 123 no. 354; San Francisco 1955, 88; Stechow 1966, 56; Eisler 1977, 145–46; Haverkamp-Begemann 1980, 209.

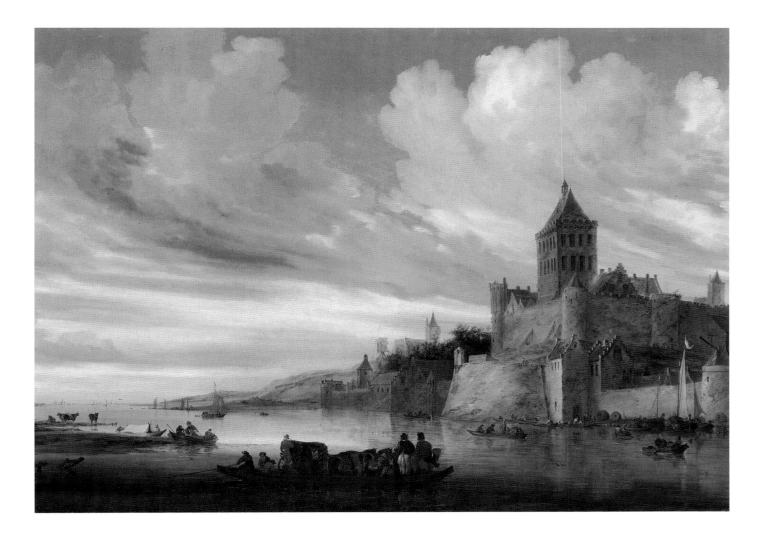

RUYSDAEL, *River View of Nijmegen with the Valkhof*

The Kress *River View of Nijmegen with the Valkhof* combines landscape painting with the topographical interests of the cityscape, an approach that gained wide popularity in Holland during the seventeenth century. After decades of war, the Dutch struggle for independence from Catholic Hapsburg Spain ended temporarily in 1609 with the Twelve Years' Truce. With this political victory a new sense of national pride found expression in the numerous literary and artistic works describing the Republic's countryside and landmarks. Nijmegen, the capital of Gelderland, held a place of great significance as one of the most ancient and historically important Dutch towns. Close to the German border, Nijmegen is situated on five low hills overlooking the river Waal, one of the Rhine's main tributaries. Since ancient times, this strategic site had been held consecutively by Batavians, Romans, Charlemagne, the Holy Roman Empire, and, in the seventeenth century, the Dutch Republic. The Roman historian Tacitus recorded Nijmegen as the seat of the Batavian revolt against the Romans; to the seventeenth-century Dutch this uprising presented an ancient precedent for the political struggle of their modern nation against the Spanish. Consequently, Nijmegen figured prominently in the writings of historians such as Johannes Smith, whose popular account was republished in the 1649 atlas of Joan Blaeu.[1] Beyond the site's historic associations, the dramatic visual contrast between the placid river and the vertical thrust of the architectural complex made Nijmegen a favorite subject for Dutch painters, including Aelbert Cuyp, Jan van Goyen, and Salomon van Ruysdael.[2]

The imperial palace at Nijmegen, crowned by the tower of the Valkhof (falcon court), was originally constructed by Charlemagne beginning in 777 and then extensively rebuilt by Frederick Barbarossa after 1155. Instead of viewing the building frontally from directly across the river, Ruysdael positioned himself at an angle to his subject. This oblique vantage point accentuates the density and massiveness of the city's fortifications, and the tower forms the apex in the composition's dominent triangular motif. Characteristic Baroque diagonals move across the surface of the canvas and into the pictorial space, heightening the dramatic effect of the image.

This is the same approach used in a number of works by Jan van Goyen, who created about thirty views of Nijmegen between 1633 and 1654.[3] Comparison with works such as Van Goyen's *View of Nijmegen* of 1641 (*fig. 1*), in the collection of the Rijksmuseum, Amsterdam, reveals how precisely Salomon has appropriated the scene as presented by his contemporary. Even errors in or artistic rearrangements of the architectural details are repeated in the Ruysdael.[4]

Consequently, it is generally thought that Salomon van Ruysdael's Nijmegen paintings are based on those by Van Goyen and are not the result of firsthand knowledge of the site itself.

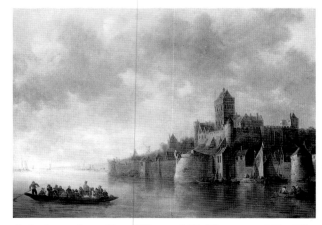

fig. 1 Jan van Goyen. *View of Nijmegen.* 1641. Oil on canvas, 36¼ x 51³⁄₁₆ in. (92 x 130 cm). Rijksmuseum, Amsterdam

The most striking aspect of the Kress *River View of Nijmegen with the Valkhof* is its strident coloration. Dated 1648, the painting records the moment when Ruysdael discarded the subdued color scheme that characterized both his own earlier works and those of Van Goyen.[5] A novel heightened palette is used throughout; the tonal gray of the sky has been replaced by a deep blue which is reflected in the water and contrasts strikingly with the gray and white clouds that sweep across the scene. These dramatic formations echo and augment the imposing castle structure. And, coupled with the surface diagonals created by the clouds' shapes and the town's skyline, they imbue the canvas with a sense of movement and rapidly changing atmospheric effects.

L.F.O.

1. Johannes Smith, *Oppidum Batavorum seu Noviomagnum* (Amsterdam, 1644); translated into Dutch by Joan Blaeu in 1649.

2. For Ruysdael's other Nijmegen views, see Stechow 1938/1975, nos. 70, 354.

3. For Van Goyen's Nijmegen paintings, see Beck 1972–73, nos. 342–70.

4. On Ruysdael's deviations from the realities of the architecture, see Haverkamp-Begemann 1980, 209, 211 nn. 28–29.

5. It should be noted that Van Goyen, too, seemed to be moving toward a new flush of color in his paintings at this time. For example, a small panel by Van Goyen on the art market in 1992, which is signed and dated 1646, has a tonal warmth created by the pale salmon ground, which the artist allowed to show through the striations of the upper layers of brushwork. See illustration in London 1992, no. 14.

Claude Gellée, called CLAUDE LORRAIN

Chamagne c. 1604/5–1682 Rome

View of Tivoli at Sunset

———⬦———

Born in the Duchy of Lorraine, Claude reached Rome possibly as early as 1613. There he worked in the household and then the studio of the painter Agostino Tassi, who specialized in architectural perspectives. Between 1618 and 1622 Claude was probably in Naples working with the innovative landscape artist Goffredo Wals. On a trip north during 1625–26, Claude journeyed to Loreto, Venice, Bavaria, and finally to Nancy (the capital of Lorraine), where he is documented as having worked with Claude Deruet. In Italy again by 1627, Claude spent the rest of his long career in Rome, where he died in 1682. He was accepted into the Academy of Saint Luke in 1633 and held several offices in the guild. By 1635 Claude's successes at landscape painting had earned him such notoriety that forgeries of his work had begun to appear on the market. Thus he began to keep the Liber Veritatis (The Book of Truth); this book of 195 drawings records nearly all of his subsequent paintings and includes many notations about the works and who acquired them. Now in the British Museum in London, the Liber is a unique document from the seventeenth century.

Many of Claude's early works are pastoral scenes painted on small copper panels. In scale, subject matter, and support these paintings reflect the influence of Wals and the early example of Adam Elsheimer and Paul Bril. But equally important inspiration came from contemporary landscape artists active in Rome, including northerners Cornelis van Poelenburgh and Bartolomeus Breenberg, and the Italian Filippo de' Angeli, called Napoletano. Like them, Claude was captivated by the antique ruins, benevolent climate, and golden light of the Mediterranean landscape. Claude gradually combined this northern vocabulary, with its interest in atmospheric effects and keenly observed detail, with the grander view of classicizing artists such as Annibale Carracci and Domenichino. The synthesis Claude created is an idealized landscape, characterized by quiet compositional arrangements with calming horizontals and meandering diagonals leading into the far distance. Light is always Claude's primary subject: its endlessly changing, shifting effects on the land, foliage, ruins, and bodies of water. The specificity with which these ephemeral effects are captured on canvas is the result of the direct study of nature, experienced firsthand and commited to memory in sketches drawn out-of-doors. The biographer Joachim von Sandrart recorded that he frequently went on sketching trips into the hills around Rome with Claude and Claude's equally famous compatriot Nicolas Poussin, collecting such plein air impressions.

1642–44
Oil on canvas, 39½ x 53½ in.
(100.3 x 136.9 cm)
The Fine Arts Museums of San Francisco
61.44.31

PROVENANCE
Edward Adolphus, 12th Duke of Somerset (d. 1885); Archibald Henry Algeron, 13th Duke of Somerset; sale, "The Stover Collection," Christie's, London, June 28, 1890, lot no. 50; with Thos. Agnew & Sons Ltd., London, 1890; acquired for Sir James C. Robinson; Sir Francis Cook, 1st Bart., Doughty House, Richmond, Surrey, before 1901; by descent to his son, Sir Frederick Lucas Cook, 2nd Bart., by 1901; by descent to his son, Sir Herbert Frederick Cook, 3rd Bart., London, by 1920; with Pinakos, Inc. (Rudolf Heineman), New York, by 1947; with M. Knoedler & Co., New York, in joint ownership with Pinakos, 1947–52; Samuel H. Kress Foundation, New York, 1952 (K1894); on loan to the M. H. de Young Memorial Museum, 1955–61; gift of the Kress Foundation to the M. H. de Young Memorial Museum, later The Fine Arts Museums of San Francisco, 1961.

SELECTED EXHIBITIONS
London 1902, no. 57; Dallas 1951, no. 49; Pittsburgh 1951, no. 62; Washington 1961–62, no. 18; Denver 1978–79, no. 19; San Francisco 1990.

SELECTED REFERENCES
Cook 1913–15, III, 61 no. 443; Cook 1932, no. 443; Walker 1955, 18; Frankfurter 1955, 58; Larsen 1955, 175; Comstock 1955, 71; Roethlisberger 1961, I, 231–32; Kitson 1967, 147; Kennedy 1969, 304; Roethlisberger and Cecchi 1975/77, 104 no. 144; Eisler 1977, 284–85; Kitson 1978, nos. 65, 81; Lee 1980, 214, 218; Rosenberg and Stewart 1987, 56–59.

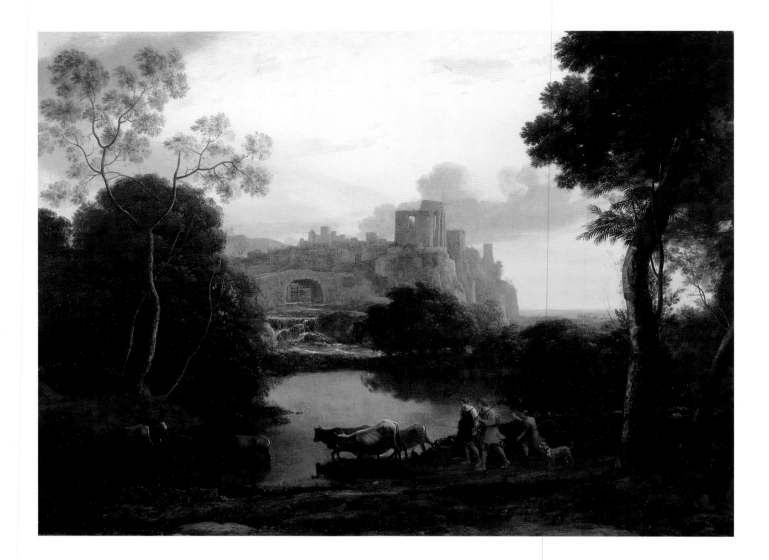

CLAUDE LORRAIN, *View of Tivoli at Sunset*

Human figures enter Claude's idyllic visions of the Roman countryside, or campagna, *as a secondary interest, providing animation, spots of color, and frequently a specific subject. It should be noted that by including characters from biblical, historical, mythical, or literary sources Claude succeeded in elevating his landscapes to the more esteemed category of history painting.*

Claude established an international clientele, including popes Urban VIII and Alexander VII, Giulio Rospigliosi (later Clement IX), Cardinal Richelieu, and Philip IV of Spain, among many others. Interestingly, however, it was not until after Claude's death that any of his works entered the collection of Louis XIV. Popular during his lifetime, Claude's work remained widely influential, his idealized landscape idiom the lens through which nature was viewed until the advent of modernism in the late nineteenth century.

Few sites in Latium have engaged the imagination as continuously as the ancient ruins of the town of Tivoli (called Tibur in Roman times), which appear repeatedly in art from the sixteenth into the nineteenth century. At this spot the Via Tiburtina, the old Roman road, descends out of the Sabine Hills into the fertile plain of the Roman *campagna*. And in a series of cascading waterfalls, the Aniene River also makes its descent from the heights at Tivoli. Picturesquely situated above the cascades are two small temples: one rectangular in design and probably originally dedicated to the Tiburtine Sibyl, the other of circular format, its eighteen columns decorating a shrine to Vesta. In a number of paintings and drawings, Claude explored the beauty of the Tivoli, capitalizing on its historic associations and felicitous juxtaposition of cliffs, ruins, waterfalls, and sweeping views of the Roman countryside.

Recent treatment in the conservation laboratory of The Fine Arts Museums of San Francisco by the museums' former paintings conservator Jim Wright has restored this sparkling view of Tivoli to Claude's accepted oeuvre.[1] Long considered autograph, the *View of Tivoli at Sunset* had been relegated to the status of a copy in the catalogue of the collection published in 1987.[2] Prior to this latest restoration, the work had a lifeless quality; old, dulled varnishes obscured the picture's spatial and coloristic relationships and subtleties; and needlessly extensive retouchings had coarsened the figures. Beyond the specifics of condition, the San Francisco painting was one of three variations of the same composition.[3] Two of these paintings, now belonging to the New Orleans Museum of Art (*fig. 1*) and a private collector in Switzerland, are recorded in Claude's *Liber Veritatis*.[4] No corresponding drawing exists in the *Liber* for the San Francisco work, however. Consequently, the visual evidence

of the painting's surface and the lack of documentary evidence led to the assumption that the San Francisco *View of Tivoli at Sunset* was not authentic.

There were, however, mitigating factors that argued in favor of Claude's authorship. Obviously from the period, the picture had been executed by a skilled artist with a sensitivity of observation and refinement of technique close to

fig. 1 Claude Lorrain. *Ideal View of Tivoli*. 1644. Oil on canvas, 46 x 57⅞ in. (116.8 x 147 cm). New Orleans Museum of Art

Claude himself. Encouragingly, the composition was not an exact copy of either of the paintings now in New Orleans or Switzerland but rather was a variant of them, with numerous differences in detail. And the presence of visible pentimenti (artist's changes) suggested that the San Francisco *View of Tivoli at Sunset* was not a mechanical copy of yet another image but was instead the result of a creative working process. One additional reassuring fact was that there are other instances where autograph paintings have been

left out of the *Liber Veritatis*.[5] Armed with these favorable indications, the museum decided to undertake conservation of the painting.

The outcome is remarkable. Removal of accumulated varnish and old retouching has revealed that the canvas is actually in a much better state of preservation than initially thought. Spatial relationships are reestablished, allowing the groundplane to recede into the pictorial space toward the horizon instead of up the surface of the canvas. The most sensitive nuances of color have been recaptured, creating the illusion of shimmering natural light and atmosphere filling the space.

Examined under the microscope, and with X-radiography and infrared reflectography,[6] idiosyncrasies of Claude's technique (such as the presence of the print of his palm, which he used to blend and smooth the paint) became visible throughout the various layers of the composition. The most exciting discovery is the underdrawing for the figural group in the foreground, which is in Claude's characteristic hand. As seen in the infrared reflectogram (*fig. 2*), the

fig. 3 Claude Lorrain. *Three People and Two Dogs*. 1642–44. Black chalk and gray wash, 7 1/16 x 10 1/4 in. (180 x 260 mm). British Museum, London

fig. 2 Claude Lorrain. *View of Tivoli at Sunset* (infrared reflectogram of cat. 31 showing artist's changes in main figure group)

painting's underdrawing closely follows the composition of a Claude drawing in the British Museum, London (*fig. 3*). "The woman in front originally was turned to face the shepherd who follows, the shepherd's staff was raised at a higher angle, the boy behind was turned more to the front and held the dog by a leash, and a second dog was directly behind the boy."[7] Starting from the drawing, Claude has adjusted the figural arrangement, establishing a forward movement of the figures to draw our attention toward the center of the composition. The correspondence of underdrawing and the London sketch is conclusive evidence that the San Francisco painting was conceived by the master himself,

for it is unlikely that another artist would have had access to Claude's drawing. But the most persuasive argument is the stunning overall effect of the painting itself. With proper cleaning, Claude's glorious representation of the warm enveloping light of the setting sun emerged in florid colors of blue and orange. Simultaneously, the fleeting effect of light filtered through the milky atmosphere of approaching evening is palpably suggested. This ability to project not only the shapes and colors of the Mediterranean landscape but also its characteristic light and the soft benevolence of its air assured Claude's success, particularly among collectors from northern Europe.

L.F.O.

1. In the preparation of this discussion, I am deeply indebted to the scholarship of my colleague and friend Marion C. Stewart, Associate Curator of Paintings, European Art Department at The Fine Arts Museums of San Francisco. The comments on the conservation treatment are based on the work of Jim Wright, now Conservator at the Museum of Fine Arts, Boston.

2. Rosenberg and Stewart 1987, 56–59.

3. Kitson (1967, 147–48) discusses the general question of variants in Claude's work, including the San Francisco painting.

4. The New Orleans *Ideal View of Tivoli* corresponds to drawing *LV* 81 (Roethlisberger and Cecchi 1975/77, no. 143). The Swiss painting, *Pastoral Landscape with Tobias and the Angel*, corresponds to drawing *LV* 65; discussed in Roethlisberger 1961, under *LV* 65; reproduced in Kitson 1978, 179.

5. This happened with some regularity with Claude's own repetitions or variants of his compositions. See Kitson 1967, 145.

6. "IR reflectography (infrared reflectography) is a technique utilizing a video camera sensitive to the infrared spectrum of light that allows one to look into the paint layers to detect underdrawings, alterations, and restorations." For further discussion of the technical analysis of the painting by conservator Jim Wright, see San Francisco 1990, 3.

7. San Francisco 1990, 3.

PIER FRANCESCO MOLA

Coldredio 1612–1666 Rome

Born in a small village near Lugano, Pier Francesco Mola moved to cosmopolitan Rome with his family in 1616. His father, a respected architect, was the author of an important guidebook to the art and architecture of Rome. Although the Cavaliere d'Arpino has been cited as Pier Francesco's first master, few specifics are known about his actual artistic training and early travels. During most of the period 1633 to 1644 he traveled in northern Italy, principally in Venice and Bologna. Exposure to the artists of the Venetian High Renaissance, including Titian (see cat. 2), Veronese (see cat. 4), and the Bassano family, to his Bolognese contemporaries, particularly Francesco Albani, and to the soft modeling found in Guercino's paintings proved pivotal to both Mola's style of painting and his choice of subject matter. From these years date numerous cabinet pictures depicting small-scale figures within lush Venetian landscape settings, an approach substantially different from the classical landscape idiom that dominated the Roman scene.

When Mola returned to Rome in 1647, his style began to change, due in part to his new sources of patronage. Commissions for altarpieces and frescoes came from important families such as the Costaguti, Pamphili, and Chigi, as well as from Pope Alexander VII. The public nature of these projects required a monumentality of scale and grandeur of design very different from Mola's early works. In the 1650s Mola achieved a powerful blending of divergent artistic impulses: Venetian colore *and Bolognese* disegno, *fortified by Roman monumentality. His figures became increasingly idealized and grew in relative scale at the expense of their natural setting. The landscape, however, maintained its evocative character in these works, relying on the richness of color and expressive execution combined with deep tonal contrasts that Mola employed to create an overall moodiness. These traits link Mola to the other leading Baroque "romantics," Salvator Rosa and Pietro Testa.*

*Artistic successes brought admission to the Academy of Saint Luke in 1655, and in 1662 he was elected president (*principe*) of that body. However, Mola's circumstances began to decline after he brought suit against Prince Don Camillo Pamphili in late 1659 for failing to complete payment for frescoes in the Pamphili Villa Valmontone, on*

32

Erminia and Vafrino Tending the Wounded Tancred

———⌁———

c. 1653
Oil on canvas, 27⅛ x 36⅛ in.
(69 x 91.8 cm)
Musée du Louvre, Paris inv. no. 399

PROVENANCE
M. Jolly, Paris; sold to Bersan Bauin (dealer); Louis XIV, 1685, Inv. Le Brun, no. 466; on loan from the Musée du Louvre to the Palais de l'Elysée, 1875; disappeared or stolen c. 1950; Jean Neger, Paris, by 1953; Samuel H. Kress Foundation (through Borislav Bogdanovich), New York, 1953 (K1969); on loan to the M. H. de Young Memorial Museum, 1955–61; gift of the Kress Foundation to the M. H. de Young Memorial Museum, later The Fine Arts Museums of San Francisco, 1961; returned to the Musée du Louvre, 1986.

SELECTED EXHIBITIONS
Paris 1987, 206–8; Lugano 1989–90, no. I.25; Birmingham 1992–93, no. 19.

SELECTED REFERENCES[1]
San Francisco 1955, 60; Lee 1967, 136–41; Cocke 1972, 39–40, 62 no. 60; Shapley 1973, 69–70; Gentry 1979, 49; Brejon de Lavergnée 1986, 373–78; Brejon de Lavergnée 1987, 77–79.

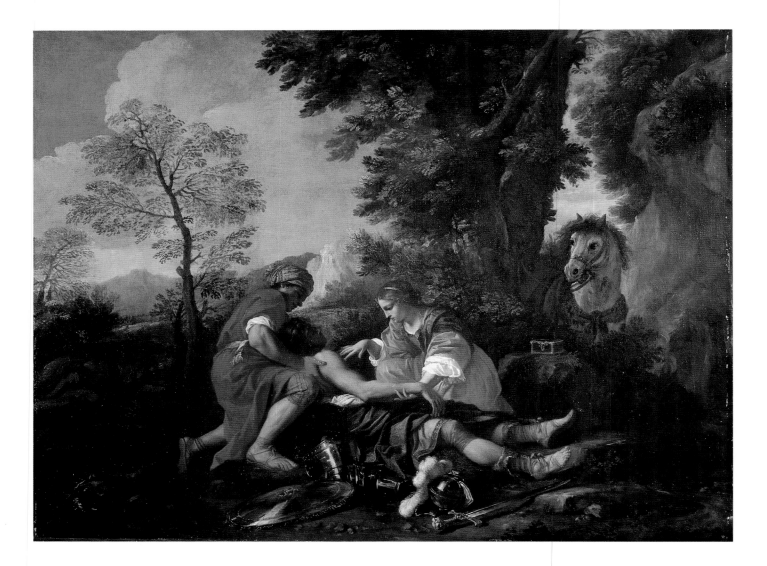

MOLA, *Erminia and Vafrino Tending the Wounded Tancred*

which Mola had worked during 1658. The proceedings ended only in 1664 with the court ruling against Mola. By that time he was already suffering from ill health, and he died in his adopted Rome in 1666. Noted for his deeply evocative paintings, Mola was also a gifted draftsman, with a particular flare for biting caricatures.

Erminia and Vafrino Tending the Wounded Tancred depicts an episode from Torquato Tasso's *Gerusalemme liberata* (*Jerusalem Delivered*), the widely popular sixteenth-century Italian epic poem about the Crusades (see cats. 5, 48). One of the secondary plots within the narrative concerns the love of the pagan princess Erminia for the Christian knight Tancred. Here Mola depicts the moment when Tancred, bleeding from wounds sustained in personal combat with the giant Argante (who lies dead in the distance), is found by Erminia and Tancred's squire Vafrino.[2] With elegantly attenuated fingers, Erminia tenderly examines the knight's injuries. This picture was acquired by Louis XIV in 1685. Later that year another work by Mola (*fig. 1*), also with a subject drawn from Tasso, joined the royal collection.[3] *Erminia Guarding Her Flocks* depicts an earlier moment in the epic when Erminia, and the reader, enjoy one of the tale's few pastoral interludes. Having briefly taken refuge among the family of a shepherd, Erminia appears in the guise of a shepherdess, carving the name "Tancred" on a tree.[4]

Although originally of dissimilar dimensions,[5] these two Tasso scenes traditionally have been treated as pendants. They are recorded in various inventories, publications, and

fig. 2 Pier Francesco Mola. *Erminia and Vafrino Tending the Wounded Tancred*. Pen and brown ink on blue paper, 7 13/16 x 10 1/16 in. (198 x 255 mm). Private collection, Paris

de l'Elysée in 1875. Sometime around 1945–50 *Erminia and Vafrino Tending the Wounded Tancred* disappeared, reappearing in the Kress Collection and then being given to San Francisco in 1961.

Samuel Kress had purchased *Erminia and Vafrino* from Jean Neger (through Borislav Bogdanovich) in Paris in 1953. It is revealing of the conditions in Europe and the state of art-historical scholarship at that moment that a work of superb quality by one of the foremost Italian painters of the seventeenth century, and from the Louvre's collection, could pass through the market in Paris unnoticed. As this exhibition demonstrates, however, it was not atypical of Samuel Kress to buy ahead of the market and express interest in an art-historical period that still awaited resuscitation after centuries of undeserved critical rebuke.[6]

As early as 1963 it was suggested in scholarly literature that the San Francisco painting was the Mola that had disappeared from the Palais de l'Elysée.[7] Thus began lengthy deliberations between the staffs at the Louvre, The Fine Arts Museums of San Francisco,[8] and the Kress Foundation in New York, which eventually led to the return of the *Erminia and Vafrino Tending the Wounded Tancred* to the Louvre in October 1986.[9]

Scholarly opinion has been divided on the dating of this work, with suggestions ranging from the early 1650s to the early 1660s.[10] On the basis of stylistic similarities, *Erminia*

fig. 1 Pier Francesco Mola. *Erminia Guarding Her Flocks*. c. 1653. Oil on canvas, 27 15/16 x 37 in. (71 x 94 cm). Musée du Louvre, Paris

documents of the seventeenth into the nineteenth century. Greatly prized in the eighteenth century, they hung together in the Petits Apartements du Roi at Versailles. After the French Revolution, they became part of the Louvre collection and together they were transferred to the Palais

and *Vafrino* and *Erminia Guarding Her Flocks* have been convincingly placed chronologically with the Hermitage's *Rest on the Flight into Egypt*, just after mid-century.[11] Together these works share the bucolic mood typical of this moment in Mola's career. Disparate artistic influences are beautifully harmonized, establishing a peaceful balance between form and color and between the figural and landscape elements.

Of the preparatory drawings associated with the former San Francisco painting, none actually present the figures in the same positions as they appear in the finished work. A beautifully animated pen-and-ink sketch (*fig. 2*)[12] from a private collection shows Mola working out the figural relationships. Tancred is represented twice in the drawing, outspread on the ground and again cradled in Vafrino's arms (much as he appears in the Louvre picture).[13] Other elements, such as the horse and the fallen giant, are indicated, but not in their final disposition. Important precedents for Mola's handling of the specific scene and the arrangement of the figures have been identified in a work from the circle of Pietro da Cortona[14] and in two paintings by Nicolas Poussin.[15] It is most likely Mola's responses to these works that are recorded in the surviving drawings.[16]

Prior to the return of the Kress Mola to Paris, its companion piece of long standing, *Erminia Guarding Her Flocks*, was sent to San Francisco for a small exhibition celebrating the cooperation of the two institutions. Side by side the two paintings illustrate Mola's complete mastery of his medium, striking a perfect balance between the elegantly idealized players and their pastoral setting, uniting them via rich color harmonies and sonorous lighting effects. The former San Francisco work is a masterpiece of poetic sensitivity, fully evocative of Tasso's emotive lines:

> Tancred look'd up, and clos'd his eyes again,
> Heavy and dim, and she renew'd her wo.
> Quoth Vafrine—Cure him first and then complain,
> Med'cine is life's chief friend, plaint her worst foe.-
>
> They pluck'd his armor off, and she each vein,
> Each joint, and sinew felt and handled so,
> And search'd so well each thrust, each cut, and wound,
> That hope of life her love and skill soon found.[17]

L.F.O.

1. For complete early bibliography see Lugano 1989–90, 179 no. I.25.

2. Canto XIX:103

3. Le Brun inventory no. 470.

4. Canto VII:6.

5. Dimensions of the former Kress picture are 27⅛ x 36⅛ in. (69 x 91.8 cm). Originally approximately 19¼ x 26½ in. (c. 49 x 67 cm), the *Erminia Guarding Her Flock* was subsequently enlarged to 27¹⁵⁄₁₆ x 37 in. (71 x 94 cm). To ameliorate further the difference in sizes, thus allowing the two paintings to be exhibited felicitously as pendants, both works were framed as ovals in the eighteenth century and recorded as ovals in subsequent documentation.

6. See Bowron essay, 44 ff.

7. Ziff 1963, 129–30 n. 19.

8. Given by the Kress Foundation to the M. H. de Young Memorial Museum in 1961, the Mola became part of the collection of The Fine Arts Museums of San Francisco when the de Young merged with the California Palace of the Legion of Honor in 1972.

9. See Brejon de Lavergnée 1986, 373–78; Brejon de Lavergnée 1987, 77–79.

10. Cocke (1972, 39) and Gentry (1979, 49) both placed the work in the early 1660s, while Rudolph (1972, 350) and Shapley (1973, 70) preferred a dating in the late 1650s. This idea was supported in the 1989–90 Lugano exhibition catalogue (Lugano 1989–90, 179). Harris (1974, 290) placed the work in the early 1650s.

11. Harris 1974, 290.

12. For the several drawings associated with the former Kress painting see Lugano 1989–90, nos. III.15, III.59, III.60.

13. Brejon de Lavergnée 1987, 208; Lugano 1989–90, 259–60 no. III.59.

14. Briganti 1962/1982, 224–25 no. 84, fig. 196; Lugano 1989–90, 70.

15. *Tancred and Erminia*, Hermitage, St. Petersburg (Blunt 1966, 142 no. 206) and *Tancred and Erminia*, Barber Institute of Fine Arts, University of Birmingham, England (Blunt 1966, 142 no. 207). See also Lee 1967, 139–40; Lugano 1989–90, 179; Birmingham 1992–93, 26, 65 no. 19.

16. See Schleier in Lugano 1989–90, 69–70. Schleier (1970, 8) also correctly identified another drawing (previously related by Cocke to the former Kress painting) as actually recording a painting *Angelica and Medaro* by Giovanni Lanfranco. See also Lugano 1989–90, 229–30 no. III.15.

17. Torquato Tasso, *Jerusalem Delivered*, trans. Edward Fairfax (New York, 1963), canto XIX:111.

Giovanni Battista Gaulli, called IL BACICCIO

Genoa 1639–1709 Rome

Gaulli, known as Baciccio (the Genoese diminutive for Giovanni Battista), spent his formative years in his native city before moving permanently to Rome around 1657. This Genoese heritage exercised a lasting influence on Baciccio's artistic character, as evidenced by the vibrancy of color, the animated draperies, and the fluid figural contours in his paintings. These traits, which Gaulli shared with other Genoese artists, including the older Valerio Castello and Giovanni Benedetto Castiglione, derive ultimately from the saturated palette and energetic brushstroke introduced to Genoa earlier in the century by Flemish artists Peter Paul Rubens (see cat. 11) and Anthony van Dyck (see cat. 13).

In Rome, Baciccio initially established himself as a portrait painter, but his fame is based on his accomplishments as one of the greatest decorators of the Baroque period. His rise to prominence during the 1660s was aided greatly by the favor of the illustrious and politically powerful sculptor Gian Lorenzo Bernini. Beginning with an altarpiece for the church of San Rocco, Baciccio secured a series of important public commissions, including those for the Roman churches of Sant'Agnese, San Marta of the Collegio Romano, and San Francesco a Ripa. Admitted to the Academy of Saint Luke in 1662, Baciccio was elected to several offices in that body, including president in 1674.

Two years earlier, at Bernini's urging, Gian Paolo Oliva, Father-General of the Society of Jesus, had awarded Baciccio the commission for the decoration of the interior nave of Il Gesù, the recently completed mother church of the Jesuit order. Gradually expanded, this project occupied Baciccio until 1685, during which time he covered the entire upper register of the interior with glorious frescoes celebrating the mysteries of the Counter-Reformation Church. The nave ceiling fresco, The Triumph of the Name of Jesus, *was unveiled on New Year's Eve, 1679. In this tumultuous scene Baciccio brought to fulfillment Bernini's Baroque synthesis of painting, sculpture, and architecture. The boundaries between each component are confounded by the bold illusionism of figures who seem to hover above or tumble into the viewer's space. Universally accepted as the culmination of Baroque illusionistic ceiling painting, the Gesù project also marked the culmination of Baciccio's career. At the end of the seventeenth century, as papal political power declined, so did artistic patronage in Rome. Change in the political climate coincided with a change in*

33

The Thanksgiving of Noah

———⟨⟩———

c. 1685–90
Oil on canvas, 64½ x 51¼ in.
(163.8 x 130.2 cm)
High Museum of Art, Atlanta 58.30

34

Abraham's Sacrifice of Isaac

———⟨⟩———

c. 1685–90
Oil on canvas, 63¼ x 51⅝ in.
(160.7 x 131.2 cm)
High Museum of Art, Atlanta 58.31

PROVENANCE
With Count Alessandro Contini-Bonacossi, Florence, before 1950; Samuel H. Kress Foundation, New York, 1950 (K1774A, *Abraham's Sacrifice of Isaac*, and K1774B, *The Thanksgiving of Noah*); on loan to the Philadelphia Museum of Art, 1950–53 (*Abraham* only); gift of the Kress Foundation to High Museum of Art, 1958.

SELECTED EXHIBITIONS
Suida 1950, no. 15 (*Abraham* only); Dayton 1962–63, no. 34 (*Abraham* only); Detroit 1965, no. 51 (*Abraham* only); Oberlin 1967, nos. 16 and 17.

SELECTED REFERENCES
Enggass 1956, 31–33; Brugnoli 1956, 26–27; Atlanta 1958, 62–65; Enggass 1964, 95, 121; Enggass 1964A, 79; Atlanta 1965–66, 24–25; Macandrew and Graf 1972, 233, 241, 242; Shapley 1973, 94; Atlanta 1984, 60–61; Atlanta 1987, 23–24.

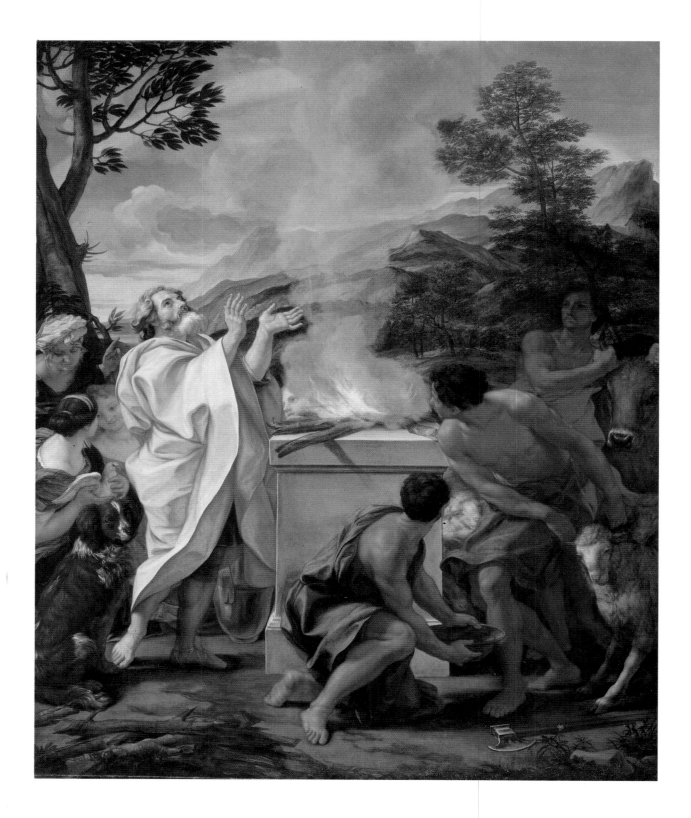

BACICCIO, *The Thanksgiving of Noah*

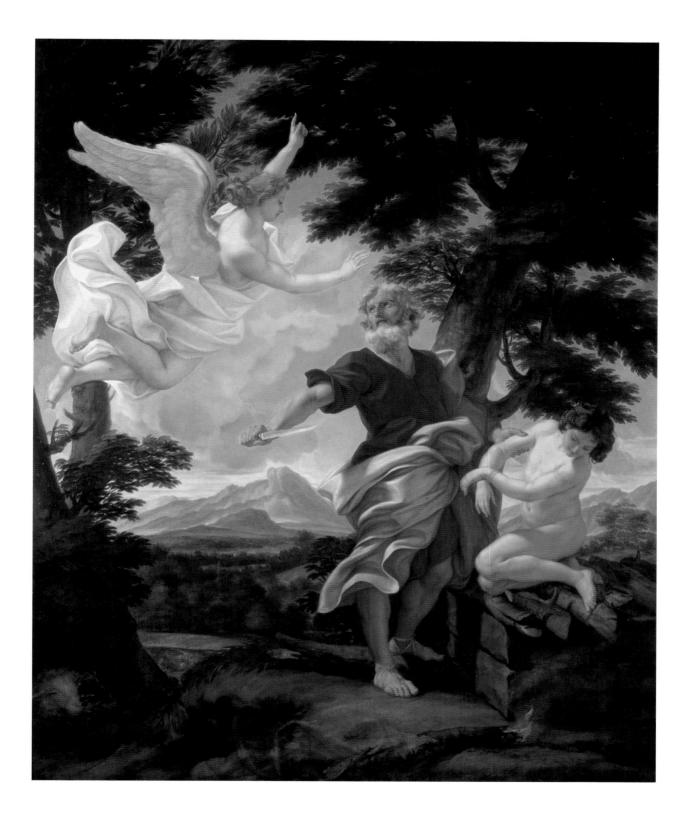

BACICCIO, *Abraham's Sacrifice of Isaac*

artistic taste, and increasingly the remaining support shifted to artists working in a more classical manner. Baciccio received fewer public commissions, and in his late works the flamboyant rhythms and sumptuous colors of the high Baroque are set aside, conceding to the ascendancy of late Baroque classicism.

Conceived as a pair, the Atlanta paintings mirror each other in size, style, coloring, and iconography. They exhibit the blonder tonalities, quieter drapery rhythms, and greater figural solemnity typical of Baciccio's art immediately following completion of the Gesù frescoes. Dating from 1685–90, *The Thanksgiving of Noah* and *Abraham's Sacrifice of Isaac* belong to a complex group of related paintings and drawings in which Baciccio is seen to rely on compositional elements borrowed from other artists as well as to reuse material from his own works.

The general format of the Atlanta *Noah* seems based on a lost composition by Poussin, known today only through a number of derivative paintings, drawings, and engravings.[1] Baciccio adopts the central pictorial elements of this prototype: Noah posed with uplifted arms, the placement of

the altar perpendicular to the picture plane, and the pose of the kneeling youth who holds one of the ritual vessels. With only minor adjustments these motifs appear in all of Baciccio's paintings of Noah's sacrifice.[2]

fig. 2

Baciccio. *Kneeling Woman Holding a Basin.* c. 1685–90. Pen and brown ink, brown and gray washes, squared for transfer, 11¼ x 7⅝ in. (286 x 193 mm). Ashmolean Museum, Oxford

Drawings by Baciccio's hand exist for the principal figures in both Kress pictures. Most are fully developed studies, working drawings squared for transfer to the canvas, such as the powerful figure of Abraham (*fig. 1*), now in Düsseldorf.[3] The lovely woman with lost-profile at the left edge of the Atlanta *Noah* is recorded in Baciccio's pen-and-ink drawing (*fig. 2*) at Oxford,[4] although in the painting a large portion of the figure is cut off by the frame and she holds a dove, not a basin. Discovery of a drawing of a similar figure (*fig. 3*)[5] by the French artist Guillaume Courtois (1628–1679), who was known in Italy as Guglielmo Cortese, initially suggested that this was the basis of Baciccio's lost-profile figure. Comparison of the Atlanta *Noah* and Cortese's *Martyrdom of Saint Andrew*, however, reveals that while the figures in the drawings are almost identical, the two women represented in the finished paintings are not; but the correspondence of the figures in the two drawings is too close in details of pose, costume, and coiffure to be coincidental. Thus it is apparent that these drawings by Baciccio and Cortese both must record a third image, probably the figure of one of the women grieving at the foot of the cross in Pietro da Cortona's fresco, the *Crucifixion*, in the Palazzo Barberini chapel, executed in 1631–32, when the young Cortese was in Cortona's studio.[6] At the same time that such

fig. 1 Baciccio. *Study for Abraham.* c. 1685–90. Black chalk, brown ink, black wash, squared for transfer, 17⅛ x 11¼ in. (435 x 285 mm). Kunstmuseum Düsseldorf, Graphische Sammlung, inv. no. FP 11292

observations help us decipher the genesis of the Kress Baciccios, they also point out the difference between twentieth-century concepts of originality and those held by artists from earlier periods. Contrary to present thinking, it was then considered a demonstration of skill to borrow a visual element from another artist's work and successfully incorporate it into a new composition.

No primary documents have yet appeared for the Atlanta paintings, but their monumental scale suggests that they were designed for a church setting. Further, the sacrificial

fig. 3

Guglielmo Cortese. *Study for a Kneeling Woman*. c. 1668. Red chalk and white heightening on brown paper, 16⁵⁄₁₆ x 10⁷⁄₁₆ in. (415 x 272 mm). Kunstmuseum Düsseldorf, Graphische Sammlung, inv. no. FP 7919

theme depicted in each is well suited for placement above or flanking an altar, that part of the church that is symbolic of God's own sacrifice of his son Jesus for the redemption of mankind. Here Baciccio depicts Noah in the act of giving thanks (in the form of burnt offerings) to the Lord after the waters of the flood have receded and the ark has settled on Mount Ararat:

> And Noah builded an altar unto the Lord; and took of every clean beast, and of every clean fowl, and offered burnt offerings on the altar.

> And the Lord smelled a sweet savor; and the Lord said in his heart, I will not again curse the ground any more for man's sake. (Genesis 8:20–21)

This is one of the significant early moments in the Bible. God, in response to Noah's obedience and thanksgiving, reestablished his covenant with man to sustain the earth and its creatures: "I do set my rainbow in the cloud, and it shall be for a token of a covenant between me and the earth" (Genesis 9:13). And in the sky above Baciccio's figures stretches the Lord's token, a rainbow.

Abraham's Sacrifice of Isaac derives from the Old Testament story of the patriarch Abraham, first in the line of important Hebrew prophets (Genesis 22:1–19). The painting repre-

sents another dramatic tale of unquestioning obedience to God's authority. To test Abraham's devotion, God ordered him to make a burnt offering of Isaac, the cherished only son of the aged Abraham and his elderly wife, Sarah. Artists have traditionally favored the climactic moment of Abraham's psychological conflict, in which spiritual obedience is pitted against family allegiance and paternal love. Here Baciccio, too, depicts the instant before Abraham is to plunge the dagger into his son, who, acquiescent, kneels on the altar pyre. Only at the second in which Abraham reaches his resolve to comply with God's demand does reprieve arrive, in the form of a lovely and gentle angel to stay Abraham's hand. These two Old Testament stories, symbols of blind faith and submission to God's will, must have appealed greatly to the clerics of the late seventeenth century, particularly in the face of Rome's declining temporal and spiritual power.

L.F.O.

1. Friedlaender 1968, 3; Blunt 1966, 158; Shapley 1973, 94.

2. The scene of Noah giving thanks is known in three earlier versions by Baciccio. There exist two horizontal versions: Palazzo Bianco, Genoa, and Pico Cellini Collection, Rome; and one vertical composition: Gasparrini Collection, Rome. See Enggass 1964A, 76–79. For the reuse of the figure of Noah as Zacharias in Baciccio's own *Birth of Saint John the Baptist*, in the Roman church of Santa Maria in Campitelli, see Enggass 1956, 30, 33, pl. 29.

3. On the important Düsseldorf collection of Baciccio drawings, see Graf 1976. Another drawing representing a sacrifice of Isaac was recently sold in the Holkham Hall sale (Christie's, London, July 2, 1991, lot no. 57). Previously attributed to Cortese, this drawing was recently given to Baciccio and identified as a preparatory study of the Kress *Abraham*. However, because only isolated details appear in both the sketch and Baciccio's painting, the drawing (if actually related to the Atlanta picture) could only be an initial conception for the design. It is interesting to note that the figure of Abraham in the drawing formerly at Holkham does not exhibit Baciccio's characteristic treatment of the draperies in diagonal (at times almost horizontal) folds that billow around the form. Rather, the drapery is articulated by ropelike folds that fall more parallel to the body's axis. On Cortese's treatment of the theme, see Graf and Schleier 1973, 797–98.

4. Macandrew and Graf (1972, 241 no. 3, pl. 3) incorrectly identified this drawing as for the central male figure kneeling in the foreground of the Atlanta picture.

5. Graf (1976, I, 39 no. 49) published this drawing as a preparatory sketch for Cortese's *Martyrdom of Saint Andrew*, commissioned in 1668 for the high altar in Bernini's church of Sant' Andrea al Quirinale, Rome.

6. See Briganti 1962/1982, 195–96 no. 44, pl. 121.

HYACINTHE RIGAUD

Perpignan 1659–1743 Paris

*A Maître des Requêtes
(Président André Pierre Hébert?)*

⎯⎯⎯⎯⎯◌⧫⎯⎯⎯⎯⎯

c. 1700
Oil on canvas, 54⅛ x 41 in.
(137.5 x 104 cm)
El Paso Museum of Art 61.1.58

Rigaud, who was to become one of the most successful court portraitists of the reign of Louis XIV, was born and raised in the far southwest of France. He studied in the provincial capital of Montpellier with the painters Paul Pezet (dates unknown) and Antoine Ranc (1634–1716), whose enthusiasm for the art of Van Dyck (see cat. 13) was important for Rigaud's early development. By way of Lyons, he went to Paris in 1681, where, as a biographer states, he already had "a certain reputation."[3] He became a student at the Académie Royale, and in the very next year obtained the grand prix, *which would have enabled him to undertake a voyage to Rome at the expense of the crown. In 1681, however, he had already been commissioned to paint eighteen portraits, and upon the advice of Charles Le Brun, director of the academy, renounced the prize to launch his career as a portraitist in the grand style.*

Admitted to candidacy for election to the academy in 1684, he was received as a history painter in 1700, and was made a professor in 1702. This eighteen-year period saw the growth and full flowering of his reputation as a portraitist of the great men and women of France. By 1688 he had received his first royal commission, for a portrait of Monsieur, Philippe d'Orléans (1640–1701), *brother of the king.[4] His subsequent career was distinguished by the court commissions that came his way, culminating in 1701 in his magnificent state portrait* Louis XIV in his Coronation Robes, *destined for the throne room at Versailles.[5] As a modern biographer remarked, "Rigaud is the painter who most faithfully represents the century of Louis XIV, not only in the majesty of his poses and the richness of the accessories and draperies with which he surrounds the people he paints, but also by virtue of the number and the variety of worthy men who served him as models. He painted six kings, thirty-six French or foreign princes, twenty-one field-marshalls, eighteen dukes, seven presidents of the supreme court, and sixty-four cardinals, archbishops, or bishops."[6] With his friend and sometime rival Nicolas de Largillierre, Rigaud was also the principal portraitist of men and women of fashion, artists, writers, bankers, and lawyers.*

On the basis of Van Dyck's example, Rigaud elaborated a number of stock portrait formulas that served him for more than fifty years. Preferring to work from painted sketches and models rather than from elaborate preparatory drawings, he used

PROVENANCE

Duchesse de Brancas, née Chazeron, until 1859; Marquis de Sinéty, Paris, from the Château de Chazeron at Loubeyrat;[1] Duc de la Rochefoucauld-Doudeauville;[2] with Wildenstein & Co., New York, perhaps by 1921; Samuel H. Kress Foundation, New York, 1944 (K1393); gift of the Kress Foundation to the El Paso Museum of Art, 1961.

SELECTED EXHIBITIONS

Paris 1927, no. 1254 (as *Président Hébert*); New York 1939, 154 no. 316 (as *Président Hébert*); New York 1943, no. 35.

SELECTED REFERENCES

Roman 1919, 94 (if this portrait is identifiable as Hébert); Réau 1925, I, 58ff.; Washington 1945, 157; Frankfurter 1946, 61; Einstein 1956, 214; El Paso 1961, no. 50; Eisler 1977, 294–95.

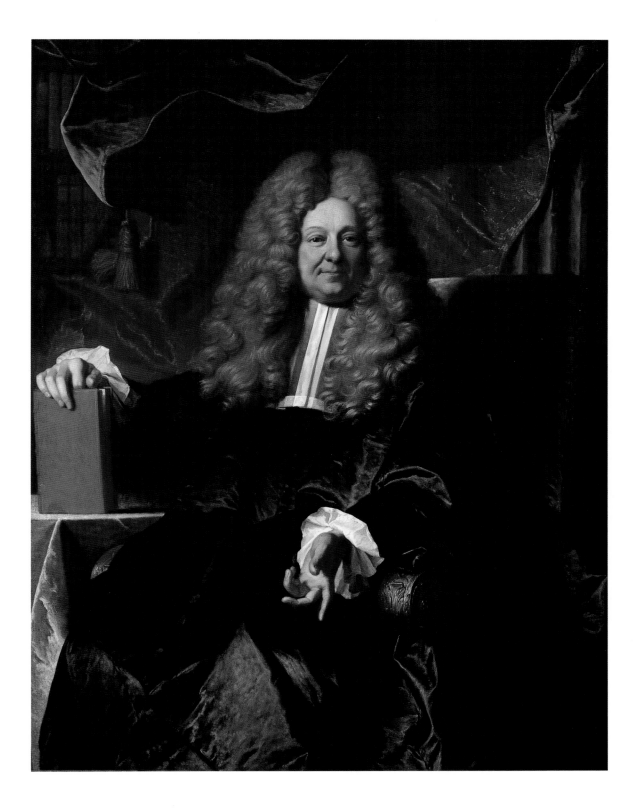

RIGAUD, *A Maître des Requêtes*

a large team of assistants to produce the hundreds of original likenesses and repetitions of his own compositions that have come down to posterity. As scholars have remarked, Rigaud's work carries on the traditions of the grand manner of Flemish portraiture but occasionally embraces the humbler, more psychologically penetrating manner of Rembrandt and his Dutch contemporaries. His own collection of paintings included eight works by Van Dyck and four by Rubens, but also seven by Rembrandt.[7]

This imposing and engaging portrait of a magistrate has been linked with a work Rigaud is known to have painted in 1702, entered in his *livre de raison* under that year as "M. Hébert," and identified by his biographer as "André-Pierre Hébert, seigneur du Buc et de Villiers, born in 1637, Conseillier of the parliament of Paris in 1659, maître des requêtes in 1675, [who] died in 1707."[8] Rigaud is known to have painted several men holding the position of *maître des requêtes*—"a magistrate whose office is to justify to

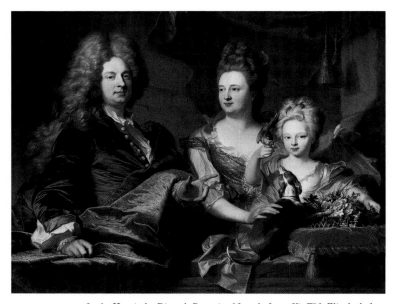

fig. 1 Hyacinthe Rigaud. *Portrait of Jean le Juge, His Wife Elisabeth de Gouy, and Their Daughter Marguerite-Charlotte Le Juge*. 1699. Oil on canvas, 44⅞ x 58 in. (114 x 147.3 cm). National Gallery of Canada, Ottawa

the Council of State the legality of the petitions of cases made to the supreme court."[9] Unfortunately, no engraving after this painting appears to have been made; no inscription survives on the canvas; no other portrait of the sitter is known to us; and nothing about the painting's provenance gives any certainty to the identification of this likeness with Hébert.

Nonetheless, in its style the painting compares favorably with works by Rigaud datable to the end of the 1690s or the first years of the eighteenth century, such as the more

complex *Portrait of Jean le Juge, His Wife Elisabeth de Gouy, and Their Daughter Marguerite-Charlotte Le Juge*, 1699 (*fig. 1*), or the *Portrait of Pierre de Bérulle*, 1709.[10]

The somewhat stiff attitude of the sitter is enlivened by the gestures of his hands, his left pointing as if reinforcing a conversational point, his right holding a book on a table-top. These are stock gestures that Rigaud or his sitter would have chosen from among many sketches worked up for other portraits. Above all, the sophisticated coloration of the painting—the sitter's somber black robes of office are set against a luxurious gold and violet curtain—and the flickering reflections of light on gilt and fabric give great elegance and dignity to the portrait of an otherwise unexceptional individual.

G.T.M.S.

1. According to information in the archives of Wildenstein & Co., the painting belonged first to the Duchesse de Brancas and only later to the Marquis de Sinéty. Eisler 1977, 294, reverses the provenance.

2. According to information in the archives of Wildenstein & Co. I am grateful to Joseph Baillio of Wildenstein for providing this new element in the painting's provenance.

3. Roman 1919, xiv.

4. Rigaud's portrait of Philippe d'Orléans is presumed lost.

5. Musée du Louvre, Paris, Inv. 7492.

6. Roman 1919, xvi–xvii (author's translation).

7. Cope 1966, 219.

8. Roman 1919, 94 n. 7.

9. George V. Gallenkamp to Colin Eisler, February 16, 1967, Kress archives of the National Gallery of Art, Washington.

10. The portrait of Bérulle is Musée du Louvre, Paris, M.I. 1104.

ANTOINE WATTEAU

Valenciennes 1684–1721 Nogent-sur-Marne

The Italian Comedians

———⌘———

Watteau, the painter of idyllic fêtes galantes, *of imaginative scenes from the theater of his day, and creator of some of the greatest and most sensitive drawings of all time, was born to a family of roof tilers in provincial Valenciennes, on the border of Flanders. His youth was spent in Valenciennes; it is assumed that he received some artistic training there, but nothing certain is known of his activity as a painter or draftsman until after his move to Paris in 1702, where he was to study with Claude Gillot (1673–1722) and Claude Audran III (1658–1734). His lack of success in the Académie Royale's prize competition in 1709 may have precipitated a return to Valenciennes, where he remained for about a year.*

Back in the capital, Watteau was received formally by the academy at the end of July 1712. In an unusual move, the academicians allowed him to choose for himself the subject of his morceau de reception. *This work, much anticipated by the academicians and much promised by the painter, was finally delivered only in 1717. It is in name and in fact the painter's masterpiece, the* Pilgrimage to the Island of Cythera, *a work that established Watteau's reputation, greatly elaborated in the nineteenth century, as a painter of dreamlike realms of erotic delight.[5] It is also a work that profoundly affected the course of French painting in the eighteenth century, its acceptance by the academy legitimizing, as it were, the evocative and anticlassical tendencies that were to flower in the art of Pater, Lancret, Boucher, and Fragonard.*

By the time of his reception at the academy, Watteau was already widely respected in the Parisian world of art. At the end of that year, he resided at the home of the influential collector Pierre Crozat; later, he lived with the painter Nicolas Vleughels, who was to become a director of the French Academy in Rome and the brother-in-law of Panini (see cat. 44). Through Crozat and Vleughels, he made the acquaintance of a wide range of artists from outside France, including Sebastiano Ricci (see cats. 37, 38), Rosalba Carriera (1675–1757), and her brother-in-law Giovanni Pellegrini (1675–1741).

For a year, in 1719–20, Watteau lived in London, where he probably painted for Dr. Richard Mead the Kress Italian Comedians. *The ministrations of Dr. Mead, one of the better-known physicians of his time, could not cure the tubercular illness from*

c. 1720
Oil on canvas, 25⅛ x 30 in. (64 x 76 cm)
National Gallery of Art, Washington
1946.7.9

PROVENANCE[1]
1719/20–1754 Dr. Richard Mead, London, painted for him by Watteau; his sale, London, March 20, 1754; bought by "Wood" for "Beckford" (Alderman William Beckford, Fonthill Abbey, or Richard Beckford, London); Wood, presumably from Beckford, with contents of house, 1755; Sir James Colebrook, presumably from Wood, by 1755; Roger Harenc, by 1764; his sale, Langford, London, March 3, 1764, lot no. 53; probably purchased there by Augustus Henry, 3rd Duke of Grafton; Thomas Baring, London, by 1857 until 1873;[2] by inheritance to his nephew Thomas George, 1st Earl Northbrook, in 1873; with Asher Wertheimer, London, by 1888; with Agnew's, London, from Wertheimer, in 1888; Edward Cecil Guinness, 1st Earl Iveagh, Co. Down, 1888–1927; by descent to Walter Edward Guinness, 1st Lord Moyne, London, 1927; with Wildenstein & Co.?;[3] Heinrich Thyssen-Bornemisza, Schloss Rohoncz, Rechnitz, Hungary, by 1930; with Wildenstein & Co., New York, c. 1936; Samuel H. Kress Foundation, New York, 1942 (K1344); gift of the Kress Foundation to the National Gallery of Art, 1946.

SELECTED EXHIBITIONS
London 1871, no. 176; London 1902, no. 40; Munich 1930, no. 348; London 1932, no. 177; Washington 1980–81, 19–20 no. 1; Washington 1984–85, 439–43 no. 71.

SELECTED REFERENCES[4]
Walpole 1762–80/1969, II, 295; Goncourt 1875, no. 68; Fourcaud 1901, 165; Staley 1902, 68, 147; Josz 1903, 430–31 n. 1; Pilon 1912, 143 n. 2; Gillet 1921, 123, 242 n. 1; Jamot 1921, 268; Dacier, Vuaflart, and Hérold 1921–29, I, 68, 70, 94–96, 99, III, under no. 204; Hildebrandt 1922, 51; Réau 1928, 70; Whitley 1928, I, 28–29; Réau 1931, 158; Parker 1931, 21, 35–36, 46; Wilenski 1931, 106; Neveux 1932, 103, 106; Wildenstein 1932, 74–75; Vertue 1933–34, 23; Cairns and Walker *Pageant* 1944, 110; Frankfurter 1944, 78; Frankfurter 1944A, 10, 24; Adhémar and Huyghe 1950, no. 211; Hurtret 1950, no. 211; Panofsky 1952, 334–40; Einstein 1956, 217–23; Parker and Mathey 1957, under nos. 561, 681–83, 702, 726, 739, 768, 810, 827, 830, 873, 875–77, 883; Courville 1958, III, 197–98; Cooke 1959, 26; Gauthier 1959, pl. LVI; Mathey 1959, 69; Mirimonde 1961, 273–79, 283; Gimpel 1963, 281; Nicolle 1963, 92–93; Christie's 1965–66, 272; Camesasca and Rosenberg 1970, under no. 203; Ferré 1972, B.21; Boerlin-Brodbeck 1973, 160–61; Eidelberg 1977, 30–34; Eisler 1977, 300–306; Mirimonde 1977, 109; Raines 1977, 57 no. 53, 62, 64; Chan 1978–79, 107–12; Sutton 1981, 329–30; Bryson 1981, 77–79; Tomlinson 1981, 12 no. 18; Roland-Michel 1982, no. 244; Washington 1982, n. 24; Posner 1983, 97–98; Posner 1984, 120, 263–69, 291, nos. 62, 64; Roland-Michel 1984, 107, 177; Paris 1987A, 40, 96, 135–37, 147, 205, 210, 211, 241, 246, 273; Vidal 1992, 41, 134, 146–47.

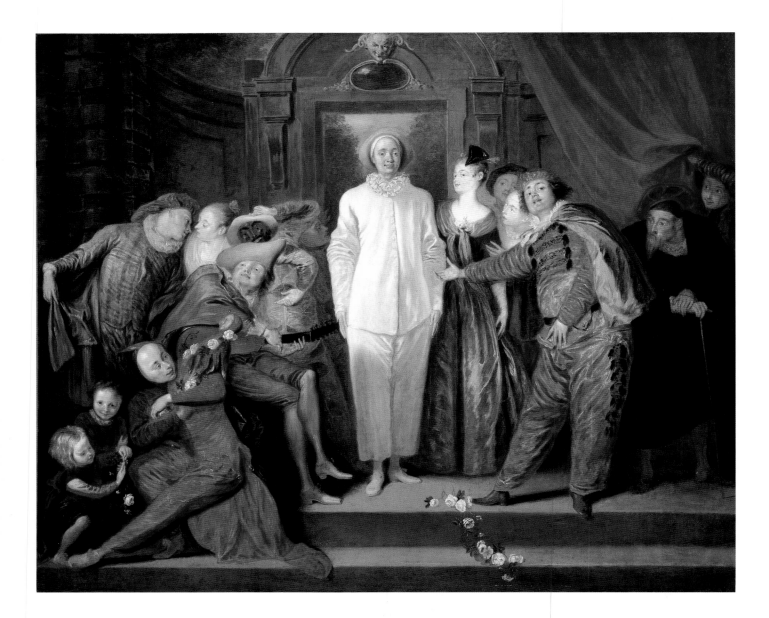

WATTEAU, *The Italian Comedians*

which Watteau suffered. He returned to France in the summer of 1720, and by the end of that year was living with his friend the picture dealer Edmé-François Gersaint (1694–1750), for whom he painted a famous interior view that was used as a shop sign.[6] In the spring of the next year, he sought a cure in the air of the country at Nogent-sur-Marne but died there in July, at the age of thirty-six.

The Italian Comedians is one of Watteau's last major works. Evidence suggests that it was probably painted during his stay in England, for Dr. Mead, who is known to have owned two paintings by Watteau in the mid-1720s, presumably the same two—*The Italian Comedians* and *Peaceful Love*—that were sold at his death.[7] Although the Washington canvas had been dismissed by some authors as a copy of a lost painting by Watteau, a sensitive restoration in 1983 removed layers of darkened, cloudy varnish and clumsy overpainting, revealing the subtlety of Watteau's modeling and brushwork. Since its exhibition in 1984, it has been generally recognized as Watteau's original.[8]

As its title suggests, the painting depicts a group of characters from the Italian *commedia dell'arte* (see also cats. 49, 50). Following his custom, Watteau shows the stock Italian characters as they had developed in France. The *Comédie Italienne*, which flourished in the last decades of the seventeenth century, had been banished from its theater in the Hôtel de Borgogne in 1697, but its characters and plots survived in the repertories of traveling shows that appeared at city and country fairs thoughout France in the first decades of the eighteenth century. As François Moureau has argued, the characters of the fairs are those that are found most often in Watteau's paintings, for the troupe of actors who came to Paris from Parma in 1716 to revive the Italian theater introduced significant changes in its cast of characters, almost completely eliminating Watteau's beloved Pierrot and Mezzetin.[9]

Working from drawings of individual figures in theatrical dress, and developing the groups through a series of compositional studies, Watteau elaborated the *mise-en-scène* of *The Italian Comedians*.[10] Pierrot stands at the center of the canvas, framed by a painted doorway behind him and wearing the classic white costume derived from the Italian character Pulcinella. Beside him stands a beautiful woman dressed in blue-gray silk, whose choice location suggests "a chief comic character," still unspecified.[11] The clown at right dressed in golden silks, who gestures to Pierrot, can be recognized as Brighella, a variant of the character Mezzetin, who is himself shown in vertical stripes at far left.[12] Beneath a red curtain at far right is an old man, who has

been identified both as the Doctor and as Pantaloon; both of these traditional characters were notoriously unlucky in love.[13] To the left of Pierrot in the painting are seated a jester, or fool, and a character playing a guitar, whose tricorne hat almost blocks out another important character from the Italian comedy, the prancing, masked Harlequin.

The assemblage of these characters on what appears to be a curtained stage has been interpreted most often as a curtain call, where a group of actors, Pierrot first among them, assembles at the end of a performance to receive the applause of the audience. Many of Watteau's paintings, including *The Italian Comedians*, depict subjects that cannot now be precisely interpreted—and which may have been vague even to Watteau's contemporaries in the eighteenth century. In Pierre Rosenberg's view, it is this complexity that lies at the heart of Watteau's genius, though as he states "ambiguity does not mean impenetrability."[14]

Similarities between the composition of *The Italian Comedians* and scenes of the life of Christ by Rembrandt led Dora Panofsky to interpret the presentation of Pierrot here as a kind of secular *Ecce Homo*.[15] While this interpretation undoubtedly reflects the curious combination of the frantic and the elegiac in Watteau's scene, it seems more likely that the artist was, as Rosenberg has suggested, using such a complex and dynamically balanced composition to draw attention to the figure of Pierrot and to create an image that is intentionally somewhat enigmatic. "An allegory of the traveling shows," perhaps, as has been argued, and with the Louvre *Pierrot* the product of "a time of synthesis, as Watteau made his definitive statements in the theatrical vein."[16]

G.T.M.S.

1. This provenance, which differs in several details from that published by Eisler 1977 or in Washington 1984–85, derives from information in the collection files of the National Gallery of Art, compiled with the assistance of the Getty Provenance Index. I am grateful to Nancy Yeide for her assistance in Washington.

2. See Waagen 1857, IV, 96–97.

3. Joseph Baillio of Wildenstein & Co., New York, notes that the painting was not on consignment to Wildenstein in 1924, as Eisler 1977 deduces from a remark in Gimpel 1963; rather, Nathan Wildenstein then asked Gimpel for his help in procuring the painting for the firm. However, Baillio has discovered a provenance listing, annotated "Lord Moyne, England," that might suggest that Wildenstein obtained the painting from Moyne or arranged the sale to Thyssen.

4. For further nineteenth-century references, see Washington 1984–85, 443. Many of the early references to *The Italian Comedians* might actually describe the copy of the painting formerly in the Groult collection and now also in the National Gallery of Art, Washington.

5. Musée du Louvre, Paris, M.I. 8525; for interpretations of the painting, see Washington 1984–85, no. 61.

6. Schloss Charlottenburg, Berlin, Staatliche Schlosser und Gartens. See Washington 1984–85, no. 73.

7. See Eisler 1977, 303, for a summary of the evidence.

8. See Eisler (1977), who catalogues the painting as "Attributed to Watteau"; see also Posner 1984, who considered it "a fine old copy"; for its restoration, see Sarah L. Fisher, "The Examination and Treatment of Watteau's *Italian Comedians*," in Washington 1984–85, 465–67.

9. See Washington 1984–85, 490.

10. For a list of the related drawings and an analysis of the process, see Washington 1984–85, no. 71.

11. Washington 1984–85, 516.

12. Washington 1984–85, 510, where fig. 17 erroneously illustrates not Brighella, at right, but Mezzetin.

13. Washington 1984–85, 513–14.

14. Washington 1984–85, 13.

15. See Panofsky 1952.

16. See Moureau in Washington 1984–85, 490; see also Opperman 1988, 359.

SEBASTIANO RICCI

Belluno 1659–1734 Venice

Ricci, born in the provincial town of Belluno, went to Venice at the age of twelve to become a pupil of Federigo Cervelli (c. 1625–c. 1700). He may also have studied with Sebastiano Mazzoni (c. 1611–1678). According to the early sources, his youth was marked by an unusually libertine way of life, although he married the girl whom he had earlier tried to poison in order to escape an entanglement. Sebastiano fled to Bologna sometime around 1680, possibly as early as 1678; he received his first important commissions in 1685–86, from the Count of San Secondo in Parma and from the Duke of Parma, Ranuccio II Farnese, who later saved him from execution in another of his amorous escapades, this time with the daughter of the painter Giovanni Francesco Peruzzini. Throughout his early career, he moved from place to place: from Bologna he went to Parma and to Pavia and back to Bologna; he eloped to Turin, from which he was banished in shame; he spent the first years of the 1690s in Rome, moving in 1694 to Milan by way of Florence, Bologna, Modena, and Parma, and returning to Venice in 1698.

The later 1690s and the first decade of the century marked Sebastiano's first real artistic maturity and his critical discovery of the art of Paolo Veronese (see cat. 4). His work in Veronese's manner varies considerably, from the pure pastiche to the more sophisticated assimilation and manipulation of classic Venetian colorism and principles of design. His fluency in Veronese's style meant that Ricci's paintings were sometimes mistaken for works by the sixteenth-century master. A Ricci Finding of Moses *(fig. 1) was purchased in 1763 by George III from Consul Joseph Smith as a work by Veronese, and may, in fact, be a copy of a lost Veronese original.[4]*

Even at a time when his reputation was secure, Ricci was forced, like many Venetian painters after him, to seek his fortune outside his native city. In the first years of the century, he worked in Austria, at Schönbrunn Palace outside Vienna, and in Florence. Around the end of 1711 or the beginning of 1712, he followed his nephew Marco (1676–1729) to England, with the intention of trying for the honor of decorating the cupola of St. Paul's—a commission given in the end to Sir James Thornhill. By the end of 1716 he returned to the Continent, where in December of that year he met Antoine Watteau

37

The Finding of Moses

———⌗———

c. 1710
Oil on canvas, 51⅞ x 42 in.
(131.8 x 106.7 cm)
Memphis Brooks Museum of Art 61.204

38

Jephthah and His Daughter

———⌗———

c. 1710
Oil on canvas, 52⅝ x 43⅛ in.
(133.6 x 109.5 cm)
Memphis Brooks Museum of Art 61.205

PROVENANCE
Probably commissioned from Ricci by Christopher Crowe of Kiplin Hall, North Yorkshire;[1] probably by descent to Sarah Talbot, Mrs. Christopher Turnor, at Stoke Rochford, Grantham, Lincolnshire;[2] with Hazlitt Gallery, London, by 1947;[3] Dr. Arturo Grassi, New York, by autumn 1947; with Ars Antiqua, New York, 1950; Samuel H. Kress Foundation, New York, 1950 (K1703, *Moses*, and K1704, *Jephthah*); on loan to the Philadelphia Museum of Art, 1950–53; on loan to the Brooks Memorial Art Gallery, 1958–61; gift of the Kress Foundation to the Brooks Memorial Art Gallery (later the Memphis Brooks Museum of Art), 1961.

SELECTED EXHIBITIONS
Louisville 1948, nos. 20, 21 (*Jephthah* catalogued as *The Greeting of Saul*); Memphis 1965–66, nos. 10, 11; Montgomery 1984 (*Moses* only); Minneapolis 1987–89 (*Jephthah* only).

SELECTED REFERENCES
Suida 1950, 18–20 no. 19; Memphis 1958, 44–47; Vaughan 1961, 286 (*Moses* illus.); Memphis 1966, 52–54; Pilo 1966, 305; Shapley 1973, 126; Daniels 1976, 70–71 nos. 223a, 223b.

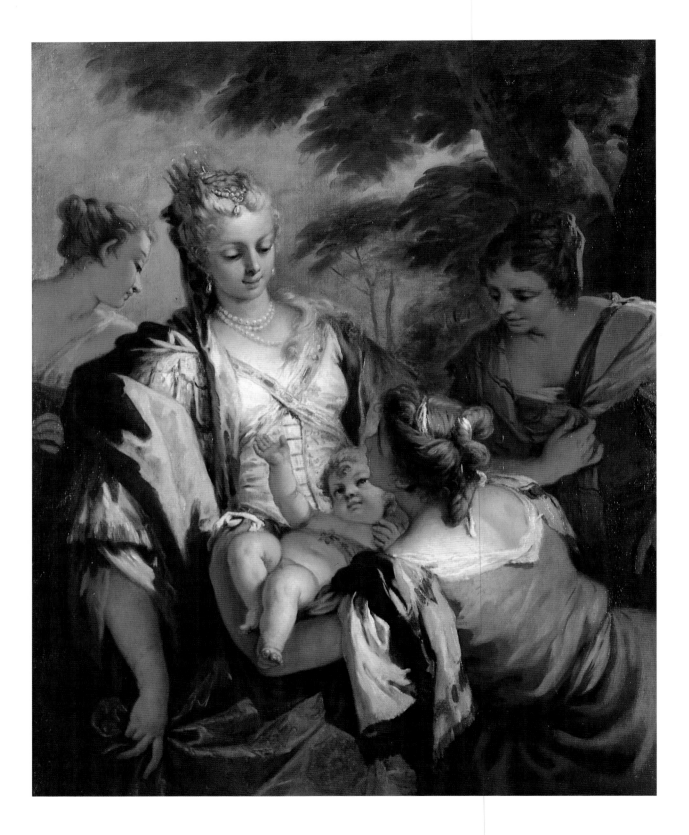

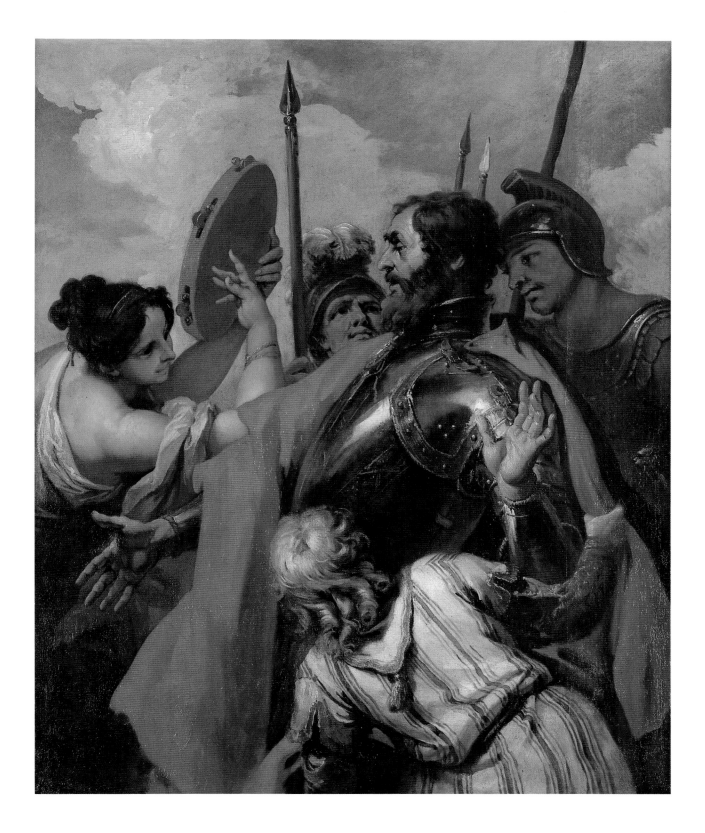

RICCI, *Jephthah and His Daughter*

(see cat. 36) at the home of the Parisian collector Pierre Crozat. His contacts in Paris were fruitful, for less than two years after his return to Venice he was elected to the French Académie Royale with a complex allegory, The Triumph of Learning over Ignorance.[5]

Joseph Smith, later the patron of Canaletto (see cats. 40, 41), employed both Sebastiano and Marco Ricci in the 1720s, and Sebastiano was kept busy with important commissions from the House of Savoy in Turin. In the early 1730s he painted a number of important large-scale works, including altarpieces at Parma, Bergamo, Venice, and Vienna. As Jeffrey Daniels points out, Ricci was very sensitive to the prices paid for his paintings, and "the enormous variation in quality and degree of finish in Ricci's work is almost certainly a reflection of the fee charged: he was the sort of painter who gave what he was paid to provide, no more and no less, in a truly professional manner."[6]

Sebastiano Ricci is rightly seen as one of the principal founders of the Rococo style in Europe. His tendency toward a historicizing mode—toward the imitation of Veronese or Pietro da Cortona or Luca Giordano—is most often enlivened by deft brushwork that in its best moments rivals the brilliance of his successors François Boucher in France or Giovanni Battista Tiepolo (see cats. 47, 48) in Italy.

fig. 1 Sebastiano Ricci. *The Finding of Moses.* c. 1720. Oil on canvas, 28 x 24⅝ in. (71.1 x 62.5 cm). The Royal Collection ©1993 Her Majesty Queen Elizabeth II

These lively paintings of Old Testament subjects are presumed to have been painted as a pair, and although their dimensions vary slightly, their opposed compositions do suggest that they were intended to balance each other. No inventory or publication has been found that mentions the paintings until after World War II, but because they came from the Turnor family, inheritors of Kiplin Hall in Yorkshire, they are thought to have formed part of the collection of Christopher Crowe, who purchased Kiplin in 1722 from his son-in-law, the fifth Earl of Baltimore.[7] Crowe, who died in 1749, was British Consul at Leghorn (Livorno) from 1705 until 1716 and acted as an agent to collectors, including the Duke of Marlborough and the Earl of Strafford. His period of residence in Italy corresponds with the proposed dating of the Memphis pair to the years around 1710, and it is known that Crowe amassed for himself a substantial collection of pictures at this time.[8] The collection, as installed at Kiplin Hall, was described after his death in two eighteenth-century publications, but no painting mentioned corresponds with either *The Finding of Moses* or *Jephthah and His Daughter.*[9]

No clue can be found in the history of the commission to explain Ricci's suggestive pairing of subjects from the Old Testament. The paintings seem, in fact, to be inversions of each other: in one painting, the daughter of the pharaoh saves from the waters an infant whom she will raise as her

son, but who will go on to be the sworn enemy of her country.[10] In the other, a heroic general, having saved his people in battle, is forced by his vow to God to sacrifice the first living creature he sees on his return—his beloved daughter.[11]

Jephthah and his daughter, a comparatively rare subject in the eighteenth century, was never again treated by Ricci. The Kress Collection *Finding of Moses*, on the other hand, may be the earliest of a group of paintings on this subject, all strongly reminiscent of Veronese's style, and almost certainly based on one or more of Veronese's paintings on the theme.[12] Among Ricci's treatments of the subject, the Memphis picture is closest in style and date to the version at the Palazzo Taverna in Rome, for which Daniels has proposed a date of around 1711.[13] A large canvas of the 1720s in the Royal Collection, London (*fig. 1*), was purchased by George III from Consul Smith, as a Veronese;[14] and the last of the treatments of the theme seems to be a version of about 1727–28, one of a group of overdoors in the Palazzo Reale in Turin.[15]

G.T.M.S.

1. Shapley (1973, 126), following all earlier publications of the Kress Collection, gives neither Crowe's first name nor the name or location of his house. I am grateful to Carol Togneri of the Getty Provenance Index and to David Alexander for helping me to identify Christopher Crowe as the collector in question. Only circumstantial evidence—family tradition, and the fact that the paintings came from the Turnor collection, the origins of which were in the Kiplin household—supports the designation of Christopher Crowe as the original owner of the paintings.

2. For information on Kiplin and its owners, see Haslam 1983. I am grateful to David Alexander for calling my attention to this article. Daniels 1976 erroneously lists the family name as "Turner."

3. According to a copy of a letter of September 9, 1950, from Arturo Grassi to William Suida in files on the Kress Collection in the Archives of the National Gallery of Art: ". . . io non acquistai direttamente i due Ricci da Mr. Turnor, ma dal Sig. Max Hevesi, di Londra (Hazlitt Gallery), nell'autunno del 1947." (I did not acquire the two Riccis directly from Mr. Turnor, but from Mr. Max Hevesi, of London [Hazlitt Gallery], in the autumn of 1946.)

4. Daniels 1976, no. 153; see Coutts 1982, 230–32; see also Levey 1964/1991, 152–53 no. 647.

5. Daniels 1976, no. 296; Musée du Louvre, Paris, Inv. 562.

6. Daniels 1976, xvii.

7. For biographical information on Crowe, see Haslam 1983.

8. Suida (Memphis 1958), Milkovich (Memphis 1966), and Shapley 1973 propose dates ranging from 1705 to 1712; see Daniels 1976, 71, where a date of 1704 is proposed, and 110, where he seems to favor a date closer

to Ricci's departure for England. There are significant parallels between the figures and gestures in these paintings and Ricci's *Allegory of Tuscany* (Uffizi, Florence), Daniels no. 94, which has been dated to 1706.

9. I am grateful to Carol Togneri and Alison Zucrow of the Getty Provenance Index for locating this information. Someday it may be discovered that the pictures entered the Kiplin collections at a later date, through purchase or through marriage.

10. The story is told in Exodus 2:1–10.

11. The story comes from Judges 11:30–40.

12. Shapley (1973) follows previous suggestions that the Veronese *Finding of Moses* now in the Gemäldegalerie, Dresden, is the prime source of inspiration for Ricci. See also n. 4 above.

13. Daniels 1976, no. 391.

14. Daniels 1976, no. 153.

15. Daniels 1976, no. 440a. A version attributed to Ricci (Daniels 1976, no. 113) was in the Caviglia Collection, Genoa, in 1922; another, formerly attributed to Ricci, in the National Gallery of Victoria, Melbourne (Daniels 1976, no. 222), is probably by Giovanni Battista Tiepolo.

Vienna 1699–1760/61 Venice

Antonio was the eldest son of Domenico Guardi (1678–1716), a minor
painter from the Trentino region north of Lake Garda, who worked both in Venice and
Vienna, where Antonio was baptized on May 27, 1699.[1] Antonio's two brothers, Francesco
(1712–1793) and Nicolò (1715–1789), also were artists, as was Francesco's son Giacomo
(1764–1835). Antonio probably received his initial artistic training from his father in
Venice. The somewhat saccharine, mystical pietism that characterizes Antonio's earliest
documented work, Saint John of Nepomuk (dated 1717; private collection), reflects a
central European sensibility derived from his father or possibly from a period of study in
Vienna after his father's death.[2] In 1719 Antonio's sister married the painter Giovanni
Battista Tiepolo (see cats. 47, 48). It is likely that Antonio would have been influenced by
his brother-in-law during the 1720s, a period when the work of Sebastiano Ricci (see cats.
37, 38) also seems to have been important to Antonio's stylistic development.

Between 1730 and 1746 Guardi worked regularly for the important
Venetian patron Field Marshal Johann Matthias von Schulenburg, who was also a
patron of Giacomo Ceruti (see cat. 51) during the 1730s.[3] As von Schulenburg's painter-in-
residence, Antonio's two main activities were executing portraits and making copies of
works by other Venetian artists.[4] Aside from the works he painted for von Schulenburg,
Antonio's artistic activity is not well documented, and thus it is extremely difficult to chart
his stylistic development.[5] In 1755 Antonio was nominated by his brother-in-law Tiepolo
as one of the thirty-six founding artists of the Venetian Accademia di Belle Arti.[6] From
the few documents and collaborative works that do exist, it appears that Antonio and
Francesco (and probably Nicolò as well) shared a studio until Antonio's death in 1760 or
1761.[7] The close artistic relationship that existed among the Guardi brothers, combined
with the almost complete absence of documentation concerning their lives and oeuvres,
has made the individual attribution of works to one Guardi or another very problematic.

Antonio and Francesco Guardi are two significant exceptions to the
rule that almost all eighteenth-century Venetian painters who are held in high regard
today were already esteemed during their lifetimes. The very low prices Antonio was paid
for his works indicate that he did not enjoy great fame and fortune as an artist while he

*Holy Family with
Saint John the Baptist and
Saint Catherine of Alexandria*

c. 1750
Oil on canvas, 23⅞ x 27 in.
(60.7 x 68.6 cm)
Seattle Art Museum 61.155

PROVENANCE
Princess Galitzin, St. Petersburg; with Count Alessandro
Contini-Bonacossi, Florence; Samuel H. Kress, New York,
1935 (K329); on loan to the National Gallery of Art,
Washington, 1939–52; on loan to the Seattle Art Museum,
1952–54; Samuel H. Kress Foundation, New York,
1954–58; on loan to The Museum of Fine Arts, Houston,
1958–61; gift of the Kress Foundation to the Seattle Art
Museum, 1961.

SELECTED EXHIBITIONS
Springfield 1937, 6 no. 22 (as Francesco Guardi); Washing-
ton 1941, 93–94 no. 292 (as Francesco); Houston 1958, no. 2
(as Francesco); Santa Barbara 1958, no. 1 (as Francesco);
Venice 1965, 34 no. 19 (as Antonio, c. 1740).

SELECTED REFERENCES
Fiocco 1952, 118 (as Francesco); Seattle 1952, 22 no. 25;
Byam Shaw 1958, 35 (as Francesco); Martini 1964, 273
n. 252 (as Antonio); Brunetti 1966, 43 (as Antonio with
the possible assistance of Nicolò); Shapley 1973, 170 (as
Antonio); Morassi 1973, I, 316 no. 47 (as Antonio); Rossi
Bortolatto 1974, no. 14 (as Francesco); Pignatti 1976, I,
169 (under no. A6, as Antonio); Rosenthal 1981, 184, 186 nn.
15, 24 (as Antonio); Steinberg 1983, 76, 172, 176
(as Antonio); Verona 1988, 215 (as Antonio); Pedrocco and
Montecuccoli degli Erri 1992, 127–28 no. 40 (as Antonio).

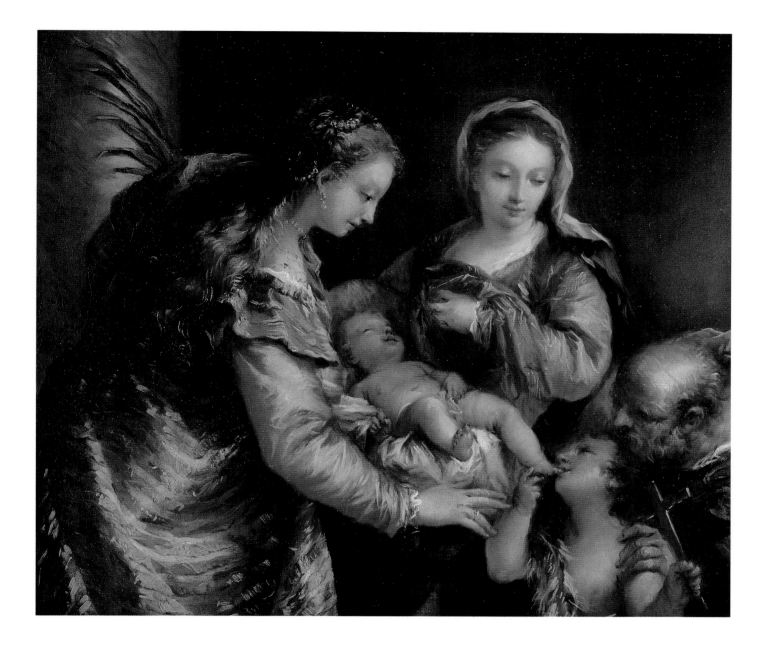

GUARDI, *Holy Family with Saint John the Baptist and Saint Catherine of Alexandria*

The *Holy Family with Saint John the Baptist and Saint Catherine of Alexandria* is a copy after a composition by Paolo Veronese (see cat. 4) in the Uffizi (*fig. 1*); there exist at least four other copies deriving from this version.[9] Since the Uffizi painting was transported to Florence in 1654, and Antonio is not known to have visited Florence, it seems probable that he based his version on one of the other copies.[10] The composition of the Seattle painting is relatively faithful to Veronese's, but the manner in which it is painted differs

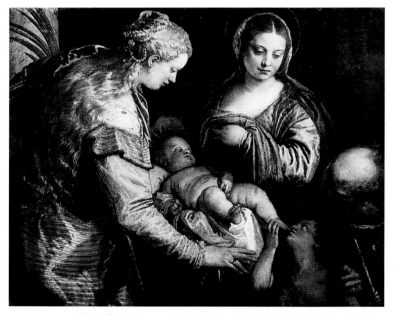

fig. 1 Paolo Veronese. *Holy Family with Saint John the Baptist and Saint Catherine of Alexandria*. c. 1560–65. Oil on canvas, 40½ x 61¾ in. (102.9 x 156.8 cm): Galleria degli Uffizi, Florence, inv. 1433

substantially from Veronese's, displaying Antonio's distinctive vibrant, shimmering brushwork. There are also a number of slight compositional variations between the two works, most notably Saint Catherine's head and right arm, the head of the Christ Child, and the slightly different pose of the young Saint John. The different technique and the subtle adjustments to the figures have the cumulative effect of creating a composition that is more graceful and more

contemporary (that is, more Baroque) than Veronese's. Guardi's painting is also imbued with a much stronger sentimentality and sense of intimacy. He achieves this through the gentler, sweeter expressions of his figures, and by the way in which he links them more closely together through their gazes and through slight adjustments in their positions, such as by moving Joseph's head closer to Saint John.[11] Guardi also made some changes in the draperies, most notably in the gown of Saint Catherine; in the white drapery behind the head of the Child, which was a light blue in Veronese's work; and in bringing up the drapery between the Christ Child's legs.[12]

The attendant female saint in Guardi's painting has been identified as either Catherine of Alexandria or Barbara, following a similar lack of agreement among scholars over the identification of the saint in Veronese's composition. Seventeenth-century writers identified the figure in Veronese's painting as Catherine, but in 1934 Fiocco suggested that she was, instead, Barbara, and this identification has generally been followed by subsequent scholars.[13] It is more probable, however, that the original identification of the saint as Catherine is correct. Barbara's usual iconographic attribute, a tower, in nowhere is evidence; the architectural element behind her is clearly a marble column. Furthermore the prominence of the ring on the saint's finger is a clear allusion to Catherine's "mystical marriage" to Christ. The saint's splendid garments and jewelry are perfectly appropriate for Catherine, who was traditionally believed to be the daughter of a king.

When the Kress painting first came to the attention of scholars in 1937, it was attributed to Francesco Guardi— a logical enough attribution since Antonio's oeuvre was almost completely unknown at the time.[14] This attribution remained unchallenged until 1964, when the painting was convincingly ascribed to Antonio.[15] As with all of Antonio's undocumented works, the dating of the picture has proven problematic. Although its similarities with Antonio's *Temperance* and *Fortitude* (private collection,

Milan), painted for von Schulenburg in 1739, have been noted, the Kress painting has been dated variously between 1739 and 1760.[16] The most satisfactory dating for the Seattle *Holy Family* would seem to be sometime in the late 1740s or early 1750s, since it shares very close stylistic affinities with Antonio's works of that period, such as the *Cybele* painted for the Palazzo Suppiei about 1751–55, the circa 1754 altarpiece for the parochial church of Cerete Basso, and the series of works painted about 1749–50 for the Venetian church of the Angelo Raffaele.[17]

D.S.

1. The Guardi family was from the Val di Sole, in the Trentino, and is recorded there in church archival documents from the sixteenth century; see Binion 1976, 75–77. Antonio's baptismal certificate from the archives of the Schottenkirche in Vienna was first published by Bassi-Rathgeb (1955, 226) and was republished in clearer form in the same year by Rasmo (1955, 152). He was named after two artists who were his godparents, the well-known Venetian painter Antonio Bellucci and the sculptor Johann Stanetti. It is generally assumed that Antonio's father, Domenico, had been invited to Vienna by his uncle, Don Giovanni, who was an important ecclesiastic at the Viennese cathedral of Saint Stephen, with close ties to Count Harrach, the influential art patron; see Binion 1976, 76–78.

2. For the *Saint John of Nepomuk*, which is signed and dated on the verso "A. Guardi fec. 1717," see Morassi 1973, I, 316 no. 52, II, fig. 53. Antonio is documented in Vienna on February 15, 1719, and as Binion (1976, 85–86) points out, he had influential relatives and family friends (including his godfather Stanetti) in Vienna, which would have made the city a logical place to complete his artistic training.

3. For Antonio's long relationship with von Schulenburg, documented through the *Reichsgraf*'s financial records, see Morassi 1960; Binion 1970; Morassi 1973, I, 47–62; Binion 1976, 89–95, 323–32; and Pedrocco and Montecuccoli degli Erri 1992, 34–42. These records comprise the single most important documentary source for Antonio's artistic activity.

4. Among the works Antonio copied for von Schulenburg were Titian's *Saint John the Baptist*, Veronese's *Marriage at Cana* and *San Zaccaria Altarpiece*, Bassano's *Nativity*, the *Temperance* and *Fortitude* by a pupil of Tintoretto, "two heads" after Strozzi, a "*Supper*" by Ricci, five *Apostles* and a hunting scene by Piazzetta, a *Madonna Adolorata* by Domenico Brusasorci, and a portrait by Rosalba Carriera; see Morassi 1973, I, 46–55. His activity as a copyist outside of von Schulenburg's patronage is documented by a bequest of December 15, 1731, which lists several copies painted by the "Guardi brothers," indicating that Francesco was working with him by this time.

5. The *regesto* published in Morassi 1973, I, 515–20, provides a fairly complete listing of documents relating to Antonio's life and career. Also see Pedrocco and Montecuccoli degli Erri 1992, 25–33, 58–66.

6. Fogolari 1913, 249; Watson 1965–66, 270. In view of Antonio's apparently insignificant stature as an artist during his lifetime, it appears likely that his nomination owed more to his familial ties with Tiepolo than to a recognition of his standing among his peers.

7. Antonio's death certificate, which is found in the archives of the Venetian church of Santi Apostoli, was first published by Fiocco (1923, 18); also see Ciccolini 1954, nos. 2,3, 190 n. 2. The confusion over the year of Antonio's death has arisen because of the Venetians' use of two calendars, one with the year beginning January 1, the other one (the *more veneto*) beginning on March 1. Since the *more veneto* was used by all Venetian churches until the Napoleonic era, the 1761 date would seem the more likely of the two.

8. For a survey of the scholarly rediscovery of Antonio, see Morassi 1973, I, 19–26; and Pedrocco and Montecuccoli degli Erri 1992, 69–73. The primary studies on Antonio are: Fogolari 1916, Arslan 1944, Maffei 1948/1951, Venice 1965, Morassi 1973, Binion 1976, and Pedrocco and Montecuccoli degli Erri 1992. Comprehensive bibliographies on Antonio are found in Morassi 1973, I, 501–13; and Pedrocco and Montecuccoli degli Erri 1992, 317–22.

9. For the Uffizi painting, see Pignatti 1976, I, 125 no. 128; a thorough discussion of Veronese's composition is found in Rosenthal's study (1981, 175–87) on the version in the Baltimore Museum of Art that she attributes to Veronese's workshop, and that Pignatti (1976, I, 169 no. A6) assigns to Veronese's son, Carletto Caliari. Marinelli (in Verona 1988, 214) thought that the Baltimore version was the oldest of the copies and probably dated from the early seventeenth century. The painting's dark background indicates that it was painted probably after 1655 (see next paragraph). In addition to the Baltimore painting, at least three other versions of Veronese's composition are known; see Rosenthal 1981, 182–84.

A recent cleaning of the Uffizi painting has revealed that the work originally had a much lighter background with a plant or vine growing by a wall. This background was overpainted with a dark pigment sometime between 1655, when the painting was reproduced in an engraving showing the original background (Verona 1988, 214), and the date of the earliest painted copy.

10. The Uffizi painting was cited by Ridolfi (1648/1914–24, I, 340) as being in the possession of the Counts Vidman in Venice. Ridolfi described the picture as "a graceful composition of the Virgin with the Christ Child in her lap, whose tender feet the young Baptist kisses; on one side is St. Joseph, supporting himself on his right [*sic*] arm, and the martyr Catherine standing by, admiring her Spouse and Lord, [all of] which are admirable figures." Boschini (1660/1966, 403 [369]) recorded the picture as in the possession of the Venetian painter Paolo del Sera, whose collection was purchased *en bloc* by Cardinal Leopoldo de' Medici and taken to Florence in 1654. It passed into the Medici ducal collection in 1675 and was transferred to the Uffizi with the rest of the ducal collection in 1798.

11. Guardi also extended Veronese's composition on all four sides, so that the figures of Saint Catherine, the Baptist, and Saint Joseph are not as abruptly truncated as they appear in the earlier work.

12. Steinberg (1983, 76) noted that the discreet addition of the drapery between the Christ Child's legs eliminated the motif of "infantile masturbation," which he felt was a significant iconographic aspect of Veronese's painting. The addition of this drapery may have been made at the request of Guardi's patron; in the Baltimore version of Veronese's painting, drapery covering Christ's genitals was added by a later artist, presumably at the behest of the painting's owner (Rosenthal 1981, 174).

13. Ridolfi 1648/1914–24, I, 340; Boschini 1660/1966, 403 [369]; Fiocco 1934, 112. Fiocco stated that the painting had been incorrectly identified as a *Mystic Marriage of Saint Catherine*, which is not precisely the way Ridolfi had described it; see n. 10 above. Shapley (1973, 170) notes that

the figure had been identified as Barbara, presumably because of the column having been misinterpreted as a tower; she described the figure simply as "a female martyr." Marinelli (in Verona 1988, 213–15) identifies the saint as Catherine, noting that John and Catherine were the protector saints of the Barbaro family for which, he hypothesized, Veronese's work might have been painted.

14. Springfield 1937, 6 no. 22.

15. Martini 1964, 273 n. 252; for other opinions, see above, under "Selected References." Brunetti (1966, 43) notes the possible collaboration of Nicolò in the painting; Rossi Bortolatto (1974, no. 14) attributes it to Francesco.

16. Zampetti (in Venice 1965, 34 no. 19) dates the painting to the fifth decade of the eighteenth century; Morassi (1973, I, 316 no. 47) dates it circa 1750–60, while Pedrocco and Montecuccoli degli Erri (1992, 127–28 no. 40) give it a date of circa 1639 on the basis of its similarity to the *Fortitude* and *Temperance*.

17. Morassi 1973, I, 323 no. 78, II, fig. 90 (*Cybele*); I, 320 no. 65, II, figs. 76, 77 (Cerete Basso altarpiece); I, 309–10 nos. 15–21, II, figs. 10–21 (Palazzo Suppiei paintings, which are now in the Cini Collection, Venice). Since the Seattle *Holy Family* is a copy after a painting by a Venetian master—the type of work Guardi executed for von Schulenburg—and the dating proposed here does not lie too far outside of the period of his known activity for the *Reichsgraf*, it is worth considering the possibility that it might have been painted for von Schulenburg. However, no work of this subject by Guardi is recorded in any of the published von Schulenburg inventories or financial documents (see n. 3 above).

Giovanni Antonio Canal, called **CANALETTO**

Venice 1697–1768 Venice

Canaletto, the greatest view painter in the history of European art, will forever be identified with his native city, Venice.[1] He was born there in 1697, the son of Bernardo Canal, who was an important designer and painter of scenery for operas. The young Canal, who soon began to distinguish himself by using the diminutive Canaletto, collaborated with his father in his early years—they painted scenery together in Rome in 1719—but by the first half of the 1720s had established himself as an independent painter of city views, or vedute. A number of paintings (four formerly in the Liechtenstein Collection and three now in Dresden) are thought to date from around 1723.[2] Canaletto's first securely dated commission, however, came from a textile merchant, Stefano Conti, who in 1725 ordered at first two, and then two more views, including three vistas of the Grand Canal and one of the church of Santi Giovanni e Paolo and the Scuola di San Marco.[3] By the next year, Canaletto had been approached by Owen McSwinney, an Irishman, who was the first to introduce his art to the English collectors who were to become his most important patrons.

In the late 1720s the critical elements of Canaletto's style became apparent. He possessed an unprecedented talent for rendering the effects of the soft light of Venice on its complex architecture. His scenes of the Piazza San Marco or of the churches and palaces that lined the Grand Canal were suffused with atmosphere, yet were clear and distinct. He was able to use his imagination to vary even the most often-repeated views and was also able to depict consciously inaccurate relationships between architectural elements, or to assume unattainable points of view, without giving his paintings any hint of falsity. On the contrary, as contemporaries remarked, "he paints with such accuracy and cunning that the eye is deceived and truly believes that it is the real thing it sees, not a painting."[4]

The novelty of Canaletto's vision brought him to the attention of critics and patrons by the end of his first decade as a painter. Canaletto seems to have met Joseph Smith, later British Consul to the Serene Republic, around 1730. Smith, an important collector in his own right, became Canaletto's principal agent, selling the artist's paintings to English clients and marketing the works by distributing elaborate collections of engraved reproductions. During the 1730s Canaletto was extremely busy meeting the commissions he received and set up a studio of painters, including his nephew Bernardo Bellotto (see cats.

40

The Grand Canal from the Campo San Vio

c. 1730–35
Oil on canvas, 44½ x 66 in. (113 x 167.5 cm)
Memphis Brooks Museum of Art 61.216

PROVENANCE
Probably painted for George Proctor, Langley Park, Norfolk; probably to his grandnephew William Beauchamp, Langley Park, 1744; by descent to Sir Reginald Proctor-Beauchamp, Langley Park; his sale, Sotheby's, London, June 11, 1947, lot no. 26; purchased by R. F. Watson; his sale, Sotheby's, London, March 23, 1955, lot no. 20; purchased by Betts; with David M. Koetser, New York; Samuel H. Kress Foundation, New York, 1957 (K2173); on loan to the Brooks Memorial Art Gallery, 1958–61; gift of the Kress Foundation to the Brooks Memorial Art Gallery (later the Memphis Brooks Museum of Art), 1961.

SELECTED EXHIBITIONS
Washington 1961–62, no. 12; Allentown 1971.

SELECTED REFERENCES
Memphis 1958, 48, 50; *Arts Magazine* 1958, 36; Pallucchini 1960, 104; Vaughan 1961A, 286; Constable 1962, II, 262 no. 187; Memphis 1966, 56–57; Berto and Puppi 1968, 96 no. 72D; Paris 1971, 39 under no. 7; Shapley 1973, 161; Corboz 1985, II, 591; Constable and Links 1989, II, 276 no. 187.

41

View of the Molo

c. 1730–35
Oil on canvas, 44½ x 63¼ in. (113 x 160.6 cm)
El Paso Museum of Art 61.1.49

PROVENANCE
Probably painted for George Proctor, Langley Park, Norfolk; probably to his grandnephew William Beauchamp, Langley Park, 1744; by descent to Sir Reginald Proctor-Beauchamp, Langley Park; his sale, Sotheby's, London, June 11, 1947, lot no. 25; purchased by Major Abbey; with David M. Koetser, New York; Samuel H. Kress Foundation, New York, 1957 (K2174); gift of the Kress Foundation to the El Paso Museum of Art, 1961.

SELECTED EXHIBITION
Washington 1961–62, no. 13.

SELECTED REFERENCES
Pallucchini 1960, 104; El Paso 1961, 41; Constable 1962, II, 219 no. 88; Berto and Puppi 1968, 97 no. 82B; Paris 1971, 39 under no. 6; Shapley 1973, 161; Corboz 1985, II, 591; Constable and Links 1989, II, 227–28 no. 88.

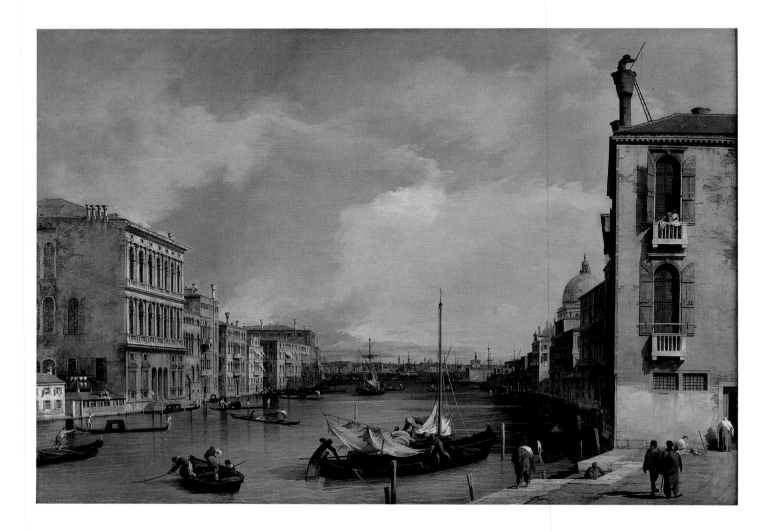

CANALETTO, *The Grand Canal from the Campo San Vio*

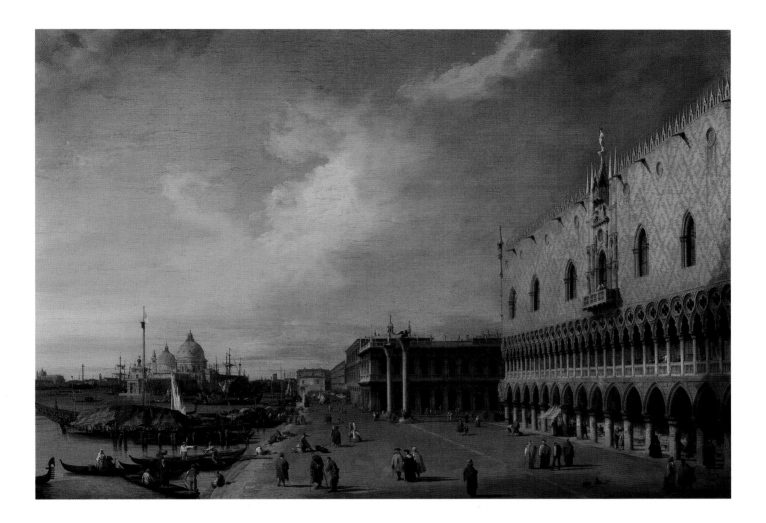

CANALETTO, *View of the Molo*

42, 43), to meet the demand. The works coming from his studio at this time sometimes reveal a mechanical quality in the treatment of buildings or figures. But his profitable relationship with Smith—not by any means exclusive, since many collectors approached Canaletto directly—lasted for more than fifteen years, until demand for Canaletto's work began to slacken in the 1740s.

For a time Canaletto busied himself making etchings, dedicated to Smith when they were published. By May of 1746, however, he had arrived in London, where he was to remain for the next decade, except for a brief interlude in Venice in 1751. The Englishmen who had purchased Canaletto's Venetian views engaged him to paint or draw prospects of London or of their country seats. He also found a market for decorative imaginary landscapes on Italianate themes.

He returned to Italy around 1755, although little is certainly known of his activities in the last years of his life. Elected to the Accademia Veneziana di Pittura e Scultura in 1763, eight full years after its founding, Canaletto died five years later and was buried in the parish of his birth.

These majestic views of Venice are exhibited here together for the first time in more than thirty years. The two were dated by W. G. Constable to the early 1730s.[5] They are thought to have been purchased by or commissioned for an eighteenth-century English patron, George Proctor, who in 1742 bought a property, Langley Park, in Norfolk, where a number of Canaletto views were documented in the early nineteenth century and where this pair remained until 1947.[6]

Both views are familiar to admirers of Canaletto's art. The view of the Molo looking to the west (cat. 41), for example, was repeated with many permutations of architectural detail and point of view. At least four very similar examples exist in which the Ducal Palace looms on the right, with the perspective focused on the Fonteghetto della Farina, the small building with an off-center arched entry at the end of the quay.[7] The Molo views range widely in scale, from the earliest, a painting on copper of about 1725–27 measuring only 17 x 23 inches, to the largest, which at 51 x 66 inches is even larger than the El Paso example.

Frequently such paintings, in which the Molo recedes into space with a strong movement to the left, were paired with views in which the movement is predominantly to the right. Most often these pendants were views of the Molo from its other extremity.[8] In the Kress pair, however, and in another in a Parisian private collection, the artist or his patron chose a rather unlikely pendant to the perspective of the Molo—a view of the Grand Canal seen from the Campo San Vio, just above the church of Santa Maria della Salute.[9]

This wide and relatively uneventful stretch of the Grand Canal is in fact the most often repeated motif in Canaletto's repertory. The earliest example is probably the canvas painted around 1723, formerly in the Liechtenstein Collection, with a much higher and more dramatic point of view; another, close in date to the Kress picture, formed part of the fourteen images of the Grand Canal purchased by George III from Consul Smith in 1762 and now at Windsor Castle. In addition to the Memphis canvas, there are at least ten others.[10]

In each of these, considerable attention is paid to the richly colored and subtly textured lateral facade of the Palazzo Barbarigo, at right, with its arched and balconied windows on the upper stories. Nothing about the way in which Canaletto paints the peeling facade of the palazzo would suggest the riches of art that it contained—for in the 1730s the Barbarigo family was known for its collection of paintings, with works by Mantegna, Raphael, Michelangelo, Correggio, Rubens, Poussin, four paintings by Titian, and a pair of views by Canaletto.[11] In a device that he was to use again and again, Canaletto places a partial view of the palace facade parallel to the picture plane, so as to anchor the otherwise somewhat oblique composition firmly in space. In many of the views of the Campo San Vio, as in the Kress

around them the bustling activity of the city, such as a chimney sweep atop the Palazzo Barbarigo, *gondolieri* plying the waters of the Grand Canal or the Lagoon, beggars, exotic travelers, or pet dogs. All of these are painted assuredly, and often with humor, and they give life and breath to the broad expanses of pavement and water in the painter's view.

G.T.M.S.

fig. 1 Canaletto. *The Grand Canal from the Campo San Vio* (detail of cat. 40)

example, a woman leans out of the upper window, her attention directed at the pavement or the canal below her (*fig. 1*).

Both the Memphis and El Paso paintings include many such telling details drawn from Canaletto's observation of the daily life of his city. Some of the figures in the compositions are depicted in the act of observing the passing scene: the woman at the balcony of the Palazzo Barbarigo; the procurators on the balcony of the Doge's Palace; the barefoot Easterner on the edge of the Campo San Vio quay; or the fashionably dressed couple on the Molo. They see

1. Details of Canaletto's biography have been drawn from Links 1982, Constable and Links 1989, and New York 1989–90A.

2. The four former Liechtenstein paintings are Constable and Links 1989, nos. 1, 182 (both Collection Thyssen-Bornemisza), and 210, 290 (both Ca' Rezzonico, Venice); the Dresden paintings are Constable and Links 1989, nos. 208, 297, 305. See New York 1989–90A, nos. 1–7.

3. The paintings, all privately owned, are Constable and Links 1989, nos. 194, 230, 234, 304. See New York 1989–90A, nos. 8–11.

4. Pietro Guarienti, ed. in Pellegrino Antonio Orlandi, *Abecedario pittorico*, 1753, 75; quoted in New York 1989–90A, 14.

5. See a letter in the Kress archives of the National Gallery of Art from Constable to the New York dealer David Koetser, in which he compares *The Grand Canal from the Campo San Vio* to other versions of the composition (see n. 3 above): the Liechtenstein canvas (before 1730, and perhaps as early as 1726–27); the painting in the Royal Collection (before 1735, and perhaps as early as 1730); and an example at the Pinocoteca di Brera, Milan (c. 1735). He saw the Memphis painting as datable between the Windsor and Brera versions.

6. See Constable and Links 1989, II, 228 under no. 88, for discussion of the picture's provenance and early history.

7. These are, together with the El Paso painting, Constable and Links 1989, no. 87, Gemäldegalerie, Berlin; no. 88a, private collection, Paris; and no. 89, private collection, in New York 1989–90A, no. 17, reproduced 111.

8. See, for example, Constable and Links 1989, no. 89, pendant to no. 117, *Riva degli Schiavone looking East*, a view from near the mouth of the Grand Canal (nos. 89, 117, present owners unknown); or the similar no. 90, pendant to no. 112, likewise a view of the quay to the east (nos. 89, 112, Wallace Collection, London).

9. The pair in a Parisian collection are Constable and Links 1989, nos. 88a, 187a.

10. The Liechtenstein picture, now in the Thyssen-Bornemisza Foundation, is Constable and Links 1989, no. 182; the Windsor painting is no. 184. Others include Constable and Links 1989, no. 183 (Gemäldegalerie, Dresden), from c. 1725–26; no. 183a, known on the New York art market in 1951; nos. 185, 186 (private collections, London); no. 187a, which has as its pendant a Molo view (private collection, Paris); no. 188 (formerly the Trustees of the Late Sir Robert Grenville Harvey); no. 189 (Count Matarazzo, São Paolo); no. 190 (Sir Christopher R. P. Beauchamp, Bart., Devonshire—this painting also belonged to George Proctor of Langley Park); 190a (sold Christie's, London, July 10, 1992, lot no. 25); and no. 191 (Pinocoteca di Brera, Milan).

11. Brosses 1799/1986, 216.

BERNARDO BELLOTTO

Venice 1721–1780 Warsaw

Bernardo Bellotto came from a distinguished Venetian family of artists. He was the son of the painter Lorenzo Bellotto and Fiorenza Domenica, the younger sister of the painter Giovanni Antonio Canal, called Canaletto (see cats. 40, 41). Bernardo was born on January 30, 1721—1720 by the Venetian calendar—and by as early as 1735 was working in the studio of his uncle, the greatest and most famous view painter in Venice.[5] The young Bellotto showed great promise: he entered the Guild of Painters in Venice in 1738; by the early 1740s he had absorbed Canaletto's style and had created a personal manner in which the deeper colors and the more intense effects of light and shadow that mark his mature work could already be distinguished. Traveling to Rome in 1742, via Florence and Lucca, Bellotto encountered the art of such contemporary view painters as Giovanni Paolo Panini (see cat. 44). In Panini's work Bellotto would have first seen the imaginary views of monuments that were to reach their full grandeur in his paintings of the 1760s (cat. 43).

Although he is considered one of the great figures of the Venetian landscape tradition, Bellotto's name is not primarily associated with views of his native city. Through the 1740s, as Bellotto matured and gradually separated himself from his uncle, he spent more and more time away from Venice. In the summer of 1747, a year after Canaletto quit Venice for England, Bellotto went north to Dresden, where at the court of Augustus III of Saxony he launched a campaign that was to last eleven years, painting series of views of the city and its environs on commission from the king or his prime minister, Count Heinrich von Brühl, or independent canvases for other patrons. For part of the period of the Seven Years' War Bellotto worked in Vienna (1759–61); he returned to Dresden for five years before his departure in 1767 for Russia. On the way to St. Petersburg, however, he was invited by King Stanislas II Augustus to join his court in Warsaw, and there he remained as court painter until his death. Bellotto's independence from his uncle notwithstanding, it is worth noting that he often signed his work "Bellotto detto Canaletto" or "Bellotto de Canaletto," and in Germanic countries he is still called by his uncle's name.

Bellotto's magnificent paintings of the late Baroque capitals of northern Europe—particularly his scenes of Dresden, Vienna, and Warsaw—display the artist's acute sense of topographical realism, conveyed through their apparently unaffected compo-

42

The Marketplace at Pirna

c. 1760
Oil on canvas, 19 x 31⅝ in. (48.4 x 79.6 cm)
The Museum of Fine Arts, Houston 61.71

PROVENANCE
Catherine II, Empress of Russia; given by her to Frederick II, King of Prussia;[1] Prussian Royal Collections until 1919; Niederländisches Palais, Berlin, purchased there by Hugo Moser, 1919;[2] Duke of Anhalt-Dessau?; with Caspari Gallery, Munich, 1930; with K. Haberstock, Berlin; Samuel H. Kress Foundation, New York, 1952 (K1914); on loan to The Museum of Fine Arts, Houston, 1953–61; gift of the Kress Foundation to The Museum of Fine Arts, Houston, 1961.

SELECTED EXHIBITIONS
Munich 1930, no. 5; Detroit 1952, no. 6; Washington 1961–62, no. 6.

SELECTED REFERENCES
Waagen 1850, no. 8350;[3] *Pantheon* 1930, 483, 487; Fritzsche 1936, VG 87; Houston 1953, no. 31; Munich 1967, no. 66; Kozakiewicz 1972, II, 173 no. 215;[4] Shapley 1973, 165–66; Camesasca 1974, 100 no. 110; Houston 1981, 74 no. 131; Houston 1989, 19, 154–55.

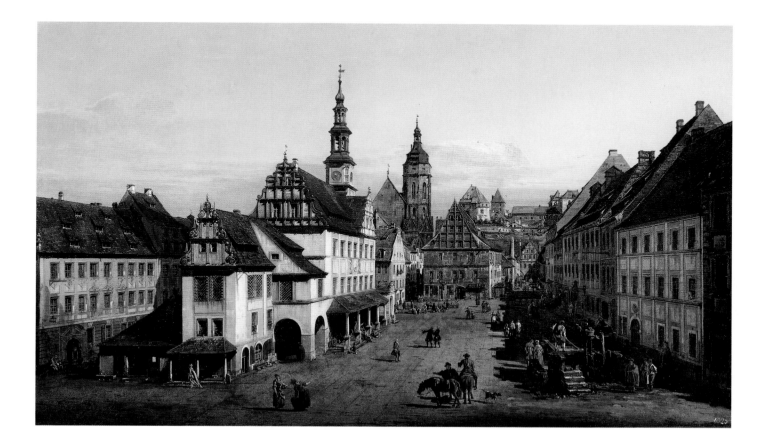

BELLOTTO, *The Marketplace at Pirna*

sitional structure and their detailed and technically flawless draftsmanship. Above all, however, it is Bellotto's artistry in rendering subtle effects of light and atmosphere that distinguishes his work from that of any of his rivals and that makes his paintings, whether topographical or imaginary, among the most compelling in the history of landscape art.

Bellotto's great work during his first, eleven-year residence in Dresden was a series of large-scale views painted for Augustus III, King of Saxony. The paintings delivered to the king, which are now in the collection of the Gemäldegalerie, comprised fourteen views of Dresden and eleven views of the suburban town of Pirna and its castle, Sonnenstein.[6] In the Dresden series, some of the paintings show sweeping panoramas of the city seen across the Elbe; more of the group record the fine architecture of the central city or broad public squares crossed by distant crowds. Working later at Pirna, Bellotto chose to emphasize the rural or suburban quality of the site: three views capture the appearance of the town seen at a distance from Posta and Kopitz on the right bank of the Elbe,[7] another four describe the outskirts of the town, including its gates and outlying quarters,[8] and three concentrate on Sonnenstein, the fortified castle that overlooks the town.[9]

Only one view shows the interior of Pirna itself, focusing on the marketplace at the town center.[10] In this composition, a version of which is presented here, the imposing building to the left of center is the Rathaus; beyond it rises the spire of the church dedicated to Mary. On either side are private residences and, at the right edge of the view, the courts, before which stand public water troughs. The composition converges on two buildings: Sonnenstein Castle is seen on a distant hill, and opening onto the marketplace is the facade of the Canaletto-Haus, so called because Bellotto, "*genannt Canaletto*," lived there for a time.

From the beginning of his work on the Dresden series, Bellotto was busy making replicas of his royal commissions for other clients. A partial set at full scale was begun for the prime minister, Count Brühl, and reduced versions, in greater or lesser numbers, were produced for other patrons. Houston's *Marketplace at Pirna* is one of three reduced autograph replicas of the view painted for Augustus around 1753–54 and is particularly close in its details to this prime version.[11]

A drawing by Bellotto relating to the group (*fig. 1*) corresponds almost exactly with the Dresden version of the composition and may have been made in preparation for it.

Scholars have speculated that Bellotto here made use of a *camera obscura*, a mechanical device employed by landscape artists to focus a view through a lens onto a surface from which it could be traced.[12] On the other hand, the drawing may be a later record of the earliest version of the composition. If historians are correct in dating the Houston canvas to 1760, the drawing, or one of the two other reduced versions, must have served the artist as a model, for he was then in Vienna and did not have access to either the king's painting or Count Brühl's version.

fig. 1 Bernardo Bellotto. *The Marketplace at Pirna.* c. 1752. Pen and brown ink, 14⅞ x 25⅝ in. (37.7 x 65 cm). Muzeum Narodwe, Warsaw

Pirna and the nearby Castle of Königstein played a key role in the history of the Seven Years' War. In late October 1756 Augustus III and his sons Xavier and Charles left Pirna and Königstein, where they had been headquartered, following by several days the surrender of their forces to the invading army of Frederick the Great of Prussia, which eventually wreaked havoc in the city. Sometime later, Frederick was given the Houston reduction of *The Marketplace at Pirna* by Empress Catherine the Great of Russia, who had acquired fifteen of Count Brühl's Dresden and Pirna views for her own collection.[13] It is interesting to speculate that the gift may have been made to commemorate Frederick's triumph over the House of Saxony and his capture of Pirna.

G.T.M.S.

1. Kozakiewicz (1972, II, 173 n. 215) asserts the provenance from Catherine the Great to Frederick II; although Shapley (1973) knew of this information, she does not include it in her entry on *The Marketplace at Pirna*, nor does she refute it.

2. See a letter of February 28, 1952, from Moser in the Kress Archives of the National Gallery of Art: "I bought the painting at the 'Niederlaendisches Palais' Unter den Linden 36 in Berlin, where all the paintings from the different Hohenzollern castles were stored after the revolution in 1918. Besides the label 'Preussische Koenigskrone' which is still on the back of the painting it had the 'General-Katalog' No. 8350. This Katalog was made by Waagen in the middle of the XIX. century."

3. This manuscript catalogue, cited by Hugo Moser (see n. 2 above), was destroyed by fire during World War II.

4. Kozakiewicz 1972 inverts the photographs of nos. 214 and 215. In the Kress composition, catalogued as no. 215, the tall house at right has two chimneys; in no. 214, formerly with M. Knoedler & Co., the same house has only one chimney. (This is confirmed by a photograph from the Knoedler archives kindly provided to me by Melissa De Medeiros, Librarian of M. Knoedler & Co., New York.) Thus on page 170, fig. 214 is actually no. 215, and on page 171, fig. 215 is actually no. 214. Kozakiewicz's identification of the Kress canvas (no. 215) with the version handled by Caspari and Haberstock remains valid.

5. Kozakiewicz 1972, I, 15 n. 1.

6. A further four views, depicting the Königstein Castle, may actually have been painted for Augustus, though they were never delivered to him; see Kozakiewicz 1972, I, 100.

7. Kozakiewicz 1972, II, nos. 188, 193, 196.

8. Kozakiewicz 1972, II, nos. 200, 205, 207, 217.

9. Kozakiewicz 1972, II, nos. 220, 225, 230.

10. Kozakiewicz 1972, II, no. 211.

11. The three reduced replicas are approximately the same size. They are Kozakiewicz 1972, II, nos. 213–15. No. 212, painted for Brühl about the same time as the royal version, was sold to Catherine II, as was the Houston version, and is now in Moscow.

12. See E. Scholze's remarks in Dresden 1964, 16.

13. See Kozakiewicz 1972, I, 102–3.

BERNARDO BELLOTTO

Venice 1721–1780 Warsaw

One of the finest paintings by Bellotto in the United States, this impressive view of a palace is part of a group of ideal views, or *vedute ideate*, dating from the artist's second stay in Dresden between 1761 and 1767. The view combines an imaginary palace courtyard in the Baroque style with relatively large genre figures in the foreground, closely observed and depicted with a straightforward realism in stark contrast to the almost bombastic grandeur of the architectural setting.

Because of the Polish dress of the moustached man standing at left, scholars had long assumed that the painting dated from Bellotto's years in Warsaw (1767–80). In both style and format, however, the *Entrance to a Palace* is close to other imaginary architectural compositions, one of which contains a fanciful self-portrait of Bellotto in the costume of a Venetian procurator (*fig. 1*), the other a depiction of Christ driving the money changers from the temple.[1]

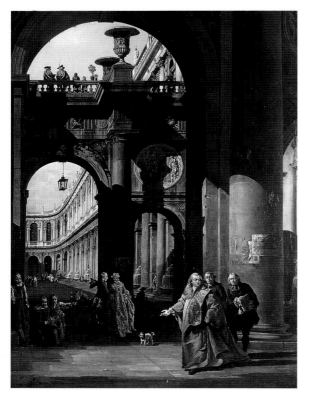

fig. 1 Bernardo Bellotto. *Architectural Capriccio with a Self-Portrait of Bellotto in the Costume of a Venetian Nobleman.* c. 1765. Oil on canvas, 60½ x 44¼ in. (155 x 112 cm). Private collection

Three richly dressed figures stand at left—two men and an adolescent boy. Two of these have been identified as the wealthy Polish landowner Voivod Franciszek Salezy Potocki and his son Stanislaw Szczesny. The third figure, a man wearing a high fur hat, is presumably a retainer.[2] It is now generally thought that the combination *capriccio*-portrait must have been painted while the Potockis were in Dresden, where the family held large estates and where Potocki had ties to Count Brühl, Bellotto's patron during his first period of residence in Saxony.[3]

The painting is a rare instance of Bellotto's interest in the portrayal of human character through gesture and expression. He seems in fact to insist on the striking contrast between the Potockis, the presumed patrons of the *capriccio*-portrait, and the other figures in the composition. The richly dressed father and son, whose feet hold the same elegant pose, are grouped at left with their servant, but they are flanked by the humblest of figures: a blind beggar at the far left, whose outstretched hand seems to echo the youthful Potocki's genteel

43

Entrance to a Palace

c. 1765
Oil on canvas, 60½ x 44¾ in.
(153.6 x 113.6 cm)
Signed at lower right:
Bernard. BELOTTO. DE. CANALETTO.
El Paso Museum of Art 61.1.50

PROVENANCE
Colonel Robert Adeane, Babraham Hall, Cambridge, England; sale, Christie's, London, May 13, 1949, lot no. 31; bought by Spiller; with David M. Koetser, New York; Samuel H. Kress Foundation, New York, 1950 (K1691); gift of the Kress Foundation to the El Paso Museum of Art, 1961.

SELECTED EXHIBITIONS
Chattanooga 1952, n.p.; Washington 1961–62, no. 5.

SELECTED REFERENCES
Washington 1951, 166–67 no. 73; Warsaw 1956, under no. 15; Bialostocki and Walicki 1957, under no. 387; Kozakiewicz 1960, 146–47; Ryszkiewicz 1961, 77; Seymour 1961, 174–75, 203 n. 28; El Paso 1961, no. 42; Dresden 1964, 3; Warsaw 1964–65, 15–16, 24 n. 1; Ivanoff 1964, I, 301; Kozakiewicz 1965, 91; Kozakiewicz 1972, II, 263 no. 332; Shapley 1973, 166; Camesasca 1974, 108–9 no. 185.

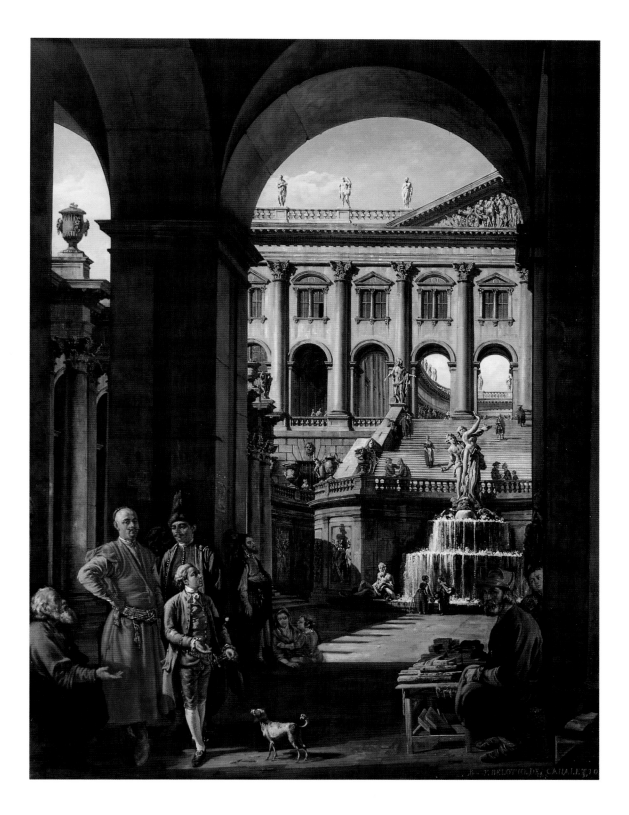

BELLOTTO, *Entrance to a Palace*

gesture, and another boy and his father, a peddler, at right. Yet another family appears in the middle ground, a poor father who stands beside his wife and child, who are seated on the steps that descend to the palace courtyard.

Bellotto conceives the facial expression of each figure independently, but there is among them a solemnity and an enigmatic gravity that is disconcerting to the modern viewer of the painting. Equally disconcerting, indeed almost surreal, is Bellotto's repeated juxtaposition of the human visages with the carved stone masks that silently punctuate the foreground.

G.T.M.S.

1. Both compositions exist in several versions. See Kozakiewicz 1972, II, nos. 333, 334, 334a, 337, 338.

2. See letter in the Kress archives, National Gallery of Art, dated November 16, 1955, from Stanislaus Lorentz, director of the National Museum, Warsaw, who states: "Le groupe de trois personnages à gauche au premier plan pourrait representer le grand seigneur polonais Francois de Sales Potocki avec son fils Stanislas Felix, agé de 13 ans en 1765. Le troisième personnage en costume de cosaque ucranien, represente probablement un domestique de confiance. Son costume parait plausible vu les immenses terres que Potocki possedait en Ucraine." (The group of three people at left in the foreground might represent the great Polish nobleman Franciszek Salezy Potocki with his son Stanislas Felix, 13 years old in 1765. The third person in the costume of a Ukrainian Cossack probably represents a trusted servant. His costume is plausible in view of the immense land holdings of Potocki in the Ukraine.) Either with his letter or at a later date, Lorentz sent W. Suida a photograph of an engraving after Marcello Bacciarelli's portrait of Potocki, which clearly demonstrates the identity of Bellotto's subject; a second-generation photocopy of this photograph survives in the Kress archives, National Gallery of Art.

3. Lorentz also writes (see n. 2 above): "Francois Potocki etait lié au parti du ministre Brühl et sejourna maintes fois à Dresde. Aussi sa presence sur le tableau ne collide pas avec l'eventualité que la toile fut peinte avant l'arrivée de Canaletto en Pologne." (Franciszek Potocki was allied with the party of the Minister Brühl and stayed often in Dresden. Thus his presence in the painting does not conflict with the possibility that the canvas was painted before Canaletto's [Bellotto's] arrival in Poland.)

GIOVANNI PAOLO PANINI

Piacenza 1691/2–1765 Rome

Panini, the foremost painter of architectural subjects in eighteenth-century Rome, may have received some training from members of the Bibiena family or their disciples. Little is known, however, of his career before 1711, when he arrived in Rome and entered the studio of Benedetto Luti (1666–1724). From the beginning Panini specialized in view paintings, above all views of ancient ruins or of baroque palaces in decay. His election to the Academy of Saint Luke in 1718–19 was the beginning of his long association with official art circles in Rome. His second wife, Caterina Gosset, was the sister of Nicolas Vleughels, director of the French Academy there; at Vleughel's death in 1737, Panini was apparently considered for appointment as his successor.[3]

In the 1730s and 1740s, Panini became as celebrated for his Roman vedute as was his contemporary Canaletto (see cats. 40, 41) for his views of Venice. Collectors went to Panini for paintings of contemporary Roman sites, such as the Piazza del Popolo, the Piazza Navona, or the interiors of Saint Peter's and the modernized Pantheon.[4] But his most important contribution was the popularization of a new hybrid view, in which the monuments of ancient Rome were faithfully rendered but fancifully combined in picturesque landscapes. In general, such arrangements derive from the seemingly abrupt juxtapositions of ruins visible in the Roman Forum, but they represent a "perfected" Forum, where only the most famous and beautiful of ruins were brought together. Panini's vedute ideate, as these were called, predate by a generation the imaginary compositions of Canaletto (see cats. 40, 41) or Bellotto (see cats. 42, 43). His views were prized by learned travelers to Rome, often from the North, who wished to return home with an evocation of their visits to the great seat of classical civilization, and who cared little that the Pantheon and the Temple of the Vestals at Tivoli—twenty miles away—should suddenly appear side-by-side.[5]

Panini painted hundreds of these ideal views over the course of his long and active career, and they were dispersed throughout Europe. In England his paintings were often collected by the same connoisseurs who patronized the Neoclassical architect Robert Adam (1728–1792). Perhaps because of his close connections to the French Academy in Rome, Panini also exerted considerable influence in France, on such artists as Claude-Joseph Vernet (1714–1789) and, above all, Hubert Robert (1733–1808).

44

The Pantheon and Other Monuments of Ancient Rome

———⟨❧⟩———

1737
Oil on canvas, 38 15/16 x 54 1/8 in.
(99 x 137.1 cm)
Signed and dated: I. P. PANINI Rom [...] 1737
The Museum of Fine Arts, Houston 61.62

PROVENANCE[1]
Arthur Lehmann, Paris; Marcel Nicolle, Paris; Hermann Heilbuth, Copenhagen; Conte Avogli-Trotti, Paris;[2] with Duveen Brothers, New York; Samuel H. Kress Foundation, New York, 1942 (K1324); on loan to The Museum of Fine Arts, Houston, 1953–61; gift of the Kress Foundation to The Museum of Fine Arts, Houston, 1961.

SELECTED EXHIBITION
Copenhagen 1920, no. 34.

SELECTED REFERENCES
Frankfurter 1944, 60, 78; Washington 1945, 143; Houston 1953, no. 27; Arisi 1961, 153–54 no. 111; London 1979, 41 under no. 19; Houston 1981, 71 no. 125; Arisi 1986, 356 no. 250.

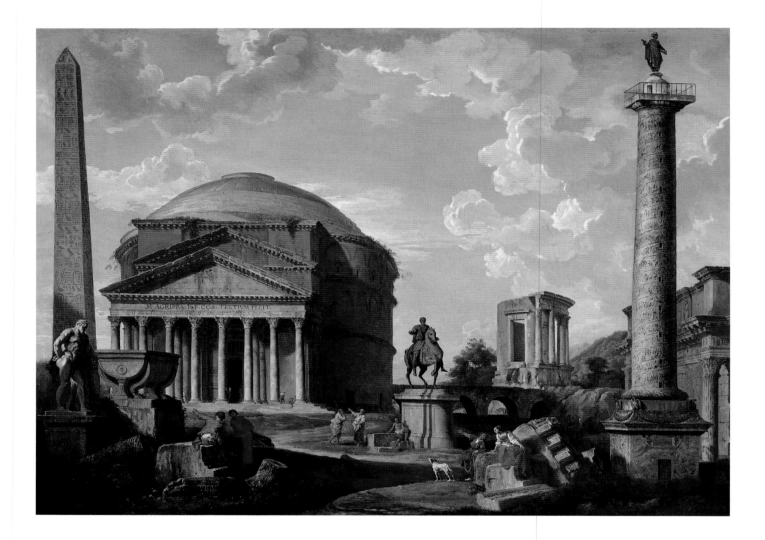

PANINI, *The Pantheon and Other Monuments of Ancient Rome*

In a sunlit landscape, against a distant range of mountains, Panini assembles some of the more famous monuments of ancient Rome. At far left stands the giant statue of Hercules, excavated in the Renaissance, which from around 1556 until 1787 was displayed in the courtyard of the Palazzo Farnese.[6] The third-century statue is seen against an obelisk that was originally placed before the temple of Ammon at Thebes by Thutmose IV and brought to Rome in the fourth century by Emperor Constantius II to adorn the Circus Maximus. There it was excavated in 1587, and placed in the piazza of San Giovanni in Laterano by Domenico Fontana in the next year.

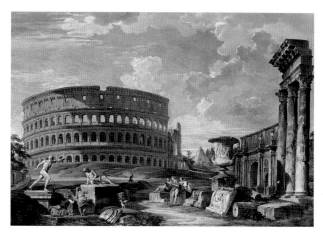

fig. 1 Giovanni Paolo Panini. *A View of the Colosseum with Other Antique Ruins.* 1737. Oil on canvas, 37¼ x 52½ in. (99 x 134.5 cm). Present location unknown

To the right of the Hercules and the obelisk Panini shows the impressive porphyry container that for centuries had stood near the Pantheon and which had been removed, in 1734, to the Basilica of San Giovanni in Laterano to serve as the future tomb of Pope Clement XII.

The most important monument in the painting is, of course, the Pantheon, the temple to all the Roman gods erected between A.D. 118 and 128 by the Emperor Hadrian on the site of another temple built by Agrippa 150 years earlier. It was certainly one of the most influential Roman buildings to have come down to modern times and was of particular importance as a model during the rise of Neoclassicism in the eighteenth century. As Panini's many views of its interior reveal, the Pantheon contains a great spherical space, rising to a coffered dome, which is illuminated from above by a single great oculus open to the sky; the principal experience of the building, as all critics have noted, is of the indefinable light and space in the interior. Although Panini in this instance depicts the building from afar, he manages to suggest something of its dependence on effects of light by silhouetting it against an area of unusually bright sky.

The right side of the painting is dominated by Trajan's Column, erected in the first decades of the second century A.D. by the Emperor Trajan. Scenes in low relief spiraling around its shaft depict his campaigns in Dacia. To the left of the column are the ruined Temple of the Sibyl from Tivoli—a picturesque monument that had attracted the attention of painters since the time of Claude Lorrain—and the equestrian statue of Marcus Aurelius, one of the few important sculptures of antiquity to have remained intact and on public view through the centuries. At the extreme right edge of the painting is part of the Forum of Nerva.

In the Houston canvas, and in its pendant, *A View of the Colosseum with Other Antique Ruins (fig. 1)*, figures dressed in antique costume are placed among the buildings, which are shown as they must have appeared in the eighteenth century. They behave much as modern tourists, gesturing in wonder at the monuments and ruins around them. Although the action, such as it is, presumably takes place in classical times, Panini does not hesitate to show the bronze statue of Marcus Aurelius upon the base designed for it by Michelangelo, nor the Column of Trajan topped by the statue of Saint Peter placed there as late as 1588.

This amalgam of ancient and modern Rome suited the taste and the needs of Panini's Grand Tour clients; views like the Houston canvas and its pendant served such collectors as visual compendia of their favorite sites. So great was the demand for Panini's productions that he was forced to repeat his *capricci* time and again, simply varying the figures or the less significant accessory statuary. The Pantheon, for example, is depicted in as many as forty paintings, the Farnese Hercules in no fewer than forty-four, and the equestrian statue of Marcus Aurelius in twenty-two.

G.T.M.S.

1. Shapley (1973, 121–22 n. 6) discounts the provenance for this painting assembled by Duveen before the acquisition of the painting by Kress, i.e.: Cardinal Melchior de Polignac, Paris, by 1738 (see Polignac 1738, 265 no. 69); Abbé Gévigney, Paris (see Paillet 1779, no. 34); Marquis de Ménars, Paris (see Basan and Joullain 1788, no. 71); M. Rousseau (said to have acquired the painting in 1782); Pierre Rousseau, Bruges (see Montangie 1858, no. 199).

2. Shapley (1973) points out that Madsen, in Copenhagen 1920, states that Heilbuth acquired the collections of both Nicolle and Avogli-Trotti.

3. Arisi 1986, 209.

4. See, for example, Arisi 1986, nos. 152, 153 (Piazza del Popolo), 157, 211 (Piazza Navona), 212, 217 (Saint Peter's), and 218–21 (Pantheon).

5. See Haskell and Penny 1981, 83–84.

6. Haskell and Penny 1981, 229.

POMPEO GIROLAMO BATONI

Lucca 1708–1787 Rome

Batoni received his initial artistic training in Lucca from his father, a distinguished goldsmith. He showed a talent for drawing at an early age, and in 1727, through the sponsorship of eight noblemen from Lucca, he was able to go to Rome. He spent his first years there drawing the ancient sculptures in the Vatican and other Roman collections and copying the works of Raphael and seventeenth-century artists like Pietro da Cortona and Annibale Carracci and his followers. Batoni's artistic development was also influenced by two older contemporary masters, Francesco Fernandi, called Imperiali, and Agostino Masucci.[6] The acclaim Batoni received for his first public commission, an altarpiece painted in 1732 for the church of San Gregorio al Celio, led to many prominent commissions including The Triumph of Venice. *The exhibition of this painting in the Saint Joseph's Day exhibition at the Pantheon on February 19, 1739, securely established Batoni's reputation as a formidable painter of classicizing historical subjects.*

His fame continued to increase during the 1740s, and in 1746 Batoni was honored with a commission to paint an altarpiece for Saint Peter's. This work, The Fall of Simon Magus, *was Batoni's most ambitious and complex history painting, but when it was unveiled in 1755 it was rejected by the commissioners. From this time onward the importance of history painting in his oeuvre declined.[7] At the same time, however, Batoni's career as a portrait painter, which had begun in the 1740s, rapidly took off. He quickly developed a considerable reputation among the international travelers who came to Rome on the Grand Tour, especially the British, and for nearly fifty years Batoni recorded their visits to the Eternal City in portraits that are among the most definitive artistic expressions of the period.*

Batoni was the preeminent painter in eighteenth-century Rome, and at the time of his death, in 1787, he was arguably the most famous artist in all of Europe. By 1800, however, his reputation had declined sharply, and only in the past thirty years have his artistic achievement and historical significance again come to be appreciated.

45

The Triumph of Venice

1737
Oil on canvas, 68⅝ x 112⅝ in.
(174.3 x 286.1 cm)
Signed on the ledge above the putto bearing the basket of fruit: *P. Batoni*
North Carolina Museum of Art, Raleigh
60.17.60

PROVENANCE

Marco Foscarini, Palazzo Venezia, Rome, 1737–40; his collection, Venice, before 1745;[1] Manfrin Gallery, Venice, sold in 1856;[2] said to have passed through Trieste to Vienna, and thence purchased by an American diplomat, 1857;[3] sale ("property of the estates of Dr. M. C. Gould and Julia Lorillard Butterfield, and private collections"), New Galleries, New York, April 3, 1916, lot no. 147, bought by Marcel Jules Rougeron; offered for sale by Rougeron, 1917;[4] sale, Hôtel Drouot, Paris, May 4, 1955, lot no. 126; with International Financing Company, Panama City, Panama; Samuel H. Kress Foundation, New York, 1956 (K2149); gift of the Kress Foundation to the North Carolina Museum of Art, 1960.

SELECTED EXHIBITIONS

Rome 1739;[5] Cleveland 1964, no. 6.

SELECTED REFERENCES

Valesio 1700–42, XX, fol. 132v; Benaglio c. 1750–53, 62–63; Algarotti 1791–94, XIII, 217; Manfrin 1856, 2 no. 10; *American Art News* 16, 7 (November 24, 1917): 1; Emmerling 1932, 22–24, 48–49, 131–32, 139; Clark 1959, 235, fig. 32; Raleigh 1960, 122–23; Clark 1963, 4–11; Haskell 1963/1980, 259, 357, 381; Hawley 1964, 316–19; Lucca 1967, 41, 104; Fehl 1971, 3–15; Fehl 1973, 21–31; Shapley 1973, 119–20; New York 1982, 5, 7, 54; Huttinger 1983, 187–91; Clark and Bowron 1985, 25, 213 no. 13; Boime 1987, 54, 63–64; Braegger 1989, 10–11.

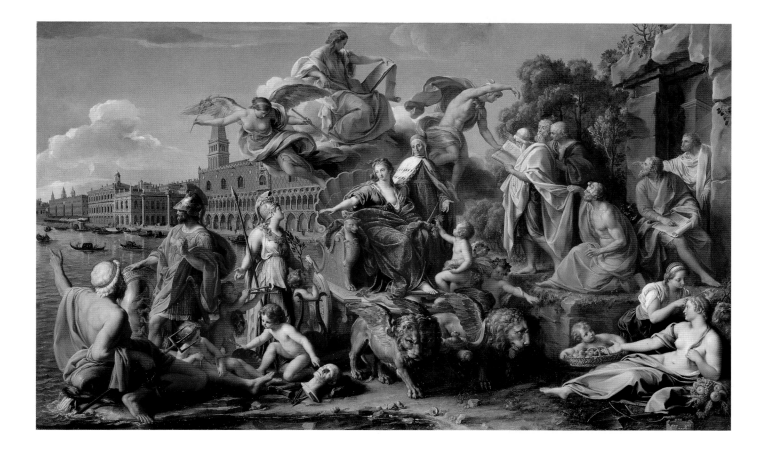

BATONI, *The Triumph of Venice*

In its size, erudite iconography, and unapologetic academicism, Batoni's *Triumph of Venice* is a formidable, even intimidating picture, as much a programmatic machine as it is a work of art. In these repects it is a valuable art-historical document that tells us a great deal about eighteenth-century history painting and the complex, amibitious aims and expectations of both artists and patrons of the period.

In the spring of 1737 Marco Foscarini (1695–1763), the newly appointed Venetian ambassador to the papal court, arrived in Rome and took up residence in the Palazzo di San Marco (the Palazzo Venezia). A member of one of Venice's oldest and most distinguished patrician families, Foscarini was an experienced diplomat with successful previous postings at the courts of Vienna and Milan. He was also a highly cultured bibliophile, deeply interested in Venetian literature and history. Three years earlier he had been appointed official historiographer of the Venetian Republic. Like his forebears Foscarini was a learned patron of the arts, and he formed a notable collection of paintings and sculptures that portrayed noteworthy literary and political figures from history, particularly Venetian history.[8]

fig. 1

Pierre Subleyras. *Portrait of Marco Foscarini*. 1737. Oil on canvas, 34⅝ x 26¾ in. (88 x 68 cm). Museo Correr, Venice 123

Soon after his arrival in Rome Foscarini commissioned three works of art: an oil portrait of himself from Pierre Subleyras (*fig. 1*); another portrait of himself, in chalk; and *The Triumph of Venice*.[9]

The Triumph of Venice was Batoni's fourth major commission and his first significant nonreligious work. Foscarini reportedly visited the artist's studio in the Palazzo Venezia daily to observe Batoni's progress on the painting, and it was undoubtedly he who was responsible for the complex iconographic program of the work. A summary description of the painting by Francesco Benaglio, Foscarini's secretary and Batoni's biographer, records that the painting illustrates "the flourishing state of the Venetian Republic when, after the wars incited by the famous League of Cambrai, peace returned and the fine arts began to flourish again, summoned back and nurtured by Doge Lionardo Loredan of immortal memory [Loredan served as Doge from 1501 to 1521] . . . with the sea, the prospect of the city, architecture, dignified personnages and spirits of all sexes and ages, symbols of literature and the fine arts."[10]

The painting's iconography and numerous pictorial and literary allusions have been studied by Anthony Clark and Philipp Fehl.[11] In the center of the composition is the scepter-bearing personification of Venice, clothed in fine Venetian brocade and seated upon a shell-backed throne that symbolizes the city's ties with the sea. The throne is mounted upon a triumphal car drawn by two winged lions, symbols of the Evangelist Mark, the patron saint of Venice. With a benign gaze and a regal gesture, Venice acknowledges several putti (*fig. 2*) who bear attributes of the arts of poetry, music, drama, painting, sculpture, and architecture. These putti are presented to her by Minerva, patron goddess of the arts, wisdom, and statecraft, who holds in her hand an olive branch, an emblem of peace. These are the arts that flourished in peacetime under the enlightened governorship of Doge Loredan, who stands on the car next to Venice. At the far left Neptune, mythological patron of Venice, points out his city to an impressed Mars, the god of war. Mars's role as the mythological patron of Rome is underscored by the motif on his shield depicting his sons Romulus and Remus, the legendary founders of Rome, being nursed by a she-wolf. Fehl suggested that this vignette of Neptune and Mars alludes to a famous epigram in praise of Venice written by the Renaissance poet Jacopo Sannazaro.[12]

On the other side of the figure of Venice, Doge Loredan attempts to draw her attention to the fruits of the harvest, brought to her by a putto and a young satyr. The satyr gestures toward a personification of the agricultural riches of the Veneto region, a figure based upon the mythological goddesses Ceres and Cybele, who reclines upon a cornucopia with implements of the harvest at her feet.[13] This figure forms an iconographic balance to Minerva and the attributes of the liberal arts, and the juxtaposition of the two goddesses underscores the painting's theme of the fertile abundance—artistic and agricultural—that Venice and the Veneto were capable of producing in peacetime under enlightened leadership.

Bearing a trumpet and a laurel branch, an ancient symbol of victory, the allegorical figure of Fame flies above Venice's chariot (*fig. 3*), ready to spread far and wide the illustrious reputation of the city (and Loredan's enlightened rule).

Seated on a cloud next to Fame is two-faced History, the older and masculine face looking back to Venice's glorious past, while the other youthful, feminine aspect reflects on

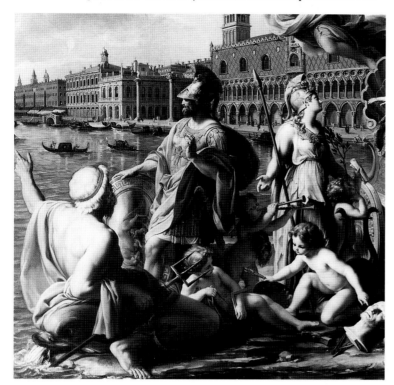

fig. 2 Pompeo Batoni. *The Triumph of Venice* (detail of cat. 45, before conservation treatment)

the lines the figure has just inscribed, which presumably describe the city's equally glorious present. On the right, forming a graceful counterbalance to the figure of Fame, is Mercury, the messenger of the gods, who presents the second volume of a history of the Venetian Republic—a subject surely close to Foscarini's heart—to a group of ancient sages who have emerged from a light-filled cave or grotto. The presence of Cerberus behind the seated philosopher indicates that this portal represents the entrance to Hades, the mythological underworld. These wise men, who animatedly study this volume, must be classical authors, like their predecessors in Raphael's *School of Athens*; as Clark noted, the figure holding the book resembles ancient busts of Plato, the beardless man behind him might be Cicero, and the blind man emerging from the entrance is very probably Homer.[14]

The programmatic theme of "the flourishing state of the Venetian Republic . . . after the wars incited by the famous League of Cambrai"—events that took place during the first quarter of the sixteenth century—may seem a peculiar one to be commissioned and designed more than two hundred years after the fact.[15] There existed clear parallels, however, between Venice's political situation at the time of

Loredan's rule and the circumstances in which the Republic found itself more than two hundred years later during Foscarini's ambassadorship. These parallels would have been apparent to Foscarini and eighteenth-century visitors to the Palazzo Venezia, where the picture was to hang. During Loredan's dogeship (1501–21), Venice's very existence had been threatened by the League of Cambrai, an alliance among France, Spain, the Holy Roman Empire, and the Papal States, whose sole intent was the destruction of the Republic. According to Venetian historiography, it was only due to Doge Loredan's political and military astuteness that the League's designs were thwarted, and Venice's certain defeat was ultimately transformed into triumph. Venetian writers noted that because of Loredan's wisdom and statecraft, Venice entered an era of lasting peace, retained its independence, and enjoyed great prosperity at a time when the rest of the Italian peninsula was plagued by continual warfare and foreign domination. The price for achieving this peace was that Venice had to abandon its policy of territorial expansion and surrender a substantial portion of its foreign empire. In peacetime, however, the civic life of the Republic prospered and caused the arts to flourish on an unprecedented level. Loredan's policy of peace and prosperity became a leitmotif in Venetian historical writing and in the iconography of Venetian art.[16]

In the early eighteenth century Venice's political situation was remarkably similar to that which it had faced under Loredan's dogeship two hundred years earlier. Under the terms of the treaty of Passarowitz (1718) dictated by

fig. 3 Pompeo Batoni. *The Triumph of Venice* (detail of cat. 45)

England and the Netherlands, Venice ceded her territorial possessions in the east to Austria. The once-mighty foreign empire of the Republic was reduced to only the city itself and the surrounding territory of the Veneto. As in the early sixteenth century, Venice once more found itself at a political crossroads, its political empire reduced by more pow-

fig. 4 Pompeo Batoni, after Flaminio Vacca. *Lion*. c. 1727–37. Red chalk, 10⅞ x 16¼ in. (277 x 414 mm). College Library, Eton College, Topham Collection, no. Bm.5, no. 57

erful rivals. The parallels between the two historic turning points would have been obvious to the Venetian historian Foscarini, and his program for Batoni's painting clearly counseled a similar political course for contemporary Venice. As official historiographer of the Republic, Foscarini must have seen it as his duty to present a political lesson from Venice's history, wherein the Republic could discover the manifold benefits that could be gained under similar circumstances. In 1737, no longer able to maintain its far-flung foreign empire, Venice could again opt for the blessings of peace and prosperity that might foster a renaissance of the arts and literature such as the one that occurred following the peace treaty concluded by Doge Loredan. This explains the prominent position of the figure of History in Batoni's painting, for History not only chronicles past events but also records and evaluates present decisions and actions, which will prove their true worth in the future.

The Triumph of Venice is a compendium of artistic motifs that illustrates the formative artistic influences on the young Batoni. The polished finish of the work and the assiduous care with which Batoni rendered the profusion of decorative details—the helmets, the iconographic attributes of the figures, even the shells scattered across the foreground—amply demonstrate the influence of his early training and career as a goldsmith.[17] The figures of Mars and Minerva are based on ancient statues in the Capitoline Museum.[18] Batoni also borrowed numerous motifs from more contemporary models. The winged lions that pull the cart may have been based on a sculpture by Flaminio Vacca that Batoni drew soon after his arrival in Rome (*fig. 4*).[19] The two-faced figure of History is probably based (albeit in reverse) on Raphael's figure of Prudence from one of the lunettes in the Stanza della Segnatura.[20] For his likeness of

the doge, Batoni must have used a painted replica or engraving after Giovanni Bellini's portrait of Loredan, which, at that time, hung in the Palazzo Grimani in Venice.[21] The group consisting of the allegorical figure and the female attendant curling her hair, in the lower right corner of the painting, must derive from similar depictions of Venus being adorned by the Graces in paintings by Annibale Carracci (such as the work in the Kress Collection in the National Gallery) and Francesco Albani.[22] Batoni had never been to Venice, and the somewhat abrupt view of the Venetian Molo in the background was probably copied from an engraved or painted view by Gaspar van Wittel (Vanvitelli).[23] Recent conservation of the painting has uncovered the left leg of Neptune, which was visible in a 1751 engraving (*fig. 5*) after the work but which was overpainted sometime between 1917 and 1956, when it was acquired by the Kress Foundation.[24] Comparison with Monaco's engraving also indicates that the painting has been cropped slightly along all four sides.

The Triumph of Venice is a testament to the ambitions of both artist and patron. A watershed commission for Batoni, it presented him with the most daunting artistic challenge of his young career. Batoni clearly intended the painting

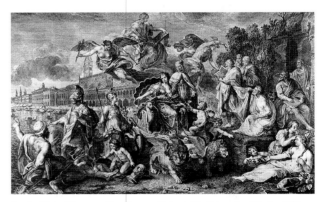

fig. 5 Pietro Monaco, after Pompeo Batoni. *The Triumph of Venice*. 1751. Engraving

to establish his reputation as the foremost history painter in Rome and as the learned successor to Raphael, Annibale Carracci, and Poussin. If, to twentieth-century eyes, the painting seems to groan under the weight of Foscarini's elaborate program, it nevertheless successfully achieved the considerable aims of Batoni and his patron.[25] Furthermore, as Clark noted, *The Triumph of Venice* is of particular art-historical interest and a landmark in the history of style. It was a Neoclassical picture before the fact, and as such, for more than twenty years, it was the most avant-garde painting in Europe.[26]

D.S.

1. Algarotti (1791–94, 13, 217) mentions the painting "in Venezia appresso il procurator Foscarini" in a letter of 1751, but as Clark notes (1959, 235 n. 4), he could only have seen the painting there before 1745.

2. Manfrin 1856, 2 no. 10, "Venezia trionfante . . . Pompeo Battoni . . . tela . . . 289 x 176 [cm]."

3. *American Art News* 16, 7 (November 24, 1917): 1.

4. *American Art News* 16, 7 (November 24, 1917): 1. Rougeron, who was born in Paris and trained under Gérôme and Vibert, was a landscape painter of some repute. In the 1936–41 editions of *Who's Who in American Art* (I, 363; III, 552), his "specialty" is listed as "restoration of paintings," so it may have been he who was responsible for overpainting the areas discussed below (see n. 24).

5. Valesio 1700–42, XX, fol. 132v.

6. The primary contemporary biographical sources for Batoni are Benaglio (c. 1750–53) and Boni (1787). The most accurate and thorough modern study of his life and career is found in Clark and Bowron 1985, 15–63.

7. See Clark and Bowron 1985, 28–29, 261–62 no. 184, fig. 173.

8. Fehl 1973, 31 n. 9. A brief biography of Foscarini appears in the *Enciclopedia italiana* (Milan, 1932) 15: 761; see also Benaglio c. 1750–53, 216–17; Molino 1795; Arnaldi 1795; Gandino 1894; Haskell 1963/1980, 259–60.

9. For the Subleyras portrait, see Clark 1963, 6 fig. 6.

10. Benaglio c. 1750–53, 62–63.

11. Clark 1959, 235; Clark 1963, 4–11; Fehl 1971, 3–15; Fehl 1973, 20–31.

12. Fehl 1971, 5–6, 13 nn. 12, 13. Sannazaro's epigram is there translated as follows:

> Neptune saw Venice rise from the waves of
> the Adriatic
> And give laws to the whole expanse of the sea.
> "Now, oh Jupiter," he exclaimed, "vaunt as
> much as you like
> The Tarpeian fortress and those walls of your
> Mars!
> And if indeed you prefer to the ocean the
> shores of the Tiber, compare but the cities:
> The one, you will say, was erected by men, the
> other by gods."

13. Many of the attributes depicted here—the cornucopia, fruits and grains, sickle, shovel—are traditionally associated with Ceres, the goddess of agriculture. The inclusion of the sheep broadens the allegorical "territory" of the figure to include animal husbandry, referring to another aspect of the fertility of the Veneto region in peacetime. The turreted "mural" crown at the bottom edge of the canvas is a traditional attribute of Cybele, the ancient Anatolian "mother goddess" who ruled over all nature. The figure in Batoni's painting may perhaps best be understood as an allegorical personification of the Veneto's natural abundance rather than specifically as Ceres or Cybele.

14. Clark 1963, 11 n. 4; see also Fehl 1971, 14 n. 18.

15. Haskell (1963/1980, 259) notes that Batoni's work was "one of the very few 'historical' pictures painted for a Venetian patron which has no reference to the triumphs of his own family but is purely devoted to exalting the state."

16. Fehl (1973, 20–31) discusses this at length, citing Alessandro Leopardi's bronze bases for the flagpoles in front of the basilica of San Marco (c. 1505), Loredan's tomb in the church of Santi Giovanni e Paolo (1572), and Palma Giovane's painting *Lionardo Loredan and the War of the League of Cambrai* (c. 1590–93) in the Palazzo Ducale, Venice (Mason Rinaldi 1984, 142 no. 535, fig. 203).

A concise overview of Venice's political situation during this period is found in J. R. Hale's essay "Venice and its Empire," in London 1983–84, 11–15.

17. Clark ("Batoni's Professional Career and Style," in Clark 1981, 106–7) writes that he believed that "Batoni's ornamental finish, which Cicognara called his 'laboriosa finitezza olandese,' is not just a matter of the spirit and taste of his century, but in Batoni's case, the natural practice of one craft adopted for another."

18. The statue of Mars is illustrated in Fehl 1971, 7. Clark (1963, 11 n. 6) notes that in the early 1740s G. B. Tiepolo copied Batoni's figure in a drawing in the Victoria and Albert Museum (Knox 1960/1975, pl. 22), and points out that Tiepolo's *Flora* in the Kress Collection (see cat. 48) may also reveal that artist's awareness of Batoni's painting. For Batoni's use of several ancient statues of Minerva for the figure in the Raleigh painting, see Clark 1959, 235.

19. In Batoni's day Vacca's sculpture, which was carved as a pendant to an ancient sculpture, was in the Villa Medici in Rome; it is now in the Loggia dei Lanzi in Florence. For Batoni's drawing, see Macandrew 1978, 145 no. 1.

The figure of Venice seated in her triumphal car may derive from Pietro da Cortona's fresco *The Triumph of Ceres* in the Villa Sacchetti at Castelfusano; see Briganti 1962/82, pls. 78, 79.

20. Raphael's fresco is illustrated in Dussler 1971, pl. 126.

21. Foscarini wrote in May 1737 that he was adorning his library in the Palazzo Venezia with portraits of notable Venetians; and it is probable that he owned a version of Bellini's portrait. Bellini's portrait is now in the National Gallery, London; see Davies 1961, 55–56; the painting is illustrated in Goffen 1989, 198 pl. 149.

22. For Annibale's painting *Venus Adorned by the Three Graces*, see Shapley 1973, fig. 132. Albani painted many versions of the theme, including works now in the Louvre and the Borghese Gallery. Clark (1959, 235) observes that Batoni borrowed the putto holding the basket of fruit directly from Albani.

23. Clark 1961, 56; Clark 1963, 8.

24. When the painting was reproduced on the cover of the November 24, 1917, issue of the *American Art News*, the leg was still visible. According to Mario Modestini, the Kress Foundation conservator, the leg had been overpainted by the time it was acquired by the foundation. Other overpainted areas that were uncovered during the recent conservation of the painting include a band of drapery across the stomach of the Ceres/Cybele figure and some additional paintbrushes held by one of the putti that had obscured the genitals of the putto behind him.

25. Benaglio (c. 1750–53, 62–63) noted that Foscarini was delighted with the painting.

26. Clark 1963, 11.

POMPEO GIROLAMO BATONI

Lucca 1708–1787 Rome

For many years the identity of the sitter for this striking portrait was unknown. In 1979 Francis Russell recognized that the young gentleman resembled William Fermor of Tusmore, Oxfordshire (1737–1806), whose portrait by Anton Raphael Mengs (1728–1779) had been acquired in 1978 by the Ashmolean Museum, Oxford (*fig. 1*).[1] From the published journals of Horace Walpole, a friend and neighbor of Fermor's mother, historians knew that Fermor had been portrayed by both Batoni and Mengs.[2] But not until the Mengs portrait appeared—inscribed "Wm. Fermor in a Masque dress. Anton Raphael Mengs pinxit Rome 1757."—was it possible to connect Fermor's name to one of the many canvases by Batoni whose subjects are still unidentified.

Batoni shows the young man—he was around twenty years old—in winter dress, wearing the luxurious fur-lined coat popular with many of the artist's British sitters,[3] including Lord Brudenell, who like Fermor sat for both Batoni (*fig. 2*) and Mengs. Although the

fig. 1 Anton Raphael Mengs. *William Fermor in a Masque Dress.* 1757. Oil on canvas, 24¼ x 18½ in. (61.5 x 47 cm). Ashmolean Museum, Oxford

fig. 2 Pompeo Batoni. *John, Lord Brudenell, later Marquess of Monthermer.* 1758. Oil on canvas, 38 x 28 in. (96.5 x 71.1 cm). The Duke of Buccleuch and Queensberry, Boughton House, Northamptonshire

painting of Fermor does not show the Colosseum, a fragment of ancient statuary, or a Roman vase (as many of Batoni's English sitters requested), Fermor is clearly presented as a *milord* on the Grand Tour, not in an imagined domestic environment but dressed as a traveler and occupied with his letters to or from home. True to form, Batoni pays particular attention to the surface textures of the sitter's costume, reveling in his talent for differentiating the smooth nap of velvet from the bristling pile of fur, the crisp folds in the paper from the pliant creases in the cuffs of the linen shirt.

46

William Fermor

1758
Oil on canvas, 39⅛ x 28¹⁵⁄₁₆ in.
(99.4 x 73.1 cm)
Inscribed on verso: *Pompeo Battoni Fecit 1758*
The Museum of Fine Arts, Houston 61.76

PROVENANCE

Baroness Donington (née Maud Kemble), London (d. 1947); her daughter, the Hon. Mrs. Irene Mary Egidia Emmott; sale, Christie's, London, April 2, 1948, lot no. 69, bought by Young; A. B. Ramsay, Cambridge; sale, Sotheby's, London, May 7, 1952, lot no. 111, bought by David M. Koetser; private collection, England; with David M. Koetser, New York; Samuel H. Kress Foundation, New York, 1953 (K1959); on loan to The Museum of Fine Arts, Houston, 1953–61; gift of the Kress Foundation to The Museum of Fine Arts, Houston, 1961.

SELECTED REFERENCES

Walpole 1762–80/1969, III, 52; Houston 1953, no. 29; Cappi Bentivegna 1964, 257 (Appendix, 61–62 no. 344); Shapley 1973, 120; Russell 1979, 16–17; Houston 1981, 75 no. 132; London 1982, 91; London 1984, under no. 27; Clark and Bowron 1985, 271 no. 205; Houston 1989, 19, 158–59.

BATONI, *William Fermor*

Few details are recorded of Fermor's life. He was the son of Lady Browne by her first husband, Henry Fermor (c. 1715–1747). He went on the Grand Tour around 1757–58, and we know that while in Rome he paid a visit to the painter Jonathan Skelton. "There has not been one English Person of Fortune to see my Performances, except a Mr. Fermor, who is on his way home," Skelton reported in late June 1758.[4] Skelton's visitors were few in number because he was widely rumored to be a Jacobite like his friend Andrew Lumisden, who served as under-secretary to James Edward Stuart, the Old Pretender, son of the deposed King James II.[5] Skelton, fearful for his reputation, mentioned Lord Brudenell as one of the noblemen who had put off visiting him upon hearing the tale that the artist was "disaffected" in his loyalties to the Crown. Fermor himself was a Roman Catholic, but there is no evidence that he had Jacobite sympathies; nonetheless it is interesting to speculate that the young man might have not have been squeamish about visiting a painter scorned by other Englishmen for his supposed support of a would-be Catholic king.

With his portraits by Batoni and Mengs, Fermor returned to England, where little else is heard of him. Twenty-five years later, he engaged in a curious correspondence with Walpole, antiquarian and author of the gothic romance *The Castle of Otranto*. In vivid detail, if at second hand, Fermor recounted to Walpole the discovery of the mummified corpse of Catherine Parr, Henry VIII's last wife.[6]

G.T.M.S.

1. See Russell 1979, 16–17.

2. Walpole 1762–80/1969, IV, 52: "Mr. Farmer, a Roman Catholic, son of Lady Brown, has his own portrait both by Mencks and Pompeio."

3. See Clark and Bowron 1985, nos. 203, 208, 211, 216. For Mengs's portrait of Brudenell, see Russell 1979, 11 fig. 3.

4. Skelton 1960, 47–48 nn. 3, 4. Skelton went on to mention the young man's aunt, "the famous Miss Isabella Fermor" (her name was in fact Arabella), the friend of Alexander Pope and the model for Belina in Pope's "Rape of the Lock."

5. See Skelton 1960, 41 n. 13, 47.

6. See Walpole 1980, vol. 42, 112–17.

GIOVANNI BATTISTA (Giambattista) TIEPOLO

Venice 1696–1770 Madrid

Baptized in Venice on April 16, 1696, Giovanni Battista Tiepolo, the son of a prosperous merchant family, would become the greatest Italian painter of the eighteenth century. Tiepolo initially trained with the Venetian Gregorio Lazzarini, a competent if uninspired late Baroque artist, whose stylistic influence on his pupil is nearly indiscernible. From these beginnings, however, Tiepolo maintained a lifelong commitment to the human form as the most expressive artistic vehicle. By 1717 his precocious genius had won him acceptance into the Fraglia, the painters' guild of Venice, as well as the early patronage of Doge Giovanni II Cornaro. Always receptive to the stylistic innovations of his contemporaries, the young artist explored the somber palette and mood of Giovanni Battista Piazzetta, who utilized a neo-Caravaggesque vocabulary. Tiepolo was intrigued by the effects of light; and although he would abandon tenebrist realism in his mature paintings, his fascination with the effects of light can be seen in the striking light/dark contrasts that are the hallmark of his celebrated drawings. Tiepolo, a masterful draftsman, manipulated both chalk and wash with unsurpassed skill and power, creating images of haunting beauty.

Also acknowledged as a superb colorist, Tiepolo adopted in his later paintings the more decorative palette of his contemporary Sebastiano Ricci (see cats. 37, 38), who had returned to Venice in 1717, and the sixteenth-century painter Paolo Veronese (see cat. 4). The blond tonality shared by these masters was not only well suited to the artistic preferences of the Rococo but was also a characteristic of the fresco medium, at which Tiepolo excelled. In addition to easel paintings and altarpieces, Tiepolo created numerous fresco decorations for both churches and secular buildings in Venice, the Veneto, and in many European cities. His most famous fresco cycle is in the Residenz at Würzburg, where Tiepolo and his sons, Giovanni Domenico (1727–1804) and Lorenzo (1736–before 1776), worked from 1750 to 1753 at the invitation of Prince-Bishop Karl Phillip von Greiffenklau. Returning to Venice, Tiepolo became president of the Venetian academy in 1755, before going to Madrid in 1762 to work for Charles III. Tiepolo died in Madrid in 1770, and with his death the great tradition of Venetian decorative painting came to an end.

Portrait of a Boy Holding a Book

c. 1745–50
Oil on canvas, 19 x 15⅜ in. (48.3 x 39.1 cm)
New Orleans Museum of Art 61.87

PROVENANCE
Viscount di Modrone, Milan; with Count Alessandro Contini-Bonacossi, Florence, before 1932; Samuel H. Kress Foundation, New York, 1932 (K232); gift of the Kress Foundation to the Isaac Delgado Museum of Art, later the New Orleans Museum of Art, 1953.

SELECTED REFERENCES
Washington 1941, 193 no. 221; New Orleans 1953/1966, 60, 62; Morassi 1962, 33; Pallucchini 1968, 111 no. 173; Shapley 1973, 142–43.

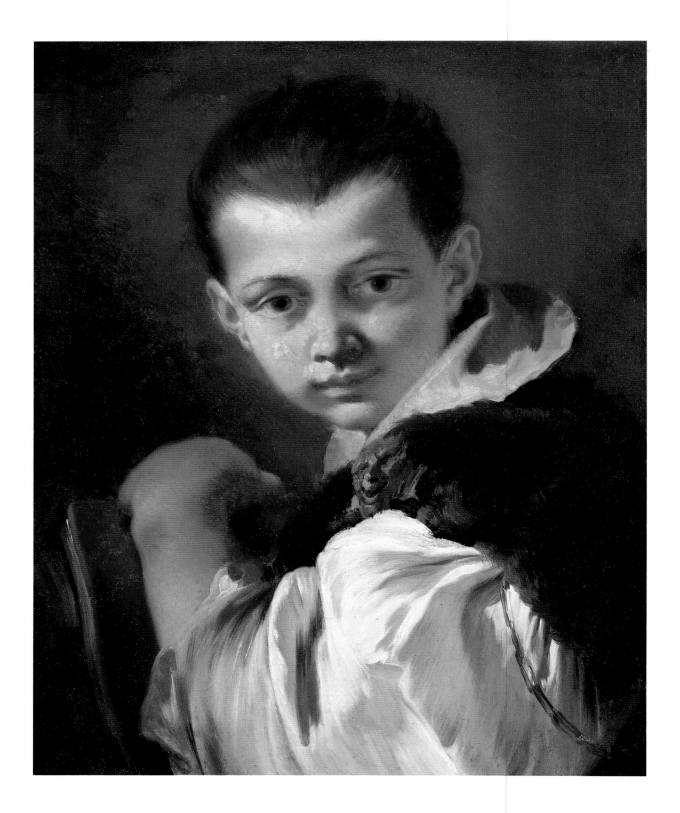

TIEPOLO, *Portrait of a Boy Holding a Book*

This painting catches Tiepolo in a delightful, lighthearted mood, a probable explanation for the popularity of the image, which was copied several times.[1] The engaging youthfulness of the sitter, combined with the informality of his pose, gives the work a simple direct appeal. Closer examination, however, reveals the artfulness with which the young subject has been posed. Although the boy's face is presented frontally, he seems just to have turned to look over his shoulder in order to establish eye contact with us. This implied movement is intensified by animated brushwork that gives the figure a windswept appearance.

fig. 1 Giovanni Battista Tiepolo. *A Portrait of Lorenzo Tiepolo.* c. 1747–50. Black and white chalk, 10¹³⁄₁₆ x 8 in. (274 x 202 mm). Fondation Custodia Institut Néerlandais, Paris, Collection Fritz Lugt

Typical of his style in the 1740s, Tiepolo uses a very painterly method of execution. Distinct parallel or radiating brushstrokes generally follow the contours, coloring and modeling the forms simultaneously. Added to this are flickering lighting effects that dance across details of costume and facial structure, accentuating the restlessness of drapery and figural outlines. The result is an image of uncompromising vitality.

The dating of this portrait has proven problematic because its informal approach, animated figural arrangement, and manner of execution are so strongly reminiscent of that of Piazzetta, whose influence is seen early in Tiepolo's career. It was not until the mid-1740s, however, that Giambattista began to explore the portrait medium with any consistency, following the visual vocabulary utilized by other eighteenth-century Venetian artists, such as Piazzetta, Rosalba Carriera, and Pietro Antonio Rotari. In addition to portraits of specific people, Giambattista and his sons also created *têtes de caractère*, fanciful portraits thought to have been inspired by a series of Rembrandt prints representing men in oriental costume. The New Orleans painting shares many compositional and stylistic traits with other accepted portraits by Tiepolo, including the *Young Man with a Sword* on the art market in 1990.[2] Both works exhibit an imaginative freshness of approach to the youthful subject and a vivacity of technique characteristic of Giambattista.

Assigning the New Orleans painting to the 1740s,[3] instead of around 1725–30 as alternatively suggested,[4] brings the *Portrait of a Boy Holding a Book* into juxtaposition with a series of drawings by Giambattista and Domenico portraying Domenico's younger brother Lorenzo. These sketches are thought to date circa 1747–50, when Lorenzo was between ten and thirteen. One of the most charming drawings from this group is a red chalk study (*fig. 1*) by Giambattista that formerly belonged to Fritz Lugt and now is in the collection of the Fondation Custodia, Paris.[5] Comparison of age, physiognomy, hairline, and the set of the ears suggests that the drawing and the New Orleans painting both represent the same captivating boy.

L.F.O.

1. For enumeration of the other versions, see Shapley 1973, 142.

2. Reproduced in New York 1990, 97 pl. 20.

3. See Washington 1941, 193; Morassi 1962, 33; and New York 1990, 96.

4. See New Orleans 1953/1966, 60, and Shapley 1973, 142.

5. Knox 1980, I, 230 no. M.166.

GIOVANNI BATTISTA (Giambattista) TIEPOLO

Venice 1696–1770 Madrid

The Empire of Flora

⎯⎯⎯⎯⎯

1743
Oil on canvas, 28¼ x 35 in. (71.8 x 89 cm)
The Fine Arts Museums of San Francisco
61.44.19

PROVENANCE
Graf Brühl, Dresden, 1744; Baron Karl Heinrich von
Heinecken, Dresden; his sale, Remy's, Paris, February 13–18,
1758; Baron de Beurnonville, Paris; his sale, Paris, May 9–16,
1881, lot no. 699; bought by M. George, Paris; Robert Lebel,
New York; Samuel H. Kress Foundation, New York, 1952
(K1890); on loan to the M. H. de Young Memorial Museum,
1955–61; gift of the Kress Foundation to the M. H. de Young
Memorial Museum, later The Fine Arts Museums of San
Francisco, 1961.

SELECTED EXHIBITIONS
Paris 1880, no. 168; Washington 1961–62, no. 93; Cedar
Rapids 1966–67; Tokyo 1992, no. 6; Fort Worth 1993, no. 28.

SELECTED REFERENCES
Molmenti 1909, 246–47, ed. 1911, 215–16; Sack 1910, 119,
218; Posse 1931, 49; Levey 1957, 89–91; Levey 1960, 250–53.;
Morassi 1962, 47; Pallucchini 1968, 109 no. 154; Thomas 1969,
40–42; Shapley 1973, 144–45; Washington 1975–76, 36;
Levey 1986, 128; Barcham 1992, 84 no. 19.

In July 1743 Count Francesco Algarotti (1712–1764), noted Venetian author and amateur, wrote from Venice to Graf Heinrich von Brühl in Dresden, describing two paintings that Algarotti had commissioned from Giovanni Battista Tiepolo.[1] With the gift of the *Empire of Flora* and its pendant, *Maecenas Presenting the Arts to Augustus* (*fig. 1*), Algarotti hoped to secure through Brühl, who was head of the government administration and artistic adviser to Augustus III, Elector of Saxony and King of Poland, appointment to the position of Superintendent of the Royal Buildings and Collections at the court of Dresden. All of Algarotti's learning and famed skill at flattery were brought to bear on the iconographic scheme of the two paintings, which celebrate the role of Count Brühl as patron of the arts on behalf of his sovereign.

At this time, Algarotti was in his native Venice as the envoy of Augustus III, seeking paintings to add to the royal collection in Dresden. In his copious writings, seventeen volumes of which were published in 1791,[2] Algarotti set forth his views on collecting and his assessments of the various artists with whom he had contact. He commended the art of Tiepolo, linking it stylistically with the work of traditional masters such as Veronese. But, more interestingly, Algarotti also compared Tiepolo with artists of the classical school, including Nicolas Poussin. From these comments we realize that Algarotti saw in Tiepolo's work history paintings cast delightfully in a decorative Rococo palette but possessing a monumentality and seriousness that could legitimately be likened to the works of the great classicist of the seventeenth century. In fact, Algarotti later prompted Tiepolo to borrow a figural element directly from Poussin for inclusion in the San Francisco painting.

Much has been written about this pair of pictures commissioned for Brühl, their style, how they augment and contrast with each other, and how they explicitly flatter Brühl and his role at Dresden's court. Although conceived as a pair,[3] stylistically the San Francisco and St. Petersburg paintings contrast markedly. The sensuality of the forms and colors in *Flora* is very different from the restrained and cerebral tone established in *Maecenas*, whose somber approach is in keeping with its relatively serious historical subject. In the company of the blind Homer and personifications of music, painting, sculpture, and architecture, the Roman Maecenas (70?–8 B.C.) is depicted counseling the ancient Emperor Augustus on artistic matters. Unrelenting in his flattery, Algarotti must have instructed Tiepolo to depict in the background of the Hermitage picture the facade of Brühl's palace on the Augustusstrasse, whose gardens overlooked the river Elbe. The parallel is explicitly drawn: Count Brühl is the modern Maecenas, giving sage counsel to the modern Augustus.[4]

In contrast, the San Francisco *Empire of Flora* is a delightful Rococo invention, featuring verdant perfumed gardens, fluttering *amorini*, and luscious blond female nudes surrounded by colorful taffetas. Algarotti's hand is seen in the interpretive program through which, like its pendant, the *Flora* pays homage to Brühl with specific references to his patronage of the arts. For example, the fountain seen beyond the walls of the garden records the *Neptune* group created by Lorenzo Mattielli for the gardens of the Marcolini Palace, where Brühl resided.[5]

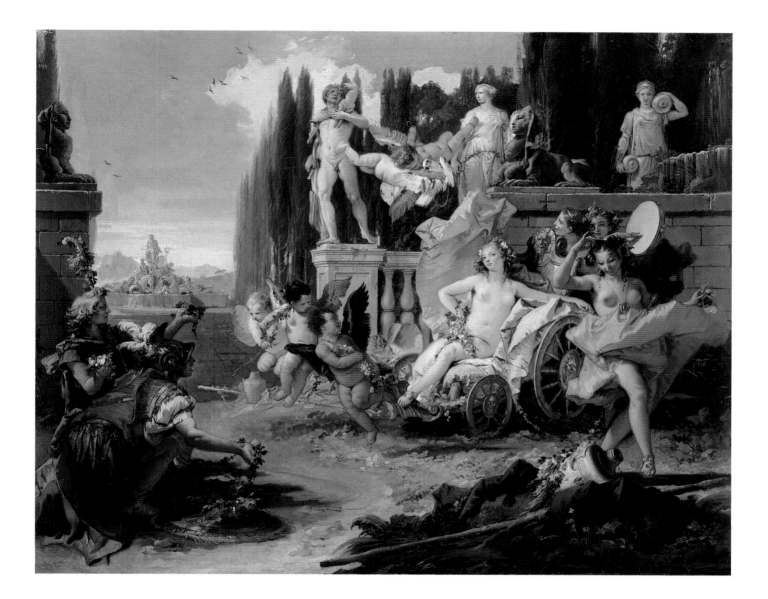

TIEPOLO, *The Empire of Flora*

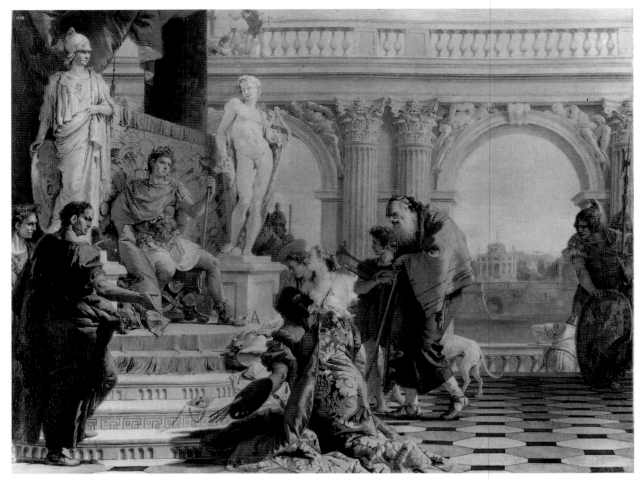

fig. 1 Giovanni Battista Tiepolo. *Maecenas Presenting the Arts to the Emperor Augustus*. 1743. Oil on canvas, 27⅜ x 35 in. (69.5 x 89 cm). Hermitage, St. Petersburg

Recent scholarship on the *Empire of Flora* has focused on identifying the specific subject Algarotti and Tiepolo wished to portray. In his letter of 1743, Algarotti describes the San Francisco painting as depicting "l'empire de Flore qui change en endroits delicieux les lieux le [*sic*] plus sauvages."[6] The painting has been interpreted as representing a *Triumph of Flora*, a reading perpetuated in Giacomo Leonardis's 1766 engraving of the work. There, the inscription reads, "Mentre la Dea de fiori in Cocchio gira / Ride la terra, e dolce l'aria spira. . . ."[7] The triumphal procession of Flora traditionally includes a frolicking entourage led by Venus, followed by Flora in a chariot drawn by putti, seemingly all of the components found in the San Francisco painting. However, Barcham has suggested that to interpret the scene simply as a celebration of Flora is to identify the cast of players incorrectly.[8] He proposes instead that the imagery of the painting is based on a famous literary source. In Barcham's interpretation, Flora is not the figure in the chariot but rather the dancing female on the far right of the composition. The pictorial model for this figure is the cen-

tral figure in Poussin's *Empire of Flora*, which belonged to Augustus III and would have been known to Algarotti from his stay in Dresden in 1742–43. Who, then, is the seductive creature in the chariot? Her identity as the enchantress Armida becomes plausible if the two male figures in the lower left corner of the composition are recognized as characters from Torquato Tasso's sixteenth-century epic tale of the Crusades, *Gerusalemme liberata* (see cats. 5, 32).

This suggestion promotes a completely new reading of the San Francisco painting. Barcham argues that the two young men, identified by their traditional attributes of rod and shield, are Carlo and Ubaldo, companions of the Christian knight Rinaldo, who was bewitched by the sorceress Armida, the niece of the leader of the Saracen army. Magically armed against the treacheries of Armida, Rinaldo's two companions make their way up the slopes of the Fortunate Isle to reach the plateau that she has cultivated as an enchanted garden. And indeed, the artist seems to give visual form to Tasso's description of Armida's lush and magical

domain, where in perpetual spring "it seems that the waters and the earth conceive and breathe love's sweetest sighs and sensibilities" (Canto XVI:16).

The idea of interpreting the San Francisco work as a depiction of the garden of Armida is seductive; the painting's lush imagery seems evocative of Tasso's florid poetry. Many correlations do exist between the basic compositional arrangement and specific pictorial motifs in this painting and Tiepolo's numerous depictions of the story of Rinaldo and Armida. In the Chicago *Rinaldo and Armida in Her Garden* (*fig. 2*),[9] for example, we encounter similar renderings of Armida's precinct, verdant and enclosed by a wall; Rinaldo joined by his comrades, Carlo and Ubaldo; and Armida herself set off from the background by a billowing swathe of cantaloupe-colored material. Nonetheless, it must be noted that the particular assemblage of characters in the San Francisco picture does not correspond with any specific moment in Tasso's narrative.[10] Either the *Empire of Flora* is meant as an elaboration of Tasso's tale, or Tiepolo simply recast his players for new roles in the Brühl painting.

Brown has convincingly reasserted the traditional reading of the San Francisco painting as celebrating Flora and the transforming powers of nature.[11] Levey's discussion of the *Empire of Flora* and of Domenico's parody on the picture, *Punchinellos Take Part in a "Triumph of Flora,"* forms the basis of this evaluation.[12] Brown also reminds us that in the inventory of Algarotti's collection the sketch after the Brühl painting is listed as "il Trionfo di Flora," the triumph of Flora. And as Tiepolo adapted an existing composition for the Brühl *Maecenas Presenting the Arts to the Emperor Augustus*,[13] so he reused his Tasso imagery for the *Empire of Flora*.

fig. 3 Giovanni Battista Tiepolo. *Head of a Young Woman* (possibly Anna Maria Tiepolo). c. 1742. Black chalk on white paper, 4⅝ x 3³⁄₁₆ in. (118 x 81 mm). Gabinetto Disegni e Stampe, Galleria degli Uffizi, Florence

No preparatory drawings for the *Empire of Flora* have been identified. However, a nearly contemporary drawing by Tiepolo (*fig. 3*), now in the Uffizi, captures the same expression and tilt of the head (although reversed) of the female figure in the chariot. Thought to portray the artist's daughter Anna Maria Tiepolo, this drawing has been related to his many renderings of Armida, but its compelling resemblance to the facial features and hauteur of the figure in the San Francisco painting has not been noted previously.

Scholars will continue to debate the subject of Tiepolo's famed *Empire of Flora*. Whatever their conclusions, one certainty is that the lusciousness of Tiepolo's palette and the sensuality of the figural forms combine in this work to create an enchanting statement of Rococo sensibility.

L.F.O.

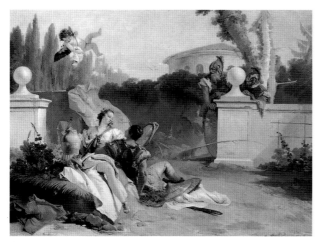

fig. 2 Giovanni Battista Tiepolo. *Rinaldo and Armida in Her Garden.* 1742. Oil on canvas, 73 x 102⅛ in. (186.9 x 259.5 cm). The Art Institute of Chicago, James Deering Bequest 1925.699

1. The letter is reprinted in Posse 1931, 48–49.

2. For a summary of the literature on Algarotti, see Haskell 1963/1980, 347 n. 1.

3. It should be noted that the two paintings bear sequential inventory numbers (*Maecenas*: "1192" and *Flora*: "1193") written in white paint along the upper left edge of the canvas. Their joint history ended when both paintings left the Brühl collection; the *Flora* entered the collection of Brühl's secretary Baron Karl Heinrich von Heinecken, the *Maecenas* was later purchased from the Brühl estate by Catherine II. On the provenance of the *Maecenas*, see Washington 1975–76, no. 6.

4. For a discussion of the flowering of Dresden as an artistic center at the time of Augustus III, see *Barock und Klassik: Kunstzentren des 18. Jahrhunderts in der Deutschen Demokratischen Republik*, Schloss Schallaburg, 1984.

5. This sculptural group still stands in modern-day Dresden, on the grounds of a hospital. Famous at the time of its completion, the fountain's central group was reproduced as a table ornament at Meissen in 1745.

6. Posse 1931, 49. "The empire of Flora, who transforms the wildest places into the most delightful scenes."

7. Frongia 1971, 221–28; Gorizia 1983, no. 237. "While the goddess of flowers rides in her chariot / the earth smiles and the breeze stirs softly." The inscription goes on: "Originale posseduto dal Sig.ʳ Co: Algarotti in Ven.ᵃ." Leonardis's engravings of the Brühl *Maecenas* and *Flora* were based on sketches that Algarotti owned; also executed by the Tiepolo, these were *ricordi* of the paintings, i.e., records of the compositions, not preparatory studies for them.

8. Barcham 1992, 84.

9. Completed by 1742, this work was part of Tiepolo's suite of paintings designed for the Tasso room in the Palazzo Dolfin-Manin in Venice. Principal components now belong to The Art Institute of Chicago, and the National Gallery, London; see Thomas 1969, 28ff., and Knox 1978, 52ff.

10. The San Francisco painting departs from other artistic renderings of the tale of Rinaldo and Armida in narrative details as well. For example, although Tasso writes of Armida, "Her breasts were naked, for the day was hot" (Canto XVI:18), traditionally she is not depicted nude as is the figure in the chariot. In addition, in no other representations of the tale do Carlo and Ubaldo appear without their helmets, protection they would hardly put aside once in the presence of the sorceress herself. Rinaldo, however, is frequently presented without his helmet, suggesting the power of enchanted love over his sense of military duty.

11. I am extremely grateful to Beverly Brown for sharing with me the manuscript for her entry on the San Francisco painting for the catalogue of the exhibition "Giambattista Tiepolo: Master of the Oil Sketch." Her observations prompted me to redefine my own thoughts on the composition.

12. Levey 1957, 89–91, and Levey 1960, 250–53. On the Punchinello drawing, now in the Heinemann collection, New York, see Gealt 1986, 180 no. 79.

13. On the sources for the *Maecenas* composition, see Brown in Fort Worth 1993, no. 27.

ALESSANDRO MAGNASCO, called Il Lissandrino

Genoa 1667–1749 Genoa

A painter of exceptional originality and inventiveness, Magnasco, whose nickname means "little Alessandro," was born on March 4, 1667. He was the son of Stefano Magnasco, a competent painter whose career was prematurely ended by his death in 1672, when Alessandro was five.[1] Shortly after his father's death, Magnasco was entrusted to the care of a Genoese merchant who took him to Milan where, in about 1680, he entered the studio of Filippo Abbiati.[2] Abbiati was prominent in Milanese artistic circles, and through his long apprenticeship Magnasco absorbed the cultural and artistic ambience of late-seventeenth-century Lombardy. The mystical and theatrical impulses of that region underpin his mature oeuvre, while the strong chiaroscuro and dark emotionalism of his early works reveal his dependence on Abbiati and Lombard Baroque painters such as Francesco del Cairo and Morazzone.

An eighteenth-century biographer wrote that Magnasco began his career as a portraitist but soon abandoned this aspect of his profession and established himself in Milan as a painter of staffage, executing the figures for various landscape specialists. Through this activity he developed the pictorial vocabulary that furnished many of the figural types—monks and nuns, picturesque wayfarers, musicians, soldiers, and low-life characters—that he was to use throughout his long and prolific career.

Magnasco's collaborative activity continued into the first decade of the eighteenth century, when he worked in Florence, at the court of the Grand Duke of Tuscany, Cosimo de' Medici. Through the Medici collections he would have encountered the moody, romantic landscapes of Salvator Rosa and the genre scenes of Jacques Callot and Giuseppe Maria Crespi, models that exerted a significant influence on Magnasco's subsequent works. Through Callot's etchings, and perhaps through actual performances at the Medici court, Magnasco would have been exposed to the Commedia dell'arte (see cat. 36). This theatrical genre provided him with a rich source of pictorial material that found expression in works like the two Kress paintings discussed below. It was also at the Medici court that Magnasco met and collaborated with Marco and Sebastiano Ricci (see cats. 37, 38), upon whom he exerted a formative influence.[3]

49

The Supper of Pulcinella and Colombina

c. 1725–45
Oil on canvas, 30¾ x 41⅜ in.
(78.1 x 105.1 cm)
North Carolina Museum of Art, Raleigh
60.17.56

50

Pulcinella Singing to His Many Children

c. 1725–45
Oil on canvas, 30 x 41 in. (76.2 x 104.1 cm)
Columbia Museum of Art, South Carolina
1954.42

PROVENANCE
Private collection, Germany; with David M. Koetser, New York; purchased in England by the Samuel H. Kress Foundation, New York, 1953 (K1952, *Pulcinella Singing*, and K1953, *Supper of Pulcinella*); gift of the Kress Foundation to the Columbia Museum of Art, 1954 (*Pulcinella Singing*); gift of the Kress Foundation to the North Carolina Museum of Art, 1960 (*Supper of Pulcinella*).

SELECTED EXHIBITIONS
Washington 1961–62, no. 58 (*Pulcinella Singing* only); Louisville 1967, nos. 27, 28; Louisville 1990, 12–13 no. 28 (*Supper of Pulcinella* only).

SELECTED REFERENCES
Columbia 1954, 55–56, 1962 ed., 113–14; Raleigh 1960, 112–13; Seymour 1961, 161 pl. 154 (*Pulcinella Singing*); Franchini Guelfi 1971, 375–76, 384, ed. 1987, 334–35, 344 (*Supper of Pulcinella*); Shapley 1973, 110; Franchini Guelfi 1977/ 1991, 162; Naples 1982, 33; Naples 1990–91, 210 no. 4.2.

MAGNASCO, *The Supper of Pulcinella and Colombina*

MAGNASCO, *Pulcinella Singing to His Many Children*

By the time of his return to Milan about 1709 Magnasco had fully developed his idiosyncratic style of painting, distinguished by a highly imaginative approach to a wide range of subjects and by an extraordinarily vigorous handling of paint applied with a heavily loaded brush. His phantasmagoric martyrdoms, tribunals, allegories, monastic subjects, genre scenes, and tempestuous landscapes populated with ghostlike monks and cavaliers and grotesque lowlifes won him great renown and the patronage of the cultural elite. Magnasco's mature works reflect many influences, but they are subsumed into his own highly independent, even eccentric style.[4] In 1735, he returned to his native Genoa, where his works were less appreciated. His output gradually waned, owing to his age and declining health. He died in Genoa on March 12, 1749.

Soon after his death Magnasco fell into critical oblivion, ignored even by the Romantics of the nineteenth century. He had no pupils and only a few isolated imitators. Though prodigious, his artistic output is poorly documented, and only a handful of his works are dated. Following a pattern similar to that of El Greco (see cat. 9) and Antonio Guardi (see cat. 39), his rediscovery began only in the first half of the twentieth century, when a few connoisseurs began collecting, writing about, and exhibiting his works.[5] Influenced by the Expressionist spirit of the period, these individuals recognized in Magnasco's art some precedents of the romantic pessimism of the art and culture of their time. This romantic interpretation, which greatly hindered a clear and objective understanding of the artist and his work, persisted until the 1970s, when Franchini Guelfi published several studies on the artist.[6] Nevertheless, in many respects Magnasco remains an enigma, and numerous aspects of his life and oeuvre are in need of further study.

The Columbia and Raleigh canvases originally were painted as pendants and are here reunited for the first time since 1967.[7] They depict characters derived from the *Commedia dell'arte*, a theatrical genre originating in mid-sixteenth-century Italy that had its roots in ancient Roman comedies and gradually evolved through Italian folklore and carnival plays.[8] From the beginnings of the *commedia* until its gradual decline in the late eighteenth century, troupes of stock characters delighted audiences all over Europe. They presented highly improvisational performances intended to illustrate the entire range of human weaknesses and the wide gulf that exists between conceited pretense and humiliating reality. The characters portrayed in *Commedia dell'arte* performances usually included the young lovers (*amorosi*) and impoverished servants (*zanni*), such as the simple-clever Arlecchino (Harlequin), the loyal, naive Colombina (Columbine), Pedrolino (Pierrot),

fig. 1 Jacques Callot. *Frontispiece for "Balli di Sfessania."* c. 1622. Etching and engraving, 2⅞ x 3⅔ in. (72 x 93 mm). National Gallery of Art, Washington, Rosenwald Collection B-13,840

fig. 2 Alessandro Magnasco. *Pulcinella Playing the Guitar.* c. 1715–20. Oil on canvas, 13⅛ x 11⅛ in. (33.3 x 28.3 cm). Private collection

and the vulgar Neapolitan Pulcinella (Polichinelle or Punch). Other stock figures included two old men (*vecchi*), one of whom was usually the miserly and jealous Venetian merchant Pantalone, and the nonsensically erudite Bolognese doctor/lawyer. Another character was the swaggering but cowardly Capitano Spavento who, over time, evolved into the more ebullient Scaramuzza or Scaramouche. The *Commedia dell'arte* furnished a rich source of material for artists from the seventeenth-century French printmaker Jacques Callot (*fig. 1*) to Picasso in his Rose period and Cubist works of the early twentieth century, long after the *Commedia*'s theatrical popularity had declined.[9]

It was in the eighteenth century, however, that the *Commedia dell'arte* received its richest and most eloquent expression in the visual arts by artists such as Magnasco, Antoine Watteau (see cat. 36), and Giovanni Battista Tiepolo (see cats. 47, 48) and his son Domenico. Whereas earlier artists tended to depict episodes from actual performances or *commedia* characters, eighteenth-century artists took these characters off the stage and gave them lives of their own. Watteau and Magnasco were among the first to do so. The Frenchman liberated his *comédie-italienne* figures from their theatrical personas (although his presentation of them is often distinctly theatrical) and concentrated on varied, often poignant emotional states of the persons behind the masks.

Rooted in the coarser vein of northern Italian genre painting, Magnasco took a more down-to-earth approach to his *commedia* subjects. His figures are more direct extensions of their vulgar and caricature-like on-stage personas. He first seems to have depicted *Commedia dell'arte* characters in a series of small compositions that portrayed them at home eating, dancing, or playing music with their children (*pulcinellini*).[10] At some later time, perhaps at the request of a patron, Magnasco used two of these compositions (*figs. 2, 3*) as starting points for the far more elaborate pair of paintings exhibited here. In the latter, Magnasco greatly increased the number of figures and placed them in more extensive, albeit dilapidated, architectural settings that call to mind his religious interiors.

At the center of both the Columbia and Raleigh compositions is the vulgar Pulcinella, the gluttonous, hunchbacked and hook-nosed Neapolitan servant. His prodigious appetite—the butt of many *commedia* vignettes and a popular subject in eighteenth-century art—is alluded to by the numerous steaming pots and huge bowls of food near him in both paintings. In the Raleigh picture, he contemplates the next bite of his meal (eels?), which will quickly find its way into his greedy maw.[11] In the painting from Columbia he is seated in a chair, singing to the accompaniment of cittern-playing *pulcinellini*; other *pulcinellini* (and their cats) sing along or go about everyday pursuits. In the

fig. 3 Alessandro Magnasco. *Pulcinella Eating.* c. 1715–20. Oil on canvas, 13⅛ x 11⅛ in. (33.3 x 28.3 cm). Private collection

Raleigh composition the activities are more varied. Pulcinella's gluttonous predilections have clearly been passed along to his offspring, two of whom stare longingly into their empty bowls. Other *pulcinellini* are depicted playing a guitar, tending the fire, eating, and sitting in bed. On the right, Colombina pulls strands of wool from a distaff.

Magnasco opens up diagonal paths into the center of the two compositions by closing off the edges of the foreground with a few objects. The figures are carefully disposed in both compositions, their placement within the settings defined through Magnasco's handling of light and color, which grow progressively dimmer from the foreground into the background. The artist achieves a subtle chromatic harmony within a very limited palette of browns and grays, enlivened by his vigorous, painterly brushwork and the thick smears of impasto (especially prominent in the foreground) that he uses to indicate foodstuffs, the ruffs of the collars, and highlights on various surfaces. The restricted chromatic range also underscores the impoverished circumstances of the figures, as does the ramshackle condition of their surroundings. The confident handling and the compositional sophistication that distinguish the works indicate that they are products of Magnasco's mature career. Thus they should be dated about 1725–45, that is, to the latter part of his Milanese period or the early part of his second Genoese period, before his deteriorating health led to a decline in his artistic powers.[12]

D.S.

1. For Stefano Magnasco, who was the pupil of the Genoese painter Valerio Castello, see Soprani and Ratti 1768–69, I, 349–50; and Frankfurt 1992, 616.

2. The most important contemporary account of Magnasco's life is Carlo Giuseppe Ratti's biography, first published in 1768–69 (Soprani and Ratti 1768–69, II, 155–62); an English translation of Ratti's vita appears in Louisville 1967. The most comprehensive recent studies on the artist are Benno Geiger's monographs, published in 1914, 1923, and 1949, and a series of works by Faustiana Franchini Guelfi, the most important of which were first published in 1971 and 1977, and reprinted in 1987 and 1991.

3. For Magnasco's collaboration with and influence upon the Ricci, see Chiarini 1971, and Pilo 1976, 42.

4. Ratti alludes to Magnasco's brief sojourns in Bologna, Turin, and Venice in the 1762 manuscript (*Storia de' pittori, Scultóri, et architetti liguri e de forestieri che in Genova operano scritta da' Giuseppe Ratti savonese in Genova MDCCLXII*, ms. 44, Archivio Storico del Comuné, Genoa) that formed the basis for his vita published in Soprani and Ratti 1768–69.

5. Geiger 1914/1949; Delogu 1931; Geiger 1945; Pospisil 1944; Genoa 1949. During the same period Magnasco's art was brought to the attention of the American public by two exhibitions devoted to the artist, one held at the Springfield Museum of Fine Arts in 1938, the other organized by the firm of Durlacher Brothers in New York in 1940. A brief survey of the critical literature on Magnasco is found in Franchini Guelfi 1971/1987, 344–45.

6. Franchini Guelfi 1971/1987; Franchini Guelfi 1977/1991.

7. Both works were originally oval, but they were subsequently altered to a rectangular format through the addition of corners; these additions appear to be of considerable age.

8. The best English-language surveys of the *Commedia dell'arte* are: Heinz Kindermann, "Commedia dell' Arte," in *Encyclopedia Britannica. Macropaedia*, 15th ed. (1974), 4, 979–87; Lea 1934/1962; and Smith 1912/1964.

9. A survey of artists' depictions of *Commedia dell'arte* subjects over the last four centuries appears in Louisville 1990; also see Naples 1990–91. For Callot's *commedia*-inspired works, see Washington 1975, 67–69, 74–77, 104–5, 120–29.

10. Illustrated in Geiger 1914/1949, pls. 178–85; and Naples 1990–91, 210–11. Franchini Guelfi (1977/1991, 162) dates the series to circa 1715–20.

11. Pulcinella's meal appears to consist of the same food that fills the plate of the corpulent gypsy in Ribera's *The Sense of Taste* in the Wadsworth Atheneum in Hartford (Hartford 1991, 320–23). Felton identifies the food as "eels or squid"; the former would seem to be the more probable.

12. Suida (in Columbia 1954/1962, 55) dates the two canvases toward the end of his second Milanese period, about 1735. Franchini Guelfi (1971/1987, 343–44) dates them somewhat later, circa 1731–45, among his "most mature" works.

GIACOMO ANTONIO MELCHIORRE CERUTI

Milan 1698–1767 Milan

Perhaps owing to Ceruti's peripatetic life-style, there are no contemporary or early accounts of his life and work, and even the place and dates of his birth (October 13, 1698) and death (August 28, 1767) were not published until 1982.[2] The details of his personal life that have come to light are quite remarkable, for from the mid-1730s until his death he simultaneously maintained two separate families. In 1717 he was married to Angiola Carozza in Milan. She was some ten years his senior and bore him several children, only one of whom survived infancy, and it was to her that the artist left his few possessions. A document of 1736 records a payment to Ceruti's "consort," Matilde de' Angelis, with whom he had four children and who, like Angiola Carozza, is recorded as living with him over the next several years.[3]

Nothing is known of Ceruti's training as an artist. In 1721 he was described as a "Milanese painter" living in Brescia, where he seems to have worked primarily as a portraitist.[4] His unpretentious, straightforward likenesses fit very well within the traditional Lombard approach to portraiture.[5] At some point, probably during the late 1720s, he began painting the life-size "portraits" of the poor, called pitocchi *(beggars), for which he is best known and which earned him the nickname "Il Pitochetto." During the seventeenth and early eighteenth centuries northern Italian artists did depict the impoverished lower classes, but their representations border on caricature, governed as they were by convention that viewed the poor as objects of satire or sentimentality. This patronizing attitude is absent from Ceruti's dignified portrayals of the poor, which are unidealized and sympathetic and are among the most original and perplexing works of the period.[6]*

By 1734 Ceruti was executing commissions outside of Brescia, and two years later he moved to Venice. There he painted pitocchi, still lifes, *portraits, and animal subjects for the formidable collector Field Marshal Johann Matthias von Schulenburg, who was also the patron of Antonio Guardi (see cat. 39).[7] Ceruti's exposure to contemporary Venetian painting and to the sophisticated Venetian clientele significantly influenced his stylistic development. His palette became noticeably brighter and more varied, his compositions more ambitious, his sitters more aristocratic. The figures in his post-Venetian works seem less beleaguered and impoverished and more content, even happy with their lot in life.*

51

The Card Game

⟶⬧⟵

c. 1738–50
Oil on canvas, 28½ x 40¾ in.
(72.4 x 103.5 cm)
North Carolina Museum of Art, Raleigh
60.17.55

PROVENANCE
Private collection, London(?);[1] with Arcade Gallery, London, 1955; with David M. Koetser, New York; Samuel H. Kress Foundation, New York, 1957 (K2182); gift of the Kress Foundation to the North Carolina Museum of Art, 1960.

SELECTED EXHIBITIONS
Fort Worth 1986, 210 no. 47; Brescia 1987, 187 no. 67.

SELECTED REFERENCES
Raleigh 1960, 112–13; Morassi 1967, 360, 365, fig. 25; Boschetto 1968, 62 n. 6 (doubting the attribution to Ceruti); Shapley 1973, 108 fig. 202; Gregori 1982, 80, 459 no. 166.

CERUTI, *The Card Game*

By 1744 the artist was living in Piacenza. A census document of 1745 records Ceruti as living in a house with Matilde and their two children, while a similar document from the following year records his residence in the same house, but with only his other wife, Angiola.[8] In 1762, and again in 1765, Ceruti made out his will in Milan.[9] The last documented work by the artist is a small portrait on copper, dated June 1767, two months before his death in Milan from a fever on August 28. Angiola Carozza and Matilde de' Angelis both died in Milan the following year; each is described in official death records as the "wife" of the late Giacomo Ceruti.[10]

Following his death Ceruti disappeared into a critical oblivion that lasted nearly two hundred years. A 1982 catalogue raisonné of his work provides an essential scholarly foundation. However, many important aspects of Ceruti's career and oeuvre—for example, his artistic training, his patrons, the artistic and literary influences behind his unprecedented depictions of the poor, the attribution and dating of many key paintings, and his influence on later (particularly nineteenth-century) artists—are in need of further study.[11]

The Raleigh painting depicts what must have been a common scene in the eighteenth century: a group of servants relaxing on a Sunday afternoon, some playing cards, some drinking wine, others simply daydreaming. Yet the subject is unique in Ceruti's oeuvre, and as a working-class conversation piece depicting neither aristocrats nor peasants but a sector of society between these two classes, it is extremely uncommon, if not unprecedented, in the history of art.[12] Scenes representing the nobility or their counterparts at leisure were a staple of seventeenth- and eighteenth-century artists throughout Europe. Pietro Longhi painted these kinds of works in Venice beginning in the early 1740s, and Ceruti may have had them in mind when he painted this picture.[13] Aristocratic conversation pieces were also popular subjects for Ceruti's Neapolitan contemporaries, such as Gaspare Traversi (see cat. 52) or Giuseppe Bonito, and it is worth noting that when the Raleigh painting first appeared on the market it bore an attribution to the "Neapolitan school." Genre scenes of the leisurely activities of the poor also were often-depicted subjects for artists—Ceruti himself painted a number of pictures of beggar boys playing cards—but these works depict an entirely different stratum of society than the working class portrayed in *The Card Game*.[14] Ceruti's painting is devoid of the artificial informality that characterizes many eighteenth-century traditional conversation pieces, and the artist also avoids the type of broad caricature and lowbrow humor typical of most seventeenth- and eighteenth-century lower-class genre paintings.

fig. 1 Giacomo Ceruti. *The Card Game* (X-radiograph detail of cat. 51)

Gregori has dated the painting to the 1740s, which seems logical in terms of its style, technical competency, and the relative sophistication of the composition, although it is possible that the work may date from the end of the 1730s.

The restrained, lighter tonality reflects the influence of Venetian eighteenth-century painting, particularly the works of Ricci (see cats. 37, 38) and Longhi, which Ceruti would have seen in the late 1730s. Ceruti's expressive, yet natural characterizations of the figures, the still life in the left foreground, and even his remarkably sensitive rendering of the two dogs represent a compendium of the kinds of works the artist was painting for his Venetian patron von Schulenburg in the late 1730s.[15] The confident brushwork and the relative complexity of the composition also indicate that the work dates from this period. With the exception of a few notably awkward religious compositions, multifigured scenes are rarely found in Ceruti's pre-Venetian oeuvre, and the natural, skillful manner in which the figures are posed and integrated into the composition suggests that the artist was at ease with this type of group subject.

X-radiographs of the painting reveal that Ceruti made significant changes in the right side of the composition (fig. 1),[16] where the artist had initially painted the figure of a woman caressing the head of the seated servant with her left hand and holding what appears to be a fan in her right hand. He eventually painted out this figure and instead substituted the little girl and the woman bending over the wicker crib. Ceruti also had originally painted a dog resting its front paws on the knees of the seated servant but ultimately decided to eliminate this vignette from the composition.

D.S.

1. Archival records of the Arcade Gallery, examined by Alex Wengraf, indicate that the painting was purchased by Paul Wengraf for the Arcade Gallery on February 8, 1955, from "Bruneman" or "Bieneman" (the handwriting of the document is not completely decipherable).

The "private collection, London" that Shapley (1973, 108) lists in the provenance of the Kress catalogue entry is probably based on a misunderstanding. She cites as her source for this information Morassi's 1967 article (360), which stated that Morassi had identified the work "una decina fa in una collezione privata di Londra" (a decade ago in a London private collection). In a letter of September 18, 1968, now in the North Carolina Museum of Art's files, Morassi wrote that he had seen the painting for the first time "about 1955(?)" at the Arcade Gallery in London, where it was attributed to the Neapolitan school, and that it was he who first suggested the attribution to Ceruti. In a letter to Paul Wengraf, dated March 5, 1955 (also in the North Carolina Museum's files), Herman Voss enthusiastically endorsed the attribution to Ceruti.

2. Prior to the discovery of Ceruti's baptismal record, scholars had hypothesized that the artist had been born in Brescia, Milan, or Piacenza, and that he might have died in any of those cities, or possibly in Dresden. Gregori (1982, 99–111) brought together and published (many for the first time) all of the archival documentation on Ceruti available at the time; the document giving the location and date of his birth and baptism is transcribed on p. 105. References to these documents and other newly discovered archival material were published by Vittorio Capara in Brescia 1987, 202–13. The most up-to-date biography of the artist appears in Renata Stradiotti's essay "Nato milanese, ma bresciano d'adozione. Nota biografica di Giacomo Ceruti," in Brescia 1987, 196–201.

3. The archival material that records Ceruti's marriage and documents his unusual living arrangements is published in Gregori 1982, 99–111, and in Capara's *Regesti* in Brescia 1987, 196–201.

4. The earliest documented work by Ceruti is a portrait signed and dated July 7, 1724 (Gregori 1982, no. and pl. 9). The portraits assigned to the 1620s indicate that Ceruti's Brescian clientele at this time was composed, almost exclusively, of the aristocracy, clerics, and nuns (who were probably the daughters of his aristocratic patrons); see Gregori 1982, nos. and pls. 1–26.

5. Ceruti's portraits were located squarely within the context of the Lombard tradition by Roberto Longhi in his introduction to the catalogue of the exhibition "I Pittori della Realità in Lombardia" (Milan 1953, i–xix). This exhibition represented a turning point in the rediscovery of Ceruti. Within Ceruti's own time, the closest parallels are found in the works of Giuseppe Ghislandi, called Fra Galgario (1655–1743), from Bergamo; see Testori 1954.

6. Some of the possible precedents for Ceruti's *pitocchi*—the works of the Le Nain brothers, Jacques Callot (whose prints Ceruti must have known), Antonio Cifrondi, Giacomo Cipper (Il Todeschini), and Giuseppe Maria Crespi—are discussed in Gregori's substantive introductory essay to her 1982 catalogue raisonné (29–99). Gregori also quite rightly stressed the fundamental differences between these precedents and Ceruti's portrayals of the poor. The essays by Mira Pajes Merriman ("Comedy, Reality, and the Development of Genre Painting in Italy") and Giovanna Perini ("Genre Painting in Eighteenth-Century North Italian Art Collections and Art Literature"), in Fort Worth 1986, 66–73, 80–85, and Bruno Passamani's essay ("Brescia e Ceruti: patrizi, popolo, pitocchi. Alla ricerca di 'fatti certi' e di 'persone vive'") in Brescia 1987, 11–28, explore some possible origins of and the sociological context for Ceruti's *pitocchi*.

7. For von Schulenburg's activity as a collector see Binion 1970; Binion 1976, 89–93; and Haskell 1963/1980, 310–15. Excerpts listing Ceruti's paintings from von Schulenburg's inventories are published in Gregori 1982, 117–19.

8. Gregori 1982, 112–13; Capara, in Brescia 1987, 205.

9. Ceruti's 1762 will was published by Gregori (1982, 114–15); Capara (in Brescia 1987, 205–7) published the artist's second will. Neither will mentions Matilde de' Angelis nor Ceruti's surviving offspring by her.

10. For the portrait see Gregori 1982, no. and pl. 259, and fig. 1. The *atto di morte* of Ceruti and his two wives are published in Gregori 1982, 116.

11. Gregori 1982.

12. The only other remotely comparable work in Ceruti's oeuvre depicts a man playing a stringed instrument for his wife and daughter (Gregori 1982, no. and pl. 82); the composition may derive from a seventeenth-century Dutch or Flemish painting or print.

The term "conversation piece" is used here in its broadest sense, as defined by Mario Praz in his monographic study on the subject (1971, 33–35). In *The Card Game* the defining line between conversation piece and genre painting is a fine one, having to do with the social class being portrayed and the fact that Ceruti's painting borrows more from the

stylistic conventions of the conversation piece than from genre paintings. Praz does not mention or illustrate any work that depicts the class of people shown in Ceruti's *Card Game*. Ceruti also painted a few works (Gregori 1982, nos. and pls. 73, 180, 193, 209) representing the aristocracy at leisure that more closely approximate the traditional conversation piece.

13. The tonality and composition of *The Card Game* are similar to Longhi's paintings; the question of whether Longhi influenced Ceruti (or vice versa) is clouded here by the uncertainty of the date of *The Card Game*. During the late 1730s Longhi painted a number of works that are essentially sanitized versions of seventeenth-century Dutch tavern scenes and depict smiling, sporting peasants. By 1741 he had turned his attention to illustrating (as his son described it) the "entertainments, conversations, arrangements, love games, and jealousies" of the Venetian aristocracy. Longhi never seems to have depicted the activities of people whose social class falls between these two groups, that is, the servant class portrayed in *The Card Game*.

14. For examples of Ceruti's card-playing *pitocchi*, see Gregori 1982, pls. 44, 45, 58, 66, 194, 195. Ceruti occasionally depicted the artisan class *at work* (Gregori 1982, pls. 51, 55, 61, 199); these works share some generic affinities with the more lighthearted paintings of his contemporary Giuseppe Gambarini (see Fort Worth 1986, 178–79 no. 33).

15. Gregori (1982, 80) and Spike (in Fort Worth 1986, 210) suggested that in *The Card Game* Ceruti borrowed motifs from other artists. Gregori pointed to a print by Cornelis Bloemaert (Gregori 1982, fig. 73) for the splendid mastiff in the foreground of *The Card Game*. While there are similarities between the poses of the two dogs, it seems unlikely that Ceruti would have had to resort to an outside model, for he was particularly adept at painting dogs (e.g., Gregori 1982, pls. 156, 163–64, 169, 200–202, 252, 255). Gregori's observation that the figure of the green-jacketed footman who leans over the left side of the table in Ceruti's painting derives from a figure of a hairdresser in a print by the French engraver Joseph Filipart (who arrived in Venice in 1737) is less plausible. The possible influence of French prints on Ceruti's painting cannot be completely discounted, however. Spike's suggestion that the still life of cooking pots and ladles in the left-hand corner of the painting is "paraphrased" from Longhi seems somewhat rash; the parallels in Longhi's works are not all that apparent, and Ceruti was an accomplished still-life painter in his own right, as demonstrated by the few interior scenes by him that include similar vessels (Gregori 1982, pls. 72, 108, 188).

16. New X-radiographs of the entire painting were made by David Goist, the former chief conservator of the North Carolina Museum of Art, who also discussed various technical aspects of the work with me.

GASPARE GIOVANNI TRAVERSI

Naples c. 1722–1770 Rome

Traversi received his training in his native city under the direction of Francesco Solimena. The stylistic influence of Solimena's florid late Baroque idiom is apparent in Traversi's early series of paintings depicting scenes from the life of the Virgin Mary, completed by 1749 for the church of Santa Maria dell'Aiuto, Naples. The artistic taste of pupil and master were not well matched, however, and a succession of other stylistic influences is discernible in Traversi's work as he sought his own personal style. Early in his career Traversi also worked as a copyist, commissioned to copy paintings by such artists as Carlo Maratta, Annibale Carracci, and Guido Reni. Noted for his imitative skills, it is not surprising that Traversi proved receptive to the stylistic manner of others.

After Solimena's death in 1747, Traversi followed the example of another of that master's students, fellow Neapolitan Francesco de Mura. Subsequently Traversi's style changed further, next responding to the tenebrism of the Neapolitan works of various seventeenth-century artists, including Caravaggio, Mattia Preti, and Jusepe de Ribera. Traversi's interest in the seicento became more pronounced after 1752 when he moved to Rome, where he is regularly documented from 1755 until his death in 1770. Traversi's first major Roman commission was a series of paintings installed in the monastery of San Crisogono in the Trastevere section of Rome, one of which is dated 1752. In their composition, lighting effects, and secular treatment of the religious subject matter, these works (now in San Paolo fuori le Mura, Rome) reveal the impact of the paintings from Caravaggio's Roman period. In the early works of that master Traversi found a style and subject matter more sympathetic to his own taste than was the decorative model of Solimena.

Continuing to paint religious subjects throughout his career, Traversi also created skillful portraits, such as the Portrait of a Canon *of 1770 in the Ganz Collection. However, his modern reputation is based on the originality of his genre scenes. These intriguing works suggest the rich flavor of everyday social intercourse, combining elements of seventeenth-century Caravaggesque realism with the lighter palette and biting social satire typical of genre painters of the eighteenth century, including Ceruti (see cat. 51) and William Hogarth.*

52

The Arts—Music

——⟨⫘⟩——

c. 1760
Oil on canvas, 59¹³⁄₁₆ x 80⅜ in.
(152 x 204.2 cm)
Signed lower left: *Gaspar Traversi P.*
The Nelson-Atkins Museum of Art,
Kansas City, Missouri F61.70

PROVENANCE
With R. Herzka, Vienna, by 1925–30; sale, Christie's, London, May 16, 1952, lot no. 26; bought by David M. Koetser, New York; Samuel H. Kress Foundation, New York, 1953 (K1957); on loan to the Birmingham Museum of Art, Alabama, 1959–60; gift of the Kress Foundation to the William Rockhill Nelson Gallery of Art, later The Nelson-Atkins Museum of Art, 1961.

SELECTED EXHIBITIONS
Washington 1961–62, no. 95; Chicago 1970–71, no. 103; Detroit 1981–82, no. 51a; Kansas City 1983, no. 24.

SELECTED REFERENCES
Longhi 1927A/1967, 239–40; Birmingham 1959, 93; Shapley 1973, 117–18; Naples 1979–80, I, 230 no. 113a; Bologna 1980, 23 n. 44, 26–27, 51, 64, 85; Barocelli 1986, 106, 108–9.

fig. 1 Gaspare Traversi. *The Arts—Drawing*. c. 1760. Oil on canvas, 59¾ x 80⅜ in. (151.7 x 204 cm). The Nelson-Atkins Museum of Art, Kansas City, Missouri

Like its pendant, *The Arts—Drawing* (*fig. 1*), also in Kansas City, *Music* demonstrates Traversi's skill at creating intriguing, if to the modern audience somewhat enigmatic, glimpses of eighteenth-century life.[1] Among the largest of the artist's genre scenes, these works present the figures almost life-size. This scale, in alliance with the direct gaze of the young lady seated at the clavichord, brings us into immediate contact with the players. By this proximity we sense that we are meant to be not simply onlookers but actual participants in the scene, completing the circle gathered about the girl.

Compositionally Traversi manipulates the figural and spatial proportions, resulting in a disconcerting ambiguity of relationships. Inconsistency of figural scale is accompanied by a claustrophobic compression of space about the large figures, and the shallow, stagelike floor is tilted clumsily toward the picture plane, instead of receding into depth. These conscious incongruities of design create an awkwardness of which the artist was surely aware and which increases our uneasiness about what is actually going on in the scene.

The expression on the face of the young lady on whom all of the attention is centered suggests that she is not enjoying herself. Annotations at the top of her musical score, "*Cantata a Voce Sola*" (Song for a single voice), sum up the situation: she sits amid, yet strangely isolated from, her male companions. It is questionable that any of them are particularly interested in her musical abilities, and there is a salacious air to the scene, established by both facial expressions and hand gestures, which is unsettling.[2]

Colorfully painted, with close attention to details of dress,[3] this is not, however, a delightful glimpse at contemporary life. And although costume and physiognomy are keenly observed and individualized, there is an artificiality of stance and a studied quality to each expression that suggest we are party to a stage performance of some sort. Acknowledging the theatrical flavor of Traversi's genre scenes, it has been proposed that the Italian *opera buffa* (comic opera) provided the artist with source material for both the situations and figural types cast in his paintings.[4] This is a very attractive idea, particularly given the great popularity of this

frivolous form of opera in the artist's native Naples. Unfortunately, while other of Traversi's compositions can be linked to specific *opera buffa* scenes,[5] no libretto has been identifed with the Kansas City pictures. It is hoped that additional research in this direction will produce results, but for the moment we are left with only the image of the Kansas City *Music* to help decipher its content,[6] perhaps aided by the lyrics of the score: *Sorge la bel aurora / i vaghi prati idora / e rende* . . . (Beautiful aurora rises / gilds the lovely morning / and renders . . .).

L.F.O.

1. I wish to thank Dr. Eliot Rowlands, Assistant Curator of European Art, The Nelson-Atkins Museum of Art, for graciously sharing with me his extensive manuscript on the two paintings by Traversi, which will appear in the forthcoming catalogue of the museum's permanent collection.

2. The mood is very different from that pervading a similar scene in a painting long held to be by Traversi but given convincingly to Traversi's contemporary Giuseppe Bonito. That painting, called *A Musical Party* (sold with its pendant, *The Poet*, Christie's, New York, January 11, 1991, lot no. 67), is characterized by a lighthearted amorousness, established by the flirtatious exchange of glances between the young female musician and the elegantly dressed young man, who is the counterpart of the disdainful figure at the far right of the Kansas City canvas.

3. I would like to thank Melissa Leventon, Curator of Textiles at The Fine Arts Museums of San Francisco, for confirming the points regarding the costumes established by Rowlands (ms. 19–22). The costumes in *Music* would have been in fashion about 1740, in other words démodé by the time the painting was executed twenty years later. It should also be noted that the informal outfit worn by the young lady would have been inappropriate garb in which to receive guests, particularly male guests.

4. See Heimburger Ravalli 1982, 34–38.

5. Heimburger Ravalli 1982, 37.

6. The titles of the Kansas City pair, *The Arts—Music* and *The Arts—Drawing* (which were assigned when the paintings came to light in the early twentieth century), provide little information about what is really happening in the two scenes. Obviously these are not conventional allegories or glorifications of the Arts, traditionally represented as Painting, Sculpture, Architecture, and Music. Rather, the art performance here affords the men at each gathering ample time to study the young performer.

FRANÇOIS-HUBERT DROUAIS

Paris 1727–1775 Paris

Drouais was the son of the portraitist Hubert Drouais (1699–1767), his

first teacher, and studied under Donat Nonotte (1708–1785), Carle van Loo (1705–1765),

François Boucher (1703–1770), and Charles-Joseph Natoire (1700–1777). By the time of

his first presentation at the Académie Royale in 1754, therefore, he had been exposed

both to the traditions of portrait painting and to the well-established fashions of the French

Rococo style. During the course of a long and fruitful career, Drouais did much to invest

French portraiture with a new lightness of manner and a new informality that rival the

example of his master Boucher.

The portraits of women and children that he exhibited in 1755, in his

first Salon, were so well received that in that year he was called to paint the grandsons of

Louis XV, the Duc de Berry and Comte de Provence—who would later ascend the throne

as Louis XVI and Louis XVIII. He chose to show them not in robes of state but playing with

a dog; he later painted the Prince and Princesse de Condé as gardeners, and the young

Comte and Chevalier de Choiseul as Savoyards playing with a marmot.[2] Such whimsical

inversions of the usual portrait déguisé, the "disguised portrait," which more often placed

the sitter in the role of a figure from ancient history or mythology, made Drouais an imme-

diate success with the fashionable world of Paris, and he was particularly in demand to

paint elegant women and their children.

The greatest boost to the artist's career came in the later 1750s with

the patronage of the royal family—Drouais was asked to paint almost every prince and

princess of the royal blood. One of the most magnificent of his portraits is the likeness

of the king's favorite Mme. de Pompadour, whom he depicted in 1763, aged forty-two, at

her tapestry loom.[3] "The famous men who had been called to paint her had made beautiful

pictures of her," as an eighteenth-century writer remarked, "but her portrait was yet to

be painted."[4] The Baron Melchior Grimm went so far as to say that Drouais was "the only

man who knows how to paint woman, because he knows how to make a likeness without

jeopardizing the delicacy and grace that is the charm of her physiognomy. Thus, I am con-

vinced that all our women will eventually want to be painted by Drouais."[5]

Group Portrait

1756
Oil on canvas, 96 x 76⅝ in. (244 x 195 cm)
Inscribed on edge of box:
fs [fils] *Drouais ce 1 avril 1756*
National Gallery of Art, Washington
1946.7.4

PROVENANCE
With Asher Wertheimer, London, until 1889;[1] Samuel
Cunliffe-Lister, 1st Lord Masham (1815–1906), Swinton
Park, Masham, Yorkshire, in 1889; John Cunliffe-Lister, 3rd
Lord Masham (1867–1924); at his death to his sister Mary
Constance Boynton, Lady Swinton, remaining in her collec-
tion until as late as 1936; Lord Duveen, Millbank, by 1937;
with Duveen Brothers, New York; Samuel H. Kress Founda-
tion, New York, 1942 (K1328); gift of the Kress Foundation
to the National Gallery of Art, 1946.

SELECTED EXHIBITIONS
London 1902, 26 no. 18 (as *A Family Group*); London 1925,
6 no. 9; Leeds 1936, no. 29; Paris 1937, 289–90 no. 108;
New York 1940, 135–36 no. 197.

SELECTED REFERENCES
Phillips 1902; Collins-Baker 1925, 300; Huyghe 1937, pl. 16;
Frankfurter 1940, 16–43, 62–6; Cairns and Walker 1944,
112–13; Frankfurter 1944, 78–79; Frankfurter 1944A, 24;
Richardson 1944, 225–26; Washington 1945, 165; Einstein
1956, 228, 230–31; Verlet 1967, 85; Walker 1974A, 329;
Eisler 1977, 322–23.

DROUAIS, *Group Portrait*

The critics referred again and again to the careful yet spontaneous surfaces of Drouais's canvases. His taste for elegance was his great gift, but he was capable of carrying this taste to excess. Many of his later portraits, from the late 1760s and 1770s, are precious to a fault; as Denis Diderot, the great critic, remarked, "All that man's faces are nothing but the most precious vermilion red laid on the whitest chalk. Let us go past his portraits quick, quick. . . ."[6] He was still the painter of fashion, however, to such sitters as the king's young mistress Mme. du Barry, whom he portrayed dozens of times. Two of these portraits were, in Diderot's words, "the most looked-at paintings in the Salon" of 1769.[7] Du Barry was shown in one as Flora, in the other in a man's costume. Two years later, in a celebrated incident, du Barry had removed from the Salon the portrait in which Drouais had depicted her as a muse, wearing a virtually transparent robe.[8] She nonetheless continued to commission many portraits from the painter, as did the king and his household: of the last portraits that Drouais exhibited, four were of members of the royal family.

Grandson and son of painters, Drouais was also the father of a painter, Jean-Germain (1763–1788), the favorite student of Jacques-Louis David (1748–1825). Drouais died, a painter of distinction and of fortune, in 1775.

The family depicted in this monumental yet engaging portrait has never been identified. An English owner whose family had purchased the painting from the dealer Asher Wertheimer believed that the painting represented "a banker to Louis XV, who had tried to corner wheat in France in the best Chicago manner."[9] This banker might have been the father of the Marquise de Pompadour, a sitter to Drouais and the king's *maîtresse en titre*. The specificity of the painting's inscribed date of the first of April—April Fool's Day, or the French *Poisson d'avril*—might lend further support to a connection with Pompadour, born Mlle. Poisson. But neither the presumed ages of the sitters nor the relative sobriety of the interior support an identification of this group with Pompadour or any member of her family. It is likely that the painting represents a family from the wealthy bourgeoisie, with sufficient means to commission such an imposing composition, one of the largest eighteenth-century French portraits to have entered an American collection.

The painting is a study in subtle harmonies among the primary colors, playing on contrasts between only slightly differing shades of the same hue. Through the left side of the canvas, for example, runs the color blue, at its most vivid in the sky seen through the window, becoming more muted as it flows through the window curtain and the dress of the little girl. The yellows and golds present in the taffeta skirt worn by the woman reflect on the gilt surfaces of fringe,

toilet articles, armchair, paneling, and on the wall clock.[10] Subdued reds and pinks are scattered throughout the canvas, in the man's breeches, the flowers in his wife's lap, and in

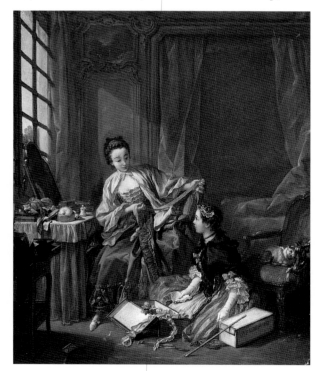

fig. 1 François Boucher. *The Milliner (Morning)*. 1746. Oil on canvas, 25 x 21 in. (64 x 53 cm). Nationalmuseum, Stockholm

the beribboned cover on the dressing table mirror. The luxurious chinoiserie brocade of the man's dressing gown, with its ground of deep claret heightened in gold and rose and its blue lining, unites all three hues.

The underlying harmony of the colors is mirrored in the mood of domestic harmony among the figures, the man bending toward his wife, the mother gesturing toward her daughter, whose powdered hair she adorns with a spray of flowers. Family harmony, indeed, can be said to be the theme of the portrait, which for all its luxury emphasizes informality and intimacy rather than grandeur and social pomp. Such informality is common enough in British conversation pieces of the first half of the century, but in France it is encountered in genre painting rather than in portraiture. In the previous generation, Nicolas Lancret (1690–1743) and Boucher had enlivened portraits with some of the devices of genre. In fact, a work of pure genre such as Boucher's *The Milliner (Morning)* of 1746 (*fig. 1*), one of a projected series on the times of the day, offers the closest parallels of subject matter and composition for Drouais's monumental portrait.

As Duncan has noted, the painting is among the earliest in France to reflect "the new concept of conjugal love and family harmony" that was articulated in the middle years of the century by such writers and philosophers as Jean-Jacques Rousseau and Denis Diderot.[11] Such ideas were certainly in vogue in the 1750s—as were new notions of children, who were seen no longer as miniature adults but as natural innocents in need of affection and education. It is difficult to say, however, whether Drouais was much influenced by social philosophy or whether his pursuit of informality may have risen out of a desire to create a novel portrait mode in painting. His 1755 portrait of the Dauphin's sons contentedly playing with a dog, for instance, anticipates by six years the publication of Rousseau's *Julie*. Drouais's invention is all the more striking when we remember that the Kress portrait is the work of an artist only twenty-eight years old.

G.T.M.S.

1. Eisler (1977, 323) includes, with a query, the French cabaret singer Aristide Bruant (1851–1925) in the provenance for this painting, but this seems extremely unlikely. Bruant, from a working-class family, did not found his cabaret *Le Mirliton* until 1887 and would simply not have had the opportunity to inherit or purchase such a painting before 1889, when Wertheimer is known to have sold the painting. See London 1991–92, 282–85.

2. 1755, Versailles; 1757, formerly collection Edmond de Rothschild; 1758, Frick Collection.

3. National Gallery, London (6440).

4. Gabillot 1905–6, pt. IV, 155 (author's translation).

5. Quoted in Gabillot 1905–6, pt. IV, 156 (author's translation).

6. Quoted in Gabillot 1905–6, pt. IV, 158 (author's translation). For more on Diderot and Drouais, see Paris 1984–85, 191–94.

7. Quoted in Gabillot 1905–6, pt. IV, 161 (author's translation).

8. See Crow (1985, 176), who like Gabillot (1905–6) suggests that the Marquis de Marigny, *Directeur des Bâtiments* and the brother of Mme. de Pompadour, may have played an important role in removing the offending painting from exhibition.

9. Eisler 1977, 323.

10. A visitor to the National Gallery in the 1970s noted that the hands of the clock, at 11:17 a.m., are positioned on minutes seventeen and fifty-six of the hour, in keeping with the painting's date: 1756.

11. Duncan 1973, 577–79.

ELISABETH LOUISE VIGÉE LE BRUN

Paris 1755–1842 Paris

The Countess von Schönfeld
with Her Daughter

---⊸⫘⊶---

Vigée Le Brun was the daughter of a minor portrait painter and his wife, a hairdresser, who was herself the daughter of a tillage farmer.[2] From these humble origins, the young Louise Vigée rose to heights of fame and, against all odds, ultimately became one of the most famous women in Europe, the chosen intimate of Marie Antoinette. The painter's father, her first teacher, died when she was twelve years old, but she continued to learn and perfect her craft, above all by copying the works of the Old Masters in Parisian private collections. She was admitted to the Academy of Saint Luke at the age of nineteen; just over a year later she married Jean-Baptiste-Pierre Le Brun, a successful picture dealer whom she had met the year before, when her family moved to the Hôtel Lubert, where Le Brun resided. In this house she eventually was to establish the first of her fashionable Salons.

In 1778 Vigée Le Brun received her most important early commission, for a portrait of Marie Antoinette, who five years later decreed that the Académie Royale should elect Vigée Le Brun to its membership. For the remaining years of the 1780s the painter was closely associated with the court, patronized by the royal family, aristocrats, and important officials in government, and in fact besieged by sitters who might be forced to wait for as much as a year for a portrait. Her career seemed assured when in 1786 her husband began to construct a luxurious neoclassical town house, called the Hôtel Le Brun, in which they were to live. But so great was Vigée Le Brun's reputation as image maker to Versailles that, in the anti-Royalist climate of the day, she was the victim of repeated, vicious attacks in the press; fictitious love letters between the painter and the exiled minister of finance, Charles Alexandre de Calonne, were published in the spring of 1789. In October of that year she escaped France with her nine-year-old daughter, not to return to her homeland for twelve years. During her exile her rights as a citizen were revoked, and in 1794 her husband was forced to divorce her on the grounds of desertion to protect himself from death or imprisonment and to safeguard his wealth—much of which, according to Vigée Le Brun, was of her making.

The artist meanwhile traveled for a time in Italy, visiting, among other cities, Turin, Parma, Florence, Rome, Naples, Venice, and Milan, where she was advised by an Austrian diplomat to seek commissions in Vienna. She resided in the capital of the

1793
Oil on canvas, 52¾ x 38½ in.
(134 x 97.8 cm)
Signed and dated at lower left: *L. E. Vigée/ Le Brun à Vienne 1793*; inscribed on verso, covered by relining: *Ursula Marg. Agn. Victoria/gräfin v. Schönfeld/geb. Gräfin Fries./geb. 1767–1805*
University of Arizona Museum of Art,
Tucson 61.13.28

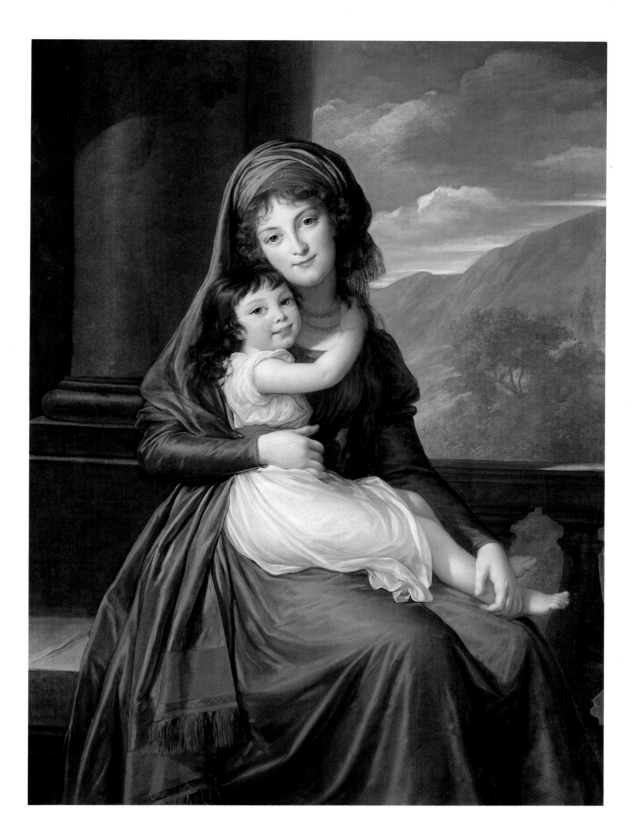

VIGÉE LE BRUN, *The Countess von Schönfeld with Her Daughter*

Habsburgs for nearly three years, from 1792 until 1795, when she settled in Russia, where she was to remain until 1801. In that year her name was at last removed from the list of proscribed émigrés, and she returned to Paris. She stayed there only until 1802, when she left for London, returning to France for good in 1805 and residing once more in the Hôtel Le Brun. For the first four decades of the nineteenth century, she was a famous member of Parisian society, prized as a marvelous relic of the Ancien Régime.

Vigée Le Brun, like Drouais before her (see cat. 53), was a portraitist par excellence of the world of wealth and fashion, whether in her native Paris or in exile elsewhere on the Continent. Her compositions of the 1780s balance a keen sense of elegance and luxury with seemingly artless poses and expressions. "The works of the modern Minerva," wrote one critic in 1783, "are the first to attract the eyes of the spectator, they call him back repeatedly, take hold of him, possess him, elicit from him the exclamations of pleasure and admiration which artists are so anxious to hear. . . ."[3] The greatest of her portraits, in their luminous, glowing facture and in their imaginative simplicity, announce the modern portrait mode that was to be perfected by Jacques-Louis David, her Republican successor, in the 1790s.

By her own account, during her stay of two and one-half years in Vienna Vigée Le Brun executed thirty-one portraits in oils and twenty-three in pastels. While this number does not equal her most productive years—1779, when she painted thirty-eight oils, and 1789, her last year in France, when her total reached thirty-seven[4]— it is still a prodigious achievement for a newly arrived exile, even one so famous as Vigée Le Brun. Her sitters, as Baillio has noted, were mostly Eastern European nobles, including the princes Czartoryski and Lubomirski, the princesses Liechtenstein and Esterhazy, and the countesses Kinska, Razomovska, Zamoiska, and Potocka.[5]

Ursula Margaretha Agatha Victoria, the Countess von Schönfeld, was the daughter of an aristocratic Austrian banker and was the wife of the ambassador from Saxony to Vienna.[6] She was, in Vigée Le Brun's own words, "very pretty and as *fashionable* as one could be," fashionable, the painter implies, to the point of snobbery.[7] Her portrait, however, is engaging and full of charm. The countess, her daughter in her lap, is shown against a landscape background— presumably modeled on the pure landscapes Vigée Le Brun is known to have painted in the outskirts of Vienna.[8] The leaves visible as pentimenti through the column at left suggest that the landscape once extended the full width of the background.

The color scheme of the painting is particularly appealing, with its blue sky, green foliage, and somber stone architecture, which set off the striking autumnal hues of the countess's coppery *changeant* silk gown and rich green scarf bordered in red. Vigée Le Brun here employs a somewhat stylized costume, in which modern elements are used in imitation of older models. "As I had a horror of the costume that women were wearing then," she wrote later, "I did all I could to make it a little more picturesque, and I was delighted, when I could gain my sitters' confidence, to be able to drape it as I fancied. We were not yet wearing shawls; but I arranged large scarves, lightly interwoven around the body and the arms, with which I tried to imitate the drapery style of Raphael and Domenichino."[9]

Vigée Le Brun's debut as a woman of fashion and a painter of merit coincided with François-Hubert Drouais's decline as the acknowledged master of the flattering female portrait. It is perhaps natural that this role fell to Vigée Le Brun. In fact she consistently painted many more portraits of women than of men: of the fifty-odd portraits of her Viennese period, more than thirty-five are of female sitters. All the same she seems to have had no particular partiality for her sex, suggesting in her memoirs that when painting women, "you must flatter them, tell them that they

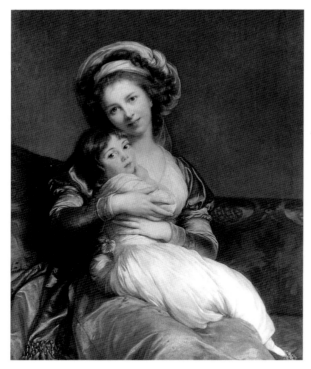

fig. 1 Elisabeth Vigée Le Brun. *Madame Vigée Le Brun and Her Daughter, Jeanne-Lucie-Louise, called "Julie."* 1786. Oil on canvas, 41⅜ x 33 in. (105 x 84 cm). Musée du Louvre, Paris

are beautiful, that they have fresh coloring, etc., etc. This puts them in a good mood," she wrote, "and makes them hold the pose more agreeably."[10]

Vigée Le Brun used as a model for her likeness of Countess von Schönfeld a self-portrait she had painted in 1786 (*fig. 1*): the earlier of two portraits in which she depicted herself as a devoted mother, embracing her young daughter Julie. As Baillio has noted, both the self-portrait and the likeness of Countess von Schönfeld are cast in the mold of Raphael's madonnas, in particular his famous *Madonna della Sedia* now in the Palazzo Pitti, Florence (see also cat. 57).[11] Por-traits of mothers and their children formed a significant part of Vigée Le Brun's practice. Already known for her delicate images of young boys and girls (as Baillio notes, she exhib-ited a disproportionate number of these at the Salon), in the 1780s she received a number of commissions from aristocratic women who wished to be depicted with their offspring, culminating in the grandiose portrait of Marie Antoinette with the *enfants de France* shown at the Salon of 1787.[12] In Vigée Le Brun's oeuvre, however, there is not one portrait in which a mother is shown with her child and its father. In fact she wholly rejects this popular group portrait type, practiced by French artists of the earlier eighteenth century—most of them men—from Hyacinthe Rigaud (see cat. 35, fig. 1) to François-Hubert Drouais (see cat. 53).

It is almost as if men, in Vigée Le Brun's universe, did not function as fathers. And in the circumstances it is easy to understand how Elisabeth Louise Vigée Le Brun might have perceived the situation of women and their families from this perspective. Having lost her own father at the age of twelve, she was subject to the ill humor and greed of her wealthy stepfather. "I detested this man," she wrote later, "all the more because he raided my father's closet, wearing his suits as they were, without even having them refitted."[13] Pierre Le Brun, her husband, is remarkably absent from the account she gives of her career late in her life, appearing only to be married to her, to withhold from her use the thou-sands of francs she earned in fees, and finally and briefly to die. By 1793, when she depicted the Countess von Schönfeld and her daughter in the very image of her own self-portrait, Vigée Le Brun had left her husband behind in France and with her daughter, Julie, had begun an indepen-dent life.

G.T.M.S.

1. According to Baillio in Fort Worth 1982, 105, the painting was offered to the Musée du Louvre by Frau Dumba's husband, Dr. Theodore Dumba, in 1932.

2. For Vigée Le Brun's biography, see Joseph Baillio's introduction and chronology in Fort Worth 1982, 6–16; my account is based on his text.

3. Louis Petit de Bachaumont, "Première lettre sur les peintures, sculp-ture & gravures exposées au Salon du Louvre," 1783, quoted in Fort Worth 1982, 8.

4. See Vigée Le Brun 1835–37/1984, II, 337–38, 343–44.

5. Vigée Le Brun 1835–37/1984, II, 347–49.

6. See Baillio in Fort Worth 1982, 105.

7. Vigée Le Brun 1835–37/1984, I, 277. See also Baillio in Fort Worth 1982, 105.

8. See Vigée Le Brun 1835–37/1984, II, 349: "plusieurs paysages fait d'après nature dans les environs de Vienne." It is difficult to understand Eisler's assertion (following Suida's in Washington 1951, 232) that the Tucson painting is the sole Vigée Le Brun to include a landscape; see in Fort Worth 1982, no. 24, *The Marquise de Pezay and the Marquise de Rougé with Her Sons*, 1787 (National Gallery of Art, Washington); no. 34, *Countess Potocka*, 1791 (formerly Kimbell Art Museum, Fort Worth); and from the same year as the Tucson portrait, no. 38, *Countess Bucquoi*, 1793 (The Minneapolis Institute of Arts).

9. Vigée Le Brun 1835–37/1984, I, 56 (author's translation).

10. Vigée Le Brun 1835–37/1984, II, 324 (author's translation).

11. Fort Worth 1982, 105. See also Baillio 1988, 98.

12. Musée National du Château, Versailles. See Fort Worth 1982, 49, 80 fig. 15.

13. Vigée Le Brun 1835–37/1984, I, 36 (author's translation).

FRANCISCO JOSÉ DE GOYA Y LUCIENTES

Fuendetodos 1746–1828 Bordeaux

Francisco Goya was born in the provinces and trained in Zaragoza before going to Madrid, where he became a disciple of the court painter Francisco Bayeu (1734–1795), whose sister he married in 1773. His early work, in emulation of Giambattista Tiepolo's decorative Rococo style (see cats. 47, 48), gave way to simpler handling of forms under the influence of court painter Anton Raphael Mengs (1728–1779). Working at court from 1775, Goya produced tapestry cartoons for the Santa Bárbara manufactory and first encountered in great number the paintings of Velázquez, who with Rembrandt became the artist most admired by the young painter.

Goya's close association with the royal family began in the next decade, first with his nomination as painter to King Charles III (1786) and later with his promotion to Pintor de Cámara *under Charles IV (1789). During the 1790s, Goya was the most successful and most fashionable artist in Madrid, patronized by the king, the queen, and members of the court, as well as by the nobility and the wealthy bourgeoisie. With one of his patrons, the glamorous Duchess of Alba, he had a celebrated liaison, broken in 1797, two years before the publication of his satirical etchings,* Los Caprichos, *which bitterly attacked the "stupidities and errors" of high society, together with the "obfuscations and lies condoned by custom, ignorance, and self-interest."[2] The etchings, flowing out of work done during the artist's convalescence from a serious illness that left him forever deaf, were the first works to reveal fully the ironic, psychologically complex Goya that was so dear to the Romantics of the nineteenth century. They were the earliest of several sets of related images that were etched over the next decades, including the* Disasters of War *(1810–20) and the* Disparates *or* Proverbios *begun in 1816–17.*

It is in the Spain of the nineteenth century, a country torn by war with foreign powers and by revolt within, that Goya—at times gravely affected by illness— produced the most profound works of his career. Among these are his great royal portraits, full of irony and astute observation, and his terrifying scenes of war, including the famous paintings of the events of the second and third of May 1808 (1814; Prado, Madrid), and the Disasters of War. *These preceded the "black paintings," a group of disturbing images—a "descent into hell"—that Goya painted between 1820 and 1823 on the walls of his country*

55

Don Ramón de Posada y Soto

After 1794
Oil on canvas, 46 x 34½ in.
(116.8 x 87.7 cm)
Inscribed at lower right corner of trompe l'oeil frame: GOYA
The Fine Arts Museums of San Francisco
61.44.26

PROVENANCE
Don José María Pérez Caballero, Madrid; his sister?, Doña Pilar Pérez Caballero de Comas, Madrid; M. Knoedler & Co., New York, by 1915; A. W. Erickson, N.Y., by 1928;[1] with Wildenstein & Co., New York, 1928; Forsyth Wickes, Newport, Rhode Island, 1929; sold to Wildenstein & Co., New York, 1947; Samuel H. Kress Foundation, New York, 1953 (K1973); on loan to the M. H. de Young Memorial Museum, 1955–61; gift of the Kress Foundation to the M. H. de Young Memorial Museum, later The Fine Arts Museums of San Francisco, 1961.

SELECTED EXHIBITIONS
Madrid 1900, no. 35; New York 1915, no. 23; San Francisco 1920, no. 80; New York 1950, no. 12; Washington 1961–62, no. 40; London 1963–64, no. 73; Madrid 1992–93, 135–36 no. 35.

SELECTED REFERENCES
Tormo y Monzó 1902, 213; Lafond 1902, 136 no. 191; Calvert 1908, 139 no. 217a; Stokes 1914, 334 no. 158; Loga 1921, 202 no. 310; Beruete y Moret 1922, 56–57; Mayer 1924, 310 no. 392; Desparmet Fitz-Gerald 1928–50, II, pls. 344, 345; Angulo Iñíguez 1944, 391–92; Sánchez Cantón 1951, 59 n. 29; San Francisco 1955, 20–21; Frankfurter 1955, 42; Trapier 1964, 12, 53; Gassier and Wilson 1971, 161, 170 no. 342; Eisler 1977, 227–28; Glendinning 1981, 242–43; Hull 1987, 85.

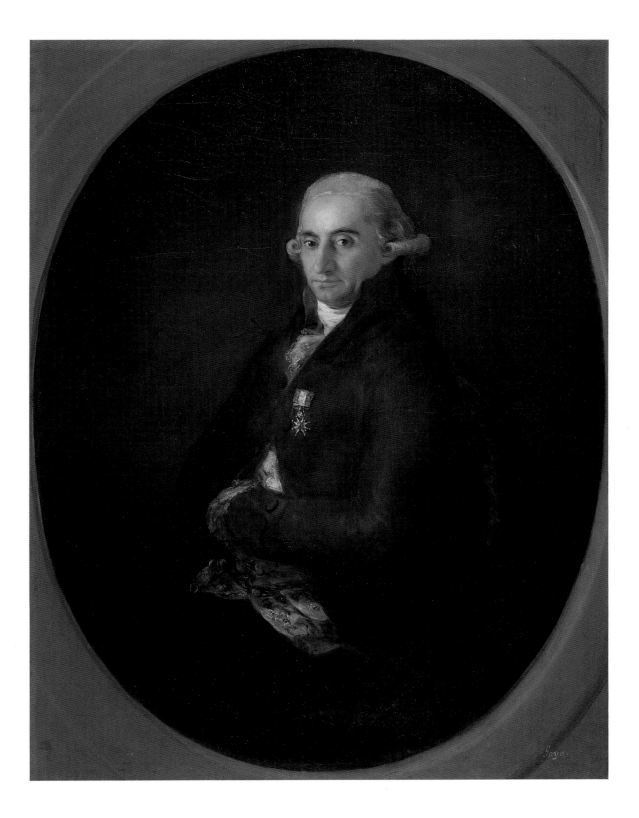

GOYA, *Don Ramón de Posada y Soto*

house near Madrid.[3] Shortly after their completion, deeply troubled by his country's rejection of liberalism and its return to a repressive absolutist government, Goya determined to leave Spain. With the permission of his patron the king, Goya emigrated in 1824 to Bordeaux, where he died four years later.

Goya's character and art exerted a profound and enduring influence on Delacroix, Manet, and Baudelaire in the nineteenth century, and on Picasso, Orozco, and even Motherwell in our own. Since his death, Goya's art—heroic, expressive, ineffably fusing the real and the irrational—has become synonymous in the public mind with the art of Spain.

Ramón de Posada, born around 1740, was a magistrate in the Spanish government of the New World, first in Guatemala, where he was sent in 1774, then in Peru, and shortly thereafter in Mexico, where in 1783 he helped to found the Academy of San Carlos in Mexico City.[4] He was back in Spain from 1794 and it is known that he met with Goya in the autumn of that year to attempt to acquire a painting by him for the Mexican academy. It is almost certain that Posada knew Goya through his political associate Gaspar Melchor de Jovellanos (1744–1811), one of the champions of liberalism and enlightenment in the 1780s and 1790s, whose sister had married Posada's brother, and who was a close friend and patron of the painter. Nigel Glendinning has proposed that the portrait was painted on the occasion of Posada's nomination to the Council of the West Indies in 1798.[5] Later, in 1812, Posada became president of the Supreme Court of Justice in Cádiz, where he died in 1814.

From the late 1780s on, portraiture occupied an important place in Goya's work, both in quantity and in quality. Most of Goya's portraits were painted on commission from the court, the nobility, or the wealthy bourgeoisie of Madrid, but others were painted to record the likenesses of friends, particularly the circle of enlightened liberals—the *ilustrados* —with whom Goya associated.[6] The portraits of the 1790s are particularly distinguished, as Goya became increasingly sure of his virtuoso technique and used exuberant brushwork to give character of expression to the simple half-length formats that he preferred.

His portrait of Ramón de Posada y Soto is one of these half-lengths, the figure seated in an oval-backed chair of French style that echoes the oval "porthole" formed by the painting's illusionistic spandrels. The neutrality of the background is offset by the vivid touches of color on the sitter's costume and by the flickering light that models his gentle expression, his clever eyes, and details such as his

embroidered waistcoat and his decoration—the Order of Carlos III. The same light, falling from the upper left of the image, strikes the shallow moldings of the oval spandrels. These spandrels, rare in Goya's art, are nonetheless a common device in seventeenth- and eighteenth-century European painting; Goya more often used a painted ledge at the bottom of a portrait to support an inscription and his signature.[7]

G.T.M.S.

1. This information, not recorded in Eisler 1977, was found in files in the Kress archives of the National Gallery of Art and in the curatorial records of The Fine Arts Museums of San Francisco. I am grateful to Joseph Baillio of Wildenstein for confirming that his firm purchased the painting from Erickson in 1928.

2. See the public announcement of the publication of the *Caprichos*, as quoted in Boston 1988–89, xcix–c.

3. Prado, Madrid. See Gassier and Wilson 1971, 317 nos. IV.1615–1627a.

4. For all details of Posada's biography, see Glendinning 1981, 242–43.

5. Glendinning 1981, 243.

6. See Gassier and Wilson 1971, 132–35.

7. The spandrels were painted over at some point in the past and were revealed in a twentieth-century restoration. Eisler (1977) compares the painting to several painted sketches for the 1801 portrait of the royal family that bear similar illusionistic spandrels. These paintings had been rejected by Gassier and Wilson 1971 (see nos. II.789, II.791, II.792), who considered them to be the work of Agustín Esteve. Goya's portrait of Manuel Quijano of 1815 in the Museo Municipal, Barcelona, seems to have similar illusionistic spandrels (Gassier and Wilson 1971, no. III.1549). For portraits incorporating a painted "ledge," see Gassier and Wilson 1971, nos. I.226, II.668–70.

JEAN-AUGUSTE-DOMINIQUE INGRES

Montauban 1780–1867 Paris

One of the more erudite and sophisticated painters of the nineteenth century, Ingres received only four years of formal education before the French Revolution interrupted his schooling in the provincial town of Montauban. His career as an artist was marked by his assertive self-promotion and self-confidence, which won him at the age of seventeen a place in the atelier of Jacques-Louis David (1748–1825). By the age of twenty-one he had obtained the Prix de Rome (an award not fulfilled until seven years later), and by twenty-six the commission for the most formal of Napoleon's imperial portraits.[3]

At the end of his term as a pensionnaire *at the Villa Medici in Rome, in 1810, Ingres decided to take up residence in the ancient capital, and remained there until 1820. For fourteen years, Ingres was one of the more famous artists in the city, painting and drawing portraits not only of French but also of English and Italian sitters, and from time to time undertaking commissions for important history paintings. He submitted works on occasion to the Salons in Paris—including, in 1819, the ill-received* Grande Odalisque *and* Roger Delivering Angelica.[4] *After a stay of four years in Florence, he returned to Paris, which he had left almost a generation before, bringing with him an altarpiece,* The Vow of Louis XIII, *that had been commissioned for the cathedral of his native town.[5]*

The painting was a great success, and with its success came Ingres's first elevation to the ranks of officialdom. Within five years he received the Cross of the Legion of Honor from the hand of Charles X; he was elected to the Académie des Beaux-Arts; he acquired a studio with an army of pupils; he completed his seminal work, the Apotheosis of Homer;[6] *and he was named, finally, a professor at the École des Beaux-Arts. By the late 1820s, then, Ingres was viewed not only as a powerful defender of the classicizing intellectual ideals of the academy in the face of its Romantic opponents—chief among them Eugène Delacroix (1798–1863)—but as the great standard-bearer of a classical tradition inherited from Raphael, Poussin, and David.*

The physical qualities of his paintings testify to Ingres's rightful place in this lineage. Line, purified through constant and decisive drawing, becomes firm contour in his painted works, defining forms that are treated in surely chosen color and set in place by even, unflickering light. And the enameled surfaces of his canvases bear hardly

56

Monsieur Marcotte d'Argenteuil

———⊱⊰———

1810
Oil on canvas, 36¾ x 27¼ in.
(93.5 x 69.3 cm)
Inscribed lower right:
Ingres. pinx. Rom. 1810.
National Gallery of Art, Washington
1952.2.24

PROVENANCE
Charles-Marie-Jean-Baptiste Marcotte d'Argenteuil (1773–1864); his son, Joseph Marcotte (1831–1893); his wife, Madame Joseph Marcotte, née Paule Aguillon (d. 1922), by 1911;[1] her daughter, Madame Marcel Pougin de la Maisonneuve, née Elizabeth Marcotte (d. 1939);[2] Private collection, London; with Wildenstein & Co., New York; Samuel H. Kress Foundation, New York, 1949 (K1650); on loan to the National Gallery of Art, 1951; gift of the Kress Foundation to the National Gallery of Art, 1952.

SELECTED EXHIBITIONS
Paris 1867, no. 440; Paris 1911, no. 14; New York 1951–52, no. 31; Louisville 1983–84, 139–42 no. 63.

SELECTED REFERENCES
Magimel 1851, no. 15; Vicaire 1864, 100–105; Merson 1867, 17, 103–4; Blanc 1870, 33–34 n. 1; Delaborde 1870, 254–55 no. 139; Montrosier 1882, 12; Lapauze 1901, I, 235ff.; Lapauze 1903, 63–64; Momméja 1904, 39, 68–69; Lapauze 1911, 95, 102, 106–12; Frölich-Bum 1924, 9; Hourticq 1928, iv, 25, 125; Fouquet 1930, 69–70; Pach 1939/1973, 42–43, 54; Alazard 1950, 45–48; Washington 1951, 236–37 no. 106; Frankfurter 1951, 35; *Art Digest* 1951, 17; Soby 1951, 162; Wildenstein 1954/1956, 172 no. 69; Naef 1958, 336–46; Ternois 1959, III, no. 119; Washington 1959, 356; Seymour 1961, 195–96; Rosenblum 1967, 82; Camesasca 1968, 92 no. 59; Eisler 1977, 364–66; Whitely 1977, 38; Naef 1977, IV, 122–24 nos. 64, 65; Ternois 1980, 46, 71; Louisville 1983–84, 139–43, 214 no. 63.

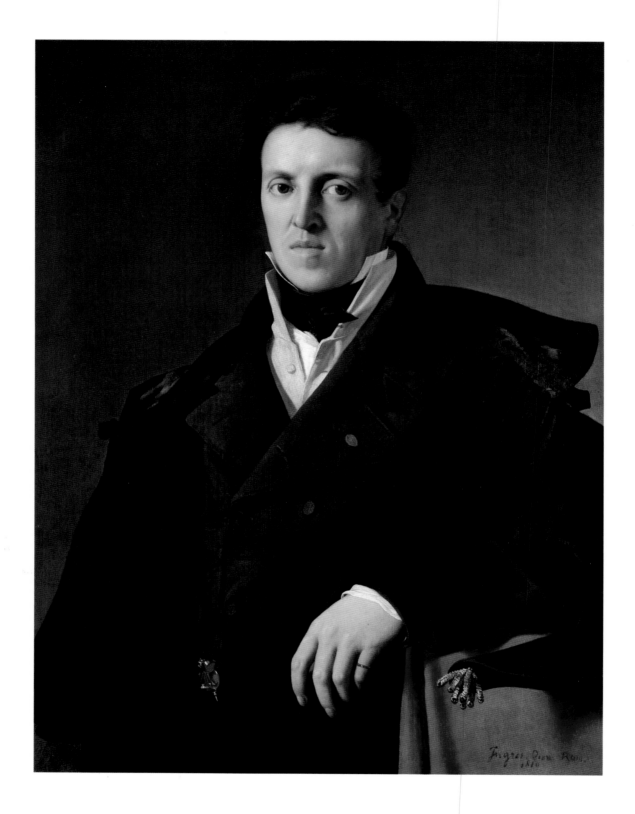

INGRES, *Monsieur Marcotte d'Argenteuil*

any trace of his brush: visible brushwork, he wrote, "becomes an obstacle to illusion . . . in place of the thought, it makes us observe the hand."[7] His paintings reveal a multiplicity of sources of inspiration, sometimes apparently contradictory, just as the abstraction that is usually perceived in his paintings is contradicted by elements of uncanny realism.

Ingres returned to Rome, as director of the French Academy there from 1835 to 1841, continuing to paint works for Parisian patrons. Major commissions from the Duc d'Orléans, the Duc de Luynes, and later from the Emperor Napoleon III marked the decades following his triumphant return to Paris, but Ingres was also in great demand as a portrait painter to the wealthy aristocracy of the reigns of Louis-Philippe and Napoleon III, a fact that he only grudgingly accepted. At his death, the contents of his studio, including not only paintings but more than four thousand drawings, were bequeathed to Montauban, his native town, which built a museum to house them.

With the commission to paint M. Marcotte, called Marcotte d'Argenteuil,[8] Ingres was to create one of the finest portraits in his oeuvre and to establish one of the most important friendships in his life. Marcotte (1773–1864) was slightly older than the painter, who at thirty was already highly respected in the international community of artists working in Rome. Marcotte had come to Italy in 1807 as an official in the Napoleonic government—an Inspector of Forests, "charged successively, from 1807 to 1811, with establishing the forestry service in the States of Genoa, the Duchy of Parma, of Tuscany, and in the States of Rome."[9] He was introduced to Ingres by the painter Edouard Gatteaux, another Prix de Rome winner, who was a *pensionnaire* at the Villa Medici, and who had been sought out by Marcotte for help in choosing his portraitist.

The young official and the painter became close friends. As Ingres's biographer Lapauze expressed it, "a half-century's friendship was sketched in before the painter's easel."[10] In addition to the portrait in oils, painted in 1810, Ingres executed two exquisite pencil drawings, one a half-length set against a panorama of Rome (*fig. 1*) and the other a classical profile bust (the latter was drawn in two versions).[11] The drawings, particularly the profile study, make clear the singular physiognomy of M. Marcotte—above all his pronounced underbite; but the image they convey of an affable, relaxed, and smiling sitter also points to the degree to which Ingres subtly reformed and accentuated his sitter's appearance of severity in the process of painting.

Indeed, the portrait is almost forbidding in its clarity and precision. The contours of each element are rigidly defined, and within them the suggestion of spatial form through

subtle shading and modeling is strictly controlled. The gray-brown background, darkest at upper left and growing lighter toward the right, sets the austere tone for the painter's brilliantly subdued color scheme of muted blues, browns, and broken black, accented by the yellow and gold of the waistcoat and a bullion tassel on the bicorne hat, as well as by

fig. 1 Jean-Auguste-Dominique Ingres. *Monsieur Marcotte d'Argenteuil.* 1811. Graphite on wove paper, 9⅝ x 7⅝ in. (24.5 x 19.4 cm). Private collection

fig. 2 Jean-Auguste-Dominique Ingres. *Pope Pius VII in the Sistine Chapel*. 1810. Oil on canvas, 29¼ x 36½ in. (74.5 x 92.7 cm). National Gallery of Art, Washington, Samuel H. Kress Collection

the crimson tablecloth and carnelian watch fob.[12] The austere harmony of design and color—which Lorenz Eitner has rightly compared to Bronzino—reflects one of Ingres's dictums: "There is no example of a great draftsman who has not had the color quality exactly suited to the character of his drawing. To the eyes of many people, Raphael did not use color; he did not use color like Rubens and Van Dyck: *parbleu*, I should say not! he would take great care not to."[13]

Marcotte and his family were to play an important role in Ingres's personal and professional life. In the year that his portrait was painted, Marcotte commissioned from Ingres a painting of the interior of the Sistine Chapel (*fig. 2*); in 1840 Ingres sent to Paris his ravishing *Odalisque with the Slave*, promised to Marcotte nearly two decades earlier.[14] Ingres painted and drew, in all, fourteen members of the Marcotte clan, with whom he had the most cordial relations. Finally, Marcotte was to introduce Ingres to a young cousin, Delphine Ramel (she addressed Marcotte as "Uncle"), who became the painter's second wife in 1852.

G.T.M.S.

1. Lapauze (1911, 95) mentions Mme. Marcotte as owner of the portrait.

2. See Naef 1977, II, 503–33.

3. Wildenstein 1954/1956, no. 27, Musée de l'Armée, Paris.

4. Wildenstein 1954/1956, nos. 93, 124; Musée du Louvre, Paris, Inv. RF 1158, 5419.

5. Wildenstein 1954/1956, no. 155; Cathedral, Montauban.

6. Wildenstein 1954/1956, no. 168. Musée du Louvre, Paris, Inv. RF 5417; originally installed as a ceiling decoration in the Salle Clarac of the Musée Charles X in the Louvre.

7. Quoted in Pach 1939/1973, 193; this text is essentially a translation of Delaborde 1870.

8. The place-name Argenteuil was used to distinguish Marcotte from his brothers, called Marcotte de Genlis, Marcotte de Quivières, and Marcotte de Sainte-Marie (the last after the patron saint of his birthday). See Naef 1958, 336 n. 1.

9. M. Vicaire, "Obsèques de M. Marcotte, ancien directeur des Eaux et Forêts," *La Revue des Eaux et Forêts*, Paris, March 1864, quoted in Naef 1958, 340, 342 n. 22.

10. Lapauze 1911, 106.

11. Naef 1977, IV, 123–24.

12. The other obvious touch of red—the rosette of the Legion of Honor—was apparently a later addition, probably by Ingres: Marcotte was not entitled to wear the rosette until he was named to the rank of *commandeur*, on his retirement in 1836. See Lorenz Eitner's entry on the portrait in the forthcoming volume on nineteenth-century French paintings for the *Systematic Catalogue of the Collection, National Gallery of Art*, n. 5. I am grateful to Professor Eitner for sharing his completed manuscript with me. If Ingres himself painted the rosette, it must in fact date from after his return to Paris in 1841.

13. For Eitner, see n. 12 above; Courthion 1947–48, I, 68 (author's translation); see also Pach 1939/1973, 178; both editions are reprints of Delaborde 1870.

14. Wildenstein 1954/1956, no. 91, National Gallery of Art, Washington, Samuel H. Kress Collection; Wildenstein 1954/1956, no. 228, Fogg Art Museum, Harvard University, Cambridge, Massachusetts.

Paris 1789–1863 Paris

*The Marchesa Cunegonda
Misciattelli with Her Infant
and Its Nurse*

———⊷⊶———

Horace Vernet, born two weeks before the fall of the Bastille, was
the grandson of two famous artists of the Ancien Régime, the landscape painter Claude-
Joseph Vernet (1714–1789) and the genre painter Jean Moreau, called Moreau le Jeune
(1741–1814). From his grandfather Moreau and from his father, Antoine-Charles-Horace,
known as Carle Vernet (1758–1836), Horace received his earliest artistic training; he
also studied with the progressive academician François-André Vincent (1746–1816).[2] His
talent and his taste were precocious: drawings from his seventh year show that he had
already taken up one of the principal motifs of his later career, the army battle.[3] In 1808,
when Théodore Géricault (1791–1824) began to visit the studio of Horace's father, the
young men formed a strong bond that was to influence Horace's work in the Romantic vein.
By the end of the first decade of the nineteenth century, his technical facility and his
fascination with Romantic subjects, particularly military themes, were firmly established.
Napoleon awarded him the Legion of Honor in 1814 for his brave defense of Paris under
enemy attack.

After the restoration of the Bourbon monarchy, Vernet became a
well-known figure in Romantic circles. His subjects were wide-ranging, from genre to his-
tory painting, and included many portraits. Like Géricault, he explored the new medium
of lithography, again concentrating on episodes from army life, but also illustrating the
works of the most popular Romantic poets, including the Englishman Lord Byron. (One
of his masterpieces, a painting of 1826, depicted Byron's hero Mazeppa.)[4] Although his
relationships with the monarchy were somewhat strained by the rejection of two allegedly
anti-Royalist paintings at the Salon of 1822, in 1828 Vernet was given the directorship
of the French Academy in Rome, where he was to remain until his nomination as professor
at the École des Beaux-Arts, Paris, in 1835. His successor at the French Academy in Rome
was Ingres (see cat. 56).

Vernet was able to reconcile the depiction of highly charged Romantic
subjects conceived with what Robert Rosenblum has called "epic passion" and a painting
style that more closely approximates the artists of the juste milieu.[5] His accommodation of
this quasi-academic, idealizing manner becomes more apparent after his return to France

1830
Oil on canvas, 52 x 41 in. (132.1 x 104.1 cm)
Inscribed at right: H VERNET *Rome 1830*
University of Arizona Museum of Art, Tucson
61.13.27

PROVENANCE
Marchesa Cunegonda Misciattelli (d. 1842) (? and her husband,
Marchese Geremia Antonio Misciattelli [1793–1865]);[1] by
descent to Marchesa Colocci Vespucci Honorati, Rome;
purchased by Count Alessandro Contini-Bonacossi, Florence;
Samuel H. Kress, New York, 1936 (K1035); on loan to the
University of Arizona Art Gallery, 1951–61; gift of the Kress
Foundation to the University of Arizona Art Gallery, later the
University of Arizona Art Museum, 1961.

SELECTED REFERENCES
Tucson 1951, no. 24; Tucson 1957, no. 24; Eisler 1977, 380–81;
Tucson 1983, 36.

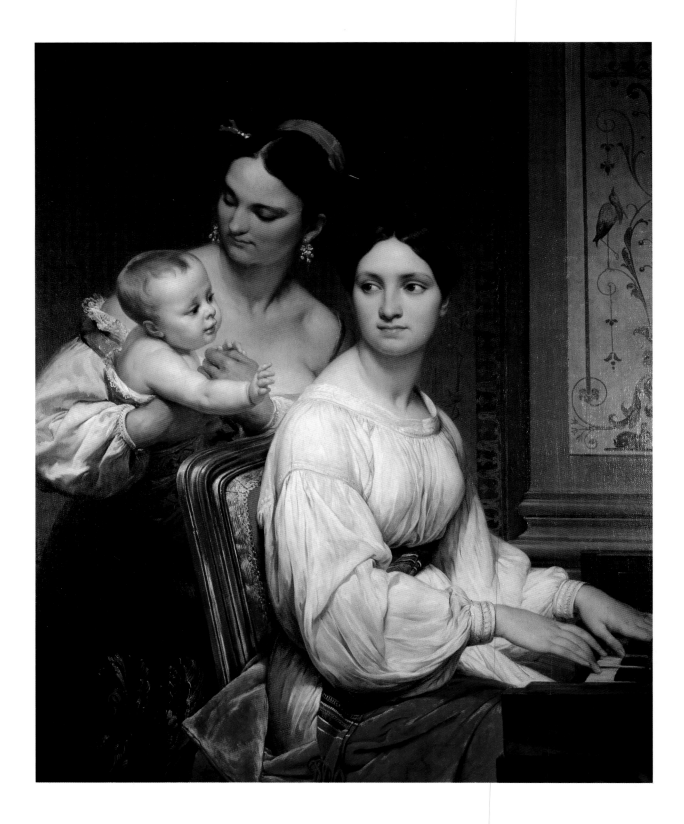

VERNET, *The Marchesa Cunegonda Misciattelli with Her Infant and Its Nurse*

*and his subsequent adoption as one of the principal painters of the reigns of King Louis-
Philippe d'Orléans (his ardent supporter since the 1820s) and the Emperor Napoleon III.
Continuing to celebrate the great military encounters of the French army, Vernet also spe-
cialized in scenes of life among the peoples of North Africa. He was honored, like Ingres
and Eugène Delacroix (1798–1863), with a retrospective exhibition at the Paris Exposition
Universelle of 1855, and died,* grand officier *of the Legion of Honor, in the same year as
Delacroix, 1863.*

Vernet painted portraits both of members of his family and of sitters for whom he worked on commission throughout his career. This painting represents the beautiful Marchesa Cunegonda Misciattelli, who married the Marchese Geremia Antonio Misciattelli in 1815 and who died in 1842. The painting dates from the beginning of Vernet's career as director of the French Academy in Rome, where the Misciattellis, related to the late Pope Leo XII (1760–1829), then lived.[6] The baby in the arms of its nurse at left often has been called a boy, though there is no sure evidence of its gender. It may be that viewers have assumed the baby to be the marchesa's son because of the close parallels between this portrait and Renaissance images of the Holy Family.

The painting, in fact, is loosely based on prototypes found in the work of Raphael (1483–1520), such as the Louvre's *Madonna of Francis I* of 1518 (*fig. 1*). Raphael's style had begun to influence Vernet during his stay in Rome, but even before his departure for Italy Vernet had depicted a scene from the life of Raphael in his *Julius II Ordering the Works of the Vatican and Saint Peter's from Bramante, Michel-angelo, and Raphael*, executed in 1827 for the ceiling of one of the galleries in the Musée Charles X at the Louvre.[7] In 1832, two years after the Misciattelli portrait, he was once again to show the young *Raphael at the Vatican* (*fig. 2*), surrounded by admirers and observed by Julius II, Leonardo da Vinci, and Michelangelo as he draws the figure of a sleeping peasant girl and her naked baby boy.[8] Vernet's painting is one of many images in French art of the 1830s and 1840s that romanticize the life of Raphael, whose youth and beauty were legendary. Many of these images posit commonplace sources of inspiration for Raphael's carefully orchestrated figural groups: in Vernet's imagination, the painter perceives a Madonna and Child in the figure of a peasant and her son, encountered by chance.[9]

Vernet himself evokes the Renaissance trope of the Holy Family in his image of the marchesa, her servant, and child. Within the symbolic framework Vernet nonetheless insists on certain concrete details to characterize the marchesa

and her household. Elements of decor, including the richly ornamental pilaster at right and the lustrous gold of the gilded side chair, disclose the marchesa's social station. And Vernet draws subtle contrasts between the two women, who otherwise resemble each other greatly: The marchesa is

fig. 1 Raphael. *The Madonna of Francis I*. 1518. Oil on canvas, transferred from panel, 81½ x 55⅛ in. (207 x 140 cm). Musée du Louvre, Paris

characterized as an elegant and refined aristocrat, schooled in music, and demurely dressed in modern clothing of a distinctly ideal and archaizing type. The nurse, on the other hand, is dressed in the costume of an Italian peasant, com-

fig. 2 Horace Vernet. *Raphael at the Vatican.* 1832. Oil on canvas, 154⅜ x 118⅛ in. (392 x 300 cm). Musée du Louvre, Paris

plete with dangling earrings, a long hairpin, and colorfully embroidered dress. The peasant woman has been nursing the baby, and her luxuriant bosom contrasts with the delicate and girlish figure of the marchesa.

G.T.M.S.

1. Eisler 1977, 381, does not list the Marchese G. A. Misciattelli in the provenance for the painting; but it seems reasonable to assume that he at least owned the portrait after his wife's death in 1842, and may have commissioned it from Vernet originally.

2. Athanassoglou-Kallmyer 1986, 17, 21–23.

3. See Paris 1980, 20.

4. Avignon, Préfecture. See Paris 1980, nos. 46, 47.

5. Paris 1980, 15.

6. Eisler 1977, 381.

7. Musée du Louvre, Paris, Inv. 8364; exhibited at the Salons of 1827 and 1833. See Paris 1980, 25.

8. Musée du Louvre, Paris, Inv. 8365; exhibited at the Salon of 1833. See Paris 1980, 27.

9. For other images of Raphael and his models, see Paris 1983–84, pls. 334, 340, 341, 345.

Bibliography

ADHÉMAR AND HUYGHE 1950. Adhémar, Helène, and René Huyghe. *Watteau, sa vie, son oeuvre*, preceded by *L'univers de Watteau.* Paris, 1950.

ALAZARD 1950. Alazard, Jean. *Ingres et l'Ingrisme.* Paris, 1950.

ALBERTON VINCO DA SESSO 1986. Alberton Vinco da Sesso, Livia. "Dal Ponte, Leandro, detto Bassano." In *Dizionario biografico degli Italiani*, vol. 32, 188–92. Rome, 1986.

ALGAROTTI 1791–94. Algarotti, Francesco. *Opere del Conte Algarotti.* 17 vols. Venice, 1791–94.

ALLENTOWN 1960. *The Samuel H. Kress Memorial Collection.* Allentown, 1960 (catalogue by Fern Rusk Shapley).

ALLENTOWN 1965. *Seventeenth-Century Painters of Haarlem.* Exh. cat. Allentown Art Museum, April 2–June 13, 1965.

ALLENTOWN 1971. "Circle of Canaletto." Exh., no cat. Allentown Art Museum, February 20–March 21, 1971.

AMSTERDAM 1977. *Opkomst en bloei van het Noordnederlandse stadsgezicht in de 17de eeuw.* Exh. cat. Amsterdams Historisch Museum, June 17–August 28, 1977; Art Gallery of Ontario, Toronto [as *The Dutch Cityscape in the 17th Century and Its Sources*], September 27–November 13, 1977.

ANGULO IÑÍGUEZ 1944. Angulo Iñíguez, Diego. "Un testimonio mejicano de la sordera de Goya." *Archivo Español de Arte* 17 (1944): 391–92.

ANGULO IÑÍGUEZ 1971. Angulo Iñíguez, Diego. *Ars Hispaniae, Pintura del siglo XVII.* Vol. 15. Madrid, 1971.

ANTWERP 1977. *P. P. Rubens, Paintings—Oilsketches—Drawings.* Exh. cat. Royal Museum of Fine Arts, Antwerp, June 2–September 30, 1977.

ARETINO 1957. *Lettere sull'arte di Pietro Aretino.* Ed. E. Camesasca. 2 vols. Milan, 1957.

ARGAN 1957. Argan, G. C. "Tasso e le arti figurative." In *Torquato Tasso.* Milan, 1957: 209–26.

ARISI 1961. Arisi, Ferdinando. *Gian Paolo Panini.* Piacenza, 1961.

ARISI 1986. Arisi, Ferdinando. *Gian Paolo Panini e i fasti della Roma del '700.* Rome, 1986.

ARNALDI 1795. Arnaldi, Lodovico. "Orazione in lode di Marco Foscarini Doge di Venezia." In G. A. Molin, *Orazioni, elogj e vite scritte da letterati patrizij.* Venice, 1795.

ARSLAN 1944. Arslan, Edoardo. "Per la definizione dell'arte di Francesco, Giannantonio e Nicolò Guardi." *Emporium* 100 (1944): 1–28.

ARSLAN 1960. Arslan, Edoardo. *I Bassano.* 2 vols. Milan, 1960.

ART DIGEST 1951. "Wildenstein's Jubilee, a Setting of Brilliants." *Art Digest* 26 (December 1951): 17.

ARTS MAGAZINE 1958. "A Double Benefaction." *Arts Magazine* 32 (May 1958): 34–39.

ASKEW 1969. Askew, Pamela. "The Angelic Consolation of St. Francis of Assisi in Post-Tridentine Italian Painting." *Journal of the Warburg and Courtauld Institutes* 32 (1969): 280–306.

ATHANASSOGLOU-KALLMYER 1986. Athanassoglou-Kallmyer, Nina Maria. "Horace Vernet's 'Academic Study of an Adolescent Boy' and the Artist's Student Years." *Record of The Art Museum, Princeton University* 45 (1986): 17–24.

ATHENS 1979–80. *Domenikos Theotokopoulos (El Greco): Some Works of His Early and Mature Years.* Exh. cat. Benaki Museum, Athens; National Pinakothek, Athens, 1979–80.

ATLANTA 1958. *Italian Paintings and Northern Sculpture from the Samuel H. Kress Collection.* Exh. cat. Atlanta Art Association Galleries, Atlanta, 1958 (catalogue by William E. Suida and Mary M. Davis).

ATLANTA 1965–66. *Masterpieces in the High Museum of Art.* Exh. cat. High Museum of Art, Atlanta, November 13, 1965–January 9, 1966 (catalogue by Paula Hancock).

ATLANTA 1984. *European Art in the High Museum.* Atlanta, 1984 (catalogue by Eric M. Zafran).

ATLANTA 1987. *Selected Works: Outstanding Paintings, Sculpture, and Decorative Art from the Permanent Collection.* High Museum of Art, Atlanta, 1987.

BAGLIONE 1642/1935. Baglione, Giovanni Battista. *Le vite de' pittori scultori et architetti dal pontificato di Gregorio XIII. del 1572 in fino a' tempi di Papa Urbano Ottavo nel 1642.* Rome, 1642; ed. cit., Rome, 1935.

BAILLIO 1988. Baillio, Joseph. "Vigée Le Brun and the Classical Practice of Imitation." In *Paris: Center of Artistic Enlightenment, Papers in Art History from The Pennsylvania State University*, vol. 4. University Park, Pa., 1988: 95–124.

BAILO AND BISCARO 1900. Bailo, Luigi, and Gerolamo Biscaro. *Della vita e delle opere di Paris Bordon.* Treviso, 1900.

BALTIMORE 1938–39. *Religious Art, An Exhibition of Fourteenth-, Fifteenth-, Sixteenth-, and Seventeenth-Century Paintings, Sculpture, Illuminated Manuscripts, Metalwork, Rosaries, Textiles, Stained Glass, and Prints* Exh. cat. Baltimore Museum of Art, December 4, 1938–January 1, 1939.

BALTIMORE 1944. *Three Baroque Masters: Strozzi, Crespi, and Piazzetta.* Baltimore Museum of Art, April 28–June 4, 1944.

BARCHAM 1992. Barcham, William L. *Giambattista Tiepolo.* New York, 1992.

BAROCCHI 1960–62. Barocchi, Paola, ed. *Trattati d'arte del cinquecento, fra manierismo e controriforma.* 3 vols. Bari, 1960–62.

BAROCELLI 1986. Barocelli, Francesco. "Di Gaspare Traversi: Due scene e un autoritratto." *Paragone* 37, 431–33 (January–March 1986): 103–13.

BASAN AND JOULLAIN 1788. Basan, F., and F. C. Joullain. *Catalogue des différents objets de curiosités dans les Sciences et Arts qui composent le Cabinet du feu M. Le Marquis de Ménars, Commandeur des Ordres du Roi . . . Capitaine-Gouverneur du Château et de la Ville de Blois.* Paris, 1788.

BASSANO DEL GRAPPA 1992–93. *Jacopo Bassano c. 1510–1592.* Exh. cat. Museo Civico, Bassano del Grappa, September 5–December 6, 1992; Kimbell Art Museum, Fort Worth, January 23–April 26, 1993.

BASSI-RATHGEB 1955. Bassi-Rathgeb, Roberto. "Un nuovo documento guardesco." *Arte veneta* 9 (1955): 226.

BAUCH 1924. Bauch, Kurt. "Beiträge zur Rubensforschung." *Jahrbuch der preuszischen Kunstsammlungen* 45 (1924): 185–90.

BAUDOUIN 1977. Baudouin, Frans. *Pietro Paulo Rubens.* Trans. Elsie Callander. New York, 1977.

BECK 1972–73. Beck, Hans-Ulrich. *Jan van Goyen.* 2 vols. Amsterdam, 1972–73.

BÉGUIN 1985. Béguin, Sylvie. "Paris Bordon en France." In *Paris Bordon e il suo tempo. Atti del convegno internazionale di studi.* Treviso, 1985: 9–27.

BEHRMAN 1972. Behrman, S. N. *Duveen.* Boston and Toronto, 1972.

BENAGLIO c. 1750–53. Benaglio, Francesco. "'Abbozzo' della vita di Pompeo Battoni pittore lucchese. . . ." In *Vita e prose scelte di Francesco Benaglio* [mss. of 1747–57]. Ed. Angelo Marchesan. Treviso, 1894: 15–66.

BERCKEN 1942. Bercken, Erich von der. *Die Gemälde des Jacopo Tintoretto.* Munich, 1942.

BERENSON 1951. Berenson, Bernard. *Del Caravaggio delle sue incongruenze e della sua fama.* Florence, 1951.

BERENSON 1952. Berenson, Bernard. *The Italian Painters of the Renaissance.* London, 1952.

BERENSON 1953. Berenson, Bernard. *Caravaggio: His Incongruity and His Fame.* London, 1953.

BERENSON 1957. Berenson, Bernard. *Italian Pictures of the Renaissance: A List of the Principal Artists and Their Works with an Index of Places: Venetian School.* 2 vols. London, 1957.

BERGAMO 1949. *Mostra del Magnasco.* Exh. cat. Bergamo, 1949 (catalogue by Antonio Morassi).

BERGSTRÖM 1956. Bergström, Ingvar. *Dutch Still-life Painting.* Trans. Christina Hedström and Gerald Taylor. New York, 1956.

BERGSTRÖM 1963. Bergström, Ingvar. "Juan van der Hamen y León." *L'Oeil* 108 (December 1963): 25–31.

BERGSTRÖM 1970. Bergström, Ingvar. *Maestros españoles de bodegones y floreros del siglo XVII.* Madrid, 1970.

BERLIN 1980. *Bilder von Menschen in der Kunst des Abendlandes.* Exh. cat. Staatliche Museen Preussischer Kulturbesitz, Berlin, 1980.

BERLIN 1991–92. *Rembrandt: The Master and His Workshop.* Exh. cat. Gemäldegalerie Staatliche Museen Preussischer Kulturbesitz, Altes Museum, Berlin, September 12–November 10, 1991; Rijksmuseum, Amsterdam, December 4, 1991–March 1, 1992; National Gallery, London, March 26–May 24, 1992.

BERTINI 1988. Bertini, G. *La Galleria del Duca di Parma. Storia di una collezione.* Bologna, 1988.

BERTO AND PUPPI 1968. Berto, Giuseppe, and Lionello Puppi. *L'opera completa del Canaletto.* Milan, 1968.

BERUETE Y MORET 1922. Beruete y Moret, Aureliano de. *Goya as a Portrait Painter.* Boston and New York, 1922.

BIALOSTOCKI AND WALICKI 1957. Bialostocki, J., and M. Walicki. *Europäische Malerei in polnischen Sammlungen, 1300–1800.* Warsaw, 1957.

BIAVATI 1977–78. Biavati, Giuliana, "Il recupero conoscitivo dei Rubens 'genovesi.'" In *Rubens e Genova* [Exh. cat. Palazzo Ducale, Genoa, December 18, 1977–February 12, 1978]: 149–203.

BINION 1970. Binion, Alice. "From Schulenburg's Gallery and Records." *The Burlington Magazine* 112 (May 1970): 297–301.

BINION 1976. Binion, Alice. *Antonio and Francesco Guardi: Their Life and Milieu.* New York and London, 1976.

BIRMINGHAM 1959. *Birmingham Museum of Art: The Samuel H. Kress Collection.* Birmingham, 1959 (catalogue by William Suida).

BIRMINGHAM 1972. *Veronese & His Studio; in North American Collections.* Exh. cat. Birmingham Museum of Art, October 1–November 15, 1972; Montgomery Museum of Fine Arts, December 5–31, 1972 (catalogue by David Rosand).

BIRMINGHAM 1992–93. *Nicolas Poussin: "Tancred & Erminia."* Exh. cat. Birmingham Museum and Art Gallery, England, October 14, 1992–January 3, 1993 (catalogue by Richard Verdi).

BISSELL 1981. Bissell, R. Ward. *Orazio Gentileschi and the Poetic Tradition in Caravaggesque Painting.* University Park, Pa., 1981.

BLANC 1862–63. Blanc, Charles. *Histoire des peintres de toutes les écoles. Ecole Française.* 3 vols. Paris, 1862–63.

BLANC 1870. Blanc, Charles. *Ingres, sa vie et ses ouvrages.* Paris, 1870.

BLANKERT 1982. Blankert, Albert. *Ferdinand Bol (1616–1680): Rembrandt's Pupil.* Doornspijk, 1982.

BLUM 1919. Blum, André. *Mme. Vigée-LeBrun; peintre des grandes dames du XVIIIe siècle.* Paris, 1919.

BLUNT 1966. Blunt, Anthony. *The Paintings of Nicolas Poussin: A Critical Catalogue.* London, 1966.

BOERLIN-BRODBECK 1973. Boerlin-Brodbeck, Y. *Antoine Watteau und das Theater.* Basel, 1973.

BOIME 1987. Boime, Albert. *Art in an Age of Revolution, 1750–1800. A Social History of Modern Art*, vol. I. Chicago, 1987.

BOK AND KOBAYASHI 1985. Bok, Marten Jan, and Yoriko Kobayashi. "New Data on Hendrick ter Brugghen." *Hoogsteder-Naumann Mercury* 1 (1985): 7–34.

BOLOGNA 1980. Bologna, Ferdinando. *Gaspare Traversi nell' illuminismo europeo.* Naples, 1980.

BOLOGNA 1986–87. *The Age of Correggio and the Carracci: Emilian Painting of the Sixteenth and Seventeenth Centuries.* Exh. cat. Pinacoteca Nazionale, Bologna, September 10–November 10, 1986; National Gallery of Art, Washington, December 19, 1986–February 16, 1987; Metropolitan Museum of Art, New York, March 26–May 24, 1987.

BONA CASTELLOTTI 1985. Bona Castellotti, Marco. "Un *San Giovanni* del Tanzio ritrovato." In *Arte all'incanto.* Milan, 1985: 28–30.

BONI 1787. Boni, Onofrio. *Elogio di Pompeo Girolamo Batoni.* Rome, 1787.

BORENIUS 1939. Borenius, Tancred. "A Tintoretto Exhibition." *The Burlington Magazine* 74 (March 1939): 138.

BOSCHETTO 1968. Boschetto, Antonio. "I 'Coniugi Bonometti' del Ceruti e qualche appunto sulla situazione." *Paragone* 19, 219 (May 1968): 55–62.

BOSCHINI 1660/1966. Boschini, Marco. *La carta del navegar pitoresco, dialogo tra un senator venetian deletante e un professor de pitura, soto nome d'eccelenza e de compare, comparti in oto venti.* Venice, 1660; ed. cit., ed. Anna Pallucchini, Venice and Rome, 1966.

BOSTON 1988–89. *Goya and the Spirit of Enlightenment.* Exh. cat. Museo del Prado, October 6–December 18, 1988; Museum of Fine Arts, Boston, January 18–March 26, 1989; Metropolitan Museum of Art, New York, May 9–July 16, 1989 (catalogue by Alfonso E. Pérez Sánchez, Eleanor A. Sayre, et al.).

BOSTON 1992. *Prized Possessions: European Paintings from Private Collections of Friends of the Museum of Fine Arts, Boston.* Exh. cat. Museum of Fine Arts, Boston, June 17–August 16, 1992.

BOSTON 1993–94. *The Age of Rubens.* Exh. cat. Museum of Fine Arts, Boston, September 22, 1993–January 2, 1994; Toledo Museum of Art, February 20–March 24, 1994 (catalogue by Peter C. Sutton et al.).

BRAEGGER 1989. Braegger, Carlpeter. *I Leoni.* Venice, 1989.

BREDIUS 1935/1969. Bredius, Abraham. *Rembrandt The Complete Edition of the Paintings.* London and New York, 1935; 3rd ed., rev. by Horst Gerson, London, 1969.

BREJON DE LAVERGNÉE 1986. Brejon de Lavergnée, Arnauld. "Grâce à un musée américain le Louvre retrouve un tableau disparu." *La revue du Louvre* 36, 6 (December 1986): 373–78.

BREJON DE LAVERGNÉE 1987. Brejon de Lavergnée, Arnauld. "A Picture by Mola Comes Back to the Louvre." *The Burlington Magazine* 129 (February 1987): 77–79.

BRESCIA 1987. *Giacomo Ceruti Il Pitochetto.* Exh. cat. Monastero di S. Giulia, Brescia, June 13–October 31, 1987.

BRIGANTI 1962/82. Briganti, Giuliano. *Pietro da Cortona: o della pittura barocca.* Florence, 1962; 2nd ed., Florence, 1982.

BRITTON 1808. Britton, John. *Catalogue raisonné of the Pictures belonging to the Most Honourable the Marquis of Stafford in the Gallery of Cleveland House* London, 1808.

BROSSES 1799/1986. Brosses, Charles de. *Lettres d'Italie du Président de Brosses.* Paris, 1799; ed. Frédéric d'Agay, Paris, 1986.

BROWN 1982. Brown, Christopher. *Van Dyck.* Oxford, England, 1982.

BROWN 1989. Brown, Beverly Louise. "Replication and the Art of Veronese." *Studies in the History of Art* 20 (1989): 111–24.

BROWN 1991. Brown, Jonathan. *The Golden Age of Painting in Spain.* New Haven and London, 1991.

BROWN AND MANN 1990. Brown, Jonathan, and Richard G. Mann. *National Gallery of Art: Spanish Paintings of the Fifteenth through Nineteenth Centuries.* Washington, D.C., 1990.

BRUGNOLI 1956. Brugnoli, Maria Vittoria. "Inediti del Gaulli." *Paragone* 7, 81 (September 1956): 21–33.

BRUKENTHAL 1964. *The Brukenthal Museum Fine Arts Gallery.* Bucharest, 1964.

BRUNETTI 1966. Brunetti, Estella. "Considerazioni guardeschi in margine alla mostra." In *Problemi guardeschi. Atti del Convegno di Studi promosso dalla Mostra dei Guardi.* Venice, 1966: 41–50.

BRUSATI 1990–91. Brusati, Celeste. "Stilled Lives: Self-portraiture and self-reflection in seventeenth-century Netherlandish still-life painting." *Simiolus* 20 (1990–91): 168–82.

BRYSON 1981. Bryson, Norman. *Word and Image: French Painting of the Ancien Regime.* Cambridge, 1981.

BUCHANAN 1824. Buchanan, William. *Memoirs of Painting, with a Chronological History of the Importation of Pictures by the Great Masters into England since the French Revolution.* 2 vols. London, 1824.

BURCHARD 1929. Burchard, Ludwig. "Genuesische Frauenbildnisse von Rubens." *Jahrbuch der preuszischen Kunstsammlungen* 50 (1929): 319–49.

BURLINGTON 1962. "The Samuel H. Kress Collection." *The Burlington Magazine* 106 (June 1962): 279 [Editorial].

BURROUGHS 1931. Burroughs, Bryson. *The Metropolitan Museum of Art: Catalogue of Paintings.* 9th ed., New York, 1931.

BYAM SHAW 1958. Byam Shaw, James. "Guardi and his brothers and his son." *Art News* 56, 10 (February 1958): 32–35, 52.

BYAM SHAW 1976. Byam Shaw, James. *Drawings by Old Masters at Christ Church, Oxford.* 2 vols. Oxford, England, 1976.

CAIRNS AND WALKER 1944. Cairns, Huntington, and John Walker, eds. *Masterpieces of Painting from the National Gallery of Art.* New York, 1944.

CAIRNS AND WALKER *PAGEANT* 1944. Cairns, Huntington, and John Walker. *A Pageant of Painting from the National Gallery of Art.* Washington, 1944.

CALIARI 1888. Caliari, Pietro. *Paolo Veronese: sua vita e sue opere: studi storico-estetici.* Rome, 1888.

CALVERT 1908. Calvert, Albert F. *Goya.* London, 1908.

CAMBRIDGE 1956. *Drawings and Oil Sketches by P. P. Rubens from American Collections.* Exh. cat. Fogg Art Museum, Cambridge, January 14–February 29, 1956; Pierpont Morgan Library, New York, March 20–April 28, 1956.

CAMESASCA 1968. Camesasca, Ettore. *L'opera completa di Ingres.* Milan, 1968; French ed., Paris, 1971.

CAMESASCA 1974. Camesasca, Ettore. *L'opera completa del Bellotto.* Milan, 1974.

CAMESASCA AND ROSENBERG 1970. Camesasca, Ettore, and Pierre Rosenberg. *Tout l'oeuvre peint de Watteau.* Paris, 1970; 2nd ed., Paris, 1983. Italian ed., Milan, 1968 [with authors Montagni and Macchia]. Also published in English in 1971 [with authors Camesasca and Sunderland].

CAMÓN AZNAR 1950/1970. Camón Aznar, José. *Dominico Greco.* 2 vols., Madrid, 1950; ed. cit., rev. ed., 2 vols., Madrid, 1970.

CAMPBELL 1990. Campbell, Lorne. *Renaissance Portraits: European Portrait-Painting in the 14th, 15th, and 16th Centuries.* New Haven and London, 1990.

CANBERRA 1992–93. *Rembrandt to Renoir: European Masterpieces from The Fine Arts Museums of San Francisco.* Exh. cat. Australian National Gallery, Canberra, November 14, 1992–January 13, 1993; National Gallery of Victoria, Melbourne, February 19–May 10, 1993; Auckland City Art Gallery, June 5–August 29, 1993.

CANOVA 1961. Canova, Giordana. "I viaggi di Paris Bordone." *Arte veneta* 15 (1961): 77–88.

CANOVA 1964. Canova, Giordana. *Paris Bordon.* Venice, 1964.

CANOVA 1985. Canova, Giordana. "Paris Bordon: Problematiche cronologiche." In *Paris Bordon e il suo tempo. Atti del convegno internazionale di studi.* Treviso, 1985: 137–57.

CANTARO 1989. Cantaro, Maria Teresa. *Lavinia Fontana bolognese, "pittora singolare" 1552–1614.* Milan, 1989.

CAPDEVILA 1936. Capdevila, José Goyanes. *El Greco, pintor mistico.* Madrid, 1936.

CAPPI BENTIVEGNA 1964. Cappi Bentivegna, Ferruccia. *Abbigliamento e Costume nella Pittura Italiana. Barocco e Impero.* Rome, 1964.

CEDAR RAPIDS 1966–67. *Inaugural Exhibition.* Exh. cat. Cedar Rapids Art Center, November 25, 1966–January 5, 1967.

CHAN 1978–79. Chan, Victor. "Watteau's 'Les Comédiens Italiens' Once More." *Revue d'Art Canadien–Canadian Art Review* 5 (1978–79): 107–12.

CHATTANOOGA 1952. Exh. cat. Chattanooga Art Association. George Thomas Hunter Gallery of Art, July 12–August 3, 1952.

CHIARINI 1971. Chiarini, Marco. "Ricci o Magnasco?" In *Atti del congresso internazionale di studi su Sebastiano Ricci e il suo tempo.* Venice, 1971: 146–50.

CHICAGO 1970-71. *Painting in Italy in the Eighteenth Century: Rococo to Revolution.* Exh. cat. The Art Institute of Chicago, September 19–November 1, 1970; The Minneapolis Institute of Arts, November 24, 1970–January 10, 1971; Toledo Museum of Art, February 7–March 21, 1971.

CHRISTIE'S 1965–66. *Christie's Bicentary Review of the Year.* (October 1965–July 1966) Bletchley, England, 1966.

CICCOLINI 1954. Ciccolini, Giovanni. "La famiglia e la patria dei Guardi." *Studi trentini di scienze storiche* 12 (1954): 29–56, 189–200, 341–56.

CLARK 1959. Clark, Anthony M. "Some Early Subject Pictures by P. G. Batoni." *The Burlington Magazine* 101 (June 1959): 232–36.

CLARK 1961. Clark, Anthony M. "A Supply of Ideal Figures." *Paragone* 139 (July 1961): 51–58.

CLARK 1963. Clark, Anthony M. "Batoni's *Triumph of Venice.*" *North Carolina Museum of Art Bulletin* 4, 1 (Fall 1963): 4–11.

CLARK 1981. Clark, Anthony M. *Studies in Roman Eighteenth-Century Painting.* Sel. and ed. Edgar Peters Bowron. Washington, D.C., 1981.

CLARK AND BOWRON 1985. Clark, Anthony M., and Edgar Peters Bowron, eds. *Pompeo Batoni: A Complete Catalogue of his Works with an Introductory Text.* Oxford, England, 1985.

CLEVELAND 1964. *Neo-Classicism: Style and Motif.* Exh. cat. Cleveland Museum of Art, September 21–November 1, 1964 (catalogue by Henry Hawley).

CLEVELAND 1971–72. *Caravaggio and His Followers.* Exh. cat. Cleveland Museum of Art, October 30, 1971–January 2, 1972 (catalogue by Richard E. Spear).

COCKE 1972. Cocke, Richard. *Pier Francesco Mola.* Oxford, England, 1972.

COCKE 1977. Cocke, Richard. "[Review of Pignatti,] *Veronese, L'Opera Completa.*" *The Burlington Magazine* 119 (December 1977): 786–87.

COCKE 1984. Cocke, Richard. *Veronese's Drawings: A Catalogue Raisonné.* London, 1984.

COCKE 1989. Cocke, Richard. "[Exhibition review] Washington/Paolo Veronese." *The Burlington Magazine* 131 (January 1989): 61–64.

COHEN 1983. Cohen, Ronald. *Trafalgar Galleries at the Royal Academy III.* London, 1983.

COLETTI 1940/1944. Coletti, Luigi. *Il Tintoretto.* Bergamo, 1940; ed. cit., Bergamo, 1944.

COLLINS-BAKER 1925. Collins-Baker, C. H. "Old Masters at Messrs. Agnew." *The Burlington Magazine* 46 (June 1925): 299–305.

COLOGNE 1977. *Peter Paul Rubens 1577–1640.* Exh. cat. 2 vols. Wallraf-Richartz-Museums, Cologne, October 15–December 15, 1977.

COLONNA DI STIGLIANO 1895. Colonna di Stigliano, Ferdinando. "Inventario dei Quadri di Casa Colonna fatto da Luca Giordano." *Napoli nobilissima* 4, 1 (1895): 29–32.

COLORNO 1994. *La collezione dei Farnese.* Exh. cat. Palazzo Ducale, Colorno [Parma], March 15–June 15, 1994; Palazzo di Capodimonte, Naples, September–November 1994.

COLUMBIA 1954/1962. *The Columbia Museum of Art: Art of the Renaissance from the Samuel H. Kress Collection.* Columbia, S.C., 1954; 2nd ed., Columbia, S.C., 1962.

COMSTOCK 1939. Comstock, Helen. "Gift of the Kress Collection." *The Connoisseur* 104 (September 1939): 150–51.

COMSTOCK 1955. Comstock, Helen. "The Connoisseur in America: De Young Museum, Gifts from Kress." *The Connoisseur* 136 (September 1955): 71–72.

CONSTABLE 1962. Constable, W. G. *Canaletto.* 2 vols. Oxford, England, 1962.

CONSTABLE AND LINKS 1989. Constable, W. G. *Canaletto.* 2 vols. 2nd ed., rev. J. G. Links. Oxford, England, 1989.

Cook 1903. *Abridged Catalogue of the Pictures at Doughty House, Richmond (Belonging to Sir Frederick Cook, Bart., M. P., Visconde de Monserrate).* London, 1903.

Cook 1905. "The Gallery at Richmond Belonging to Sir Frederick Cook, Bart., M. P., Visconde de Monserrate." *Les Arts* 44 (1905): 2–32.

Cook 1907. *Abridged Catalogue of the Pictures at Doughty House, Richmond (Belonging to Sir Frederick Cook, Bart., Visconde de Monserrate).* London, 1907.

Cook 1913–15. *A Catalogue of the Paintings at Doughty House, Richmond & Elsewhere in the Collection of Sir Frederick Cook, Bt., Visconde de Monserrate.* 3 vols. London, 1913–15.

Cook 1932. *Abridged Catalogue of the Pictures at Doughty House, Richmond, Surrey in the Collection of Sir Herbert Cook, Bart.* London, 1932.

Cook 1944. Cook, Walter S. "El Greco's Laocoon in the National Gallery." *Gazette des beaux-arts* ser. 6, 26 (1944) [published in 1947]: 261–72.

Cooke 1959. Cooke, H. Lester. *French Painting in the Sixteenth–Eighteenth Centuries in the National Gallery of Art.* Washington, D.C., 1959.

Cope 1966. Cope, Maurice E. "Hyacinthe Rigaud." In *Encyclopedia of World Art*, vol. 12. New York, Toronto, and London, 1966.

Copenhagen 1920. *Catalogue of a Collection of Paintings.* Exh. cat. Danish Museum of Fine Art, Copenhagen, Autumn 1920 (catalogue by Karl Madsen).

Corboz 1985. Corboz, André. *Canaletto, Una Venezia immaginaria.* 2 vols. Milan, 1985.

Cossío 1908/1972. Cossío, Manuel B. *El Greco.* Madrid, 1908; ed. cit., rev. ed., *Dominico Theotocopuli El Greco.* Barcelona, 1972.

Courthion 1947–48. Courthion, Pierre. *Ingres, raconté par lui-même et par ses amis.* 2 vols. Paris, 1947–48.

Courville 1958. de Courville, X. *Un apôtre de l'art du théâtre au XVIIIe siècle. La Leçon 1732–1753.* 3 vols. Paris, 1958.

Coutts 1982. Coutts, Howard. "A Ricci Pastiche or a Copy of a Lost Veronese?" *Arte veneta* 36 (1982): 230–32.

Crosato Largher 1964. Crosato Larcher, Luciana. "Per Gabriele Caliari." *Arte veneta* 18 (1964): 174–75.

Crosato Larcher 1967. Crosato Larcher, Luciana. "Per Carletto Caliari." *Arte veneta* 21 (1967): 108–24.

Crosato Larcher 1968. Crosato Larcher, Luciana. "[Review of Marini] *L'opera completa del Veronese*." *Arte veneta* 22 (1968): 220–24.

Crosato Larcher 1969. Crosato Larcher, Luciana. "Note su Benedetto Caliari." *Arte veneta* 23 (1969): 115–30.

Crosato Larcher 1972. Crosato Larcher, Luciana. "Proposte per Francesco Montemezzano." *Arte veneta* 26 (1972): 73–91.

Crosato Larcher 1976. Crosato Larcher, Luciana. "Note per Alvise Benfatto del Friso." *Arte veneta* 30 (1976): 1.

Crow 1985. Crow, Thomas E. *Painters and Public Life in Eighteenth-Century Paris.* New Haven and London, 1985.

Cust 1900. Cust, Lionel. *Anthony van Dyck: An Historical Study of His Life and Works.* London, 1900.

Cust 1911. Cust, Lionel. *Van Dyck, a Further Study.* London and New York, 1911.

Dacier, Vuaflart, and Hérold 1921–29. Dacier, E., A. Vuaflart, and J. Hérold. *Jean de Julienne et les graveurs de Watteau au XVIIIe siècle.* 4 vols. Paris, 1921–29.

Dallas 1951. *Four Centuries of European Painting.* Exh. cat. Dallas Museum of Fine Arts, October 6–31, 1951.

Daniels 1976. Daniels, Jeffery. *Sebastiano Ricci.* Hove, Sussex, 1976.

Dauterman, Parker, and Standen 1964. Dauterman, Carl Christian, James Parker, and Edith Appleton Standen. *Decorative Art from the Samuel H. Kress Collection at the Metropolitan Museum of Art: The Tapestry Room from Croome Court, Furniture, Textiles, Sèvres Porcelains, and Other Objects.* London, 1964.

Davies 1961. Davies, Martin. *National Gallery Catalogues. The Earlier Italian Schools.* 2nd ed., London, 1961.

Davies 1976. Davies, David. *El Greco.* Oxford, England, and New York, 1976.

Dayton 1939–40. "Nine Masterpieces from the Collection of Samuel H. Kress, New York." Exh., no cat. Dayton Art Institute, December 1, 1939–April 8, 1940 [reviewed in *The Art News*, December 23, 1939, 13].

Dayton 1962–63. *Genoese Masters: Cambiaso to Magnasco 1550–1750.* Exh. cat. Dayton Art Institute, October 19–December 2, 1962; John and Mable Ringling Museum of Art, Sarastoa, Florida, January 5–February 17, 1963; Wadsworth Atheneum, Hartford, March 19–May 5, 1963 (catalogue entries by Robert and Bertina Suida Manning).

Dayton 1965–66. *Hendrick Terbrugghen in America.* Exh. cat. Dayton Art Institute, October 15–November 28, 1965; Baltimore Museum of Art, December 19, 1965–January 30, 1966.

De Dominici 1742–45. De Dominici, Bernardo. *Vite de' pittori, scultori ed architetti napoletani.* 3 vols. in 2. Naples, 1742–45.

de' Giorgi 1988. de' Giorgi, Elsa. *L'eredità Contini-Bonacossi.* Milan, 1988.

De Jonge 1938. De Jonge, C. H. *Paulus Moreelse, Portret- en Genreschilder te Utrecht 1571–1638.* Assen, 1938.

De Jongh and Vinken 1961. De Jongh, E., and P. J. Vinken. "Frans Hals als voortzetter van een emblematische traditie. Bij het Huwelijksportret van Isaac Massa en Beatrix van der Laen." *Oud Holland* 76 (1961): 117–57.

De Vecchi 1970. De Vecchi, Pierluigi. *L'opera completa del Tintoretto.* Milan, 1970.

De Vito 1984. De Vito, Giuseppe. "Ritrovamenti e precisazioni a seguito della prima edizione della mostra del '600 napoletano." In *Ricerche sul '600 napoletano.* Milan, 1984: 7–83.

De Vries 1975. De Vries, Lyckle. "Gerard Houckgeest." *Jahrbuch der Hamburger Kunstsammlungen* 20 (1975): 25–26.

Delaborde 1870. Delaborde, Henri. *Ingres, sa vie, ses travaux, sa doctrine, d'après les notes manuscrites et les lettres du Maître.* Paris, 1870.

Delogu 1931. Delogu, Giuseppe. *Pittori minori liguri, lombardi, piemontesi del seicento e del settecento.* Venice, 1931.

Demetz 1958. Demetz, Peter. "The Elm and the Vine: Notes toward the History of a Marriage Topos." *Publications of the Modern Language Association of America* 73 (1958): 521–29.

Denver 1971. *Baroque Art: Era of Elegance.* Exh. cat. Denver Art Museum, October 3–November 15, 1971.

Denver 1978–79. "Masterpieces of French Art: The Fine Arts Museums of San Francisco." Exh., no cat. Denver Art Museum, December 26, 1978–February 18, 1979; Wildenstein & Co., New York, March 14–April 27, 1979; The Minneapolis Institute of Arts, May 24–July 1, 1979.

Desparmet Fitz-Gerald 1928–50. Desparmet Fitz-Gerald, Xavière. *L'Oeuvre Peint de Goya, Catalogue Raisonné.* 4 vols. Paris, 1928–50.

Detroit 1929. *Eighth Loan Exhibition of Old Masters, Paintings by Anthony Van Dyck.* Exh. cat. The Detroit Institute of Arts, April 3–20, 1929.

Detroit 1952. *Venice 1700–1800. An Exhibition of Venice and the Eighteenth Century.* Exh. cat. The Detroit Institute of Arts, 1952; The John Herron Art Museum, Indianapolis, 1952.

Detroit 1965. *Art in Italy, 1600–1700.* Exh. cat. The Detroit Institute of Arts, April 6–May 9, 1965.

Detroit 1981–82. *The Golden Age of Naples: Art and Civilization under the Bourbons 1734–1805.* Exh. cat. The Detroit Institute of Arts, August 11–November 1, 1981; The Art Institute of Chicago, January 16–March 8, 1982.

d'Hulst 1988. d'Hulst, R.-A. *Jacob Jordaens.* Trans. from the Dutch by P. S. Falla. London and Ithaca, N.Y., 1982.

Dresden 1964. *Resümee der wissenschaftlichen Konferenz Bernardo Bellotto, gen. Canalett.* [Publication of papers given at the conference held May 12–13, 1964, at the Staatlichen Kunstsammlungen Dresden, Gemäldegalerie Alte Meister, on the occasion of the German-Polish Bellotto exhibition.]

Du Mortier 1984. Du Mortier, Bianca M. "De handschoen in de huwelijkssymboliek van de zeventiende eeuw." *Bulletin van het Rijksmuseum* 32, 4 (1984): 189–201.

Dubon 1964. Dubon, David. *Tapestries from the Samuel H. Kress Collection at the Philadelphia Museum of Art: The History of Constantine the Great Designed by Peter Paul Rubens and Pietro da Cortona.* London, 1964.

Duncan 1973. Duncan, Carol. "Happy Mothers and Other New Ideas in French Art." *The Art Bulletin* 55 (December 1973): 570–83.

Dussler 1971. Dussler, Luitpold. *Raphael: A Critical Catalogue of his Pictures, Wall Paintings and Tapestries.* London and New York, 1971.

Eidelberg 1977. Eidelberg, M. P. *Watteau's Drawings, Their Use and Significance.* New York and London, 1977.

EINSTEIN 1956. Einstein, Lewis. "Looking at French Eighteenth Century Pictures in Washington." *Gazette des Beaux-Arts* 48 (May–June 1956): 213–50.

EISLER 1977. Eisler, Colin. *Paintings from the Samuel H. Kress Collection: European Schools Excluding Italian.* Oxford, England, 1977.

EKKART AND NIEUWENHUIS 1994. Ekkart, Rudolf E. O., and Erik N. Domela Nieuwenhuis. "Two Portraits by Paulus Moreelse." *The Minneapolis Institute of Arts Bulletin* 67 (1994: forthcoming).

EL PASO 1940–41. Exh., no cat. Texas Centennial Museum, College of Mines and Metallurgy, El Paso, December 7, 1940–January 1, 1941.

EL PASO 1961. *El Paso Museum of Art. The Samuel H. Kress Collection.* El Paso, 1961 (catalogue by Fern Rusk Shapley).

EMERSON 1961. Emerson, Guy. "The Kress Collection: A Gift to the Nation." *National Geographic* 120 (December 1961): 822–65.

EMMERLING 1932. Emmerling, Ernst. *Pompeo Batoni, Sein Leben und Werk. Inaugural-Dissertation zur Erlangung der Doktorwürde einer Hohen Philosophischen Fakultät der Universität Köln* Darmstadt, 1932.

ENGGASS 1956. Enggass, Robert. "Baciccio: Three Little Known Paintings." *Paragone* 7, 73 (January 1956): 30–35.

ENGGASS 1964. Enggass, Robert. *The Paintings of Baciccio: Giovanni Battista Gaulli 1639–1709.* University Park, Pa., 1964.

ENGGASS 1964A. Enggass, Robert. "Addenda to Baciccio: I." *The Burlington Magazine* 106 (February 1964): 76–79.

FABBRO 1967. Fabbro, C. "Tiziano. I Farnese e l'Abbazia di San Pietro in Colle nel Cenedese." *Archivio storico di Belluno, Feltre e Cadore* (January–June 1967): 3.

FEHL 1961. Fehl, Philipp. "Veronese and the Inquisition. A Study of the Subject Matter of the so-called 'Feast in the House of Levi.'" *Gazette des Beaux-Arts* ser. 6, 58 (December 1961): 325–54.

FEHL 1971. Fehl, Philipp. "A Literary Keynote for Pompeo Batoni's 'The Triumph of Venice.'" *North Carolina Museum of Art Bulletin* 10, 3 (March 1971): 3–15.

FEHL 1973. Fehl, Philipp. "Pictorial Precedents for the Representation of Doge Lionardo Loredano in Batoni's *Triumph of Venice.*" *North Carolina Museum of Art Bulletin* 12, 4 (Spring 1973): 20–31.

FELTON 1983. Felton, Craig. "Southern Baroque." In *Encyclopedia of World Art*, vol. 16, 177–94. New York and London, 1983.

FERRÉ 1972. Ferré, J. *Watteau.* 4 vols. Madrid, 1972.

FINLEY 1973. Finley, David Edward. *A Standard of Excellence: Andrew W. Mellon Founds the National Gallery of Art at Washington.* Washington, D.C., 1973.

FIOCCO 1923. Fiocco, Giuseppe. *Francesco Guardi.* Florence, 1923.

FIOCCO 1925–26. Fiocco, Giuseppe. "Il Ridotto ed il Parlatorio del Museo Correr." *Dedalo* 6 (1925–26): 538–46.

FIOCCO 1934. Fiocco, Giuseppe. *Paolo Veronese.* Rome, 1934.

FIOCCO 1952. Fiocco, Giuseppe. "Il problema di Francesco Guardi." *Arte veneta* 6 (1952): 99–120.

FISCHKIN 1925. Fischkin, Rose Mary. "Tintoretto's 'Baptism of Clorinda.'" *Bulletin of the Art Institute of Chicago* 19, 5 (May 1925): 59–60.

FLORENCE 1991. *Artemisia.* Exh. cat. Casa Buonarroti, Florence, June 18–November 4, 1991.

FOGOLARI 1913. Fogolari, Gino. "L'Accademia veneziana di Pittura e Scultura nel Settecento." *L'Arte* 16 (1913): 241–72, 364–94.

FOGOLARI 1916. Fogolari, Gino. "Un dipinto settecentesco della chiesa di Belvedere presso Aquileia." *Arte cristiana* 4 (1916): 97–98.

FÖRSTER 1906. Förster, Richard. "Laokoön im Mittelalter und in der Renaissance." *Jahrbuch der preuszischen Kunstsammlungen* 27 (1906): 149–78.

FORT WORTH 1982. *Elisabeth Louise Vigée Le Brun.* Exh. cat. Kimbell Art Museum, Fort Worth, June 5–August 8, 1982 (catalogue by Joseph Baillio).

FORT WORTH 1985. *Spanish Still Life in the Golden Age 1600–1650.* Exh. cat. Kimbell Art Museum, Fort Worth, May 11–August 4, 1985; Toledo Museum of Art, September 8–November 3, 1985 (catalogue entries by William B. Jordan).

FORT WORTH 1986. *Giuseppe Maria Crespi and the Emergence of Genre Painting in Italy.* Exh. cat. Kimbell Art Museum, Fort Worth, September 20–December 7, 1986 (catalogue by John Spike et al.).

FORT WORTH 1993. *Giambattista Tiepolo: Master of the Oil Sketch.* Exh. cat. Kimbell Art Museum, Fort Worth, September 18–December 12, 1993.

FORTUNATI PIETRANTONIO 1986. Fortunati Pietrantonio, Vera. *Pittura bolognese del '500.* 2 vols. Bologna, 1986.

FOUQUET 1930. Fouquet, Jacques. *La vie d'Ingres.* Paris, 1930.

FOURCAUD 1901. Fourcaud, L. de. "Antoine Watteau." *Revue de l'Art ancien et moderne* [a series of articles published from 1901–9].

FRANCHINI GUELFI 1971/1987. Franchini Guelfi, Fausta. "Alessandro Magnasco." In *La Pittura a Genova e in Liguria.* Genoa, 1971, II, 361–86; rev. ed., Genoa, 1987, II, 325–45.

FRANCHINI GUELFI 1977/1991. Franchini Guelfi, Fausta. *Alessandro Magnasco.* Genoa, 1977; rev. ed., Soncino, 1991.

FRANKFURT 1992. *Kunst in der Republik Genua, 1528–1815.* Exh. cat. Schirn Kunsthalle, Frankfurt, September 5–November 8, 1992 (catalogue by Mary Newcome Schleier et al.; Magnasco entries by Fausta Franchini Guelfi).

FRANKFURTER 1932. Frankfurter, Alfred M. "Eighteenth Century Venice in a New York Collection." *The Fine Arts* 19 (December 1932): 7–10, 30.

FRANKFURTER 1940. Frankfurter, Alfred M. "383 Masterpieces of Art." *Art News Annual* 38 (May 25, 1940): 16–43, 62, 64, 66.

FRANKFURTER 1944. Frankfurter, Alfred M. *The Kress Collection in the National Gallery.* New York, 1944.

FRANKFURTER 1944A. Frankfurter, Alfred M. "French Masterpieces for the National Gallery." *Art News* 43, 10 (August 1–31, 1944): 9–10, 24.

FRANKFURTER 1946. Frankfurter, Alfred M. *Supplement to the Kress Collection in the National Gallery.* New York, 1946.

FRANKFURTER 1951. Frankfurter, Alfred M. "Washington: celebration, evaluation." *Art News* 50 (April 1951): 26–35, 62–63.

FRANKFURTER 1955. Frankfurter, Alfred M. "The Kress Gift to San Francisco." *Art News* 54 (April 1955): 40–43, 57–58.

FRIED 1978. Fried, Alexander. "The Career of Walter Heil." *The Fine Arts Museums of San Francisco: Report 1976–78.* San Francisco, 1978: 42–47.

FRIEDLAENDER 1955/1972. Friedlaender, Walter F. *Caravaggio Studies.* Princeton, 1955; ed. cit., Princeton, 1972.

FRIEDLAENDER 1968. Friedlaender, Walter. *The Drawings of Nicolas Poussin.* London, 1968.

FRITZSCHE 1936. Fritzsche, H. A. *Bernardo Bellotto genannt Canaletto.* Magdeburg, 1936.

FRÖLICH-BUM 1924. Frölich-Bum, Lili. *Ingres, sein Leben und sein Stil.* Vienna and Leipzig, 1924.

FRONGIA 1971. Frongia, M. Luisa. "Giacomo Leonardis incisore di riproduzione." *Arte veneta* 25 (1971): 221–28.

GABILLOT 1905–6. Gabillot, Camille. "Les trois Drouais." *Gazette des Beaux-Arts* 34 (1905): 177–94 [part I], 288–98 [part II], 384–400 [part III]; 35 (1906): 155–74 [part IV], 246–58 [part V].

GALLI 1940. Galli, Romeo. *Lavinia Fontana pittrice 1552–1614.* Imola, 1940.

GANDINO 1894. Gandino, F. "Ambasceria di Marco Foscarini a Roma, 1737–40." *Miscellanea di storia veneta* ser. 2, 2 (1894).

GARAS 1985. Garas, Klara. "Opere di Paris Bordon di Augusta." In *Paris Bordon e il suo tempo. Atti del convegno internazionale di studi.* Treviso, 1985: 71–78.

GARRARD 1989. Garrard, Mary D. *Artemisia Gentileschi: The Image of the Female Hero in Italian Baroque Art.* Princeton, 1989.

GASKELL 1990. Gaskell, Ivan. *The Thyssen-Bornemisza Collection, Seventeenth-Century Dutch and Flemish Painting.* London, 1990.

GASSIER AND WILSON 1971. Gassier, Pierre, and Juliet Wilson. *The Life and Complete Work of Francisco Goya.* New York, 1971.

GAUTHIER 1959. Gauthier, M. *Watteau.* Paris, 1959.

GEALT 1986. Gealt, Adelheid. *Domenico Tiepolo, The Punchinello Drawings.* New York, 1986.

GEIGER 1914/1949. Geiger, Benno. *Alessandro Magnasco.* Berlin, 1914; ed. cit., Italian ed., Bergamo, 1949.

GEIGER 1945. Geiger, Benno. *I Disegni del Magnasco.* Padua, 1945.

GENOA 1949. *Mostra del Magnasco.* Exh. cat. Palazzo Bianco, Genoa, 1949 (catalogue by Antonio Morassi).

GENOA 1977–78. *Rubens e Genova.* Exh. cat. Palazzo Ducale, Genoa, December 18, 1977–February 12, 1978.

GENTRY 1979. Gentry, Jean. *Pier Francesco Mola.* Lugano, 1979.

GERSON 1959. Gerson, Horst. "[Review of] Benedict Nicolson, *Hendrick Terbrugghen*." *Kunstchronik* 12, 11 (November 1959): 314–19.

GERSON 1973. Gerson, Horst. "Symposium: Rembrandt's Workshop and Assistants." In *Rembrandt after Three Hundred Years: A Symposium* [1969]. The Art Institute of Chicago, 1973: 19–31.

GHIRARDI 1984. Ghirardi, A. "Una pittrice bolognese nella Roma del primo Seicento: Lavinia Fontana." *Il Carrobbio* 10 (1984): 148–61.

GILLET 1921. Gillet, L. *Un grand maître du XVIIIe siècle, Watteau.* Paris, 1921.

GIMPEL 1963. Gimpel, R. *Journal d'un collectionneur, marchand de tableaux.* Paris, 1963.

GLENDINNING 1981. Glendinning, Nigel. "Goya's Patrons." *Apollo* 114 (October 1981): 236–47.

GLÜCK 1931. Glück, Gustav. *Van Dyck, des Meisters Gemälde [Klassiker der Kunst 13].* 2nd ed., rev., New York, 1931.

GOFFEN 1989. Goffen, Rona. *Giovanni Bellini.* New Haven and London, 1989.

GOLDNER 1981. Goldner, George R. "A 'Baptism of Christ' by Veronese in the Getty Museum." *The J. Paul Getty Museum Journal* 9 (1981): 111–26.

GOLDSCHEIDER 1938. Goldscheider, Ludwig. *El Greco.* London, 1938.

GONCOURT 1875. Goncourt, E. de. *Catalogue raisonné de l'oeuvre peint, dessiné et gravé d'Antoine Watteau.* Paris, 1875.

GORIS AND HELD 1947. Goris, Jan-Albert, and Julius S. Held. *Rubens in America.* New York, 1947.

GORIZIA 1983. *Da Carlevarijs ai Tiepolo, Incisori veneti e friulani del Settecento.* Exh. cat. Palazzo Attems, Gorizia, 1983; Museo Correr, Venice, 1983.

GRABSKI 1985. Grabski, Józef. "Rime d'amore di Paris Bordon: strutture visuali e poesia rinascimentale." In *Paris Bordon e il suo tempo. Atti del convegno internazionale di studi.* Treviso, 1985: 203–11.

GRAF 1976. Graf, Dieter. *Die Handzeichnungen von Guglielmo Cortese und Giovanni Battista Gaulli.* 2 vols. Düsseldorf, 1976.

GRAF AND SCHLEIER 1973. Graf, Dieter, and Erich Schleier. "Some unknown works by Guglielmo Cortese." *The Burlington Magazine* 115 (December 1973): 794–801.

GRAVES 1913–15. Graves, Algernon. *A Century of Loan Exhibitions 1813–1912.* 5 vols. London, 1913–15.

GREGORI 1982. Gregori, Mina. *Giacomo Ceruti.* Cinisello Balsamo [Milan], 1982.

GUDIOL 1962. Gudiol, Jose. "Iconography and Chronology in El Greco's Paintings of St. Francis." *The Art Bulletin* 44 (September 1962): 195–203.

GUINARD 1956. Guinard, Paul. *El Greco: A Biographical and Critical Study.* Geneva and New York, 1956.

HAAK 1984. Haak, Bob. *The Golden Age: Dutch Painters of the Seventeenth Century.* New York, 1984.

HAARLEM 1969. *Frans Halsmuseum Haarlem.* Haarlem, 1969.

HAARLEM 1986. *Portretten van echt en trouw, Huwelijk en gezin in de Nederlandse kunst van de zeventiende eeuw.* Exh. cat. Frans Halsmuseum, Haarlem, February 15–May 19, 1986.

HAARLEM 1993. *Judith Leyster, A Dutch Master and Her World.* Exh. cat. Frans Halsmuseum, Haarlem, May 14–August 15, 1993; Worcester Art Museum, September 18–December 5, 1993.

HADELN 1924. Hadeln, Detlev von. "Tintoreto [sic] as Illustrator of Torquato Tasso." *Art in America* 12 (1924): 156–57, 161.

HADELN 1926. Hadeln, Detlev von. "Two Paintings of the Baptism by Paolo Veronese." *Apollo* 4 (September 1926): 104–6.

HAMILTON 1942. Hamilton, Edith. *Mythology.* New York, 1942.

HARRIS 1974. Harris, Ann Sutherland. "[Review of Cocke] *Pier Francesco Mola*." *The Art Bulletin* 56 (June 1974): 289–92.

HARTFORD 1947. *A Loan Exhibition of Fifty Painters of Architecture.* Exh. cat. Wadsworth Atheneum, Hartford, October 30–December 25, 1947.

HARTFORD 1991. *Wadsworth Atheneum Paintings II: Italy and Spain, Fourteenth through Nineteenth Centuries* (catalogue by Jean K. Cadogan et al.).

HASKELL 1963/1980. Haskell, Francis. *Patrons and Painters: A Study in the Relations Between Italian Art and Society in the Age of the Baroque.* London, 1963; ed. cit., New Haven, 1980.

HASKELL AND PENNY 1981. Haskell, Francis, and Nicholas Penny. *Taste and the Antique.* New Haven, 1981.

HASLAM 1983. Haslam, Richard. "Kiplin Hall, North Yorkshire." *Country Life* (28 July 1983): 202–5 [part I]; (4 August 1983): 278–81 [part II].

HAUTECOEUR 1945. Hautecoeur, Louis. *Les peintres de la vie familiale.* Paris, 1942.

HAVERKAMP-BEGEMANN 1969. Haverkamp-Begemann, Egbert. "[Exhibition review] Rembrandt und seine Schule. Zur Ausstellung in Kanada." *Kunstchronik* 22, 10 (October 1969): 281–89.

HAVERKAMP-BEGEMANN 1980. Haverkamp-Begemann, Egbert. "Dutch and Flemish Masters of the Seventeenth Century." *Apollo* 111 (March 1980): 207–16.

HAWLEY 1964. Hawley, Henry. "Neoclassicism in Italian Pictures." *Antiques* 536, 3 (September 1964): 316–19.

HEIMBÜRGER RAVALLI 1982. Heimbürger Ravalli, Minna. "Data on the Life and Work of Gaspare Giovanni Traversi (1722?–1770)." *Paragone* 33, 383–85 (January–March 1982): 15–42.

HELD 1959/1986. Held, Julius S. *Rubens, Selected Drawings.* New York, 1959; rev. ed., Mt. Kisco, N.Y., 1986.

HELD 1980. Held, Julius S. *The Oil Sketches of Peter Paul Rubens: A Critical Catalogue.* 2 vols. Princeton, 1980.

HELM 1915. Helm, Henry. *Vigée-Lebrun, Her Life, Works, and Friendships.* Boston, 1915.

HESS 1960. Hess, Thomas B. "Culture as the Great American Dream." *Art News* 60, 8 (December 1960): 35–36, 52, 54–55.

HILDEBRANDT 1922. Hildebrandt, E. *Antoine Watteau.* Berlin, 1922.

HILL AND POLLARD 1967. Hill, G. F., and Graham Pollard. *Renaissance Medals from the Samuel H. Kress Collection.* London, 1967.

HIRST 1981. Hirst, Michael. *Sebastiano del Piombo.* Oxford, England, 1981.

HOFRICHTER 1989. Hofrichter, Frima Fox. *Judith Leyster, A Woman Painter in Holland's Golden Age.* Doornspijk, 1989.

HOFSTEDE DE GROOT 1908–27. Hofstede de Groot, Cornelis. *A Catalogue Raisonné of the Works of the Most Eminent Dutch Painters of the Seventeenth Century.* 8 vols. London, 1908–27.

HOLLSTEIN 1949–92. Hollstein, F. W. H. *Dutch and Flemish Etchings, Engravings and Woodcuts ca. 1450–1700.* 40 vols. Amsterdam, 1949–92.

HOLT 1947. Holt, Elizabeth G. *Literary Sources of Art History; an Anthology of Texts from Theophilus to Goethe.* Princeton, 1947.

HOOKHAM CARPENTER 1844. Hookham Carpenter, William. *Pictorial Notices: consisting of a memoir of Sir Anthony Van Dyck. . . .* London, 1844.

HORSIN-DÉON 1851. Horsin-Déon, S. *De la conservation et de la restauration des tableaux.* Paris, 1851.

HOUBRAKEN 1718, 1719, 1721. Houbraken, Arnold. *De groote Schouburgh der Nederlantsche konstschilders en schilderessen.* 3 vols. Amsterdam, 1718, 1719, and 1721; rep., Amsterdam, 1976.

HOUCK 1899. Houck, M. E. "Mededeelingen betreffende Gerhard Terborch, Robert van Voerst, Pieter van Anraedt, Aleijda Wolfsen, Derck Hardensteijn en Hendrick ter Brugghen." *Verslagen en mededeelingen der Vereeniging tot beoefening van Overijsselsch regt en geschiedenis*, 1899: 348–95.

HOURTICQ 1928. Hourticq, Louis. *Ingres, l'oeuvre du maître.* Paris, 1928.

HOUSTON 1953. *The Samuel H. Kress Collection at the Museum of Fine Arts.* Houston, 1953 (catalogue by William E. Suida).

HOUSTON 1958. *The Guardi Family.* Exh. cat. The Museum of Fine Arts, Houston, January 13–February 16, 1958.

HOUSTON 1981. *The Museum of Fine Arts, Houston, A Guide to the Collection.* Houston, 1981 (introduction by William C. Agee).

HOUSTON 1989. *A Permanent Legacy: 150 Works from the Collection of The Museum of Fine Arts, Houston.* New York, 1989 (introduction by Peter C. Marzio).

HUEMER 1977. Huemer, Frances. *Corpus Rubenianum Ludwig Burchard, Part XIX: Portraits.* Brussels, London, and Philadelphia, 1977.

HULL 1987. Hull, Anthony H. *Goya: Man Among Kings.* New York, 1987.

HURTRET 1950. Hurtret, A. *Watteau, Nogent, les Gobelins.* Paris, 1950.

HUTTINGER 1983. Huttinger, Eduard. "Il 'mito' di Venezia." In Giandomenico Romanelli, *Venezia Vienna: Il mito della cultura veneziana nell'Europa asburgica*. Milan, 1983.

HUYGHE 1937. Huyghe, René. *La peinture française, XVIIIe et XIXe siècles (figures et portraits)*. Paris, 1937.

INDIANAPOLIS 1954. *Pontormo to Greco: The Age of Mannerism; A Loan Exhibition of Paintings and Drawings of the Century 1520–1620*. Exh. cat. The John Herron Art Museum, Indianapolis, February 14–March 28, 1954 (catalogue by Robert O. Parks).

INDIANAPOLIS 1958. *The Young Rembrandt and His Times; a Loan Exhibition of Dutch Painting of the First Four Decades of the Seventeenth Century*. Exh. cat. John Herron Art Museum, Indianapolis, February 14–March 23, 1958; The Fine Arts Gallery, San Diego, April 11–May 18, 1958 (catalogue by David Carter).

INGAMELLS 1992. Ingamells, John. *The Wallace Collection Catalogue of Pictures. IV: Dutch and Flemish Painting*. London, 1992.

INHOFE 1992. Inhofe, Marilyn Metcalfe. *The History of the Samuel H. Kress Foundation's Dispersal of Renaissance Paintings and Sculpture to the Philbrook Museum of Art and Selected Regional Museums*. Unpublished M.A. thesis, University of Tulsa, 1992.

IVANOFF 1964. Ivanoff, N. "Canaletto." In *Kindlers Malerei Lexikon*. 6 vols. Zurich, 1964: I, 607–12.

JAFFÉ 1954. Jaffé, Michael. "Rubens at Rotterdam." *The Burlington Magazine* 96 (February 1954): 53–58.

JAFFÉ 1965. Jaffé, Michael. "Van Dyck Portraits in the De Young Museum and Elsewhere." *Art Quarterly* 28, 1–2 (1965): 41–55.

JAFFÉ 1969. Jaffé, Michael. "Some Recent Acquisitions of Seventeenth-Century Flemish Painting." *National Gallery of Art, Reports and Studies in the History of Art 1969* 3 [Washington, 1970]: 7–34.

JAFFÉ 1977. Jaffé, Michael. *Rubens and Italy*. Oxford, England, 1977.

JAMESON 1844. Jameson, Anna Brownell. *Companion to the Most Celebrated Private Galleries of Art in London*. London, 1844.

JAMOT 1921. Jamot, P. "Watteau Portraitiste." *Gazette des Beaux-Arts* 4 (November 1921): 257–78.

JORDAN 1964–65. Jordan, William. "Juan van der Hamen y León: A Madrilenian Still-Life Painter." *Marsyas* 12 (1964–65): 52–69.

JOSZ 1903. Josz, V. *Watteau. Moeurs du XVIIIe siècle*. Paris, 1903.

JUDSON 1959. Judson, J. Richard. *Gerrit van Honthorst, A Discussion of his Position in Dutch Art*. The Hague, 1959.

JUDSON 1961. Judson, J. Richard. "[Review of] Benedict Nicolson, *Hendrick Terbrugghen*." *The Art Bulletin* 43, 4 (December 1961): 341–48.

JUDSON 1969. Judson, J. Richard. "[Exhibition review] Rembrandt in Canada." *The Burlington Magazine* 111 (November 1969): 703–4.

KANSAS CITY 1983. *Genre*. Exh. cat. The Nelson-Atkins Museum of Art, Kansas City, Missouri, April 5–May 15, 1983.

KEHRER 1914. Kehrer, Hugo. *Die Kunst des Greco*. Munich, 1914.

KEHRER 1926. Kehrer, Hugo. *Spanische Kunst*. Munich, 1926.

KEHRER 1939. Kehrer, Hugo. *Greco als Gestalt des Manierismus*. Munich, 1939.

KELLY 1939. Kelly, Francis M. "Note on an Italian Portrait at Doughty House." *The Burlington Magazine* 75 (August 1939): 75–77.

KENNEDY 1969. Kennedy, I. G. "Claude Lorrain and Topography." *Apollo* 90 (October 1969): 304–9.

KETTERING 1983. Kettering, Alison McNeil. *The Dutch Arcadia, Pastoral Art and Its Audience in the Golden Age*. Totowa, N.J., and Montclair, N.J., 1983.

KITAURA 1986. Kitaura, Yasunari. "El procedor artístico de El Greco." *Boletin del Museo de Prado* 7 (1986): 85–91.

KITSON 1967. Kitson, Michael. "Claude Lorrain: Two Unpublished Paintings and the Problem of Variants." In *Studies in Renaissance and Baroque Art Presented to Anthony Blunt on his 60th Birthday*. London, 1967: 142–49.

KITSON 1978. Kitson, Michael. *Claude Lorrain: Liber Veritatis*. London, 1978.

KNOX 1960/1975. Knox, George. *Catalogue of the Tiepolo Drawings in the Victoria and Albert Museum*. London, 1960; 2nd ed., London, 1975.

KNOX 1978. Knox, George. "The Tasso Cycles of Giambattista Tiepolo and Gianantonio Guardi." *The Art Institute of Chicago Museum Studies* 9 (1978): 49–95.

KNOX 1980. Knox, George. *Giambattista and Domenico Tiepolo: A Study and Catalogue Raisonné of the Chalk Drawings*. 2 vols. Oxford, England, 1980.

KOPPER 1991. Kopper, Philip. *America's National Gallery of Art: A Gift to the Nation*. New York, 1991.

KOZAKIEWICZ 1960. Kozakiewicz, Stefan. "Lorenzo Bellotto, syn Bernarda i zagadnienie jego wspólpracy z ojcem." *Biuletyn Historii Sztuki* 22 (1960): 140–57.

KOZAKIEWICZ 1965. Kozakiewicz, Stefan. "Un pittore quasi sconosciuto, Lorenzo Bellotto, figlio di Bernardo e una serie bellottiana di vedute di Roma." In *Venezia e la Polonia nei secoli dal XVII al XIX [Civiltà Veneziana, Studi, 19]*. Venice and Rome, 1965: 87–103.

KOZAKIEWICZ 1972. Kozakiewicz, Stefan. *Bernardo Bellotto*. 2 vols. Greenwich, Conn., 1972.

KUBLER AND SORIA 1959. Kubler, George, and Martin Soria. *Art and Architecture in Spain and Portugal and Their American Dominions 1500 to 1800*. Harmondsworth, Middlesex, 1959.

KUSCHE 1964. Kusche, Maria. *Juan Pantoja de la Cruz*. Madrid, 1964.

LAFOND 1902. Lafond, Paul. *Goya*. Paris, 1902.

LAFUENTE FERRARI AND PITA ANDRADE 1975. Lafuente Ferrari, Enrique, and José Manuel Pita Andrade. *El Greco: The Expressionism of His Final Years*. New York, 1975.

LANZI 1795–96. Lanzi, Luigi. *Storia pittorica della Italia dal Risorgimento delle Belle Arti fin presso al fine del XVIII secolo*. 2 vols. in 3. Bassano, 1795–96.

LAPAUZE 1901. Lapauze, Henry. *Les dessins de J.-A.-D. Ingres au Musée de Montauban*. 5 vols. Paris, 1901.

LAPAUZE 1903. Lapauze, Henry. *Les portraits dessinés de J. A. D. Ingres*. Paris, 1903.

LAPAUZE 1911. Lapauze, Henry. *Ingres, sa vie et son oeuvre*. Paris, 1911.

LARSEN 1955. Larsen, Erik. "The Samuel H. Kress Collection at the M. H. de Young Memorial Museum, San Francisco." *Apollo* 61 (June 1955): 172–77.

LARSEN 1988. Larsen, Erik. *The Paintings of Anthony van Dyck*. 2 vols. Freren, 1988.

LATTUADA 1989–90. Lattuada, Riccardo. "Osservazioni su due inediti di Massimo Stanzione." *Prospettiva* 57–60 (1989–90): 232–40.

LAWRENCE 1991. Lawrence, Cynthia. *Gerrit Adriaensz. Berckheyde (1638–1698), Haarlem Cityscape Painter*. Doornspijk, 1991.

LEA 1934/1962. Lea, Kathleen M. *Italian Popular Comedy: A Study in the Commedia dell' Arte, 1560–1620* 2 vols. Oxford, England, 1934; 2nd ed., New York, 1962.

LEAMINGTON 1947. *Re-opening Exhibition of Oil Paintings . . . Selected from the Cook Collection* Exh. cat. Royal Leamington Spa Art Gallery, July 28–August 30, 1947, September 21–November 15, 1947.

LEE 1967. Lee, Rensselaer W. "Mola and Tasso." In *Studies in Renaissance and Baroque Art Presented to Anthony Blunt on his 60th Birthday*. London, 1967: 136–41.

LEE 1980. Lee, Thomas P. "Recently Acquired French Paintings: Reflections on the Past." *Apollo* 111 (March 1980): 212–23.

LEEDS 1868. *National Exhibition of Works of Art, at Leeds, 1868*. Exh. cat. Leeds, 1868.

LEEDS 1936. *Masterpieces from the Collections of Yorkshire and Durham*. Exh. cat. City Art Gallery, Leeds, July 6–31, 1936.

LEIDEN 1926. *Jan Steen Tentoonstelling*. Exh. cat. Stedlijk Museum "De Lakenhal," Leiden, 1926.

LENINGRAD 1976. *Paintings from American Museums*. Exh. cat. Hermitage Museum, Leningrad, February 11–March 24, 1976; Pushkin Museum of Fine Arts, Moscow, April 8–May 20, 1976; Museum of Ukranian Art, Kiev, June 3–July 15, 1976; Bielorussian Museum of Fine Arts, Minsk, July 30–September 10, 1976.

LEONE DE CASTRIS AND MIDDIONE 1986. Leone de Castris, Pierluigi, and Roberto Middione. *La Quadreria dei Girolamini*. Naples, 1986.

LEVEY 1957. Levey, Michael. "Tiepolo's *Empire of Flora*." *The Burlington Magazine* 99 (March 1957): 89–91.

LEVEY 1960. Levey, Michael. "Two Paintings by Tiepolo from the Algarotti Collection." *The Burlington Magazine* 102 (June 1960): 250–57.

LEVEY 1962. Levey, Michael. "Notes on the Royal Collection II: Artemisia Gentileschi's *Self-Portrait* at Hampton Court." *The Burlington Magazine* 104 (January 1962): 79–81.

LEVEY 1964/1991. Levey, Michael. *The Later Italian Pictures in the Collection of Her Majesty the Queen.* Cambridge, 1964; 2nd ed., 1991.

LEVEY 1986. Levey, Michael. *Giambattista Tiepolo: His Life and Art.* New Haven and London, 1986.

LIEDTKE 1979. Liedtke, Walter A. "Pride in Perspective: The Dutch Townscape." *The Connoisseur* 200 (April 1979): 264–73.

LIEDTKE 1982. Liedtke, Walter A. *Architectural Painting in Delft.* Doornspijk, 1982.

LIFE 1953. "The Great Kress Giveaway." *Life* 35 (16 November 1953): 146–64.

LINKS 1982. Links, J. G. *Canaletto.* Ithaca, 1982.

LOGA 1921. Loga, Valerian von. *Goya.* Berlin, 1921.

LONDON 1798–99. *Catalogue of the Orleans' Italian Pictures . . . Exhibited for Sale by Private Contract* Mr. Bryan's Gallery, London, December 26, 1798, and following days.

LONDON 1821. *Pictures of the Italian, Spanish, Flemish, and Dutch Schools.* Exh. cat. British Institution, London, 1821.

LONDON 1832. *Pictures by Italian, Spanish, Flemish, Dutch, and English Masters.* Exh. cat. British Institution, London, 1832.

LONDON 1871. *Works of the Old Masters.* Exh. cat. Royal Academy of Arts, London, 1871.

LONDON 1887. *Exhibition of the Works of Sir Anthony van Dyck.* Grosvenor Gallery, London, 1887.

LONDON 1895–96. *Exhibition of Spanish Art Under the Patronage of Her Majesty the Queen Regent of Spain.* Exh. cat. The New Gallery, London, 1895–96.

LONDON 1902. *Works by Old Masters.* Exh. cat. Royal Academy of Arts, London, Winter 1902.

LONDON 1902A. *A Selection of Works by French and English Painters of the Eighteenth Century.* Exh. cat. Guildhall Corporation Art Gallery, London, 1902.

LONDON 1909. *A Loan of Pictures by Jan Steen.* Exh. cat. Dowdeswell Galleries, London, May–June, 1909.

LONDON 1912. *Winter Exhibition.* Exh. cat. Royal Academy, London, 1912.

LONDON 1913–14. *Illustrated Catalogue of the Exhibition of Spanish Old Masters in Support of the National Gallery Funds and for the Benefit of the Sociedad de Amigos del Arte Española.* Exh. cat. Grafton Galleries, London, 1913–14 (catalogue by Maurice W. Brockwell).

LONDON 1914. *Venetian School.* Exh. cat. Burlington Fine Arts Club, London, 1914.

LONDON 1925. *Pictures by Old Masters.* Exh. cat. Thomas Agnew and Sons, London, 1925.

LONDON 1927. *Catalogue of the Loan Exhibition of Flemish & Belgian Art, a Memorial Volume.* Exh. cat. Royal Academy of Arts, London, 1927.

LONDON 1932. *French Art, 1200–1900.* Exh. cat. Royal Academy of Arts, London, January–March, 1932.

LONDON 1950. *A Loan Exhibition of Works by Peter Paul Rubens, Kt.* Exh. cat. Wildenstein & Co., London, 1950 (catalogue by Ludwig Burchard).

LONDON 1950–51. *Exhibition of Works by Holbein & Other Masters of the 16th and 17th Centuries.* Exh. cat. Royal Academy of Arts, London, 1950–51.

LONDON 1953–54. *Flemish Art 1300–1700.* Exh. cat. Royal Academy of Arts, London, 1953–54.

LONDON 1963–64. *Goya and His Times.* Exh. cat. Royal Academy of Arts, London, Winter 1963–64.

LONDON 1979. *Old Master Paintings and Drawings.* Exh. cat. P. & D. Colnaghi & Co., London, June 19–August 3, 1979.

LONDON 1981. *Exhibition of Old Masters.* Exh. cat. Knoedler Gallery, London, May 7–June 6, 1981.

LONDON 1981A. *A Dealer's Record: Agnew's 1967–81.* London, 1981.

LONDON 1982. *Pompeo Batoni (1708–87) and His British Patrons.* Exh. cat. Greater London Council, The Iveagh Bequest, Kenwood, June 8–August 30, 1982 (catalogue by Anthony Clark, Edgar Peters Bowron, and Francis Russell).

LONDON 1982–83. *Van Dyck in England.* Exh. cat. National Portrait Gallery, London, November 19, 1982–March 20, 1983 (catalogue by Oliver Millar).

LONDON 1983–84. *The Genius of Venice, 1500–1600.* Exh. cat. Royal Academy of Arts, London, November 25, 1983–March 11, 1984.

LONDON 1984. *Art, Commerce, Scholarship: A Window onto the Art World—Colnaghi 1760 to 1984.* Exh. cat. P. & D. Colnaghi & Co. London, November 7–December 15, 1984.

LONDON 1991–92. *Toulouse-Lautrec.* Hayward Gallery, London, October 10, 1991–January 19, 1992; Galeries Nationales du Grand Palais, Paris, February 21–June 1, 1992 (catalogue by Claire Frèches-Thory, Anne Roquebert, and Richard Thomson).

LONDON 1992. *Dutch and Flemish Old Master Paintings.* Exh. cat. Johnny van Haeften, London, 1992.

LONGHI 1915/1961. Longhi, Roberto. "Battistello." *L'Arte* 18 (1915): 58–75, 120–37; repr. in *Opere complete di Roberto Longhi. I. Scritti giovanili 1912–1922.* 2 vols. Florence, 1961: I, 177–211.

LONGHI 1916/1961. Longhi, Roberto. "Gentileschi padre e figlia." *L'Arte* 19 (1916): 245–314; repr. in *Opere complete di Roberto Longhi I. Scritti giovanili 1912–1922.* 2 vols. Florence, 1961: I, 219–83.

LONGHI 1927/1967. Longhi, Roberto. "Terbrugghen e la parte nostra." *Vita artistica* 2 (1927): 105–16; repr. in *Opere complete di Roberto Longhi. Saggi e ricerche 1925–1928.* 2 vols. Florence, 1967: II, 163–78.

LONGHI 1927A/1967. Longhi, Roberto. "Di Gaspare Traversi." *Vita artistica* 2 (1927): 145–67; repr. in *Opere complete di Roberto Longhi. Saggi e ricerche 1925–1928.* 2 vols. Florence, 1967: II, 189–219.

LONGHI 1943. Longhi, Roberto. "Ultimi studi sul Caravaggio e la sua cerchia." *Porporzioni* 1 (1943): 5–63.

LONGHI 1950. Longhi, Roberto. "Un momento importante nella storia della 'Natura Morte.'" *Paragone* 1, 1 (January 1950): 34–39.

LONGHI 1952. Longhi, Roberto. "Caravaggio en de Nederlanden, catalogus, Utrecht-Anversa, 1952." *Paragone* 3, 33 (September 1952): 52–58.

LÓPEZ NAVIO 1962. López Navio, José. "La gran colección de pinturas del Marqués de Leganés." *Analecta Calasanctiana* 8 (1962): 260–330.

LOS ANGELES 1976–77. *Women Artists 1550–1950.* Los Angeles County Museum of Art, December 21, 1976–March 13, 1977; University Art Museum, University of Texas at Austin, April 12–June 12, 1977; Museum of Art, Carnegie Institute, Pittsburgh, July 14–September 4, 1977; The Brooklyn Museum, October 8–November 27, 1977 (catalogue by Ann Sutherland Harris and Linda Nochlin).

LOUISVILLE 1948. *A Gallery of Eighteenth Century Venetian Paintings.* Exh. cat. The J. B. Speed Art Museum, Louisville, June 2–29, 1948.

LOUISVILLE 1967. *Alessandro Magnasco (1667–1749).* Exh. cat. The J. B. Speed Art Museum, Louisville, February 20–March 26, 1967; University of Michigan Museum of Art, Ann Arbor, April–May, 1967.

LOUISVILLE 1983–84. *Ingres. In Pursuit of Perfection: The Art of J. A. D. Ingres.* Exh. cat. The J. B. Speed Art Museum, Louisville, December 6, 1983–January 1984; Kimbell Art Museum, Fort Worth, March 3–May 6, 1984 (catalogue by Patricia Condon et al.).

LOUISVILLE 1990. *The Mask of Comedy: The Art of Italian Commedia.* Exh. cat. The J. B. Speed Art Museum, Louisville, September 11–November 4, 1990 (catalogue by Eleonora Luciano).

LUCCA 1967. *Mostra di Pompeo Batoni.* Exh. cat. Palazzo Ducale, Lucca, July–September, 1967 (catalogue ed. Isa Belli Barsali); 2nd ed., Lucca, 1985.

LUCCO 1980. Lucco, Mauro. *L'opera completa di Sebastiano del Piombo.* Milan, 1980.

LUGANO 1989–90. *Pier Francesco Mola: 1612–1666.* Exh. cat. Museo Cantonale d'Arte, Lugano, September 23–November 19, 1989; Musei Capitolini, Rome, December 3, 1989–January 31, 1990.

MACANDREW 1978. Macandrew, Hugh. "A Group of Batoni Drawings at Eton College and Some Eighteenth-Century Italian Copyists of Classical Sculpture." *Master Drawings* 16 (1978): 131–50.

MACANDREW AND GRAF 1972. Macandrew, Hugh, and Dieter Graf. "Baciccio's Later Drawings: A Re-Discovered Group Acquired by the Ashmolean Museum." *Master Drawings* 10 (Autumn 1972): 231–59.

McBride 1940. McBride, Ruth Q. "Old Masters in a New National Gallery." *The National Geographic Magazine* (July 1940): 1–50.

MacLaren and Brown 1991. MacLaren, Neil. *National Gallery Catalogues. The Dutch School 1600–1900.* 2 vols. Rev. and exp. ed. by Christopher Brown. London, 1991.

Madrid 1900. *Las Obras de Goya.* Exh. cat. Ministerio de Instrucción Pública y Bellas Artes, Madrid, May 1900.

Madrid 1982–83. *El Greco of Toledo.* Exh. cat. Museo del Prado, Madrid, April 1–June 6, 1982; National Gallery of Art, Washington, July 2–September 6, 1982; Toledo Museum of Art, September 26–November 21, 1982; Dallas Museum of Fine Arts, December 12, 1982–February 6, 1983 (catalogue by William Jordan et al.).

Madrid 1983–84. *Pintura española de bodegones y floreros de 1600 a Goya.* Exh. cat. Museo del Prado, Madrid, November 1983–January 1984.

Madrid 1990. *Alonso Sánchez Coello y el Retrato en la Corte de Felipe II.* Exh. cat. Museo del Prado, Madrid, June–July, 1990.

Madrid 1992–93. *Goya, La Decada de los Caprichos, Retratos 1792–1804.* Exh. cat. Real Academie de Bellas Artes de San Fernando, Madrid, October 26, 1992–January 10, 1993.

Maffei 1948/1951. Maffei, Fernanda de. *Gian Antonio Guardi pittore di figura.* Verona, 1948; ed. cit., Verona, 1951.

Magimel 1851. Magimel, Albert. *Oeuvres de J. A. Ingres . . . gravés au trait sur acier par Ale. Reveil 1800–1851.* Paris, 1951.

Mâle 1932/1951. Mâle, Emile. *L'Art religieux de la fin du XVIe siècle, du XVIIe siècle, du XVIIIe siècle; étude sur l'iconographie après le Concile de Trente, Italie-France-Espagne-Flandres.* Paris, 1932; ed. cit., rev. ed., Paris, 1951.

Mallè 1961. Mallè, Luigi. *Le arti figurative in Piemonte dalle origini al periodo romantico.* Turin, 1961.

Malvasia 1678/1841. Malvasia, Carlo Cesare. *Felsina pittrice: vite de' pittori bolognesi.* Bologna, 1678; ed. cit., 2 vols., Bologna, 1841.

Manchester 1857. *Art Treasures of the United Kingdom, Loan Exhibition.* Exh. cat. Manchester, 1857.

Manfrin 1856. *Catalogo dei quadri esistenti nella Galleria Manfrin in Venezia.* Venice, 1856.

Manke 1963. Manke, Ilse. *Emanuel de Witte.* Amsterdam, 1963.

Manzini and Frati 1969. Manzini, Gianna, and Tiziana Frati. *L'opera completa del Greco.* Milan, 1969.

Marini 1968. Marini, Remigio. *L'opera completa del Veronese.* Milan, 1968.

Martin 1954. Martin, Willem. *Jan Steen.* Amsterdam, 1954.

Martin 1968. Martin, John Rupert. *Corpus Rubenianum Ludwig Burchard, Part I: The Ceiling Paintings for the Jesuit Church in Antwerp.* London and New York, 1968.

Martini 1964. Martini, Egidio. *La pittura veneziana del '700.* Venice, 1964.

Mason Rinaldi 1984. Mason Rinaldi, Stefania. *Palma il Giovane.* Milan, 1984.

Mathey 1959. Mathey, J. *Antoine Watteau, peintures réapparues, inconnues, ou négligées par les historiens, identification par les dessins, chronologie.* Paris, 1959.

Maxon 1953. Maxon, John Moore. "A Scene from Tasso by Jacopo Robusti Il Tintoretto." *Museum Notes. Rhode Island School of Design* 11, 1 (Fall 1953): 1–4.

Maxon 1957. Maxon, John Moore. "Two Notes on Tintoretto." *Bulletin of the Rhode Island School of Design* 44, 2 (December 1957): 1–2.

Mayer 1910. Mayer, August L. "Der Racionero Alonso Cano und die Kunst von Granada." *Jahrbuch der königlich preussischen Kunstsammlungen* 31 (1910): 1–29.

Mayer 1924. Mayer, August Liebmann. *Goya.* London and Toronto, 1924.

Mayer 1931. Mayer, August. *El Greco.* Berlin, 1931.

Memphis 1932–33. *An Exhibition of Italian Paintings Lent by Mr. Samuel H. Kress to Brooks Memorial Art Gallery.* Exh. cat. Brooks Memorial Art Gallery, Memphis, December 4, 1932–January 1, 1933.

Memphis 1958. *The Samuel H. Kress Collection.* Brooks Memorial Art Gallery, Memphis, 1958 (catalogue by William E. Suida).

Memphis 1965–66. *Sebastiano and Marco Ricci in America.* Brooks Memorial Art Gallery, Memphis, December 19, 1965–January 23, 1966; University of Kentucky Art Gallery, Lexington, February 13–March 6, 1966 (catalogue by Michael Milkovich).

Memphis 1966. *The Samuel H. Kress Collection.* Brooks Memorial Art Gallery, Memphis, 1966 (catalogue by William E. Suida; rev. by Michael Milkovich).

Merson 1867. Merson, Olivier. *Ingres, sa vie et ses oeuvres, avec catalogue des oeuvres du Maître par Émile Bellier de la Chavignerie.* Paris, 1867.

Middledorf 1976. Middledorf, Ulrich. *Sculptures from the Samuel H. Kress Collection: European Schools XIV–XIX.* London, 1976.

Milan 1953. *I Pittori della realità in Lombardia.* Exh. cat. Palazzo Reale, Milan, April–July, 1953 (catalogue by Roberto Longhi, Renata Cipriani, and Giovanni Testori).

Milan 1973. *Il Seicento lombardo.* Exh. cat. 3 vols. Palazzo Reale, Milan, 1973.

Millar 1954. Millar, Oliver. "Charles I, Honthorst, and Van Dyck." *The Burlington Magazine* 96 (February 1954): 36–42.

Milwaukee 1966. *The Inner Circle.* Exh. cat. Milwaukee Art Center, September 15–October 23, 1966.

Minneapolis 1987–89. *Selections from the Permanent Collection of Memphis Brooks Museum of Art.* Exh. cat. The Minneapolis Institute of Arts, June 1, 1987–July 31, 1989.

Minott 1962. Minott, Charles I. "An Additional Note on Terbrugghen's 'David and the Singers.'" *North Carolina Museum of Art Calendar of Events* 5, 10 (August–September, 1962).

Mirimonde 1961. Mirimonde, A. P. de. "Les sujets musicaux chez Antoine Watteau." *Gazette des Beaux-Arts* 58 (November 1961): 249–88.

Mirimonde 1977. Mirimonde, A. P. de. *L'iconographie musicale sous les rois Bourbons. La musique dans les arts plastiques, XVII–XVIIIe siècles.* 2 vols. Paris, 1977.

Moffitt 1984. Moffitt, John F. "A Christianization of Pagan Antiquity: Giovanni Andrea Gilio da Fabriano, Antonio Possevino, and the 'Laocoön' of Domenico Theotocopouli, 'El Greco.'" *Paragone* 35, 417 (November 1984): 44–60.

Moir 1967. Moir, Alfred. *The Italian Followers of Caravaggio.* 2 vols. Cambridge, Mass., 1967.

Mojana 1989. Mojana, Marina. *Valentin de Boulogne.* Milan, 1989.

Molino 1795. Molino, Sebastiano. "Orazione in lode di Marco Foscarini Procurator di S. Marco." In G. A. Molin, *Orazioni, elogj e vite scritte da letterati patrizij.* Venice, 1795.

Molmenti 1909/1911. Molmenti, Pompeo. *G. B. Tiepolo.* Milan, 1909; 2nd ed., Paris, 1911.

Moltke 1965. Moltke, J. W. von. *Govaert Flinck, 1615–1660.* Amsterdam, 1965.

Momméja 1904. Momméja, Jules. *Les grands artistes, leur vie, leur oeuvre: Ingres.* Paris, 1904.

Montangie 1858. *Catalogue de Tableaux anciens du Cabinet et de la Bibliothèque délaissés par M. Pierre Rousseau (1802–1857), artiste-peintre et sculpteur.* Bruges, 1858 (catalogue by J. F. Montangie *fils*).

Montgomery 1984. Exh., no cat. Montgomery Museum of Fine Arts, Montgomery, Alabama, October 7–December 2, 1984 [exhibition to supplement *The Biblical Paintings of J. James Tissot*].

Montpensier 1866. *Catálogo de cuadros, dibujos y esculturas pertenecientes á la galería de SS. AA. RR. los Sermos. Sres. Infantes, Duques de Montpensier en su palacio de Sanlúcar de Barrameda.* Seville, 1866.

Montreal 1942. *Masterpieces of Painting.* Exh. cat. The Montreal Museum of Fine Arts, February–March 1942.

Montreal 1969. *Rembrandt and His Pupils.* Exh. cat. The Montreal Museum of Fine Arts, January 9–February 23, 1969; Art Gallery of Ontario, Toronto, March 14–April 27, 1969 (catalogue by David Carter).

Montrosier 1882. Montrosier, Eugène. *Peintres modernes, Ingres, H. Flandrin, Robert-Fleury.* Paris, 1882.

Moore 1990. Moore, Susan. "On Baer's Walls." *Art & Auction* 13 (July/August 1990): 66, 68, 70, 72.

Morassi 1960. Morassi, Antonio. "Antonio Guardi ai Servigi del feldmaresciallo Schulenburg." *Emporium* 131 (1960): 147–64, 199–212.

Morassi 1962. Morassi, Antonio. *A Complete Catalogue of the Paintings of G. B. Tiepolo.* Greenwich, Conn., 1962.

Morassi 1967. Morassi, Antonio. "Giacomo Ceruti detto il 'Pitochetto,' pittore verista." *Pantheon* 25, 5 (September–October 1967): 348–67.

Morassi 1968. Morassi, Antonio. "Un Battesimo inedito di Paolo Veronese." *Arte veneta* 22 (1968): 30–38.

Morassi 1973. Morassi, Antonio. *Guardi. Antonio e Francesco Guardi.* 2 vols. Venice, 1973.

Moschini 1954. Moschini, Vittorio. *Canaletto.* Milan, 1954.

Muller 1972. Muller, Priscilla E. *Jewels in Spain 1500–1800.* New York, 1972.

Müller Hofstede 1965. Müller Hofstede, Justus. "Bildnisse aus Rubens' Italienjahren." *Jahrbuch der staatlichen Kunstsammlungen in Baden-Württemberg* 2 (1965): 89–154.

Müller Hofstede 1974. Müller Hofstede, Justus. "Two Unpublished Drawings by Rubens." *Master Drawings* 12 (Summer 1974): 133–37.

Munich 1910. *Sonderausstellung El Greco.* Exh. cat. Alte Pinakothek, Munich, 1910.

Munich 1930. *Italienische Malerei, Venezianer des 16–18. Jahrhunderts.* Exh. cat. Galerie Caspari, Munich, August 1930.

Munich 1967. *Album Galerie Haberstock.* Exh. cat. Munich, 1967.

Münz 1952. Münz, Ludwig. *A Critical Catalogue of Rembrandt's Etchings* 2 vols. London, 1952.

Naef 1958. Naef, Hans. "Ingres's Portraits of the Marcotte Family." *The Art Bulletin* 40 (1958): 336–46.

Naef 1977. Naef, Hans. *Die Bilniszeichnungen von J. A. D. Ingres.* 5 vols. Berne, 1977.

Naples 1979–80. *Civiltà del '700 a Napoli 1734–1799.* Exh. cat. 2 vols. Museo e Gallerie Nazionali di Capodimonte, Naples, December 1979–October 1980.

Naples 1982. *La Commedia dell'Arte e il teatro erudito.* Exh. cat. Naples, 1982.

Naples 1984–85. *Civiltà del Seicento a Napoli.* Exh. cat. Museo di Capodimonte and Museo Pignatelli, Naples, October 24, 1984–April 14, 1985.

Naples 1990–91. *Pulcinella maschera del mondo. Pulcinella e le arti dal cinquecento al Novecento.* Exh. cat. Castello S. Elmo, Naples, November 6, 1990–January 6, 1991.

Neveux 1932. Neveux, Pol. "L'exposition d'art français à Londres." *L'Illustration* 4638 (January 1932): 99–106.

New Brunswick 1983. *Haarlem: The Seventeenth Century.* Exh. cat. The Jane Vorhees Zimmerli Art Museum, Rutgers University, New Brunswick, N.J., February 20–April 17, 1983 (catalogue by Frima Fox Hofrichter).

New Haven 1987–88. *A Taste for Angels: Neapolitan Painting in North America 1650–1750.* Exh. cat. Yale University Art Gallery, New Haven, September 9–November 29, 1987; John and Mable Ringling Museum of Art, Sarasota, January 13–March 13, 1988; Nelson-Atkins Museum of Art, Kansas City, Missouri, April 30–June 12, 1988.

New Orleans 1953/1966. *The Samuel H. Kress Collection in the Isaac Delgado Museum of Art.* New Orleans, 1953 (catalogue by William E. Suida); 2nd ed., rev. by Paul Wescher, New Orleans, 1966.

New Orleans 1962. *Fêtes de la Palette.* Exh. cat. Isaac Delgado Museum of Art, New Orleans, 1962–63.

New York 1915. *The Loan Exhibition of Paintings by El Greco and Goya for the Benefit of the American Women War Relief and the Belgian Relief Fund.* Exh. cat. M. Knoedler & Co., New York, January 1915.

New York 1939. *Masterpieces of Art: Exhibition of the New York World's Fair, 1939.* Exh. cat. New York World's Fair, May–October 1939.

New York 1939A. *A Loan Exhibition of Paintings by Jacopo Robusti Il Tintoretto.* Exh. cat. Durlacher Brothers, New York, February 20–March 18, 1939.

New York 1940. *Catalogue of European and American Paintings 1500–1900: Masterpieces of Art.* Exh. cat. New York World's Fair, May–October, 1940 (catalogue by Walter Pach).

New York 1941. *Art Objects and Furnishings from the William Randolph Hearst Collection.* Exh. Saks Fifth Avenue, Gimbel Brothers, and Hammer Galleries, New York, 1941.

New York 1943. *A Loan Exhibition of Fashion in Headdress, 1450–1943.* Exh. cat. Wildenstein & Co., New York, April 27–May 27, 1943.

New York 1945. *Dutch Masters of the Seventeenth Century.* Exh. cat. M. Knoedler & Co., New York, February 5–24, 1945.

New York 1946. *Caravaggio and the Caravaggisti.* Exh. cat. Durlacher Brothers, New York, March 4–30, 1946.

New York 1950. *A Loan Exhibition of Goya for the Benefit of the Institute of Fine Arts, New York University.* Exh. cat. Wildenstein & Co., New York, November 9–December 16, 1950 (catalogue by José López-Rey).

New York 1951–52. *Wildenstein Jubilee Loan Exhibition 1901–1951: Masterpieces from Museums and Private Collections.* Exh. cat. Wildenstein & Co., New York, 1951–52.

New York 1962. *Baroque Painters of Bologna and Neighboring Cities.* Exh. cat. Finch College Museum of Art, New York, February 27–April 8, 1962.

New York 1964–65. *Genoese Painters: Cambiaso to Magnasco 1550–1750.* Exh. cat. Finch College Museum of Art, New York, October 15, 1964–February 1, 1965 (catalogue by Robert L. Manning).

New York 1967. *The Italian Heritage; an Exhibition of Works of Art Lent from American Collections for the Benefit of the Committee to Rescue Italian Art.* Exh. cat. Wildenstein & Co., New York, May 17–August 29, 1967.

New York 1968. *The Artist and the Animal.* Exh. cat. M. Knoedler & Co., New York, May 7–24, 1968 (catalogue by Claus Virch).

New York 1969. *Florentine Baroque Art from American Collections.* Metropolitan Museum of Art, New York, April 16–June 15, 1969 (catalogue by Joan Nissman).

New York 1981. *Masterworks from the John and Mable Ringling Museum of Art.* Exh. cat. Wildenstein & Co., New York, April 1–May 8, 1981; The Tampa Museum, Florida, June 14–September 6, 1981 (catalogue by Denys Sutton).

New York 1982. *Pompeo Batoni (1708–1787): A Loan Exhibition of Paintings.* Exh. cat. Colnaghi, New York, November 17–December 18, 1982 (catalogue by Edgar Peters Bowron).

New York 1985. *The Age of Caravaggio.* Exh. cat. Metropolitan Museum of Art, New York, February 5–April 14, 1985; Museo Nazionale di Capodimonte, Naples, May 12–June 30, 1985.

New York 1989. *Eugène Delacroix: Paintings and Drawings, Peter Paul Rubens: Three Oil Sketches.* Exh. cat. Salander-O'Reilly Galleries, New York, November 15–December 30, 1989.

New York 1989–90. *Velázquez.* Exh. cat. Metropolitan Museum of Art, New York, October 3, 1989–January 7, 1990 (catalogue by Antonio Dominguez Ortiz, Alfonso E. Pérez Sánchez, and Julián Gállego).

New York 1989–90A. *Canaletto.* Exh. cat. Metropolitan Museum of Art, New York, October 30, 1989–January 21, 1990 (catalogue by Katharine Baetjer and J. G. Links).

New York 1990. *Important Old Master Paintings.* Exh. cat. Piero Corsini, Inc., New York, Fall 1990.

New York 1991. *The Drawings of Anthony van Dyck.* Exh. cat. Pierpont Morgan Library, New York, February 15–April 21, 1991; Kimbell Art Museum, Fort Worth, June 1–August 11, 1991 (catalogue by Christopher Brown).

Nicolle 1963. Nicolle, A. *The World of Harlequin.* Cambridge, 1963.

Nicolson 1952. Nicolson, Benedict. "Caravaggio and the Netherlands." *The Burlington Magazine* 94 (September 1952): 247–52.

Nicolson 1956. Nicolson, Benedict. "The Rijksmuseum 'Incredulity' and Terbrugghen's Chronology." *The Burlington Magazine* 98 (April 1956): 103–10.

Nicolson 1957. Nicolson, Benedict. "Terbrugghen repeating himself." In *Miscellanea Prof. Dr. D. Roggen.* Antwerp, 1957: 193–203.

Nicolson 1958. Nicolson, Benedict. *Hendrick Terbrugghen.* London, 1958.

Nicolson 1958A. Nicolson, Benedict. "De Heilige Hieronymus van Hendrick Terbrugghen." *Bulletin Museum Boymans-van Beuningen* 9, 3 (1958): 86–91.

Nicolson 1960. Nicolson, Benedict. "Second Thoughts about Terbrugghen." *The Burlington Magazine* 102 (November 1960): 465–73.

Nicolson 1979. Nicolson, Benedict. *The International Caravaggesque Movement: Lists of Pictures by Caravaggio and His Followers throughout Europe from 1590 to 1650.* Oxford, England, 1979.

Oberlin 1967. *An Exhibition of Paintings, Bozzetti and Drawings by Giovanni Battista Gaulli, called Il Baciccio.* Exh. cat. Allen Memorial Art Museum, Oberlin College, Oberlin, Ohio, January 16–February 13, 1967 (catalogue entries by Ellis Waterhouse and H. Lester Cooke).

OPPERMAN 1988. Opperman, Hal. "[Exhibition review] 'Watteau, 1684–1721.'" *The Art Bulletin* 70 (June 1988): 354–59.

ORBAAN 1920. Orbaan, J. A. F. *Documenti sul barocco in Roma.* Rome, 1920.

ORLANDI 1704/1719. Orlandi, P. A. *Abecedario pittorico.* Bologna, 1704; ed. cit., Bologna, 1719.

OSMOND 1927. Osmond, Percy H. *Paolo Veronese: His Career and Work.* London, 1927.

OTTLEY 1818. Ottley, William Young. *Engravings of the Most Noble the Marquis of Stafford's Collection of Pictures in London* 2 vols. London, 1818.

PACH 1939/1973. Pach, Walter. *Ingres.* New York and London, 1939; 2nd ed., New York, 1973.

PADUA 1990. *Pietro Paolo Rubens.* Exh. cat. Palazzo della Ragione, Padua, March 25–May 31, 1990; Palazzo delle Esposizioni, Rome, June–August 1990; Società per le Belle Arti ed Esposizione Permanente, Milan, September–October 1990 (catalogue by Didier Bodart).

PAILLET 1779. *Catalogue d'une riche collection de tableaux des peintres les plus célèbres des différentes écoles, gouaches, miniatures . . . qui composent le Cabinet de M. L'Abbé de Gevigney, gardes des titres et généalogies de la Bibliothèque du Roi.* Paris, 1779 (catalogue by A. J. Paillet).

PALLUCCHINI 1960. Pallucchini, Rodolfo. *La pittura veneziana del settecento.* Venice and Rome, 1960.

PALLUCCHINI 1968. Pallucchini, Anna. *L'opera completa di Giambattista Tiepolo.* Milan, 1968.

PALLUCCHINI 1984. Pallucchini, Rodolfo. *Veronese.* Milan, 1984.

PALLUCCHINI AND ROSSI 1982. Pallucchini, Rodolfo, and Paola Rossi. *Tintoretto: le opere sacre e profane.* 2 vols. Milan, 1982.

PALM 1969. Palm, Erwin Walter. "El Greco's *Laokoon*." *Pantheon* 27 (1969): 129–35.

PALM 1970. Palm, Erwin Walter. "Zu zwei späten Bildern von El Greco." *Pantheon* 28 (1970): 294–99.

PANOFSKY 1952. Panofsky, Dora. "Gilles or Pierrot?" *Gazette des Beaux-Arts* 162 (May–June 1952): 334–40.

PANTHEON 1930. *Pantheon* 6 (1930): 483, 487.

PARIS 1867. *Catalogue des tableaux, études peintes, dessins, et croquis de J.-A.-D. Ingres.* Paris: Palais de l'Ecole Impériale des Beaux-Arts, 1867.

PARIS 1880. Exh. Musée des Arts Decoratifs, Paris, 1880.

PARIS 1911. *Ingres.* Exh. cat. Galerie Georges Petit, Paris, 1911.

PARIS 1927. *Le Siècle de Louis XIV.* Exh. cat. Bibliothèque Nationale, Paris, February–April, 1927.

PARIS 1937. *Chefs d'oeuvres de l'art français.* Vol. I. Palais National des Arts, Paris, 1937 [catalogue].

PARIS 1952. *La Nature Morte de l'Antiquité à Nos Jours.* Exh. cat. Musée de l'Orangerie, Paris, 1952.

PARIS 1971. *Venise au dix-huitième siècle.* Exh. cat. Orangerie des Tuileries, Paris, September 21–November 29, 1971.

PARIS 1980. *Horace Vernet (1789–1863).* Exh. cat. Académie de France à Rome; Ecole nationale supérieure des Beaux-Arts, Paris, March–July, 1980 (introduction and catalogue by Robert Rosenblum).

PARIS 1983–84. *Raphael et l'art français.* Exh. cat. Grand Palais, Paris, November 15, 1983–February 13, 1984.

PARIS 1984–85. *Diderot et l'art de Boucher à David: Les Salons: 1759–1781.* Exh. cat. Hotel de la Monnaie, Paris, October 5, 1984–January 6, 1985.

PARIS 1987. *Nouvelles acquisitions du Departement des Peintures (1983–1986).* Exh. cat. Musée du Louvre, Paris, 1987.

PARIS 1987A. Moureau, François, and Margaret Morgan Grasselli, eds. *Antoine Watteau (1684–1721), le peintre, son temps, et sa légende* [publication of papers given at the Watteau colloquium held at the Grand Palais in Paris, October 1984]. Paris and Geneva, 1987.

PARKER 1931. Parker, Karl T. *The Drawings of Antoine Watteau.* London, 1931.

PARKER AND MATHEY 1957. Parker, Karl T., and Jacques Mathey. *Antoine Watteau. Catalogue complet de son oeuvre dessiné.* 2 vols. Paris, 1957.

PAUWELS 1951. Pauwels, C. H. "Nieuwe toeschrijvingen bij het oeuvre van Hendrick ter Brugghen." *Gentse bijdragen tot de kunstgeschiedenis* 13 (1951): 153–67.

PEDROCCO AND MONTECUCCOLI DEGLI ERRI 1992. Pedrocco, Filippo, and Federico Montecuccoli degli Erri. *Antonio Guardi.* Milan, 1992.

PEPPER 1983. Pepper, Stephen. "[Review of Bissell] *Orazio Gentileschi and the Poetic Tradition in Caravaggesque Painting.*" *The Burlington Magazine* 125 (November 1983): 699–700.

PEPPER 1984. Pepper, D. Stephen. *Bob Jones University Collection of Religious Art: Italian Paintings.* Greenville, S.C., 1984.

PHILADELPHIA 1984. *Masters of Seventeenth-Century Dutch Genre Painting.* Exh. cat. Philadelphia Museum of Art, March 18–May 13, 1984; Gemäldegalerie, Staatliche Museen Preussischer Kulturbesitz, West Berlin [as *Von Hals bis Vermeer*], June 8–August 12, 1984; Royal Academy of Arts, London, September 7–November 18, 1984.

PHILLIPS 1902. Phillips, Claude. "French and English Art at the Guildhall." *Daily Telegraph* (London), June 21, 1902.

PIGLER 1931. Pigler, Andor. "Pacecco de Rosa muvészetébez." *Archaeologiai Értesito* 45 (1931): 148–67, 331–36.

PIGLER 1956. Pigler, Andor. *Barockthemen: eine Auswahl von Verzeichnissen zur Ikonographie des 17. und 18. Jahrhunderts.* 2 vols. Budapest, 1956.

PIGNATTI 1976. Pignatti, Terisio. *Veronese.* 2 vols. Venice, 1976.

PIGNATTI AND PEDROCCO 1991. Pignatti, Terisio, and Filippo Pedrocco. *Veronese. Catalogo completo dei dipinti.* Florence, 1991.

PILO 1966. Pilo, G. M. "Sebastiano and Marco Ricci in America." *Arte veneta* 20 (1966): 305–6.

PILO 1976. Pilo, G. M. *Sebastiano Ricci e la pittura veneziana del settecento.* Pordenone, 1976.

PILON 1912. Pilon, E. *Watteau et son école.* Paris, 1912.

PITTALUGA 1925. Pittaluga, Mary. *Il Tintoretto.* Bologna, 1925.

PITTSBURGH 1951. *French Painting (1100–1900).* Exh. cat. Carnegie Institute, Pittsburgh, October 18–December 2, 1951 (introduction by Charles Sterling).

PITTSBURGH 1954. *Pictures of Everyday Life: Genre Painting in Europe, 1500–1900.* Exh. cat. Carnegie Institute, Pittsburgh, October 14–December 12, 1954.

POLIGNAC 1738. *Inventaire du Mobilier et des Collections Antiques et Modernes du Cardinal de Polignac.* Paris, 1738.

POPE-HENNESSY 1963. Pope-Hennessy, John. *The Portrait in the Renaissance.* Princeton, 1963.

POPE-HENNESSY 1965. Pope-Hennessy, John. *Renaissance Bronzes from the Samuel H. Kress Collection: Reliefs, Plaquettes, Statuettes, Utensils and Mortars.* London, 1965.

PORTLAND 1967–68. *75 Masterworks.* Exh. cat. Portland Art Museum, Oreg., December 12, 1967–January 21, 1968.

PORTLAND 1972. "Primates in Art." Exh., no cat. Portland Art Museum, Oreg., August 15–September 17, 1972.

POSNER 1971. Posner, Donald. *Annibale Carracci: A Study on the Reform of Italian Painting around 1590.* 2 vols. New York, 1971.

POSNER 1983. Posner, Donald. "Another Look at Watteau's 'Gilles.'" *Apollo* 117 (1983): 97–98.

POSNER 1984. Posner, Donald. *Antoine Watteau.* London and Ithaca, N.Y., 1984.

POSPISIL 1944. Pospisil, Maria. *Magnasco.* Florence, 1944.

POSSE 1931. Posse, Hans. "Die Briefe des Grafen Francesco Algarotti an den sächsischen Hof und seine Bilderkäufe für die Dresdner Gemäldegalerie, 1743–1747." *Jahrbuch der preussischen Kunstsammlungen* supp. 52 (1931): 1–73.

PRAZ 1971. Praz, Mario. *Conversation Pieces: A Survey of the Informal Group Portrait in Europe and America.* University Park, Pa., and London, 1971.

PROVIDENCE 1938–39. *Dutch Painting in the Seventeenth Century.* Exh. Rhode Island School of Design, Providence, December 1938–January 1939.

PROVIDENCE 1968–69. *Baroque Painting: Italy and Her Influence.* Exh. cat. Rhode Island School of Design, Providence, 1968–69 (catalogue by Stephen E. Ostrow).

PUYVELDE 1947. Puyvelde, Leo van. *The Sketches of Rubens.* London, 1947.

PUYVELDE 1950. Puyvelde, Leo van. *Van Dyck.* Brussels, 1950.

RAINES 1977. Raines, R. "Watteaus and 'Watteaus' in England before 1760." *Gazette des Beaux-Arts* 89 (February 1977): 51–64.

RALEIGH 1956. *Rembrandt and His Pupils: A Loan Exhibition.* Exh. cat. North Carolina Museum of Art, Raleigh, November 16–December 30, 1956 (catalogue by W. R. Valentiner).

RALEIGH 1960. *The Samuel H. Kress Collection North Carolina Museum of Art.* Raleigh, 1960 (catalogue by Fern Rusk Shapley); 2nd ed., Raleigh, 1965 (catalogue by Fern Rusk Shapley and W. R. Valentiner).

RALEIGH 1984. *Baroque Paintings from the Bob Jones University Collection.* North Carolina Museum of Art, Raleigh, July 7–September 2, 1984 (catalogue by David H. Steel, Jr.).

RALEIGH 1992. *The North Carolina Museum of Art: Introduction to the Collections.* Ed. Edgar Peters Bowron. Raleigh, 1983; ed. cit., rev. ed., Raleigh, 1992.

RASMO 1955. Rasmo, Nicolò. "Recenti contribuiti a Giannantonio Guardi." *Cultura atesina* 9 (1955): 150–59.

REARICK 1962. Rearick, W. Roger. "Jacopo Bassano: 1568–9." *The Burlington Magazine* 104 (December 1962): 524–33.

REARICK 1988. Rearick, W. Roger. *Paolo Veronese: Disegni e dipinti.* Exh. cat. Fondazione Giorgio Cini, Venice, 1988.

RÉAU 1925. Réau, Louis. *Histoire de la Peinture Française au XVIIIe Siècle.* 2 vols. Paris and Brussels, 1925.

RÉAU 1928. Réau, Louis. "Watteau." In A. Dimier, *Les peintres français du XVIIIe siècle.* 2 vols. Paris and Brussels, 1928.

RÉAU 1931. Réau, Louis. *Histoire de l'expansion de l'Art français-Pays Scandinaves-Angleterres, Amerique du Nord.* Paris, 1931.

RÉAU 1955–59. Réau, Louis. *Iconographie de l'art chrétien.* 3 vols. Paris, 1955–59.

REINACH 1905–23. Reinach, Salomon. *Répertoire de peintures du moyen âge et de la renaissance (1280–1580).* 6 vols. Paris, 1905–23.

REMBRANDT CORPUS 1982–89. Rembrandt Research Project. *A Corpus of Rembrandt Paintings.* 3 vols. Dordrecht, Boston, and London, 1982–89.

RICHARDSON 1944. Richardson, Edgar P. "A Family Portrait by Drouais in the National Gallery." *The Art Quarterly* 7 (Summer 1944): 224–27.

RICHARDSON 1958. Richardson, Edgar P. "Notes on Special Exhibitions: The Young Rembrandt and His Times, in Indianapolis." *The Art Quarterly* 21 (Autumn 1958): 287–92.

RIDOLFI 1648/1914–24. Ridolfi, Carlo. *Le Maraviglie dell'arte ovvero le vite degli illustri pittori veneti e dello stato descritte da Carlo Ridolfi.* Venice, 1648; ed. cit., ed. Detlev von Hadeln, 2 vols., Berlin, 1914–24.

RIDOLFI 1648/ENGGASS 1984. Ridolfi, Carlo. *The Life of Tintoretto, and of His Children Domenico and Marietta.* Translated and with an introduction by Catherine Enggass and Robert Enggass, University Park, Pa., and London, 1984.

ROBINSON 1868. Robinson, John Charles. *Memoranda on Fifty Pictures, Selected from a Collection of Works of the Ancient Masters* London, 1868.

ROBINSON 1907. Robinson, J. Charles. "The Bodegones and Early Works of Velazquez Part III: The Altar-piece of Loeches." *The Burlington Magazine* 11 (August 1907): 318–25.

ROETHLISBERGER 1961. Roethlisberger, Marcel. *Claude Lorrain: The Paintings.* 2 vols. New York, 1961.

ROETHLISBERGER AND CECCHI 1975/77. Roethlisberger, Marcel, and Doretta Cecchi. *L'opera completa di Claude Lorrain.* Milan, 1975; subsequently published as *Tout l'oeuvre peint de Claude Lorrain.* Paris, 1977.

ROGELIO BUENDÍA 1983. Rogelio Buendía, José. "Humanismo y simbología en El Greco: el tema de la serpiente." *Studies in the History of Art* 13 (1983): 35–46.

ROLAND 1984. Roland, Margaret. "Van Dyck's Early Workshop, the *Apostle* Series, and the *Drunken Silenus.*" *The Art Bulletin* 66, 2 (June 1984): 211–23.

ROLAND-MICHEL 1982. Roland-Michel, Marianne. *Tout Watteau.* Paris, 1982.

ROLAND-MICHEL 1984. Roland-Michel, Marianne. *Watteau, An Artist of the Eighteenth Century.* Secaucus, N.J., 1984.

ROMAN 1919. Roman, Joseph Hippolyte. *Le Livre de Raison de Peintre Hyacinthe Rigaud.* Paris, 1919.

ROOSES 1888. Rooses, Max. "Beschryvinge van de Schilderyen door P. P. Rubbens eertyts voor onse Marbere Kercke geschildert tot Plafons. . . ." *Bulletin-Rubens* 3 (1888): 272 ff.

ROOSES 1886–92. Rooses, Max. *L'Oeuvre de Rubens.* 4 vols. Antwerp, 1886–92.

ROSENBERG AND STEWART 1987. Rosenberg, Pierre, and Marion Stewart. *French Paintings 1500–1825: The Fine Arts Museums of San Francisco.* San Francisco, 1987.

ROSENBLUM 1967. Rosenblum, Robert. *Ingres.* New York, 1967.

ROSENTHAL 1981. Rosenthal, Gertrude, ed. *Italian Paintings, XIV–XVIIIth Centuries, from the Collection of The Baltimore Museum of Art.* Baltimore, 1981.

ROSSI 1977. Rossi, Paola. "Attività di Domenico Tintoretto, Santo Piatti e Giuseppe Angeli per la Scuola di San Rocco." *Arte veneta* 31 (1977): 260–72.

ROSSI BORTOLATTO 1974. Rossi Bortolatto, Luigina. *L'opera completa di Francesco Guardi.* Milan, 1974.

ROTTERDAM 1953–54. *Olieverfschetsen van Rubens.* Exh. cat. Museum Boymans, Rotterdam, 1953–54 (catalogue by Egbert Haverkamp-Begemann).

RUBENS 1955. Rubens, Peter Paul. *The Letters of Peter Paul Rubens.* Trans. and ed. Ruth Saunders Magurn. Cambridge, Mass., 1955.

RUDOLPH 1972. Rudolph, Stella. "Recensioni e informazioni, Pier Francesco Mola: la monographia di R. Cocke e nuovi contributi." *Arte illustrata* 5 (1972): 350–52.

RUSSELL 1979. Russell, Francis. "The British Portraits of Anton Raphael Mengs." *National Trust Studies* (1979): 9–19.

RYSZKIEWICZ 1961. Ryszkiewicz, A. *Polski portret zbiorowy.* Breslau, Warsaw, and Krakow, 1961.

SACK 1910. Sack, Eduard. *Giambattista und Domenico Tiepolo.* Hamburg, 1910.

SALERNO 1954–55. *Opere d'arte nel salernitano dal XII al XVIII secolo.* Exh. cat. Duomo, Salerno, 1954–55 (catalogue by Ferdinand Bologna).

SAN FRANCISCO 1920. *The Loan Exhibition of Paintings by Old Masters in the Palace of Fine Arts.* Exh. cat. The San Francisco Museum of Art, October–November, 1920 (catalogue by J. Nilsen Laurvik).

SAN FRANCISCO 1938. *Exhibition to Venetian Painting from the Fifteenth Century through the Eighteenth Century.* Exh. cat. The California Palace of the Legion of Honor, San Francisco, June 25–July 24, 1938.

SAN FRANCISCO 1939. *Masterworks of Five Centuries.* Exh. cat. Golden Gate International Exposition, San Francisco, 1939.

SAN FRANCISCO 1955. *The Samuel H. Kress Collection: M. H. de Young Memorial Museum.* San Francisco, 1955 (catalogue by William E. Suida).

SAN FRANCISCO 1990. *Claude Lorrain: A Study in Connoisseurship.* Exh. brochure. M. H. de Young Memorial Museum, San Francisco, May 5–June 24, 1990.

SÁNCHEZ CANTÓN 1951. Sánchez Cantón, F. J. *Vida y Obras de Goya.* Madrid, 1951.

SANDRART 1675/1925. Sandrart, Joachim von, *Joachim von Sandrarts Academie der Bau-, Bild- und Mahlerey- Künste von 1675.* Nuremburg, 1675; ed. cit., ed. Rudolf Arthur Peltzer, Munich, 1925.

SANTA BARBARA 1958. *Paintings by Francesco Guardi.* Exh., no cat. Santa Barbara Museum of Art, March 7–April 6, 1958 [exh. checklist printed in *Santa Barbara Museum of Art Calendar,* March 1958].

SARASOTA 1949. *Catalogue of Paintings: The John & Mable Ringling Museum of Art.* Sarasota, 1949 (catalogue by William E. Suida).

SARASOTA 1958. *A. Everett Austin, Jr.: A Director's Taste and Achievement.* Exh. cat. John and Mable Ringling Museum of Art, Sarasota, February 23–March 30, 1958; Wadsworth Atheneum, Hartford, April 23–June 1, 1958.

SARASOTA 1976. *Catalogue of the Italian Paintings before 1800* [in the John and Mable Ringling Museum of Art]. Sarasota, 1976 (catalogue by Peter Tomory).

SARASOTA 1980–81. *Dutch Seventeenth Century Portraiture: The Golden Age.* Exh. cat. John and Mable Ringling Museum of Art, Sarasota, December 4, 1980–February 8, 1981 (catalogue by William H. Wilson).

SARASOTA 1984–85. *Baroque Portraiture in Italy, Works from North American Collections.* Exh. cat. John and Mable Ringling Museum of Art, Sarasota, December 7, 1984–February 3, 1985; Wadsworth Atheneum, Hartford, March 20–May 20, 1985 (catalogue by John T. Spike).

SAXL 1927–29. Saxl, Fritz. "[Review of] August L. Mayer, *El Greco.*" *Kritische Berichte zur kunstgeschichtlichen Literatur,* 2 vols. Leipzig, 1927–29.

SCHAEFFER 1909. Schaeffer, Emil. *Van Dyck: des Meisters Gemälde [Klassiker der Kunst 13].* Stuttgart and Leipzig, 1909.

SCHAMA 1987. Schama, Simon. *The Embarrassment of Riches. An Interpretation of Dutch Culture in the Golden Age.* New York, 1987.

SCHILLER 1972. Schiller, Gertrud. *Iconography of Christian Art.* 2 vols. Greenwich, Conn., 1972.

SCHLEIER 1970. Schleier, Erich. "Aggiunte a Guglielmo Cortese detto il Borgognone." *Antichita viva* 9 (1970): 3–25.

SCHUCKMAN 1986. Schuckman, C. "Did Hendrick ter Brugghen revisit Italy? Notes from an unknown manuscript by Cornelis de Bie." *Hoogsteder-Naumann Mercury* 4 (1986): 7–22.

SCHÜTZE 1992. Schütze, Sebastian. "Observations sur l'oeuvre de jeunesse de Massimo Stanzione et ses liens avec Simon Vouet et les autres peintres français à Rome." In *Simon Vouet. Actes du colloque international* [Galeries Nationales du Grand Palais, Paris, February 5–7, 1991]. Paris, 1992: 225–44.

SCHÜTZE AND WILLETTE 1992. Schütze, Sebastian, and Thomas Willette. *Massimo Stanzione: l'opera completa.* Naples, 1992.

SCHWANENBERG 1937. Schwanenberg, Hans. "Leben und Werk des Massimo Stanzioni. Ein Beitrag zur Geschichte der Neapolitanischen Malerei des XVII. Jahrhunderts." Ph.D. dissertation, Bonn, 1937.

SCHWARTZ 1985. Schwartz, Gary. *Rembrandt: His Life, His Paintings.* New York, 1985.

SEATTLE 1938. *Venetian Paintings from the Samuel H. Kress Collection.* Exh. cat. Seattle Art Museum, August 1–25, 1938; Portland Art Museum, Oreg., September 1–26, 1938; Montgomery Museum of Art, October 1–31, 1938.

SEATTLE 1952. *Samuel H. Kress Collection, Italian Art, Seattle Art Museum.* Seattle, 1952 (catalogue by William Suida).

SEATTLE 1954. *European Paintings and Sculpture from the Samuel H. Kress Collection.* Seattle, 1952 (catalogue by William Suida).

SEATTLE 1962. *Masterpieces of Art.* Exh. cat. Seattle World's Fair, April 21–October 21, 1962.

SEATTLE 1991. *Selected Works, Seattle Art Museum.* Seattle, 1991.

SEGAL 1988. Segal, Sam. *A Prosperous Past: The Sumptuous Still Life in the Netherlands 1600–1700.* Amsterdam, 1988.

SESTIERI 1932. Sestieri, Ettore. *Catalogo della Raccolta . . . di S. E. il Principe Don Gerolamo Rospigliosi.* Rome, 1932.

SEYMOUR 1961. Seymour, Charles. *Art Treasures for America, An Anthology of Paintings and Sculpture in the Samuel H. Kress Collection.* London, 1961 (prefaces by John Walker and Guy Emerson).

SHACKELFORD AND VAUGHN 1987. Shackelford, George T. M., and Carolyn Vaughn. "Early European Metalwork in the Museum Collection." *The Museum of Fine Arts, Houston Bulletin* 11, 1 (Fall 1987): 3–9.

SHAPLEY 1966. Shapley, Fern Rusk. *Paintings from the Samuel H. Kress Collection. Italian Schools XIII–XV Century.* London, 1966.

SHAPLEY 1968. Shapley, Fern Rusk. *Paintings from the Samuel H. Kress Collection. Italian Schools XV–XVI Century.* London, 1968.

SHAPLEY 1973. Shapley, Fern Rusk. *Paintings from the Samuel H. Kress Collection. Italian Schools XVI–XVII Century.* London and New York, 1973.

SHAPLEY 1979. Shapley, Fern Rusk. *Catalogue of the Italian Paintings. National Gallery of Art.* 2 vols. Washington, D.C., 1979.

SIGNORINI 1983. Signorini, Rodolfo. *La Fabella di Psiche e Altra Mitologia: Secondo l'Interpretazione pictorica di Giulio Romano nel Palazzo del Te a Mantova.* Mantua, 1983.

SIMPSON 1986. Simpson, Colin. *Artful Partners: Bernard Berenson and Joseph Duveen.* New York, 1986.

SKELTON 1960. Ford, Brinsley, ed. "The Letters of Jonathan Skelton Written from Rome and Tivoli in 1758, together with Correspondance relating to his Death of 19 January 1759." *The Thirty-Sixth Volume of the Walpole Society, 1956–58.* Glasgow (1960): 33–82.

SLATKES 1965. Slatkes, Leonard J. *Dirck van Baburen (ca. 1595–1624), a Dutch painter in Utrecht and Rome.* Utrecht, 1965.

SLIVE 1970. Slive, Seymour. *Frans Hals.* 3 vols. London, 1970.

SMITH 1829–42. Smith, John. *A Catalogue Raisonné of the Works of the Most Eminent Dutch, Flemish, and French Painters. . . .* 9 vols. London, 1829–42.

SMITH 1912/1964. Smith, Winifred. *The Commedia dell' Arte.* New York, 1912; rev. ed., New York, 1964.

SMITH 1982. Smith, David R. *Masks of Wedlock: Seventeenth-Century Dutch Marriage Portraiture.* Ann Arbor, 1982.

SOBY 1951. Soby, James Thrall. "Two Ingres Paintings at the National Gallery." *Magazine of Art* 44 (May 1951): 162.

SOPRANI AND RATTI 1768–69. Soprani, Raffaello, and Carlo Giuseppe Ratti. *Vite de' pittori, scultori, ed architetti genovesi.* 2 vols. Genoa, 1768–69.

SPEAR 1982. Spear, Richard E. *Domenichino.* 2 vols. New Haven and London, 1982.

SPINOSA 1984. Spinosa, Nicola. *La pittura napoletana del '600.* Milan, 1984.

SPRINGFIELD 1937. *Francesco Guardi.* Exh. cat. Springfield Museum of Fine Arts, Mass., February 20–March 21, 1937 (catalogue by John Lee Clark).

STALEY 1902. Staley, E. *Watteau and His School. Great Masters in Painting and Sculpture.* London, 1902.

STECHOW 1938/1975. Stechow, Wolfgang. *Salomon van Ruysdael.* Berlin, 1938; 2nd ed., Berlin, 1975.

STECHOW 1965. Stechow, Wolfgang. "Terbrugghen in America." *Art News* 64, 6 (October 1965): 47–51, 61–62.

STECHOW 1966. Stechow, Wolfgang. *Dutch Landscape Painting of the Seventeenth Century.* London, 1966.

STEINBERG 1983. Steinberg, Leo. "The Sexuality of Christ in Renaissance Art and in Modern Oblivion." *October* 25 (Summer 1983): 1–122; reprinted as a separate book, with same title and pagination, New York, 1983.

STERLING 1981. Sterling, Charles. *Still Life Painting from Antiquity to the Twentieth Century.* 2nd ed., rev., New York, 1981.

STOKES 1914. Stokes, Hugh. *Goya.* New York, 1914.

STRYIENSKI 1913. Stryienski, Casimir. *La Galerie du Régent Philippe, Duc d'Orléans.* Paris, 1913.

SUIDA 1940. Suida, William. "Die Sammlung Kress, New York." *Pantheon* 13 (December 1940): 272–83.

SUIDA 1950. Suida, William. "The Samuel H. Kress Collection: Catalogue." *The Philadelphia Museum Bulletin* 46 (Autumn 1950): 1–23.

SULLIVAN 1974. Sullivan, Scott A. "A Banquet-Piece with Vanitas Implications." *Bulletin of the Cleveland Museum of Art* 61 (1974): 271–81.

SUMOWSKI 1983. Sumowski, Werner. *Gemälde der Rembrandt-Schüler.* 5 vols. Landau, 1983.

SUTTON 1981. Sutton, Denys. "Aspects of British Collecting Part I. IV. The Age of Sir Robert Walpole." *Apollo* 114 (November 1981): 328–39.

SUTTON 1990. Sutton, Peter C. *Northern European Paintings in the Philadelphia Museum of Art, from the Sixteenth through the Nineteenth Century.* Philadelphia, 1990.

SUTTON 1992. Sutton, Peter C. *Dutch and Flemish Seventeenth-century paintings: The Harold Samuel Collection.* Cambridge, England, 1992.

TASSO 1581/1962. Tasso, Torquato. *Jerusalem Delivered [1581]. The Edward Fairfax Translation, newly introduced by Roberto Weiss.* Carbondale, Ill., 1962.

TAYLOR 1948. Taylor, Francis Henry. *The Taste of Angels.* London, 1948.

TERNOIS 1959. Ternois, Daniel. *Les dessins d'Ingres au Musées de Montauban. III: Les portraits.* Paris, 1959.

TERNOIS 1980. Ternois, Daniel. *Ingres.* Milan, 1980.

TESTORI 1954. Testori, Giovanni. "Il Ghislandi, il Ceruti, e i veneti." *Paragone* 5, 57 (September 1954): 16–33.

THE HAGUE 1977. *Mauritshuis. The Royal Cabinet of Paintings: Illustrated General Catalogue.* The Hague, 1977.

THE HAGUE 1990-91. *Great Dutch Paintings from America.* Exh. cat. Mauritshuis, The Hague, September 28, 1990–January 13, 1991; The Fine Arts Museums of San Francisco, February 16–May 5, 1991 (catalogue by Ben Broos et al.).

THOMAS 1969. Thomas, Hylton A. "Tasso and Tiepolo in Chicago." *Museum Studies* 4 (1969): 27–48.

THOMAS 1991. Thomas, Christopher A. *The Architecture of the West Building of the National Gallery of Art.* Washington, D.C., 1991.

THOMAS 1993. Thomas, Bernice. "Five & Dime Design." *Historic Preservation* (January/February 1993): 62–70.

TIETZE 1948. Tietze, Hans. *Tintoretto: The Paintings and Drawings.* London, 1948.

TIETZE AND TIETZE-CONRAT 1944. Tietze, Hans, and Erica Tietze-Conrat. *The Drawings of the Venetian Painters in the XVth and XVIth Centuries.* New York, 1944.

TIETZE-CONRAT 1955. Tietze-Conrat, Erica. *Mantegna: Paintings, Drawings, Engravings.* London, 1955.

TOKYO 1992. *European Masterworks from The Fine Arts Museums of San Francisco.* Exh. cat. Tokyo Metropolitan Art Museum, April 10–June 14, 1992; Fukuoka Art Museum, July 1–July 26, 1992; Osaka Municipal Museum of Art, August 8–September 13, 1992; Sogo Museum of Art, Yokohama, September 23–October 25, 1992.

TOLEDO 1976. *The Toledo Museum of Art: European Paintings.* Toledo, 1976.

TOMKINS 1989. Tomkins, Calvin. *Merchants and Masterpieces: The Story of the Metropolitan Museum of Art.* New York, 1989.

TOMLINSON 1981. Tomlinson, R. *La fête galante: Watteau et Marivaux.* Geneva, 1981.

TORMO Y MONZÓ 1902. Tormo y Monzó, Elías. *Las Pinturas de Goya y su clasificación cronológica.* Madrid, 1902.

TOWNSEND 1991. Townsend, Richard P. *The Samuel H. Kress Collection at Philbrook.* Tulsa, 1991.

TOZZI 1933. Tozzi, Rosanna. "Notizie biografiche su Domenico Tintoretto." *Rivista di Venezia* 12 (June 1933): 299–316.

TOZZI 1937. Tozzi, Rosanna. "Disegni di Domenico Tintoretto." *Bollettino d'Arte* 31 (1937): 19–31.

TOZZI PEDRAZZI 1960. Tozzi Pedrazzi, Rosanna. "La maturità di Domenico Tintoretto in alcune tele ritenute di Jacopo." *Arte antica e moderna* 12 (October–December 1960): 386–96.

TOZZI PEDRAZZI 1964. Tozzi Pedrazzi, Rosanna. "Le storie di Domenico Tintoretto per la Scuola di S. Marco." *Arte veneta* 18 (1964): 73–88.

TRAPIER 1964. Trapier, Elizabeth Du Gué. *Goya and His Sitters.* New York, 1964.

TREVISO 1984. *Paris Bordon.* Exh. cat. Palazzo dei Trecento, Treviso, September–December 1984 (catalogue by Giordana Canova et al.).

TUCSON 1951. *Twenty-five Paintings from the Collection of the Samuel H. Kress Foundation at the University of Arizona.* University of Arizona, Department of Art, Tucson, 1951 (catalogue by William E. Suida).

TUCSON 1957. *The Samuel H. Kress Collection at the University of Arizona.* Tucson, 1957 (catalogue by William E. Suida).

TUCSON 1983. Bermingham, Peter, ed. *Paintings and Sculpture in the Permanent Collection.* University of Arizona Museum of Art, Tucson, 1983.

TUFTS 1974. Tufts, Eleanor M. "A successful 16th-century portraitist. Ms. Lavinia from Bologna." *Art News* 73, 2 (February 1974): 60–64.

TULSA 1953. *Paintings and Sculpture of the Samuel H. Kress Collection. Philbrook Art Center.* Tulsa, 1953 (catalogue by William E. Suida).

TULSA 1991. *The Philbrook Museum of Art: A Handbook to the Collections.* Tulsa, 1991.

TURIN 1959–60. *Tanzio da Varallo.* Exh. cat. Palazzo Madama, Turin, October 30, 1959–January 31, 1960 (catalogue by Giovanni Testori).

UTRECHT 1952. *Centraal Museum Utrecht. Catalogus der Schilderijen.* Utrecht, 1952.

UTRECHT 1986–87. *Nieuw Licht op de Gouden Eeuw: Hendrick ter Brugghen en tijdgenoten/Holländische Malerei in neuem Licht. Hendrick ter Brugghen und seine Zeitgenossen.* Exh. cat. Centraal Museum Utrecht, November 13, 1986–January 12, 1987; Herzog Anton Ulrich-Museum, Braunschweig, February 12–April 12, 1987.

UTRECHT 1993–94. *Het gedroomde land. Pastorale schilderkunst in de Gouden Eeuw.* Exh. cat. Centraal Museum Utrecht, May 29–August 1, 1993; Schirn Kunsthalle Frankfurt, September 25–November 28, 1993; Musée National d'Histoire et d'Art, Luxembourg, December 11, 1993–January 26, 1994 (catalogue by Peter van den Brink).

VALENTINER 1930. Valentiner, W. R., ed., with Ludwig Burchard and Alfred Scharf. *Unknown Masterpieces in Public and Private Collections.* New York, 1930.

VALENTINER 1946. Valentiner, Wilhelm R. "Rubens' Paintings in America." *The Art Quarterly* 9, 2 (Spring 1946): 153–68.

VALESIO 1700–42. Valesio, Francesco. *Diario di Roma.* 20 vols. Archivio capitolino, Rome, 1700–42; repr. Milan, 1977.

VAN GELDER 1946. Van Gelder, J. G. "Vroege Werken van Govert Flinck." *Mededlingen van het Rijksbureau voor Kunsthistorische Documentatie* 1 (1946): 26–28.

VAN MANDER 1604/1936. Van Mander, Carel. *Dutch and Flemish Painters, Translation from the Schilderboeck.* Translation and introduction by Constant van de Wall, New York, 1936 [originally published 1604].

VAN THIEL 1971. Van Thiel, Pieter J. J. "De aanbidding der koningen en ander vroeg werk van Hendrick ter Brugghen." *Bulletin van het Rijksmuseum* 19, 3 (December 1971): 91–116, 136–39.

VAN WESTRHEENE 1856. Van Westrheene, T. *Jan Steen, Étude sur l'art en Hollande.* The Hague, 1856.

VASARI 1568/1878–85. Vasari, Giorgio. *Le vite de' più eccellenti pittori, scultori ed architettori.* Florence, 1568; ed. cit., ed. Gaetano Milanesi, 9 vols., Florence, 1878–85.

VAUGHAN 1961. Vaughan, Malcolm. "The Connoisseur in America: Kress Gift to North Carolina." *Connoisseur* 147, 593 (May 1961): 224–25.

VAUGHAN 1961A. Vaughan, Malcolm. "Mr. Kress and the American People." *Connoisseur* 148, 598 (December 1961): 276–87.

VENICE 1965. *Mostra dei Guardi.* Exh. cat. Palazzo Grassi, Venice, June 5–October 10, 1965 (catalogue by Pietro Zampetti).

VENICE 1990–91. *Tiziano.* Exh. cat. Palazzo Ducale, Venice, June 2–October 7, 1990; National Gallery of Art, Washington, October 28, 1990–January 27, 1991.

VENTURI 1928. Venturi, Adolfo. *Storia dell'arte italiana. IX. La pittura del Cinquecento. Parte III.* Milan, 1928.

VENTURI 1929. Venturi, Lionello. *Storia dell'arte italiana. IX. La Pittura del Cinquecento. Parte IV.* Milan, 1929.

VENTURI 1933. Venturi, Lionello. *Italian Paintings in America.* 3 vols. New York and Milan, 1933.

VERLET 1967. Verlet, Pierre. *The Eighteenth Century in France, Society, Decoration, Furniture.* Rutland, Vt., 1967.

VERONA 1988. *Veronese e Verona.* Exh. cat. Museo del Castelvecchio, Verona, July 7–October 9, 1988 (catalogue by Sergio Marinelli et al.).

VERTUE 1933–34. Vertue, G. "George Vertue's 'Notebooks.'" *The Walpole Society* 22 (1933–34).

VETTER 1969. Vetter, Ewald W. "El Grecos *Laokoon* 'reconsidered.'" *Pantheon* 27 (1969): 295–98.

VEY 1962. Vey, Horst. *Die Zeichnungen Anton van Dycks.* 2 vols. Brussels, 1962.

VICAIRE 1864. Vicaire, M. "Obsèques de M. Marcotte, ancien directeur general des Eaux et Forêts." In *La Revue des Eaux et Forêts.* Paris, 1864: 100–105.

VIDAL 1992. Vidal, Mary. *Watteau's Painted Conversations: Art, Literature, and Talk in Seventeenth- and Eighteenth-Century France.* New Haven and London, 1992.

VIENNA 1937. *Italienische Barockmalerei.* Exh. cat. Palais Pallavicini, Vienna, May 14–June 15, 1937.

VIGÉE LE BRUN 1835–37. Vigée Le Brun, Elisabeth. *Souvenirs de Madame Louise-Elisabeth Vigée le Brun.* 3 vols. Paris, 1835–37.

VIGÉE LE BRUN 1835–37/1984. Vigée Le Brun, Elisabeth. *Souvenirs.* 3 vols., Paris, 1835–37; rev. ed., 2 vols., Paris, 1984.

VIRGIL/FITZGERALD 1981. *The Aeneid Virgil.* Translated by Robert Fitzgerald. New York, 1981.

VON FRANK ZU DÖFCRING 1930. Von Frank zu Döfcring, Karl Friedrich. *Kress Family History.* Vienna, 1930.

VON SCHNEIDER 1933. Von Schneider, A. *Caravaggio und die Niederländer.* Marburg/Lahn, 1933.

VORAGINE C. 1295/1969. Voragine, Jacobus de. *The Golden Legend of Jacobus de Voragine.* Translated and Adapted from the Latin by Granger Ryan and Helmut Ripperger. New York, 1969.

VOSS 1910. Voss, Hermann. "Die falschen Spanier." *Der Cicerone* new series 2 (1910): 5–11.

VOSS 1910–11. Voss, Hermann. "Kritische Bemerkung zu Seicentisten in den römischen Galerien." *Repertorium für Kunstwissenschaft* 33 (1910): 212–21; 34 (1911): 119–25.

WAAGEN 1838. Waagen, Gustav Friedrich. *Works of Art and Artists in England.* 3 vols. London, 1838.

WAAGEN 1850. Waagen, Gustav Friedrich. *Preussische Koenigskrone General-Katalog.* Berlin, 1850 [manuscript destroyed by fire during World War II].

WAAGEN 1854. Waagen, Gustav Friedrich. *Treasures of Art in Great Britain: Being an Account of the Chief Collections of Paintings, Drawings, Sculptures, Illuminated MSS., &c. &c.* . . . 3 vols. London, 1854.

WAAGEN 1857. Waagen, Gustav Friedrich. *Galleries and Cabinets of Art in Great Britain.* London, 1857 [supplement to Waagen 1854].

WALKER 1952. Walker, John. "Your National Gallery of Art After Ten Years." *The National Geographic Magazine* (January 1952): 73–103.

WALKER 1955. Walker, John. "The Kress Collection and the Museum." *Arts Digest* 29 (March 1955): 17–23.

WALKER 1956. Walker, John. "The Nation's Newest Old Masters." *The National Geographic Magazine* (November 1956): 619–57.

WALKER 1974. Walker, John. *Self-Portrait with Donors: Confessions of an Art Collector.* Boston and Toronto, 1974.

WALKER 1974A. Walker, John. *National Gallery of Art.* New York, 1974.

WALPOLE 1762–80/1969. Walpole, Horace. *Anecdotes of Painting in England.* 4 vols. London, 1762–80; repr., New York, 1969.

WALPOLE 1980. Lewis, W. S., and John Riley, eds. *Horace Walpole's Miscellaneous Correspondence, III.* [vol. 42 of series] New Haven, 1980.

WARSAW 1956. *Wystawa malarstwa wloskiego w zbiorach polskich, XVII–XVIII w [Exhibition of Italian Paintings in Polish Collections, 17th–18th Centuries].* Exh. cat. Muzeum Narodowe, Warsaw, April 15–May 31, 1956 (catalogue by J. Bialostocki and J. Starzynski).

WARSAW 1964–65. *Drezno i Warszawa w twórczosci Bernarda Bellotta Canaletta [Bernardo Bellotto Canaletto in Dresden and Warsaw].* Exh. cat. Muzeum Narodwe, Warsaw, September–November 1964 (extended until January 1965); Muzeum Narodwe, Krakow, 1965 (catalogue by S. Lorentz, S. Kozakiewicz, and H. Menz). Exhibition previously shown [as *Bernardo Bellotto gennant Canaletto in Dresden and Warschau*] at the Albertinum, Dresden, December 8, 1963–August 31, 1964.

WASHINGTON 1941. *National Gallery of Art. Preliminary Catalogue of Paintings and Sculpture. Descriptive List with Notes.* Washington, D.C., 1941.

WASHINGTON 1945. *Paintings and Sculpture from the Kress Collection.* National Gallery of Art, Washington, 1945 (catalogue by David E. Finley and John Walker).

WASHINGTON 1951. *Paintings and Sculpture from the Kress Collection Acquired by the Samuel H. Kress Foundation 1945–1951.* National Gallery of Art, Washington, 1951 (catalogue by William E. Suida).

WASHINGTON 1956. *Paintings and Sculpture from the Kress Collection Acquired by the Samuel H. Kress Foundation 1951–1956, National Gallery of Art.* Washington, D.C., 1956 (catalogue by William E. Suida and Fern Rusk Shapley).

WASHINGTON 1959. *Paintings and Sculpture from the Samuel H. Kress Collection.* National Gallery of Art, Washington, 2nd ed. 1959.

WASHINGTON 1961–62. *Art Treasures for America: An Anthology of Paintings and Sculpture in the Samuel Kress Collection.* Exh. cat. National Gallery of Art, Washington, December 10, 1961–February 4, 1962.

WASHINGTON 1975. *Jacques Callot Prints & Related Drawings.* Exh. cat. National Gallery of Art, Washington, June 29–September 14, 1975 (catalogue by H. Diane Russell et al.).

WASHINGTON 1975–76. *Master Paintings from The Hermitage and The Russian State Museum, Leningrad.* Exh. cat. National Gallery of Art, Washington, July 30–September 9, 1975; M. Knoedler & Co., New York, September 16–October 29, 1975; The Detroit Institute of Arts, November 6–December 9, 1975; Los Angeles County Museum of Art, December 16, 1975–January 25, 1976; The Museum of Fine Arts, Houston, February 4–March 16, 1976; The Fine Arts Museums of San Francisco, August 6–October 9, 1976.

WASHINGTON 1980–81. *Picasso: The Saltimbanques.* Exh. cat. National Gallery of Art, Washington, December 14, 1980–March 15, 1981 (catalogue by E. A. Carmen, Jr.).

WASHINGTON 1982. *Eighteenth-Century Drawings from the Collection of Mrs. Gertrude Laughlin Chanler.* Exh. cat. National Gallery of Art, Washington, June 20–September 6, 1982 (catalogue by Margaret Morgan Grasselli).

WASHINGTON 1983. *Painting in Naples from Caravaggio to Giordano.* Exh. cat. National Gallery of Art, Washington, February 13–May 1, 1983 [shown previously at the Royal Academy of Arts, London].

WASHINGTON 1983–84. *Leonardo's Last Supper: Precedents and Reflections.* Exh. cat. National Gallery of Art, Washington, December 18, 1983–March 4, 1984.

WASHINGTON 1984–85. *Watteau 1684–1721.* Exh. cat. National Gallery of Art, Washington, June 17–September 23, 1984; Galeries Nationales du Grand Palais, Paris, October 23, 1984–January 28, 1985; Schloss Charlottenburg, Berlin, February 22–May 26, 1985 (catalogue by Margaret Morgan Grasselli and Pierre Rosenberg).

WASHINGTON 1985–86. *The Treasure Houses of Britain.* Exh. cat. National Gallery of Art, Washington, November 3, 1985–March 16, 1986.

WASHINGTON 1988–89. *The Art of Paolo Veronese 1528–1588.* Exh. cat. National Gallery of Art, Washington, November 13, 1988–February 20, 1989 (catalogue entries by W. R. Rearick).

WASHINGTON 1989–90. *Frans Hals.* Exh. cat. National Gallery of Art, Washington, October 1–December 31, 1989; Royal Academy of Arts, London, January 13–April 8, 1990; Frans Halsmuseum, Haarlem, May 11–July 22, 1990.

WASHINGTON 1990–91. *Anthony van Dyck.* Exh. cat. National Gallery of Art, Washington, November 11, 1990–February 24, 1991 (catalogue by Arthur Wheelock et al.).

WATERHOUSE 1972. Waterhouse, Ellis. "Some Painters and the Counter-Reformation before 1600." *Transactions of the Royal Historical Society* 22 (1972): 103–18.

WATSON 1965–66. Watson, Francis J. B. "The Guardi Family of Painters." *Journal of the Royal Society of Arts* 14 (1965–66): 266–89.

WEALE 1889. Weale, James W. H. *A Descriptive Catalogue of the Collection of Pictures belonging to the Earl of Northbrook.* London, 1889.

WEINBERG 1961. Weinberg, Bernard. *A History of Literary Criticism in the Italian Renaissance.* Chicago, 1961.

WELLER 1992. Weller, Dennis. *Jan Miense Molenaer (c. 1609/10–1688): The Life and Art of a Seventeenth-Century Dutch Painter.* Ph.D. dissertation, University of Maryland, 1992.

WESCHER 1963. Wescher, Paul. "Die Kress-Schenkung für Raleigh." *Pantheon* 21, 1 (January–February 1963): 8–13.

WESTMACOTT 1824. Westmacott, Charles Molloy. *British Galleries of Painting and Sculpture* London, 1824.

WETHEY 1955. Wethey, Harold E. *Alonso Cano: Painter, Sculptor, Architect.* Princeton, 1955.

WETHEY 1962. Wethey, Harold E. *El Greco and His School.* 2 vols. Princeton, 1962.

WETHEY 1969–75. Wethey, Harold E. *The Paintings of Titian.* 3 vols. London, 1969–75.

WHEELOCK 1977. Wheelock, Arthur K., Jr. *Perspective, Optics, and Delft Artists around 1650.* New York and London, 1977.

WHITELY 1977. Whitely, Jon. *Ingres.* London, 1977.

WHITLEY 1928. Whitley, William T. *Artists and Their Friends in England 1700–1799.* 2 vols. London and Boston, 1928.

WILDENSTEIN 1932. Wildenstein, Georges. "L'exposition de l'Art français à Londres, le XVIIIe siècle." *Gazette des Beaux-Arts* 7 (January 1932): 54–76.

WILDENSTEIN 1954/1956. Wildenstein, Georges. *Ingres.* Paris, 1954; ed. cit., 2nd ed., London, 1956.

WILENSKI 1931. Wilenski, R. H. *French Painting.* New York, 1931; repr. 1949, 1979.

WINTER PARK 1991. *Italian Renaissance and Baroque Paintings in Florida Museums.* Exh. cat. Cornell Fine Arts Museum, Rollins College, Winter Park, Fla., March 14–May 5, 1991 (catalogue by Arthur R. Blumenthal).

YOUNG 1825. Young, John. *A Catalogue of the Collection of Pictures, of the Most Noble the Marquess of Stafford, at Cleveland House, London* 2 vols. London, 1825.

ZANETTI 1771. Zanetti, Antonio Maria. *Della pittura veneziana e delle opere pubbliche de' veneziani maestri.* Venice, 1771.

ZERI 1976. Zeri, Federico. *Italian Paintings in the Walters Art Gallery.* 2 vols. Baltimore, 1976.

ZIFF 1963. Ziff, Jerrold. "Background, Introduction of Architecture and Landscape: A Lecture by J. M. W. Turner." *Journal of the Warburg and Courtauld Institutes* 26 (1963): 124–47.

Index of Works in the Exhibition, by Artist

Index of Works in the Exhibition, by Location